Tales
Things
Tell

Princeton University Press

Princeton and Oxford

Tales Things Tell

Material Histories of Early Globalisms

Finbarr Barry Flood
and Beate Fricke

Contents

A Note on Transliteration vi
A Note on Dating vi
A Note on Geographic Terms vi
Acknowledgments vii

Introduction: Archives, Flotsam, and Tales of Globalism 1

Part 1. From al-Andalus to Germany: Objects, Techniques, and Materials

Chapter 1. Melting, Merchandise, and Medicine in the Eastern Mediterranean 23
Censers on the Market 23
Ore and Origins 33
Changing Shapes 38
Incense and Medicine 41
Censers in Motion 44
Temporalities 46

Chapter 2. Knowledge and Craft in Medieval Spain and Germany 53
Innovation in Making Niello 53
The Nature of Niello 55
Three Different Histories of Niello 56
Inspiration and Imitation 73
Spiral as Essential Structure 77
Spiral as Sign 79

Chapter 3. Coconuts and Cosmology in Medieval Germany 87
A Composite Object 87
Looking Beyond and Within 92
Treasures and Trophies 95
Changing Functions 99
Fruits from Paradise 101
Incarnated Knops 107

Part 2. From Iraq to India and Africa: Technologies, Iconographies, and Marvels

Chapter 4. Magic and Medicine in Medieval Mesopotamia 113
 Magic-Medicinal and Incantation Bowls 113
 Poison Bowls and Precedents 118
 Hydrophobia and Surrogacy 127
 Serpents, Scorpions, and Quadrupeds 131
 Similarity and Sympathy 135
 Constellation, Commodification, and the Portable Library 138

Chapter 5. Distance Made Tangible in Medieval Ethiopia 147
 An Equestrian Relief 147
 Prophet, Saint, and King 157
 Princely Hunters 162
 Maritime Chimeras 165
 Indian Antecedents? 171
 Objects, Images, and Material Connections 183

Chapter 6. Narrative and Wonder in the Indian Ocean 191
 An Iraqi *Maqāmāt* 191
 Sailors and Slaves in a Maritime Cosmopolis 196
 The Artist as Exegete 204
 A Wondrous Interlude 211
 A Magical Denouement 215
 Anachronisms, Survivals, and Revivals 219

Conclusion: Global, Local, and Temporal 229

 Notes 235
 Bibliography 253
 Index 283
 Image Credits 292

A Note on Transliteration

In order to make the text as accessible as possible, diacritics have been used only when titles are cited, and when words or phrases are transliterated from the original language.

A Note on Dating

Dates given throughout are according to the secularized Latin Christian era known as the Common Era. Exceptions are made when objects, monuments, and texts are dated according to the Islamic (*hijri*) calendar. In these cases, both *hijri* (H) and Common Era (CE) dates are given.

A Note on Geographic Terms

Rather than referring to regions by terms that reflect their geographic position relative to Europe, continental descriptors are used throughout. For example, "west Asia" instead of "Near or Middle East," "east Asia" instead of "Far East," etc.

Acknowledgments

The chronological and geographic scope of this project means that it has necessarily benefited enormously from the advice and assistance of a wide range of colleagues and friends. Without a Collaborative Research Fellowship from the American Council of Learned Societies (ACLS) in 2016, it would never have seen the light of day. The book has also received substantial support from the European Research Council (ERC) project "Global Horizons in Pre-Modern Art" based at the University of Bern.

The discussion of incense in chapter 1 benefited tremendously from discussions with Theresa Holler, whose forthcoming study "The Other Herbal: Literature and Art as Medicine" addresses the conjunction between medical knowledge and religious practice in early and high medieval art. Ivan Drpić graciously read and commented on the entire chapter.

Chapter 2 benefited from discussions with Corinne Mühlemann and Latin translation suggestions made by Aden Kumler and Christoph Sander. An earlier version of this research was presented with Corinne Mühlemann as part of a workshop in Madrid for the IS-LE COST Action CA18129: "Islamic Legacy: Narratives East, West, South, North of the Mediterranean (1350–1750)," organized by Borja Franco and Antonio Urquízar Herrera.

Finbarr Barry Flood would like to acknowledge a special debt to the late Marilyn Heldman (d. 2019) for her generosity in sharing critical insights into the history and historiography of Ethiopian art during many conversations. Those insights were invaluable to the development of chapter 5.

For advice and assistance of various kinds we are immensely grateful to Andrea Meyers Achi, Tamar Alpenidze, Semeneh Ayalew, Mzia Chikhradze, Yemane Demissie, Ivan Drpić, Ivan Foletti, Helina Gebremedhen, Elizabeth Giorgis, Jacopo Gnisci, Andrew Griebeler, Lyla Halsted, Theresa Holler, Zumrad Ilyasova, Jitske Jasperse, Katherine Kasdorf, Franz Kirchweger, Irina Koshoridze, Meekyung MacMurdie, Griffith Mann, Therese Martin, Kindeneh Mihretie, Corinne Mühlemann, Livia Notter, Saskia Quené, Sasha Rossman, Marika Sardar, Emilie Savage-Smith, Andrew Sears, Nino Simonischwili, Gia Toussaint, Marina Warner, Ittai Weinryb, Nadia Wipfli, and Ahmed Zekariyya.

For assistance with obtaining or supplying images, we owe warm thanks to Nebahat Avcıoğlu, Serpil Bağcı, Lamia Balafrej, Elizabeth Bolman, Massumeh Farhad, Adeline Jeudy, Stephennie Mulder, and Bas Snelders. Thanks are also due to Andreas Kostopoulos and the American Research Center in Egypt, to Marta Gamba and the librarians of the Biblioteca Civica Angelo Mai in Bergamo, to Jeremy Johns and the Khalili Research Centre, University of Oxford, and to Fahmida Suleiman and the Royal Ontario Museum in Toronto. We are grateful to Matilde Grimaldi for creating the maps accompanying each chapter.

For their indispensable help with everything from images and research materials to cartography, we are deeply indebted to Elena Filliger, Amélie Joller, Gregor von Kerssenbrock-von Krosigk, and Mariko Mugwyler.

We are immensely grateful to Michelle Komie at Princeton University Press for her support with this project, and for the incisive comments and suggestions of the three anonymous reviewers who read the initial manuscript. Our gratitude is also due to Sara Lerner and Francis Eaves for guiding us through the production press.

The completion of the manuscript of this book was greatly facilitated by the hospitality provided by Nina Zimmer and Michael and Pia Jarrell. We owe a debt of gratitude to them, and to all who have so generously supported the project.

Introduction

Archives, Flotsam, and
Tales of Globalism

Art history has tricked itself into believing that it is a discipline of images, when really it has always been a discipline of objects.[1]

—Michael Yonan, "Toward a Fusion of Art History and Material Culture Studies," *West 86th* 18/2 (2011), 240.

In an article entitled "Seeing the Past," published in the journal *Past and Present* in 1988, the historian Roy Porter wrote, "[I]n their workaday practice the vast bulk of historians remain latter-day iconoclasts. Our training encourages us to assume the primacy of written records in terms both of reliability and representativeness."[2] In the decades since this was written, a "material turn" in the humanities has done much to remedy the idea that history inheres only in texts and inscriptions. Rather than serving as supplements to written matter, the "real" stuff of history, artifacts and images are increasingly deployed as sources from which historians craft their narratives. In addition, recent approaches to pre-modern textual archives have acknowledged that the documentary value of textual archives is inseparable from the form and materials used to fashion the written sources that they contain.[3] This interest in integrating the documentary values of texts and things, and acknowledging texts as things, has coincided with a recent fascination with rethinking subject–object relations, witnessed in attention to the potential agency of material objects and to embodied engagement with them—from the material traces that objects have left on manuscripts and texts, for example.[4]

Moving beyond a traditional tendency to privilege semantic content or immaterial meaning over questions of form (codex versus role, or the forms of script used), medium (paper, papyrus, parchment, etc.), or use, such approaches foreground the objecthood of all kinds of archives.

The past decade has also witnessed the proliferation of historical and theoretical works written on and from objects as primary sources.[5] The writing of object histories, or of history from objects, inverts the traditional role of objects as props or supplements to historical narratives based primarily on inscriptions and texts, challenging the idea that historical truth inheres exclusively in written documents.[6]

We are, however, often confronted with objects that lack any kind of meta-data detailing their origins, the routes along which they traveled, and their meanings in the places in which they came to rest. In such cases there is a tendency to take for granted the capacity of the artifact to function as a kind of document whose historical value can be correlated with relevant secondary documents, such as inscriptions, historical texts, and other objects. This is despite the fact that the challenge of coordinating fragmentary material evidence with textual references to objects that are often marked by conventional ideals and specialized terminology is less than straightforward.[7] There are, moreover, times and places when the textual archive is extremely thin, or non-existent, for a variety of reasons. As the archaeologist Mark Horton noted in 2004, writing of medieval exchanges between northwestern India and East Africa, "[i]f we were to rely solely upon documentary evidence, then much of the trade of the Indian Ocean maritime world would be invisible."[8] In such cases, the documentary and historical value of material culture, whether archaeological remains, architecture, or artifacts, is fundamental.

The book that follows represents a collaboration between two medievalists who often face the challenge of writing histories for which artifacts, images, or monuments are the primary, or the only available, documentary evidence. That challenge is even more acute when objects or the ideas and techniques that they embody circulate beyond the boundaries naturalized in modern disciplinary specializations. This is the case with the objects discussed in the six following chapters. Each chapter presents a case study focused on a specific object or class of objects that indexes histories of circulation and reception across a geography from northern Europe to Ethiopia, and from the Red Sea to India. The case studies explore the circulation and reception of artifacts, imagery, and techniques across geographic and temporal distances, but also conversions and transformations that illuminate forms of cross-cultural and cross-temporal exchange that lie beyond the scope of most kinds of textual materials available to historians.[9] The studies range in medium from metal vessels to manuscripts, and from multimedia reliquaries to stone reliefs.

The six case studies are presented in two distinct but loosely interrelated sections. In part 1, we present a series of analyses concerning the circulation of objects, materials, and techniques between the Islamic lands of the Mediterranean (including their substantial non-Muslim communities) and the Christian kingdoms of al-Andalus and northern Europe. The final chapter in this section introduces a kind of material—coconut— that originated in the Indian Ocean but came to be enshrined in a German reliquary. This provides a segue into part 2, which moves us from

the Mediterranean to the Red Sea and Indian Ocean, considering the evidence for the inter- and intra-cultural reception of various forms of technologies, iconographies, and narratives of long-distance circulation. Sketching a series of direct and indirect connections between the central Islamic lands, the Horn of Africa, and western India, the three final chapters also consider the transcultural circulation of beliefs and knowledge concerning prophylaxis and protection from illness or misfortune and the practices that they inspired.

Implicit in the structure of the volume and the content of its chapters is the role, as a kind of hinge between both sections of the book, of Egypt: a region whose importance is apparent from the frequency with which we return to its cultures and histories, even if no single chapter is dedicated to an artifact of Egyptian provenance. The division between the two sections may initially seem arbitrary, but it reflects a distinction evident in the remarkable materials recovered from the Cairo Geniza, which document extensive trade networks extending across the Mediterranean from al-Andalus to Egypt, and from Egypt down the Red Sea to Yemen and across the Indian Ocean, but as distinct and non-overlapping circuits of exchange, the fulcrum of which was Cairo.

Our objects have been chosen for their ability to highlight segmented circuits of exchange between northern Europe, the Mediterranean, the central Islamic lands that were the heartlands of the Abbasid caliphate (750-1258), East Africa, and Asia. The chapters engage with both east–west and north–south exchange, acknowledging the role of the Mediterranean as a "connecting sea" but paying equal attention to the Red Sea and Indian Ocean worlds.[10] In many of our case studies, maritime connections were necessary but not sufficient conditions of reception: the intersections between sea and land routes were no less crucial. Taken together, the case studies loosely delineate a series of intersecting cultural geographies, stretching from Andalusia and central Europe in the west to Egypt, Iraq, and India in the east, and to the direct and indirect contacts of both with the highlands of Ethiopia at the southern extremities of the Abbasid and Fatimid caliphates. In contrast to some recent object-oriented histories of globalism, there is no claim of comprehensive transhistorical or transregional coverage, and no attempt to offer a total history of global connections (were such a thing possible), even for the periods under consideration. The so-called Silk Road—which, along with Mediterranean studies, has become emblematic of recent work on cross-

cultural exchange and early globalism—barely features in what follows, for example.[11] Instead, by offering "thick" analyses of six different objects or object types, our aim is to demonstrate the potential that micro-analyses hold for writing macro histories of connectivity while also foregrounding other transregional networks that have received less scholarly attention.

In some cases, the precise point of origin and date of our chosen objects is uncertain; in others the chronology of their circulation must be deduced from the evidence of reception. They reflect a range of possibilities, from an absolute absence of any textual documentation, to objects for which a reasonable amount of historical data can be constituted from unassociated but contemporary (or near-contemporary) sources, to images that mediate between different genres of texts, but do so visually. Where we do make use of written sources, we deploy a range of texts whose use is not necessarily standard in the interpretation of pre-modern art and architecture. These include lapidaries, legal texts, medical treatises, and travel narratives.[12]

Some of the objects that we analyze are well known, long integrated into the art-historical canon, even if the dimensions explored here have been ignored or neglected. Others are barely known and have hardly received any published attention. Taken together, however, they cut across a high-low divide that has been particularly pervasive in our own discipline of art history, with architecture or painting standing at the apex of a series of media favored by pre- or early modern elites: a hierarchy often reproduced in lecture hall and museum. Many (but not all) of the objects that feature in the chapters that follow were not produced in a courtly milieu, but were commodities made for the market, or even banal materials that gained value through the process of circulation and consequent status as rarities far from their points of origin.

Our collaboration on this project has extended over six years, a period marked by significant developments globally, and in the fields and disciplines within which we work. Both of us have been the authors of earlier publications demonstrating the value of images, objects, and material culture in general for understanding histories of transcultural circulation and reception that are not addressed in textual sources, or that offer alternative perspectives on those that are.[13] These works have, however, focused on specific object types or regions. By contrast, our case studies here move beyond a regional focus, to highlight material connections that contribute to understanding

early histories of globalism. The three studies in each of the two main sections of the book are written by a single author. Unlike many collaborations, which aim for the synthetic harmonization of individual voices, we have retained our differences in emphasis and register, acknowledging variations in approach fostered by our respective training and instincts as intrinsic to the process of collaboration. Every chapter is, however, informed by the discussions and exchanges, critiques and suggestions that have been fundamental to the research and writing.

Working on complex cross-cultural materials demands a range of skills that lie beyond the capacity of any single scholar. Despite the inevitable limitations of any collaboration, our hope is that looking collaboratively across and beyond our fields—whether with the eyes of a western medievalist on the Islamic world or an Islamicist on medieval Christendom—will contribute to scholarship on pre-modern connectivity at a moment when the need for collaborative approaches to complex material that crosses boundaries and established disciplinary specializations in so many ways is becoming ever more pressing.

Archives

Our original title for this book, and for the collaborative project out of which it emerged, was "Archives of Flotsam: Objects and Early Globalism." The rationale for this choice is explained below. However, at the request of the press, concerned about the potential ambiguities (rather than the intended synergies) evoked by the conjunction of the two framing metaphors, the book appears under its current title. Narrative, the telling of tales, is central to the craft of the historian, who is often obliged to (re)construct historical phenomena from fragments, whether carefully curated or random survivals, to fill the gaps created by disparities in the documentary or material remnants of the past with subjective choices and assumptions that are not always made explicit, yet without lapsing into invention, or the writing of fiction. As this suggests, the tales that can be told from material remains are potentially multiple even if not infinite. Despite the poetic alliteration of the final title of this book, our preference throughout is to refer to those material remains as "objects" rather than "things." The latter term has enjoyed considerable popularity in certain forms of modernist discourse,[14] while the former remains more common among scholars of premodernity. Although the distinction between things and objects in modern scholarship is often

predicated on questions of perception and the relative value afforded materiality, the choice of a term that might be seen as dialectically opposed to the "things" of our title is in no way meant to diminish attention to questions of materiality. Nor is it intended to sideline consideration of the relationship between objects and the human subjects who produce, perceive, and use them: topics that surface at many points below. Instead, like the original framing metaphor for the book, with its ambiguous tension between archive and flotsam, the play between terms is intended to highlight the ambiguities and slippages that characterize those relationships and the ways in which we perceive and write about them.

Our original choice of the archive as one of two framing metaphors for the six case studies that follow resonates with a recent turn to the archive as a historical-material phenomenon across the humanities. This offers precedents for endeavors to broaden the range of materials available to historians beyond those associated with a courtly milieu. We think, for example, of attempts to reconstruct the cultural, material, ritual, and social life of Jewish merchants from Egypt, Yemen, and elsewhere, resident on the south coast of India in the twelfth century, from their letters preserved in the Cairo Geniza (a conventional term for a vast store of documents found in the Ben Ezra synagogue of Fustat in Cairo) and in other Cairene synagogues.[15] These related histories provide profound insights into the transregional networks that stretched from India to the Red Sea and the Mediterranean in the period covered by several of our case studies. They demonstrate how rich the possibilities are for crafting complex transcultural and transregional histories from randomly preserved materials found outside the world of rulers and the court. A recent cache of medieval documents excavated in the trade emporium of Quseir al-Qadim on the Red Sea coast of Egypt, for instance, preserves documentary traces of merchants, not the kinds of carefully crafted official documents found in royal archives. Nonetheless, this mundane archive of paper fragments was crucial in enabling historians to reconstruct cultural, economic, and social histories to which the maritime and terrestrial networks connecting the Red Sea to the Indian Ocean and Mediterranean were central. These histories included insights into aspects of social practice such as the role of amulets and magic in offering protection to those moving along often treacherous maritime routes: a topic to which we will return in chapter 6.

Unlike these archives, which contain corpora of documents written on paper or cloth, the case

studies that follow are concerned with objects. Although the very term "archive" may conjure an image of dusty repositories of fragile and crumbling texts, or even a wonderfully well-ordered storehouse of documents and manuscripts, recent work on historical archives and libraries has reminded us that "everything in an archive is an object," while also drawing attention to the surprisingly common presence within them of a range of artifacts, from inscribed clothing to "objects without writing that become documents exclusively by virtue of context."[16] The inclusion of such objects in archives of traditional form suggests the need to broaden our understanding of what constitutes an archival document. Here, however, rather than focusing on objects preserved alongside written documents in royal, mercantile, or state archives, we aim to foreground the archival value of objects *in general*:[17] not as supplements to the textual record, but as sources of aesthetic, historical, iconographic, and technical knowledge in their own right that, like the materials preserved in traditional archives, are capable of documenting, preserving, and transmitting information about historical phenomena. Their role in this regard is as relevant to cross-cultural circulation and reception in the past as it is to our own endeavors as historians working transculturally and transtemporally in the present. In the particular context of this volume, we foreground the value of objects as documents capable of illuminating remarkable patterns of transregional circulation and reception that we see as integral to forms of early globalism. Our approach is, perhaps, the mirror reflection of a recent tendency, influenced by contemporary art practices, to view archival materials "as both historical resources and aesthetic objects of contemplation and display."[18]

For us, the archival value of images, objects, and monuments is inseparable from questions of facture, form, and materiality: objecthood and archival value coincide.[19] Until recently the objecthood of traditional archives has often been considered secondary or irrelevant to their informational content. For much of the second half of the twentieth century, a similar tendency manifested itself in our own discipline of art history, reinforced by the dominance of iconographic studies. At their most extreme, these have tended to treat objects and images in much the same way as historians have traditionally treated their textual sources: as vehicles for immaterial meanings to be decoded according to their conformity (or not) to a variety of textual sources, thus sidelining the agency of artisans who might innovate or draw on non-canonical or oral versions of familiar narratives and tales now preserved in written sources.

The value of iconographic analysis is not in doubt. It has, for example, been demonstrated by recent studies of iconographical innovations in western medieval, Byzantine, and Islamic art highlighting the evidence that these offer for cross-cultural or transregional reception in ways that complicate traditional art-historical notions of regional style, or even the passive reception implied by notions of "influence."[20] However, while by no means rejecting the value of iconographic analysis—indeed we make abundant use of such approaches in several of our case studies—we see this as but one among many approaches in the methodological toolbox of the art historian or historian of material culture more generally.

The great appeal of the material turn is precisely its ability to overcome the traditional dichotomies and oppositions between texts, images, and things by emphasizing the need to attend to questions of facture, function, materials, and technique that, far from being secondary to meaning, are intrinsic to it. Rather than reducing our approach to one of hunting elusive textual documentation alone, therefore, we put our primary emphasis on the need for close attention to the artifacts themselves; to consideration of form, materials, scale, and technique. Such analysis offers a starting point, a necessary but not sufficient condition for revealing aspects of making and reception not generally documented in texts and inscriptions, even where these are available, and for considering what work our chosen objects did in the worlds that made them or in which they came to rest.

Even the most fragile of objects can travel over remarkable distances as commodities or gifts, forging commonalities in the material cultures of elites, for example, or unfolding new perspectives for a beholder even outside the elite milieu: an innovative usage, or novel stories not even imagined or intended by their makers. Objects can ignite new ideas, point out novel lineages of thought, and can develop a power they did not have in their original contexts. They can heal, cause miracles, and inspire or participate in new rituals. The mediating capacity of objects can, on occasion, assume dimensions which we would call today "transmedial," with motifs transmitted between artifacts made in different materials and different contexts, as we shall see in chapters 1, 4, and 5.

In addition, objects that circulate can function as sources of technical information and vectors

of its dissemination. Recent anthropological and sociological approaches to the diffusion and adoption of artisanal techniques have emphasized the central role that artisans play in such phenomena, "because only expert artisans are able to understand the advantages of the properties of a new technique and are therefore in a position to select it."[21] In addition, insights into the circulation of artisanal forms of knowledge, modes of making, in early modern Europe and across Eurasia have demonstrated the importance of embodied knowledge, observation, imitation, and repetition as primary vectors for the transmission of technical knowledge that cannot be fully apprehended by textual or verbal description.[22] Among the best documented cases from the Islamic world, we might mention the technique of luster, an adaptive use of metallic glazes formerly applied to glass on ceramics. The technique developed in Iraq around the ninth century and was exclusive to the region until the late tenth century, when it appeared in Egypt (and later, Syria and Iran). These developments are assumed to reflect the migration of artisans, since "the technique cannot be copied simply by the observation of objects."[23]

In other cases the transfer of knowledge about modes of making can be associated with the circulation of portable artifacts that acted as de facto reservoirs of such knowledge. In the medieval Islamic world, it has even been suggested that textiles functioned as vectors for the transmission of mathematical knowledge.[24] The appearance of new techniques sometimes represents an adaptive extrapolation from the experience of objects that have traveled long distances—this may be the case with the niello metalworking technique discussed in chapter 2. Similarly, the deployment of block-printing for the production of amulets in Egypt (and possibly elsewhere) from the tenth century may either represent the transmission of a tradition of xylography that originated in pre-Islamic China, or an adaptation from the block-printing of textiles, many of which traveled to Egypt from Gujarat on the west coast of India.[25] The sudden emergence of a major inlaid metalwork industry in eastern Iran around the middle of the twelfth century, on a scale not previously seen, may likewise reflect the sudden availability of silver-inlaid Indian brass sculptures taken as booty or of metalworkers brought westwards following campaigns of expansion into north India, or both.[26]

In the latter case, the sudden proliferation of a technique that was not previously widespread in this region suggests the mobility of artisans and/or techniques that in other cases has been inferred

from the presence of forms and motifs. The presence of metalworkers trained in the Islamic lands in Constantinople in the tenth century has, for example, been inferred from the form and ornamentation of certain silver vessels.[27] Yet, we know surprisingly little about the artisans responsible for crafting such artifacts. In the case studies that follow, we rarely have the names of the artisans who crafted our objects. Even when we do, these do not necessarily tell us much; we know the name of the calligrapher and painter responsible for the manuscript discussed in chapter 6, for example, but little more about him.

The constitution of every archive is governed by mechanisms of inclusion and exclusion, often reflecting the articulation and operation of underlying power structures.[28] Such archival evidence as survives "has been shaped not only by the exigencies of recording mode and medium, and unforeseen events, but also by human agency, which could include destruction and always involved selection."[29] When it comes to the archival potential of extant objects, mechanisms of exclusion and inclusion often operate according to visibility. These include both the practical capacity to analyze material residues of the past (based on questions of survival, physical access, and so forth) and the particular vision of the historian, with its inevitable blind spots and preferences. There is, in addition, an unavoidable irony in the basic methodological fact that, in order to function as archives in the sense imagined here, objects must be translated into prose through description: another selective and often subjective art.[30]

The objects that constitute the disparate archive we have assembled for this volume enable us to access traces of use, practices of ornamentation, and technologies of production, among other phenomena. However, less visible (and therefore less accessible) are oral or verbal practices associated with these objects' function and use.[31] In addition, while we can trace some of the trajectories followed by the objects that form our case studies, we are often unsure as to whether these were direct or mediated, and of the relative role that maritime and terrestrial networks played in their mobility. In the absence of accompanying meta-data, large parts of their voyages remain invisible. A salutary example involves a group of early Islamic Egyptian and Iraqi textiles preserved in the monastery of Debra Damo in Tigray, Ethiopia, until the second half of the twentieth century when they were sold on the art market and entered museum collections as Egyptian and Iraqi textiles. Were it not for the fact that they had

been documented in their Ethiopian context in the 1930s (part of a scholarly project associated with the Italian Fascist occupation of the country), this phase in their biographies would have been completely obscured.[32] Similarly, in the case of the censers discussed in chapter 1, in most cases the site of production is unknown, as is the region in which they were used and kept, buried, or preserved until they were sold. These two cases also exemplify the way in which modern practices of collecting and the market, through which pre-modern artifacts are divorced from any context, devoid of provenance, can produce them as various kinds of "flotsam."[33]

As this suggests, like all archives, our object archives are fragmentary, partial, and constituted both by the operation of human agency and historical contingencies. Whether resulting from the operation of serendipity or human agency, the necessary pre-selection of all archival materials extends to the work of the modern historian of material culture and the role that the objects of our study play in the micro-histories and macro-narratives that we construct. In addition, whether taking a comparative approach or focusing on histories of connectivity, the writing of histories that involve more than one culture or region is challenged by questions of commensuration arising from significant differentials in the natures of the available archives and/or their relative standing within historiographic traditions that have invariably skewed toward Europe. As Bonnie Cheng notes,

> Meaningful comparisons between regions requires roughly balanced sets of sources; and despite the vast material, textual, and oral traditions in Africa, China, India, or the Islamic world, these regions have not yet attracted generations of scholars to the study of their art forms in a way parallel to classic traditions in Europe.[34]

Adding to the methodological challenges, our ability to write histories about and from objects is inevitably shaped by gaps or lacunae in the material record, which may or may not reflect historical realities. The different ways in which these inflect our readings of the object archive are addressed in each of the chapters that follow. As we shall see in chapter 2, for example, such lacunae can also lead to uncertainty about whether we are dealing with independent or related transregional phenomena. Similarly, in chapters 4 and 5 the paucity of the extant evidence impels us to ask whether we are dealing with regional continu-

ities in the circulation and production of certain kinds of artifacts and images, or periodic revivals amounting to more temporally disjunct phenomena. These uncertainties need to be acknowledged, and raise questions about chronology and periodization that we will return to in the Conclusion.

Our material archive is characterized by the absence of commensuration in ways that may or may not accurately reflect the constitution of the pre-modern networks to the existence of which it attests. We note, for example, that the abundance of pre-modern Islamic ceramics, metalwork, and textiles that survives in medieval Christendom does not seem to be reflected in a similar range of medieval European materials in the Islamic world or further east. At least for the period we are discussing, with a major focus on the twelfth and thirteenth centuries, it may well be that goods of European manufacture, including luxury goods, were simply not in the same demand in the Islamic lands as were raw materials, or not in demand to the same extent as Islamic portable objects were in Europe:[35] what may be due to the vagaries of survival may also be the product of a wide range of cultural factors of various sorts. Many of the Islamic materials preserved in Europe were once collected in church treasuries or princely collections, both of which often formed the basis of modern museum collections.[36] This is true even of outside continental Europe: Georgia or Ethiopia, for example, are regions whose church treasuries contain a remarkable array of portable artifacts that originated in the central Islamic lands (Egypt, Syria, and Iraq), as we shall see in chapter 5.

Adding to the challenge of writing history from such sources is the fact that the materials available to us are often singular; this can reflect the fact that they were rarities or unica at the time of their production, but might also be the result of chance survival, through simply being collected and preserved. Some of the studies that follow deal with examples of objects which appear today as rarities, but were in fact produced in multiples or series; this is the case with the metal vessels discussed in chapters 1 and 4, for example. Other objects among our case studies are unique survivals, archives constituted in singularity rather than multiplicity, as individual components of a more extended corpus. This might seem at odds with the very idea of an archive as a collection, but in our fields, entire historiographic or interpretive edifices have often been built on a very slim evidential base. As a result, a single artifact, image, monument, or text has the potential to radically reconfigure existing landscapes of interpretation,

challenging established canons, historiographies, and cultural imaginaries.

The problem of singularity is amplified when objects travel. Many of the images and objects to be discussed had traveled long distances, adding to their perceived rarity and value in the premodern cultures that viewed, used, and copied them. In addition, some of the objects considered here include materials that were mundane in the lands in which they originated, but precious rarities in the distant places to which they traveled. They include skillfully crafted artifacts such as those discussed in chapters 3 and 5: rock crystal carvings included in Christian reliquaries, and gem- or paste-encrusted Indian shields found in Ethiopia. But they also include natural materials such as coconut, or ostrich egg. Artifacts in which such materials are combined (see chapter 3) are quite literally composite, but some of our case studies concern artifacts that are composite in their combination or constellation of images and texts with different histories, and often different origins (see chapters 4, 5, and 6). In some instances, these composite images draw upon iconographies that originated in far-distant lands, but that were made accessible by their presence on portable objects (ceramics, metalwork, textiles) that circulated widely (such as those discussed in chapter 5).

Flotsam

Considering the vagaries involved, the objects that constitute our material archive resemble flotsam, cast on the shores of our own time like the ambergris or coconuts discussed in some of our case studies, carried by the ocean currents until collected as rarities. The metaphor seems especially apt for a book in which maritime connections play a starring role (albeit often in conjunction with terrestrial routes that lay far from the sea), whether those of the Mediterranean, Indian Ocean, Gulf, or Red Sea. The metaphor of flotsam also underlines the fact that many of the case studies lack contemporary meta-data; in many cases, even the date and origins or provenance of the chosen artifacts are disputed.

Despite its limitations, the contingencies associated with the idea of flotsam might even be seen as an advantage, imbuing such materials with archival value that does not easily lend itself to the totalizing narratives of linear, synchronic, or teleological history. Since our choice of objects is inevitably governed by contingencies of various sorts, our chosen metaphor of flotsam is intended to mitigate the totalizing implications

of an archive seen as a closed system of empirical facts. The point is well made by the cultural historian Jessica Berenbeim, who writes as follows of the experience of encountering unwritten objects of various sorts preserved in archives of written documents:

> That emotional intensity of connection offered by the object itself is then locked in a mutually reinforcing opposition with the ostensibly disinterested context of the archival system. This dynamic relation therefore fuses the subjective and objective states that are, paradoxically, both fundamental to ideas about the production of historical knowledge.[37]

If, however, the idea of flotsam admits of the contingencies and subjectivities that inevitably govern our approaches to the past through its material traces, it also reminds us that, unlike jetsam—that which is deliberately discarded—flotsam is often not intentionally abandoned, but cast upon the ocean by the vagaries of chance, either by falling overboard or due to shipwreck (with resulting legal ambiguities regarding ownership). Of course, such a metaphor risks marginalizing the operation of human agency, which often determined the trajectories along which our objects traveled as commodities, curiosities, gifts, relics, or souvenirs. Yet even the trajectory of flotsam is marked by the operation of both agency and contingency; flotsam is, for example, subject to the motion of ocean currents until salvaged from the sea or cast upon the shore. Just as the currents that carry flotsam may be shifting and inconstant but rarely random, so the tides that carried most of the materials discussed in these chapters were commercial, diplomatic, or pilgrimage networks along which people, things, and ideas flowed and whose precise trajectories and intensities were determined by a shifting constellation of ecological, economic, and political factors, even if we cannot always fully reconstruct these.

Like flotsam cast upon distant shores, the objects discussed below bear signs of use, and reuse, of transition and transformation, documenting journeys not always recorded in written sources. Just as object archives may be singular or multiple, they may be constituted by the operation of individual or collective agency. Their trajectories may not have been known and their archival potential may or may not have been acknowledged or realized at their point of origin. They nonetheless have a capacity to act as reservoirs of aesthetic, historical, and technical knowledge: networked

histories of making, meaning, and reception constituted relationally. The Islamic metalwork discussed in chapter 2 was not produced to act as a technical exemplar; nonetheless, through a kind of reverse engineering, it served to transmit a particular technique, that of niello, to artisans in Christendom. Conversely, the Islamic metal bowls discussed in chapter 4 were inscribed with a vast array of data concerning their intended function and conditions of production, a knowing nod to their own potential status as material archives of illustrious histories and instrumental knowledge capable of generating copies.

If the objects discussed in the chapters that follow sometimes resemble flotsam, then the activities of the historian resemble those of the beachcomber, whose capacity to offer narrative reconstructions of the past is not only limited by the availability of what is cast upon the shore, but once again by questions of visibility—by the fact that their eyes will inevitably be attuned to certain kinds of forms and materials but not to others, for example. Inevitably, when it comes to collaborative writing over such a wide cultural geography, many kinds of imbalances, differential emphases, and lacunae both reveal and perform themselves. While the tendency to focus on luxury goods or artifacts associated with elites (especially those preserved in European and American collections) reveals itself in almost all of the fields across which we range, this is especially true of art-historical enquiry. The discipline of archaeology has been much more sensitive to the need to take a more expansive approach to historical materials, but this has sometimes led to an emphasis on commercial exchange at the expense of other forms of culture contact. There are also significant variations in the emphases of contemporary scholarship across continents and regions. Recent scholarship on the Indian Ocean region has, for example, criticized the persistent focus on commercial exchange rather than other mechanisms of circulation, including diplomacy and gifting; conversely, studies of textile production in medieval Europe have criticized the focus on luxury goods, museum pieces, and diplomatic exchange at the expense of the consideration of more utilitarian production and commercial factors.[38]

In addition, the selection of the case studies presented in this volume inevitably reflects choices made on the basis of our own experience, interests, and training, as medievalists and as white Europeans attempting to sketch the outlines of a series of loosely connected histories that extend well beyond Europe. For the philosopher Michel de Certeau, it is in fact historians themselves who create fragments, the shards from which histories are reconstructed, through a selective treatment of historical materials organized according to periods and taxonomies, which privilege some and marginalize or sideline others, sweeping them aside as historical detritus that cannot be shoehorned into the categories of analysis that (explicitly or otherwise) structure scholarly narratives: dynastic, sectarian, nationalist, and so forth.[39] But it is precisely those things that don't quite fit, that are "out of place" according to prevailing taxonomic structures, that offer the richest materials for demonstrating the latters' limits.

A recent study of medieval documents excavated in the Red Sea trade emporium of Quseir al-Qadim captures the necessity of weaving a narrative from what are often random survivals, arguing that in such cases, "there can be no storytelling in the traditional sense; what we witness here is a pastiche of scrambled shreds in search of a narrative."[40] Similarly, the art historian George Kubler worked in the field traditionally known as "pre-Columbian" art, in which names of artists or craftsmen were generally lacking. There were no primary sources which described the process of making the objects that he studied, nor were there textual sources that described how these objects were used and received. In the face of these challenges, Kubler emphasized the importance of paying attention to form. He introduced a theory of morphology paired with temporality. He suggested that we examine objects as elements within formal chains that stretch over time. Every now and again, a "prime object" will emerge that seems to have been triggered by a significant change in the trajectory of what he termed "the chain of objects." This object could then trigger a change itself. These prime objects enable us, Kubler suggested, to analytically crack open otherwise "voiceless" objects, since they draw our attention to an event, or a moment of contact/rupture, which demands analysis. He wrote that "[t]he history of art in this sense resembles a broken but much-repaired chain made of string and wire to connect the occasional jeweled links surviving as physical evidence of the invisible original sequence of prime objects."[41]

The bowls discussed in chapter 4 below seem to have been first produced at a particular moment in the twelfth century, but to have been produced subsequently through a practice of copying existing models. However, they represent a combination of elements drawn from earlier, pre-existing traditions with novel types. They thus attest to Kubler's observation that "every work of

art is a bundle of components of different ages," or, in the terms of the art historian Georges Didi-Huberman, to the "impure time" of the artwork.[42] The phenomenon raises significant questions regarding the temporality of such objects, to which we will return in our Conclusion, but it also suggests that it may be more apt—and more interesting—to try to understand certain kinds of objects as part of entangled spatio-temporal networks, rather than products of a single place or time.

Consequently, while Kubler's focus was on the artist who produced a "prime object," our own approach shifts the focus from a prime object, master artist, or originary culture to the relational elements of a network whose traces we can glimpse but that we can never fully reconstruct. In what follows, we try to consider the histories (including origins) of our objects in relation to the transcultural networks (commercial, diplomatic, epistemological, religious, etc.) that they articulated and within which they were embedded. We may never fully understand the entire network or fully understand the actions or motivations of the human actors involved in the production, distribution, and reception of these objects; but we can still recover fragmentary elements of these stories by grounding the largely neglected histories of making and reception that are our focus in close attention to the objects themselves: to their formal, iconographic, and technical qualities.

We should emphasize that we are not suggesting a "return to the object" as a self-subsisting artifact, with all the problems of that approach. Nor are we aiming to write the "biographies" of objects, despite the current popularity of these following Igor Kopytoff's classic 1986 essay on the cultural biography of things.[43] Although the context of this essay is often ignored, Kopytoff introduced the concept of object biography to describe the status change of the slave, transformed from a human agent to a commodity, an object of trade.[44] Inspired by Kopytoff's essay, archaeologists and art historians have seized upon "biographical" histories of objects as a way of moving beyond a static focus on origins or singular meanings. Within current debates about acquisition and provenance, such a move has attracted criticism for naturalizing the presence of non-Western artifacts in Euro-American museums, as being just one more moment in their unfolding histories.[45] Less often acknowledged are the ways in which the popularization of object biographies, the exclusive focus on things, ignores or marginalizes the profoundly disturbing implications of Kopytoff's essay for the degradation and trans-

formation of living human subjects into objects. And yet, it is impossible to divorce questions of commodification, labor, and violence from the histories enabled by objects. Several objects in our case studies may have involved slave labor and/or were traded along routes that, although often celebrated as sources of cosmopolitan connection, were also those along which those coerced into forced labor or slavery traveled, as we shall see in chapter 6.

Rather than championing the idea of the object as either self-subsisting or as the subject for the writing of biographical histories, our starting point is the need to take objects seriously as archival documents capable both of transmitting aesthetic, iconographic, and technical knowledge and of playing a role in the narrative reconstruction of the past. Once again, questions of visibility are central to our capacity to activate the archival value of historical flotsam. The appearance of new kinds of imagery, imported artifacts, or objects locally crafted using non-local materials or new techniques are all useful indexes of the kinds of pre-modern connectivity with which this volume is concerned. However, the methodological role of such "things out of place" in modern reconstructions of pre-modern connectivity depends on a number of subsidiary moves that scholars make, but which are rarely acknowledged explicitly in the analysis: the capacity to distinguish diachronic iconographies from synchronic novelties, for example, or to identify the point of origin of certain artifacts or materials, often based on comparisons provided by earlier published examples of similar things.[46] Such analysis is always already permeated by a dialectic between sameness and difference—such as the relationship between novelty and rarity, or, conversely, the attenuation of novelty value as certain forms or materials become naturalized through repetition.

It is here that the kinds of unique survivals that appear as flotsam come into their own, providing material testimony to the reality of pre-modern long-distance connections and insights into their nature and effects. Among such flotsam, we might include an Indian ivory datable to the first century CE excavated from the ruins of Pompeii, a sixth-century Himalayan bronze Buddha found at the Viking site of Helgö in Sweden (along with Irish, continental, and Mediterranean artifacts) (fig. 1), or Chinese Buddhist images and sutras on paper and silk excavated from a ninth- or tenth-century grave at Moshchevaya Balka in the Caucasus, possibly belonging to a trader.[47] Such artifacts not only materialize the abstractions of long-distance networks, but remind us of

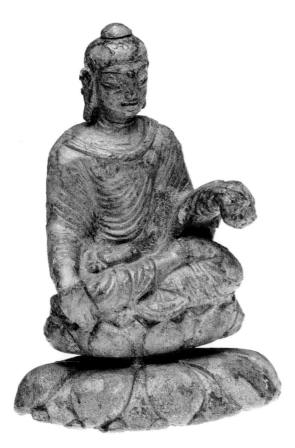

Fig. 1 Buddha figure from Kashmir or Swat, 6th–7th century CE, excavated at Helgö in Sweden. Bronze; h. ca. 8.5 cm. Stockholm, Statens historiska museum.

the human agents whose mobility defined them long before the current era of global mobility. In addition to the materials and regions discussed in this volume, archaeological excavations of a Viking longhouse and Viking sagas tell us of travelers from Iceland to Newfoundland long before Columbus. Similarly, the Walsperger map (1449) includes hints at possible earlier maritime voyages to South America.[48] Such material evidence can sometimes be supplemented by accounts of pre- and early modern travelers from Africa, Asia, and Europe, reminding us of the mobility of certain individuals or classes of people across various kinds of networks linking all three continents.[49] However, the mobility of such free agents and their capacity to record their travels must be set against the forced mobility of human beings along the same networks and the subaltern labor necessary to sustain them—subjects that will be addressed in chapter 6.

With notable exceptions, analysis of the kinds of archaeological finds that are central to reconstructing such histories of mobility sometimes privileges questions of local identity, function, and dating in relation to regional histories and historical events, rather than considering the implications of certain materials for histories of transregional circulation and translocal reception.[50] Certain highly mobile objects assumed new roles in the contexts in which they came to rest, being reimagined and reused in innovative ways that differed from their original function. In addition to the examples discussed in chapter 2, objects from the east that traveled west, we might consider the case of a golden double cup made in the Rhineland in the twelfth century (fig. 2) but excavated from a grave in the Ukraine. Metal cups produced in medieval Europe and Byzantium often traveled remarkable distances eastward. These include a cup made in Europe found close to the Ob' river in Siberia (fig. 3).[51] The vessel is made of gilt silver and niello, a technique producing the blackish sections in the background for the interlaced decoration, which will be discussed at length in chapter 2. Such luxury objects may have traveled as gifts for diplomatic exchange or marriages, as booty in warfare, or as merchandise along trade routes. Objects such as glass vessels, metalwork, items of fashion, or jewelry traveling east or south from Europe are, however, far less documented than objects traveling west or north from the Islamic lands or further east.[52]

Such objects highlight the need to consider origins but also questions of portability and reception. Art-historical scholarship has tended to focus on the former rather than the latter, giving primacy to the endeavor to re-embed an object "out of place" (either geographically or taxonomically) within its culture of origin. Yet, if both vessels just cited demonstrate how far European objects could in fact travel toward the east, the context in which the former cup was found provides further insights into aspects of reception. The cup was discovered in the coffin of a deceased "prince" of the Qıpchaqs, a nomadic, Turkic tribe on the Black Sea steppe. The special role of the cup was indicated by its placement apart from other vessels and the associated remains of a powdery sediment (perhaps a medicament or pharmacological substance). As Renata Holod and Yuriy Rassamakin point out, while such vessels were likely "initially imported to the steppe themselves as containers or gifts, [they] seem to have been adapted to local usage in the aid of this wounded leader."[53] This kind of reimagining and repurposing of objects and of the imagery that they bear and the technical information that they encode is characteristic of many instances of cross-cultural and transregional reception in the case studies comprising this volume.

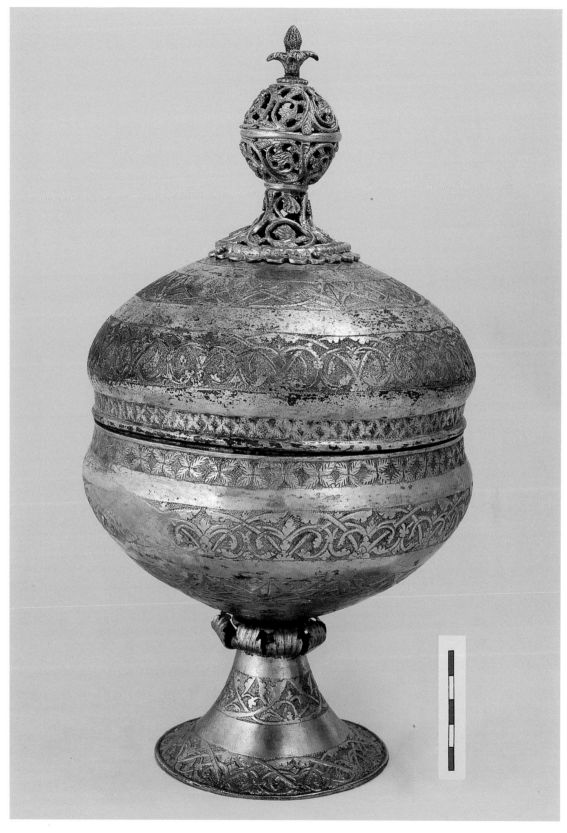

Fig. 2 Covered cup from Chungul Kurgan, Ukraine, made in the Rhineland, mid-12th-13th century. Kyiv, Museum of Historical Treasures of Ukraine.

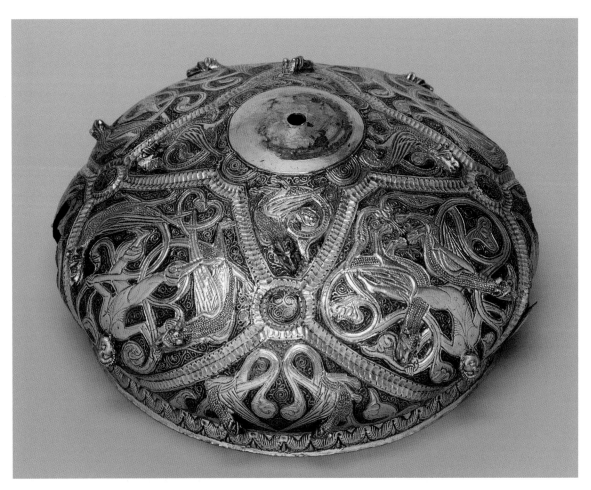

Fig. 3 Bowl of a drinking cup, Europe, 12th century. Silver, silver gilt, and niello; 7.9 × 17.5 cm. New York, Metropolitan Museum of Art (Cloisters Collection), inv. no. 47.101.31.

In the case of the cup found in a burial in the Ukrainian steppe, it is uncertain whether the object traveled to its Black Sea resting place by land or by sea. Since many of the case studies that follow concern maritime and oceanic connections, an interesting counterpart to the kinds of mobile vessels and rare survivals excavated on land can be found in an example of flotsam that we do not discuss in the chapters that follow, but which is highly relevant to our theme. This concerns a ship that sailed between the Levant (then contested between the Seljuq Turks of Iran and the Fatimid caliphs of Egypt) and the ports of the Black Sea, then mostly held by the Christian rulers of Byzantium, and which foundered off Serçe Limanı near Bodrum on the west coast of Turkey around 1025. The ship was carrying glass cullet, a raw material, but also contained everyday artifacts and personal effects. That they ended up on the seabed of the Mediterranean along with the now long-vanished remains of the crew was a cruel

accident of history, a reminder of the reason for the terror that maritime voyages inspired, even in seasoned travelers, and the consequent recourse to protection, a theme to which we will return in chapters 5 and 6.

However unfortunate, by that accident some of the structure and many of the contents of the vessel were preserved, providing a snapshot of eleventh-century trade, interregional contacts, and mercantile mobility. Among the objects recovered from the Serçe Limanı wreck was a 17 cm-long bronze sword hilt (fig. 4). The hilt is decorated with a stylized bird of a very particular type, known in Sanskrit as a *hamsa*, or celestial swan, a creature common in eleventh- and twelfth-century Indian temple carvings (see fig. 170), and once widely diffused in other media.[54] Painted or carved on portable objects, like many of the mythical creatures we will encounter in our case studies, the *hamsa* often traveled abroad from its Indian homeland, alighting far from home, including

in the highlands of Ethiopia, as we shall see in chapter 5. The long-distance circulations and receptions to which these survivals bear witness may seem surprising, but they were by no means unique. Around the same period, iconographic elements derived from Indian, likely Buddhist or Jain, and even Chinese sources appeared on an ivory casket made for the Byzantine Christian elites of Constantinople.[55]

Since the iconography and imagery of this sword hilt recovered as flotsam from the eastern Mediterranean is clearly Indic in origin, it might reasonably be assumed that the object represents the random survival of an Indian artifact in the medieval Mediterranean. However, despite its imagery, the form of the hilt is consistent with an eastern Mediterranean tradition of weaponry, while scientific analysis of the bronze comprising the hilt indicates an east European or Near Eastern source for the metals from which it was fashioned. The transport of such ores over long distances would not be without precedent: recent research has identified statues crafted in Ife, in Nigeria, as using lead from Lower Saxony, for example, or statues made in Tada, also in Nigeria, as using copper mined in the French Massif Central at the turn of the fourteenth century.[56]

On the basis of this disjunction between iconography, form, and metal content, the excavators of the Serçe Limanı hilt concluded that the hilt was *either* made in India using an unfamiliar form and materials imported from further west, *or* was produced in the eastern Mediterranean by an artisan familiar with Indian iconographies.[57] On the available evidence, we cannot decide between the two, but one other possibility is that it was made for or by members of an Indian diaspora involved in Mediterranean trade in the eastern Mediterranean during the first half of the eleventh century.[58] Evidence for the presence of Indians in the medieval Mediterranean has never been systematically studied, but, in addition to trade, warfare and slavery were clearly mechanisms for the circulation of human agents across and beyond Africa, south Asia, and the Islamic world, as we shall see in the chapters that follow.

Both the cups and sword hilt and the contexts in which they were found raise interesting questions about diasporas, displacement, and mobility, and our ability to read or recognize all of these aspects of the past that are germane to our own project. While we may not be able to answer the complex questions raised by such intriguing objects, our capacity to pose them at all not only rests on their chance survival, but also results from the possibility of deploying a range of analytical tools that effectively compensate for the lack of any accompanying meta-data, including texts or inscriptions.

Globalism

Oscillating between the contingencies of flotsam and the documentary potential of the archive, the objects of the case studies that follow constitute archives of flotsam. This guiding metaphor undergirds an approach that acknowledges a productive tension between the particularities of production, reception, and survival, and the capacity of certain objects to illuminate more global histories of contact and connection. This book is written at a moment when the production of transcultural and transregional histories of circulation and reception is burgeoning. The proliferation of such scholarship under the rubric of early globalism reflects contemporary discourses and experiences of globalization. But it also reflects an increasing awareness of the limitations of the disciplinary frameworks within which we work as scholars of the past: their inability to account for many of the complexities associated with pre- and early modern phenomena of mobility. As medievalists working in different regions, the present authors are familiar with the limits imposed by the epistemological structures within which we operate, too often partitioned according to disciplinary specialties, their limits often set according to region, religion, or modern national boundaries.

Attempts to transcend these limits in writing pre- and early modern global history (including cultural history) have adopted a variety of methods and models, that might broadly be distinguished as a comparative approach (offering a synchronic snapshot that cuts between different geographies, for example) or, alternatively, those more concerned with historical connections and exchanges between cultures and regions.[59] Each approach has its pitfalls related to historiographic and methodological lacunae or imbalances in the extent and nature of the relevant archives.

In an overview of recent approaches to premodern globalism, the art historian Alicia Walker notes that many share a common goal: "to shift scholarly approaches away from a focus on origins and localities as the defining factors of history and toward the consideration of movement across boundaries traditionally defined by language, religion, ethnicity, and geography."[60] Our own approaches owe a debt to many of these endeavors, including the idea of connected history with its emphasis on transcultural entanglements,[61]

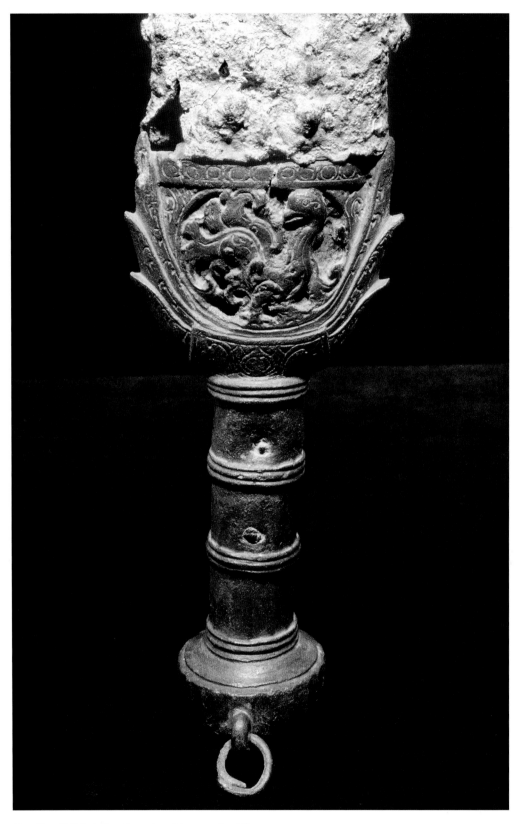

Fig. 4 Sword hilt featuring a *hamsa* (auspicious swan) motif,
before 1020 CE, excavated in the Serçe Limanı shipwreck,
Turkey. Bronze; l. 25 cm, hilt 17 cm.

and *histoire croisée*, an approach that considers the multiplicity of historical connections and intersections, while also acknowledging the role of the modern historian as a participant in the phenomena that she narrates.[62]

Early work on the histories of globalism tended to focus on economic and commercial criteria, on the mobility of commodities, financial instruments, and materials. More recently, other forms of mobility, related to diplomacy and gifting, for example, have attracted scholarly attention, while yet other approaches have used the interrelations between religion and trade as a frame for exploring global history.[63] Yet even here there are disparities, with certain regions of the world (Africa, for example) seen as contributing little more than natural resources and raw materials, rather than being granted full participation in complex multifaceted histories of circulation and connectivity.

In addition, a notable aspect of recent object-oriented approaches to early globalisms is a consistent focus on early modernity, the period from roughly 1500 to 1750 CE.[64] In practice, this both privileges the writing of histories for which greater archival resources are available than for earlier periods, and often constitutes such histories as expanded, more global versions of European history. The inevitable foregrounding of European engagements with the world that results from the privileging of early modernity risks compounding a double marginalization of the so-called pre-modern and non-west while simultaneously consolidating and reinscribing Europe in its traditional role, at the center of things. By contrast, our case studies are intended to highlight histories of production, circulation, and reception which do include the region today known as Europe, but only as one region among many. Indeed, Europe was largely irrelevant to the remarkable circuits of exchange and mobility between North Africa, the Horn, the Gulf, and the Indian Ocean discussed in the second part of this book, offering the possibility of a historically and materially grounded approach to decentering or provincializing Europe.[65]

If the presentist thrust of the contemporary humanities risks contributing to the marginalization of the pre-modern in ways that reinforce the hegemony of Euro-American history, it needs to be acknowledged that the discipline of medieval studies is itself marked by significant phenomena of marginalization. In addition to questions of ethnicity, race, and labor, the traditional Christocentric and Eurocentric emphases of medieval studies are relevant here.[66] The need to acknowledge intercultural connections and shared tastes

is increasingly common in studies of the medieval Mediterranean,[67] but in many of these Islam comes into focus largely because of its contacts with Christendom. Similar patterns are apparent in scholarship on histories of circulation and connections in other regions. Although historians have outlined the role of the Indian Ocean in a shifting configuration of transregional cultural and economic connections in which Africa, the Mediterranean, and west and south Asia were imbricated before the period of European dominion,[68] insofar as African involvement is concerned, even here a skewing toward the early modern period is evident. As a result, while early modern Afro-Eurasian, including Afro-Indian, connections have received increased attention in recent scholarship,[69] similar connections in preceding periods are just coming into focus as a result of growing attention to archaeological and art-historical evidence for contacts between East Africa, the Horn, Arabia, and western India in the eleventh through thirteenth centuries, and indeed even at much earlier periods.[70]

Where attempts have been made to construct more coherent, holistic, and inclusive histories of the pre-modern world, these have sometimes reproduced or reinforced boundaries that may or may not be relevant to the materials from which such histories are constructed. Welcome initiatives to integrate the study of medieval Africa into a more global framework have, for example, sometimes been structured along sectarian lines, dealing with histories of Christian, Jewish, and Islamic communities as if distinct, despite the crossings and intersections apparent in the materials discussed in chapter 5. A recent call for medieval Ethiopia to be included within a more global approach to medieval studies notes the need to "consider more fully the place of medieval Ethiopia in the history of early Christian societies, in terms of economic and social history," in order to bring to light "new histories of connectivity, regional circulation and exchange."[71] An alternative approach, closer to the one adopted here, might see the cultures of the Horn as marking a significant point of intersection between the Christian ecumene of the East and what has been called Islamicate Eurasia.[72] Indeed, as we shall see, the materials from Ethiopia suggest that its medieval connections extended beyond both.

The privileging of early modernity reflects and reinforces a kind of literalism resulting from a conflation of universal and global history. This assumes that one can speak of the global in any meaningful sense only after a historically situated consciousness of the entire globe emerged, a

development often equated with the appearance of Europeans on the continents of the Americas (and, later, Australasia).[73] This is taken as axiomatic by world systems theorists such as Immanuel Wallerstein, who correlates the origins of the modern world system with the rise of Europe.[74] By contrast, in a celebrated work published in 1989 the historian Janet Abu-Lughod argued the need to recognize a fourteenth-century "world system" that emerged before the period of European hegemony. For Abu-Lughod, a key factor was the Mongol conquests of west Asia in the mid-thirteenth century, which integrated regions from Anatolia to China within a unified imperial formation fostering the emergence of intersecting or segmented networks of circulation and exchange that facilitated long-distance exchange between merchants and producers.[75]

Recent attempts by archaeologists, historians, and art historians to rethink early globalisms from a material culture perspective have suggested that the phenomenon existed as far back as the early historic period, and included circuits not well represented in Abu-Lughod's reconstruction, such as West Africa and northern Europe.[76] Some globalized approaches to pre-modernity have situated themselves in a single century, or a specific year, while others have taken a diachronic perspective, traversing a millennium or more. Some have argued for the existence of a globalized late antiquity marked by artistic interconnections, an incipient globalization in the sixth century, or the existence of a world system in the period between 600 and 900 CE, and so forth.[77] In addition, some historians have argued the need for a periodization of world history based on the nature and density of cross-cultural interactions as a fundamental criterion of taxonomy.[78]

Rather than insisting on a moment of origin, or thinking of globalism as a single continuous phenomenon, we might think in terms of nodes and networks defined and exploited by forms of connectivities that waxed and waned over time. Writing of the distinction between globalism and globalization, the political scientist Joseph Nye suggested that "[g]lobalism, at its core, seeks to describe and explain nothing more than a world which is characterized by networks of connections that span multi-continental distances." The distinction acknowledges differences in the scale and speed of modern and pre-modern global connectivity, but avoids insisting on the absolute alterity of pre-modernity on the one hand, and, on the other, asserting a teleology of connectivity that validates contemporary phenomena of globalization. As Geraldine Heng notes,

To attest to the world's interconnectivity as forms of globality, or as the globalisms of different eras, perhaps better retains a sense of the variety and character of the global connectivities of those earlier eras, without yoking all to a single relationship with contemporary globalization, and forcing a resemblance.[79]

Nye acknowledges that, in contrast to more Eurocentric notions, which insist that the global requires a historically situated consciousness of the entire globe, "[g]lobalism is a phenomenon with ancient roots. Thus, the issue is not how old globalism is, but rather how 'thin' or 'thick' it is at any given time."[80] The challenge, therefore, is to try to reconstruct something of the shifting configurations, the waxing and waning of the networks of various kinds that fostered connectivity. As the historian Alan Strathern reminds us, "[t]he celebration of connectedness in global history writing risks analytical banality unless we are also able to make visible temporal and geographic variations in its extent."[81]

Our case studies tack between the micro-level of analysis—focusing on the objects themselves and the particularities of their reception in specific locales—and the implications of both of these for histories and theories of early globalism that operate at a macro-level. As the historian Carolyn Steedman puts it, in mobilizing their archives to tell tales of the past, historians endeavor "to conjure a social system from a nutmeg grater."[82] The present study is not immune to this impulse, selecting six case studies out of the many possible in order to sketch a loose history of African and Eurasian connectivities. But in addition to highlighting the vagaries of all historical reconstruction, the trajectory from object to system also illuminates a relationship between the micro-level of analysis and the macro-level of interpretation. The narratives that we construct from our case studies range in scale from the micro-level of technique and iconography to macro-histories of mobility and reception that illuminate entanglements between cultural geographies sometimes imagined as distinct, if not self-contained. Like many of our objects themselves—assemblages or constellations in which the whole is greater than the sum of its parts—our micro-histories suggest the outlines of macro-histories of circulation and reception, connecting what are often imagined as unrelated cultural geographies.[83] In this regard, our approach is close to that of historians who have adopted a "micro-spatial" approach to histories of globalism, eschewing the recon-

struction of world-scale phenomena in order to consider "periods when the interlocking of various regional systems did not extend to the globe as a whole." Significantly, such approaches have acknowledged the value of objects for narrative reconstructions of globalism, whether as indexes of cultural connection, as synthetic residues of global difference, or as imaging the global networks in which they are embedded.[84]

Our selected case studies range in date from late antiquity to the fourteenth century, with a particular focus on what European historians see as the "long twelfth century," between roughly 1050 and 1250 CE. We are aware that some of the connectivities that we discuss have a longer history, even if the networks that fostered these connections waxed and waned. But our aim is to focus attention on a period that saw a series of major developments across Eurasia and Africa, yet whose importance has often been eclipsed by subsequent developments, whether the emergence of the world system fostered by the Mongol empires, or the globalisms of early modernity. This long twelfth century preceding the Mongol sack of Baghdad in 1258 has long attracted the attention of historians of the Islamic world who have, whether implicitly or explicitly, seen it as marking a self-reflexive intensification of transregional connectivity both within the Islamic world and beyond its borders.[85] In the European sphere discussed in the first part of this book, the period saw growing exchange between al-Andalus, southern Italy, and northern European schools, markets, and courts. Although manifest, with differing intensities and consequences, in different regions, related economic and technological developments included growing productivity of manufacture, farming, and the rise of merchant capitalism, together with increasing urbanization and a growth in scholarly activities intimately related to mobility and textual translation. These significant developments were reflected in an impressive rise in the production of written documents, accompanying and recording economic, technological, and artistic innovation.

The period also saw significant cultural and political transformations that fostered connectivity between northern Europe, the Mediterranean, west Asia, Africa, and east Asia,[86] including the Crusades, the conquest of northern India by a Muslim dynasty, an intensification of maritime connections between East Africa, the Gulf, and India, and the establishment of an Ethiopian dynasty with direct or indirect connections to these regions.[87] In addition to the fostering of networks constituted by diplomatic exchange, pilgrimage, and scholarship (among other spheres), the period also saw the rise of powerful mercantile confederations or guilds in southern India, Egypt, and northern Europe: developments discussed in the relevant chapters that follow.

The period covered by our case studies is particularly difficult to label, especially since different regions have embraced different terms and approaches regarding its periodization. In European art history, this period is often termed "medieval," indicating its traditional role as an interstice or interlude, a "Middle Age" between classical antiquity and the Renaissance, both traditionally seen (however problematically) as high-water marks of European humanistic culture.[88] Although some western "medievalists" have rejected the term, recently a case has been made for its continued utility, and even for extending its purview in contemporary scholarship to the history of regions such as West Africa or Ethiopia.[89]

On the other hand, the term "pre-modern" enshrines a concept of the modern which is teleological in its assumptions and profoundly Eurocentric in many of its incarnations, and which often produces the cultures and histories of the past as a negative image of the modern, a necessary foil. Conversely, the teleological thrust of many concepts of modernity serves (implicitly or otherwise) to locate those contemporary cultures seen as inadequately modern in a persistent pre-modern or medieval past.[90] In this sense, the "pre" of pre-modern is comparable to the "non" of non-Western. Both are forms of negative coding. There is no easy solution to the significant challenges posed by periodization, even when dealing with a single cultural context. In our own writing, we move between the use of the terms "medieval" and "pre-modern," partly as a way of acknowledging the instability and problematic nature of both terms and the periodization that they imply.

The problem of periodization in cross-cultural contexts is raised in a much more basic way by the use of different calendrical systems in different geographies and regions, challenging any simple opposition between modern and pre-modern periods within a linear concept of historical time.[91] These differences throw into stark relief problems of commensuration closely allied to questions of power and representation in the writing of any transregional history, problems with both spatial and temporal implications. Writing of current phenomena of globalization, the anthropologist Michel-Rolph Trouillot puts the issue succinctly: "Which temporalities do we privilege? Which spaces do we ignore? How do

we set the criteria behind these choices? A world perspective on globalization requires attention to differential temporalities and the uneven spaces that they create."[92] In this volume, we make use of just two of the calendrical systems; those, that is, that reflect concepts of temporality most immediately relevant to our own positions as a western medievalist and an Islamicist: the Common Era (CE), or recently secularized western Christian solar dating system, which takes as its starting point the date traditionally given for the birth of Christ; and the *Hijri* system (H) used in the lunar calendar adopted by most Islamic cultures, the year zero of which is the migration of the nascent Muslim community from Mecca to Medina in 622 CE. Beyond the macro-level of calendrical systems, however, the selectivity of the choices that we make in representing chronology and temporality are no less apparent at the micro-level of dating our chosen objects, a topic to which we will return in our Conclusion.

Like the images and artifacts that they present, our analyses in the six case studies presented in the chapters that follow attempt to move across and beyond the limits of field and discipline. In various ways, they illustrate how networks of diverse sorts (artisanal, commercial, diplomatic, or pilgrimage networks, for example) cut across and between particular cultural, economic, and political formations, fostering forms of circulation, exchange, and reception that offer rich materials for histories of early globalisms.[93]

Each of the chapters addresses a different set of practices and processes. Chapter 1 analyzes a corpus of bronze censers with Christian narrative imagery that were highly mobile. It explores connections between Palestine and the eastern Mediterranean along trade routes that extended north to the Caucasus. The chapter highlights connections between healing and narration that inform the dynamic function of the censers, their association with aromatics imported over long distances, and the potential of the evaporating smoke that they produced to connect heavenly and earthly realms. Chapter 2, by contrast, focuses not on mobile objects, but on the movement of artisanal and technical knowledge. Pursuing the route of a specific artistic technique—the making of leaded niello—from the western Mediterranean and Spain to central Europe and Germany, it demonstrates how primary sources describing the technique tell a tale rather different from that told by the surviving objects that exemplify it. Chapter 3 addresses the movement not of a particular class of object, but of a specific material—coconut—combined with Islamic rock crystal in the framing

of a precious relic. It demonstrates how knowledge about the palm tree bearing these fruits combined with Christian cosmological ideas to produce a conceptual and material assemblage of opaque and semi-transparent materials marked by carefully orchestrated contrasts between visible and hidden elements of the resulting whole.

Chapter 4 returns to themes of healing and narration, and the relationship between objects, practices, and rituals, this time in the Islamic lands. It examines an enigmatic series of metal bowls produced at the northern edge of the heartlands of the Abbasid caliphate, in southern Anatolia or northern Iraq. Used for healing and protection, the bowls appear to be a novel kind of commodity, in which long-established amuletic and talismanic technologies were brought into constellation with forms of imagery newly introduced to the arts of the Islamic lands. The monumental relief analyzed in chapter 5 then explores the mobility of some of this imagery beyond the southern limits of the Abbasid caliphate, at its point of intersection with a kingdom ruled by African Christian elites. Carved from the living rock, and so intimately rooted to place, this may seem like an exception to the condition of portability associated with the rest of the artifacts that we discuss. Yet, even here, the details of the carving reveal innovative engagements with imagery likely derived from portable objects that traveled long distances by land and sea, illuminating interconnections between western Asia, south Asia, and the Horn of Africa that have often been occluded both by disciplinary specializations and the lack of written documentation. The sixth and final chapter elucidates the interrelationships between different verbal, visual, and textual modes of narrating such transregional connectivities in the Indian Ocean world. Its subject is an image cycle in a thirteenth-century Iraqi manuscript, which evokes the maritime connections between the central Islamic lands, India, and East Africa. In addition to the insights that they provide into the mobility around the Indian Ocean littoral, the images provide a graphic illustration of the ways in which magico-therapeutic practices similar to those discussed in chapter 4 could be deployed as protection at moments of existential threat, including those occasioned by the sorts of voyages essential to the phenomena of mobility that underlie all our case studies.

The chapters sketch a series of loosely connected histories and cultural geographies whose relations were sometimes direct, sometimes indirect. We seem in some instances to be dealing with examples of transcultural reception, and at

others with the transtemporal expression of parallel traditions with common roots in the world of late antiquity and its legacies to the Christian kingdoms of southern Europe, Africa, and to the Islamic world. In other cases, both are in play. Consequently, the materials analyzed in the chapters that follow not only offer a challenge to bounded notions of cultural geography and spatiality, but invite us to rethink questions of chronology and temporality, a topic to which we return in our Conclusion.

Taken cumulatively, our archives of flotsam suggest a thickening of Eurasian and African connectivity in the eleventh and twelfth centuries. We might, therefore, offer the tentative suggestion that the transcontinental connectivities whose histories we will discuss in the following case studies laid some of the foundations for the world system that emerged with the Mongol conquests. It was a system which, as Janet Abu-Lughod reminds us, was foundational for our own era of globalization.[94]

Part 1

From al-Andalus to Germany
Objects, Techniques, and Materials

Chapter 1 Melting, Merchandise, and Medicine in the Eastern Mediterranean

Chapter 2 Knowledge and Craft in Medieval Spain and Germany

Chapter 3 Coconuts and Cosmology in Medieval Germany

Map 1 Locations of the principal sites discussed in chapter 1. Map by Matilde Grimaldi

Chapter 1

Melting, Merchandise, and Medicine in the Eastern Mediterranean

Censers on the Market

In the year 1939, the chemist Friedrich Ludwig Breusch fled Nazi persecution and moved to Istanbul, where he resided until 1971. On his way to work every day, he passed through the city's bazaar, where he purchased seven antique bronze censers (including those shown in figs. 5 and 6).[1] Starting in the late 1800s, over one hundred bronze censers like these, decorated with Christian scenes, surfaced on the art market in North Africa, the Levant, and around the Black Sea. Most were bought by private collectors like Breusch and by museum curators developing their collections, such that a significant number landed in Europe and the United States (see figs. 11 and 12).

These censers were objects on the move: made of highly durable material and weighing relatively little (usually between 540 and 1,470 grams), they were relatively easy to transport and could remain in use for extended periods. The body of these bronze vessels fits comfortably into an adult palm, their upper opening measuring between 8 and 13 cm wide and their height varying between 6.5 and 9.5 cm.[2] When filled with burning coals and pieces of incense, the vessels became too hot to touch; eyelets extended above (or, for shorter censers, holes placed just below) the upper frame provided openings to which three sets of chains were attached. These enabled a censer to be carried or hung so that its scent could fill the air during religious ceremonies. Indeed, a few examples are still fitted with chains and with a small three-armed mount, also made of bronze (see figs. 11 and 21).

These objects can be dated only to roughly between the sixth to the twelfth centuries, and we do not know where, when, or by whom they were made. In this sense, they have come down to us as a form of flotsam, unmoored from time and place by virtue of their mobility. This lack of knowledge regarding dating and origins may have contributed to the fact that since 1900 only a handful of scholars have studied bronze censers with Christian scenes. Significantly, most of these researchers have come from marginalized fields or regional "area studies" within the discipline of art history. Other scholars have conducted their research on these censers in countries with limited access to relevant publications and have found themselves hampered by travel restrictions.[3]

Of the 108 censers preserved in public and private collections in Europe, west Asia, and the United States,[4] very few have received technical analysis.[5] All that we know for certain about these bronze censers is that, like the magic medicinal bowls that will be discussed in chapter 4, they seem to have been produced in relatively large numbers. We can neither locate nor date them with certainty, however. They seem to have circulated widely and the process of their circulation as well as their appearance on the market (both when they were made and subsequently) indicates a widespread and enduring interest that has nonetheless failed to shed much light on their origins and initial functions. The censers are most often assumed to have originated in the Holy Land, but this has not been proven conclusively.[6] Other censers recovered from hoards or excavations in the Holy Land are not decorated with Christian scenes (fig. 7). Furthermore, in the Byzantine world—especially after the sixth century and as opposed to in the medieval West—pilgrimage to the Holy Land played only a minor role in Christian practices.[7] Most of the censers we are concerned with here were found either in North Africa or the Levant, or around the Black Sea—regions, that is, where Christian communities coexisted with a growing Muslim population. This might support the argument that the censers were primarily used for local liturgical practices

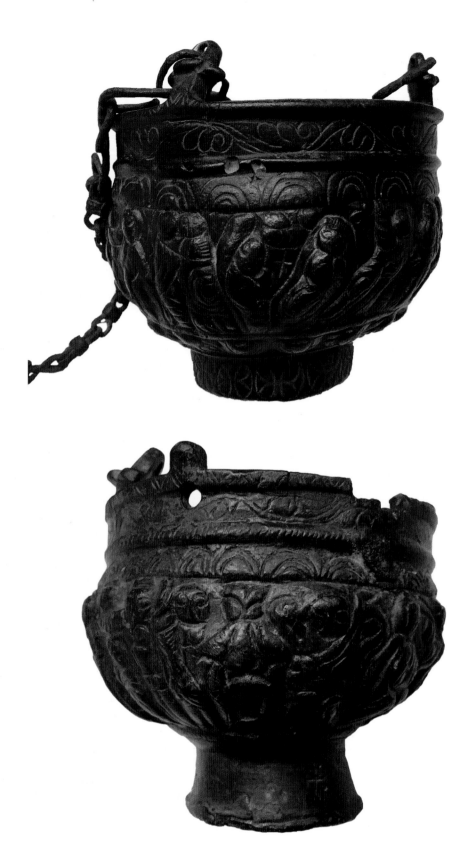

(TOP) *Fig. 5* View of the Visitation and Nativity from a censer with New Testament scenes, 6th–9th century. Bronze; h. 10.8 cm, dtr. 10.9 cm. Basel, Antikenmuseum, inv. no. BRE 644.

(BOTTOM) *Fig. 6* View of the Marys at the tomb of Christ from a censer with New Testament scenes, 6th–9th century. Bronze; h. 10.4 cm, dtr. 11 cm. Basel, Antikenmuseum, inv. no. BRE 643.

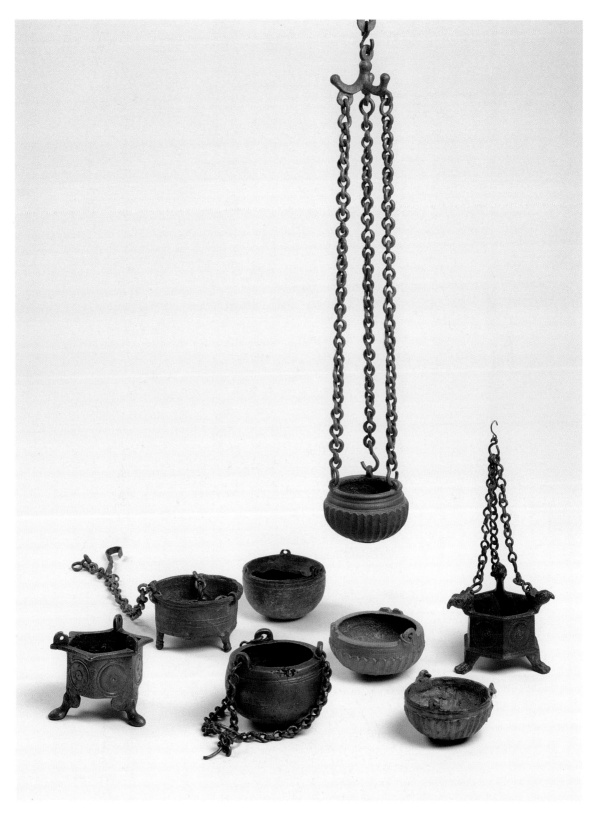

Fig. 7 Censers from the Holy Land, Byzantine. Bronze; dtr. 6–10 cm.
Jerusalem, Israel Antiquities Authority, inv. nos. 9645.I, 4446.I,
862.M, 40-1235, 52-111, 56-2, 78-1294, 97-4048.

Fig. 8 Photomontage of the narrative friezes of censers BRE 644,
BRE 643, and BRE 646 in the Antikenmuseum, Basel
(= Billod (1987), pl. 4).

Fig. 9 Drawing of the narrative frieze of censer BRE 644
in the Antikenmuseum, Basel (= Billod (1987), fig. 1).

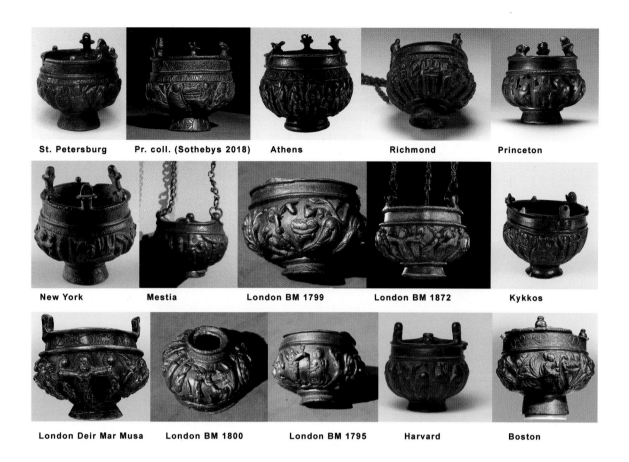

Fig. 10 Bronze censers with Christian scenes, ca. 600–1200 CE.

in Christian communities but not produced explicitly (or exclusively) for Christian pilgrims.

The censers appeared on the art market in the first decade of the twentieth century, when they entered numerous private and public collections. The lack of written sources relating to their acquisition has severed any potential ties that might identify their site(s) of origin, even through oral transmission in the form of tales told by collectors and vendors. We must therefore rely on the visual analysis of the objects and on the reconstruction of their material and cultural contexts. This is the case with the purchase by Friedrich Breusch—with which we began this chapter—of seven very different censers, containing four, five, or nine scenes, at the Istanbul bazaar in the mid-twentieth century (figs. 8 and 9). They lack any written evidence regarding their origin before appearing on the market.

Tellingly, none of the 108 bronze censers preserved today is an outright copy of another. This is important to note, since their mode of production, namely metal casting, could have lent itself to creating many iterations of a single form from one mold. Most censers were further worked over after they were cast, when lines, ornaments, and folds were hammered into their surfaces. In terms of fabrication, it seems that either the censers were cast with molds that were destroyed in the process, or that their production was so plentiful that no two versions of the same model have survived, since the objects were disposable. If they were, in fact, products of medieval "mass production," it is rather ironic that not a single identical pair has survived.

Narrative friezes on the censers presenting episodes from the life of Jesus range from four to twelve scenes per censer (fig. 10). On the basis of their iconography, a date of around 600 CE seems plausible for the earliest of the censers, while some were probably made significantly later.[8] This early date appears to be corroborated by similarities that the vessels present when viewed in relation to other objects: the positions of Jesus's crib and Mary in the Nativity scene (see fig. 5); the emphasis on the dove above Jesus in the baptism scene (fig. 11); Jesus's long tunic in the crucifixion scene (figs. 12 and 19); and the shape of his tomb

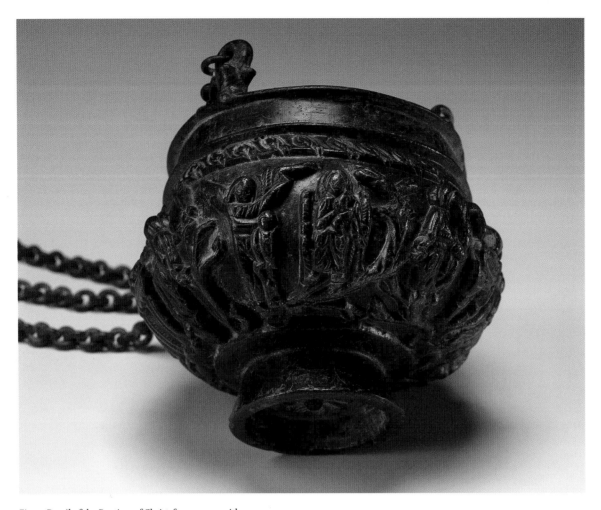

Fig. 11 Detail of the Baptism of Christ, from censer with scenes from the life of Christ, 6th or 7th century. Bronze; 11.43 × 12.1 cm. Richmond, VA, Virginia Museum of Fine Arts, inv. no. 67.27.

(see fig. 6) appear in paintings of Syrian origin dating to circa 600 CE. The friezes are most frequently compared to two paintings depicting the same scenes: the first is in the Rabbula Gospels, an illuminated manuscript of Syrian origin (fig. 13); the second is the painted lid of a wooden pilgrim casket from Palestine, now in the Vatican (fig. 14). Scenes revealing other similarities can be found on objects such as pilgrim ampullae or flasks (fig. 15); Byzantine amuletic armbands wrought in silver and bronze (fig. 16); and *eulogiae*, small tokens made from the clay of pilgrimage sites (figs. 17 and 18). The iconographical similarities across such a diverse group of objects used by Christians in private devotion, pilgrimage, and public religious ceremonies have strengthened the hypothesis that the earliest bronze censers were made at the same time, around 600 CE, and in the same Syro-Palestinian region; although, as we shall see, the issue is far from clear-cut.

Despite a general consensus on the range of possible dates, not a single censer can be dated with certainty—through contextual information from an excavated site, for example—and the iconographic or stylistic similarities are not strong enough evidence to support a firm chronology. In several cases where more precise dating has been suggested it has been based on comparisons with objects of differing materials, genres, and qualities. Inscriptions in languages such as Arabic, Armenian, Greek, or Syriac were added to some censers, which can aid in solidifying chronologies.[9] However, the question of whether this occurred immediately after casting or significantly later is a matter of scholarly debate.[10] Moreover, few of the dozen or so inscriptions display script characteristics that can be dated by paleographic analysis. Two early inscriptions that were probably contemporary to their production are found on censers preserved today in Geneva

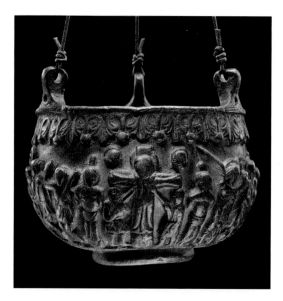

Fig. 12 Detail of the Crucifixion, from a censer with scenes from the Life of Christ, 6th or 7th century. Bronze; h. 8.3 cm, dtr. 11 cm. Berlin, Skulpturensammlung und Museum für Byzantinische Kunst, inv. no. 15/69.

(TOP RIGHT) *Fig. 13* Easter scenes (the Crucifixion, Marys at the empty tomb, and the risen Christ) from the so-called Rabbula Gospels, Syriac, ca. 586 CE. Parchment. Florence, Biblioteca Medicea Laurenziana, Plutei 1.56, fol. 13r.

(BOTTOM) *Fig. 14* Inside view of the painted lid of the so-called Vatican pilgrim casket from the treasury of the Sancta Sanctorum, possibly Syria, late 6th or early 7th century. Wood, gold foil, and encaustic; 24 × 18.4 × 1 cm. Vatican City, Museo Sacro, inv. no. 61883.2.1–2.

(TOP) *Fig. 15* Pilgrim's ampulla with (symbolic) crucifixion and Marys at the tomb of Christ, early Byzantine, 6th–early 7th century. Lead; 4.6 cm. Washington, DC, Dumbarton Oaks, inv. no. BZ.1948.18.

(BOTTOM) *Fig. 16* Bracelet with engraved New Testament scenes, Byzantine, 6th or 7th century. Silver; dtr. 7.9 cm. Columbia, MO, Museum of Art and Archaeology, inv. no. 77.246.

and Copenhagen. A Syriac inscription on a censer now in Geneva includes a final 'a' (aleph) of a type that has been employed in Syria since the eighth century.[11] An Arabic inscription on a censer now in Copenhagen written in early Kufic script reads, "In the name of Allah, made by Yaqʿub, son of Ishaq from Damascus." It not only points to the eighth century because of the script employed, but also refers to the city of Damascus in Syria as the home of the craftsman or his father.[12]

The idea that pilgrims brought these censers from the Holy Land to their hometowns has long been the dominant explanation for their widespread dissemination, a hypothesis that has never been questioned. Since 1910, when this was first proposed, knowledge about the circulation of ore, commodities, and humans (including slaves, soldiers, and merchants) during the early Christian era has significantly increased.[13] This chapter revisits the mobility of these portable objects, questioning pilgrimage as the primary reason for the censers' widespread dissemination and suggesting a broader framework for understanding their manufacture, their global dissemination, and the imagery found on their exteriors.

The lack of written primary sources detailing the histories of these objects does not mean that the censers constitute historical "dead ends." Instead, we need to improvise a methodology for addressing some of the lacunae in the historical record. The starting point must be an analysis of the objects themselves, which constitute a form of archive that may be mobilized to this end. We can, for example, scrutinize their morphological transformations, moving then to analyze images

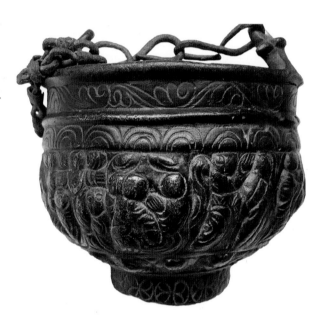

(TOP LEFT) *Fig. 17* Pilgrim token depicting Christ's baptism, from Qal'at Sem'an, Syria, 6th or 7th century. Terracotta; dtr. 1.6 cm. London, British Museum, inv. no. 1973,0501.29.

(TOP RIGHT) *Fig. 18* Eulogia token depicting the women at the tomb of Christ, from Beth Shean, mid-6th–early 7th century. Clay; dtr. 4 cm. Jerusalem, Israel Antiquities Authority, inv. no. 2479; 52-125 (token C).

(BOTTOM) *Fig. 19* View of the flight to Egypt and Crucifixion, from a censer with New Testament scenes, 6th–9th century. Bronze; h. 10.8 cm, dtr. 10.9 cm. Basel, Antikenmuseum, inv. no. BRE 644.

of them in use, and to connect censer histories with different types of evolving ritual practices known from textual and visual sources. Instead of relying on textual sources alone, we must seek the history of these objects in relation to that of other objects, as well as to what we know about changes in cultural practices and visual culture during the era when they were likely made and distributed. By embedding these censers in a larger network of knowledge about the early Christian past, we can understand them as archives of their own scattered history and as testimonies to a widespread and interconnected, though now lost, visual culture.

As archaeologist William Anderson has pointed out, it is art historians who have been largely responsible for setting the agenda for studying early Christian antiquities, such as these censers. Except for eulogia tokens and flasks related to the cult of Saint Menas at Abu Menas, near Alexandria in Egypt, the material culture of Byzantine pilgrimage has not been subject to rigorous taxonomic analysis, analyses of fabrics, surveys of finds, and considerations of context. These techniques all help to determine where artifacts came from, which is essential for establishing historical context.[14] Art historian André Grabar suggested in 1958 that certain pilgrim flasks originated in Constantinople, while more recent scholarly discussions tend to interpret their iconography as depictions of early Christian shrines in Palestine.[15] In the 1990s, devotional objects related to pilgrimage were analyzed with particular attention to written pilgrimage accounts, and were considered with regard to the objects' function as votive gifts used during private devotion or for protection, like an amulet.[16] In the case of censers, the great diversity of their morphologies, iconographies, locations at which they entered the art market, and inscriptions—alongside even vaster differences in their quality and manufacture—casts doubt on whether early bronze censers featuring Christian scenes all originated in one place. Some scholars have wondered whether—and these remain open questions to which we shall return—the censers were in fact made over a more extended span of time and across a larger regional expanse than has been previously assumed.

These questions of origin and collecting are one further reason why the censers resist seamless embedding in narratives of this period that have been written by historians of early Christian and Byzantine art. To theorize this resistance, the censers could be described as "flotsam" in the stream of writing histories: they are objects with the power to reveal the inherent forces that drive the construction of narratives about the past. As we unpack their potential meanings, we are required to challenge ideas about certain categories of connections and narratives that have been established retrospectively. Among these is the idea that pilgrims carried these bronze censers from the Holy Land to Egypt, the Levant, and sites around the Black Sea, as far as the mountain churches of Svaneti in Georgia.

Like all the objects discussed in this book, these bronze censers furnish a kind of material archive in themselves. If we attend to them closely, we can reveal aspects of a historical record that have hitherto remained obscured. In order to unlock this archive, it is necessary to combine technical and visual approaches and analyses with considerations of historical change across cultural and religious practices and their related visual cultures. The censers we are concerned with here not only traveled geographically, but also invited their users to embark on different kinds of journeys in time and space through the objects' religious uses, which were deeply connected to strategies of visual depiction. Like the materials discussed in the following chapters, they offer us an opportunity to grasp how different layers of time and space (geographical as well as spiritual) are embedded in these objects' histories on the level of both representation and circulation. They testify, moreover, to the fact that the medieval world was not isolationist, but was geographically and culturally expansive and entangled. Indeed, the censers demonstrate the highly interconnected nature of very distant regions during this period: Africa, west and east Asia, and Europe.

One way to approach these questions, one adopted in what follows, is to reconstruct the movements of the objects and the experiences of their use "from the ground up"—moving from materials such as ore in the earth and frankincense from trees to ephemeral incense smoke and swirling evocations of the cosmos in church spaces. We move from situating censers in a particular time and space, through consideration of their production, to challenging the notion of their rooted origins by acknowledging their fundamental mobility. The mobility of the censers was echoed in their contents, since incense circulated via trade routes; next, therefore, we address the medical and sacred associations of frankincense. The chapter concludes by moving from the micro- to the macro-level of analysis, addressing the movements of the censers and their smoke in church settings, with particular consideration of the relationships between the objects' architecture, shape, and phenomenology.

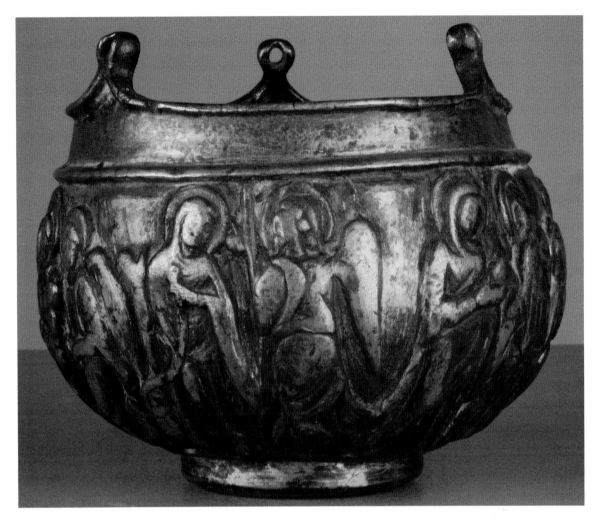

Fig. 20 The Annunciation, from a censer with New Testament scenes, 12th century. Bronze; 11.6 × 12.2 cm. Dresden, Staatliche Kunstsammlungen, Skulpturensammlung im Albertinum, inv. no. ZV 2673.

Ore and Origins

Ore used for bronze production in the eastern Mediterranean during late antiquity could have come from Cyprus, the Timna valley, or Georgia, but the location of the craftsmen who designed, cast, hammered, and polished these censers is unknown. As mentioned previously, several hints point to the larger region of what would be today Palestine, Israel, Lebanon, or Syria.[17] If their production began in the sixth or early seventh century, this would mean that they were produced when the area was under Byzantine rule; if they were fabricated later, the region formed part of the first Islamic empire, the Umayyad caliphate. "Syro-Palestinian," therefore, has been the term most frequently used to categorize these objects geographically. The assumption that they

were made in this region is intricately bound to the question of whether the earliest bronze censers with Christian scenes were indeed made in the sixth to seventh centuries, or if a significant number of them are ninth- to twelfth-century copies modeled after older censers and fabricated in Armenia, Egypt, Georgia, or even Europe (see map 1).[18] Among the arguments for later datings are loss of depth in some of the narrative reliefs; changes to the iconography of the crucifixion scene depicted on the censers; the position of figures depicted in the scene of Jesus's birth; and scenes depicted on very few extant examples of the censers, such as the Visitation, Doubting Thomas, and the Ascension.[19] The inclusion of details such as figures turning their backs toward the viewer (so-called *Rückenfiguren*) might support the later dating of a few censers (fig. 20).[20] Art historians of

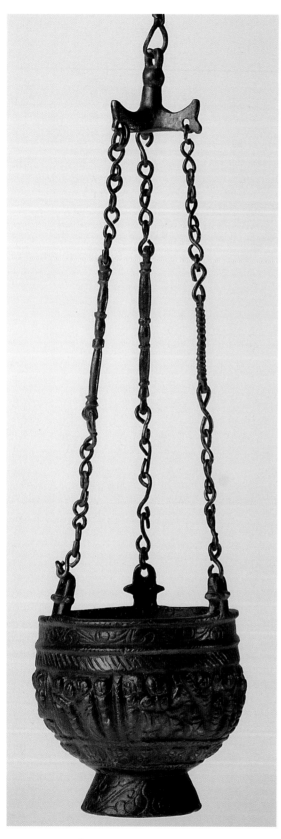

Fig. 21 Censer with New Testament scenes, 7th century. Bronze; h. 9.2 cm, dtr. 10.3 cm. Geneva, Musée d'art et d'histoire, inv. no. AD 2400.

Europe have attributed this invention to painters active in the West around 1300, but there are in fact several earlier depictions of figures depicted as seen from the back in Byzantine and Islamic art.[21]

Beyond the question of place and date, it is worth considering a number of technical questions relating to the censers. Did their mode of production have an impact on their shape and appearance? Little more than a mixture of ore, a small oven, a sand pit, and experience in melting smaller bronze objects was required. On the basis of close empirical and visual analysis, Ilse Richter-Siebels identified four different procedures for producing the censers.[22] For the first of these, wax plates were laid over a fire-resistant core. Craftsmen (or perhaps women) modeled the censer in wax, either from a real or an imagined model. The wax model was then covered with a fireproof layer, with metal sticks connecting the core to the outer layer. Channels for the flow of the melting wax and, later, for the molten bronze created the interior space around which the vessel's skin formed. Both the core and the wax models would have been lost in this procedure. If the craftsperson had instead wanted to preserve the models, it would have been possible to fashion them out of gesso, from which casts could have been made in one, two, or three pieces. Wax could have been pressed into these negative forms and their interiors filled with a mixture of gesso, sand, and brick dust. This second procedure would have had the advantage of reusable models. A third possible procedure would have required a clay or gesso model for each narrative scene on the vessels' exteriors. A positive wax copy could have been produced from each of these models. As in the first procedure, these wax plates would have been attached to a fire-resistant core. A final possibility is that craftspeople made only the figurative relief friezes from a negative model, and added ornamental friezes above and below the narrative frieze at the censer's core by free-sculpting them. This technique is known from Gallo-Roman terra-sigillata vessels as well as from medieval Islamic ceramics with molded relief (see, e.g., fig. 156).[23] This would explain the inorganic formal tension between the density of the narrative frieze, packed with figures in deep relief, and the stand and upper ornamental bands, which are relatively flat and take up a lot of space for rather simple ornamented friezes, often covering over two thirds of a vessel's surface (see, e.g., figs. 10 and 21).

This formal tension across the structural elements of the censers (stand, frieze, and ornamental bands) could also be the result of comb-

ining different techniques. For example, two of the censers preserved in Basel (shown in figs. 5, 6, 19 and 22) display an ornamental frieze with curved lines resembling half halos or an arcade running directly above the heads of the narrative frieze figures. The vertical supports of the arches do not align with the heads of the figures depicted in the frieze below, however. Instead, they frequently link figures belonging to two separate narrative scenes in a manner that does not appear to be intentional. The vast difference in style between the upper part of the narrative frieze, including the heads of the figures, and the semicircular decoration above could well be explained by their being made through two separate production processes. While the central part of some censers can sometimes manifest sophistication in terms of representing depth, the upper ornamental zones are often significantly less sophisticated in terms of technical execution—even though they take up an equal amount of space. It seems reasonable to suggest, therefore, that they may have been made in sections by different artisans, or that specific elements of certain censers served as models for later ones.

This variation in production techniques enabled makers to experiment with expanding and extending the censers' forms in order to enlarge the space for burning coal and incense. When they did so, they kept the narrative frieze consistent but extended the ornamental zones and sometimes supplied taller stands upon which the censer could rest. The censers manifest differences not only between their ornamental bands and narrative friezes, but also among their stands, shapes, and chain mounting devices. These elements do not seem to derive from a single model that was reproduced as a whole; like the objects' ornamentation, their structural elements seem to have been brought together in a relatively flexible manner. Instead of understanding their "mass production," therefore, in modern terms of conformity and standardization, we should appreciate that the censers appear to have been produced for a market receptive to ad hoc solutions and the variety that this produced. In other words, precisely on account of the differences between them, which indicate that they were not created following a standardized model, we may hypothesize that these objects were produced en masse.

The large scale of their production is further indicated by certain aspects of their facture that offer hints about how they were received, as well as made. They display, for instance, signs of repair and of imperfect production (fig. 22). In some examples, the burning charcoal seems to have corroded the bottom part of the vessel so that the base had to be repaired (fig. 23). The entire base is missing only in shorter censers (fig. 24), while those with a higher stand and deeper vessel mostly underwent only partial repairs of the base, if any. In addition, several censers are cracked or have holes in their upper parts. This may be because they were made of unconventional, less durable mixtures of metals (e.g., equal percentages of tin and lead).[24] To protect the vessels from their burning coals, a metal inlay would have been an integral part of the original censers. With few exceptions, however, these inlays seem to have been lost.[25] Based on the damage some censers display, it seems that an increase in the height of their bases and the width of their bodies may have also made for better stability overall and a more secure means of being handled and carried during ritual use.

The hypothesis outlined above regarding the censers' large-scale production and distribution appears to be further borne out by the fact that makers imprinted them with markings to be found on the objects' undersides. These include images of flowers, people seated or standing, a mask, even an eagle (fig. 25). Following earlier scholars, we suggest that these may be trademarks indicating which workshop produced the censer. It has been suggested that these motifs were made as a wax positive that was cast separately and then applied to the bottom of the vessel before the censer itself was cast.[26] Some silver censers display similar motifs, such as the rosette decorating the base of the Attarouthi censer (fig. 25a), one of three silver censers formerly owned by a Christian church at Attarouthi in Syria (see fig. 29), while other, mostly older silver censers have markers on their bases guaranteeing the quality of the silver.[27] Silver differs from bronze, however, in that it is much more valuable. The trademarks on the bronze censers thus ought to be understood not as indicators of quality, but as marks used to calculate how many objects were made by a given craftsperson or workshop. If many such objects were made, the marks may have been used to keep track of inventory for book-keeping purposes. The marks themselves buttress these assumptions, indicating that workshops fabricated a large number of similar censers—objects that were clearly in demand. Perhaps the marks also served to consolidate a market presence—"branding," as it were—for particular makers.

If the censers provide some insights into the process of their own production, a broader context might be sought in other changes in visual culture, which point to deeper transformations in

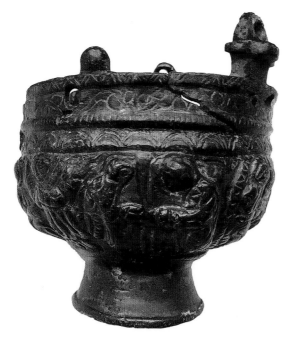

(TOP LEFT) *Fig. 22* View of the Visitation of Christ's tomb, from a censer with New Testament scenes, 6th–9th century. Bronze; h. 10.4 cm, dtr. 11 cm. Basel, Antikenmuseum, inv. no. BRE 643.

(TOP RIGHT) *Fig. 23* View of the damaged base of censer with New Testament scenes (see fig. 22).

(RIGHT) *Fig. 24* View of the baptism of Christ and damaged base of a censer depicting New Testament scenes, 8th or 9th century. Bronze; h. 7.4 cm, dtr. 10.9 cm. London, British Museum, inv. no. 1912,0718.1.

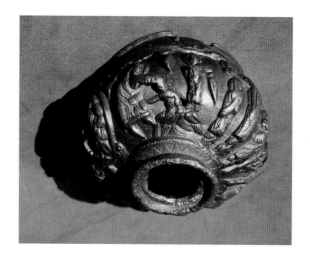

religious and cultural practices that also had an impact on objects used in private or public rituals, including censers. Indeed, the turn from the sixth to the seventh centuries, when the earliest bronze censers with Christian scenes seem to have been made, marks an extremely important moment in the history of the Christian icon—and of the role of religious images in the Christian practice of veneration more generally. The oldest preserved Christian icons date to this period, which saw the transition from "pagan" to new Christian forms of image veneration.[28]

In addition, the emergence of censers decorated with images drawn from the story of Jesus seems to have coincided with a broader surge of figurative decoration on religious objects related to ritual use and pilgrimage, such as ampullae for oil, clay eulogia tokens, amulets, and lamps (see figs. 15–18). However, scholarship to date has focused on icons, pilgrimage, and Christian visuality. As a consequence, potential similarities between the decoration and uses of other kinds of objects such as ivory vessels—pyxides or medical boxes (fig. 26)—and bronze censers have not yet been explored. Just because these objects depict the same scenes and were produced in large numbers (and thus not crafted with perfection as their end goal) does not necessarily mean that our censers were made for the same purpose as other "pilgrimage art"—as suggested by several scholars.[29] However, seen in this expanded field, the significance of the censers may reside less in their status as pilgrimage objects than in their ability to point to more far-reaching shifts both in the cultic veneration of images and in the new role of figurative representation in Christian religious art—as well as to the intimate connection between healing and religious practice in the early medieval period.

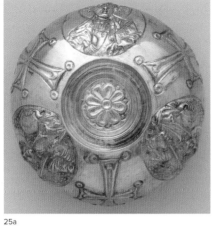

25a

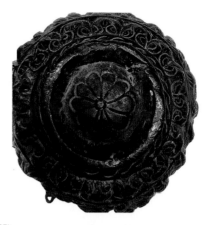

25b

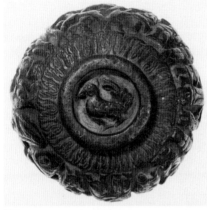

25c

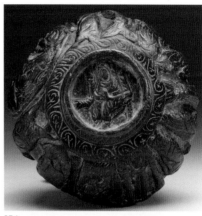

25d

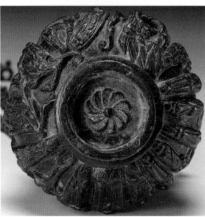

25e

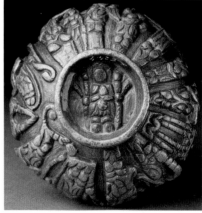

25f

Fig. 25a View of the base of a censer showing a youthful Christ with a cruciform halo, two archangels, and crosses, Attarouthi, Syria, from the Attarouthi Treasure, ca. 500–650. Silver; 8.2 × 13.2 cm. New York, Metropolitan Museum of Art, inv. no. 1986.3.11.

Fig. 25b View of the base of a censer with New Testament scenes, 6th–9th century. Bronze; h. 10.8 cm, dtr. 10.9 cm. Basel, Antikenmuseum, inv. no. BRE 644.

Fig. 25c View of the base of a censer with scenes from the Life of Christ, 6th or 7th century. Bronze; h. 8.3 cm, dtr. 11 cm. Berlin, Skulpturensammlung und Museum für Byzantinische Kunst, inv. no. 15/69.

Fig. 25d View of the base of a censer with New Testament scenes, 7th or 8th century. Bronze; 11.7 × 13.9 × 14.1 cm. Baltimore, Walters Art Museum, inv. no. 54.2575.

Fig. 25e View of the base of a censer with New Testament scenes, 6th or 7th century. Bronze; 11.43 × 12.07 cm. Richmond, VA, Virginia Museum of Fine Arts, inv. no. 67.27.

Fig. 25f View of the base of a censer with New Testament scenes, 6th or 7th century. Bronze. Paris, Musée du Louvre, inv. no. E 11710.

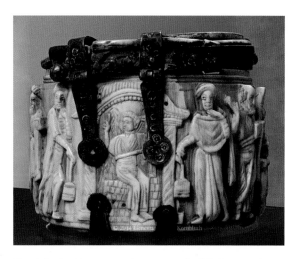

Fig. 26 Pyxis with women at the empty tomb of Christ greeted by an angel, Roman soldiers as guards, and bearded man with a scroll, 6th century. Ivory with metal mounting; 7.2 (8.4 with lid) × 10.4 cm. The hinges and ring are medieval replacements of a late antique metal mounting. Sion, Musée d'histoire du Valais (dépôt du Chapitre Cathédral de Sion), inv.no. MV 152.

The censers' value as historical sources can be better recognized and understood when we also analyze their imagery in relation to relevant secondary documents, including other material objects originating from the same cultural milieu, as well as to historical texts and inscriptions on other censers. Aside from material considerations, therefore, we argue the need to attend conceptually to the ways in which images build stories on the surfaces of censers, considering how their pictorial programs link to the growing importance of images in Christian contexts during this period.

Changing Shapes

Let us begin by attending to the relationship between form and content, between the specific form of the censers and the narratives that unfold around their bodies. To reconstruct the development of the forms used for Christian censers, it is necessary to bring together knowledge from late antique, early Christian/Byzantine, and pre-/early Islamic metalwork; to juxtapose the particulars we have about late antique Roman censers—which often feature hexagonal or round forms with relatively low brims—with those of extant early Christian censers (fig. 27). Initially, these were often also hexagonal in shape, with saints in medallions on their lateral sides (figs. 28 and 29). From early on, there may have been a connection between the architectural spaces in which these censers were used—baptisteries, mausolea, martyria, or church buildings with a hexagonal

structure or rotunda at their core—and the censers' shape. By contrast, later Christian censers favored depictions of the unfolding story of Jesus as the central focus of their external decoration.[30]

Fifth- and sixth-century silver censers provide us with an especially good model for investigating the development of the round Syro-Palestinian bronze censers embellished with Christian scenes. Silver censers can usually provide us with a date based on the quality stamp that appears on their bottom side; by comparison or extrapolation, this can help to date bronze objects of similar shape. Silver censers can be divided into two groups by shape: hexagonal or round (figs. 28 and 29).[31] Among the extant silver censers from this period, both hexagonal and round, several are ornamented with figurative decoration on their outside—for example, standing saints or bust portraits placed in architectural forms or medallions—but almost none have survived that are embellished with scenes from the life of Jesus that present a linear narrative like those on the bronze censers.[32] In the late fifth and sixth centuries, too, we encounter a very large number of bronze censers that are not embellished with narrative figurative decoration at all, alongside the round censers with narrative subjects presented here. These unembellished censers are both hexagonal and round (fig. 27), suggesting that they and the decorated censers coexisted during the period when the popularity of the latter seems to have taken off. The datable silver objects hint at the fact that early censers may have been oriented more toward decorative programs that highlighted framed, individual elements (e.g., crosses or saints) than toward the kind of integrated narratives that we see in the bronze censers under discussion.

The scant number of extant silver censers makes it difficult to draw any general conclusions about them, but we do see fewer ecclesiastical items made of silver in the archaeological record after the seventh century—even though we have textual references that suggest that silver continued to be used to make such objects.[33] Perhaps the more valuable silver censers were simply melted down. This lacuna is typical of the sorts of gaps in the archival and material records discussed in the Introduction, gaps that frustrate any sense of absolute analytical certainty, but that can nonetheless be addressed by moving laterally, improvising methodologies and drawing on the widest possible range of sources available.

While they often share important structural features with silver censers, bronze censers were a cheaper and more durable option. Thanks to the more secure dating of extant silver objects, we can

estimate that similar but unmarked bronze versions date from the same period. The hexagonal silver censer preserved in Munich shown below (fig. 28)—which has been dated to the reign of the Byzantine emperor Mauricius Tiberius (582–602) on the basis of the stamp on its underside—has a similar structure, if not similar decoration, to that of certain bronze censers. Like the bronze censer that has no figurative decoration on its sides (fig. 27), the top of the Munich vessel sports a fully preserved dome-shaped knop from which three larger and three smaller rays radiate downwards, terminating in small balls fitted with rings from which to suspend chains (fig. 28). A band on this censer also has an inscription, placed above a set of six arcades each of which frames six distinct standing and haloed figures: Jesus between Peter (right) and Paul (left), and the Virgin between two archangels.[34] The hexagonal format lent itself particularly well to decorative programs featuring busts and medallions, which could occupy the architectonic spaces of the vessel as they may have been envisioned in connection with larger architectural superstructures: a single saint could reside in each window, tabernacle, or arcaded fold of the hexagon. The hexagonal form thereby encouraged a formal and perceptual experience different from that associated with the round censers, whose continuous surfaces lent themselves better to unfolding narrative depictions of the progressing Christian story. Starting from about the seventh century, the hexagonal form appears to have gradually given way to the round format, indicating a growing interest in or desire for censers with narrative depictions linked to specific moments and locations in Jesus's life. Hexagonal formats did not completely disappear, but the one shape does seem to have gradually eclipsed the other. Not only did rounded bronze enhance the narrative potential of the censers, but the less expensive material also offered a means of spreading the Christian story more widely, since cheaper censers could be produced and disseminated in greater numbers.

The increasing importance of narratives may have inspired the production of taller censers, affording more space for the unfolding of these across the bodies of the censers. Sometimes the narrative scenes appear somewhat awkwardly constrained by the narrow dimensions allotted them (see, for example, figs. 5, 6, and 19). In earlier examples, too, the scenes are contained in a rather narrow frieze in comparison to those on taller (later) censers. Furthermore, the upper limit of the figurative frieze, which often sharply demarcates the heads of the figures from the bands of

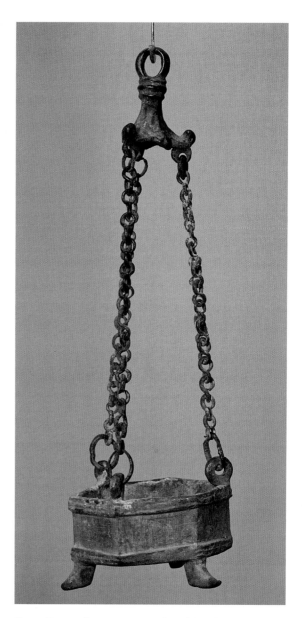

Fig. 27 Hexagonal censer, Byzantine, late 5th or 6th century. Bronze; 5.1 × 6.6 × 14 cm, h. 22.5 cm (with chain). Bloomington, IN, Eskenazi Museum of Art (Indiana University), Burton Y. Berry Collection, inv. no. 75.110.21.

ornamental friezes above, can appear squeezed between non-narrative ornamental decorations (e.g., bands of waves or flowers). While earlier round censers have only one band of ornamental decoration along their upper rims (or just an inscription), in later examples we often encounter two friezes of ornaments, added to both the upper and lower edges of the vessels. Perhaps the central part of these older examples served as a model for the makers of the later Syro-Palestinian bronze censers, who added the upper and lower ornaments to enlarge the vessels, significantly

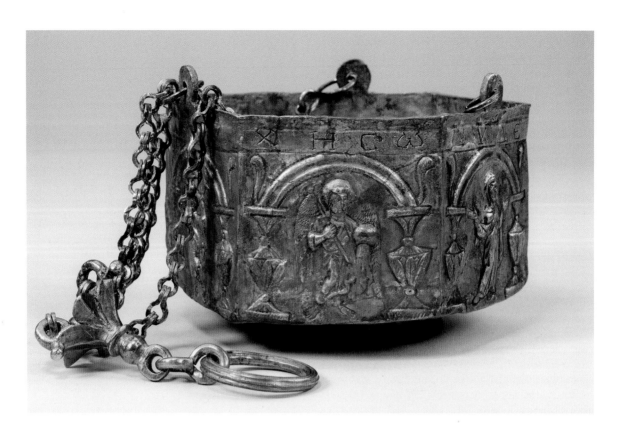

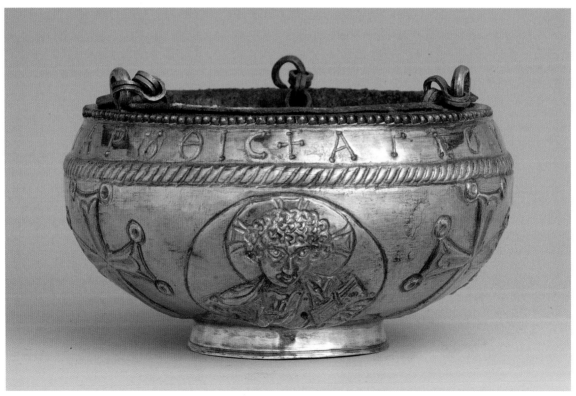

(TOP) *Fig. 28* Hexagonal censer with figurative decoration, Byzantine, 582–602. Silver; h. 9.5 cm, dtr. 13.5 cm. Munich, Bayerisches Nationalmuseum, inv. no. 65/46.

(BOTTOM) *Fig 29* Censer with a youthful Christ with a cruciform halo, two archangels, and crosses, Attarouthi, Syria, from the Attarouthi Treasure, ca. 500–650. Silver; 8.2 × 13.2 cm. New York, Metropolitan Museum of Art, inv. no. 1986.3.11.

increasing their height without fundamentally changing their decorative content. This would imply that shorter censers served as models for taller censers, though these still used the same models for narrative friezes, indicating a formal and technical evolution alongside iconographical development.

Our hypothesis with regard to the slow disappearance of hexagonal censers and the continuing presence of round ones is that shorter round bronze censers with narrative friezes served as a formal model for the earliest such, whose height had been increased by the addition of taller stands at the bottom and ornamental friezes at the upper edge.[35] This added height may have afforded some protection to the person carrying burning charcoal in a vessel close to the body; it also offered the possibility of adding protruding knops with holes for the chains so that the body of the vessel did not have to be pierced and the narrative frieze could remain intact.

However, we should be wary of conceiving of these objects in terms of originals and copies, or in terms of centers and secondary or peripheral sites of production. The interpretation of a censer from Africa provides a cautionary tale to qualify such assumptions, which bring with them notions of hegemonic centers and outlying peripheries. The censer in question (fig. 30) is round, bronze, and from the site of Old Dongola in Nubia. (This was a region along the Nile stretching into present-day Egypt and Sudan with an important Christian kingdom, to which we will return in chapter 5.) It has been suggested that a round silver censer from Byzantium might have been one of a type that served as a (lost) model for this kind of Nubian censer.[36] Both the silver censer from Attarouthi (see fig. 29) and the Nubian bronze one are decorated with medallions as opposed to narrative scenes. Consequently, it has been asserted that the censer from Dongola "must be a copy made in Nubia based on a silver original from the Byzantine sphere."[37] That it was produced in Nubia is not in question: it bears a Nubian inscription written in Greek letters; the material and technique are also evidence of non-Byzantine origin. However, the comparisons that have been drawn with ornaments decorating Byzantine silver objects from the fourth to the seventh century are vague; and all the objects proposed as comparisons originate, moreover, in different regions of the Byzantine empire. There is, therefore, no reason to assume that the Nubian censer was a copy of a metropolitan Byzantine product. A more convincing explanation would be that round bronze censers decorated with saints in medallions between crosses or ornaments were widespread, and that each region developed its own iconographic type. Thinking about objects in this way reverses a diffusionist center-periphery account of their history, which appears to be much more complex than that suggested by the traditional hierarchical dichotomy between metropolitan model and provincial copy.

Investigating the inorganic qualities of these censers provides insights into how they may have developed over time, based on traces of an embedded memory built into the objects themselves. Their idiosyncratic features—such as the mismatch of space allocated for narrative scenes—illustrate how objects archive a forgotten history of evolving structural and formal changes. What has further become evident through this object-based analysis is the novelty of including a narrative series of consecutive scenes telling the story of Jesus's life. The evolution of the vessels' structural form (shifts in height and shape) converges with an apparently new interest in depicting time and space in narrative terms. This is achieved not by granting more space in terms of the width of the frieze, but rather through an evolution from hexagonal to round forms that highlight narrative linearity and that take advantage of the wrap-around effect of the 360-degree frieze.

Incense and Medicine

As noted previously, these bronze censers have carried little with them by way of a historical record. As a result, their history cannot be written in the traditional way, focusing on a specific moment in a specific region. In addition to the morphological analysis just undertaken, we must write this history in relation to that of other objects and to our knowledge of the changes in cultural practices and visual culture during the era in which they and the censers were likely made and distributed.[38]

While the medicinal properties of incense have previously been overlooked in analyses of the censers, the spiritual journey orchestrated by their narrative scenes dovetails with their contents' curative characteristics. When used, the vessel was filled with *olibanum*, the resin of various *boswellia* plants, and then lit. The resin of the boswellia tree, known as frankincense, was traded from Sudan, Ethiopia, southern Arabia, Somalia, and other East African regions to Europe and Central Asia during this period.[39] In the case of censers decorated with narrative Christian scenes, the incense emerging from them would have underscored the sacredness of the ritual being

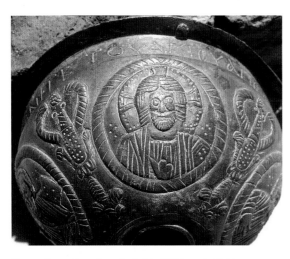

Fig. 30 Censer from the cathedral in Old Dongola, Nubia, 6th–10th century. Possibly bronze or brass; h. 5.5 cm, dtr. 13.2 cm.

performed. Dora Piguet-Panayotova, writing of silver censers, paints a vivid picture of their use:

> the lamps, candelabra and polycandela with their multiflame light were used to please the eye, while the burning incense put the finishing touch to the solemn atmosphere, with its fragrant clouds rousing the sense of smell. And these clouds, rising up from the thymateria [censers] into the air, also visualized the idea of prayers ascending to God.[40]

This merging of sensual experience, object, space, and liturgy can also be found in first-hand pilgrim accounts and from scribbled votive inscriptions referring to incense found on broken pottery (known as *ostraca*), as well as in hymns that, when sung, facilitated the sensual conflation of object, space, and time, thereby enhancing the religious efficacy of the ritual. This efficacy implied healing, whether in the form of future salvation or the healing of more immediate medical ills. As we will see in chapter 6, the medical use of incense was pervasive in the medieval Islamic world, an inheritance from late antiquity. Both forms of healing implicated physical (body) and spiritual (soul) aspects, and both connected the present to the hope for a better future.[41]

The curative effect of incense was explicitly emphasized by the Byzantine chronicler Theophanes (d. 818) in a description of the crypt of Saint John at Emesa (Hims in Syria), to which one of the supposed heads of John the Baptist was transferred and "wherein to this very day it is worshipped by the faithful and honored with both material and spiritual incense while it pours cures upon all who come to it in a spirit of faith."[42] The gifting of incense was part of the veneration of saints, as the inscription on another bronze censer explicitly emphasizes: "Receive this incense and give health to all!"[43] That this censer (now in Syracuse in Sicily: one more indication of these objects' mobility) bears an inscription mentioning incense, and yet has no figurative or narrative ornamentation, highlights the importance of incense at the time.

Interest in the medical effects of incense within early medieval culture may have contributed significantly to the censers' meaning and importance—and hence to their widespread production and distribution.[44] The relationship between form and function was, apparently, not haphazard, despite the objects' often rough—or expedient—construction. Contents and container presented varying modes of travel and movement across physical, spiritual, and economic realms.

An image of a censer in use can be found carved on a basalt relief found near Qal'at Sem'an, the location of an early Byzantine monastery in northern Syria, in which Saint Symeon the Elder is shown being visited by a pilgrim swinging a censer (fig. 31). Symeon's pilgrimage site drew the devout from across the ancient world, including the Ghassanid Arab Christians who protected the Byzantine borders in the region. While the bearded pilgrim swings the censer to evoke the saint's aid, a dove places a wreath over his hood. The floating scent and the winged messenger clearly connect the earthly and heavenly realms. Bissera Pentcheva, demonstrating the particular import of incense for the saint's cultic veneration as well as the role the substance played for pilgrims, has emphasized the importance of smell during this period:

> In a world where foul-smelling spirits were regarded as the cause of diseases and misfortunes, fragrance was understood as cure and protection against them. Symeon the Stylite, who was filled with air, spirit and fragrance, through them brought life, health and good smell.[45]

Symeon's healing power was dispensed through the eulogiae, the pilgrimage tokens made with earth from his shrine (fig. 32).[46]

Insights into the medicinal associations of incense can be found in a text that enjoyed wide circulation both in the late antique world and in its later Arabic translation, in which the Greek botanist, apothecary, and doctor Dioscorides

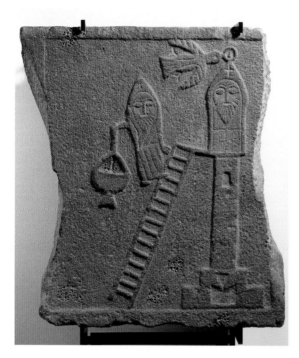

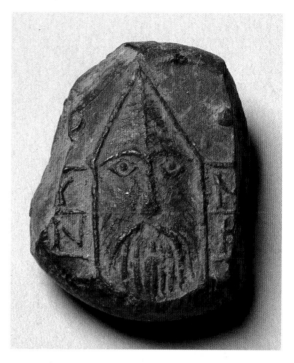

Fig. 31 Relief with a depiction of Saint Symeon, possibly Syria, 5th or 6th century. Basalt; 84.5 × 76 × 18.5 cm. Berlin, Skulpturensammlung und Museum für Byzantinische Kunst, inv. no. 9/63.

Fig. 32 Pilgrim token of Saint Symeon the Stylite, Syria, 6th or 7th century. Baked clay; 2.8 × 2.2 × 1.2 cm. Baltimore, Walters Art Museum, inv. no. WAM 48.2666.

(d. ca. 90 CE) was explicit about the healing properties of incense: he describes how it helps to heal wounds and ailments of the skin when mixed with milk or vinegar and pitch and applied to injured parts of the body. It soothes young mothers with inflamed breasts, he observes, when prepared as ointment with cimolian earth and rose oil, or can be poured into the ears against infections, together with sweet wine. Incense ash was thought to heal cancer; the bark of the boswellia tree was believed to be an effective remedy for illnesses of the eye and to have other healing properties.[47] Dioscorides warns, however, that boswellia must be used carefully and responsibly, because it could be deadly even to healthy people if taken with too much wine.

Primary sources from this early period suggest that the medical effects of incense were thought to be particularly strong—sometimes miraculous—if the substance was used in the presence of holy relics.[48] This is particularly relevant in relation to the censers discussed here, because their ornamentation refers directly to specific miraculous occurrences and holy sites. If someone were using a censer either as part of a ritual intended to have curative effects or as a votive gift from the Holy Land, the spiritual and physical powers of its incense would have been seen as amplified or augmented through the vessels' direct references

to events from Jesus's life, including the Stations of the Cross, and sometimes even to miracles of healing: Jesus's healing of a woman who had been bleeding for many years, for example.[49]

Whereas relics are usually hidden inside a container, the scent of frankincense emerged from the censer-container, enveloping both viewer and object in a fragrant cloud of curative smoke. This sweet emanation, combined with a direct reference to relics, would have been thought to contribute to the incense's curative powers. Together with the images on the censer, the scent and the smoke would have stimulated the user's memory and imagination in the service of healing. Regarding the phenomenological aspects of scent, Alfred Gell has written that "to manifest itself as a smell is the nearest an objective reality can go towards becoming a concept without leaving the realm of the sensible altogether."[50] In the case of censers, smell accompanied—and mobilized—religious journeys through space and time toward a celestial future in which the sweetness of the afterlife and salvation exceeded that which could be experienced on Earth: a cure that was beyond the terrestrial and the "sensible."

Faith in these mediating powers, connecting the earthly and heavenly realms, is also evident in primary sources contemporary with the production of these censers. As patriarch Germanos I of

Constantinople (d. 733) states in his *Ecclesiastical History*, the vessel, and the fire and sweet-smelling smoke refer respectively to the womb of the Virgin and to Jesus, and in doing so emphasize Jesus's double nature. Germanos refers explicitly to the ritual of baptism, emphasizing that the vessel's interior "points to the font of holy baptism, taking into itself the coal of divine fire, the sweetness of the operation of the Holy Spirit, which is the adoption of divine grace through faith, and exuding a good odor."[51]

It seems unlikely to be a coincidence that the trade routes for frankincense shifted around the beginning of the sixth century, when the earliest of the censers in question were probably made. This was precisely the time at which the ancient incense route linking Oman and Yemen to the Hijaz region of western Arabia and north to Damascus in Syria became an East African sea route.[52] The continued flow of incense is suggested by eastern and western authors such as Ibn Khurdadhbih and Theodulph of Orleans, who inform us about the incense trade routes from east to west in the middle ninth century, when Ibn Khurdadhbih still refers to Oman as "the country of incense."[53] These geopolitically inflected changes in the flow of commerce encourage us to consider further how the narratives presented as images on the censers and their contents intersect.

Censers in Motion

In addition to texts concerning the trade in incense and its role in the kinds of long-distance circulations—a pre-modern form of globalism—to which the censers attest, consideration of other objects too can help us to better understand the intertwined religious and medical aspects of these objects. A particularly intriguing example that provides further evidence for censer use is the Trier Ivory, a Byzantine carved ivory panel depicting a procession. A wide range of potential dates, ranging from the fourth to the tenth century, have been suggested for the ivory, and there is still debate over the panel's subject. What can be said for certain is that it depicts the transfer of a set of relics from one place to another (fig. 33).[54] The relics are contained in a small box held by two priests riding in a chariot pulled by two horses. An architectural structure featuring an image of Jesus in a tympanum (top left) seems to indicate the relics' origin: a large church building at least two stories high with lavishly ornamented capitals on top of massive pillars. The destination of the procession is a basilica with three naves, tall windows in the clerestory, and a semi-circular apse (lower right). An audience holding candles watches the procession from inside a three-story building framed by arcades at the bottom and with rectangular windows on the first floor. Some figures have even climbed on top of the church in order to obtain a better view. A priest with a crozier and a cross diadem receives the phalanx at the basilica.

Among the audience members occupying the first floor of the background building, we can discern no fewer than nine figures who are watching the event with censers in their hands.[55] Several art historians have pointed out that when the sixth-century Roman poet Corippus described the funeral cortège of the Byzantine emperor Justinian (d. 565) passing through the Chalke gate of the imperial palace toward the Church of the Holy Apostles in Constantinople, he wrote that "many burned incense for his passing."[56] What is relevant here is that it is not the priests who are swinging the censers as part of a liturgical ceremony; rather, it is the people watching the event who hold the censers' chains in their hands. The lower parts of the censers seem to rest upon the frieze below, such that it is unclear whether they are sitting on the ground or hanging from their chains.[57] The important point, however, is that the presence of a relic and its sacred status appear intimately linked to the scent of burning incense.

The objects that many Western pilgrims brought back from trips to the Holy Land included pilgrim's flasks, oil lamps, and pectoral crosses. These, like incense burners, were also considered to encapsulate sacred power: having touched sacred sites, the objects were thought to possess the same powers as relics, because of their direct relationship to specific holy places or saints. These objects often contained dust and oil or enclosed relics such as fragments believed to be of the True Cross (see, e.g., fig. 15). Healing powers were therefore attributed to both contents and containers, as with pilgrim tokens (see figs. 17, 18, and 32), just as the incense in the sixth-century censers was thought to have miraculous curative qualities.

In addition to visual sources such as those considered above, certain primary sources provide glimpses into how censers were generally used. By the end of the fourth century, the Spanish pilgrim Egeria was describing the use of censers in the Church of the Holy Sepulchre in Jerusalem thus: "After these three psalms and three prayers are ended, censers are brought into the cave of the Anastasis so that the whole basilica of the Anastasis is filled with odors."[58] This clearly indicates the objects' deployment in a liturgical context, which contributed to the olfactory dimension of the

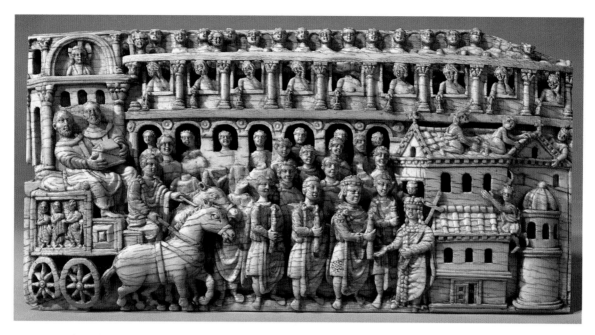

Fig. 33 Ivory plaque depicting a relic procession, the so-called Trier Ivory, possibly Byzantine, variously dated 4th–10th century. Ivory; 13.1 × 26.1 cm. Trier, Museum am Dom, inv. no. 2.

church atmosphere. When used liturgically, these objects revealed powers not possessed by the censer in itself, but activated by its use.[59]

The figurative mosaic decoration of liturgical spaces reveals how incense was gifted and provides us with clues regarding what types of censer were in use at the time when the mosaics were made. In the sixth-century floor mosaic in the Church of Cosmas and Damian in Gerasa (present-day Jerash, in Jordan), one of the two donors—the *paramonarios* (a lower order church officer who assisted at mass), a guard named Theodoros—is depicted with a censer in his hand, perhaps to emphasize the act of offering a donation (fig. 34).[60] The donor holds a short censer, hexagonal in shape, its three chains in his right hand. A similar censer with little feet at its base appears together with a reliquary box in a depiction of Saint Zacharias in the sixth-century mosaics of the Euphrasian basilica in Poreč (now in Istria, Croatia) (fig. 35). The hexagonal censer depicted in the Gerasa mosaic might be similar to a censer now preserved in a museum collection (see fig. 27), while the censer in Poreč might be round. In the Poreč example, Saint Zacharias stands close to the physician saints Cosmas and Damian, which underscores the close relationship between votive giving, healing, and relic veneration. The image hints, too, at how the gifting of censers may also have been linked to the medicinal qualities associated with the vessels. These examples point to the intimate relationship

between objects and saints as part of medical and spiritual discourse in individual as well collective cult practices during this period.

As the eulogiae—tokens made of earth from sacred sites in Palestine and Syria (see figs. 17, 18, and 32)—indicate, the power of sacred sites such as the tombs of martyrs to generate so-called secondary relics, which could transfer holiness to another object by means of contact or touch, was not limited to the Holy Land.[61] By touching (primary) relics that had had contact with a saint during his or her lifetime, these secondary relics were produced by a process of being filled with sacred dust or oil and were then used like medicine. In his *History of the Franks*, Gregory of Tours (d. 594) tells several stories in which dust, oil, or relics are used as efficacious cures for medical problems.[62] It is to this same tradition that incense belongs; during the eighth and ninth centuries, the medical use of incense was either experiencing a significant increase or was simply better documented in recipes that have been preserved from the later period.[63]

Medical practice in medieval Christendom operated at the intersection of microcosm and macrocosm. The intertwined relationship between the liturgical object and the human body as microcosms was always perceived and treated in relation to the architecture of the church or shrine as representations of the macrocosm. This relationship has been addressed by scholars for

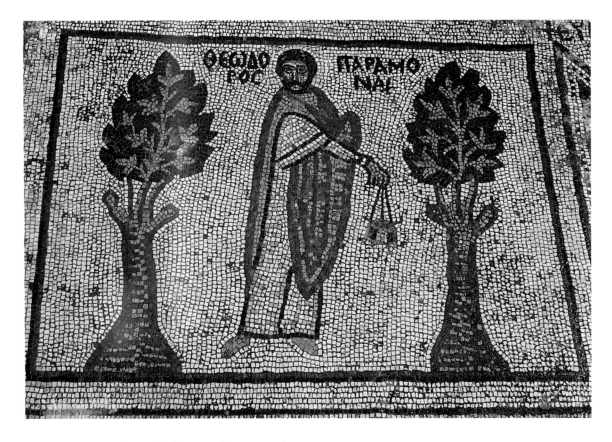

Fig. 34 Floor mosaic at the Church of Cosmas and Damian, Jerash (Gerasa), Jordan, showing one of the two donors, the *paramonarios* Theodoros, with a censer. Rectangular mosaic panel framed by a *tabula ansata*; 0.9 × 2.79 m (excluding ansae), letter h. 6 cm (line 1), 8 cm (other lines).

other early Christian liturgical objects, including shrines, large round candleholders, and altar decorations.[64] But censers, although they seem to have been similarly conceived and fabricated, have rarely been discussed in this context. The close connection between liturgical object and liturgical space, the ritual of gifting incense, and its smell as a messenger to the heavenly realms is expressed in an epigram by the Byzantine poet, soldier, and monk John Geometres (d. ca. 1000) circumscribing a small work by a goldsmith that was probably worn by a pious Christian during a devotional ceremony:

> This small work is a great image of all:
>> The gold is air; silver, light; the stones,
>> Choruses of stars: these images of the celes-
>> tial and heavenly above
>> Appear alongside coals and perfume,
> Which all serves as a sacrifice to the Lord.[65]

An interesting open question, therefore, is whether the shift to round censers can be con-nected to parallel developments in Christian architecture.[66] The addition of little roofs joining the chains (see figs. 27 and 28, in comparison to the tomb depicted in fig. 6) and the occasional mixture of square and round forms in high-medieval censers might support the hypothesis of such a link between built sacred space and litur-gical object.[67] This remains a rich area for future scholarship to explore.

Temporalities

We have already investigated what the censers' bodies recount through analysis of their produc-tion. The articulation of narratives upon their surfaces offers yet another source for locating these objects in time. The bronze censers collected by Friedrich Ludwig Breusch in Istanbul (among them those seen in figs. 5, 6, and 38) can be divided into two distinct types: six show Christian scenes on their exteriors, while one is embellished with non-narrative images of the Nile, replete with birds and other animals. Those with Christian

scenes are part of the large group of 108 extant examples (see fig. 10); the one with the Nilotic scene is rare and has never so far been discussed alongside the others.[68]

The differences between the two types of censers purchased by Breusch are striking. One vessel invites the beholder to explore a river view that wraps around it, with no specific beginning or end (see fig. 36); the images on the other six censers unfold as a linear narrative based on key moments from the story of Jesus, from the Annunciation through his baptism, crucifixion, and entombment (see figs. 5 and 6).[69] The Nilotic decoration includes lotus flowers, dolphins, fish, humans in boats, birds, and ducks. A diving human figure may refer to the biblical story of Jonah and the whale but may also be read simply as a diver in the waves drawn among water lilies and fish.[70] The ornamentation has neither a particular starting point nor a specific narrative that unfolds from scene to scene. If we imagine the smoke from the frankincense together with the water scenes, we might consider that its billowing would have helped emphasize the (visual) allusion to undulating waves and the (acoustic) splashes of water, the scented fumes then adding smell to the sensory register. The smoky heat of burning charcoal inside the vessel would also have stood in stark contrast to the cooling waves depicted on its exterior.

The way in which temporality is depicted on these objects affects how each type of censer must have been received and perceived. In one case, we are invited to dive into refreshing water, play with dolphins, and watch birds cross the sky above the Nile. The evocation of river scenery combined with billows of incense smoke invites the beholder to imagine the sounds of the river: splashing water, the paddle hitting the river's surface, and the cries of birds. The interlacing of synesthetic moments, along with the aesthetic interplay between the container's imagery and the effects of its contained matter, was surely key to how this object was perceived. These visual impressions, evoking the sensations of sound, touch, and scent do not situate the beholder at one specific moment. The eye is instead drawn to explore the vessel's various images freely: the viewer is not directed to follow a specific ritualized path, and no particular event or time in the past, present, or future is indicated by the censer's images. The object does not, on its own, even allow us to identify the religion or ritual in whose service it might have been used. This stands in stark contrast to the temporality represented by the group of censers featuring scenes of biblical or Christological narratives, upon which

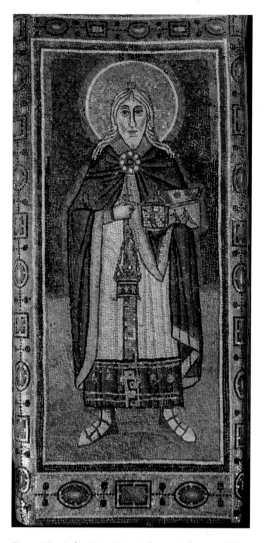

Fig. 35 Mosaic depicting Saint Zacharias, in the apse of the Euphrasian Basilica in Poreč, Croatia, 6th century.

we have been focusing until now. These vessels tell a concrete story with a beginning, middle, and end that prompts a quite different type of sensory experience.

In the censer with Nilotic scenes (fig. 36), the evocation of river scenery combined with billows of incense smoke issuing from the vessel would have invited the beholder to imagine the sensual experience of the river—its smells, sights, and sounds. As in the case of the metal magic-medicinal bowls that we will encounter in chapter 4, around which sight, taste, and touch came together, the conflation of these sensory experiences must have been integral to how the object was experienced. A key quality of these impressions is that they do not situate the beholder at one specific moment; they are multivalent, like the scent and smoke that would have

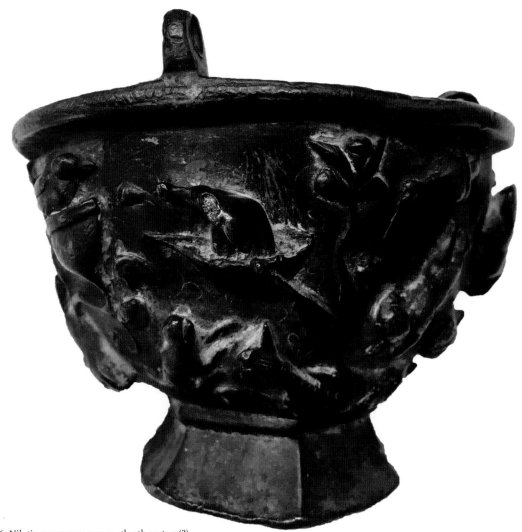

Fig. 36 Nilotic scenes on a censer, 4th–5th century(?).
Bronze; 7.3 (with lobes: 8.5) × 10.7 cm.
Basel, Antikenmuseum, inv. no. BRE 650.

emanated from the censer. Viewers could explore the vessel's different facets without following a prescribed sequence, just as they could smell the censers' contents as these dispersed in multiple directions. With no specific narrative or directionality, the type of temporality suggested by the Nilotic vessel is fluid. On its own, the object does not even reveal a specific religious affiliation, though the water motif may indicate that it served a ritual function in the baptismal liturgy. Nilotic scenes or depictions of Okeanos, the personified ocean, often served as decoration on early Christian church mosaic floors,[71] as well as on contemporary textiles that embellished tunics. For example, a Coptic silk bearing a Nilotic scene (fig. 37) gives us a sense of how such motifs traveled or were shared and transmitted across objects made in entirely different media and contexts. A tradition that may well have begun in weaving

could appear in molten bronze, where the timelessness of idyllic scenery might come to draw attention to the rise of linear narration.

The temporality of the Nilotic images contrasts with that represented in the more common narrative censer. The decoration of objects used in Christian rituals underwent a significant change around the sixth century with regard to how historical events and time were represented. From this period onward, narrative scenes appear, too, on Christian pilgrim flasks and pyxides (see figs. 15 and 26), in contrast to the single, atemporal symbols or saints that previously ornamented these kinds of objects.[72] It seems unlikely to be a coincidence that the linear narrative as a decorative mode for liturgical objects emerged in late antiquity during the transition from Greco-Roman and Egyptian polytheistic beliefs to Christianity (and, eventually, to the established

Fig. 37 Tunic decoration with Nilotic scenes, Egypt, 4th–6th century. Wool tapestry on a linen ground; 13.5 × 28 cm. Riggisberg (Bern), Abegg-Stiftung, inv. no. 805.

Christian practices that emerged during the early medieval period). Christian eschatology, after all, is organized around the promise of salvation and an imminent Last Judgment, a chronological narrative that unfolds in a linear manner.[73]

A closer look at objects—such as censers—used during the Mass or for individual devotion may more clearly demonstrate this shift. The "reader" of the scenes decorating the exteriors of the censer bears witness to the narrative of the life of Jesus as recorded in the Gospels: by examining this story told through images, the beholder is asked to travel mentally to the sites where the depicted events occurred. The linear narrative decoration of the later censers thus invited (holders and) beholders to journey "virtually" to the Holy Land to explore and celebrate the events and miracles of the Gospels. Individual scenes, however, would have been hard to discern in the context of handling the object with its glowing charcoal and smoky exhalations, both of which would have hindered a viewer's attempt to link the nine individual images into a coherent story. Smoke, heat, and movement—the swinging of the censer—would have hampered legibility. These perceptual difficulties imply (be)holders who can be assumed already to know what they are looking at, and who were thus able to recognize and distinguish between the scenes depicted from cues provided by specific gestures or by the precise positions of figures. Details such as the wings of angels, the throne, the cross of the Crucifixion, the heights of the heads, and the reference to the roof

of the Holy Sepulchre would have prompted such a viewer to call the story to mind from memory.

Antoninus, author of a pilgrim account written in the 570s, elaborates upon how pilgrims engaged with pilgrimage sites in the Holy Land, describing the precious adornments and votive gifts that had been placed around them. Antoninus's text prompts the suggestion that the decoration of pilgrim sites may well have influenced the decoration of objects acquired by pilgrims after the turn of the seventh century, when the earliest bronze censers were made—the date being pointed to by the censers' iconographic similarities to other seventh-century objects mentioned above, such as the long tunic Jesus wears in the crucifixion depicted in the Rabbula Gospels (see fig. 13).[74] Antoninus is much more explicit about the rituals that were performed at these sites than was the fourth-century Egeria, although the earlier pilgrim does say that censers emitting fragrant smoke were carried about. No text specifically mentions censers as votive gifts, but the differences in practices described in these two accounts reveal that votive giving and the custom of bringing ex-votos to the sites might have contributed to establishing a market in the Holy Land for portable objects such as ampullae, censers, pyxides, and oil lamps decorated with scenes recalling the historical events at the sites of their occurrence (see figs. 14–18).[75]

The custom of taking objects such as oil, frankincense, and secondary relics such as stones home perpetuated across time and geography their

healing power and helped pilgrims to remember rituals experienced in person. Recalling the events of Jesus's life did not, of course, simply do service to his memory; it also constituted an imitative or mimetic practice at the heart of the devotional self of the Christian. As Ivan Drpić has pointed out, "in the realm of personal piety, the self is constituted by its connectedness to a divine or saintly other."[76] Embedded into the pilgrim's practice of tracing Jesus across the Holy Land, censers allowed pilgrims and their home communities to assume normative mimetic roles: of the servant of a holy figure, the repentant sinner, the grateful giver, the affectionate lover, the caring mother or sister carrying a vessel with healing power.[77] The role of narrative imagery on these censers was crucial for this process of connecting past with present.

The story presented on the censers thus aimed to spark a sort of multilayered mental journey that could take a devout Christian through the episodes of Jesus's life. This was not a cartographical voyage, but instead took advantage of the linearity of the Christian narrative in order to transport censer bearers and viewers evocatively to a space that was simultaneously physical and spiritual. The pseudo-geographical journey was evoked through the depictions of Jesus's life, which viewers could associate with specific locations in west Asia, such as Bethlehem or Jerusalem. The spiritual voyage operated on two intersecting levels: in relation first to the Christian journey from Earth to Heaven, and second to the medicinal and curative discourses that were current at the time. For a person leaving a censer as a votive gift at a sacred site such as the Church of the Holy Sepulchre, or returning from a pilgrimage to the Holy Land with memories of specific individual sites, knowledge of the historical events of Christianity may have commingled with hopes encouraged by incense of a promised cure for ailments of either body or soul. The narrative of Christian salvation would have been enhanced by both the imagery on the censer and the medicinal qualities attributed to fragrant incense. Each of these disparate elements spoke of a movement from past (the pilgrim's prior journey or Jesus's life story) through the present toward the promise of the future.

For viewers with no personal memories of the sites depicted in biblical scenes, then, but who had listened to pilgrims' stories, could recognize the Gospel events represented on the censers' exteriors, and had absorbed the scent of incense during the mass, these vessels may well have provided sensory evidence of what had not, and perhaps could not, be experienced directly. And as we shall see in chapter 4, surrogacy was not confined to objects that played a devotional and therapeutic function in medieval Christendom alone: practices of surrogacy of a slightly different kind are also associated with certain kinds of metal vessels designed to heal and protect in the medieval Islamic world.

The beholders of censers with Christological scenes would thus have been embedded sensorially into the Christian narrative in a way that used the ritual of the mass as a means of spiritual travel. Censers, in other words, would have rendered palpable the major moments of Jesus's life on Earth in a manner that exceeded visual representation, by means of their movement within the space of the church and the way in which this movement combined with the clouds of scented smoke and images that emerged from and embellished them. The point can be made by analyzing an example preserved in Basel that is decorated with nine biblical scenes, providing us with the richest visual account of biblical events depicted on any bronze censer. These scenes are, however, difficult to discern on the object itself—and even in the drawn version of them (see figs. 5 and 9).[78] The cycle begins with the event set in Nazareth and celebrated on March 25—the Annunciation. Here, the viewer encounters a winged angel who raises his right hand toward Mary, who is placed right next to him. The Annunciation is followed by the meeting of the two pregnant mothers, Mary and her cousin Elizabeth. The women embrace closely, perhaps in the hills of Judaea, near Jerusalem and Bethlehem.[79] During the early medieval period, this event was celebrated five days after the celebration of the Annunciation, on March 30. The next scene is of the birth of Jesus, celebrated of course on December 25 or January 7. The site of this miraculous event was one of the earliest mentioned locations in pilgrims' accounts: the Church of the Nativity in Bethlehem. The next two scenes were also thought to have taken place in Bethlehem, though in this rendering it is hard to distinguish one scene from the other. Only the raised hand of the angel announcing the birth of Jesus to two shepherds demarcates the Nativity from the next event. The three heads facing the beholder—lined up next to each other in front of a seated woman holding a child—indicate that the scene depicts the Adoration of the Magi. Jesus's childhood is not addressed further in this sequence, as his baptism, featuring John the Baptist to the left and two angels to the right, appears next, displayed clearly as a separate event that is presumed to have occurred on the shore of the river Jordan. The entry of Jesus to Jerusalem—

celebrated on Palm Sunday and introducing Easter week—is depicted with one apostle following the donkey and another spreading out clothes as if to greet a triumphant king (Luke 19:35–38).[80] The Crucifixion, on Mount Calvary, is followed by a scene representing the women visiting the tomb (fig. 38). Yet, on the Basel censer, the Holy Sepulchre is either missing entirely or the beholder is asked to imagine its roof through the indication of two bent beams joined between the two heads of the two Marys, who themselves hold a vessel for ointment—or perhaps a censer.

The pictorial strategy employed in this image on the censer in Basel, like the frieze as a whole, encourages the participation of the (be)holder in the narrative. Moving the censer in a circle, one could embark on a double pilgrimage, journeying both to sites in the Holy Land and back in time. As the viewer's eye moved around the circular object, time passed, progressed: it moved through Jesus's life, tracing his suffering along a path to salvation. The user's visual journey around the censers' perimeters and the spiritual crescendo of the Christian mass aimed to lure the participant backwards into the sacred past of Jesus's life on Earth and into the promised future of eternal salvation. This retracing of the story, then, was the means by which censers could bring the faithful not only to Jesus's salvation, but also toward their own potential personal salvation. The narrative of the frieze conjoined the temporal and the spatial, quite literally bringing the story full circle. Indeed, the viewer's eye moves from birth through life to death, returning to rebirth as the story recommences upon its completion at that singular narrative point on the censer's orb. The beholder is thereby carried along with a temporality that moves both forward and in an unending circle. Repetition (of images, of ritual) perhaps somewhat paradoxically aims to propel time forward from Earth to Heaven, life to death, and, ultimately, as the vessel turned, resurrection. Votive giving and the use of censers may just as easily have involved local participants as travelers, since these are rituals widely practiced not just among a specific group such as pilgrims. Incense, too, was widely attributed with curative capabilities, potentially making censers popular not only with pilgrims but also with a public who believed in the positive effects of fragrant smoke on both body and mind.

The analysis offered here has endeavored to demonstrate how much information is archived and instantiated in the bronze censers themselves. Through a holistic analysis undertaken with regard to morphology, technique, function, and

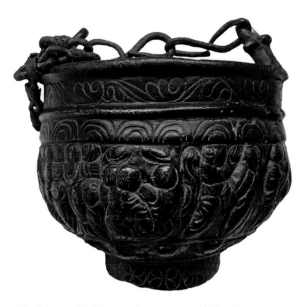

Fig. 38 View of the last scene from a censer with New Testament scenes, two women at the tomb of Christ, 6th–9th century. Bronze; h. 10.8 cm, dtr. 10.9 cm. Basel, Antikenmuseum, inv. no. BRE 644.

iconography, this chapter has aimed to add new tesserae to the (fragmented) mosaic from which the early history of the Christian censer can be reconstructed. Marooned in museum collections and church treasuries with little certainty about date and provenance, the objects' own bodies are themselves archives that bear witness to their deeply entangled histories, marked by connections to both specific locales and transregional trade and pilgrimage routes. This is a history that was never recorded, but which can be rendered legible by close attention to the evidence of the objects themselves in relation to what we can deduce about their function from contemporary textual and visual evidence.

We do not know when the production of these censers ceased, though it lasted at least until the twelfth century (see fig. 20), when the basic narrative scenes from earlier examples were still being copied even as new elements—such as the figure turning its back toward the beholder—were being introduced and the shape and structure of the censers continued to shift. Most of the chapters that follow are concerned with this later period, which marks the terminus ad quem of the censers. However, each pursues a different aspect of transregional and transcultural circulation as manifest in objects produced in a variety of media. In chapter 2, we remain focused on the eleventh and twelfth centuries, but rather than tracking the movement of objects and their functions, we pursue the potential transmission of knowledge between the craftsmen who made them.

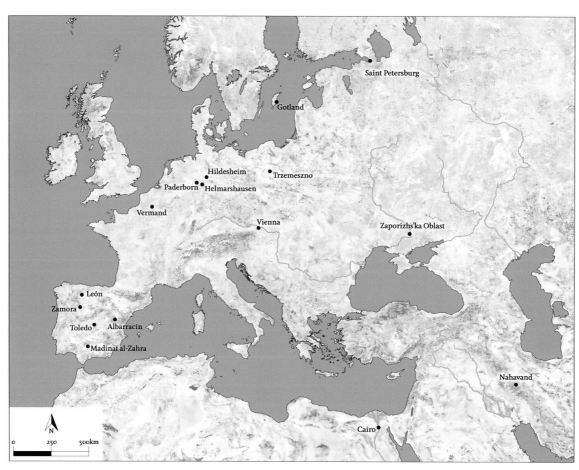

Map 2 Locations of the principal sites discussed in chapter 2. Map by Matilde Grimaldi

Chapter 2

Knowledge and Craft in Medieval Spain and Germany

Innovation in Making Niello

Whereas chapter 1 explored the mobility of a specific type of object, here we investigate how technical knowledge traveled. The chapter focuses on knowledge about one specific technology—leaded niello work—and its circulation among goldsmiths working in different regions of Europe.[1] In general, crafting techniques can travel via three different (but not necessarily distinct) channels: craftspeople teaching others through oral transmission and practical demonstration, written manuals describing the technical process, and objects that themselves circulated. In the last circumstance, objects become silent agents, revealing techniques that may previously have been unknown to makers—who can then attempt to imitate such methods of making in their own practice. A novel technique that circulated only through objects in the absence of explanatory texts or contact between makers would, however, have posed a significant challenge to craftspeople: in such an instance, no related knowledge about the technique would have been transmitted through instructional texts or any encounter between makers, the object serving as the one and only archive of its own making. It would need to act in itself as a convincing ambassador for a novel technique's advantages.

A small eleventh-century silver casket preserved today in León in Spain could have been just such an ambassador, serving as the keystone in the history of niello, a decorative metalworking technique. The León silver casket may have served to launch a significant change in the production of niello inlays, shifting from a niello based on two metals to a niello based on three (figs. 39 and 40).

Niello is a mixture of metal sulfides. When it is heated, it melts, or is softened, and flows into engraved lines, creating a contrast with the metal surface in which it is embedded. Although the technique was already in use during antiquity,

the ingredients deployed to make niello changed over time. Silver sulfide and silver/copper sulfide (bimetallic niello) were not immediately superseded by silver/copper/lead sulfide (trimetallic, or leaded, niello), but instead they coexisted for a time. Trimetallic niello offered craftsmen certain advantages, however, as the addition of lead meant that the temperature used to melt the niello could be lowered, allowing for the creation of more delicate and sophisticated designs. This led to the eventual triumph of the trimetallic over the bimetallic material, with significant implications for the production and meaning of certain kinds of metalwork, as we shall see.

Here we consider the trimetallic niello surfaces of a group of objects probably originating in southern Spain, during the first Taifa period—the decades of political fragmentation following the collapse of the Umayyad caliphate of Córdoba in 1009.[2] A focus on their spiral ornaments in particular provides a springboard for investigating the question of technical knowledge transfer as it relates to the novel deployment of trimetallic niello technique. A close examination of the moments of failure and material losses of inlaid niello apparent in these objects can allow their silent histories to speak and can provide insight into the technique's development.

Scholars to date have never doubted the place of origin of the León silver casket (fig. 39), which has been pinpointed as Fatimid Egypt. This chapter instead suggests an origin for this casket in southern Spain. This reattribution of the casket to Andalusia is rooted in a reading of the traces that knowledge about the making of leaded niello has left in manuals describing the medieval craft of ornamenting metal objects; it is also based on a comparative visual analysis of silver objects decorated with filigree spirals from Byzantium, Afghanistan, and the Mediterranean. In

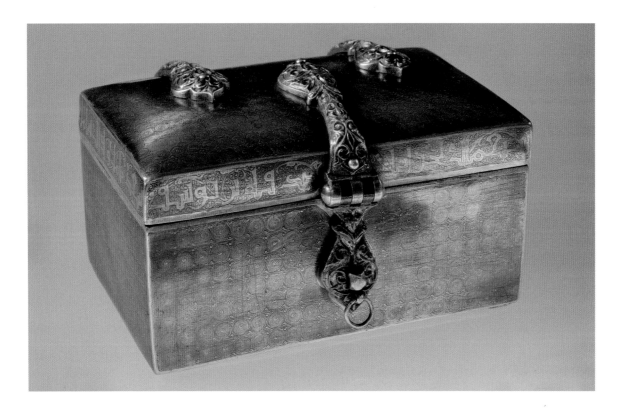

Fig. 39 Casket of Sadaqa ibn Yusuf, al-Andalus(?), dated 1044–47, signed as "made by ʿUthman." Silver, gilt, and niello; 7.5 × 12.4 × 7.9 cm. León: Real Colegiata de San Isidoro.

Fig. 40 Detail of signature of ʿUthman, on the casket of Sadaqa ibn Yusuf (see fig. 39).

reconsidering the casket, this chapter addresses the difficulties of working with material-cultural archives that originate in very different parts of the medieval world, yet show striking similarities regarding their structural features: in this case, metal objects from opposite ends of the Islamic world—al-Andalus and Afghanistan—that deploy the knowledge of trimetallic niello and a preference for spiral ornaments. Yet any written documents informing us about the production, trade, and use of metalwork in both regions are so different (if not indeed completely absent) that they cannot support any definitive assertions about origins for the technique or preference for certain kinds of ornament. Instead, here we suggest mobilizing the objects themselves as archives, considering how they were made and what their makers needed to know to achieve the visual effects so characteristic of their products.

We begin by examining written treatises that describe niello technique, before proceeding to a visual analysis of specific objects such as the casket from León. In conclusion, the chapter argues that the growing popularity of trimetallic niello technique for liturgical objects in the Latin West may have been linked to theological ideas about

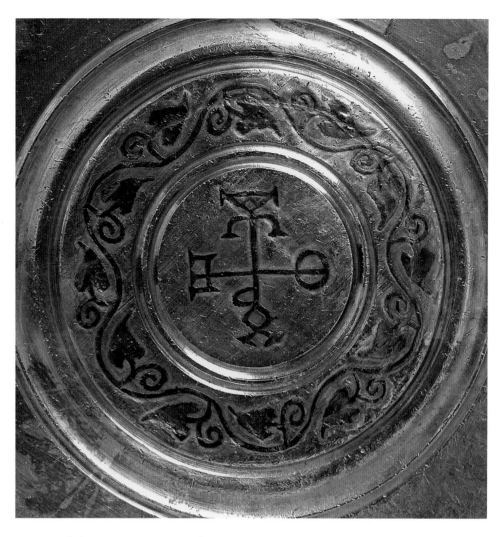

Fig. 41 Detail of monogram on a Byzantine plate, 610–13. Silver; 13.3 × 2.4 cm. New York, Metropolitan Museum of Art, inv. no. 52.25.2.

the tripartite nature of the Christian God. References to the vine, the spiral, and the Trinity may have come together to encourage the deployment of the new technique. Before exploring the confluence of making and meaning, however, we first cast a glance at the nature of niello as a substance, and delve into the surviving manuals in Latin, Greek, and Arabic addressing niello technique.

The Nature of Niello

There are two main types of niello.[3] While the Latin term *nigellum* (somewhat black, a little bit black) emphasizes color, the Persian *mīnā* was the term primarily used for glass and vitreous objects, including for the decoration of surfaces of metal, ceramic, and glass. It was also used to describe a type of glass containing lead created in imitation

of enamel.[4] Etymologically, the word refers to something spiritual or heavenly, but in the medieval period it became a term frequently used for molten glass that revealed an oscillating pattern after cooling.[5] There is no known term for niello in Arabic, but in his famous early fourteenth-century treatise on ceramics the Iranian author Abu'l-Qasim refers to it as "burnt silver" (Persian: *sim-i sukhta*).[6] The Greek word for it, meanwhile, is rooted in the verbs *egkoptō* (cut across [something]) or *ekaiō* (burn into [something]).

The first type of niello is composed of two metals, copper and silver sulfite; it was mentioned by Pliny, and had been known in the Latin West since the third or fourth centuries CE.[7] For example, the monogram "Theodore A" on a seventh-century silver plate was made by hammering unleaded, heated niello (fig. 41). This object is dated securely, on the

basis of the stamps on the back of the plate, which are from the beginning of the reign of Byzantine emperor Heraclius (610-641).[8] The technique required the goldsmith to hammer a somewhat malleable mass into the cavities of a metal surface, an approach made necessary because the melting point of bimetalllic niello is significantly higher than that of trimetallic niello and thus is closer to the melting points of silver or gilded silver. Since the melting point of the casket's material was close to that of the inlay, the technique required either an extremely precise and consistent temperature in the goldsmith's furnace, or more pressure to work the (less) malleable mass into the cavities of the metal surface of the vessel. The inlay needed to be literally banged in with a blunt instrument like a hammer to avoid deforming the vessel.

The second type of niello was invented during the medieval period—we discuss where and when below—and is composed of three metals: silver sulfite, copper, and lead. This leaded niello can only be used in molten form, such that the liquid mixture of metals slides into incisions on an object's surface at about 450°C, a much lower temperature than almost 1000°C of soft unleaded niello. The addition of lead to a mass of molten copper and silver sulfite not only significantly reduced its melting point, but also enhanced the malleability of the molten metals. Once the mass was hot, the goldsmith would add more silver sulfite while pouring the molten metals into a clay vessel whose interior had been prepared with borax, salmiak, and silver sulfite. This new mixture was then poured onto a flat surface, cooled, and broken into small pieces of niello. These were crushed into a powder and applied to the clean surface of a metal object using a fine stick or a brush.[9] As Susan La Niece has pointed out, "silver sulfide and silver/copper sulfide were not superseded immediately by the silver/copper/lead sulfide mixture, but the latter type rapidly gained in popularity, presumably because of its technological advantages."[10]

To produce spiral ornaments like those we find in the León casket (see fig. 40), fine silver bands were either applied and then firmly joined to the silver surface, the darker lines of the niello setting the silver spiral into relief, *or* fine lines were worked into the silver surface to form spiral-shaped cavities into which niello powder and the flux (materials added to promote fluidity) were placed, so that heat could melt the niello to create a smooth and even surface. To produce such fine and subtle ornamentation, leaded niello, soda, and borax are necessary. The mineral borax made niello yet more malleable and further reduced its

melting point, thus allowing it to fuse smoothly and more permanently with its silver carrier.[11] With leaded niello, the melting points of vessel and inlay drew apart, which meant that the metalsmith could experiment with a greater variety of forms, the niello being more supple and flexible. This raises questions about our reconstruction of the history of trimetallic niello: Which medieval primary sources mention the new ingredients? Where and when did the shift from bimetallic to trimetallic niello happen? Moreover, can we link the mention of new ingredients and the new process of production to the objects that survive today?

Three Different Histories of Niello

The history of niello can be told in three different ways—based on written manuals, based on visual analysis of nielloed objects, and based on analysis of specific ornaments used for niello decorations. Like that of the early Christian bronze censer, the history of niello is a history wherein the stories told by objects differ from accounts in surviving written primary sources.

The written history of niello leads us to manuals written in Arabic, in ancient Greek, and in Latin. The two oldest Islamic primary sources describing the making of niello were written in Yemen by al-Hamdani (ca. 330 H/942 CE), who describes only two metals and does not mention lead. On the other hand, Abu'l-Qasim's recipe, from Iran around 1300, gives one part silver, one part copper, and one-twelfth part lead.[12] However, the fact that leaded niello is mentioned in even older manuals written in ancient Greek and in Latin seems to point to an origin of the technique in Byzantium or the Latin West. But as we shall see, to rely on these textual sources alone in considering origins would be misleading.

The eleventh-century Greek manuscript *On the Noble and Illustrious Art of the Goldsmith* also describes the niello fabrication process as including small amounts of lead.[13] The existence of this Greek text has been used to support the attribution to Byzantium of an object (fig. 42) that has been thought for decades to be the oldest known object whose niello contains lead. We shall see, however, that neither this attribution nor the object's dating is certain and that both in fact rely on problematic assumptions.

Later craftsmen's manuals describing the production of leaded (trimetallic) niello in the Latin West record that the technique increases the material's malleability and reduces its required temperature.[14] The tracts *De coloribus et arti-*

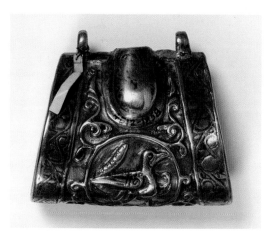

Fig. 42 Flask, possibly Islamic, 11th or early 12th century. Silver with niello. London, Victoria and Albert Museum, inv. no. 4512–1858.

Fig. 43 Amulet-case, Islamic, 11th century. Silver, gilt, and niello; h. 2.6 cm. London, British Museum, inv. no. 1939,0313.1.

bus romanorum (On the colors and crafts of the Romans), written by an otherwise unknown Heraclius, and De diversis artibus (On various crafts), by a German monk and priest called Theophilus (d. 1125), both mention lead in their discussions of niello. The niello recipe appears in the third part of Heraclius's text, an addition dating to around 1200 (the first parts are a century or two older).[15] Heraclius does not mention the necessary amount, however. By contrast, Theophilus prescribes an unusually high proportion of lead.[16]

The two earliest Latin sources that mention leaded niello, the Mappae clavicula and the Liber sacerdotum, are extremely difficult to date. The Mappae clavicula, a medieval Latin text containing recipes for metalwork, glass, mosaics, and dyes and tints, is a translation of an Arabic original; however, in this collection, the recipe for niello only appears in the most complete surviving document, the so-called Phillipps-Corning manuscript. This version of the text dates to the twelfth century; the part on niello is not included in the ninth-century manuscript version of the Mappae clavicula now located in Selestat in eastern France. Both manuscripts of this text include several ingredients that point to an Arabic original: for example, the use of the terms alquibriz for sulfur, atincar for borax, and alcazar for tin.[17]

The Liber sacerdotum also includes a recipe for the production of niello.[18] The date of this manuscript is, however, equally difficult to pinpoint; it is generally dated to the tenth or eleventh century. Historian of science Marcellin Berthelot points out that the frequent use of Arabic words indicates a Spanish origin for this text.[19] Based on a close reading of the surviving primary sources that relate information about the production of leaded niello, it seems that the knowledge recorded in the

Latin and Greek texts is derived from (lost) Arabic originals, which points to an origin of the trimetallic niello technique in southern Spain before the tenth or eleventh century. What we can conclude from the comparison of the ingredients, and from the fact that the terms for them used in Latin point to an Arabic etymological origin in written primary sources describing the technique, first in eleventh-century Byzantium and then at the beginning of the twelfth century in Germany, is that both the Latin and Greek texts were based on older Arabic or Persian sources that must have mentioned lead; sources that are now lost.

Surviving niello objects, however, tell a different story about the origins and dissemination of the technique than do written manuals. Silver sulfite/copper niello is found as early as the sixth century in the Latin West, but no leaded niello object is known to have been made there before the twelfth. To date, the oldest object made with the later trimetallic technique was long considered to be a flask now in the Victoria and Albert Museum (see fig. 42). But this flask is extremely difficult to date and, although there has been speculation that it was perhaps made in Byzantium, no comparable Byzantine object has survived.[20] Based on formal comparison with Islamic amulet cases, it seems more plausible, therefore, that it came from an Islamic region and was made at the turn of the eleventh to twelfth century.[21] A gilded silver amulet case (now in the British Museum) that bears a relationship to the flask, for instance, has been more securely dated to the eleventh century, and probably originates from Nihavand in today's Iran (fig. 43).

Part of the difficulty with tracking the transmission of niello techniques has been that very few objects made with niello have been subject

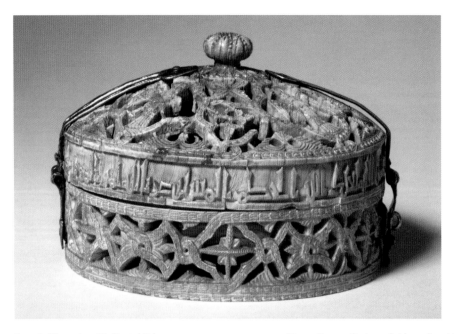

Fig. 44 Ivory pyxis, probably made at Madinat al-Zahra, near Córdoba, ordered by Caliph al-Hakam II, under the direction of Durri al-Saghir, ca. 964 CE. Ivory; h. 7 cm, dtr. 10 cm. London, Victoria and Albert Museum, inv. no. 217-1865.

(FACING PAGE) *Fig. 45* Zamora Pyxis, probably made at Madinat al-Zahra, near Córdoba, ordered by caliph al-Ḥakam II, under the direction of Durri al-Saghir, ca. 964 CE. Ivory; h. 17.7 cm, dtr. 10.3 cm. Madrid, Museo Arqueológico Nacional, inv. no. 52113.

to technical analysis. It was only recently that the niello parts of ivory objects made in Andalusia have been seriously investigated to determine their chemical and physical make-up. It has now been posited that the earliest surviving leaded niello objects—such as the hinges and clasps of ivory caskets known to have been made in Andalusia (figs. 44 and 45)—were already being produced in the eleventh century in Islamic regions, and not in Byzantium or in the Latin West.[22] Already in the eighth and ninth centuries, glassmakers at Córdoba in Ummayad Spain were experimenting with lead, thereby obtaining lower melting temperatures.[23] Silversmiths working in al-Andalus might have been inspired by glassmakers to experiment with lead to achieve a similar effect for the fabrication of niello.

Regardless of its source, the new leaded niello technique enabled craftsmen to ornament more complex shapes such as those of round vessels or lobed bowls, which could then be decorated with extraordinarily fine linear surface structures to be filled with niello inlay. The surfaces of these more complex objects could, moreover, attain a new degree of polish, shine, and evenness, as we can still admire in the remarkably smooth silver niello casket at León mentioned above, with its delicate spiral ornamentation upon the vessel's slightly convex cover as well as on the exterior sides of its silver body (see figs. 39–40). The artistic decisions

that were made regarding the elegantly inscribed texts inlayed into the casket's silver "skin" are equally sophisticated and detailed. The subtlety of the leaded niello ornamentation is unmatched by other medieval niello inlay work on silver. The composition of the decoration is based on the number seven: it features seven perfectly round vertical and twenty-one horizontal spirals on the longer side panels; seven vertical and fourteen horizontal spirals on the shorter side panels. The convex cover was carefully composed so that it spans fourteen spirals in width and twenty-one spirals in length. The number of spirals of the two longer lateral sides and the number of spirals on the convex lid would thus be equal, if some had not been omitted to accommodate hinges and latches.

Each spiral consists of two very thin joined silver bands that serve as dividers, creating compartments filled with black niello. These fine strips are soldered onto the silver panel, spiraling out at an exactly equal distance so that the niello filling in between them also forms an almost perfect black spiral (see fig. 40). At only a few points on the casket do silver strips touch, or does the niello filling, at other points, overlay the silver strips. The end of each silver strip curls in the opposite direction to the spiraling arm, to form a little counter-curl. These curls mark the "corners" of each of the spirals, thus suggesting an imaginary

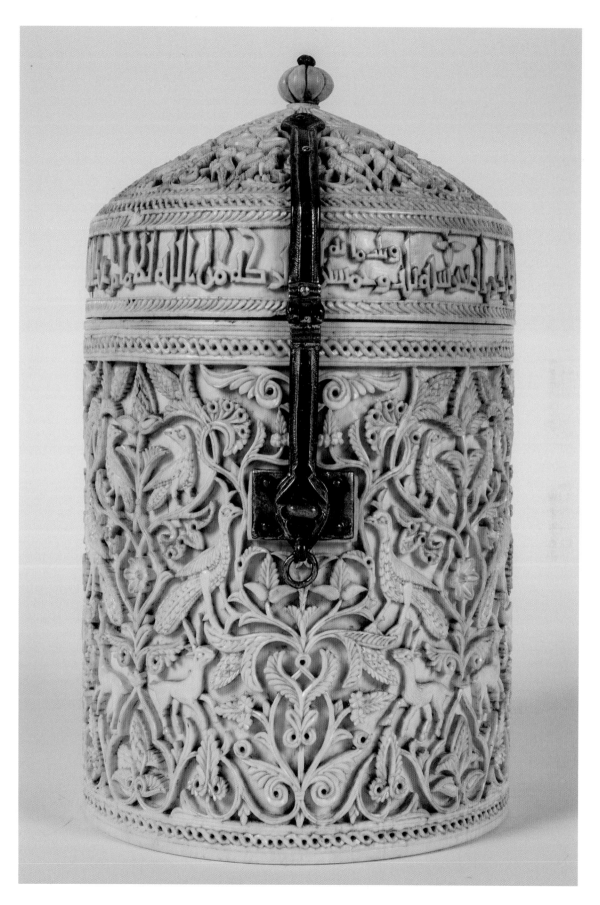

horizontal grid on the surface delineated by the fine and uninterrupted line of a silver strip. The Arabic inscription in angular Kufic script around the sides of the upper lid was applied with silver strips (see fig. 39). In between and behind the letters of the inscription, irregular spirals spread out, forming a dark background that enhances the legibility of the Arabic letters. Some of these are foliated, terminating in leaf-like shapes that form a pattern and often stretch over the arch of a single word at the same time as they indicate word endings and mark the beginnings of new words.

When one lifts the casket's lid, one discovers that the clasp for the lock was part of the original construction, not attached later. The metalsmith's signature is hidden by the clasp but integrated as a horizontal bar above the lock that divides a floral ornament with two buds above from two leaves next to the lock's knop (see fig. 40). Although the niello work is executed using very different patterns, elements, and shapes, the space between the silver bands that creates the grooves for the niello filling seems always to have been soldered at equal distances. Overall, in other words, the craftsmanship is complex and excellently executed, such that decorative patterns of negative and positive spaces combine harmoniously (and according to a regular, numerical system) in a manner that enhances as well as clarifies the script emblazoned upon the object. This level of artistic execution was possible because of the tripartite composition of the niello itself, as well as the skill of the craftsman, who clearly knew how to produce objects of great complexity and aesthetic sophistication in the new trimetallic niello technique.

As mentioned before, the casket in León has been attributed to Fatimid Egypt. This attribution is based on the inscription, which provides us with the artist's name, 'Uthman (see fig. 40), and informs readers that the casket was made for the treasury of Sadaqa ibn Yusuf. Stefano Carboni has identified the patron as Abu Mansur Sadaqa ibn Yusuf al-Falahi, an Iraqi Jew who served as vizier of the Fatimid caliph of Egypt al-Mustansir billah between 1044 and 1047; hence the casket's suggested origin in Fatimid Egypt.[24] However, since it was made for an Iraqi Jew, it could well have come from another location, such as Baghdad or al-Andalus. It could also have been made slightly earlier, as no other information about Sadaqa ibn Yusuf's life or his whereabouts has been uncovered. Cynthia Robinson has pointed out similarities to objects made in Islamic Andalusia, but because Sadaqa ibn Yusuf only appears in the written records of Fatimid Egypt, not of Islamic Spain, she has suggested that the casket

may have been made in Egypt. This attribution privileges the written record, even though there are few connections between the casket and other objects originating in Egypt, and much stronger connections to objects from Islamic Andalusia, as we will see. Furthermore, we cannot exclude with certainty the possibility that a craftsman or a manuscript describing the technique may have traveled to León from elsewhere, leading to the production of the León casket in Spain.[25] Indeed, most of the evidence from the objects themselves points to southern Spain in the tenth and eleventh centuries as the most likely location from which knowledge about the production of trimetallic niello inlays originated, or at least proliferated.

Among the niello ornamented objects that survive from this period in Iberia, several key examples have not yet been chemically analyzed, meaning that we can only assume that lead was added into the niello from the fineness and sophistication of their decorations and the smoothness of the objects' surfaces, which are similar to those of the León casket. The oldest examples in the Latin West that have been subject to analysis, and which definitely contain leaded niello, include the background of a cross from northern Spain, now in New York (ca. 1125–75; figs. 46 and 47) and the Wilten chalice and paten (ca. 1160–70; figs. 48 and 49).[26]

A technical and visual analysis of the objects themselves suggests an origin for the technique was in tenth- or eleventh-century Islamic Spain. The discrepancy between the first written allusion to the use of the lead in the primary sources and the first known instance of its use in surviving objects is striking. The primary sources describe the addition of lead early in the Latin West (twelfth century) and later in the Eastern sources (mentioning lead only in the fourteenth century). However, the existence of Islamic objects that employ trimetallic niello as early as the eleventh century indicates that objects made with leaded niello and texts describing the technique must have traveled by various routes and at differing speeds.

We might consider, in addition to the different trajectories of objects and texts describing the techniques by which they were produced, the expanded possibilities for ornament enabled by the new technique of trimetallic niello. These are especially apparent in the use and development of spiral ornaments, for which there seems to have been a preference. Three objects—the casket at León, a casket now in Madrid (from León; fig. 50), and a perfume flask in Teruel, Spain (figs. 51 and 52) are all small vessels with relatively complex,

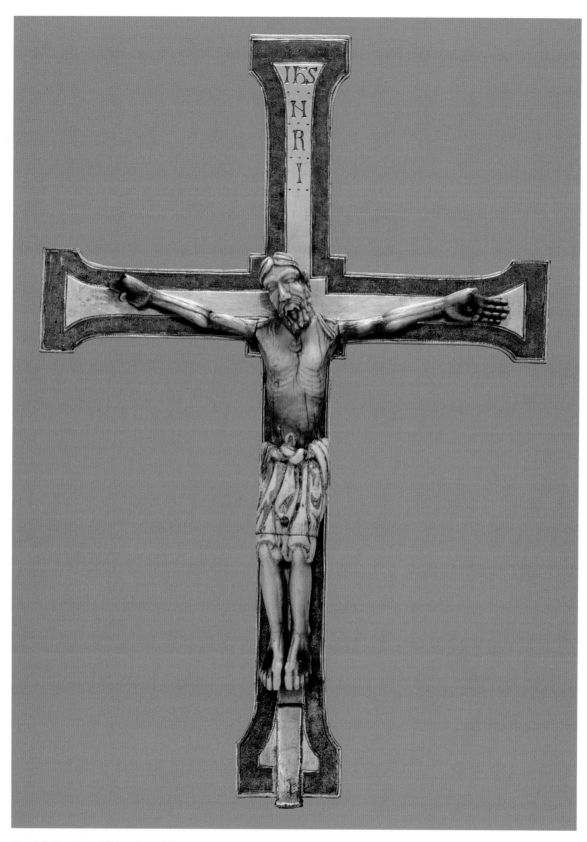

Fig. 46 Reliquary crucifix, north Spanish, ca. 1125–75. Silver, silver gilt,
and niello (cross), ivory and gilding (body); 26.7 × 18 × 2.4 cm.
New York, Metropolitan Museum of Art, inv. no. 17.190.221.

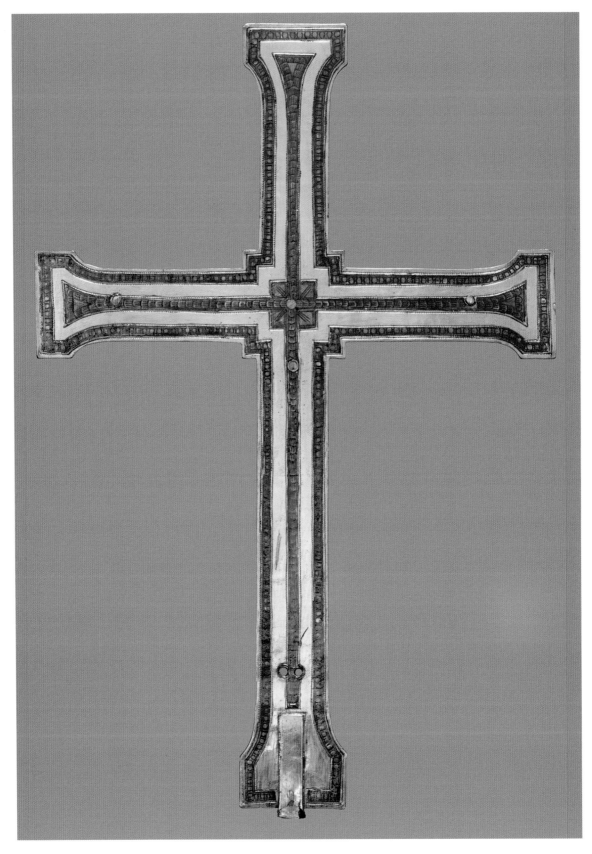

Fig. 47 Reliquary crucifix, reverse (see fig. 46).

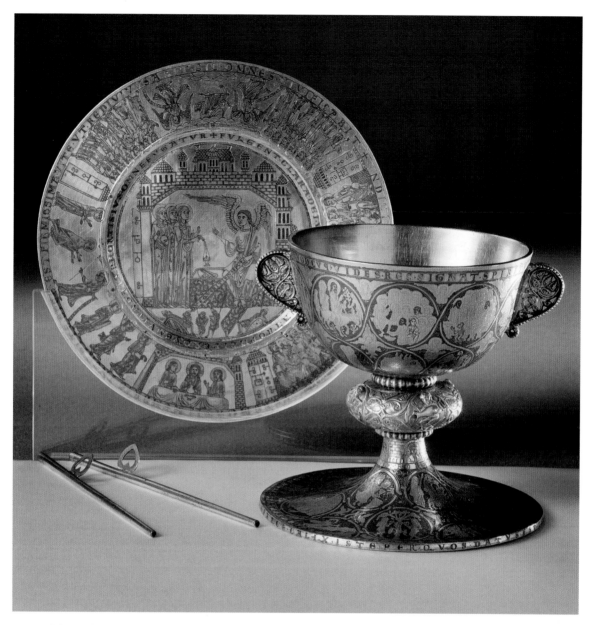

Fig. 48 Chalice with paten and fistulae: the so-called Wilten chalice, Lower Saxony, ca. 1160s. Silver, gilt, and niello; h. 16.7 cm (chalice), dtr. 23.5 cm (paten), l. 19.6 cm (fistulae). Inscription along the upper border of the chalice reads "+HIC QVOD CV[m]Q[ue] VIDES RES SIGNAT SPIRITVALES EST QVI·VIVIFICAT·S(ed)·NIL·CARO·PRODEST." Vienna, Kunsthistorisches Museum, inv. no. Kunstkammer 8924.

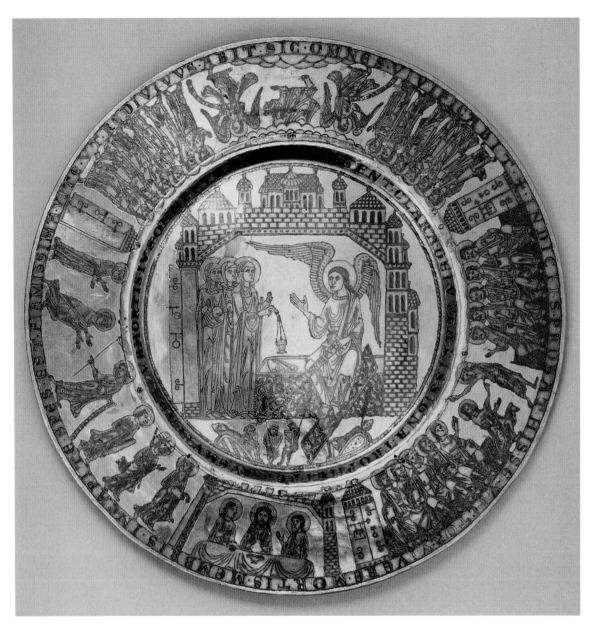

Fig. 49 Inscriptions on the Wilten paten (see fig. 48): (beginning and ending at the cross at 2 o'clock): INDICIIS PROBAT HIS SE VICTOR VIVERE MORTIS MEMBRIS IN CAPITE SPES EST FIRMISSIMA VITE VT REDIVIVVS ABIT SIC OMNES VIVIFICABIT (inner ring, beginning and ending at 12 o'clock): FVLGENT CLARA DEI VITALIS SIGNA TROPHEI PER QVEM VITA DATVR MORTIS IVS OMNE FVGATVR.

Fig. 50 Casket from the Colegiata de San Isidoro, possibly made in León, 11th century. Silver and niello; h. 5.5 cm, w. 11 cm, d. 6.5 cm. Madrid, Museo Arqueológico Nacional, inv. no. 50889.

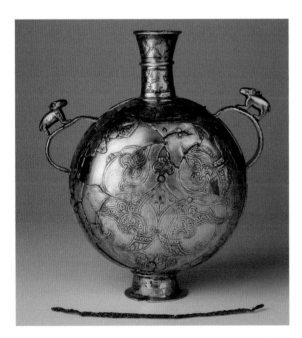

Fig. 51 Zahr's scent flask (or Albarracín flask), commissioned by ʿAbd al-Malik ibn Jalaf, al-Andalus, mid-11th century. Silver, gilt, and niello; h. 16.1 cm, w. 16.3 cm, d. 12.2 cm. Teruel, Museo Provincial de Teruel, inv. no. 00629.

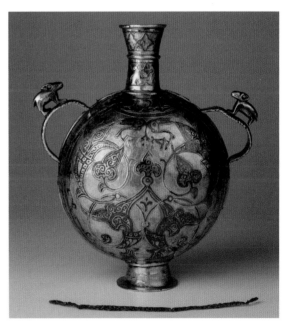

Fig. 52 Reverse of Zahr's scent flask (or Albarracín flask) (see fig. 51).

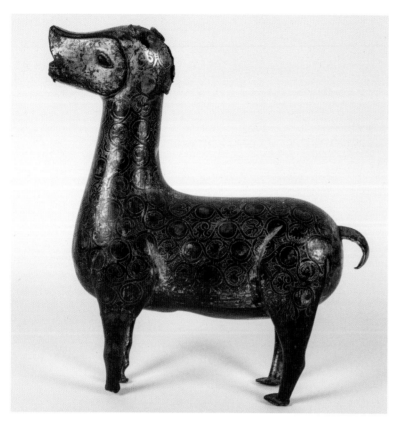

Fig. 53 Fountainhead in the shape of a stag from Madinat al-Zahra, al-Andalus, second half of 10th century. Bronze; h. 32.3 cm, l. 31.5 cm, w. 10 cm. Madrid, Museo Arqueológico Nacional, inv. no. 1943/41/1.

slightly convex surfaces into which niello was inlayed. Spiral ornaments dominate each of these objects. Their curved surfaces point to the use of leaded niello for the reasons mentioned above: the significantly lower melting point of trimetallic niello would have facilitated this kind of modeling in silver.

As Carboni has observed, moreover, the overall spiral decoration found on the León casket has no parallels in Fatimid art,[27] whereas this motif was widespread in Islamic Spain. Three bronze Islamic objects have similar ornamental patterns,[28] and these may all have been produced in related workshops in Spain. They included two quadrupeds—formerly waterspouts—from Córdoba (fig. 53), one now in Florence (fig. 54), and a bronze griffin in Pisa (fig. 55). Robinson has suggested Toledo in the Taifa period as the place of origin of another casket, closely related to the one in León (see fig. 50). This casket also has a slightly vaulted lid, but its form is oval, not rectangular. Here, however, the spirals do not constitute the background of the entire surface but rather only

fill in ornamental vine leaves and branches; the casing itself is silver. Again, we find an inscription band running along the upper lip: its Kufic script along with its ornamental pattern reveal close similarities to a silver scent flask preserved at Los Tajadillos, Teruel, that bears the Arabic name "Zahr" (see figs. 51 and 52). The surface of the scent flask, however, unlike that of the two caskets, is made up of two distinct layers: the silver background is polished and emphasizes the slightly raised intertwined ornamental vines that circumscribe the vessel's body. The inscription and the ornaments at the vessel's neck are also slightly raised. The niello inlays sit on the silver background, while the silver structure of the vines that frame the channels into which the niello was poured is slightly raised; the body of the vessel, therefore, is not flattened down to a single level. Thus while the niello layer on the scent flask is raised, the surface of the León casket (see figs. 39 and 40) is smooth and slightly curved.

These observations lead to various potential hypotheses related to the transmission of

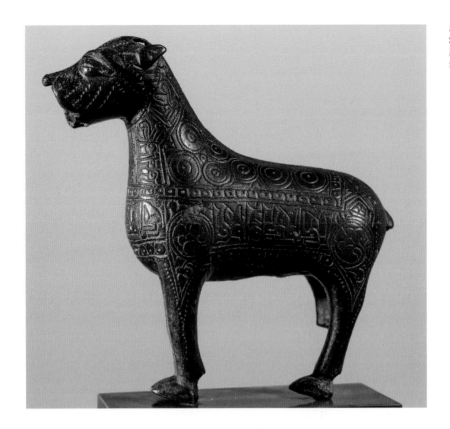

Fig. 54 The Bargello quadruped, Spain, 11th century. Bronze. Florence, Museo Nazionale del Bargello, inv. no. 63c.

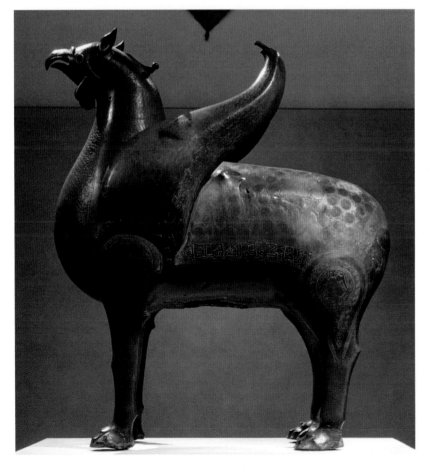

Fig. 55 The Pisa Griffin, Spain, 11th or 12th century. Bronze; h. 107 cm, l. 87 cm, w. 43 cm. Pisa, Museo dell'Opera del Duomo.

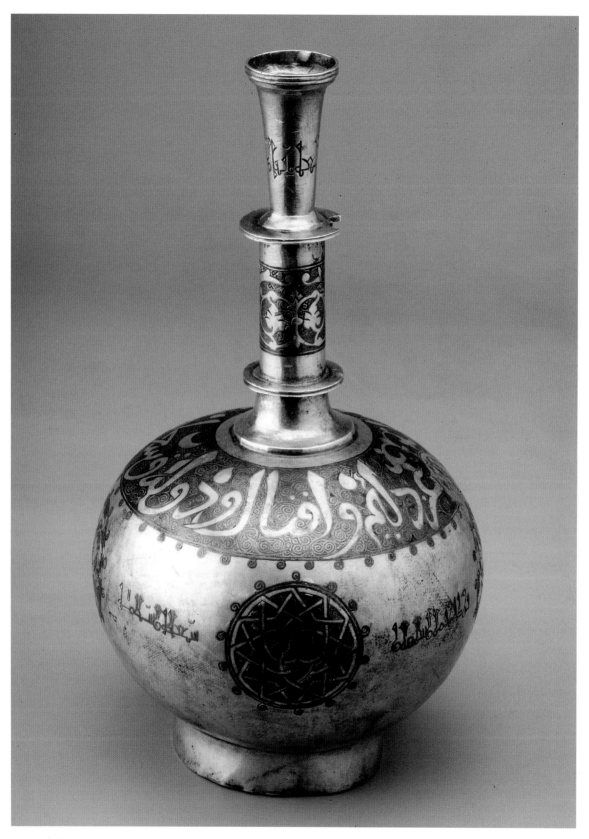

Fig. 56 Flask for rose-water, with benevolent Arabic inscriptions,
Iran, second half of 11th century. Silver and niello; h. 20.6 cm,
dtr. 11.5 cm. St. Petersburg, State Hermitage Museum, inv. no. S-504.

knowledge about tripartite or trimetallic niello. The silver casket at León could have been imported to southern Andalusia, where it subsequently inspired the production of similar objects, such as the oval casket and the scent flask (see figs. 50-52). Alternatively, it could have been made in Spain, perhaps at Toledo. Because of its previously unquestioned attribution to Fatimid Egypt, Spanish objects like the scent flask have also been described as showing "not only local influences but those from outside the peninsula as well."[29] This implies the influence of Fatimid art on the production of the niello flask, but such assumptions about attribution raise significant methodological questions. The attribution of the León casket to Egypt, as we saw above, is based upon a single inscription related to a peripatetic person who happened to have served for two years at the Fatimid court.[30]

On the Teruel flask, we again encounter delicate niello ornamentation, including spirals, lavishly composed inscriptions, and curved silver surfaces (see figs. 51 and 52). The spirals fill the gaps in the silver and accompany the floral elements, spreading out from them. Large portions of the vessel's body are slightly recessed but not filled with niello—a significant difference from the León casket. Marked similarities can be observed between the casket in Madrid, the Teruel flask, and another silver bottle, now in Saint Petersburg (fig. 56). The last of these has a convex surface, delicately designed bands with carved inscriptions (around the vessel's neck), and niello inlay around its belly; it has been dated to the eleventh or twelfth century and attributed to the Ghaznavid empire of eastern Iran and Afghanistan. Ghaznavid craftsmen were celebrated for their silverwork and had easy access to silver mines; they even sent silver door revetments to the Ka'ba, the focal shrine of Islam in Mecca.[31] The blackish tone of these vessels and the cavities filled with niello spirals that ornament them on varying raised and recessed levels suggest that they were made with a trimetallic niello technique.

Looking at this corpus as a whole, we see that the casket from León (see figs. 39 and 40), the flask now at Teruel (see figs. 51 and 52), and the bottle in Saint Petersburg (fig. 56) reveal the closest similarities with respect to the spiral ornamentation used in their nielloed parts. The composition of these objects, including the casket in Madrid (see fig. 50), is very balanced and combines script, spirals as background patterns behind inscriptions, and the spiral as their primary ornamental form. But the Teruel flask was composed with a design conceived for a two-layer surface: the ornamental structures on its surface have deployed niello

Fig. 57 Casket from the so-called Harari hoard, possibly made in Iran, 11th or 12th century. Copper, silver, gilt, and niello. Jerusalem, The Museum for Islamic Art.

spirals as *filling* between the leafy ornaments. This very consciously created a second layer: niello slightly raised above the body of the vessel. The Saint Petersburg bottle is similarly designed, though it has a completely smooth surface. Inscriptions on this object are filled with niello or set in silver letters into the nielloed parts.

Because none of these four objects (the caskets in Madrid and León and the bottles from Teruel and Saint Petersburg, figs. 39, 50-52, and 56) has been subject to technical analysis that would allow us to ascertain whether they use leaded niello, we can only speculate about a connection between Ghaznavids and craftsmen in Andalusia. However, all four containers reinforce the impression that spirals are the primary ornamental form used in trimetallic niello technique. They are used as a regular pattern all around the objects, filling the spaces between floral ornamentation at the bottle necks as well as spaces around inscriptions. These striking parallels are obvious in the use of niello inlays, the inscriptions, and the complex vaulted surfaces of the containers into which niello was worked.

To this group we might add two caskets from the Harari hoard, discovered in Iran at Nihavand and today kept in the Museum for Islamic Art in Jerusalem (fig. 57), on the basis of their deployment of vines with three-lobed leaves filled with spirals as ornament. The size of these caskets and their vaulted upper lids would also seem to point to a similar origin. The objects found together in this treasure trove clearly came from different places and therefore exemplify a wide variety of

Fig. 58 Casket of Hisham II, dated 366 H/976 CE, signed as work of Badr and Zarif, al-Andalus. Wood, silver, gilt, and niello; h. 27 cm, l. 38.5 cm, d. 23.5 cm. Girona, Museu de la Cathedral de Girona, inv. no. 64.

(RIGHT) *Fig. 59* Detail of the signature, casket of Hisham II (see fig. 58).

styles and production techniques.[32] Neither the caskets from the Harari hoard, nor the Ghaznavid objects, nor the bottle from Saint Petersburg have been subject to technical analysis, nor are any of them securely dated. We can only speculate, therefore, as to whether the technical knowledge required to produce leaded niello was developed independently in different regions (al-Andalus and eastern Iran), or invented in al-Andalus, and traveled via manuals, objects, and/or craftsmen. Only technical analysis, regarding the presence of lead in nielloed objects, will help to clarify this issue.

The observations above, based on visual analyses of objects that have traveled far and bear little or no written reference to their cultural origin or site of production, are supported by recent technical analysis performed on another group of objects: ivory caskets and pyxides from Andalusia. Testing of niello mounts on these ivory objects, especially two objects commissioned by the second caliph of Córdoba, al-Hakam II (d. 976)—the so-called al-Hakam pyxis (see fig. 44) and the so-called pyxis of Zamora (made in 353 H/964 CE; see fig. 45)—has revealed that their niello work contains lead and that they were fabricated in eleventh-century Spain.[33] A casket made for the Umayyad caliph of Córdoba Hisham II (fig. 58), meanwhile, was not made with leaded niello;[34] nonetheless, it has one striking similarity to the León casket, in the position of the signature of the goldsmith. In both cases, the names of the craftsmen are only exposed once the lid is lifted (see fig. 40; fig. 59). However, the use of niello is very different on each casket: Particularly distinct is the niello used for the inscription: plain niello fills the Arabic letters, sitting elevated upon the gilded surface. The letters are not inlayed into an even, smoothened surface, as they are in the León casket.[35]

This observation endorses the first part of art historian Mariam Rosser-Owen's suggestion that "the introduction of lead in niello should be redated, and possibly reattributed to the Islamic world."[36] A problem with current scholarship is that each region is still often considered separately. The Islamic world, Byzantium, and the Latin West are treated as isolated entities, as if objects, materials, and craftsmen would have only circulated within the boundaries of these territories and never beyond their borders. Many of the artifacts discussed in this volume demonstrate the limits of such an approach.[37]

The case of niello raises particularly interesting questions regarding the three potential ways to transfer technical knowledge: through

Fig. 60 Reliquary with heart-shaped lid. Rock crystal, silver, and niello. Capua, Museo Diocesano di Capua.

the movement of artisans, objects, and technical descriptions. Although historiography has been narrowly focused on specific regional developments and traditions, objects often either traveled far from their site of production, or—complicating the writing of this history even further—have characteristics that cannot be attributed securely to a specific "original" region. Some objects addressed here have already been identified as either Byzantine or Islamic (see figs. 42 and 43); others as being of Fatimid, or Iranian, or Spanish origin (see fig. 39).

The case of the decoration of intricately shaped metal objects is particularly apt for exploring the possibilities of the new technology of leaded niello, while also highlighting the problem of origins. The heart-shaped lid of a rock crystal ewer in the Museo Diocesano in Capua (fig. 60) furnishes an excellent example. Here again we encounter a case where art-historical scholarship on medieval craftsmanship has placed too much weight on written primary sources and not enough on the evidence offered by the object itself. Avinoam Shalem has pointed out, for instance, the problem involved in attributing a Fatimid origin to all extant rock crystal ewers.[38] Rather than assuming an Egyptian origin, it may well be that the single-hinged lid of the rock crystal ewer at Capua was actually made in Spain, along with two heart-shaped boxes preserved in the León treasury.

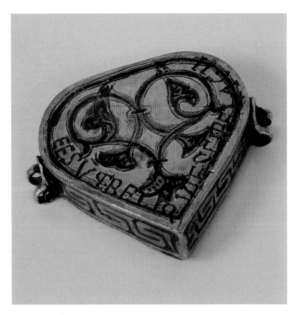
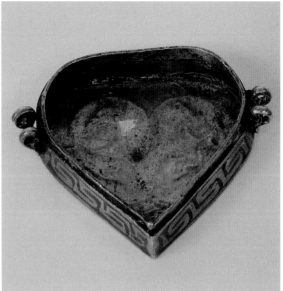
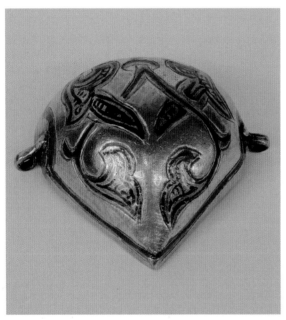

(TOP) *Fig. 61* Inside and outside view of the bottom of a heart-shaped box with relics of Saint Pelagius, al-Andalus, first half of 11th century. Silver, gilt, and niello; 2.1 × 3.3 × 3.2 cm. León, Real Colegiata de San Isidoro.

(BOTTOM) *Fig. 62* Inside and outside view of the top of the lid of a heart-shaped box with relics of Saint Pelagius (see fig. 61).

While the nielloed body of one of these reliquaries in León has flat surfaces, its top is vaulted (figs. 61 and 62). Closed by means of two hinges, the box displays on its top the same fine nuances of dark lines and slightly lighter greyish shades emphasizing the organic structure of the leafy ornamental vines that come together at the core of the container's upper lip. Again, made of gilded silver, the flat bottom part of the box reveals a Latin inscription that was added later, when the small container was turned into a Christian reliquary. The inscription details its contents: relics of Saint Pelagius, a Christian who suffered martyrdom at Córdoba during the reign of the Umayyad caliph ʿAbd al-Rahman III (300–350 H/912–961 CE). The absence of Arabic inscriptions has led to the suggestion that such boxes (several of which have survived) may have been produced for the Christian community during the Taifa period.[39]

To better understand the implications of these visual observations, we should consider the advantages that a novel niello technique would have offered to makers, and assess these advantages in the context of realities on the ground in particular regions. Was there a preference for objects preserved in the same treasuries, for example in León, to share a specific appearance or aesthetic qualities?[40] What about the locks, the hinges, and the metal straps that close these objects: are their particular shapes aspects of the objects' ornamentation, or simply practical additions that cover the carefully crafted decoration? Together with further technical analysis of the material composition of nielloed objects, answers to these questions can help us start to better understand where, why, and how knowledge transfer occurred both in relation to these specific objects and as a general principle. This approach can also help us begin to distinguish between different types of knowledge transfer: when objects travel without texts; when craftsmen journey to teach techniques; when drawings or objects from far lands inspire new decorative patterns locally; or when written manuals are carried from place to place.

Inspiration and Imitation

Once the trimetallic niello technique was established, it inspired imitators. An attempted imitation of the new leaded niello technique can be detected in the casket today preserved at the Museo Arqueológico Nacional in Madrid and dated to the twelfth century (fig. 63).[41] It remains an open question whether this casket was produced in Andalusia or in northern Spain. The misspellings in the Arabic inscription, the significantly less elegant use of niello, the probable absence of leaded niello, and the roughness of the carving would support the latter origin. These characteristics would also suggest that the casket was made after the arrival of the leaded niello casket at León (see figs. 39 and 40) that seems to have inspired it. The "northern" casket could thus testify to an attempt by craftsmen in northern Spain to imitate an object without achieving the same level of technical refinement. If indeed this is an example of craftsmen being unable to master a foreign technique, the imitation may not simply be discounted as a failure, but can instead be read as providing evidence for how knowledge developed and/or traveled via mobile objects that inspired experiments with new techniques, whether successful or not.

We know that in the twelfth century three silver caskets were present in the León treasury. According to a written record that claims to be from 1063 but was probably from the following century, an ivory casket in the treasury contained three silver ones.[42] However, it is unclear whether these were rectangular or heart shaped.[43] The historian Liam Moore has demonstrated how these "historical" documents and objects interacted to fulfill specific goals—that is, how the relics inside the reliquaries along with the documents informing the reader about the history of their conservation reinforced the power attributed to them and helped to prove their authenticity.[44] The twelfth century seems to have been a crucial time in Spain in terms of memorialization of the past—or retelling it in light of current changes, most notably the union of the Kingdom of Castile and the Kingdom of León in 1157. It was equally a crucial phase in the technical history of leaded niello, when we can observe in Spain, and also in Germany, a shift from two- to three-metal niello. As we saw above, in contrast to the Islamic lands, for which objects themselves (rather than texts) attest to the use of trimetallic niello from at least the eleventh century, the adoption of the technique in medieval Christendom is documented both by written sources describing the addition of lead and by the technical analysis of exemplars.

Two other objects of interest made in or for Spain augment this history of leaded niello knowledge transfer. One is a portable altar for Sancha of León-Castilla (d. 1159), daughter of Queen Urraca and Raymond of Burgundy (fig. 64). The altar consists of a wooden box covered entirely with silver

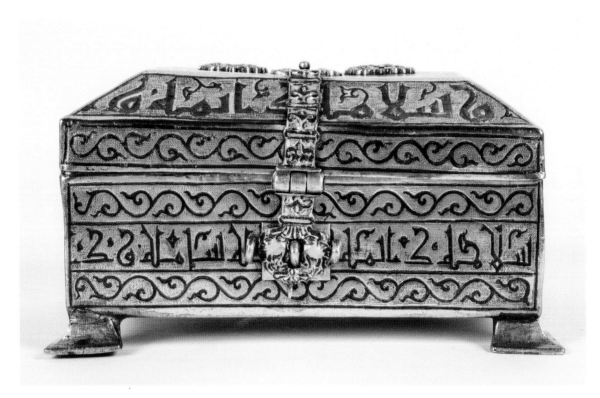

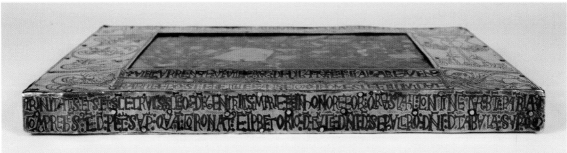

(TOP) *Fig. 63* Silver casket with blessings, from the Colegiata de San Isidoro, al-Andalus, 11th century. Silver, gilt, and niello; h. 11 cm, l. 18.7 cm, d. 12.7 cm. Madrid, Museo Arqueológico Nacional, inv. no. 50867.

(BOTTOM) *Fig. 64* Altar of Infanta Sancha Raimúndez, León, 1144. Breccia di Aleppo (marble), silver, and gilded silver; 17.2 × 26.5 × 2.2 cm. León, Real Colegiata de San Isidoro.

strips that, on top, expose a marble plate made of breccia from Aleppo.[45] The upper part of the altar is gilded, and the symbols of the four evangelists are engraved in the four corners on the shorter sides; fantastical creatures and a medallion with the symbol of Christ the Lamb with a flag are engraved in the gilded strips that round out the decorative ensemble. An inscription made of niello runs in two lines on each longitudinal side of the altar's top, continuing around all four sides of the 2.2 cm-high object. According to its inscription, the altar was made in 1144.[46] Jitske Jasperse has reconstructed the object's history, noting that Anselm, bishop of Bethlehem, consecrated the altar (the wooden box and marble inlay) in Beth-

lehem, and then sent it to Sancha, who had its decoration completed.[47] According to this version of events, the niello strips would have been produced in Spain.[48] This would explain the archaic use of large Carolingian letters, like those favored in the eighth or ninth centuries, with rather slim bodies in comparison to their height, and the use of the title *regina* (queen) for Sancha—a title that first appears in charters dating from 1147-48—at the beginning of the upper inscription.[49]

The inscription is composed of niello inlays divided into four rectangular silver strips attached with silver nails to the sides, and two strips for the upper side along the long edges of the altar's stone. It runs,

[top] Queen Sancha, [daughter] of Rai-
mundo, silvered me. In the year 1144 since
the Incarnation of the Lord, seventh indic-
tion, sixth concurrent, on the eighth day
before the Kalends of August [July 25],
this altar was dedicated by the venerable
Anselm, bishop of Holy Bethlehem, in the
name of the holy and undivided [Trinity].

[sides] Trinity and [in the name of] of the
sacred cross and of Mary, the most holy
immaculate mother of God, and in honor of
those whose relics are contained here: of the
blessed Patriarch Abraham, of the Virgin
Pelagia, of the Annunciation to holy Mary
and Elizabeth, of the stone of the greeting to
holy Mary, of the birth of the Lord, of the crib
of the Lord, of the location of the Transfigura-
tion on Mount Tabor, of the Holy Spirit,
of the table of the Last Supper, of Mount
Calvary, of the rock called Gethsemane where
the Lord was taken, of the stone where he was
crowned at the fortress, of the Cross of the
Lord, of the sepulchre of the Lord, of the table
where the Lord ate fish, roast, and honey-
comb, of the rock of the ascension of the Lord
on the Mount of Olives, of the tomb stone
in the temple of the Lord, of the finding of
the Holy Cross on Mount Calvary, of Mount
Sinai, of the bed of holy Mary on Mount Zion,
of the sepulchre of Holy Mary in the valley of
Jehoshaphat [50]

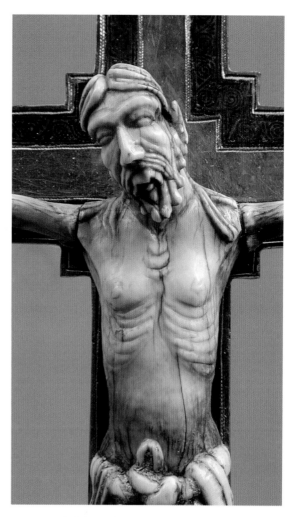

Fig. 65 Detail of Christ, reliquary crucifix, north Spanish, ca. 1125–
75. Silver, silver-gilt, and niello (cross), ivory and gilding (body);
26.7 × 18 × 2.4 cm. New York, Metropolitan Museum of Art, inv.
no. 17.190.221.

Jasperse has pointed out that the object needed
to be turned in the hands of the reader in order for
the text to be read, and that it was meant to be read
by a single individual.[51] Furthermore, the use of
an old-fashioned script, the playful combination
of different heights for some of the vowels, and
the use of two lines for the verticals and diagonal
connectors reveals the effort expended upon the
inscriptions. The nails, for instance, are carefully
placed inside or beneath the letters' bodies so as
to not obscure them. This method of attaching
inscriptions with letters of varying scale using
protruding nails on niello strips stands in stark
contrast to the smooth surface and elegant com-
position of the inscriptions embedded into the
surfaces of silver caskets from Andalusia.

Another object used in the celebration of the
mass and produced in twelfth-century Spain is a
crucifix to which an ivory sculpture of Christ's suf-
fering body is affixed (fig. 65).[52] The crucifix served
as reliquary (see figs. 46 and 47).[52] The metalsmith
who made this crucifix also applied to it spirals
employing what is unquestionably a leaded niello

background. The nielloed spirals on the crucifix
are not as fine as those found on the niello casket
in León executed by ʿUthman (see fig. 40), but the
metalsmith has clearly mastered the new tech-
nology. What these two objects, both made after
ʿUthman's niello casket arrived at León, demon-
strate is that when novel objects travel, craftsmen
are encouraged to imitate their style as well as the
as yet unknown techniques used to produce them.
These objects display the range from success to
failure in such attempts.

In order to be certain whether leaded niello
was employed in their making, it would be cru-
cial to undertake a technical analysis. The use of
trimetallic niello, as we shall see, does not apply
only to the kinds of profane objects that were later
used to contain sacred ones, such as relics, even if
not originally made for a liturgical or religious

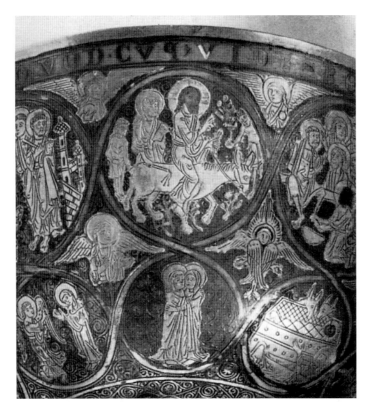

Fig. 66 Detail of the Wilten chalice (see fig. 48).

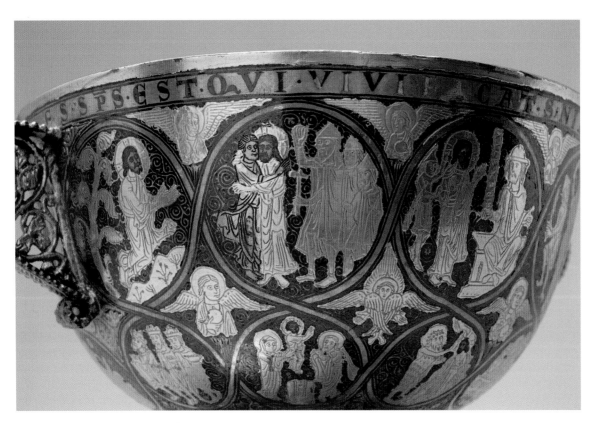

Fig. 67 Detail of the Wilten chalice (see fig. 48).

Chapter 2

context. The technique is especially significant with regard to objects made specifically for a liturgical purpose. In Christian contexts, silver, copper, and lead were often used for objects related to liturgical acts performed at the altar, such as patens and chalices, and even extended to the altars themselves. These three metals seem to have been considered appropriate materials for the making of such objects because they resonated with the concept of the Trinity—the Christian idea of three persons in one God—a connection referenced, for instance, in the inscription on the portable altar (see fig. 64) transcribed in translation above. Such references were not, moreover, confined to the Iberian Peninsula.

Spiral as Essential Structure

After its appearance in Germany in the twelfth century, trimetallic niello achieved a new level of popularity for the production of patens and chalices (see figs. 48 and 49, and 66-68). The three metals brought together by this new technique must have been understood together to constitute an ideal material for liturgical objects, reflecting the literal allusion to the divine power of the Trinity in the inscription, in the case of the Spanish portable altar (see fig. 64), and in the chalices made in twelfth-century Germany to which we will now turn. Typical in this respect are the Wilten chalice and paten (see fig. 48; figs. 66 and 67), now in Vienna, an ensemble consisting of objects used to present the bread and wine in the celebration of the eucharist during the Christian mass.[53] The set was made in Germany by the goldsmith Roger of Helmarshausen. It has been suggested that Roger is the author Theophilus Presbyter, who, as we saw above, wrote one of the most valuable extant primary sources describing in detail the production of leaded niello. Both chalice and paten demonstrate a mastery of trimetallic niello, as has been confirmed by recent analysis.[54] An interesting attempt to imitate this same technique without the use of leaded niello can be observed in the case of the chalice and paten from Gnesen/Gniezno, which were made for the cathedral at Tremessen/Trzemeszno, now in Poland (figs. 68 and 69). This is a particularly revealing case of objects whose manufacture and meaning share a particular bond.[55]

What connects the Wilten chalice with the Spanish objects discussed above is not just the use of trimetallic niello, but also the deployment of spiral ornaments. This patterning appears in the decoration of both the Wilten chalice and that now preserved in Gniezno. On the former, we

find spirals in the scene of the presentation of the Christ Child at the temple next to Mary as well as between the Virgin's legs and on the altar block, where the spirals are almost bare (fig. 67). On the lower part of the chalice, close to the knop or grip, the niello inlays have completely worn off, exposing the underlying silver surface (see fig. 66). The loss of the inlays reveals how essential the form of the spiral is for the longevity of niello. The rings of the spiral's arms serve as "carriers" for the inlays and contribute to the stability of the raised surface of niello work. A larger convex niello surface that was not divided into smaller compartments with silver partitions (as on the León casket [see fig. 39], for example) would render the surface unstable and prone to the loss of the inlaid material.

A comparison with a late Roman spear mount in the Vermand Treasure (excavated from a warrior grave in France) is instructive. This object, made with unleaded niello, shows us how the dark paste was pressed into cavities (fig. 70). The inlaid spirals are partly covered by niello that was hammered into the body of the golden shaft. With larger nielloed sections on a raised surface, such as the convex body of the chalice, the importance of setting spirals into the background becomes clear: the technique simultaneously supports the structural integrity of the object and keeps he niello stable. In the Wilten chalice (see figs. 66 and 67), the combination of leaded niello, with its lower melting temperature, and the resulting option of letting the liquid mass flow into a multitude of tiny compartments or channels created by two strips spiraling outward, enabled the metalsmith to increase the size of the nielloed surface.

As in the background of the Spanish cross (see fig. 65) or on the vessel today in Saint Petersburg (see fig. 56), the spirals of the Wilten chalice (see fig. 67) create a regular pattern and fill the areas next to the active figures. However, in the case of the last of these this decorative system is also reversed within the same field: the active figures are composed of gilded silver zones into which lines are carved and filled with niello. Because the niello and the silver have worn away, we find only parts of the figurative elements still intact. On the chalice, only halos and other individual elements were supposed to be "gold"; the background displays the grey and black spiral pattern. This is distinct from the paten, where the gilded parts were applied to the background (see fig. 49). The goldsmith's artful use of gilded background for the paten (front) and inlaid niello for the lines composing the figures and their surrounding elements, simultaneously reversing this system

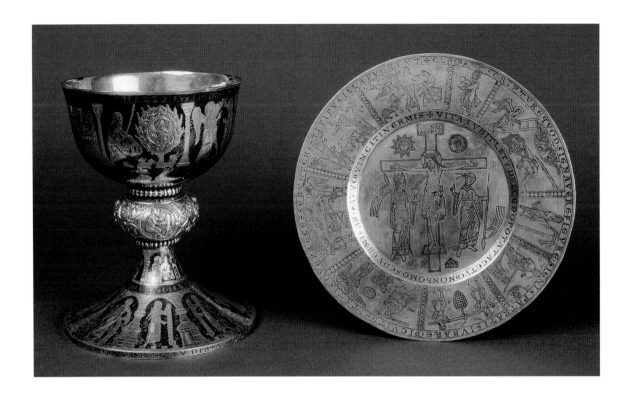

Fig. 68 Chalice and paten from Trzemeszno, possibly made in southern Germany, ca. 1190. Silver, gilt, and niello; h. 17 cm (chalice), dtr. 12.5 cm (paten). Gniezno, Muzeum Archidiecezji Gnieźnieńskiej.

(RIGHT) *Fig. 69* Detail of the Trzemeszno chalice (see fig. 68).

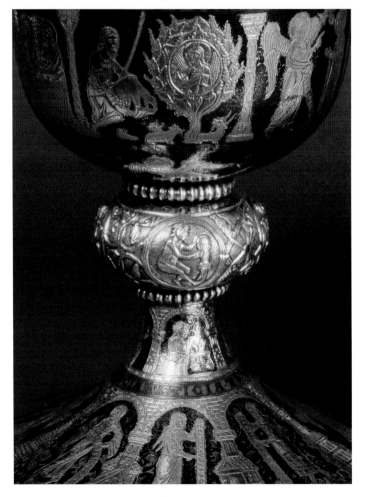

for the chalice's outer decoration, indicates the sophistication of the ensemble's composition. In a Christian context, the spiral was not a coincidental choice of an ornamental form. Rather, as these objects demonstrate, it was employed for structural reasons—as well as for the religious associations it brought to the celebration of the eucharist.

Spiral as Sign

A clue about how to read material references to the Trinity as a sign might have been thoughtfully embedded into the inscription of the related paten made for the abbey at Tremessen (now Trzemeszno in central Poland) and today kept at Gniezno (see figs. 68–69). Two words for "sign" are used in the inscriptions on the paten at Gniesza and the Wilten one now in Vienna, and each has a different valence. On the former, made of bimetallic niello, we read the frequently used word *signum*; on the latter, made with trimetallic niello, we read the rare word *indicium*. The inscription on the latter reused an older text about the Trinity that was composed by the French ecclesiastic Hildebert of Tours (d. 1133).[56] In his third sermon on Epiphany, the celebration of the Adoration of the Magi, Hildebert discusses the rare term *indicium* (sign) in a central passage, by way of explaining how the Trinity can be understood and how the trinity of signs that comprise it can be understood as apparitions of the Trinity itself: "Through the trifold signs [. . .] Christ has manifested on Earth, and God has appeared in everything else."[57] The choice of the rare *indicium* in place of the common *signum* for this text is no coincidence. The same word was also chosen as part of the inscription in the Wilten ensemble (see figs. 48, 66, and 67). On the lower part of the paten's bottom, it is written that Christ has risen from death and his resurrection is a visible sign (*indicium*), proof of the promise of eternal life for Christians.[58]

The chalice made for the abbey at Tremessen, now at Gniezno, may have been a gift from Duke Henry the Lion of Saxony (d. 1195), who ruled a large territory stretching from the North Sea to the Alps and Westphalia to Pomerania, as far as the realm of Polish king Bolesław IV (1146–1172). Patrick De Winter explicitly points out that the "decorative spirals of the chalice inlaid in niello and the engraved figures reserved in gilt-silver clearly follow precisely the technical pattern of the Wilten example [that is, the chalice made for Wilten Abbey, today in Vienna; see figs. 48, 66 and 67], albeit with greater emphasis on architectural elements."[59] In both cases, the spiral decoration

Fig. 70 Mount for spear shaft from the Vermand Treasure, Roman, ca. 400. Silver gilt and niello; 3 × 2.8 × 2.6 cm. New York, Metropolitan Museum of Art, inv. no. 17.192.143.

is found on the chalices (used for the wine), but not on the paten (for offering the host). Also in both cases, some of the spirals received vegetal additions such as flowers, buds, or leaves. The reference here clearly points to the vine, which in early Christian art was a motif understood as referring to wine as a symbol for the resurrection: in the performance of the eucharist, the fruit of the vine was believed to be transformed into the blood of Christ, and was offered in the chalice to the community, recalling Christ's promise of eternal life to Christian believers.

The inscription on the Wilten chalice addresses the liturgical ceremony, the transfiguration of Christ, and the promise of salvation itself (see fig. 48). The Latin inscription along its upper border again emphasizes the visual nature of the representations on the chalice as symbolic of spiritual experience and the animating power of the spirit:

> Whatever you see here signifies/marks spiritual things/matters[;] it is the spirit that vivifies[,] but [or: and (?)] the flesh profits not.[60]

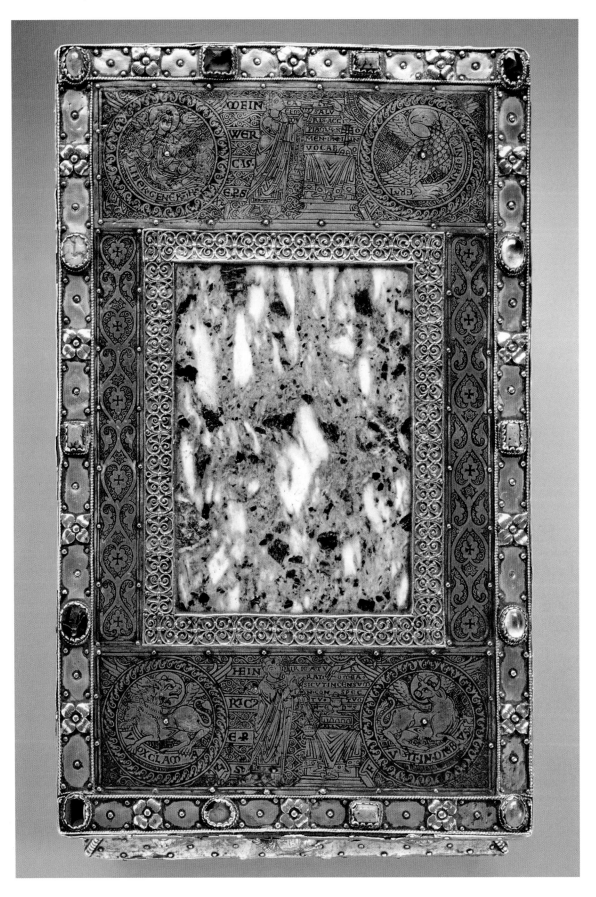

During the Christian ritual, the believer imbibes the sacred wine through narrow metal straws that are also part of the Wilten ensemble. While drinking the wine—believed to have been transformed into the blood of Christ—the faithful could read parts of the inscription addressing them directly: *Hic* [. . .] *vides* (Here you see [. . .]). The text surrounding the chalice refers explicitly to the connection between visible signs (*res*) and invisible ideas related to Christian spirituality. The inscription makes clear that the power behind the transformation of wine into the blood of Christ is the Holy Spirit, which is also the origin of the power to illuminate the believer's mind to understand that it is the Holy Spirit itself rather than the sign (the spiral, the vine, the fruit of the vine, the wine) that unleashes the divine power of vivification ("it is the spirit that vivifies").

The link between the ornamental form of the vine and the celebration of the eucharist becomes closer still in a portable altar also made by the goldsmith Roger of Helmarshausen (who, as we saw, may also have been the author of one of the most valuable extant primary sources describing the trimetallic niello technique), at the turn of the twelfth century (figs. 71 and 72). Here, between the symbols for Matthew and John, a host inscribed with a cross hovers above a chalice in the raised hands of the bishop celebrating the mass (fig. 72). The eyes of Meinwerk (the bishop of Paderborn in western Germany between 1009 and 1036) gaze upward toward an (invisible) God, and the host seems to touch the spiral of the vine above. This depiction of the bishop is only visible from above—from the perspective of a beholder standing close to the altar. The two scenes—Henry the Lion and the altar, which he had himself commissioned, and upon which the chalice is placed; and Bishop Meinwerk holding up the chalice—decorate the top and bottom of the portable altar.[61] Henry is depicted swinging a censer (of a form different from those discussed in chapter 1), while in the scene above, the hand of God blesses the chalice and the host. In this context, it seems no coincidence that the maker Roger was closely identified with niello.

The use of trimetallic niello for an object that reflects explicitly upon its own essential role in celebrating the eucharist seems symbolically loaded by design. The depictions simultaneously integrate figurative or narrative elements with the decorative spirals of the vine, also rendered in trimetallic leaded niello, such that the object's eucharistic purpose and the figures that animate this purpose, as well as the "decorative" technique of niello, converge semantically in multiple ways.

(FACING PAGE) *Fig.* 71 Portable altar of Bishop Meinwerk, German, early 11th century, probably from the workshop of Roger of Helmarshausen. Wood, marble, copper, pearls, gemstones, silver, gilt, and niello; 16.5 × 21.2 × 34.5 cm. Paderborn, Erzbischöfliches Diözesanmuseum und Domschatzkammer, inv. no. DS 2.

(ABOVE) *Fig.* 72 Detail of Bishop Meinwerk, portable altar of Bishop Meinwerk (see fig. 71).

The explicit and implicit references to the Trinity in the inscription and in the decoration of the vessel were created by the very metalsmith who is closely linked to the first manual describing the procedure of making trimetallic niello. In this manual, he speaks to the importance of the unity of of all three, ornamental form, matter, and ritual.[62]

As the ornamentation of this portable altar indicates, then, the addition of a third metal—lead—to the niello technique advanced the metalsmith's ability to produce very fine ornaments by significantly lowering the inlay mixture's melting point, bringing us back to the points made at the beginning of this chapter. This innovation was described in a Byzantine manual, and as early as the eleventh century was being implemented by Islamic silversmiths who exploited the ornamental potential of the spiral in objects kept today at León, Madrid, Teruel, and Saint Petersburg (see figs. 39, 50-52, and 56). A century later, German goldsmiths described the technique and applied it to objects used for the celebration of the eucharist. In this manner, the technique of applying trimetallic niello, which likely originated in Islamic lands, came to embed itself into the making of objects used to celebrate the Holy Trinity, evincing a new Christian dimension of this evolving metalwork technology. At the same time, a preference for spiral ornament

Fig. 73 Lid of dragon-bowl, found at Muzhi, Siberia, second half of 12th century. Silver, niello, gilding, casting, chasing, and riveting; h. 8.6 cm, dtr. 15.5 cm. Muzhi Museum, inv. no. OF 216.

Germany and the Netherlands), being found in Siberia, Gotland, and the Ukraine respectively. As Marshak's studies on metalwork in Central Asia have indicated, several niello objects ornamented with spirals are difficult to locate, have traveled widely, and have no concrete sites of origin—such that, as he noted, it is hard to define which object influenced which.[64] Several objects mentioned in this chapter feature in his scholarship, in which he has tried to identify their positions between the Islamic "Orient" and western Europe.

In light of increased attention to the significant change from bimetallic to trimetallic niello, enabling silversmiths and goldsmiths to produce finer niello ornaments through the lowering of the melting point, we can suggest a reconstruction of how the new technology traveled through the different cultural contexts in which it appeared. Like flotsam caught in the currents of cross-cultural exchange only dimly perceived in texts, attention to the objects that deploy this technological innovation provides a glimpse of a fundamental relationship between craftspeople, their knowledge, and their work, beyond the gaps in the textual archive. Although we cannot reconstruct how, where, and when exactly their knowledge regarding the possibilities of trimetallic niello traveled, the few traces they have left are sufficient to show the global range of their network.

Consideration of nielloed metalwork produced in al-Andalus as a kind of "missing link," and attention to significant technological changes in the techniques used to produce niello that are explored here, supplement Marshak's observations and support his arguments. What they add is the suggestion that, through the changes in the techniques for the production of niello, we can trace how innovations were transmitted across the dispersed regions involved: Iran, Central Asia, Byzantium, al-Andalus, and the Latin West. The combination of niello with elevated, gilded, three-dimensional ornamentation that represents fertile nature growing beyond the flat surface of the vessel can also be found in liturgical objects such as a crozier that was produced in the same twelfth-century Rhine-Meuse area (fig. 75). However, we cannot identify the origin(s) of our two cups mentioned above with certainty: similar examples have been found in Sweden (fig. 76), though the ornamental decoration of the New York cup (see Fig. 3), with its dragons and nudes inhabiting vines, points to twelfth-century Rhine-Meuse production.[65] Both cups display the use of spiral niello beyond the liturgical realm, in which, as we have shown, trimetallic spirals can refer to the Christian idea of the Trinity.

on these objects had both structural and iconographic significance. The final part of the story involves the trading of such European metalwork, using niello spirals as backdrops, as luxury goods far to the east.

As we mentioned above, formal similarities or shared ornamental tastes can make it difficult to attribute certain kinds of objects to specific times and places, a feature only reinforced by portability and mobility. The archaeologist and art historian Boris Marshak has discussed the differences between Iranian objects with spiral niello backgrounds and niello objects from Byzantium, emphasizing that there are strong parallels between artifacts from the twelfth-century Latin West and others from eleventh-century Khorasan (Iran/Afghanistan) that all make use of a spiral niello background.[63] Two cups, a lid, and the bowl discussed in our Introduction (see figs. 2 and 3; figs. 73 and 74) were made in medieval Europe, but surfaced far away from their place of origin in the Rhine-Meuse area (today between northwestern

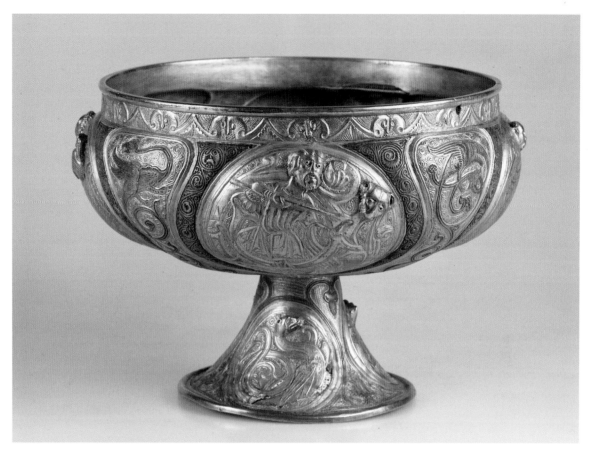

Fig. 74 Bowl, 12th century. Silver, nielloed, chased, engraved, and gilded; dtr. 17 cm. St. Petersburg, State Hermitage Museum, inv. no. Φ-810.

The cups and the bowl demonstrate how far some objects—especially luxury objects—traveled toward the east, even if the volume of European finds is small compared to that of the Islamic luxury materials preserved in European church treasuries. Prior to the twelfth century, the direction of trade moved primarily from east to west, with only very few objects leaving traces of travel in the opposite direction. By contrast, beginning in the twelfth century, along with significant innovations occurring in the craft of goldsmithery, we find more objects made in the Latin West moving as gifts for diplomatic exchange or marriage, as booty from wars, or as merchandise along trade routes.

So far, scholars have struggled to locate the origin of such objects with certainty. We argue that they were produced in the same region at the same time as the liturgical objects that we have just discussed—both groups use niello, spirals as backdrop, gilded parts, sometimes even three-dimensional elements. Though on the basis of visual analysis only, we presume they were made

with trimetallic niello, too.[66] As in the case of the objects considered above that were made for liturgical use, with close connections to Christian ideas about the Trinity, they are ornamented with niello spirals and gilded elements, and show figurative scenes.

What the history of transmission discussed in this chapter suggests is that the written sources—the surviving manuals describing the fabrication of niello in the Islamic context, in Byzantium, and in the Latin West—convey a misleading picture. The decisive innovation—that is, the addition of lead to lower the melting point of niello—is first mentioned in twelfth-century Latin sources. This use of trimetallic instead of bimetallic mixture enabled the goldsmiths to produce niello inlays on curved and uneven surfaces, and contributed significantly to their ability to create extremely fine ornaments, using spirals as a backdrop. However, as the visual and chemical analysis of the objects shows, this innovation was the fruit of Islamic silversmiths, perhaps inspired by glass-makers, who had added lead in order to lower

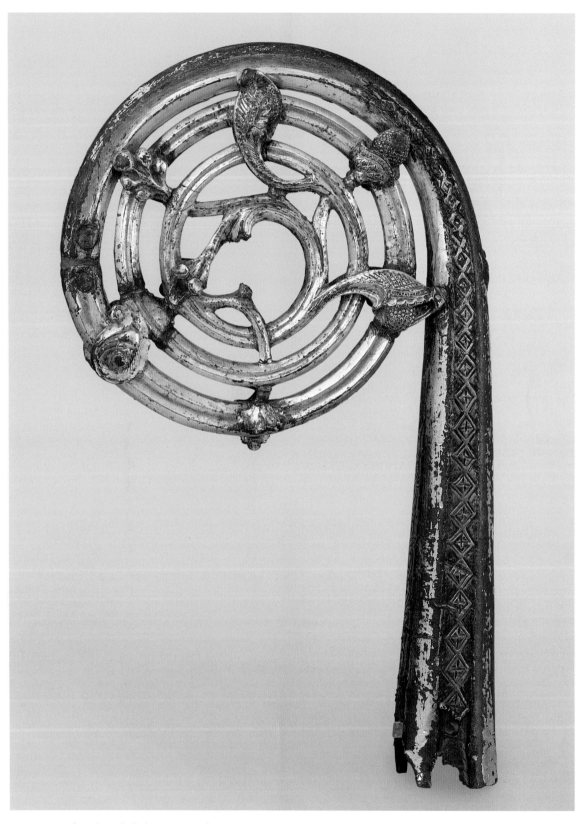

Fig. 75 Crozier from the Cathédrale Saint-Pierre-de-Lisieux
(Lisieux), Limoges, 12th century. Bronze, gilt, and niello;
14.5 × 8.5 cm. Paris, Musée du Louvre, inv. no. OA9593.

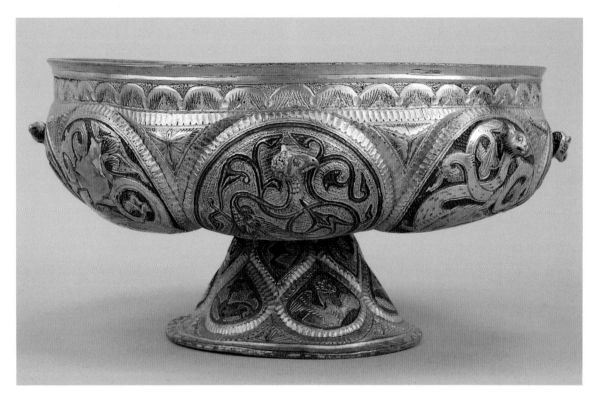

Fig. 76 Bowl found at Dune (Gotland), 12th century. Silver gilt and niello; 13.2–13.7 × 7.3 cm. Stockholm, Statens historiska museum, inv. no. 6849:2.

melting points even earlier. Only further analysis can reveal whether this innovation occurred first in Andalusia, or was the fruit of silversmiths working in the Ghaznavid empire, which stretched from Khorasan (northeastern Iran) to Afghanistan and northern India, in the eleventh and early twelfth centuries.

What is clear is that the innovative use of a trimetallic mixture to produce nielloed objects was adopted by goldsmiths working in northern Spain, and then in Germany. They favored the use of trimetallic niello particularly for objects with a close connection to the Christian idea of the Trinity, and created objects to be used for the celebration of the eucharist. The objects created by these craftspeople in the twelfth century in these regions were likewise made of silver and used spirals as a backdrop in the finely ornamented nielloed parts, but also included three-dimensional elements, some of which were gilded. In addition to producing artifacts for use in Christian rituals, connecting objects that exploited the potential of trimetallic niello (which we have argued originated in the Islamic lands) with the spiritual idea of the power of the Trinity to reveal the hidden, these makers crafted items for profane use, such as cups or bowls. These bowls were traded or gifted, and surfaced in distant regions in the east, as far away as Siberia.

As this case study of a technological innovation traveling through different cultures reveals, the primacy afforded to written sources describing the technology can be misleading, necessitating a corrective based on a close analysis of the objects themselves. Activating the archival potential of objects employing the new technology not only complicates the story of niello, but also suggests the need to rethink stories of origins that operate on many levels.

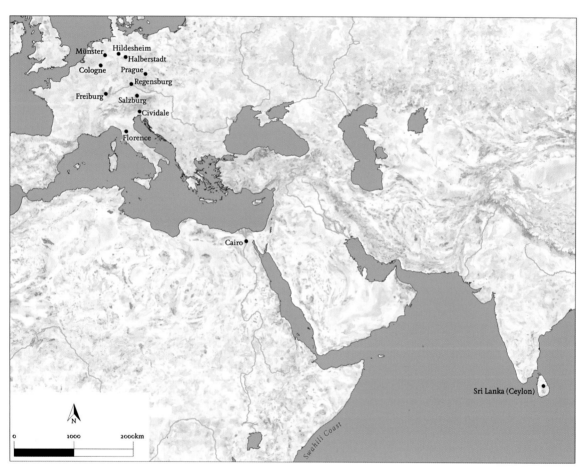

Map 3 Locations of the principal sites discussed in chapter 3. Map by Matilde Grimaldi

Chapter 3

Coconuts and Cosmology in Medieval Germany

A Composite Object

The two preceding chapters consider the movement of objects and techniques around and beyond the Mediterranean world. This chapter traces the movement of a material: coconut, which traveled from regions of the globe with tropical vegetation to medieval Europe. While written sources remain silent about most parts of the coconuts' journey, we can analyze the objects into which coconuts were embedded in order to reconstruct aspects of this history. Coconuts were made the centerpieces of creations by medieval metalsmiths engaged in making vessels intended for use in Christian churches and for preservation in their treasuries. Analyzing these composite objects helps us understand the wider cultural context of coconuts, their origins, and the qualities they were thought to embody. In addition, it reveals the logic potentially undergirding one specific medieval object that joined a coconut with a reused rock crystal vessel: made in an Islamic context, it yet came to house a relic of Christ's blood.[1]

This unique vessel was fabricated during the thirteenth century for the treasury at the cathedral of Münster in western Germany (fig. 77). It incorporates a coconut-cum-goblet with a rock crystal lion that was carved perhaps in Iraq, by an Abbasid craftsman, or in Egypt, by a Fatimid craftsman, and was later mounted in Münster on the coconut goblet's gilded lid.[2] The ultimate origin of the raw crystals used in such Islamic objects likely lay in east Africa, possibly in the Comoros,[3] lending further transregional valences to the object. The rock crystal lion was altered through the creation of this sophisticated object, in a manner that transformed it such that it came to reference the Christian story. The flag, cross, and golden band around the lion's collar, for example, enhance the impression that the lion has become a lamb, alluding to the *agnus Dei*,

the lamb of God that symbolizes the sacrifice of Christ. This lamb is harnessed in gold: a thin golden belt is attached to its collar and runs down across its breast, securing the relic inside the goblet with bolts and latches.

Vessels made of rock crystal and crafted by artisans from Islamicate regions were not uncommon at this time, and often enclosed Christian relics;[4] but coconut was rarely present in Christian church treasuries. Indeed, the metalsmiths who made the Münster object were working with a material that had yet to leave traces in written accounts of the Latin West: the oldest Latin text mentioning a coconut cup like the Münster goblet was written by Simon of Genoa (d. 1303).[5] The art historian Max Geisberg concludes his authoritative review of the object by stating, "The whole thing has no parallel."[6] What is so unique about the Münster goblet is the way in which it integrated a novel use of a rare, imported material—coconut—with the reuse of a carved rock crystal vessel (fig. 78). This juxtaposition is unexpected and, as Geisberg noted, without precedent.

Yet the coconut goblet at Münster may have been part of a larger group of objects made in this region at this time—the so-called "ostensories." The term derives from the Latin verb *ostendere* (to show); ostensory vessels could exhibit different types of venerated objects, such as relics, or the host—the bread used to celebrate holy communion in remembrance of the Last Supper of Christ and his apostles prior to the Crucifixion. (Like the wine that is believed to be transformed into Christ's blood during the celebration of the mass, as described in the previous chapter, the bread, in the form of the host, is believed to be transformed into his flesh.) Unlike ostensories, which reveal their contents through the use of transparent materials, the opaque, dark-shelled

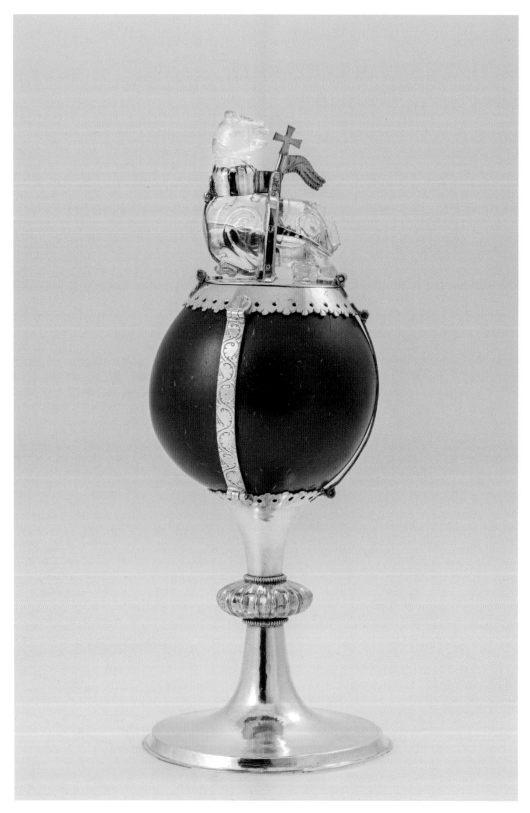

Fig. 77 Coconut goblet used as reliquary or pyxis: rock crystal
carvings Abbasid or Fatimid, 9th or 10th century; chalice and
mounts possibly Westphalian, mid-13th century. Coconut, rock
crystal, silver, and gilt; 27.5 × 11.1 cm. Münster, Domkammer
St. Paulus, inv. no. E.6.

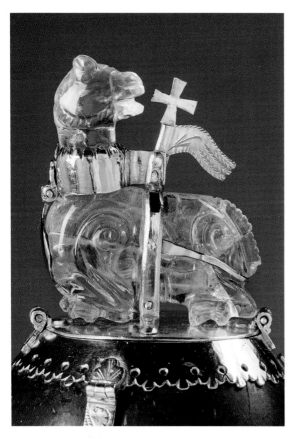

Fig. 78 Coconut goblet used as reliquary or pyxis (see fig. 77): detail showing the rock crystal carvings.

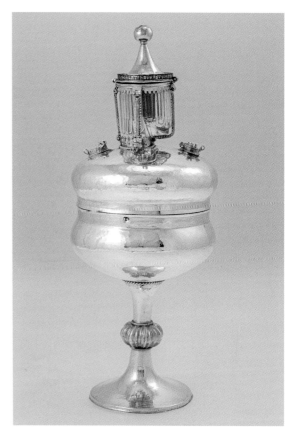

Fig. 79 Relic vessel in the form of a double cup: rock crystal carvings Abbasid, 9th or 10th century; chalice and mounts possibly Westphalian, mid-13th century. Coconut, rock crystal, silver, gilt, and niello; h. 32.3 cm, dtr. 9.6 cm. Münster, Domkammer St. Paulus, inv. no. E.6.

coconut "displays" its contents in a different way. An important question, therefore, is why an opaque material was used in this instance, instead of the transparent materials that made the contents of other ostensories clearly visible.

The Münster coconut was mounted on a pedestal made easy to grasp by the participants in a religious ceremony, who may have carried the object around and placed it on an altar. This coconut is supported by a funnel-shaped silver pedestal with a knop-like structure in the middle of its slimmer stem, similar to the base of several other liturgical vessels produced during this period and in this region. On each of their lids was placed another object that had traveled far and was originally made for a profane use: a chess figure made from rock crystal (fig. 79), a perfume flask (figs. 78 and 82–84) or a drinking vessel (fig. 81). All of these objects share a number of characteristics: they carry a transparent vessel containing a relic, although some relics have not survived or are kept elsewhere today (fig. 80a); they measure between 20 and 35 cm in height; and they were

mounted on a stand with a knop, perhaps to make them easier to grip while being held or carried around in procession. Several incorporate rock crystal elements originating in a non-Christian context (figs. 80b,c and 81). We do not know, however, whether their primary purpose was to be carried in a procession so as to activate the power of the relics preserved within them or if they were more often placed on or near the altar during the mass. As in the case of the specific uses of the censers discussed in chapter 1, such gaps in the archive leave us to improvise answers to such questions as best we can on a basis of analysis of the objects themselves and a context provided by fragmentary textual and visual sources.

The thirteenth century saw a significant rise in the numbers of relics and reliquaries kept in church treasuries.[7] At the same time, a new form of shrine came into being: a kind of open cupboard with single compartments erected behind the high altar or as part of the larger construction of the high altar. Such a design allowed for the permanent display of liturgical objects such

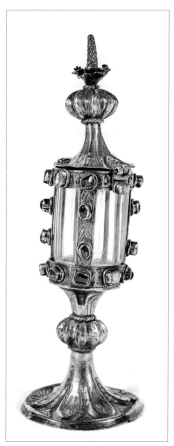

80a

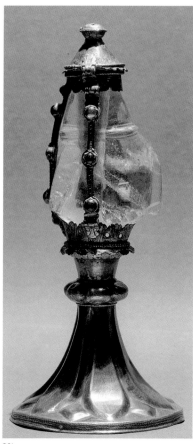

80b

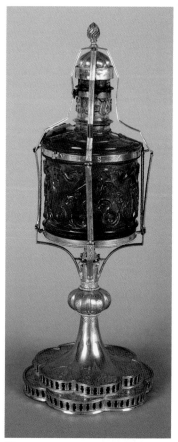

80c

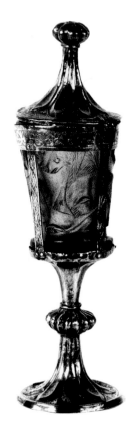

Fig. 80a Ostensory with rock crystal cylinder, Quedlinburg (Saxony-Anhalt), 1250s. Rock crystal, silver, gilt, gemstones, and glass stones; h. 17.2 cm. Quedlinburg, Domschatz Stiftskirche St. Servatii.

Fig. 80b Ostensory in the shape of a fish: rock crystal Fatimid, 10th century; mount Quedlinburg, mid-13th century. Rock crystal, silver, gilt, and textile, with relic; h. 12.1 cm. Quedlinburg, Domschatz Stiftskirche St. Servatii.

Fig 80c Reliquary of the miraculous blood: rock crystal Egyptian, 10th or 11th century; mounts Venetian, 14th century. Rock crystal and gold; h. 24 cm. Venice, Basilica di San Marco, inv. no. Santuario 63.

(LEFT) *Fig. 81* Ostensory with so-called Hedwig-beaker: glass possibly Sicilian, 12th century; mounts German, second quarter of 13th century. Glass and silver; 28.5 × 8.5 cm. Minden, Domschatz, inv. no. 94.

as reliquaries, ostensories, chalices, and sculptures when they were not in active use; we will return to such a display at Münster later.[8]

These liturgical vessels can be divided in two groups according to their structure and to how they might have been used: some preserved sacred objects and were hinged on their upper part, only to be opened occasionally to reveal the relics they contained; others were constructed as two parts that could either be used together as a single vessel or easily separated to be used as two. One ostensory of this latter type, comparable to the coconut goblet, is still in the cathedral treasury of Münster today (fig. 79). This type of vessel is called a double chalice, because its two parts can be presented as a single piece, or its upper part can be detached such that each part serves as a cup. The upper vessel is surmounted by a transparent chess-piece that can be held in order to separate the two cups and which becomes a knop underneath the freestanding cup once it is turned over for use; the lower vessel remains as it was prior to the separation: a goblet standing firmly on its pedestal. The former chess-piece at one time carried a relic inside, just as the lion/lamb did in the case of the coconut goblet.

The two objects shown in figures 77 and 79 were likely originally part of a larger ensemble that consisted of liturgical items made either entirely of rock crystal, such as the now lost high altar of the cathedral at Münster, or by incorporating pieces of rock crystal, such as the double chalice (fig. 79) discussed above or the Gothic sculpture of Mary, mother of Christ, with a rock crystal attached to her chest, also preserved in the treasury at Münster.[9]

What connects these two Münster ostensories and demarcates them from the rest of the group is that they can be opened—the lid of the coconut goblet, too, can be removed to become a second cup, with its former chess-piece top again constituting a knop (that in this instance can be detached). This raises several questions. What was thought to be the connection between these objects' visible and invisible contents? How did the lower vessel relate semantically to the upper "container"? These are queries to which we return below. Moreover, in the case of the coconut goblet, the deployment of this exotic material—with its references to distant lands and its repurposing of a rock crystal lion as the lamb of God—prompts us to consider not only why and how these objects came to be physically conjoined, but also how this conjunction materializes philosophical ideas far beyond mere physical horizons.

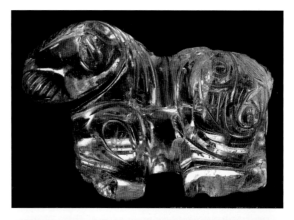

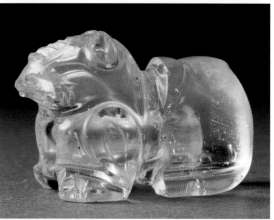

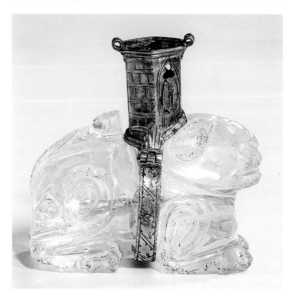

Fig. 82 Rock crystal bottle in the shape of a lion, Fatimid, ca. 900–950. Rock crystal; 4 × 6 × 2.5 cm. London, British Museum, inv. no. FBIs.12.

Fig. 83 Small flask in the form of a lion, Egypt, 11th century. Rock crystal. Paris, Musée du Louvre, inv. no. OA 7799.

Fig. 84 Small flask in the form of a lion, Egypt, 11th century; mounts, 13th century, Cologne. Rock crystal, silver, and gilt; 6.3 × 6.5 × 3.2 cm. Cologne, St. Ursula, Schatzkammer.

Looking Beyond and Within

One of the most densely nuanced—as well as immediately noticeable—ways in which geographical and spiritual horizons intersect in the Münster goblet is in the rock crystal figure of the lion/lamb that surmounts it. The transformation of lion into lamb was a process more extreme than were the alterations to the coconut. The rock crystal element was made as a bottle for perfume or oil (see fig. 78). Comparison of this lion-shaped bottle to other rock crystal lions suggests that its head and body may not have derived from the same carved animal. Indeed, rock crystal lions now in London, Cologne, and Paris reveal significant differences in the design of the head, and especially with regard to the long neck of the Münster beast (see figs. 82–84). It may well be that the animal poised on the lid of the Münster coconut goblet was composed from more than one animal-shaped vessel.[10] The head, now sitting loosely in its rough setting, may have been cut from its crystal body and turned backwards to assume the shape of an *agnus Dei* (lamb of God) (see fig. 78)—or, at least, this is what has been assumed by scholars to date. But in fact, it remains unclear whether the two parts ever formed a single animal's body. Perhaps two entirely different rock crystal objects, a head and a body, were joined together by the maker to look like an *agnus Dei*. Indeed, the form of the whole vessel is predicated upon the notion of joining one element to another and thereby transforming them into something new. This might hint at a self-reflexive nod toward a change in function of the entire object from chalice to reliquary; but given our lack of information about its functions, this observation can only be speculative.

In any case, the beholder can gaze through the crystal and see—or rather not quite see, but *know*—that there is a relic inside: the holy blood of Christ (a counterpart for the fragment of the True Cross once in the coconut below it), wrapped in red silk, about which the inventory of the cathedral treasury of 1622 tells us the following: "In the lamb of God: of the blood of our Lord, in the black nut: of the wood of the Lord."[11] While this converted rock crystal element seems, then, to have been imbued with a clear meaning, how are we to parse the relationship between lion-turned-lamb and the coconut which it surmounts?

A rare and cherished treasure from afar, this particular coconut must have had a long journey before it became the bowl of the Münster goblet.[12] Other materials from Africa, Central Asia, India, the Philippines, and Java, such as camphor, sandalwood, and frankincense, have been recorded in written sources as goods traveling to the Latin West during the medieval period.[13] Some of the documents of the eleventh and twelfth centuries recovered from the Geniza (a storage area for worn books or any kind of written paper) of the Ben Ezra synagogue in Fustat (for an example, see fig. 126) mention coconuts, as do primary sources in Arabic such as encyclopedic and medical texts.[14] However, contemporary Latin sources, including those describing trade routes and goods reaching the Latin West with such merchandise from far-off places, remain silent until the late eleventh to early twelfth centuries: the time when scholarly texts in Arabic were being translated into Latin.

Rolf Fritz has analyzed the written traces of coconuts in the Latin West, and variations in their names across different European languages (e.g., *meer-nuss* or *muscatnusz* in German; *noix neyre* or *muscades* in French), in wills, inventories, trade records, and travel accounts.[15] Textual sources describing their medical use, documenting relevant agricultural practices, and detailing trade records in Greek, Latin, Arabic, and Persian indicate that coconuts were associated with Iran and/or India.[16] An early mention of coconut in Latin—as *nux indica*—can be found in the twelfth-century Latin manuscript on medicinal herbs entitled *Circa instans* (also known as *The Book of Simple Medicines*), a description of 270 pharmaceuticals attributed to Mattheus Platearius, a physician at Salerno.[17] The earliest illustrations of the coconut were only made subsequently to the arrival of the Münster coconut in northern Germany. Some illustrations in Western herbal manuscripts dating to the fourteenth century show the coconut's outer coat; others depict the bare inner "nut" (figs. 85 and 86).[18] Illuminated manuscripts from the eleventh century that are filled with descriptions of the world by the late antique Egyptian voyager Cosmas Indikopleustes depict the harvest of coconuts from palm trees (fig. 87). Just as the presence of three metals in the niello inlay, discussed in chapter 2 above, led theologians to connect the technique with the idea of the Christian Trinity, so, in the Latin West, a trinitarian meaning was often attributed to coconuts, perhaps inspired by the three indentations found on their tops.[19]

The earliest coconuts known in the Latin West are preserved in Christian treasuries located at sites that had access to the trade routes of the Hanseatic League, a defensive and commercial confederation connecting cities across the North and Baltic seas between the thirteenth and seventeenth centuries. They included the coconut

Fig. 85 Nutmeg and coconut, from the *Tractatus de herbis*, ca. 1280–1310, attributed to Bartholomæus Mini de Senis, Salerno. Parchment; 36 × 24 cm. London, British Library, MS Egerton 747, fol. 67v.

Fig. 86 Coconut (*nux indica*), from a herbiary known as the
Compendium salernitanum, text by Matthaeus Platearius, produced in
northern Italy, possibly Venice, ca. 1350-75. Parchment; 30 × 20 cm.
New York, Pierpont Morgan Library, MS M.873, fol. 65v.

Fig. 87 Depiction of a coconut tree, from *Codex sinaiticus graecus* 1186, fol. 203r, Cappadocia(?), 11th century. Sinai (Egypt), St. Catherine's Monastery.

goblet at Münster (see fig. 77) and the slightly earlier chalice of Saint Heribert at Cologne (fig. 88). The latter has coconut parts embedded into a chalice, from which the saint supposedly had drunk and which was therefore venerated as a relic; the Münster goblet, by contrast, with its dark, polished sheen, uses the natural shape of the coconut as the bowl of the upper part of the chalice.[20] Similar objects dating from the first half of the fourteenth century have been recorded or are actually preserved in church treasuries not far from Münster: at Hildesheim (from the convent of the Holy Cross; fig. 89), Essen, Lüneburg, and from the cathedral treasury of Kamień Pomorski (previously Cammin).[21] These cities might all have had access to maritime trade routes via the Hanseatic League.

Another group of objects that include coconut among their materials can be found in locations connected by other trade routes, likely through the ports of Venice or Genoa. These vessels feature a body fashioned from coconut in Italy, and were collected by the Austrian archdukes; they are listed in historical inventories made of the collection at Salzburg and are preserved today in Florence (figs. 90 and 91), in Regensburg (fig. 92), and Freiburg (fig. 93) in southern Germany, and in Cividale del Friuli (fig. 94) and at Schloss Ehrenburg (Südtirol/Alto Adige) in northeast Italy. While they all have a core dating to the fourteenth century, several of these vessels have been subject to later additions and reworkings.[22]

All the vessels in both groups of early European coconut objects in the Latin West share a specific quality: the blackness of the coconut wood is emphasized through surface polishing, and, in numerous instances, the coconut form was transformed by fourteenth-century metalsmiths into items that could be opened. Sometimes, as

we have seen, two halves of a coconut served as the upper and lower parts of a double chalice. The vessels now at Cividale, Schloss Ehrenburg, and Regensburg were also endowed with an inner metallic lining that contrasts with the polished exterior such that the interior gleams with an otherworldly, glistening sheen. This practice points to a potential use of the vessel as cup for a liquid, for example during the mass, when congregants receive the wine of the eucharist.

Clearly the makers of these objects were interested in creating a visual contrast between the coconut's surface and the interior of the chalice and/or goblet. Yet despite this material contrast, both visual experiences hinted at spaces beyond everyday experience: the dark exterior wood of the coconut came from afar; the interior suggested a realm beyond the terrestrial and the richness of the divine. This juxtaposition explains why the coconut was cherished by late medieval goldsmiths who produced precious vessels for liturgical use in Christian church services. However, although sources do inform us that objects made with coconuts were present in the treasuries of the Latin West, these same sources do not tell us what people actually did with them.

Treasures and Trophies

Very divergent explanations have been offered regarding the use of rare and exotic materials in objects from Christian treasuries. Precious materials such as lapis lazuli, which originated in the quarries of Afghanistan, and rock crystal, which was difficult to cut skillfully (Western craftsmen not only lacked the skill but also the tools to handle this task until the thirteenth century), were highly desirable for lavish ecclesiastical ornamentation.[23] These materials were hard to come by, difficult to work, and very expensive; this made their recycling, reuse, and repurposing important. The cameo of the Roman emperor Augustus (d. 14 CE), reused in the Cross of Lothair (named for the Carolingian king Lothar II [d. 869] but made for a member of the Ottonian dynasty, possibly the Holy Roman emperor Otto III [d. 1002], around the year 1000) in the treasury of Aachen Cathedral, and the multitude of gemstones included in the twelfth-century shrine made to house the bodies of the three Magi at Cologne Cathedral are examples that scholars have pointed to as instances of the conscious reception of antiquity. Any historical discontinuities in the imperial line (or even the complete lack of such a line) could be downplayed by the repurposing of Augustus's cameo, which embedded the Ottonian

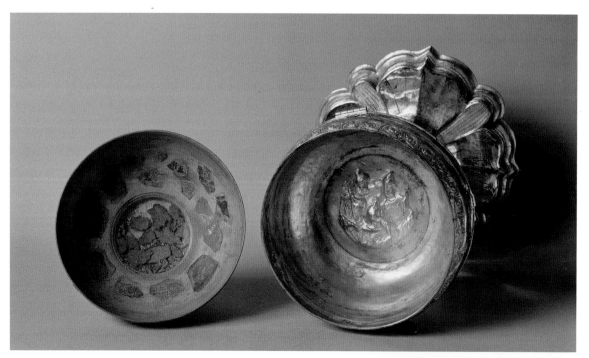

(ABOVE) *Fig. 88* Reliquary-ciborium with the chalice of Saint Heribert, Cologne, 13th century. Coconut, silver, and gilt; h. 43 cm, dtr. 14 cm. Cologne, Katholische Pfarrkirche Sankt Heribert.

(RIGHT) *Fig. 89* Coconut reliquary, probably Hildesheim, second half of 14th century. Coconut, silver, gilt, and enamel; h. 29 cm, Hildesheim, Heilig-Kreuz-Kirche.

FACING PAGE

(TOP LEFT) *Fig. 90* Double chalice from the treasury of the archbishops of Salzburg, possibly Venetian, early 14th century. Coconut and silver. Florence, Palazzo Pitti, Museo degli argenti, inv. no. 11 Bg III.

(TOP RIGHT) *Fig. 91* Coconut cup from the treasury of the archbishops of Salzburg, Italian(?), 14th century. Coconut, gilded silver, and enamel. Florence, Palazzo Pitti, Museo degli argenti.

(BOTTOM LEFT) *Fig. 92* Double chalice, the so-called Johanniswein-pokal, late 14th century. Coconut, copper, and brass. Regensburg, Dominikanerkirche.

(BOTTOM MIDDLE) *Fig. 93* Coconut reliquary with miniature of Saint Mary Magdalene, probably made in Freiburg, ca. 1400. Coconut, copper, rock crystal, and parchment; h. 37.5 cm. Freiburg im Breisgau, Städtische Museen, Augustinermuseum, inv. no. K 31/19.

(BOTTOM RIGHT) *Fig. 94* Double chalice, possibly Venetian, first half of 14th century. Coconut, copper, and silver. Cividale del Friuli (Udine), Museo Cristiano.

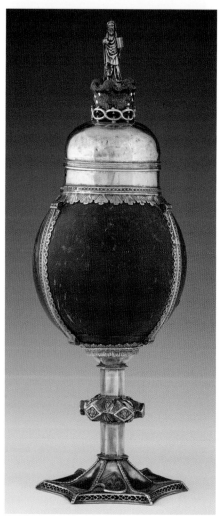

Chapter 3

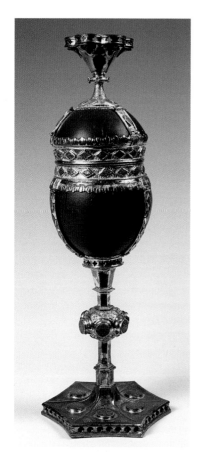

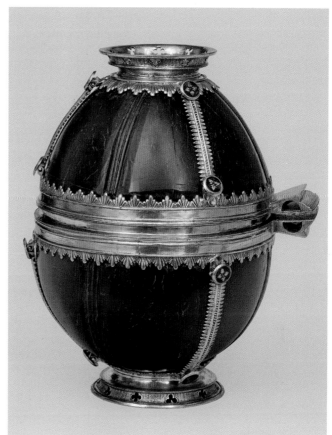

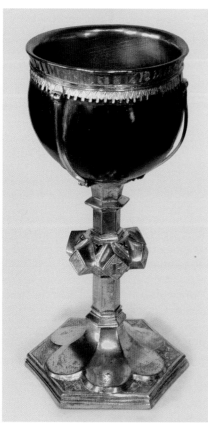

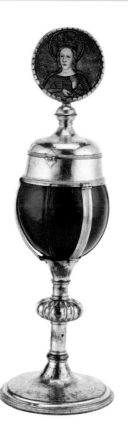

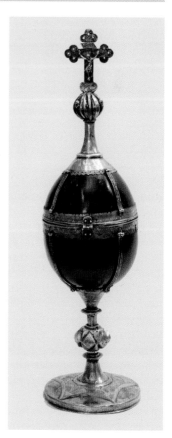

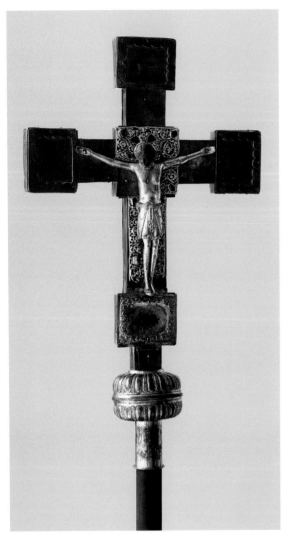

Fig. 95 Crucifix, the so-called Herimann-Ida-Kreuz: head late antique (Roman); crucifix Cologne, 11th century; crucifix filigree 13th century. Wood, bronze, lapis lazuli, and copper; 41 × 28 × 8 cm. Cologne, Kolumba (diocesan museum), inv. no. H 11.

ruler into a feigned ancient genealogy. The fact, moreover, that a lapis lazuli portrait of a Roman empress could be mounted as the head of Christ in the eleventh-century Herimann-Ida Cross at Cologne (fig. 95), and the presence of antique Byzantine ivories within the ambo of Holy Roman emperor Henry II (d. 1024) at Aachen, have been seen as evidence that the preciousness of the reused material surpassed the meaning conveyed through form. That the reused carving was a female face, a nude, or even a pagan god mattered less than the idea that Christ's head deserved to be rendered in lapis lazuli, a rare precious stone.

One way of analyzing such repurposing, which is rarely engaged with directly in our sources, is

to approach it from, as it were, a slightly oblique angle. A particularly revealing text, which has not yet been discussed in this context, is the Roman poet Ovid's famous aphorism "materiam superabat opus" (the work surpassed the material). This idea received very little attention in antiquity but, as Peter Cornelius Claussen has demonstrated, it enjoyed a very wide reception after it was quoted by Abbot Suger (d. 1151), who famously rebuilt the cathedral of St-Denis in Paris in a Gothic style.[24] The phrase was prominently embedded by Suger into an object shaped like an eagle that incorporated a Roman vessel of marble, inscribed into the golden band around the eagle's neck. In his text about the dedication of St-Denis, the abbot refers to the object as a *vas*, and refers neither to its form nor to its meaning, instead emphasizing the value of its materials.[25] This long tradition of giving primacy to the value of materials over the potential meaning conveyed through the forms of objects has contributed to the plausible idea that Christian works incorporating antique elements were perceived as valuable and desirable not because of their form (or the figures they presented), but because they deployed rare materials of ancient pedigree.

In addition to classical and late antique elements, a wide variety of objects originating in an Islamic—mostly secular—context were reused in Western Christian church treasuries during the medieval period. This has convinced several scholars that the recycling of these vessels from the Arab south, or from west Asia functioned as a *mise-en-scène* of conversion—a display of Christian superiority in trophies of war, for example, in the context of the Crusades; or that it was a consequence of relic translations (fig. 96).[26] This suggestion has been criticized for its assumption of a stark opposition between Christian and Islamic cultures; recently, arguments have been brought forward in favor of more polyvalent explanations, in the context of which the problematic term "hybrid" has been introduced for objects understood as testimonies to cross-cultural heritage and exchange, reflecting the fact that portable objects circulated widely across great distances and distinct cultures.[27] The notion that there were strong religious contradictions embedded into Christian treasury objects that crossed Islamic-Christian boundaries has been analyzed recently with regard to whether the more or less peaceful coexistence (*convivencia*) of religions in southern Spain, Sicily, southern Italy, and the Mediterranean East was myth or reality. The idea has also come under scrutiny of late in terms of the rich yet problematic historiography of Islamic and/or Islamicate art.[28]

Eva Hoffman and Scott Redford have suggested that such repurposings of Islamic materials ought to be discussed as part of a "dynamic process of transculturation that created connections across political and religious spheres, spatially as well as temporally."[29] Such a connection is particularly evident in the coconut goblet at Münster, which combines a material that traveled far with an object that had its identity transformed from that of a "profane" lion to that of a sacred lamb signifying Jesus Christ and incorporating a blood relic. However, even at a glance it is evident that the flattening implied by the dichotomies of Christian/Muslim or conversion/transformation does not do justice to the goblet's visual complexity. To think in terms of either religious opposition or of peaceful religious coexistence being manifest in such cross-cultural constructions is to fail to acknowledge the sophisticated ways in which the object's makers combined and connected disparate elements. Like many of the items of "flotsam" discussed in this volume, the Münster goblet requires an approach that acknowledges *both* the long-distance connections and circulations to which it attests *and* the implications of its creation and reception in a particular time and place, with its own established beliefs and traditions. The complexity of the goblet's construction begs close reading rather than sectarian categorization: such objects demanded and still demand types of viewing predicated upon a dialectic of connection and separation, conversion and convergence; these are objects that provoke a kind of looking that sees both far afield and deep within. To explore the richness of the artful physical and conceptual juxtapositions seen in the Münster goblet, we must further unfold its meanings by considering its potential functions—an aspect of its history that, as previously mentioned, is elusive insofar as written sources are concerned.

Changing Functions

Written sources regarding liturgical practices in churches that have preserved coconut vessels in their treasuries are silent regarding their actual use. Based on the entries of later treasury inventories, one might reasonably assume that most of these objects served as reliquaries, but whether that was their primary function at an earlier moment we cannot confirm from contemporary accounts. The entry on the Freiburg vessel (see fig. 93) in Rolf Fritz's study of coconut vessels in medieval and early modern Europe includes the suggestion that it "may [have been] originally a profane [i.e., non-liturgical] drinking vessel."[30]

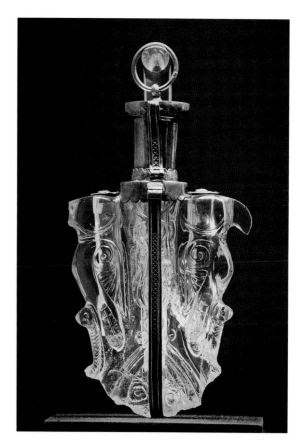

Fig. 96 Reliquary with flask in the shape of two birds: rock crystal flask Fatimid, 10th century; mount Quedlinburg (Saxony Anhalt), mid-13th and 14th centuries. Rock crystal and silver; 18 × 10.5 cm. Quedlinburg, Domschatz Stiftskirche St. Servatii.

This theory was possibly inspired by the notion, documented for the early modern period, that coconuts could protect the drinker from poison, or by the use of coconut as an antidote to poison in other regions—the Moroccan traveler Ibn Battuta (d. 1369) describes the trade and use of coconut drinking vessels in the Maldives.[31] But this hypothesis does not attribute sufficient importance to the Münster goblet's inclusion of a crystal lamb containing a relic of Christ, or to the medallion with a portrait of Saint Mary Magdalene on the top of the Freiburg cup (see fig. 93). Why add a relic or a saint to a vessel originally used for nonsacred purposes, and why place saints and relics on its lid? Did the primary function of the vessel involve it being opened at all? We cannot answer these questions with certainty for the vessels preserved at Münster or Freiburg, but we will return to them since, as we shall see, it is crucial that early coconut vessels in particular were connected to saints and/or served as reliquaries.

This is particularly evident—and well documented—in the case of the vessel preserved

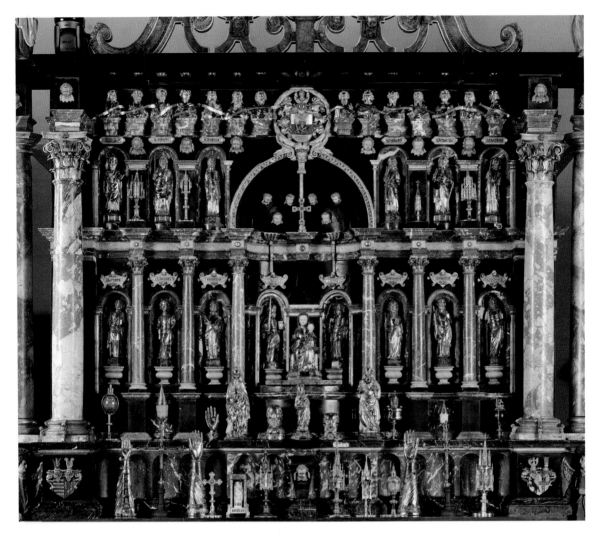

Fig. 97 Old altar construction by Gerhard Gröninger, with display
of reliquaries, statuettes of saints, and other treasure objects
(picture taken in 2014). Münster, Domkammer, St.-Paulus-Dom.

at Münster (see figs. 77 and 78). The dark brown
polished coconut at the center of this object is
vertically banded by three flat strips of gold deco-
rated with a carved motif of tendrils, below which
is a horizonal band of fleshy leaves, also wrought
in gold.[32] The coconut rests on these leaves, which
are punctured with holes and open upward, out
of the chalice's stem. The knop-shaped grip in
the middle of the pedestal base, ornamented with
a pattern of indentations, is decorated at the top
and the bottom with a filigree pearl filament sur-
rounding the trunk. The lower part of the pedestal
bears no decoration other than its gleaming sil-
ver surface.

The matching widths of the latches compris-
ing the upper three hinges of the vessel, the two
hinges holding the silver lid, and another hinge
attached to the animal's collar suggest that the

principle compositional elements of the goblet
were designed and assembled simultaneously:
the coconut vessel, the hinged silver lid, and the
carved animal resting upon it.[33] Like the altar
discussed in chapter 2 (see fig. 64), the goblet con-
tained a wide variety of relics. A 1622 inventory of
the cathedral's treasury, written on the occasion of
the erection by Gerhard Gröninger of a new main
altar housing fifty-seven reliquaries (fig. 97), lists
an astonishing forty-six further relics that were
stored inside the coconut:

In the black nut with the crystal lamb of
God: In the very lamb of God of the blood
of our Lord, in the nut itself of the wood
of the Lord, of the tomb of the Lord, of
the statue to which the Lord was bound
and flagellated, of the crib of the Lord, of

Chapter 3

the table of the Last Supper of the Lord, of the stone from which the Lord ascended to heaven, of the table at which the Lord and his followers ate grilled fish and honey, of the oil of the blessed Mary, of the socks of the blessed Mary, of the stone on which the blessed Mary died, of the vestments of the blessed Mary, of his tomb, of Saint Anne, of Saint John the Baptist, of Aaron's rod, of the apostle Saint Peter, of the apostle Saint Barnabas, of the apostle Saint Bartholomew, of the apostle Saint Simon, of the apostle Saint Jacques, of the apostle Saint Paul, of the apostle Saint Andrew, of the apostle Saint Jacques, of the apostle Saint Thomas, of the evangelist Saint Luke, of the evangelist Saint Matthew, of Saint Stephen, of Saint Lawrence, of Saint Vincent, of the bishop Saint Nicolas, of the holy innocents, of the bishop Saint Martin, of Saint Benedict, of Saint Bernard, of the virgin Saint Catherine, of Saint Mary Magdalene, of the virgin Saint Agatha, of Saint Agnes, of Saint Lucia, of Saint Ursula, of the virgin Saint Barbara, of the vestment of the virgin Saint Juliana, of Saint Margaret, of the eleven thousand virgins, of the bishop and our patron Willehad, who collected these relics from the church in Hildesheim.[34]

Each of these relics is still preserved. The list is based on the *cedulae* (fig. 98): the small strips of parchment with inscriptions about the relics' origins—still extant—accompanying and identifying each one.[35] Troublingly, the textiles were recently replaced without preserving the original material. The knowledge that the textile wrappings around the relics would have provided—regarding when they were wrapped, trade connections, and perhaps further links to other church treasures—is now lost; yet paleographic analysis of the *cedulae* points to the thirteenth century as the date of the goblet's manufacture and suggests its original function as a reliquary.[36]

Whether or not the relics were found intact when the coconut goblet was opened in 1622 is unclear, as is the question of whether they were placed within it from the very beginning or if the vessel became a container for other relics in the treasury at a later date. It was not unusual for a former liturgical object to be converted into a reliquary during this period. For example, a chalice and paten in the treasury at Basel, known as the Eptingen goblet (fig. 99), was created around 1270 and turned into a reliquary before 1477.[37] As with

the Münster example, the Eptingen goblet has two hinges that attach the paten to the former chalice to enable the enclosure of relics. These hinges render the change to the vessel's form and function evident to the beholder.

The stark contrast in the Münster goblet between the dark wooden shell, referencing the relic of the True Cross within, and the transparency of the rock crystal on top, bearing the Savior's blood, constitutes a *mise-en-scène* of a very sophisticated sort. Christ's invisible earthly remains are embodied by drops of blood soaked into a piece of cloth that is embedded within the crystal figure such that their transfigured presence manifests as pure light. This transformation could hardly find a more appropriate material presentation: the son of God, sacrificed by his own father like a lamb, and this lamb of God dissolving into drops of blood refracted by the crystal, dematerialized and rematerialized as rays of light. The additional allusion to the vessel's sacred contents (specifically the relic of the True Cross) relies not only on the shape of the lamb but also upon the red silk that enshrouds the relic and glimmers through the translucent container so that the vessel becomes not only an embodiment of Christ's transfiguration but also an agent of visual and material transformation.

Fruits from Paradise

The coconut is able to mirror these concepts thanks to its associations with Paradise. Although unseen, the heavenly light proffered by its concealed sacred contents as a promise of the beyond echoes with that beyond whence the foreign coconut originated as a material object. The location of the Earthly Paradise, like the origin of the coconut—also called the "Indian nut"—was indeed, in this period, presumed to be "India." The Italian Franciscan Giovanni de' Marignolli (d. after 1357) traveled to the court of the Mongol khan and crossed the Gobi Desert to arrive at Peking, where he was received at the imperial Chinese court. He then continued his journey toward the coast of Malabar in southern India, reaching Quilon (Kollam) in 1348. From there he sailed via "Seyllan" or Ceylon (today Sri Lanka) to the islands of Indonesia and returned westward through the Gulf, reaching Naples in 1353. According to his account, the Earthly Paradise was located on the island of Ceylon, where the local monks had a special connection to the first parents of humankind, Adam and Eve, as well as to the apostolic community, with whom they still shared some eating habits. His text explicitly mentions coconuts being from Ceylon:

Fig. 98 Textile wrappings enclosing different relics and paper labels,
so-called *cedulae*, describing the origin of the relics in Münster
Cathedral. Münster, Domkammer, St.-Paulus-Dom.

Our first parents, then, lived in Seyllan [Ceylon] upon the fruits I have mentioned [. . .]. They eat only once a day, and never oftener; they drink nothing but milk or water; they pray with great propriety of manner; they teach boys to form their letters, first by writing with the finger on sand, and afterwards with an iron style [i.e., stylus] upon leaves of paper, or rather I should say upon leaves of a certain tree. In their cloister they have certain trees that differ in foliage from all others. These are encircled with crowns of gold and jewels, and there are lights placed before them, and these trees they worship. And they pretend to have received this right by tradition from Adam, saying that they adore those trees because Adam looked for future salvation to come from wood. And this agrees with that verse of David's, *Dicite in gentibus, quia Dominus regnabit in ligno* [Say ye among the Gentiles, the Lord hath reigned (Psalm. 95:10)] [. . .].

These monks, moreover, never keep any food in their house till the morrow. They sleep on the bare ground; they walk barefoot, carrying a staff; and are contented with a frock like that of one of our Minor Friars (but without a hood), and with a mantle cast in folds over the shoulder *ad modum Apostolorum* [in the manner of the apostles]. They go about in procession every morning begging rice for their day's dinner. The princes and others go forth to meet them with the greatest reverence, and bestow rice upon them in measure pro-portioned to their numbers; and this they partake of steeped in water, with coco-nut milk and plantains. These things I speak of as an eye-witness.[38]

The notion that the blessed, the saints, and the prophets from the Old Testament resided in the Earthly Paradise was renegotiated during the thirteenth century. The Christian theologian Augustine of Hippo (d. 430) from Carthage (near the modern city of Tunis) had promoted the idea of a terrestrial paradise—a location on Earth whose existence, according to the Dominican friar and theologian Ulrich von Strassburg (d. 1277), was questioned only by Origen of Alexandria (d. ca. 253) and a few heretics.[39] As most travelers from the Latin West who reached the place where the Earthly Paradise was presumed to be did not mention it at all, Giovanni de' Marignolli was an exception.[40] Although his account was written a

century after the coconut goblet was assembled in northern Germany, we may nevertheless use it as general context for a new interpretation of the striking ensemble.

According to Giovanni de' Marignolli, the community at Ceylon still preserved a particular connection to the community of the apostles as evidenced by the monks' habits of eating, living, and worshiping. Trees and the fruits they produced played a particular role in local monastic culture; they produced the material on which the monks wrote as well as their food. Fruit was, moreover, an object of veneration.

With these characteristics and practices of the monks of Ceylon in mind, we suggest that the relics in the Münster vessel, representing the apostolic community, martyrs, bishops, and saints, are presented as residing within an orb that represented the Earthly Paradise, and that the crystalline lamb of God glimmering above likewise embodies heavenly Paradise. As Bernhard Pabst has pointed out, the location of the terrestrial paradise in India or Ceylon originated not in the Latin West but in Islamic accounts. Legends centered around the most important mountain of Ceylon, known as Adam's Peak, where a footprint was venerated by Buddhists as belonging to the Buddha and by Muslims as belonging to Adam.[41] De' Marignolli himself took measurements of the footprint and refers to a Muslim pilgrim from Spain who did the same.[42] Enriching information that came from other written accounts with his own observations, he writes that the vestments Adam and Eve made after the Fall of Man were woven from coconut fibers, similar to those one could still see worn by the inhabitants of Ceylon. He even suggested changing the Latin adjective used in Genesis to describe Adam and Eve's clothes after the Fall from *pelliceas* (fur) to *filiceas* (fiber).[43] After describing the appearance of the palm tree that produces coconuts, he discusses the fruit and its use in detail:

But there is the coconut, the bark of the tree is very soft, it has very beautiful leaves like a palm tree, little baskets are made of the five, and the sixth is used for siding the houses with wood, and certainly posts and planks; from the skin, robes are made; from the shell, cups and vases. The shells protect against poison.[44]

We do not go so far as to claim that the coconut goblet's makers would have read the same Islamic legends as did de' Marignolli. However, as we shall see in chapter 6, medieval narratives

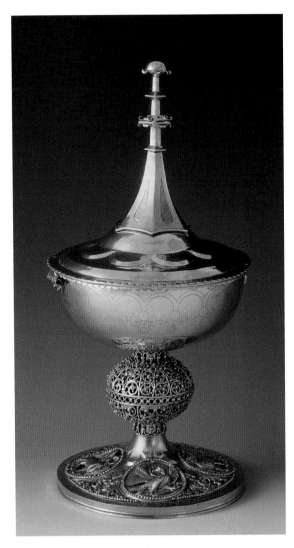

Fig. 99 The so-called Eptingen Chalice, upper Rhine, probably Basel, early 13th century. Gilded silver, beaten, engraved, and punched, with filigree; 33.7 × 15.5 cm. Basel, Historisches Museum, inv. no. 1882.84.

of the marvelous or wondrous traveled over long distances; it is possible, therefore, that the object may have traveled together with oral accounts pointing to the coconut as a fruit of terrestrial paradise. This would have furnished the coconut with an epistemological foundation rendering it a particularly apt vessel for the relics of saints that came to reside within it, just as the blood of Christ preserved in the rock crystal and mounted above it would have pointed toward Heaven. The decoration of the lids and embellished knops point to the celestial zone. We view these elements not as supplements, but as essential aspects of the object, included purposefully as crucial sources of information for the (be)holder. But before turning fully to the group of coconut reliquaries in the Latin

West, we would like to consider the protective aspect of the shell mentioned in Giovanni de' Marignolli's account, which states that the coconut's shell protects against poison.

One aspect of early coconut goblets has clearly preserved the sense of a fruit freshly plucked from the palm and containing a special liquid, with its shell protecting against poison. Early examples of coconuts mounted by European goldsmiths tended to fulfill one of two functions. First, they were often transformed into cups or goblets holding a treasure, for example a relic. Belief in the power of coconut shells to neutralize poison was most widespread during the early modern period. People poured dubious liquids into the shell, sometimes reinforcing its power with bezoar stones (also believed to have the ability to neutralize poison) attached to a coconut vessel.[45] We suggest that the practice of using coconuts as reliquaries was established later and has overshadowed an earlier Christian use of coconut cups in the celebration of the mass during the thirteenth and fourteenth centuries. Pouring wine into cups in which it would be transformed into Christ's blood would have required that the coconut be lined with a precious metal so that it would not rot or deteriorate. The protective power of drinking from a coconut shell in the medieval Latin West was not, moreover, attributed to the shell itself, but arose rather from the coconut's presumed divine origin as a gift from the Earthly Paradise.

We have some examples from the late Middle Ages (fourteenth and fifteenth centuries) of coconuts that are mounted as a double cup (see figs. 90, 91, and 94) such that, when closed, the pedestal of the upper cup stands vertically, upside-down (see fig. 90). In this case, the upper edges of both cups are lavishly decorated with enameled red and blue lozenges within which a royal lily appears. In view of the highly elaborate nature of these kinds of objects, it seems clear that much effort was expended in their design and creation.

However, we have no written records describing, nor images depicting, how such double cups were actually used. We can guess from the metal lining of the cups—as distinct from that of the coconut goblet at Münster—their shape, and from the fact that they were objects held by church treasuries that they might have been used to celebrate the mass. One could even imagine that the host was offered to congregants in one of the cups and wine in the other.

The union of two cups in a single vessel results in an unconventional shape, with the upper pedestal stretching, freestanding, into the air. This structural solution can be found in similar ves-

sels that incorporate different foreign materials, such as ostrich eggs (figs. 100 and 101).[46] The ostrich egg vessel preserved in the Halberstadt cathedral treasury (fig. 101) has important similarities to, but also differences from, the coconut goblets we have discussed thus far. The soft ivory tone of the eggshell contrasts starkly with the dark, polished surface of the coconut in Münster (see fig. 77), though both materials produce an even, soft sheen. The softness of these natural materials—eggshell and nutshell—is emphasized by the metal frames enclosing them. These frameworks consist of a pedestal, gilded bands with hinges, a golden rim, and further gilded elements placed upon their lids. In both cases, the distant origins of the natural materials point to the "edge" of the world, where it was assumed that not only the Earthly Paradise, but also lands roamed by dragons and other fantastical creatures (such as those that will be encountered in chapters 5 and 6 below) were located.

The ostrich-egg vessel features bands shaped like dragons holding the lower cup with lions and griffins embellishing the upper, subtly hinting that the egg might have held an exotic creature from distant territories beyond the known world. According to medieval encyclopedic entries in Latin on dragons and griffins that describe their qualities and properties, magical powers were attributed to these animals. The choice of these motifs for the bands enclosing the ostrich egg suggests that the medieval goldsmith working in thirteenth-century Germany did not know the precise species of animal that would have hatched from this egg, though he might well have guessed that the treasure in his hands was a dragon's egg. While later records from church treasuries written in the fifteenth and sixteenth centuries clearly name the object as an ostrich egg, for the thirteenth century such documents are extremely rare.

The goldsmith who created the dragon bands lavishly adorned with gemstones and who carefully crafted golden fetters around the dragon's claws holding the egg in its place might have learned about the creatures from a widely disseminated late antique encyclopedic tract knows as the *Physiologus*. This text was presumed to have been written originally in Greek and translated into Latin in the fourth or fifth century; its translation into Arabic, Armenian, Coptic, Ethiopic, Syriac, and several Slavic languages meant that it found very wide dissemination in manuscript form. The *Physiologus* describes many different animals, including birds and fantastical creatures, as well as stones and plants; to their descriptions the text adds moral content in anecdotal form, along with

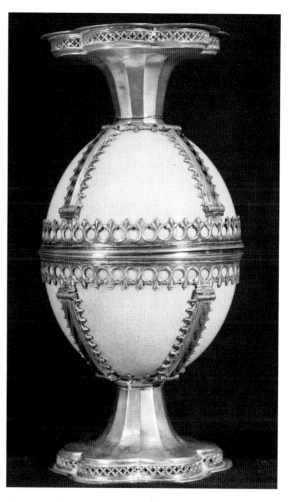

Fig. 100 Double cup, Austria, first half 15th century, from the treasury of the archbishops of Salzburg. Ostrich eggshell and silver; h. 29 cm. Florence, Palazzo Pitti, Museo degli argenti, inv. no 151.

biblical passages or references to the passion of Christ. At the end of the entry on the panther, its enemy the dragon is paid particular attention. Not only closely related to Satan, the source of all evil in Christian theology, dragons were also linked to poison and to the idea of Christ's resurrection after three days entombed:

> Even so the Lord God, the Giver of joy, is gracious to all creatures, to every order of them, save only the dragon, the source of venom, that ancient enemy whom he bound in the abyss of torments; shackling him with fiery fetters, and loading him with dire constraints, he arose from darkness on the third day after he, the Lord of angels, the Bestower of victory, had for three nights endured death on our behalf. [. . .] The dragon, author of all wickedness, / Satan, the ancient adversary whom, /

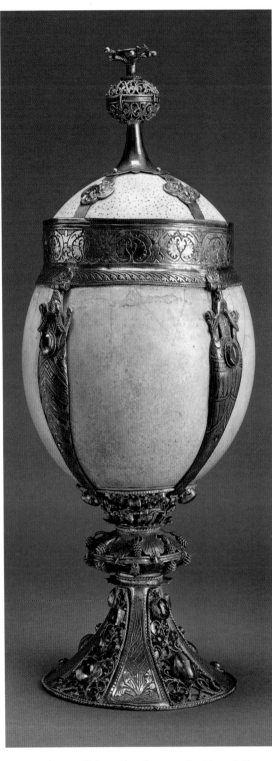

Fig. 101 Ciborium, Halberstadt, 13th century. Ostrich eggshell, with silver, niello, gemstones, and inner lining; h. 33.5 cm (24.9 cm without lid).

fettered with fire, shackled with dire constraint, / into the pit of torments God cast down. / The third day Christ arose from out the grave, / for three nights having suffered death for us, / He, Lord of angels, he in whom alone / is hope of overcoming.[47]

Such images help us to make sense of the dragon clasps cradling a foreign beast's egg. They are "fettered with fire," the goldsmith having crafted them using the heat of his fire; the dragon's claws are tightly bound. Knowledge of dragons, mediated through a widespread and oft-translated encyclopedic text, could have informed not only medieval craftsmen but also their audiences: the (be)holders of the treasured objects they created. These assumptions about dragons, including their connection to poison in general, and the reference to Christ's containment of the devil (who was often represented as a dragon) come together to suggest that Christ can always overcome all evil. Christian beliefs about the potency of this fantastical creature and Christ's power to vanquish it are connected in the encyclopedic tract. The composition of the coconut and ostrich goblets references a globe both dark and light, as well as something hidden or only partially visible in both vessels, speaking to an audience that assumed Christ and the saints were acting from the divine realm to protect believers in the earthly realm from the devil's spells and other evils.

In contemporary religious, medical, and magical practice, it was believed that seeing images of saints or touching sacred objects could help to overcome evils such as illness, doubt, or disbelief. It should come as no surprise, therefore, that, like the coconut goblet in Münster (see fig. 77), the reliquary in Halberstadt (see fig. 101) holds several relics, in textile wrappings, from a whole series of Christian saints: Nicolas, George, Margaret, Verena, Mary Magdalene, Elisabeth, Anne, Paul, Andrew, Jacob, and Mary, as well as a particle from the True Cross and a piece of the stone on which Christ was said to have rested when praying at Gethsemane.[48] As with the Münster goblet, it is unclear at what point these relics were placed into the ostrich reliquary. Most of these objects were not made all at once or used in the same way over time, but were instead subject to changes of function, perhaps due to shifting tastes regarding their decoration. Elements that had a purpose—like a second pedestal for the upper, smaller cup—may have been abandoned or even replaced at a later time.

This may be what caused the replacement of the upper pedestal with a crucifix, as is now visi-

ble above the knop on top of the upper cup of the Cividale goblet (see fig. 94). To fabricate this object, the coconut was divided almost evenly, and each half placed within three bands of gilded silver connected with hinges on both sides to conical structures below and above. Each such structure is embellished by a frieze of lobed leaves, with each leaf separated from the next by a hole. The same kind of decoration is used to hold the coconut halves of the Hildesheim and Münster vessels, an ornamental choice that underscores the organic origin of the coconut: a fruit produced by nature and plucked from a tree. Where the rims of the two cups meet, a frieze with sharp teeth (several now broken off) divides the upper and lower parts of the coconut goblet; stronger hinges hold both halves in place. A small lobed bowl decorates the very top, upon which the crucifix was mounted. The goblet preserved in the Cammin (Kamień Pomorski) treasury until the Second World War is similarly crowned with a crucifix above an assemblage of coconut and a miniature tower erected over the lid.[49] Crosshatching points to a now lost enamel coating; holes suggest that something was attached to the trefoil ends of the cross. The replacement of the upside-down pedestal with figurative element directs us toward a second group of early coconut vessels: those surmounted by a figural knop.

Incarnated Knops

The connection between the Earthly Paradise and heavenly realms is yet more explicit in this second group of early coconut vessels, which include closed containers with a figural embellishment added to the lid (see figs. 78, 89, 93, and 94). For closed vessels such as these, the figures—painted or sculpted saints—reference the hidden contents of the coconut container below, revealing to the beholder what may be preserved inside and, at the same time, creating a tension between the object's upper and lower parts.

The figures that were placed on the lids of early coconut goblets are striking: each one inhabits its vessel and guards its contents. The figures also constitute the knop-like handles that one would need to grasp in order to lift the upper part of the coconut from the lower. At Freiburg we see Mary Magdalene depicted on a round enameled medallion (see fig. 93). A red inscription to her right that lists her name and those of Saint Dominic and Saint Thomas may indicate that the coconut below at one time carried relics of all three saints. Mary Magdalene wears a crown over her long blonde locks and presents before her in her two hands a round vessel topped with a knop. The halo

surrounding the three leaves of her crown clearly marks the figure as a saint. Her striped dress is divided down the middle, with red stripes on her left side and green on her right.

Enamel is a transparent or opaque layer of fused powdered glass on a metal surface that produces a colorful glaze. To implement this design, the goldsmith had to combine several techniques: he punched little decorative holes, for example, in the halo's frame and at the bottom of the crown; he applied reddish and green enamel with a brush, using dots of it to indicate red and green jewels on Mary Magdalene's halo and crown. He also added a lighter red for her skin and black for the contours of her eyes, dress, crown, and halo. The enameled medallion is positioned within a round setting by little rounded lobes slightly pressed toward it.

At Hildesheim, an elegantly sculpted figure of a standing saint likewise needs to be grasped if one is to lift the upper part of the coconut (see fig. 89). Such repeated use is likely what reduced the scroll that the saint holds in his right hand to a worn stump. The book in his left suggests his identification as an author contributing a book to the biblical canon or as a prophet. Rather strange and seemingly unique is the mount upon which he stands, where the goldsmith's white dots have rendered a meadow flowering across gentle rolling hills. A 1546 record listing the treasures owned by the church describes the saint as Andrew the Apostle.[50] If this is accurate, he has lost his attribute—a cross in the shape of the letter X—one leg of which would have touched the saint at his own lower right leg. However, the book is an unusual attribute for Andrew, and such records sometimes misidentify saints, especially those depicted on early objects. The hill feature, which at one time was coated with a layer of dark green enamel, could suggest Saint Thomas instead. This apostle was the author of a gospel that was not included in the canonical scriptures of the Latin Bible. He was sent to India as a missionary and died on the Little Mount near Chennai (Madras), and thus in the region believed to be the Earthly Paradise; as we shall see in chapter 5, his cult was renowned as far away as Egypt and Ethiopia.

The use of *émail en ronde bosse*, a difficult technique in which enamel glaze was used to coat rounded structures and figures in three dimensions, points to an origin for the object in Paris, where goldsmiths had invented this skillful approach to applying molten glass, around 1400. The lower silver hill, however, surrounded by a slim golden band, could instead have been produced at an earlier date. Indeed, the golden

figure of the saint, the three silver bands holding the coconut in place, the frieze with three lobed leaves at the upper and lower rim of the coconut, and the pedestal could all have been made during the first half of the fourteenth century; while the little green enameled hill, sprinkled with white flowers and surrounded by a fence made of golden branches, clearly derive from the later date.[51] As Jörg Richter has noted, the ensemble we see today was not the first mounting this particular coconut had experienced: two marks at the upper edge of the shell provide clear evidence of an earlier setting also involving a metal mount.[52] This would suggest an object made in two steps: coconut, lower and upper leaf friezes, three metal strips with six hinges, and silver hill, together with saint, as the first phase; coat of arms, enameled green hill with flowers, and golden fence, together with reworking of the pedestal, as the second.

Comparing these early coconut goblets with figures as handles reveals the striking relationship goldsmiths managed to express between the upper part with its visible saints, all residing in Heaven, and the lower part based on Earth. In this company, the Münster coconut goblet loses something of its uniqueness: it becomes evident that the use of rock crystal to simultaneously expose and obscure referenced the heavenly sphere, just as the coconut in turn referenced the earthly. In the former, according to Christian belief, the saints reside until after the Last Judgment, when the separation between the heavenly and earthly realms becomes no more and all resurrected Christians regain their ability to see truly, even to see God himself. This ability had been taken from mankind as a punishment for original sin: Christian exegetes since Saint Paul have emphasized that, after Adam and Eve ate the apple from the Tree of Knowledge in Paradise—as recounted in the first book of the Bible—human vision was reduced such that people could see only a reflection of the truth. True vision, according to these thinkers, would be only restored on the last day, after the end of time, when humans would be once again granted the ability to see God.

The figure of a saint, or a relic, upon a coconut—a fruit from Paradise—held a particular meaning for the Christian (be)holder. The visible reference to the saint (in the vessels in Freiburg and Hildesheim) and to the relic inside the crystal lamb in Münster as figurative representations of what may have been preserved inside the coconut also referenced the invisible divine sphere where saints and the Trinity reside until the end of time.

The specific materiality of these figures is what references a non-material reality; their materials

were thus chosen with care. Enamel and rock crystal are both translucent or transparent and yet do not in most cases fully reveal what lies behind them, providing only a glimpse of what is underneath their surfaces. Insights into the meaning of such materials may be gleaned from medieval lapidaries: texts which describe the appearance, qualities, and associations of specific stones. Writing in the ninth-century Latin West, Christian theologian Hrabanus Maurus goes beyond most traditional lapidary cataloguing systems that align a specific stone with colors, effects, and healing powers to signal more significant meanings for rock crystal, such as the sacrament of baptism, and the incarnation of Christ.[53] Monk and theologian Berengaudus of Ferrières (840-890) went a step further, comparing the clarity of crystal to the purity of saints' minds and human perfection— that is, to Christ himself.[54] The intersections between Latin and Arabic lapidaries have yet to be studied systematically in terms of their likely mutual debt to late antique traditions (a subject to which we return in chapter 6). Nevertheless, both traditions expressly link rock crystal to Paradise, locate the origin of gemstones in Paradise, and/or emphasize the clarity of gems, attributing healing powers to them.[55] Medieval authors in the West also connect the location of the Earthly Paradise (south Asia) to places where gemstones are found.[56]

The orb-like shape of the Münster coconut and the stark contrast between its dark wood and the shining crystal above it make implicit (and even, we might argue, explicit) reference to earthly and heavenly realms, as well as to the role of liturgy and the eucharist in mediating the relationship between these: during the Christian mass it is believed that the terrestrial becomes divine, just as the coconut that arrived upon the seas as flotsam rises up, through the vessel's form, to become transformed into a crystal surface poised above it.

The medieval associations of materials foreign to the Latin West, such as coconut and rock crystal, that have come under scrutiny in this chapter have distinctly cosmological dimensions. It thus becomes evident that, no matter what functions goblets, chalices, pyxes, or reliquaries may have served at different moments of their lives as treasury objects, earthly and celestial paradises are linked in these treasures through the materials of coconut and rock crystal. Furthermore, figures— whether depicted saints or actual relics—placed on top of coconut vessels could act as mediators from their lofty position—the heavenly sphere— while remaining connected to the earthly realm through relics, establishing a powerful connection

between the two realms. Metalsmiths' creations of this kind, therefore, actively "incarnate" each vessel, whose very materiality constitutes the bond between Heaven and Earth. The coconut's geographical allusion to the Earthly Paradise, and the allusion by its form to the globe, strengthen this imagined link that, for Christians, will one day become real: the two realms will merge at the end of time when, according to the Book of Revelation, the union of the two Jerusalems will restore true sight to resurrected believers.

We ought not, however, to limit our analysis of these forms to binary distinctions between center and periphery, local and foreign, heavenly and earthly. For in their guise as integral structural components of liturgical objects, the disparate and far-flung elements of both coconut and crystal lion also relate the terrestrial realm of the coconut (that paradisiacal fruit shaped like an orb) to the heavenly realm—the wrapped relic of Christ's blood in the rock crystal flask. The beholder does not have to traverse several spheres to reach God's celestial residence; they must simply gaze into the hollow belly of the rock crystal to catch a glimpse of divine power wrapped in red silk. Multiple traversals—geographical, material, spiritual—thus converge through the juxtaposition of coconut and crystal.

The foregoing analysis, moving from formal and visual investigation of coconut goblets to consideration of traces in written sources about the uses of coconuts, and an examination of the ways in which coconut and crystal relate to medieval ideas about earthly and heavenly paradises, leads us to a number of reflections. Early coconut cups suggest that, when coconut was used as the body of a vessel, assumptions about its presumed origin in the Earthly Paradise played an essential role in deciding how the resulting liturgical object was to be designed, especially at Münster (see fig. 77) and Freiburg (see fig. 93). Their distant origin and connection to paradise on Earth (India and Sri Lanka) distinguished coconuts from other precious materials, making the former particularly apt as containers for relics. As we have seen, coconuts could also be broken into pieces (see fig. 88) and incorporated into other objects, in the manner of holy relics. In medieval Christian thought, the corporeal remains of saints were considered to be imbued with sacred power that enabled them to act as a direct conduit to the saint in Paradise. Relics thus provided a "virtual" connection to the "real" saint through the idea of the holy figure's presence. In other words, though saints were "in" Paradise, they were simultaneously present on Earth through their relics, a simultaneity alluded to by the combination of crystal and coconut in the Münster goblet, with their evocation of celestial and earthly paradises.

The coconut vessels in Freiburg and Münster are excellent examples of objects that play with ideas about presence on Earth and in Heaven by housing relics of Christ and putting their omnipresence on visual display. At Münster, the symbol for Jesus Christ—the lamb of God—resides above the coconut's dark, round, earth-like orb, a symbol of the Earthly Paradise in Sri Lanka, which God gazes over, together with the angels to his right and left in the crystalline sky of Heaven. The goblet thus indexes its location as a composition—an assemblage—that traverses multiple intersections and horizons; it aims to manifest its sacred connection to realms unseen and (as yet) unknown in ways that legitimate its presence on Earth as an active agent of transformation.

Part 2

From Iraq to India and Africa
Technologies, Iconographies, and Marvels

Chapter 4 Magic and Medicine in Medieval Mesopotamia

Chapter 5 Distance Made Tangible in Medieval Ethiopia

Chapter 6 Narrative and Wonder in the Indian Ocean

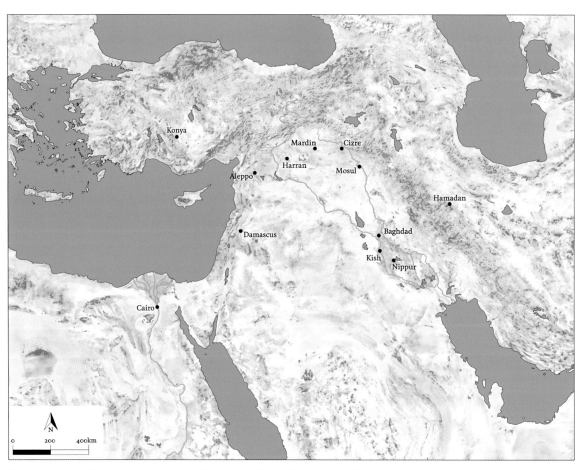

Map 4 Locations of the principal sites discussed in chapter 4. Map by Matilde Grimaldi

Chapter 4

Magic and Medicine in Medieval Mesopotamia

They also sell publicly copper cups on which are engraved inside and out many pernicious and unknown words, with images of vipers, scorpions, spiders, toads, caterpillars, and the names of the most pernicious venoms and other beasts, such as rabid dogs; on each of which animals are inscribed specific characters; they drink from these cups, in order to be preserved from and cured of all sorts of poisons; because those who sell them assure [the buyers] that they were manufactured under [the sign of] certain constellations which confer this virtue on them.

—Eugène Roger, *La Terre Sainte, ou, Description topographique tres-particuliere des saints Lieux, & de la Terre de Promission* [. . .] (Paris, 1664), 317.

Magic-Medicinal and Incantation Bowls

The reliquary from Münster discussed in chapter 3 represents an assemblage of diverse materials brought into constellation, a marvelous receptacle worthy of its contents. This chapter concerns itself with a different type of assemblage which, no less than the Christian reliquary, is more than the sum of its parts. It considers a form of metal bowl first introduced to Western scholarship in 1739, in a volume devoted to presenting a diverse range of unique monuments related to the religions of ancient peoples. In an appendix to the work, its author, Jacques Martin, published the earliest analysis and image of a type of Islamic magic-medicinal bowl (fig. 102) that became known in subsequent scholarship as a "poison bowl" or "poison cup."[1]

Cast from bronze or brass, copper alloys, the bowls are engraved with figurative imagery, magical symbols, and religious texts designed to cure or protect against a range of ailments, illnesses, and misfortunes (fig. 103). While often filled with liquids that would absorb the cumulative healing power of their engravings for ingestion, they could also be placed on or near the body or used to sprinkle liquids imbued with their protective potency. Some of the inscriptions on the bowls describe them as talismans, relating them to a more extensive network of protective objects and practices that bridge divisions between medicine, magic, and piety that are often imagined as absolute in modernity.[2]

Magic-medicinal bowls are among the most enigmatic and paradoxical examples of medieval Islamic metalwork to have come down to us. They are enigmatic because their provenance and often their exact dates are difficult to pin down with precision; they seem to have first appeared in the eastern Mediterranean or west Asia in the twelfth century. They are paradoxical because, unlike the bronze censers discussed in chapter 1, they travel with significant meta-data, engraved with extensive inscriptions relating to their function and use. Nonetheless, their origins, place of production, and chronology are disputed. As a result, they are somewhat adrift, a state reinforced by the fact that, until recently, they have been marginal to the canonical narratives of Islamic art history.

This is in addition to the complications associated with the chronology and dating of individual examples of the bowls. Even where they bear absolute dates, these dates are often at odds with the known chronology of the amirs or sultans named on them.[3] There is even some doubt as to whether all examples are in fact medieval, perhaps because of the practice of copying mentioned on many of the bowls, which advertise the fact that they are copied from models associated with fabled persons and places. Taken as a whole, however, the inscriptions on published examples of what are

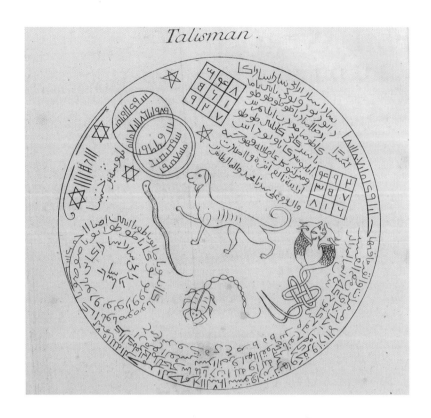

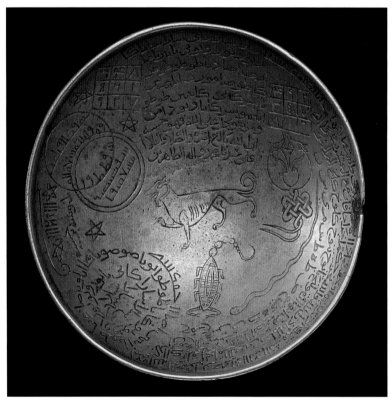

(TOP) *Fig. 102* Drawing of a magic-medicinal bowl ("poison bowl"), from Jacques Martin, *Explication des divers monuments singuliers qui ont rapport à la religion des plus anciens peoples* (Paris, 1739), pl. XII.

(BOTTOM) *Fig. 103* Engraved magic-medicinal bowl ("poison bowl"), Jazira, 12th–13th century(?). Copper alloy; dtr. 11.1 cm. Copenhagen, Davids Samling (The David Collection), inv. no. 36/1995.

believed to be the earliest examples of Islamic magic-medicinal bowls bear the names of amirs and sultans belonging to the Zangid, Ayyubid, Mamluk, and Rasulid dynasties who held sway over Egypt, Syria, Arabia, and Yemen between the twelfth and fourteenth centuries. This suggests that we are dealing with a temporally and regionally circumscribed phenomenon. The earliest plausibly dated examples bear the name of Nur al-Din ibn Zangi (r. 1146–1174), ruler of Syria and counter-Crusader. Although this does not necessarily imply any direct connection, the invocation of his name is significant, since Nur al-Din was closely associated with a revival of classical medicine and founded a celebrated hospital (*bīmāristān*) in Damascus (see fig. 212), which served as the model for others in Cairo and elsewhere.[4]

It is, therefore, not surprising that some of the earliest textual references to magic-medicinal bowls occur in medieval medical and veterinary texts, which describe copper and tin bowls inscribed with Qur'anic verses written in saffron, verses that are then washed with water which is then applied to the body or drunk. The use of saffron in such contexts continues a pre-Islamic tradition.[5] One of the earliest textual references to the use of such engraved metal bowls occurs in an annotated manuscript on medicine dated 663 H/1242 CE. This contains a recipe for engraving a magic formula against colic on a bowl of walnut wood (suggesting a lost tradition of such bowls in ephemeral materials) or on a red copper plate or bowl when Scorpio is in the ascendant. A significant point of overlap with the extant magic-medicinal bowls is the idea that the afflicted person should either drink from the bowl or, alternatively, appoint an agent or proxy to do the same, in which case we are told that he can expect a slight delay in the effect.[6]

Yet, for all the uncertainties about dating and provenance, the bowls are unusual among surviving examples of medieval Islamic metalwork in the extent and nature of the inscriptions that they bear. In contrast to the censers discussed in chapter 1, and unlike most portable objects from the medieval Islamic world, which reveal little about their function, these are uniquely loquacious objects, providing information about their intended function, the precise manner in which they should be deployed, and sometimes about the circumstances of their engraving. Their inscriptions attest to their efficacy against an array of ailments, from the nullification of sorcery and the evil eye, to the bite of a rabid dog or serpent or sting of a scorpion, fever, childhood illness, poor

milk flow of nursing mothers, colic, fever, stomach pains, hemorrhoids, migraine, kidney and spleen stones, and paralysis of the face and mouth.[7] The properties of the bowls as advertised in their inscriptions sometimes extend to other uses documented in earlier, pre-Islamic amulets and talismans: protection on a voyage, or how to make a favorable impression when embarked on the dangerous business of appearing before a figure of authority.[8] In short, despite the chronological aporias associated with them, these artifacts come with significant meta-data: carefully curated and therefore selective to be sure, but no less remarkable for this.

Although the Islamic metal bowls seem to first appear in the twelfth century, it is something of an *idée recue* in modern scholarship that their antecedents lie in a series of inked ceramic bowls produced in late antique Iraq, which bear apotropaic inscriptions written in Aramaic, Mandaic, Syriac, and other languages, along with schematic images of the demons against whom protection was sought, often bound or chained (fig. 104).[9] The assumption of a relationship is reflected in the tendency to extend the term "incantation bowl," by which the Aramaic bowls are known, also to the medieval Islamic bowls.[10]

The insistence upon an Iraqi origin for all magical or protective practices involving inscribed bowls has led to convoluted diffusionist hypotheses.[11] As we have seen in preceding chapters, persons and objects do move. There are also remarkable instances of disjunctive continuities involving the use of surviving antiquities as models, as we shall see in chapter 6. But there is little to connect all these traditions beyond the shared preference for the bowl form itself. At once a domestic artifact and a magical technology, the use of the bowl in rituals of divination and protection is well documented in other regions such as late antique Egypt, for example, connecting the world of the supernatural with the most fundamental locus of human life, and with its quotidian rituals.[12] Moreover, the bowl form itself echoes the role of protective or imprisoning circles and rings in a wide range of occult imagery and practices.[13] In this respect, the bowl might even be seen as a transhistorical constant of amuletic or talismanic and therapeutic practice in the eastern Mediterranean and west Asia.

Asserted on the basis of little evidence, the insistence on a relationship between the Aramaic incantation bowls and medieval Islamic magic-medicinal bowls flies in the face of numerous chronological, iconographic, and functional differences, which make the late antique ceramic

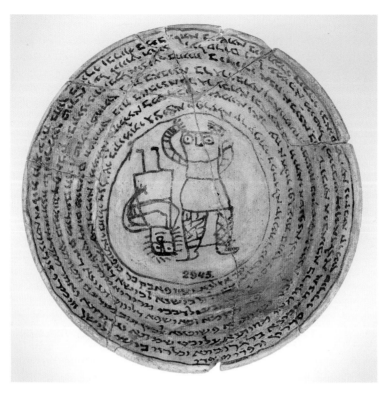

Fig. 104 Aramaic incantation bowl bearing images of what are probably demons, one chained at the feet, Nippur, Iraq, 3rd–4th century. Ink on ceramic, dtr. 18.3 cm. Penn Museum, Philadelphia, inv. no. B2945.

bowls unconvincing prototypes for the later metal vessels.[14] In the first place, although the production of the incantation bowls continued into the first century of Islamic rule, with a small number inscribed in Arabic,[15] there is a significant chronological gap between the disappearance of the Iraqi incantation bowls around the seventh century and the mid-twelfth century, when the Islamic metal bowls seem to appear. It is unclear whether the disappearance of the former can be linked to the rise of Islam, but it is possible that inked ceramic bowls from archaeological sites in the region will, when eventually studied, help to narrow this gap in the archive. Indeed, some inked vessels from early Islamic contexts bearing Arabic inscriptions seem also to have borne images of demons similar to those found on the Aramaic bowls.[16] However, with a single exception, images of demons are absent from the repertoire of later metal magic-medicinal bowls.[17] Where there are occasional overlaps with the imagery of the Islamic bowls—the presence of images of dogs or scorpions on both, for example[18]—these reflect a very common threat against which many types of magical technologies were directed in many different times and places.

Moreover, the geography of the Aramaic bowls is remarkably circumscribed: their use seems to have been confined to south central Iraq, especially the region around the ancient sites of Kish and Nippur.[19] There is little evidence for the production of later metal magic-medicinal bowls in these regions; insofar as such bowls can be associated with Iraq, it is northern Iraq that is in question, as we shall see. Finally, the functional differences between the late antique and medieval Islamic bowls are striking. The pre- and early Islamic Iraqi bowls were designed to be buried and hidden in domestic spaces, sometimes in conjoined pairs and often at thresholds or in corners: traps for the demons that they depicted.[20] By contrast, the Islamic bowls had a close relationship to the human body, and were designed to be drunk from, for washing or sprinkling the body, or placed in contact with it.

The insistence in modern scholarship on a necessary relation between the Islamic engraved metal bowls and pre-Islamic Iraqi inked bowls in the face of the many chronological and functional disjunctions reflects a tendency to create narratives of continuity based on surviving materials, often at the expense of practices involving

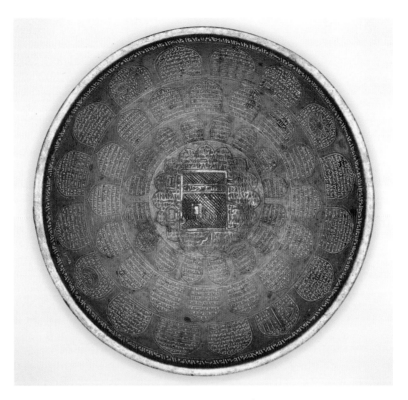

Fig. 105 Magic-medicinal bowl bearing the image of the Ka'ba
and the date 580 H/1184–85 CE. Copper alloy with inlaid silver;
dtr. 19 cm. An inscription claims that the bowl was engraved in
Mecca. Kuwait, The al-Sabah Collection, inv. no. LNS 945.

more ephemeral media, which leave little trace in the material record. In the case of the Islamic engraved metal bowls, more convincing prototypes for both content and function might be sought in earlier practices of inking texts drawn from the Qur'an on bowls which were erased or wiped with water or other liquids prepared for ingestion or sprinkling. The practice of imbibing the ink of Qur'anic verses inscribed on paper, bowls, or other media washed with water for curative or therapeutic purposes is attested from the eighth or ninth century.[21] Although sometimes contested, such practices were (and are) widespread in many parts of the Islamic world,[22] and were also current among medieval Jewish communities of the eastern Mediterranean, perhaps inspired by similar Islamic traditions.[23]

The prescriptions on such inked bowls were both ephemeral and often personalized, catering to the specific needs of named clients. By contrast, brass or bronze magic-medicinal bowls (the distinction awaits metallurgical analysis) were not targeted at individualized ailments, and were often produced in multiples. Capable of being reused as many times as required, what they lack is specificity regarding their user. The appearance

of the engraved metal bowls in the twelfth century seems, therefore, to represent an intensive commodification of an existing tradition, or traditions. Despite this, there are reasons for doubting that the engraved bowls represent a simple continuity with more ephemeral practices that had existed from the earliest days of Islam. Instead, they seem to bring into constellation a range of magical technologies with different histories and trajectories, complicating the temporality of the bowls.

There are, moreover, significant differences in scale, iconography, and epigraphic content among what appear to be the earliest metal bowls (compare figs. 103 and 105, for example). Even if the practice of erasing and imbibing selected Qur'anic verses provides a general context, it therefore seems unlikely that any single model can account for this diversity. On the contrary, distinct genres of such bowls distinguished by their size, elaboration, and iconography seem to have arisen in different regions of the eastern Mediterranean and west Asia around the second half of the twelfth century. Thanks to a recent study of a large corpus of bowls undertaken by the art historian Robert Giunta, we now have sufficient data

to offer a preliminary overview. The available evidence suggests that the earliest examples of the entire published corpus of what are believed to be the earliest magic-medicinal bowls can be associated with three regions: the Jazira region of northern Iraq and southern Anatolia in the twelfth and thirteenth centuries; Egypt and Syria in the Ayyubid and Mamluk period (twelfth through fourteenth or fifteenth centuries); and Mecca in Arabia in the same period (fig. 105), although it is possible that the bowls were engraved rather than produced there.[24]

Poison Bowls and Precedents

The bowls associated with all three regions are quite distinct in their iconography. Rather than considering them as a unified tradition with a single point of origin, a more productive approach might lie, therefore, in considering existing types on a case-by-case basis. Here, I would like to concentrate on the type of bowl first published by Jacques Martin (see fig. 102). Bowls of this type are often referred to in modern scholarship as "poison cups" or "poison bowls," although their claimed efficacy ranged well beyond the realm of toxicology. At the risk of perpetuating this reduction, for the sake of convenience I will refer to the bowls by this term throughout.

The bowls in question are the smallest, most standardized, and least technically ambitious of all the published magic-medicinal bowls. They vary in appearance from copper-red to silver or gold (see fig. 103; figs. 106–108); some seem to be made of tinned copper, or high tin bronze, although no metallurgical analysis has been undertaken, as far as I know. Ranging in diameter between 10.5 and 11.1 cm, these shallow bowls have a height between 2 and 3 cm. Around thirty-five such bowls are known, and there are likely many more that have yet to be documented.[25]

The outside of these bowls is usually quite plain, with the exception of an enchained ring of six-pointed stars around the base and an Arabic inscription on the exterior of the rim listing all the afflictions, difficulties, and maladies addressed through use of the bowl (fig. 108b,c). These include fever, nosebleed, colic, distress, abdominal pain, hemorrhage, pregnancy, difficult labor, and diminished lactation in a nursing mother. Interestingly, and for reasons unclear, they do not include the evil eye, mention of which is common on other types of bowl.[26] Nor do they refer to themselves as talismans, as do some of the inscriptions found on other types of magic-medicinal bowls, despite their astrological

associations (considered below). The texts and images on the bowls show a particular concern with the bites of rabid dogs and serpents, and the sting of scorpions. They include instructions for use: the bowls should be used with water (hot or infused with saffron); for certain ailments the water should be swallowed in one draught; for others the user needs to drink three times; for a woman in labor, the water should be used to wash the body, whereas for nosebleed it should be used to wash the face or water should be snuffed from the bowl, a prescription also mandated to increase the milk of a nursing woman. The inscriptions on such bowls often indicate that either the afflicted or their agent can make use of the bowl, implying that the benefit is transmitted to the afflicted even when a surrogate is used.[27]

If the exteriors of the bowls make restrained use of engraving, their interiors are, by contrast, dense with an array of images, symbols, and texts (fig. 109). These are remarkably uniform, consisting of a combination of dog, snake, scorpion, and two-headed dragons with knotted tails. Around these figures are arranged a pair of magic squares, magic seals, magical (or "pseudo-") scripts, stars, and Qur'anic verses. The engravings of the interiors are striking for their density (a feature common to other classes of such bowls) and for their lack of symmetry (a striking contrast to the design of other types of medieval Islamic magic-medicinal bowls). The packed variety of their interior engravings offers a good example of what a modern anthropologist might call "cognitive stickiness": their ability to draw our attention and hold our gaze, a common characteristic of amuletic and talismanic artifacts.[28]

The iconography of the bowls is remarkably standardized (compare figs. 103 and 106–109): not only do the same images, symbols, and texts occur, but generally in precisely the same relation and orientation. There are occasional variants that this class of bowls seems to have inspired, recognized by the use of some but not all of their iconographic elements, often in conjunction with non-standard symbols and signs (fig. 110),[29] but their homogeneity is striking and exceptional among the extant corpus of Islamic magic-medicinal bowls.

Their consistency notwithstanding, the "poison bowls" actually exist in two slight variants. Both make use of magic squares: grids containing numerals which yield the same figure when added along their vertical or horizontal lines. However, in one variant the sum of all rows in both magic squares yields 15 (figs. 107 and 109); in another, only one magic square yields this result, while the sum of the numerals in the other square is not

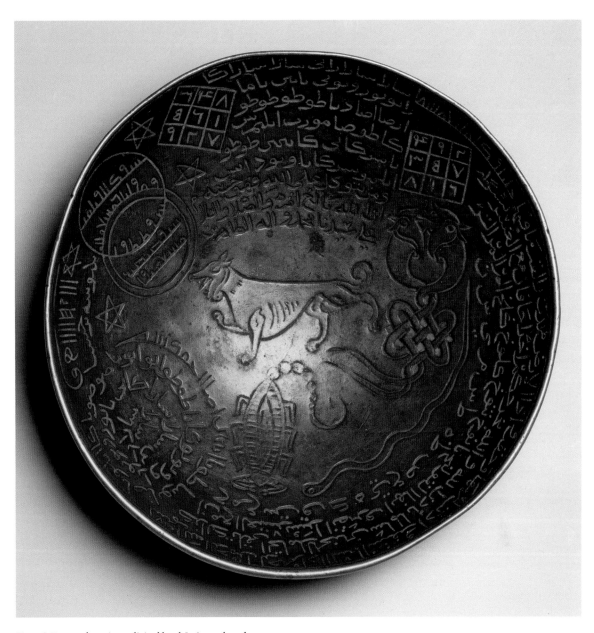

Fig. 106 Engraved magic-medicinal bowl, Jazira, 12th–13th
century(?). Copper alloy; dtr. 10.8 cm. Berlin, Museum für
Islamische Kunst, inv. no. I.1992.7.

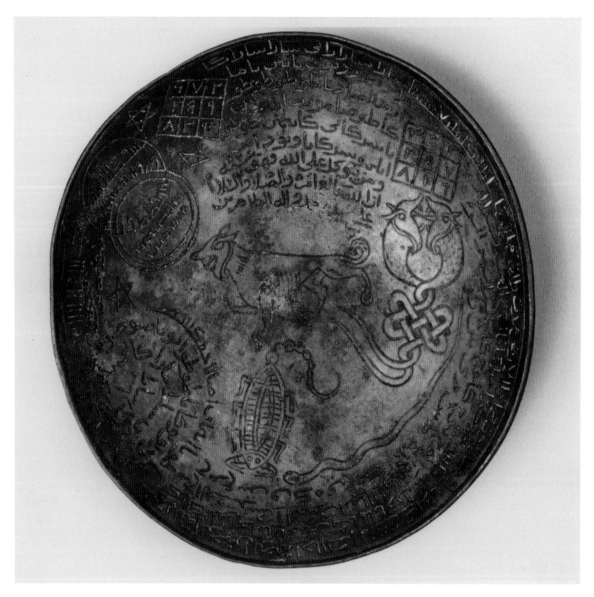

Fig. 107 Engraved magic-medicinal bowl, Jazira, 12th–13th century(?).
Copper alloy; dtr. 10.8 cm. Berlin, Ethnologisches Museum,
inv. no. IB 1116.

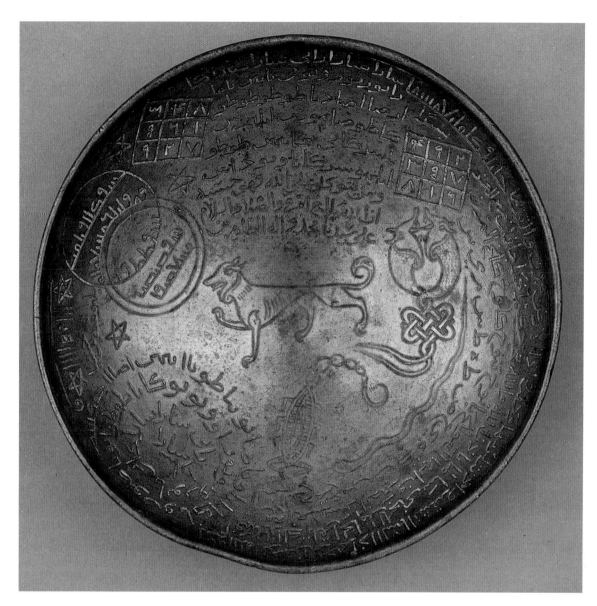

108a

108b

108c

Fig. 108 Engraved magic-medicinal bowl, Jazira, 12th–13th century(?). Copper alloy; dtr. 10.5 cm. Toronto, Royal Ontario Museum, inv. no. L976.34.

Magic and Medicine in Medieval Mesopotamia

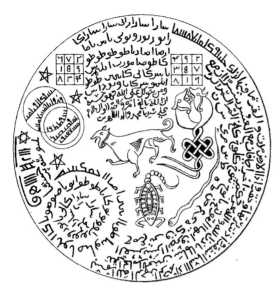

Fig. 109 Drawing of an engraved brass magic-medicinal bowl ("poison bowl") (from Rehatsek (1873–74)).

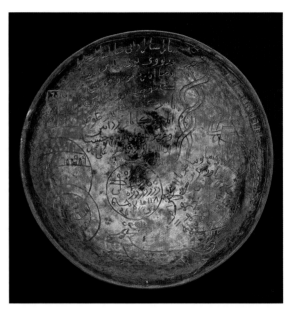

Fig. 110 Engraved magic-medicinal bowl, a variant on the "poison bowls" seen in figs. 102, 103, and 106–109, place and date of manufacture unknown. Tinned copper. London, Science Museum, inv. no. A159073.

regularized (figs. 103, 106, and 108).[30] The reason for the divergence in content between the two squares in some of the bowls is not clear, since their efficacious properties generally depend on the additive consistency of their numbers; but it does suggest that at least two closely related variants served as models.

The appearance in all "poison bowls" of at least one (and often two) 3 × 3 magic squares whose sides and diagonals add up to 15 is particularly interesting in light of the value ascribed to such squares in aiding childbirth, a usage mentioned in Iraqi texts on alchemy and magic as early as the ninth and tenth centuries. Interestingly, this form, the most common type of magic square found in medieval Islamic amulets and talismans, was attributed to Balinus or Apollonius of Tyana, a fabled Greek maker of metal talismans, whose name is invoked on some late antique engraved metal amulets from the eastern Mediterranean.[31]

Despite their uniformity, the bowls exist in such numbers that it is difficult to imagine them as products of a single workshop. Instead, we might look for parallels in studies of engraved metal amulets from the late antique and early Islamic eastern Mediterranean, which indicate that multiple engravers shared the same models, which sometimes consisted of earlier examples.[32] There are, as we shall see, striking iconographic overlaps between the imagery of some of the "poison bowls" and certain kinds of metal amulets

and talismans produced in the medieval Islamic world,[33] and it is entirely possible that both sorts of artifacts were engraved by the same artisans.

Of the makers of the "poison bowls," however, we know very little, although their production would have required a range of technical knowledge, from metal casting to engraving, knowledge of the Qur'an, and occult imagery and symbols. Three or four bowls bear the name of a Muhammad ibn Yunus, likely their engraver (or possibly that of the workshop in which they were engraved), whereas one variant bears the name of al-Hajj 'Uthman al-Baghdadi, suggesting an Iraqi connection, to which I will return.[34] However, the names of owners or patrons are generally absent, making it likely that they were produced for the market. Inscriptions on a magic-medicinal bowl of a quite different type, which bears the name of the Mamluk sultan al-Zahir Baybars, tells us that it was engraved on the first of Rajab 641 (December 21, 1243) and completed on the thirtieth day of Ramadan 641 (March 18, 1244).[35] The distinction between engraving and completion is not clear, but the dates given suggest that the production process of some bowls could be extended.

However, with a single possible unverified exception, none of the published examples of the "poison bowls" bears a date.[36] The bowls rarely bear any clue as to provenance, but sometimes indicate that they were copied from the treasury or library (khizāna) of the citadel in Damascus

or copied from the treasures or royal treasures (*al-dhakhāʾir al-malakiyya*) of al-Mansur, presumably the Abbasid caliph al-Mansur (r. 754–775 CE), founder of Baghdad.[37] The association with famed predecessors no doubt enhanced the attractiveness of the objects in question (and probably their cost), while also advertising their proven effectiveness in ways that will be considered below.

Despite the wealth of information inscribed on this type of bowl, questions of date and provenance remain. Opinion has been split, with one school of thought attributing them to Mamluk Egypt or Syria and another to the Jazira region of southern Anatolia and northern Iraq.[38] Similarly, the date of the bowls has been a matter of controversy, with opinion ranging from the twelfth or thirteenth centuries to a much more recent date. The evidence presented here supports an origin in the Jazira, but the question of dating is more complicated.[39] It has been suggested that some of the extant bowls are modern, not medieval, and a whiff of the fake has even been sensed around some examples. However, it is difficult to see exactly where any fakery might lie, since many of the bowls announce themselves as copies of earlier models. Significantly, there is no claim that any bowl is itself ancient; the claim is rather that it was copied from an older model—whether directly or via a chain of copying (as with some other types of magic-medicinal bowls) is not specified.

Even if the type originated in the mid-twelfth century, the epigraph of this chapter describes bowls that sound remarkably similar being offered for sale in the markets of Jerusalem around 1630 CE. Like other types of Islamic magic-medicinal bowls, the "poison cups" may have been faithfully copied for centuries. Insisting on their status as copies, the bowls themselves may have served as models or templates for the production of later examples of the same type, further obscuring the question of absolute dating. The use of existing bowls as models would not be surprising given the evidence for the deployment of models in the production of some contemporary Islamic metalwork.[40]

Certain details in the engravings of the bowls are archaic, among them numerals that appear in their magic squares. These include the use of a cipher in the form of a reversed B (rather than the more common cipher resembling o) for the number 5. This form of the numeral is well documented in Arabic manuscripts of the twelfth and thirteenth centuries, and in some Latin translations of Arabic texts dating from this period but, with the exception of copies of earlier inscriptions and texts, later fell into desuetude.[41] Its

presence is, therefore, among the indications of an early date for the prototype(s) of the "poison bowls," whatever the dates of individual examples.

The Arabic verb used on several bowls of this type to indicate that they were copied from existing exemplars is *naqala*. The consistent use of this term rather than some of the alternatives employed on other medieval Islamic magic-medicine bowls is suggestive. At least when it relates to the copying of certain kinds of documents, *naqala* implies a carrying over between material supports: "Naqala is about receiving a text, taking one's place in the chain of transmission by accepting it from someone before you in the relay, and then taking on the responsibility of transferring it from one written object to another."[42] Underlining the practice of copying, transcription, and transmission which complicates the chronology of medieval magic-medicinal bowls in general, the choice of this term may also reflect the fact that the earliest bowls of this type drew on a range of amuletic and talismanic imagery possibly copied from a wide array of materials.

Given their explicit claim to be copies, and the perpetuation of archaic forms in their engravings, it is possible that the series of bowls as a whole reflects the impact of one or more of what the anthropologist George Kubler called a "prime object," an originary artifact standing at the head of a tradition that it initiates. While Kubler's notion of synchronic origins is open to criticism, as we saw in our Introduction, his idea seems especially relevant to the magic-medicinal bowls, which can be related to earlier traditions, but seem to represent a new form of complex commodity that appeared at a particular moment.[43]

In Kubler's view, the identification of the prototypical object is often frustrated by the fact that under most circumstances "the prime objects have disappeared into the mass of replicas, where their discovery is most difficult and problematic."[44] There are parallels here with the methodological frustrations arising from the philologist's search for textual archetypes: manuscripts that stand at the head of a chain of copies.[45] But beyond the question of the original, the idea of a series connected through copying seems relevant to the bowls, enigmatic yet loquacious objects, which play havoc with the certainties of absolute chronology.

The role of copying in the production of the bowls suggests that a system of seriation and replication associated with many kinds of pre-modern magical technologies was considered more important to the efficacy of the bowls than precise chronology.[46] This is perhaps not surprising, given

the use of models and prototypes in the copying of certain magical formulae and prescriptions and their faithful perpetuation across remarkable intervals of time.[47] For the moment, therefore, we may have to abandon the possibility of certainty with regard to the date of any individual example, in favor of an approach which, taking its cue from the practice of copying, attempts instead to say something about where and when the first examples of this bowl type, the prime object or objects that initiated the series, may have come into being. Given the formal and iconographic stability engendered by the practice of copying, inclusions and omissions in the content of the bowls offer some helpful clues.

In the first place, the engravings in this class of bowl never include a kind of script that was integral to the magical technologies of the eastern Mediterranean from the second or third centuries, and which may have evolved from Greek, possibly under Egyptian influence. Conventionally known as *charaktêres*, these include ring letters, signs with characteristic circular terminals (see figs. 118 and 126).[48] Outside the eastern Mediterranean they were rarely used; only very few published examples of the much earlier Aramaic or Syriac incantation bowls from Iraq sometimes cited as prototypes for Islamic magic-medicinal bowls use such signs.[49] By contrast, the use of such scripts continued in the eastern Mediterranean into the Islamic period, appearing on certain types of magic-medicinal bowls that bear the names of the Mamluk amirs and sultans of Egypt and Syria.[50] That they are entirely absent from the "poison bowls" suggests that these belong to a different tradition.

In the second place, the names of only two cities are found on this class of bowl, never together and always in relation to the model from which they were purportedly copied: Damascus is explicitly mentioned as the locus of the model on some bowls, while others imply Baghdad by situating the model in the treasury of the Baghdad caliph al-Mansur. This suggests that both cities were points of reference for the region in which this type of bowl originated. Damascus was the center of the first Islamic dynasty, the Umayyads (r. 661–750 CE), Baghdad the capital of the Islamic world under the Abbasids (r. 750–1258 CE). Moreover, in the twelfth century, when the first examples of the metal magic-medicinal bowls seem to have been produced, both cities were major cultural-political hubs.[51]

Such claims of association locate the efficacy of the bowls in a long-established tradition of providing a royal imprimatur but, more importantly, they suggest that in the region where the bowls

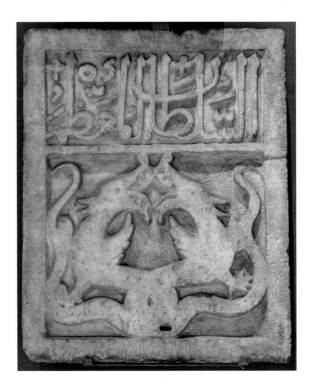

Fig. 111 Engraved relief with facing dragons, found in the funerary complex of sultan al-Muʾayyad Shaykh (d. 1421 CE) in Cairo; likely a spolium from Anatolia, 12th–13th century. Marble; 92 × 73 cm. Cairo, Museum of Islamic Art, inv. no. 1120.

were first produced, the major points of historical and urban reference were Syria and Iraq. Neither Cairo nor Egypt is mentioned on the "poison bowls," as one might imagine if the cups were of Egyptian origin, nor do they contain the names of any sultans of the Ayyubid and Mamluk dynasties that ruled these regions and whose names appeared on other kinds of magic-medicinal bowls. Instead, the evidence to be presented here suggests that the "poison bowls" first emerged in the Jazira, an area watered by the Tigris and Euphrates rivers that lay between northern Syria, southeastern Anatolia, and northern Iraq; in other words, a region equidistant from both Baghdad and Damascus, forming the third point of a roughly equilateral triangle that can be drawn between all three.

To this may be added the rarity of double-headed or entangled dragons such as those engraved in the "poison bowls" in the arts of Mamluk Egypt. In fact, the most convincing Egyptian parallel, a carved marble relief featuring confronted, entangled, and snarling dragons with flickering tongues, found in the funerary complex of the sultan al-Muʾayyad Shaykh in Cairo (1421 CE) (fig. 111) is almost certainly a spolium, a thirteenth-century Anatolian carving brought to

Chapter 4

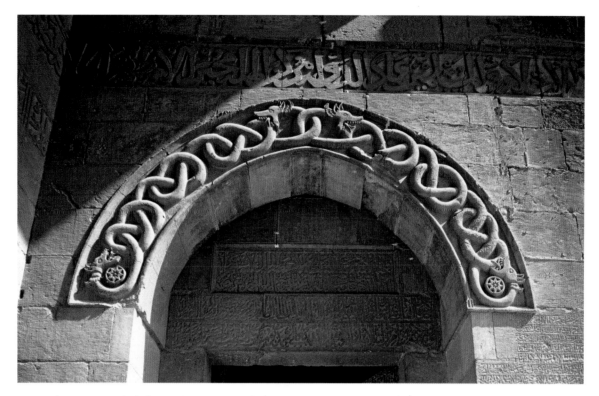

Fig. 112 The Serpent Gate (Bāb al-Ḥayyāt), an entrance to the cita-
del of Aleppo surmounted by an entangled pair of double-headed
dragons enclosing solar symbols, ca. 606 H/1209–10 CE.

Cairo.[52] By contrast, in the twelfth and thirteenth centuries southern Anatolia and northern Iraq and Syria were rich in monumental and porta-ble figurative works, including astrological and talismanic imagery featuring such dragons.[53] It was in fact in the Jazira that the image of con-fronted dragons or serpents (it is often difficult to tell them apart), with open jaws and flicker-ing tongues, similar to those on the bowls, first appeared at this time.[54]

Amulets and talismans against snakes and scorpions are among the most common forms of protective technologies produced in late antiq-uity and the medieval Islamic world. However, the cities of eastern Anatolia, northern Syria, and the Jazira seem to have been particularly well furnished with a wide range of large- and small-scale apotropaia and talismans directed against the threat posed by the kinds of venomous crea-tures depicted in the magic bowls.[55] Some were of stone, while others were of metal. The historian Ibn Shaddad (d. 1285 CE) mentions two copper talismans against snakes in the form of jinn in the city of Harran in the Jazira,[56] a place associ-ated with occult beliefs and practices. The traveler and writer al-Harawi (d. 1215 CE) reports that a church in the city of Mayyafariqin contained a talisman against snakes, a statue in the form of a double-headed serpent.[57] In neighboring Arme-nia, a thirteenth-century chronicler reports the existence of two petrified dragons whose bellies produced water used to cure snake bites,[58] a func-tion comparable to that of the bowls.

Related forms of imagery were especially common around entrances to buildings and cities (fig. 112), where they had a protective func-tion, harnessing the "writhing, grabbing, hissing, growling forces of dragons" and other beasts such as lions to protect both individual monuments and urban landscapes.[59]

An idea of how these dragon talismans may have looked is perhaps provided by a series of cast bronze door knockers from the Friday Mosque of Cizre (Jazirat ibn ʿUmar), datable to the first decades of the thirteenth century CE, which show a pair of dragons set between a lion's head (fig. 113). The tails of these protective dragons are entangled, their bodies are not; rather than facing like the dragons in the bowls, they are addorsed, turning back to bite themselves. As has often been noted, the extant knockers are closely related to those in a drawing for a palace door included in a celebrated work on automata by Badiʿ al-Zaman al-Jazari (d. 603 H/1206 CE). In al-Jazari's drawing,

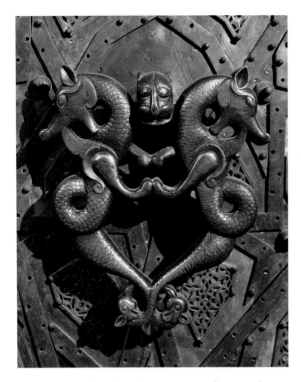

Fig. 113 Door knockers from the Great Mosque of Cizre, southeastern Anatolia, 13th century. Bronze; 30 × 22.4 cm. Istanbul, Türk ve İslam Eserleri Müzesi/Museum of Turkish and Islamic Arts, inv. no. 3749.

Fig. 114 Drawing for a door knocker of the Artuqid palace at Amid (modern Diyarbakr) from Badiʿ al-Zaman al-Jazari's *Book of Knowledge of Ingenious Mechanical Devices*, completed 602 H/1206 CE. Istanbul, Topkapı Palace Museum, TSM A. 3472, fol. 169a.

two snarling, open-jawed dragons whose tails are joined by a single knot face each other, in the process of devouring a knop in the form of a lionhead. The ensemble recalls contemporary descriptions of talismans from the region.[60] The manuscript was produced at the court of the Artuqids, who reigned over parts of southeastern Anatolia and the Jazira (fig. 114; see map 4). The Artuqids were major patrons of art and architecture who had a well-documented interest in technologics of various sorts, including those associated with astrology, automata, and talismans.[61]

It is in fact in the Artuqid domains that the closest comparison for the dragons in the bowls can be found, in the form of a pair of interlaced dragons that appears on the copper coinage of the Artuqid ruler Fakhr al-Din Qara Arslan ibn Dawud (r. 539–562 H/1144–1174 CE) (fig. 115). On the coins of Fakhr al-Din, the dragons are squeezed somewhat awkwardly into the lower left corner of a coin modeled on an earlier Byzantine one depicting Christ. Whether or not these were part of the original design or were counterstamped on the coin (which seems unlikely), all the evidence points to them being contemporary with Qara Arslan's rule. Although lacking the trailing tail of the dragons on the bowls, the tails

interlace to form a prominent quadripartite knot, and continue to form an arched frame. Remarkably, this seems to be the earliest dated example of the dragon motif that was to enjoy such popularity in the arts of the Jazira (and of northern Syria and Iraq more generally) for the next century.[62] The iconography may hark back to much earlier, possibly Central Asian, prototypes, highlighting the contemporary circulation of such dragon imagery across Eurasia.[63]

The overall form of the interlaced confronting dragons is strikingly similar to that of the dragons in the bowls; even the somewhat odd, off-center placing of the dragons on the coins recalls the clear preference for a non-symmetrical arrangement. While the formal similarities between the dragons on the coin and those engraved in the magic bowls supports an attribution to the Jazira made on other grounds, the date of the coin provides a possible terminus ad quem, or terminus post quem, for the earliest bowls of this type.

This is not to say that the "poison bowls" were produced under royal patronage. On the contrary, their highly standardized form indicates that they were produced in multiples, presumably as commodities. Nonetheless, the interest in apotropaic and talismanic imagery in the arts of the Jazira

Fig. 115 Copper dirhams of Fakhr al Din Qara Arslan (r. 1144–1174 CE), Artuqid ruler of the Jazira, struck at Hisn Kayfa on the Tigris; modeled on an earlier Byzantine prototype showing the enthroned Christ, but with a superimposed pair of entwined facing dragons below an arch. Upper image: Nomos Auctions, May 24, 2020, lot 1074, https://nomosag.com/default.aspx?page=ucAuctionDetails &auctionid=15&id=1074&p=11&s=&ca=0&type=webauction (accessed December 4, 2022); lower image: American Numismatic Society, inv. no. ANS 1959.102.17.

in the late twelfth and early thirteenth centuries provides a likely context for their production, an impression reinforced by the appearance and nature of the entangled dragons in the bowls. The snarling dragons on the coinage are on the point of swallowing an orb, probably representing the sun. The ensemble recalls al-Jazari's design for a door knocker, in which the lion may stand for the zodiacal sign of Leo, the domicile of the sun. It has been suggested that the addition of the dragon to these coins commemorates the occurrence of a partial solar eclipse, a swallowing of the sun, in 1145 CE, a connection to which I will return below.[64] The astrological and talismanic associations of the dragons are perfectly coherent with what we know about the other engravings in the bowl and their function, as we shall see.

Hydrophobia and Surrogacy

The bowls harness the power of Qur'anic verses, celestial forces, images, and magical numbers and letters. That these are related to function, to the relief of the ailments listed on the lip of the bowls, can hardly be doubted. The Qur'anic texts

in the bowls have been carefully chosen for their references to deliverance, easing hardship, preservation and protection; their relevance to the ailments mentioned on the lips of the bowls is both explicit and implicit. For example, among the verses engraved on the outer lip of the vessels are Qur'an 71:18 and 84:1–4. Both refer to the earth casting out what is in it, and are presumably related to the use of the bowls to aid childbirth. However, chapter 71 of the Qur'an, from which the former quotation is drawn, is named after Noah, whose name was invoked in medieval cures for snake and scorpion bite.[65] In addition to their literal content, it seems that the connotations of some chosen verses could extend the range of their efficacy.

Also present are names of what appear to be spiritual intermediaries (*rūḥānīyyāt*), and inscriptions containing clusters of consonants, enigmatic letters that preface certain Qur'anic verses and which were believed to possess occult properties.[66] Similarly, the magic squares in the bowls are of a type whose use to ease childbirth is documented in Arabic texts on the occult as early as the ninth century, while some of the magical seals within

the bowls are mentioned in medieval texts as efficacious against the predations of the creatures depicted alongside, and referenced on the rims of the bowls.[67] The presence of the figurative images might be seen as advertising the stated capacity of the bowls to heal the venom of the scorpion, snake, and rabid dog, perhaps for the illiterate. But, like the accompanying Qur'anic verses, the operation of the images extended well beyond this literal register, as we shall see.

The eclecticism of the bowls mirrors the eclecticism of medical practice in some of the most reputed hospitals in the medieval Islamic world. In the fourteenth century, for example, treatment of patients in the famous hospital of Nur al-Din in Damascus (see fig. 212) included both natural substances and amulets inscribed with figures and numbers.[68] Moreover, the range of operation of the bowls—including cure from dog bite, scorpion sting, and fevers—is similar to that against which various animal products, herbs, and minerals were prescribed by physicians in the medieval Islamic world.[69] An interesting suggestion of correspondences between the Qur'anic inscriptions and figurative ornamentation of medieval Anatolian and Syrian hospitals and those found on the magic-medicinal bowls awaits investigation.[70]

The therapeutic function of the bowls is reflected in their design, which encourages an intimate relation to the human body. With a diameter of 10-11 cm, most of these bowls fit snugly in the palm of a hand. Moreover, the long list of ills against which they might be employed is engraved on their exterior rims, in exactly the place that the lips of those afflicted by illness or venom (or their agent) would touch when drinking from the bowl (see fig. 108b,c). In this way, the inscription naming the dangers from which protection is sought not only constitutes the therapeutic nature of the bowls, but also functions both as a legible prescriptive text and an efficacious image or sign. The engraved text is part of an active constellation of engraved images, symbols, and words whose power is absorbed into the body even through the touch of the lips, the site of utterance, that precedes the act of ingestion. The placement allows the user to enact a relationship between inscription, orality, and the body that is common to protective and prophylactic technologies, not only in the Islamic world.[71]

The elixir produced within the bowls worked through contact, in which a variety of mediating liquids (in the case of the "poison bowls," water, sometimes saffron-infused) absorbed the efficacious potency of the engraving and facilitated its absorption by the human body. The liquid medi-

ator can be envisaged as fashioning itself into the forms incised in the bowls, filling the concavities of the incisions through which word and image were engraved, much as the stylus of old-fashioned record players scoured the grooves of vinyl discs to activate their inert contents and render them up for consumption. Alternatively, we might imagine the incised lines of the engraved metal surface as imprinting the mediating liquid (however ephemeral the imprint) in a manner comparable to the seals and stamps used in both magical and medicinal practices.[72]

The ingestion of healing liquids infused with blessings is not exclusive to Islam, but is also documented among Christian communities in the medieval Jazira. Such practices are central to a text that was produced in the region in the century after that in which the "poison bowls" seem to have first emerged. This is an illustrated copy of the apocryphal gospel *The Infancy of Jesus*, produced in Mardin in 1299, within the Artuqid domains whence the bowls seem to have originated.[73] Although this comes from a Christian milieu, the religiously heterogeneous nature of the region is well documented. The drawings in the manuscript provide graphic testimony to stories involving magic, possession, and miraculous healing that offer potential insights into the contemporary logic underlying the sorts of practices that are associated with the magic-medicinal bowls. The most relevant of these are tales of Jesus healing snake bite or demonic possession by means of water infused with his swaddling clothes, or by the afflicted drinking the water in which Jesus had bathed.

The idea that water infused with prophetic relics had curative properties was common to Islam, but it is the imagery of the manuscript that is particularly germane, often depicting the demonic force causing illness in the form of a serpent or a rabid dog. In one particularly striking image, the demon appears as a snarling dog from which twin dragon-like heads spring (fig. 116).[74] Seen in this light, some of the animals in the "poison bowls" may evoke the widespread belief in the role that demons played in the etiology of illness.[75] Just as the canine, serpentine, and scorpion figures in the bowl may be read as both agents of pain and poison and their cure, so the dragon emblematizes the demonic forces at work in illness and their negation; the knot that joins its two bodies is a common feature of medieval Islamic amuletic or apotropaic imagery.[76]

The association between demonic force, snake bite, and rabies may shed light on one of the most puzzling aspects of the inscriptions on the

25

Fig. 116 Drawing of a boy cured of a demon, *Il Vangelo dell'infanzia*, northern Iraq, 1299 CE. Florence, Biblioteca Medicea Laurenziana, Orientali 387, fol. 26r.

"poison bowls": a specification that an appointed agent or proxy (*rasūl*) can drink from the bowl. This is included in the texts found on several types of Islamic magic-medicinal bowls, but is especially common on those under discussion.[77] When present on the bowls, the texts often specify that the afflicted or his agent should drink from the bowl three times, a formula that appears more commonly on documented examples of "poison bowls" than on any other bowl type.

Threefold repetition is a commonplace of magical-therapeutic practice, but the implication is that the healing power is transmitted to the afflicted individual through the mediation of the agent who drinks from the bowl. The idea that the bowl's efficacy could be mediated or transmitted via a human agent who would not himself or herself derive benefit from drinking the contents of the bowl raises a range of intriguing practical and theoretical questions. Even accepting the imitative or mimetic constitution of the agent as the double of the patient, the mechanism of transfer is unclear, since the very idea of the bowls seems to depend on "contagious magic," necessitating contact with the bowl through application or ingestion of mediating liquids that have been in contact with it.[78] How exactly the role of an agent relates to this principle is far from clear.

Despite these uncertainties, the practice of proxies seems to have been quite common, for the idea that a person bitten by snakes or stung by a scorpion can appoint a proxy to drink water ritually infused with a cure is also found in some medieval Arabic bestiaries.[79] Such texts emphasize that the person will be cured "by the grace [or permission] of God" (*bi-idhn Allāh*), a common formula on the magic-medicinal bowls, including some of the "poison bowls," which seems to address concerns about the legitimacy of their use.[80] The phrase appears in the Qur'an (3:49), where it validates the divinely empowered miracles of Jesus (a prophet in Islam), including healing the sick. Some of the texts describing the use of proxies specify that the therapeutic ritual

25

is to be accompanied by the recitation of specific formulae (what modern translators often describe as "meaningless words"). Similar formulae are engraved on the bowls, underlining the likelihood that their deployment entailed a verbal dimension, and was accompanied by incantations and recitations.

One could imagine a range of circumstances in which it might be necessary to use an agent: when the afflicted was too weak or ill to raise the bowl to their lips; when the afflicted did not have direct access to such a bowl, and so forth. However, a simpler and more immediate answer lies perhaps in the combination of texts and images on the bowl. The inscriptions on the exterior rims of all of the examples of this class of bowl state that they are effective against the sting of scorpions, serpent bite, or the bite of a rabid dog. Images of all these creatures are engraved in their interiors, suggesting that these were intended to function in an active, curative capacity. One notable and fairly consistent feature of the dog depicted in the bowls is that it appears with one front paw raised and open jaws within which a slavering tongue is usually visible (see fig. 109). There could be no more graphic evocation of the threat posed by a rabid dog.[81]

Like a scorpion sting or snake bite, the bite of a mad dog was believed to introduce a venom into the body. According to the humoral theory inherited from Greek medicine, the effect of the venom was similar to illness, in that it created a disequilibrium in the four fundamental elements or humors of the body—blood, phlegm, black bile, and yellow bile—resulting in melancholic delusions or hallucinations. A recognized symptom of rabies was hydrophobia, the pathological aversion to water in any form. Indeed, it was dehydration, rather than the toxic effects of the bite itself, that was held responsible for death resulting from the bite of a mad dog.

A common idea relating to those bitten by a rabid dog was that when regarding their own image in a mirror, they saw instead a canine. Similarly, aversion to water was believed to result from the fact that those bitten by a dog suffered hallucinations in which they saw the image of the dog that bit them appear in the water that they were offered to drink, taking their own reflection for that of the dog that bit them.[82] In other words, the image of the afflicted reflected in water, as in a mirror, was taken as the reflection of the beast itself, in a mimetic identification between the afflicted and the cause of the affliction. This belief, which derives from Greek sources, is found in the work of two physicians working in Bagh-

dad, Yahya ibn Sarabiyun (fl. ninth century CE) and al-Kashkari (d. 1023 CE). Quoting the Greek physician Rufus of Ephesus (d. ca. 110 CE), Ibn Sarabiyun writes about rabies,

> Rufus said: This disease is a kind of melancholy since the venom itself resembles the melancholic humor. This cause is close to what some people say, namely that they imagine [taṣawwara] seeing the image [ṣūra] of the dog which bit them, in water, so that they are afraid.[83]

The resulting problem of how to persuade a rabid person suffering from hydrophobia to drink is addressed in some late antique lapidaries, which prescribe the use of certain kinds of engraved sealstones to overcome the problem.[84] The recognized aversion to water, and the therapeutic problems arising from this resistance, may explain the otherwise puzzling idea that an agent could be appointed to drink from the bowl on behalf of the afflicted. But it does not explain why it was thought appropriate to depict the dog in the bowls, producing as a material reality precisely the scenario that caused the afflicted such terror. A clue is provided by a passage in a compendium on the medical use of animals and animal parts written by ʿIsa ibn ʿAli, court physician to the Abbasid caliph of Baghdad al-Muʿtamid (d. 279 H/892 CE), and also found in later medical treatises:

> The one bitten by a rabid dog is afraid of drinking water, and if he drinks from a vessel, there should be a finger from the right paw of a dog inside it, then it will not harm him thanks to this.[85]

The inclusion of a dog's paw in the bowl that holds the sustaining water counteracts the hallucinatory vision of the dog that appears within it, enabling the afflicted to drink without fear. Given the complex play between image and beast, part and whole, that characterizes this scenario, it is surely not too far-fetched to see the inclusion of the image of the quadruped in the "poison bowls," infusing the water within, as fulfilling a function analogous to the more literal inclusion of the fragment of a dog's body. The presence of the animal in the bowl seems to break the spell of mimetic identification, the part or likeness of the dog countering the reflected image of self as dog that the rabid individual sees in the water offered them to drink. But, in the case of the magic-medicinal bowls, the image does more than persuade the afflicted to drink (thereby con-

tributing significantly to the therapeutic regime), forming part of an ensemble designed to counter the toxin of the bite itself. In order, therefore, to understand the extended logic behind presenting the cause of the affliction to the afflicted, which might at first appear as cruel or perverse, we need to consider the theory and practice of medieval theriacs and talismans. These protective and curative technologies operated along a sliding scale ranging from the human body to the entrances to mosques (see fig. 113), or even the defense of city gates (see fig. 112).[86]

Serpents, Scorpions, and Quadrupeds

The juxtaposition of dog bite, snake bite, and scorpion sting on the bowls accords with medieval Arabic texts on toxicology, in which the bite of a rabid dog is seen as injecting toxic saliva, like the poison of the snake or scorpion. The therapeutic logic of such texts operates according to principles of sympathy characterized by both homeopathy and antipathy—the idea that "like cures like" (*similibus similia curantur*) or, alternatively, that like repels like. According to a toxicological tract of the ninth or tenth century associated with the alchemist and polymath Ibn Wahshiyya, for example, the most reliable cure for scorpion bite is to kill the scorpion and fasten it on the stung part of the body; for the bite of a mad dog, the blood of the dog should be smeared on the wound and its liver fed to the victim, its body then cremated and added to a concoction to be consumed by the afflicted.[87] Similar practices are prescribed in texts on "Prophetic medicine," a therapeutic regimen based on Qur'anic remedies and those recommended by the Prophet Muhammad.[88]

Medieval Arabic theriacs, many produced in Iraq around the time that the "poison bowls" seem to have first appeared, also prescribe the flesh of the snake or an infusion of the flesh of snakes as a cure for snake bite.[89] Homeopathic cures developed in other medieval Islamic texts on theriacs or antidotes describe how the bodies of poisonous snakes could be soaked in water to produce a dilute solution of venom, a homeopathic solution to be drunk by those bitten—a scenario shown in an illustrated text on toxicology produced in Iraq in the thirteenth century. In the image seen here (fig. 117), we see the serendipitous discovery of the reason why water drawn from a particular vessel had proved effective as a cure for the venom of snake bite: it was because several snakes had drowned and infused the water with their essence and venom, producing a natural homeopathic antidote.[90]

In the magic-medicinal bowls, images of the snake, scorpion, and quadruped infused the liquids used in the bowls, producing a dilute solution of the poisons associated with these venomous creatures that would act as remedy for those afflicted by their venom. This belief in the ability to infuse liquids with homeopathic or therapeutic properties related to the toxins generated by living creatures suggests that the ontology of the images in the bowls extends beyond representation. By harnessing the malign potency of the depicted beasts in a way which makes their venom present, the images are much more than depictions; they are constituted as active agents within the assemblage of the bowl.

Moreover, the images in the bowls may address discrete concerns, but these are brought into a constellation, not just formally or spatially, but also conceptually and therapeutically. In their recommendations for persuading those suffering from hydrophobia as a result of rabies to drink, late antique lapidaries recommend infusing water with amulets comprised of a compound of organic substances and a certain stone engraved with images, including that of a scorpion.[91] Similar cross-fertilizations are found in medieval Arabic compendia on the medical use of animals and animal parts, including that of the ninth-century Baghdad court physician, 'Isa ibn 'Ali. Like many late antique and later Islamic examples of the genre, this commends the preparation of snakes and scorpions for use in a range of medical concoctions and therapies that often assume a sympathetic or antipathetic relation in which like cures or repels like—the application of boiled scorpion cures the sting of this beast, for example, or dried and fumigated scorpion repels scorpions from the house.[92] What is particularly striking, however, is the reported capacity of the scorpion to cure the poison inflicted by the bite of a rabid dog. A formula found in several versions of the text explains that "if a scorpion is taken, its abdomen split open, and the bite of the rabid dog is bandaged with it, then this will cure it, with the permission of God, may He be exalted."[93]

As we saw, the latter phrase is standard on many of the magic-medicinal bowls. However, the juxtaposition proposed here raises the possibility that the images in the bowls may also work in combination or conjunction in quite complex ways, rather than simply addressing the malady with which they are most obviously associated. This impression is reinforced by the recommendation in the text just quoted to suspend an actual (presumably dead) scorpion from the arm or neck of a woman to prevent miscarriage or, alternatively, to

Fig. 117 Illustration showing the accidental discovery of an antidote for snake venom, when water in which a serpent has drowned is consumed: *Kitāb al-diryāq* (Book of theriacs), Iraq, 595 H/1198–99 CE. Paris, BnF MS Arabe 2964, fol. 5.

engrave the image of the beast on a seal (*khātam*) to ensure a safe or easy delivery, a stated function of the bowls.[94] Once again, what is especially compelling is the equivalence suggested between the beast and its image in terms of efficacy.

The combination of serpent, scorpion, and quadruped in the bowls is of some antiquity, perpetuating a triad associated with prophylaxis and protection long before the advent of Islam. The conjunction of lion, scorpion, and serpent, often with star(s) and magical scripts is found on several types of late antique amulets which contain explicitly Christian imagery and seem to have been produced in Syria or Palestine in the fifth and sixth centuries (fig. 118).[95] Such imagery was

widely dispersed, since it also appears on Byzantine amulets from the eastern Mediterranean and Sasanian seals produced in Iran or Iraq, which feature scorpion, snake, moon, and stars in conjunction with other beasts.[96]

Even earlier precedents may be found in the association between dog, scorpion, and snake as venomous agents of evil and illness in Mesopotamian belief and therapeutic practice. A Neo-Sumerian incantation for counteracting the venom injected by a rabid dog, scorpion, or snake recommends the bitten person to drink from a vessel of water infused by the recitation of the spell, for example. The same trio is associated with the imagery on Bronze Age amulets from Iraq intended

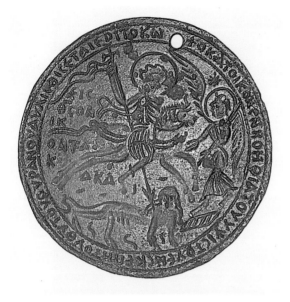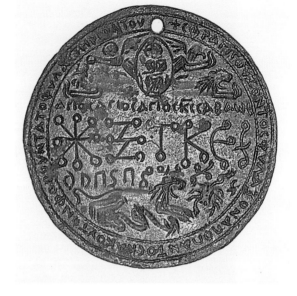

Fig. 118 Engraved amulet showing a holy rider spearing a leonine demoness on one side and a maiestas scene with magic signs (*charaktêres*) and a lion and scorpion below, eastern Mediterranean, 5th–6th century. Bronze; dtr. 5.4 cm. Ann Arbor, MI, University of Michigan Kelsey Museum of Archaeology, inv. no. 26119.

to protect against the predations of Lamashtu, a demoness who menaced women in childbirth and their offspring (fig. 119).[97] The context is suggestive, both in view of the constellation of maladies (including problems with childbirth and the poisons of animal bites) against which the later Islamic bowls claim to be effective, and the suggestion of continuities with Assyrian and Babylonian imagery in the art of medieval Iraq.[98] Like the demonic appearance of the rabid dog in the medieval Iraqi manuscript just discussed (see fig. 116), the associations of this triad of venomous creatures underline the antiquity and persistence of the belief that physical and metaphysical phenomena were intertwined in the etiology of illness.[99]

The combination of snake, scorpion, and lion continued to be invoked in texts on Islamic amulets and talismans, including those used both for negative and for positive purposes.[100] The lion, scorpion, and star combination appears on a series of early Islamic bronze, copper, lead, and silver amulets or seals loosely attributed to Iran, although they may well have been produced over a wider area (fig. 120). These amulets have never been studied as a group, but were evidently produced in large numbers. Some may have been used to imprint earth used for medicinal purposes (fig. 121), a usage that parallels the role of similar images in generating imprinted water in the magic-medicinal bowls.[101]

Such seals were among the eclectic amuletic designs engraved on the reverse of Anatolian and Iranian magic mirrors of the eleventh to thirteenth centuries, repertoires that perhaps served as models or prototypes for the production of three-dimensional examples. An image and description of such a seal appears in a remarkable compendium on the occult produced in central Anatolia around 1272–73 CE (fig. 122), not far from the Artuqid realm in which I have argued that the magic-medicinal bowls under discussion originated, and to which some of the magic mirrors engraved with similar designs have been attributed.[102]

Lion, scorpion, and snake are also linked in certain traditions of the Prophet Muhammad which are commonly invoked in the genre of Prophetic medicine. Like the texts on the bowls, some early examples of such texts commend the drinking or sprinkling of saffron-infused Qurʾanic verses in order to assist childbirth.[103] They also commend the use of Qurʾanic incantations against the threat posed by this trio of biting and stinging beasts. In his compendium of Prophetic medicine, Ibn Qayyim al-Jawziyya (d. 1350 CE), recommends seeking refuge from God against "any lion and any black beast, from the serpent and the scorpion."[104] It is, therefore, perhaps not surprising that the triad of quadruped, scorpion, and snake appears in Islamic texts on medicines, poisons, and theriacs and on

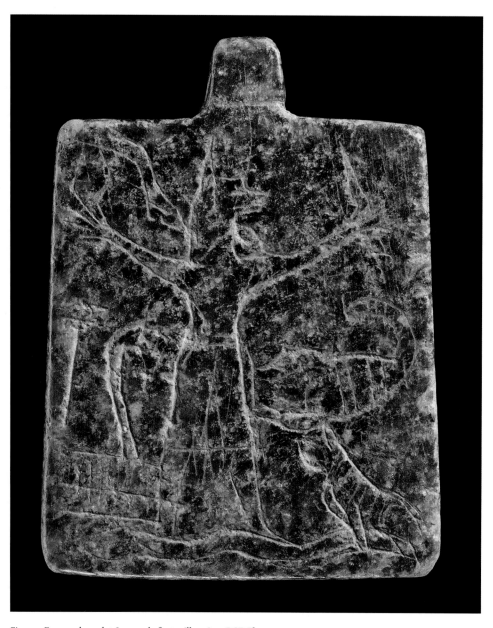

Fig. 119 Engraved amulet, Iraq, early first millennium BCE. The child-killing demoness Lamashtu is shown standing on a snake and flanked by her familiars, a scorpion and dog. The same trio of dog, scorpion, and snake appears on the reverse. Pierced stone; h. 4.2 cm. Oxford, Ashmolean Museum, inv. no. AN 1968.1291.

engraved metal amulets, including those likely to be from Anatolia or the Jazira.[105] Such portable artifacts may even have echoed more monumental talismanic ensembles. By the tenth century CE, for example, the city gate of Hamadan in western Iran was provided with a talisman against inclement weather in the form of a lion (perhaps intended to exploit a sympathetic relation to the constellation Leo, domicile of the sun) flanked by talismans against snakes and scorpions; all three

were ascribed to Balinus, the classical Apollonius of Tyana, a renowned maker of urban talismans to whom some medieval Islamic authors ascribed the invention of the magic square that appears in the "poison bowls."[106]

The same triad of beasts features in one of the most influential medieval Arabic compendia on the occult, the corpus attributed to Ahmad al-Buni (d. 1225 CE), in which a sigil similar to that found in the magic-medicinal bowls (fig. 123) is said to

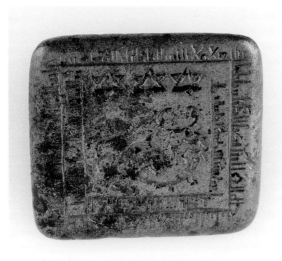

Fig. 120 Amulet or seal, Anatolia, Syria, or Iran, 9th–11th century, showing a quadruped, scorpion, and stars, surrounded by a frame of Linear Kufic. Lead; 2.1 × 2.1 cm. Paris, Musée du Louvre, inv. no. MAO 1222.

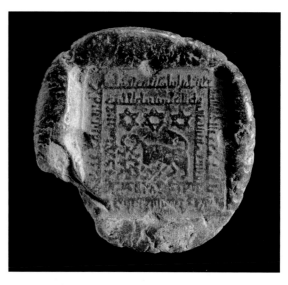

Fig. 121 Impression of a seal similar to that seen in fig. 120. Clay; dtr. of entire object 3 cm. London, British Museum, inv. no. 1991,0727.4.

be useful for protection against snakes, scorpions, and roaring lions. The sigil goes by various names and was often said to stand for the greatest name of God. According to al-Buni, it was inscribed on the door of the Kaʿba, the focal shrine of Islam in Mecca, had multiple protective functions when inscribed, and could be drunk in circumstances that are not clear but that seem relevant to its appearance in the bowls.[107] Its presence serves as a reminder that the inscriptions, seals, squares, and symbols engraved in the bowls were designed to work in conjunction with, perhaps even amplify, the effect of the figurative elements in the bowl. As Persis Berlekamp has noted, images employed in talismans "are not efficacious in isolation," but function as part of a larger whole, to which inscription, material, sign, and temporality are often equally relevant.[108]

Similarity and Sympathy

Although the zoomorphic imagery in the bowls —the snakes and canine and dragon figures— seem to reflect the operation of the principle of *similia similibus curantur*, like cures like, this literal register is not the only one in which it functions. The imagery in the bowls is echoed by that found on contemporary metalwork and large-scale astrological reliefs on medieval monuments in southeastern Anatolia, northern Iraq, and Syria, some of which seem to have been designed to draw upon the powers of their associated luminaries.[109] In her study of these talismans, Berlekamp

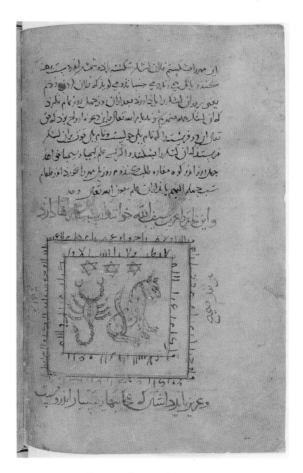

Fig. 122 Drawing for an amulet or seal, from a miscellany of occult texts known as the *Daqāʾiq al-ḥaqāʾiq* (Subtleties of truths), Anatolia, 670–71 H/1272–73 CE. Paris, BnF, MS Persan 174, fol. 37v.

suggests that they operated according to multiple models of efficacy that were not necessarily logically congruent, nor even fully articulated, including both symmetry and sympathy.[110] In addition to the role of symmetry or mirroring in the functioning of the bowls, they are likely to have exploited the perception of sympathetic relationships between celestial conjunctions, images, signs, words, and materials.

Rather than belonging to some lesser "folk" version of "scientific" healing techniques, the use of amulets often had a complementary and symbiotic relationship to medicine, based on the idea that pharmacological substances, stones, and amulets were capable of exploiting the occult properties of natural things.[111] Through the idea of sympathetic relationships, those properties were seen as having an essential relationship to certain cosmic forces that could be exploited for positive or negative ends. Hence, many of the pharmakons prescribed in medieval theriacs such as that of Ibn Wahshiyya are to be prepared under certain astrological conjunctions; a herbal concoction for the cure of a mad dog's bite is, for example, to be prepared in a vessel set before the planet Venus during its nightly ascent or descent and retrieved before the rising of the sun.[112]

In the same way, some of what seem to be the earliest magic-medicinal bowls specify that they were engraved under auspicious or favorable constellations, including when the moon was in the zodiacal constellation of Scorpio.[113] This claim does not appear on any of the published "poison bowls," but nevertheless a relation to astral medicine, to the idea that the power of the cosmic luminaries can be harnessed for therapeutic purposes, seems likely.

The lion-scorpion conjunction appears, for example, on an early Islamic hematite amulet, a green stone with blood-like red inclusions, which had been favored for use against eye ailments, hemorrhage, and the bites of venomous animals in antiquity.[114] In addition to its mimetic evocation of blood, this is a stone that in ancient lapidaries has a sympathetic relationship to Mars, suggesting that the scorpion on such seals may evoke both the threat of the beast and the domicile of the planet Mars.[115] Such astral associations are made explicit in some of the medieval Islamic therapeutic practices designed to exploit the sympathetic correspondences between images, stars, and certain kinds of substances. The tenth-century Andalusian grimoire Ghāyat al-Ḥakīm (Goal of the sages), often known by the name of its Latin translation, Picatrix, describes the therapeutic consumption of an aqueous solution

Fig. 123 Detail of the sigil seen in "poison bowls" (see figs. 102, 103, and 106-109) (from Rehatsek (1873-74)).

of incense (a common component of magical-medicinal practices) stamped with the image of a scorpion engraved on a bezoar stone under the rising sign of Scorpio, whose ascendancy also determined the moment when the seal should be impressed on the incense. In a practice that seems to continue the tradition of late antique magical gems (see fig. 128), other texts refer to a carnelian ring engraved with the image of a scorpion which should be pressed against a scorpion bite, or recommend dipping a ring inscribed with a scorpion image in water then consuming the water as a theriac under an auspicious celestial conjunction.[116] The conjunction points to a relationship between similarity and contagion that is no less relevant to the magic-medicinal bowls, and to the ambiguous role of the scorpion as both pharmakon and potential astrological sign.[117]

Similarly, the production of powerful metal seals (capable, for example, of cultivating the friendship of a ruler) engraved with the image of the lion, snake, and scorpion is mentioned by the polymath Ibn Khaldun (d. 1406 CE). The images are to be engraved at an auspicious moment, when the sun is in the first or second decan of Leo, the domicile of the sun, which should also be the moment when the seal is used to stamp the amulets produced from it.[118] The role of zoomorphic imagery in such seals and talismans highlights the likelihood of a sympathetic role attaching to the figures on the engraved metal amulets and in the magic-medicinal bowls, often in conjunction with six-pointed stars.

In addition to their other functions, it is possible that the images in the bowls evoked or enacted a sympathetic relation to the constellations of Leo and Scorpio.[119] However, the quadruped in the magic-medicinal bowls bears little resemblance to a lion: the mane has been lost or reduced to a vestigial curling protrusion under the chin and the snout is more pointed (compare figs. 103 and 106-109). It bears more resemblance to a snarl-

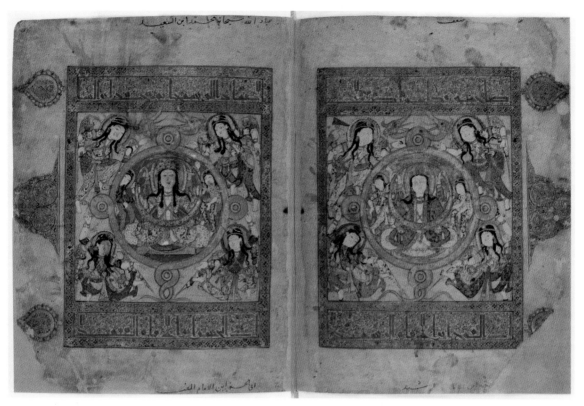

Fig. 124 Double frontispiece of a copy of the *Kitāb al-diryāq* (Book of theriacs; see fig. 117), showing a personification of the moon devoured by dragons. Paris, BnF, MS Arabe 2694, fols. 36–37.

ing, salivating dog, an image that is perhaps more directly suited to the function of bowls designed to cure dog bite. In one or two examples, the canine appears to have been transformed into a ram, perhaps by reference to the constellation Aries.[120] In this respect it is noteworthy that according to the astrological theory in which planets have exaltations and dejections (points at which they are at their most powerful and weakest), Aries was the dejection, the lowest point, of Saturn, the planet whose influence was believed to be responsible for melancholy.[121] Since medieval Arab doctors such as Ibn Sarabiyun compare the disruptive effects caused by dog bite and its associated venom on the balance of the bodily humors to those associated with melancholy, it is possible that the dog–ram configuration was intended to diminish the power of Saturn, the planet governing a psychological ailment analogous in its effects to rabies. Ambiguities between canine, leonine, and ovine iconographies may, therefore, derive less from a misreading or misunderstanding as a result of copying than from the deliberate concatenation of distinct but related theories of efficacy, reinforcing the impression that the imagery in the bowls functions in different registers simultaneously.

This is further suggested by the presence of the fourth zoomorphic engraving in the bowls, for alongside the well-established triad of quadruped, snake, and scorpion, the engravings in the bowls also include a strikingly novel iconographic type: the double-headed dragon. Like the image of the dog, the jaws of each dragon are depicted open, snarling. Unlike the dog, snake, and scorpion, the specific threat posed by the pair of entwined dragons is not obvious. However, a cosmological and talismanic function for such imagery is well documented in northern Iraq and the Jazira, the region where this type of bowl seems to have first appeared, and at exactly the period when it seems to have originated. Entwined dragons with knotted tails encircle personifications of the moon on the frontispiece of a well-known copy of the *Kitāb al-diryāq* (Book of antidotes), a text erroneously attributed to the Greek physician Galen (d. ca. 210 CE), produced in northern Iraq in 595 H/1198–99 CE (fig. 124). The manuscript "can be situated at the intersection of popular and esoteric interest in toxicology," something equally true of the "poison bowls."[122] Acting as a nexus between pharmacology, toxicology, and the occult sciences, the bowls render the knowledge

contained in such texts immediately accessible in applied form.

On the frontispiece, the dragons surrounding the moon likely represent the pseudo-planet Jawzhar, whose image appears on a range of buildings and objects produced in Iraq and Anatolia in the twelfth and thirteenth centuries. Jawzhar was the harbinger of lunar and solar eclipses, its voracious twin jaws capable of swallowing the cosmic luminaries.[123] The disappearance of the cosmic luminaries led to a state of affairs that, no less than the appearance of venomous beasts, generally presaged ill.[124] Paradoxical as it may seem, a common solution was to deploy the image of the ecliptic dragon against the effects and forces that it represented in contexts needing protection: at entrances and gates, for example (see fig. 112). Just as the appearance of the entwined dragons on Artuqid coins (see fig. 115) may commemorate a solar eclipse, the completion of the *Kitāb al-diryāq* coincided with a partial solar eclipse. Evoking both the destructive malevolence of wild beasts and the double-headed dragon believed to cause solar and lunar eclipses by swallowing the sun or moon, the beasts were often shown subdued by, or subordinated to, powerful human agents such as saints or rulers. Instead of like curing like, here the operative principle is that of like repelling like. The best-known example is a relief above the now destroyed Talisman Gate in Baghdad, which shows a seated ruler, perhaps the Abbasid caliph al-Nasir who restored the gate in 1221, holding the tongues of a pair of knotted dragons (fig. 125).

Of course, the deployment of images of malevolent beasts even in an apotropaic or therapeutic capacity is a risky business. Here it is worth returning to the spatial arrangement of the engravings on the bowls (see figs. 102 and 103, and 106–109). While at first glance their eclecticism suggests a randomness to the arrangement, this is not the case. A consistent feature of the bowls is the careful choreography of the figurative imagery at the center. No doubt this was intended to maximize the contact which ensured the efficacy of the infusions produced in the bowls, but it also had the effect of enclosing these threatening images within a dense, continuous network of seals, magic squares, and Qur'anic verses. On other kinds of magic-medicinal bowls, each of the anthropomorphic or zoomorphic figures is circumscribed and confined by an enclosing medallion.

There may be a hierarchy implied by the arrangement of the "poison bowls," from the outer ring of signs and texts associated with less religiously contested practices of protection to the more problematic figurative imagery at the cen-

ter. Indeed, such imagery sometimes attracted the opprobrium of medieval jurists who believed it to contravene the proscriptions on depicting living beings found in the traditions of the Prophet Muhammad;[125] this may be one reason for the frequency with which claims that the bowls were approved by the first four caliphs of Islam (famed for their piety), or that they heal by the grace or permission of God, appear in the inscriptions on them. The arrangement has the effect of confining, imprisoning, or ringing the images of malevolent beasts with an enclosing or encircling shield of protective devices whose efficacy derives neither from similarity or sympathy, but from Qur'anic and prophetic precedents. The arrangement finds parallels in some modern technologies of protection from the Islamic world.[126]

Constellation, Commodification, and the Portable Library

The "poison bowls" seem to have appeared in the Jazira region in the late twelfth or early thirteenth century. Despite the presence of inscriptions on some claiming that they were copied from older models held in Baghdad or Damascus, they appear to contain innovative conjunctions of earlier talismanic and therapeutic technologies along with novel iconographies. In this, the bowls share with many kinds of medieval amuletic, reliquary, and talismanic objects produced in medieval Christendom or the Islamic world the quality of assemblage.[127] The marked insistence on the status of the bowls as copies of earlier originals in the inscriptions that they bear is likely intended to lend an aura of antiquity, authenticity, and efficacy to what is actually a new commodity form, by deploying a topos long established in relation to amuletic and talismanic artifacts and formulae.

The temporality of these objects is complicated not only by the implicit claim for enchained antiquity, but also by the fact that, seen from a longue durée perspective, they bring a wide range of pre-existing preventative and prophylactic technologies into constellation with new forms of protective imagery, each with its own history. The earliest incarnations of the "poison bowls," the assumed prototype(s) from which this series originated, exploited, extended, and updated elements of protective and therapeutic technologies that had been in use for centuries. Among these, the combination of quadrupeds, stars, scorpions, and snakes had been integral to amuletic and practice, long before the advent of Islam, over a

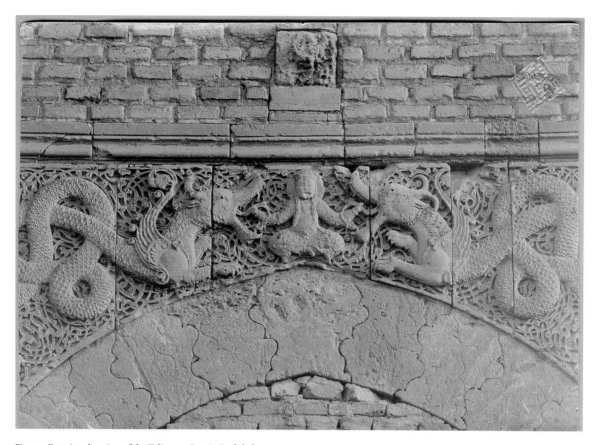

Fig. 125 Exterior elevation of the Talisman Gate in Baghdad, built in 1221 CE, showing detail of a carved figure with confronted dragons on a spandrel (photograph Ernst Emil Herzfeld).

region extending from the eastern Mediterranean to Iraq and Iran. Similarly, the practice of ingesting selected Qurʾanic verses is documented from the early centuries of Islam, as is the use of magic squares for some of the purposes mentioned in the bowls that bear them. The therapeutic use of such squares in bowls inscribed with Qurʾanic verses is also mentioned in texts on Prophetic medicine.[128]

But to these stalwarts of occult healing and protection were added new kinds of imagery with cosmological and talismanic potential, including the image of the double-headed dragon. This seems to have first entered the repertoire of Islamic art in the Jazira in the twelfth century. The iconography of the beast may itself hark back to much earlier, possibly Central Asian, prototypes, but its appearance in Iraq illustrates a contemporary Eurasian circulation and reception of the dragon image.[129] Thus, while many of the elements in the "poison bowls" have antecedents stretching back into late antiquity, the first bowl(s) in this diachronic series likely entailed a precocious deployment of this most "modern" of protective technologies.

The different temporalities of the elements brought together in the bowls is clearly visualized in the distinct scripts that they employ: pointed cursive scripts for Qurʾanic verses; unpointed cursive script for magical texts based on repeated strings of consonants, and a script known as Linear Kufic composed of angular letters attached to a continuous baseline (see figs. 102 and 109). The same script is widely used on Islamic magical seals and amulets (see figs. 120 and 121).[130] In amulets and talismans, as on the magic-medicinal bowls, Linear Kufic seems to function as a kind of meta-script, a special signifier of efficacy, easily distinguished visually from accompanying more curvilinear "legible" scripts, especially those containing Qurʾanic quotations.[131] The origins of Linear Kufic are not clear, but its most characteristic feature—the continuous baseline connecting the letters—may owe something to late antique Greek and Coptic magical texts in which especially efficacious terms were subject to overstrikes, "to elevate them from mundane writing" by producing the effect of a near-continuous overlining when strings of magic names and terms appeared together.[132]

Like some of the numerals inscribed in the magic squares in the "poison bowls," the letter forms of Linear Kufic are somewhat archaic. They perpetuate a form of calligraphic script developed in the late seventh century and subsequently used for the copying of the Qur'an until the tenth. From this point on, it began to be replaced by more cursive (and legible) forms of script such as those employed here, rendering the quotations from sacred scripture the most legible of all the texts in the bowl and conferring on them a visual distinction from non-Qur'anic scripts and texts.[133] The juxtaposition of archaic angular and more contemporary cursive scripts renders visible the different temporalities even of the inscriptions on the bowls, while reminding us of the close connection between antiquity or archaism and efficacy in many magical-medicinal artifacts from the medieval Islamic world.

Just as the imagery of the bowls finds an echo in many of the architectural talismans from southern Anatolian and northern Iraq and Syria, so the combination of occult technologies with distinct historical trajectories finds analogies in contemporary architecture. One thinks, for example, of the early thirteenth-century walls of Konya, capital of the Seljuq sultans of Anatolia, on the exterior of which antique sculptures were combined with newly carved figurative reliefs, and quotations from the Qur'an and Hadith and from the Persian royal epic the Book of Kings (Shāhnāma), in order to defend and protect the city.[134] More than its visual eclecticism, the combination of orthodox Islamic sources with royal allusions and pre-Islamic imagery captures perfectly the spirit of the "poison bowls."

Seen in this light, the assemblage or constellation through which the bowls were constituted and within which they functioned may have concatenated the efficacy of the individual elements or even invested the whole with emergent properties, its cumulative efficacy transcending the sum of its parts.[135] Nor should it be forgotten that this assemblage included both the mostly anonymous makers and engravers of the bowls (who may or may not have been the same individual) and the users whose ailing bodies they were designed to engage at a variety of intimate levels. As complex assemblages, production of the "poison bowls" required knowledge of a range of technologies and techniques, from metallurgy (for casting) and engraving to Qur'anic exegesis, seals, mathematics, and perhaps even ritual techniques and incantations. The inscription of Qur'anic verses in such a therapeutic vessel recalls traditions of inking selected verses on bowls wiped with water

for ingestion attested from the earliest days of Islam. But it also recalls the role of Qur'anic incantation (ruqya) in Prophetic medicine, where the recitation of certain verses is especially mandated against the envious gaze (the "evil eye"), snake bite, and scorpion sting, suggesting a possible oral dimension to the moment of the engraving of the bowls or their use.[136]

The accretional or aggregative nature of the bowls is in keeping with the spirit of many kinds of "magical" technologies, despite the claims for linear transmission made in many medieval inscriptions and texts. Texts on magic or talismans, even those ascribed to a specific author, are, for example, often additive or accretional miscellanies, and diverse texts on such subjects were often bound together in one volume, a single composite artifact comprised of multiple traditions and voices, each with its own temporality. The constellation of distinct therapeutic technologies drawn from earlier traditions in the bowls invites comparison with late antique or medieval grimoires, a comparison enhanced by the emphasis on copying in the inscriptions that the bowls bear. Medieval grimoires recovered from the Cairo Geniza, a vast repository of medieval paper documents found in the Ben Ezra synagogue in Fustat, an area of Cairo, combine diverse recipes for amulets with prescriptions for the healing of scorpion bites, for assisting childbirth, for making a positive impression on rulers, or for quelling a storm at sea, all on the same folios (fig. 126). Some of these are copies of ancient formulae (or incorporate partial elements derived from them); others are of more recent vintage, often combining formulae written in different languages and scripts, including Aramaic, Arabic, Hebrew, and Judeo-Arabic.[137]

In the case of the bowls, this quality of assemblage constitutes them as portable compendia of cumulated knowledge rendered up for practical application. In this sense, another point of comparison might be with books and libraries. Medieval Christian gospel manuscripts sometimes claim to be copied from originals held in the treasury of the Byzantine emperors in Constantinople, part of a strategy to assert accuracy and authority that underlines the functional intersections between libraries and treasuries as repositories of knowledge.[138] But such claims are especially evident in relation to amulets and talismans. The association with figures or sites of royal authority is a feature of early Islamic amulets, just as many medieval Arabic treatises on magic and medicine insist on the antiquity of the knowledge that they contain.[139] These invocations constitute

Fig. 126 Bifolium from a grimoire in Hebrew and Aramaic found in the Cairo Geniza, Egypt, 11th–12th century(?) giving the end of a recipe to quell a storm at sea, followed by recipes for a barren woman, to open locks, scorpion bite, to prevent miscarriage, to facilitate childbirth, for one who trembles with fear, and for a "בל תחתף". Paper; each leaf 18.6 × 25.1 cm. Cambridge, Cambridge University Library, Taylor-Schechter Collection, classmark T-S K1.19.

a double validation: an assertion that the knowledge embodied in the object is "tried and tested" (*mujarraba*, a phrase often used in the texts on magic-medicinal bowls), and an ascription of that knowledge to ruler figures associated with magical wisdom and technology, such the prophet-king and magician Solomon, or the Abbasid caliph al-Maʾmun (r. 813–833 CE), whose interest in occult matters is well known.[140]

Claims, such as those made on the "poison bowls," that amulets, talismans, and magical texts were copies of originals kept in temples and treasuries were already made in some of the Greek magical papyri from Egypt, and are common in early Islamic occult texts. The *Ghāyat al-Ḥakīm*, or *Picatrix* (cited above), written in al-Andalus

around 950 CE, claims that some of its therapeutic and talismanic formulae, including composite images, were copied from a manuscript found in a temple built by Cleopatra.[141] Such continuities with pre-Islamic practices may be relevant to the claim that the bowls replicate the design of prototypes kept in royal treasuries, which were indeed repositories of marvels and wondrous—including magical—objects.[142] Inscriptions claiming that the "poison bowls" were copied from models kept in the citadel of Damascus or (by implication) in Baghdad may be a canny marketing device, but, like earlier magical texts, they suggest that the bowls "use selected aspects of cultural memory to validate their claim to authority."[143] In this sense, despite the difficulties of locating any single

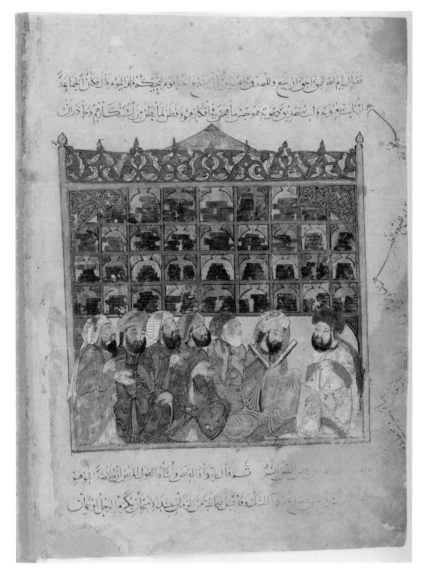

فقال الايام النور اجرّ از ربع و اللصق و ضعف من اربع و احدى الى لحجوم عده للبلايه عمم فاكن الجماعه

ان الباسطيع وسيه و ابت بصر يوموضوه ومحبس مدهس في افكار هرم وفطل لما بطن من اتت گام انت كام اران

Fig. 127 A scene in a library, from al-Hariri's *Maqāmāt*
(Assemblies), copied by Yahya al-Wasiti, Baghdad(?),
634 H/1237 C.E. Paris, BnF, MS Arabe 5847, fol. 5b.

example in time and space, and their consequent role as objects unmoored, as forms of flotsam, the bowls present themselves as the ultimate archives, preserving a record of ancient technologies made available for practical application in the present.

The location of a hypothetical original in a royal treasury is a topos established in therapeutic contexts as early as the Abbasid period; it occurs several times, for example, in the book on the useful (mainly medical) properties of animals penned by a physician at the ninth-century Abbasid court, ʿIsa ibn ʿAli. In several cases, we are told, a remedy prescribed in the text was either sourced from or preserved in the treasuries of kings (*khizāʾin al-mulūk*). In another case, it

is a specific class of object—knives with handles made from rhinoceros horn, capable of detecting poison—that is kept in royal treasuries.[144] Such objects might well have been among the wondrous things housed in royal treasuries, but the more abstract or esoteric realm of knowledge that their production requires is also implicitly located in the same place.

More than a simple strategy to validate a magico-medicinal object or the knowledge underlying its efficacy, the ambiguities here between treasures consisting of therapeutic or prophylactic objects, magico-medicinal potions, and the applied knowledge that both embody is perhaps explained by the denotative range of the

Arabic term used in such texts: *khizāna*. Often translated as "treasury," the term can also denote a library, an obvious place to store transmitted knowledge (fig. 127). In fact, on certain Mamluk magic-medicinal bowls the reference is quite clearly to the fabled library of the Abbasid caliphs in Baghdad, a repository of ancient knowledge rendered available for Islamic usage as a result of the translation movement undertaken by the Abbasid caliphs in Baghdad in the eighth and ninth centuries CE.[145] The association is perhaps not surprising, given the common topos of medieval Arab physicians discovering extraordinary medical or magical knowledge in the manuscripts preserved in the libraries of their royal patrons.[146] But it is surely no coincidence that the instigator of that translation movement was the Abbasid caliph al-Mansur, an association hinted at by the claim on some of the "poison bowls" to have been copied from a model that was among the treasures of al-Mansur.[147] This is not only in keeping with a contemporary penchant for naming royal figures on artifacts not necessarily produced for them, but also with a tendency to locate scientific knowledge under the aegis of royal figures, a phenomenon especially evident in scientific manuscripts produced in Syria and Iraq during the twelfth and thirteenth centuries.[148]

Although the focus here has been on a single bowl type, the question of why production of these kinds of metal bowls began in different regions, including Egypt, Syria, and Iraq from the twelfth century, remains open. However, this was a moment marked by a proliferation of commodities ranging from ceramics and metalwork to illustrated manuscripts, many featuring figurative imagery. Despite the invocation of royal imagery and titles, the phenomenon has been associated with the emergence of a "middle class" that expanded the potential base of patronage. This is especially well documented in the regions in which the bowls seem to have emerged, and was often accompanied by significant technological innovation.[149] It seems likely that the metal bowls, with their wide-ranging applications and in many case the absence of any named user, represent a commodification (or more intensive commodification) of an existing tradition of inking bowls with efficacious verses, now brought into constellation with a diverse range of healing and protective technologies, from magic squares and sigils to figurative imagery.

As innovative commodities produced at a moment when Iraq, Iran, and Syria seem to have been awash with new possibilities for market and home, the "poison bowls" find suggestive analo-

Fig. 128 Engraved gem with a scorpion, eastern Mediterranean, 2nd–4th century CE (?). Yellow jasper; 1.4 × 1.1 cm. Bloomington, IN, Eskenazi Museum of Art (Indiana University), Burton Y. Berry Collection, inv. no. 76.93.4.

gies in the magical gems and engraved amulets produced in the eastern Mediterranean in the centuries before the emergence of Islam (fig. 128). Like the Islamic bowls whose functions and techniques they prefigure, these magical gems brought together on a single object efficacious texts and images drawn from a variety of sources. They are assemblages that "concentrate in a single object all the active ingredients of ancient magical technology, the powers of the stone, of colour, of jewellery, and of performative words, images and signs." According to a recent analysis, "their products represented a repository of ancient, often exotic knowledge" while also representing "cutting-edge magical technology."[150] Such amulets and gems were copied from grimoires or models, something that also seems true of "poison bowls."[151] Magical gems were novel commodities whose perceived efficacy depended on their claim that they stood in a long-established tradition. Exactly the same might be said of the "poison bowls."

As we shall see in chapter 6, belief in the talismanic and therapeutic efficacy of certain stones survived in the medieval Islamic world and, occasionally, one can point to direct intersections between belief in the amuletic virtues of semi-precious stones and the world of Islamic magic-medicinal bowls. Semi-precious stones such as calcedony, jasper, and lapis were, for example, set in brass magic-medicinal bowls used by Ottoman water-sellers in the sixteenth century.[152] At the same period, a specific class of Iranian magic-medicinal bowls produced in Safavid Iran included a small turquoise bead in their interiors,

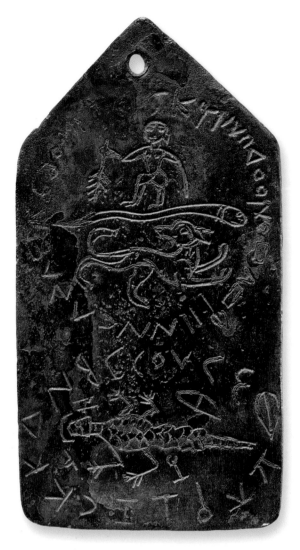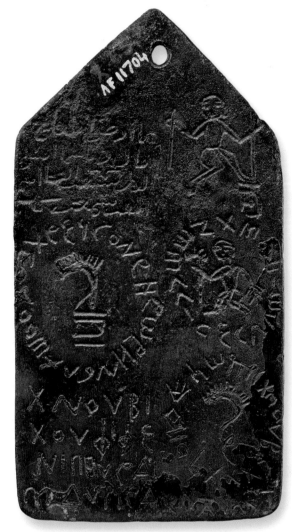

Fig. 129 Engraved plaque, Egypt, early Islamic period, with discrete examples of imagery for producing amulets and gems, and inscriptions in Coptic and Arabic. Copper; 9.6 × 5 cm. Paris, Musée du Louvre, inv. no. AF 11704.

its presence likely reflecting contemporary beliefs that the stone protects from scorpion, snake, and spider bite.[153] The form of these Ottoman and Safavid bowls, with a central raised omphalos, is, however, quite different from that of those under discussion here, reflecting a morphological change whose implications await investigation, but which seems to have occurred at some point around 1400, when the balance between the use of texts, symbols, and figurative imagery on such bowls shifted in favor of script.[154]

Although separated by chronology and geography, in their combination of matter and engraving, word and image, and in their attempts to harness the potency of auspicious constellations, late antique magical gems and seals and medieval Islamic magic-medicinal bowls might be seen as distinct expressions of occult technologies related through the role of incision and engraving and their consequent potential to mark or imprint lithic, viscous, or even liquid mediators capable of transmitting their efficacy. The operational mode of both was also comparable: just as the bowls could either be placed against the affected parts of the body or else used for ingesting liquids permeated by their efficacious engravings, late antique lapidaries describe the therapeutic use of certain semi-precious stones or magical gems, which could be tied to the body, or ground and dissolved in liquid to be applied to bites and wounds, or prepared for internal consumption as a pharmakon.[155]

Moreover, some rare survivals from late antique and early Islamic Egypt of what appear to be metal models for the production of such gems, offer interesting analogies for the much later bowls. These small metal plaques are densely engraved with eclectic (and discrete) amuletic iconographies (fig. 129), including stalwarts of much earlier Egyptian amuletic and talismanic imagery, such as "Horus on the crocodiles," an image of the Egyptian deity subduing fearsome or poisonous beasts that, accompanied by magical spells, was often washed with water designed for ingestion as a theriac.[156] The imagery includes a depiction of Horus in his role as protector against wild beasts including snakes and dogs or lions, employing imagery comparable to that found much later on the Islamic bowls. These plaques seem to have functioned as compendia of models on which amulet-makers and gem engravers could draw. Although belonging to another tradition, the technical and conceptual analogies with the engraved assemblage united in the later Iraqi bowls are suggestive.

Bringing so many different magical technologies into constellation on a single artifact that can be held in the hand, the bowls evoke something of this kind of earlier metal grimoire. In this sense, it may not be too far-fetched to suggest that the bowls invite the kind of copying through which they claim to have been generated, further frustrating any attempt at the absolute dating of individual examples.

However, a significant difference between late antique magical gems and the medieval magic-medicinal bowls lies in the recourse to Qur'anic verses, seals that employ the formal qualities of Arabic script, and the implied attempt to provide the bowls with a divine imprimatur, emphasized on many of them by the insistence of their inscriptions that they heal by the authority or grace of God. A further difference lies in the emphasis on the efficacious nature of the material—the stones comprising late antique gems might or might not be engraved, but their very matter was itself understood as efficacious, often by virtue of a sympathetic relation to particular constellations or planets. By contrast, and somewhat oddly, the metal content of the bowls, which might conceivably have extended the sympathetic relationship with astral or planetary forces, is rarely referenced in their inscriptions, even though the idea of sympathetic correspondence between certain metals and planets was well established in medieval Islamic texts on talismans.[157]

A magic-medicinal mirror produced in Anatolia in 548 H/1153 CE, bearing images of the planets and an inscription indicating that it was used for alleviating ills, including the pains of childbirth and paralysis, also indicates that it was cast from seven metals as the sun passed through the sign of Aries. The function and iconography of the mirror has led to suggestions that such an object may have provided a model for the "poison bowls" that seem to have originated in the same region and at the same time.[158] As we saw above, the effects of mirroring produced in the dialectic between the engravings of the bowl and the reflection of their users in the liquid medium that they contained may have played a significant role in their perceived efficacy against certain ailments, most obviously rabies. The possibility of a relationship to such literal mirrors remains an open one, therefore, although the eclecticism of the bowls suggests a wider range of sources, and the consistent absence of any reference to their metallic materials is puzzling. This may, however, reflect the fact that the tradition developed out of earlier practices using bowls made of more ephemeral materials such as ceramic and even wood,[159] explaining what otherwise seems like a curious omission, given all the indications of a desire to maximize the efficacious potential of the bowls.

Despite this and other oddities, the origins of the "poison bowls" should be sought in the Jazira, a region rich in talismanic imagery and practices, in the second half of the twelfth century. This was an extraordinary moment that saw an exponential increase in the production of portable objects in the central Islamic lands, across a range of media, including ceramics, metalwork, and manuscripts. Many of these developments were centered in Iraq, especially Baghdad and the northern city of Mosul, close to where I have suggested that the "poison bowl" type of magic-medicinal bowls originated. If the knotted dragons engraved on these cups represent a novel addition to the repertoire of Islamic art, a dynamic reception of a new figurative type, they appeared at a moment when other kinds of chimerical and mythical beasts such as griffins, harpies, and sphinxes proliferated in the arts being produced in these regions. Some of these beasts were of considerable antiquity, with a history that long pre-dated Islam. Once integrated into the repertoire of Islamic art, however, they often roamed over considerable distances, appearing in the most unexpected of cases, as we shall see in the following chapter.

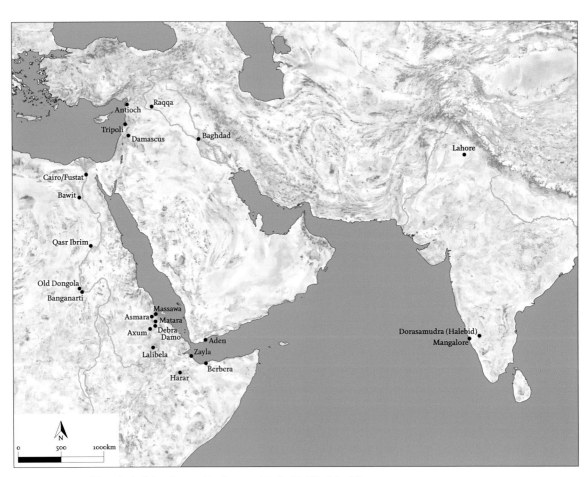

Map 5 Locations of the principal sites discussed in chapter 5. Map by Matilde Grimaldi

Chapter 5

Distance Made Tangible in Medieval Ethiopia

An image, every image, is the result of movements that are provisionally sedimented or crystallized in it.

—Georges Didi-Huberman, *The Surviving Image: Phantoms of Time and Time of Phantoms; Aby Warburg's History of Art*, trans. by Harvey Mendelsohn (University Park, PA: Pennsylvania State University Press, 2016), 19.

An Equestrian Relief

In a pioneering article published in 2010, the art historian Ewa Balicka-Witakowska surveyed evidence for contacts with the Islamic world reflected in medieval Ethiopian art. Her analysis suggested a highly selective engagement, often marked by the adoption of individual iconographic elements, an active and agentive appropriation rather than a passive or wholesale adoption. She noted, however, that "unfortunately the written sources offer almost no information" about the context of these engagements or the transregional circulations and connections to which they attest. Instead, she wrote, "we have to rely on artistic material."[1] In other words, like the nielloed objects discussed in chapter 2 above, or the medieval magic-medicinal bowls discussed in chapter 4, artifacts bearing witness to the reception of materials that originated in the Islamic world constitute their own archive. In this case, often devoid even of the epigraphic meta-data engraved on the bowls.

Recent research has helped provide a richer understanding of some of the historical circumstances that surrounded the commissioning and production of the medieval Ethiopian artifacts and monuments in question, but it is often still the case that we are left to deduce what we can from analysis of the buildings and images themselves. This is even the case with the rock-cut churches of Lalibela in the central highlands of Ethiopia, the most renowned medieval monuments in a region that lacks little in terms of spectacular pre-modern architecture. A UNESCO World Heritage site, the churches are a major focus of pilgrimage and Ethiopia's premier tourist attraction.

The topographic setting, form and scale of the structures comprising the two complexes at Lalibela make a profound impression. But the most lavishly ornamented is the church of Beta Maryam (House of Mary) (fig. 130). Like the neighboring church of Medhane Alam (Saviour of the World), Beta Maryam is believed to have been excavated during the reign of King Lalibela, scion of a dynasty conventionally known as the Zagwes who ruled between the eleventh century and 1270. While the precise dates of Lalibela's reign are unknown, it included the years between 1204 and 1225.[2] Apart from the wonders of its rock-carved architecture, Beta Maryam is celebrated for the wealth of its paintings. The interior surface of the church is covered with an extraordinarily exuberant array of imagery, which includes Old and New Testament scenes, heraldic devices, and animal imagery.[3] These were part of a contemporary East Christian artistic koine, many elements of which were also common to the Islamic art of the eastern Mediterranean. The double-headed eagle that appears at several points in the interior paintings of the church is an obvious case in point (fig. 131), found from medieval Byzantium and Seljuq Anatolia to Syria and Ethiopia.[4] Whatever the particularities of its early history, by the twelfth or thirteenth century the motif often appeared in connection with courtly imagery and royal monuments. Its appearance at Lalibela thus hints at engagements with a wider world extending to the north and east of medieval Ethiopia.

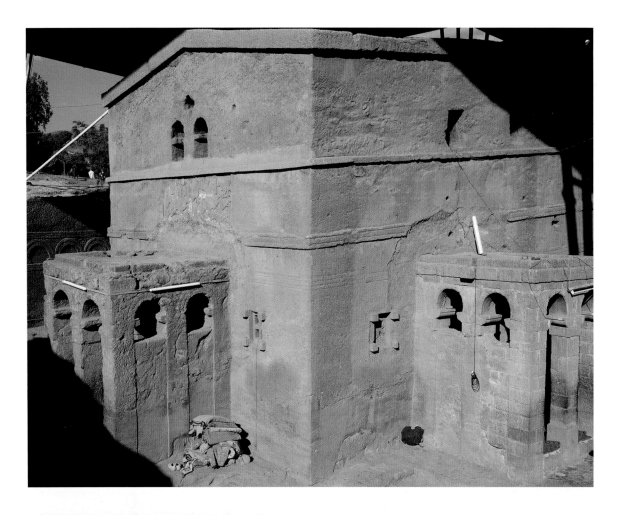

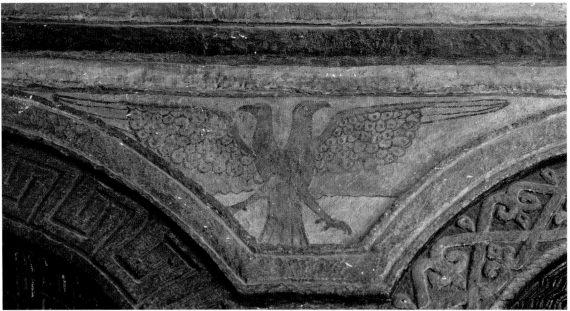

(TOP) *Fig. 130* The rock-cut church of Beta Maryam (House of Mary), Lalibela (Ethiopia), early 13th century(?), with an equestrian relief visible above the porch on the left.

(BOTTOM) *Fig. 131* A double-headed eagle among the interior paintings of Beta Maryam, Lalibela.

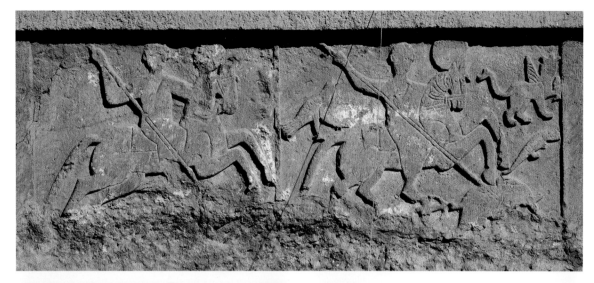

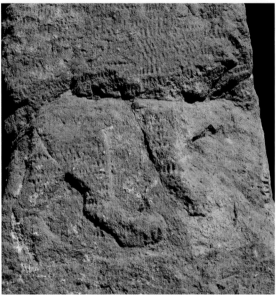

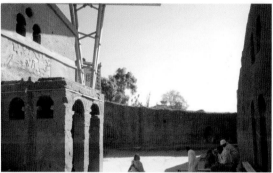

The same is also true of a spectacular, if enigmatic, panel carved in low relief on the west facade of the church (figs. 132 and 133) featuring two equestrian figures chasing a range of beasts, including an elephant, a crocodile, and a chimera. This is the best preserved of a series of low-relief carvings situated around the main entrance to the building, evidently intended to emphasize and enhance it. The panel appears directly above a projecting porch that bears the remains of zoomorphic carvings, including what appear to be a lion (fig. 134) and a giraffe similar to that found among the interior paintings of the church (fig. 135). Lions, giraffes, and elephants were native to Ethiopia: all three were among the diplomatic gifts carried from the Zagwe court to the Ayyubid sultan of Egypt around 1206 CE.[5]

(TOP) *Fig. 132* Carved relief of two equestrian figures above the main (western) entrance to Beta Maryam, Lalibela.

(MIDDLE RIGHT) *Fig. 133* Western porch of Beta Maryam, Lalibela, with the relief seen in fig. 132 above on the left. On the right are the double windows of an upper chamber possibly used as a royal loggia, seen in fig. 136.

(MIDDLE LEFT) *Fig. 134* Remains of a zoomorphic carving on the left-hand pillar of the porch of Beta Maryam seen in fig. 133.

(BOTTOM) *Fig. 135* A fragmentary painting of a giraffe among the interior paintings of Beta Maryam, Lalibela.

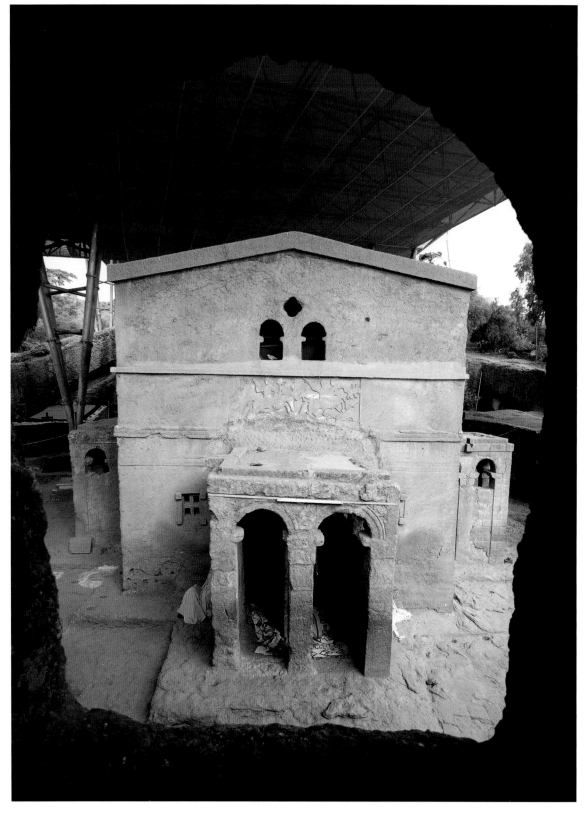

Fig. 136 The western facade of Beta Maryam, Lalibela, showing the porch with zoomorphic reliefs on its pillars (see fig. 134) and the relief above (see fig. 132), as viewed from the loggia seen on the right of fig. 133.

Figurative reliefs are relatively unusual in medieval Ethiopian art, but also occur elsewhere in Lalibela and at other sites.[6] A pair of stone relief lion and elephant capitals, probably from a destroyed medieval church, were recorded at Bihat in Eritrea in the 1940s; the figure of an antelope was carved on the interior facade of a rock-cut church at Ambager, south of Lalibela, of uncertain date but likely medieval. Recent research has also brought to light remarkable pre-Christian stone reliefs carved on the walls of a cave church at Washa Mika'el south of Lalibela; these include a hunt scene. The theme, technique (including the use of incised lines and paint for modeling), and the presence of giraffes, elephants, and chimeras offer interesting parallels to the later Beta Maryam relief.[7]

The Beta Maryam relief panel is, however, unusual among the range of medieval materials known from Ethiopia for its scale and elaboration. Recessed within a simple rectangular frame, it faces an elevated rock-cut chamber across a narrow courtyard (figs. 133 and 136), measuring roughly 3.5 × 1.5 meters.[8] It shows two equestrian riders in motion with shields raised in their left hands, while spearing prey with a lance thrust from the right.[9]

There are clear iconographic differences between each frame; that on the left (fig. 137) has a sparer, less cluttered appearance that distinguishes it from the busier, more frenetic scene on the right, where the equestrian figure is surrounded by a rich array of animals (fig. 138). The rider has a raptor perched on the back of his horse, and gallops forward to spear a tusked elephant assisted by a diminutive standing archer who takes aim at the beast, while also seeming to pursue a lizard-like creature with a segmented body, probably a crocodile.[10] At the top right of the frame a creature recognizable as a sphinx seems to flee, while turning to face the viewer and raising a fish in its left paw. The prey of the rider on the left has been lost by the erosion (or possible excision) of the rock below. However, in east Christian art of the late antique and medieval periods, pairs of equestrian saints are often depicted spearing distinct prey, usually a demonic foe in human form, paired with a rider impaling a demonic reptilian or zoomorphic form.[11] It is possible, therefore, that the relief originally featured the defeat of two distinct but related foes: the demise of evil in human form on the left, and the zoomorphic hunt now preserved on the right panel.

One peculiarity of the relief in its current condition is the minimal articulation of internal features such as faces. The basic outlines of the figures are incised, along with details such as saddles, lances, wings, scales, and harnesses, but with the notable exception of one horse's head, the internal articulation is rudimentary. It seems likely that the relief was originally finished with a coat of plaster, with the finer details articulated in polychromatic paint. This is the case with the wall paintings in the interior of the church, which were executed on a thin layer of gypsum or plaster applied to the surface of the living rock from which the church was cut (see fig. 135).[12]

Unlike the paintings within the church, many of which bear painted captions in the Ethiopian liturgical language, Ge'ez, no such dipinti or other written pointers survive today to help interpret the relief on the exterior of the church. While the value of iconographic analysis for dating the Lalibela monuments has been questioned,[13] so far archaeological data have been useful in providing a relative rather than an absolute chronology for the site. The complexities of the site suggest the need for multiple analytical strategies, rather than championing any single methodology over others. In the absence of any accompanying textual meta-data, an obvious starting point is a close visual analysis of the scene itself.

A significant detail, which has attracted little attention, is the thin vertical framing line separating the riders (see figs. 132, 137, and 138). In effect, this extends the outer frame into the center of the relief, indicating clearly that these are two distinct, if related, images. That they were intended to be read in succession proceeding from left to right seems certain; not only is there no overlap between the scenes, but the hoof of the left-hand rider comes up hard against the central divider rather than crossing it, as do the tail feathers of the falcon on horseback in the succeeding frame, emphasizing a terminal limit.

Another question is whether these two frames depict distinct figures, or a single rider shown in successive modes or moments. Despite the common equestrian theme, there is a distinct difference in feel between both frames, the bare ground of the rider on the left contrasting sharply with the dense array of animal and half-human creatures populating the succeeding frame. And yet, the figures themselves are remarkably similar. It has been pointed out that contemporary Islamic rulers, including the Seljuqs of Anatolia, were sometimes represented in dual modes,[14] but there may in fact have been sources of inspiration closer to home. The rulers of Axum, the great Ethiopian trading kingdom that flourished until the seventh century, were represented in dual modes on their coinage (fig. 139). Especially on certain

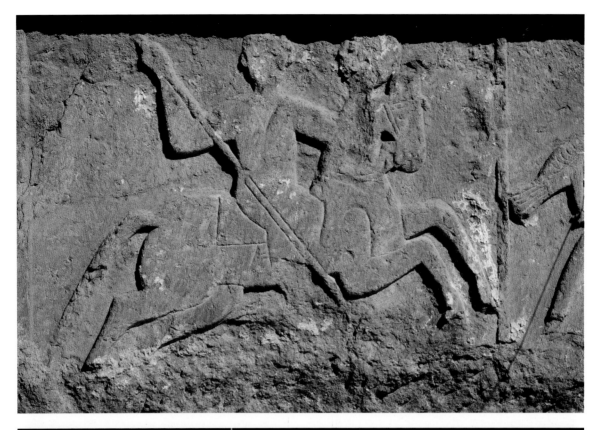

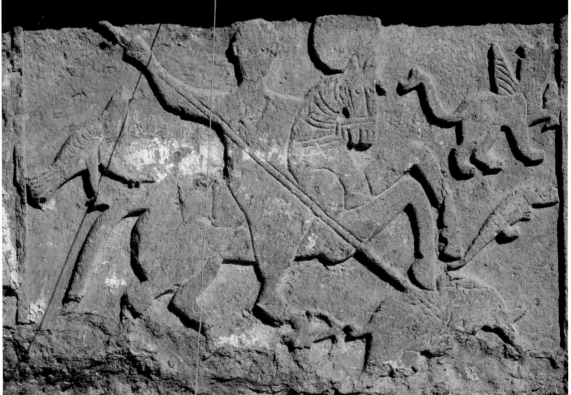

(TOP) *Fig. 137* Detail of the equestrian figure on the left side of the relief above the entrance to Beta Maryam, Lalibela, seen in fig. 132.

(BOTTOM) *Fig. 138* Detail of the equestrian figure on the right side of the relief above the entrance to Beta Maryam, Lalibela, seen in fig. 132.

Chapter 5

Fig. 139 Coin issued in the name of Ousanas, ruler of Axum, northern Ethiopia (ca. 323–345 CE), showing the ruler on the obverse and reverse wearing an identical headcloth and ear ornament. Silver; dtr. 1.4 cm. Oxford, Ashmolean Museum, inv. no. HCR51180.

copper and silver (and more rarely gold) Axumite coin issues, obverse and reverse each bear a portrait depicting the ruler in identical mode.[15] A late afterlife for this convention at Lalibela may seem unlikely, but continuities in Axumite royal practice have been detected in the use of three regnal names by the Zagwe rulers and the later mining of Axumite royal imagery in medieval Ethiopian art has been demonstrated.[16]

This is not to prejudge the dichotomy in modern scholarship, which has generally been split between a secular and a sacred reading of the scene, identifying the riders either as royal riders or equestrian saints. It does seem likely that the relief represents a symbolic battle between a champion (or champions) of Christianity and the forces of disorder and evil, a long-established theme in eastern Christian art. The beasts being hunted in the Lalibela relief may, by implication, include those originally carved on the pillars below the relief (see fig. 134), in addition to the menagerie painted in the interior of the church (see fig. 135).

With its symbolization of the triumph of good over evil, the subduing of nature is a theme with self-evident relevance to the legitimacy of a Christian ruling house. Between the eleventh and thirteenth centuries the equestrian rider spearing a human opponent or a dragon was a common figure in Christian reliefs and wall paintings, from Egypt to Iraq, often set above the entrance to churches or sanctuaries as guardian figures (fig. 140), a tradition to which the Beta Maryam relief conforms.[17] However, in contemporary examples, the paired warrior-saints usually face each other, rather than appearing in consecutive frames, as is the case at Lalibela.

Attempts have been made to locate the ultimate sources of the Lalibela relief in the fifth- and sixth-century Sasanian art of Iran, mediated by the art of the Islamic lands.[18] But whether it is analytically useful to describe these carvings as Sasanian, almost six centuries after the demise of that dynasty, is open to doubt. Moreover, with some significant exceptions, the imagery of the relief is better understood as part of a Christianized iconography deeply rooted in the arts of late antiquity.

That Ethiopia formed part of a late antique iconographic koiné linking Eurasia and Africa, within which certain motifs and themes circulated widely, is demonstrated by a series of wooden panels from the ceiling of a sixth-century church dedicated to the Virgin near Asmara in Eritrea (now destroyed). Like the more famous carved ceilings from the monastery of Debra Damo in Tigray, the Asmara carvings depicted a whole menagerie of wild beasts, including an elephant and rhinoceros. Amidst them appeared riders spearing prey, including a figure spearing a serpent and a rider holding a circular shield aloft in his right hand (fig. 141), as in the later Lalibela relief.[19]

Painted versions of similar compositions, in which animals, chimeras, and equestrian figures spearing dragons are juxtaposed, can be found on the western ceiling in the church of Yemrehanna Krestos near Lalibela, datable to the late twelfth or early thirteenth century (fig. 142).[20] However, the chronological lacuna between the appearance of such images in the Axumite and the later Zagwe periods exemplifies the kind of gap in the archive discussed in our Introduction. It is difficult to know how to interpret the apparent absence of

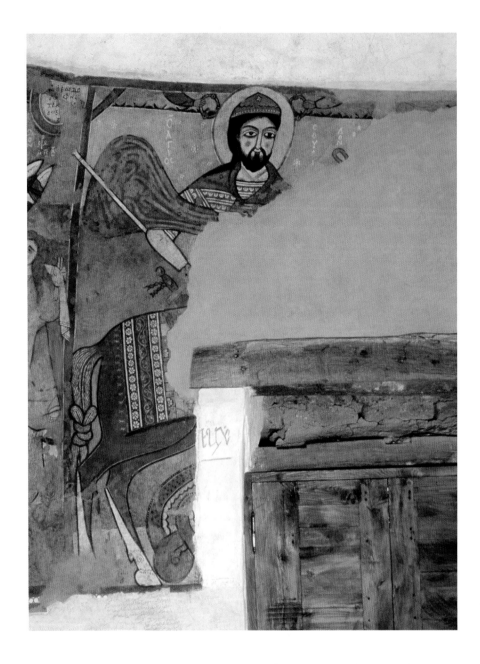

Fig. 140 The remains of a wall painting showing Saint Theodore Stratelates (left) and Saint Sisinnios spearing dragons, set above the entrance to the church in the Monastery of Saint Anthony, Red Sea, Egypt, ca. 1230 CE. Cairo, American Research Center in Egypt, no. N22-23, ADP/SA 1999.

(FACING PAGE TOP) Fig. 141 Wooden panels from the church of Saint Mary, Asmara, Eritrea, 5th-6th century (= Anfray (1965), pl. VII).

(FACING PAGE BOTTOM) Fig. 142 Detail from the paintings on the western ceiling in the church of Yemrehanna Krestos near Lalibela, 12th or 13th century, showing an equestrian figure spearing a dragon or snake.

evidence across six centuries or more. Are we dealing with forms of continuity that the material record does not attest to—a kind of imagery that was integrated into the repertoire of Ethiopian art at an early date and continued in use subsequently? Or is this a case of two distinct and potentially unrelated moments of connectivity, in both of which the image enjoyed a transregional circulation that included Ethiopia? While the available evidence does not permit one to decide between these alternatives, it remains an open possibility that the motif of the rider dispatching a reptilian or zoomorphic foe had been deeply rooted in the Christian iconography of Ethiopian art long before it appeared at Lalibela.

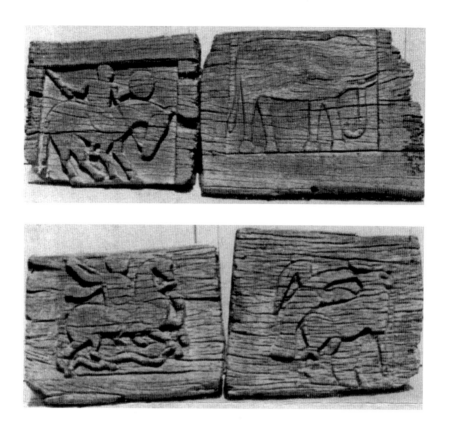

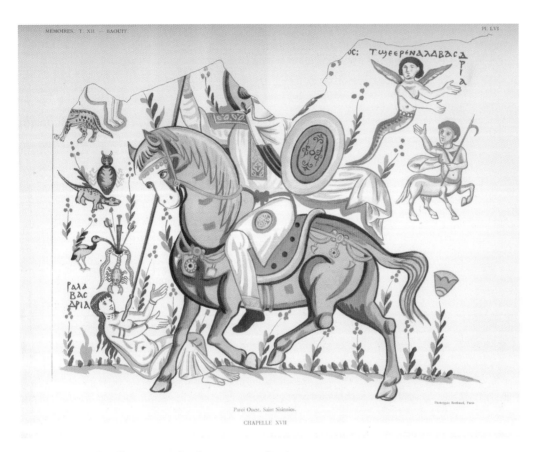

MÉMOIRES. T. XII. — BAOUIT. PL. LVI

ΤΨΕΕΡΊΝΑΛΑΒΑCΑ
Ρ
Ι
Α

ΡΑΛΑ
ΒΑC
ΑΡΙΑ

Paroi Ouest. Saint Sisinnios.

Phototypie Berthaud, Paris

CHAPELLE XVII

Fig. 143 Drawing of a wall painting in Chapel 17, monastery of Bawit, Middle Egypt, 5th–6th century, depicting Saint Sissinios spearing the demoness Alabasdria with an image of the "much-suffering eye" directly above (= Clédat (1904), pl. LVI).

As regards the identity of the figures in the Beta Maryam relief, the Asmara riders lack halos, so the absence of halos associated with the Lalibela riders is not decisive evidence against their identification as saintly figures,[21] especially since the finer details of the relief are likely to have been completed with painted plaster. This is not to insist that the figures are in fact saintly protectors. On the contrary, the setting of this dramatic evocation of the hunt directly above the main entrance to Beta Maryam, its pillars carved with further natural and mythical beasts, heightens the iconographic ambiguities; and all the more so since the relief faces an elevated chamber that, based on its relationship to the church, including its vantage point over the equestrian relief, has recently been identified as a royal loggia (see figs. 133 and 136).[22] And yet, a split between a secular and a sacred reading of the image may say more about modern taxonomies than about medieval imaginaries, especially considering notions of royalty associated with the Zagwe rulers, several of whom assumed the role of priest-king—a phe-

nomenon noted by Arabic chroniclers as early as the eleventh century.[23]

Moreover, one of the most striking (and potentially relevant) aspects of the image of an equestrian figure spearing a serpent, dragon, or other foe is its formal consistency yet simultaneous capacity to attract "multiple and parallel identities," a phenomenon notable in frontier areas with both Christian and Muslim communities, such as medieval Anatolia.[24] Indeed, part of the reason for the popularity of the equestrian figure across a wide contemporary geography likely lay in its polysemy, its associations with both princely pursuits and protection, and consequent capacity to assume the attributes of hunter, ruler, or saint.[25] In the Coptic context, this polyvalence has been attributed to a "passion for synthesizing seemingly disparate phenomena into an underlying unity by means of enigmatic combinations, overlapping relationships, and an almost endless progression of associations."[26] This is no less likely to be true of the Beta Maryam relief.

Prophet, Saint, and King

A frequent point of comparison for the Beta Maryam relief has been a wall painting found in a monastery at Bawit in Middle Egypt (fig. 143).[27] Datable to the sixth century, the wall painting shows Saint Sisinnios (identified in Greek) mounted on a horse. This was one of two wall paintings at the site that depicted Sisinnios as a mounted warrior spearing a fallen female demon identified in Greek as Alabasdria.[28] In the better-documented painting, from Chapel 17, Saint Sisinnios was paired with the mounted figure of the Coptic soldier-saint Phoibammon.[29]

The image of Sisinnios spearing the demoness appears to have been a popular one in late antique Egypt, for it survives in two contemporary stone reliefs.[30] As we saw in chapter 4, the image of the ecliptic dragon was commonly deployed at the entrances of citadels and palaces in northern Syria and the Jazira (see figs. 112–114) to ward off ill omens. The image of the equestrian dragon-slayer often fulfilled a similar apotropaic function in the churches of the region, from Anatolia to Egypt.[31] In the early thirteenth-century paintings in the monastery of Saint Anthony in the Eastern Desert of Egypt, for example, the saints Theodore Stratelates and Sisinnios were deployed next to and above the interior entrance to the church (see fig. 140). The location, and the fact that these are the only equestrian figures in the paintings shown spearing dragons (in the form of large, knotted serpents), suggests that they were present in an apotropaic capacity, protecting the church at one of its most vulnerable points.[32]

A recent study of the image of the "holy rider," including images of Sisinnios, argues the need to acknowledge a persistent connection between the contexts in which images of equestrian dragon-slayer saints appear and the desire to harness their role as sources of supernatural protection.[33] In the much earlier painting at Bawit, this function is made explicit by the iconography of the scene. Sisinnios is surrounded by a myriad of menacing animals and hybrid creatures, while on the right-hand side a centaur armed with a pike and a hybrid winged creature with a serpentine tail and a human face and body, the daughter of the demoness, acclaim each other. The content and eclectic effect of the ensemble, the equestrian saint hunting a living incarnation of evil surrounded by a menagerie of wild beasts, does indeed bear comparison with the Lalibela relief. Like the relief, the earlier painting offers up "a field teeming with small animals and half-human creatures that conjure up images of demonic forces and

desires,"[34] reinforcing the likelihood that the Beta Maryam relief also had an apotropaic or protective function.

Sisinnios was a saint of somewhat mysterious origins, variously located in Antioch or further east in the Sasanian world; a variant of the name appears on some of the Aramaic ceramic magic bowls discussed in chapter 4 above (see fig. 104), where it is invoked to protect against demons.[35] The performative nature of the Bawit image is reinforced by the presence to the left of the scene of an image of the "much-suffering eye." The image was intended to deflect the malevolent gaze, deploying the strategy of like repelling like that was later harnessed in the Islamic magic-medicinal bowls discussed in chapter 4. It did so by showing the eye under attack from a range of piercing weapons and the beaks, fangs, and stings of poisonous creatures, including snakes and scorpions. The depiction of penetration and poisoning was intended to deflect by mimesis the toxic effects of the envious or malevolent gaze (the "evil eye").[36] Above this an owl (a standard component of such iconography), a reptile (a crocodile or lizard), and a hyena complete the sense of a landscape inhabited by wild and disturbing fauna.

The Bawit painting provides a large-scale echo of a combination of images found on a series of late antique amulets which present the much-suffering eye on the reverse of an image of the mounted rider spearing a female demon (fig. 144). This is generally assumed to be the child-killing demon known variously as Alabasdria, Gyllou, Lamashtu, or Lilith, a figure long associated with amulets (see figs. 118 and 119).[37] The remnants of the body of a small human creature in the top left of the Bawit scene (see fig. 143) may have been intended to depict the infant formerly menaced by the now defeated demoness. In the *Testament of Solomon* (collated by the sixth century, if not earlier), the demoness is named Abyzou: the association is maintained on many amulets of this type, which identify the rider in Greek as Solomon. In this way the amulet and its efficacy provide a mimetic echo of the seal with which Solomon is said to have subdued the demons, an identification made explicit on some amulets which bear the epithet *sphragis theou* (seal of God).[38]

The image of the holy rider spearing a demonic figure continued to appear on amulets produced in the eastern Mediterranean into the Islamic period, sometimes alongside invocations of God's name in Arabic.[39] But the identity of the rider was not fixed. On some hematite and metal

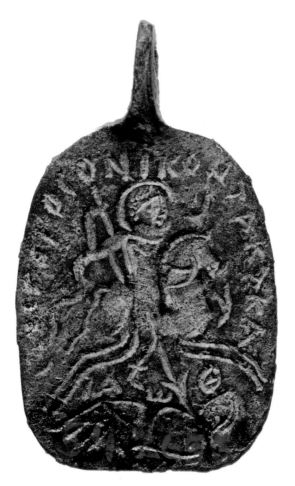

Fig. 144 Amulet, eastern Mediterranean, 5th–6th century, showing a "holy rider" spearing a demoness and "much-suffering eye" on the reverse. Bronze; 5.2 × 3.1 × 1.2 cm. Baltimore, Walters Art Museum, inv. no. 54.2653.

amulets ascribed to fifth- or sixth-century Syria-Palestine, the rider spearing the female demon is identified in Greek as Solomon, on others as Sissinios.[40] On other metal amulets both names appear together, sometimes accompanied by an angel identified as Araph, possibly Solomon's vizier,[41] or the rider is accompanied by an inscription ordering the demonic figure to flee, under the pursuit of a triad: Solomon, Sisinnius, and Sisinnarius.[42] The latter saint is likely the brother of the former who, according to some versions of the Sisinnios legend, was instrumental in dispatching the child-killing demon; on certain epigraphic semi-precious stone amulets, Sisinnios and Sisinnarius are named together along with other powerful names.[43] The protective role of such figures on portable amulets seems to anticipate or prefigure that of the similar equestrian figures set as guardians at entrances to medieval churches in the eastern Mediterranean and beyond.

The identification of the demon-slaying rider as Solomon/Sisinnios continued on Christian amulets produced in the eastern Mediterranean as late as the eleventh or twelfth century (figs. 144 and 145); that is, close to the period when Beta Maryam is believed to have been excavated and ornamented. On many of these the demon-slaying rider is identified as Sisinnios, while a series of magical signs on the obverse is accompanied by a Greek inscription invoking the seal of Solomon.[44] This oscillation of the identity of the holy rider between Old Testament prophet-king and Christian saint is especially intriguing in light of the centrality of Solomonic kingship to medieval Ethiopian monarchy. The instrumentalization of the very idea of Solomonic kingship by the Solomonid dynasty that displaced the Zagwes, the builders of Lalibela, in 1270 has been well documented. The Solomonids promoted their rule as a restoration of the Solomonic house after

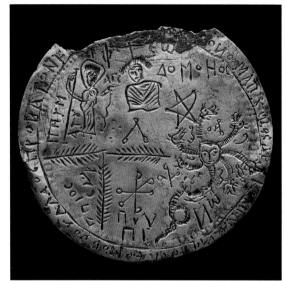

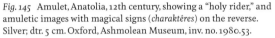

Fig. 145 Amulet, Anatolia, 12th century, showing a "holy rider," and amuletic images with magical signs (*charaktêres*) on the reverse. Silver; dtr. 5 cm. Oxford, Ashmolean Museum, inv. no. 1980.53.

a Zagwe interregnum. However, recent scholarship has drawn attention to the likelihood that the association of Ethiopian monarchy with Solomon preceded the advent of the dynasty that seized power in 1270, concluding that "a core of the Solomonid myth was associated with Ethiopia in a period contemporary with the Zagwe dynasty."[45] Seen in this light, it is conceivable that the ambiguous identity of the holy rider, with its long-established Solomonic associations, resonated with the patrons of the Lalibela church.

The theme of the holy rider trampling and spearing a naked female demon proliferated closer to the date of the Lalibela relief in the tenth- and eleventh-century wall paintings of Christian churches in Egypt and Nubia. A partially preserved painting from Tebtunis in the Fayyum region of Egypt, depicting a mounted rider assailing a hybrid demon very similar to that depicted at Bawit—part female, part serpent—has been identified as Sisinnios.[46] As late as the eleventh century a similar image appears in the art of neighboring Nubia, painted on the walls of the lower church at Banganarti near Old Dongola (in modern Sudan). The figures have been identified as Saint Sisinnios and the demoness Alabasdria, a suggestion reinforced perhaps by the discovery of a paper amulet containing a Greek version of the Sisinnios legend at Qasr Ibrim in Nubia. The image has been suggested as a "missing link" between the image of the saint (known in Ethiopia as Susenyos) on late antique amulets and on much later Ethiopian healing scrolls (fig. 146).[47] Extant

examples of such scrolls only exist from around the eighteenth century, but certain aspects of the iconography of the Ethiopian scrolls seem to hark back to late antique amulets and Islamic talismans in complex ways that remain to be adequately explored. These include, for example, depictions of the demoness as a hybrid creature, part human part serpent, exactly as on some sixth- or seventh-century amulets from the eastern Mediterranean (see fig. 118).[48]

The figure of Sisinnios (or Susenyos), his role as the slayer of a child-killing demon, and his protective capacities were known in Ethiopia before the date of the earliest extant scrolls, for an Ethiopic account among the widely dispersed versions of the legend of the saint that has come down to us provides the historiola for the images on the scrolls. The precise chronology is unclear, but it is likely that the legend went through a long and complex process of both oral and textual transmission.[49] In the most common version, the demon is the saint's sister, Wĕrzĕlyā, whose predations the saint ended, spearing her from horseback.[50] The Ethiopic text preserves the magico-medicinal and exorcistic context of many versions of the legend, recommending that a prayer to Saint Sisinnios should be inscribed as an amulet and hung upon the body. A relationship to earlier Solomonic legends is likely, for in the *Testament of Solomon* the child-killing female demon Abyzou reveals to Solomon that her capacity to harm children can be abated by writing her secret names, or that of her angel adversary Raphael, on an amulet worn on the

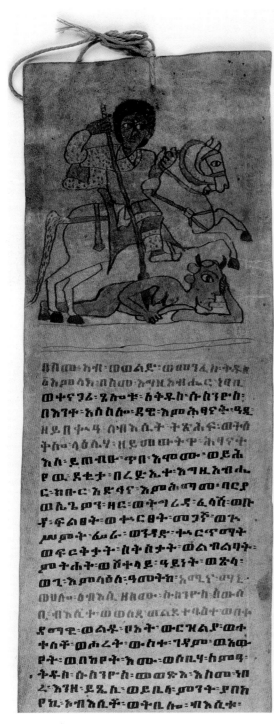

Fig. 146 Detail of a healing scroll, Ethiopia, 18th–19th century, showing Saint Susenyos spearing a demon. London, Wellcome Collection, attrib. 4.0 International (CC BY 4.0).

body; similar prayers can be found in Coptic texts and inscribed on Arabic amulets.[51] In addition to safeguarding children, the Ethiopic version of the prayer of Sisinnios is said, like its Arabic and Coptic equivalents, to be efficacious against a range of physical and supernatural ailments, from dysentery, the flux, plague, and typhus to the evil eye, the Zar (a form of possession), and the malice of demons and magicians.[52] This belief underlies the popularity of the image of the mounted Susenyos spearing his demonic sister on Ethiopian healing scrolls (fig. 146).

Certain Greek versions of the legend describe Saint Sisinnios and his companion as "God's hunters," underlying the overlap between profane and supernatural dimensions of the combat against evil.[53] Moreover, in these versions, the demon attempts to flee in the form of a fish, leaping into the sea, or by becoming airborne, only to be pursued by the saints transformed into hawks. Neither detail appears in the single Ethiopic version of the legend that has come down to us, but the connection of the child-killing demon with the sea is ancient, appearing already in some of the Aramaic incantation bowls discussed above in chapter 4 (see fig. 104).[54] This maritime connection and role of the fish and raptor are suggestive, considering the appearance of both in the Lalibela relief (see figs. 132, 137, and 138)[55]

In the Lalibela relief, hunting and spearing are closely related to the capacity of the equestrian figure to exert control over the natural world or, more specifically, the various threats that it poses, both physical and spiritual. The endeavor might be compared to those contemporary Iraqi reliefs mentioned in chapter 4, which show ruler figures taming the double-headed dragon that causes eclipses (see fig. 125). The capacity to tame wild beasts is attributed to certain saints in later Ethiopian texts,[56] but here the animals, far from being tamed, seem feral, pursued and chastised. In this sense, the relief is closer in spirit to the Bawit wall painting (see fig. 143), or to medieval frescoes from Nubia, including images from Old Dongola, of Christ or saints trampling embodiments of evil in zoomorphic form including lions, snakes, basilisks, and crocodile-like creatures, a theme found in earlier Christian wall paintings from Egypt.[57] The combination literalized the imagery of Psalm 91 (90):13: "Thou shalt walk upon the asp and the basilisk: and thou shalt trample under foot the lion and the dragon." Both the text and the imagery that it inspired were already popular on late antique amulets from the eastern Mediterranean.[58] The Nubian wall paintings may be seen as large-scale evocations of this protection from

Fig. 147 Amulet, Byzantine, 5th–6th century, or electrotype copy of a Byzantine amulet, with Christological scenes on one face and on the other an image of Pantheos with the iconographic attributes of Horus trampling the crocodiles and holding scorpions, inscribed in Greek: "Sisinnios tramples you down, filthy one. You no longer have strength. Solomon's seal has rendered you impotent." Bronze; 5.8 × 4.4 cm. London, British Museum, inv. no. 1938,1010.

evil, allegorized by the taming of threatening or noxious wild beasts, a theme with an obvious relevance to the Beta Maryam relief.

The theme of the "master of the animals" was an established one. An early seventh-century wall painting from the monastic settlement at Kellia, south of Alexandria, for example, shows the capacity of the Cross to tame the various animals of disorder that accompany it, including crocodile, lion, and hippopotamus.[59] The iconography may preserve a vestigial remnant of Horus on the crocodiles, an image of the Egyptian deity taming dangerous beasts, including crocodiles and scorpions. Like the Islamic magic-medicinal bowls discussed in chapter 4, such imagery and its accompanying magical texts were sometimes activated by being washed with water, which absorbed the efficacy of incised and engraved therapeutic formulae and was then ingested as a kind of pharmakon.[60] The imagery of Horus on the crocodiles survived into the early Islamic period, abbreviated, transformed, and Christianized (see fig.

129).[61] On one intriguing amulet of the fifth or sixth century (fig. 147), the names of Saint Sisinnios and of his companion (here identified as Bisisinnos) are invoked along with Solomon's seal in a Greek inscription that accompanies a Christianized version of Horus as master of wild and noxious animals, including the crocodile.[62]

Like that of the creatures depicted on the magic-medicinal bowls discussed in chapter 4, quite literally enclosed within a circle of efficacious formulae and signs, the role of animals in these iconographies is often ambiguous. On the one hand they represent chaos and even demonic forces. On the other, by virtue of their taming they operate in a register of efficacious mirroring common to many kinds of apotropaic imagery. In the paintings from Bawit and elsewhere, the crocodile plays a dual role as a malefic creature capable of being tamed or subdued by the saint, even as the holy rider subdues the beasts he hunts. Something of these associations seems to have persisted in various hagiographies in which Coptic saints

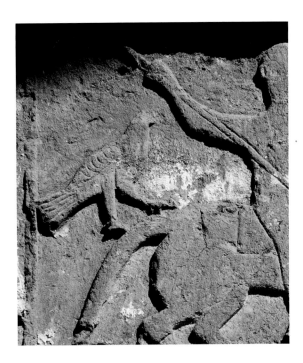

Fig. 148 Detail of the equestrian rider carved over the entrance to Beta Maryam, Lalibela, seen in figs. 132 and 138.

(and Muslim holy men) tame crocodiles or reptiles, including demons assuming zoomorphic or hybrid form.[63]

Such ambiguity and ambivalence are at odds with the iconographic approach taken in much art-historical discourse, often characterized by recourse to precise identifications and singular meanings. Yet, the polyvalence that it implies pervades the imagery of the Lalibela relief and its petrified bestiary. That the rider at Lalibela is engaged in the suppression of the reptile is clear: while the right hoof of his horse tramples the back of the elephant, the left traps the tail of the crocodile, this being emphasized by the angle at which the tip of the tail diverges from the orientation of the body as a whole (see figs. 138 and 162).

Just as at Lalibela, on the walls of early medieval Coptic monasteries animals observed from nature are accompanied by menacing chimeras and hybrids.[64] In the Sisinnios painting from Bawit (see fig. 143), the daughter of the demon Alabasdria takes the form of a hybrid, winged creature, with a human head and torso and a reptilian tail. Along with her depiction as a long-tailed, human-headed lioness, this is a form in which the demoness speared by the holy rider appears on some contemporary amulets (see fig. 118).[65] At Bawit, the acclamatio of this chimera by a centaur recalls the role of centaurs, satyrs, and wild beasts as demonic or threating apparitions in the biog-

raphies of Coptic saints, such as the hermit saint Anthony (d. 356) and the anchorite Paul of Thebes (d. ca. 342), which emphasize the devil's capacity to assume a host of zoomorphic forms, including that of hybrids.[66] The association of half-human, half-animal hybrids with evil is also found in medieval Nubian paintings,[67] and may be relevant to the survival of the centaur among the demonic creatures seen being dispatched by warrior saints on later Ethiopian healing scrolls.[68]

The presence of chimeric or hybrid creatures alongside representatives of the natural world in such contexts only heightens the parallels with the Lalibela relief, which terminates in the image of a sphinx clutching a fish (see fig. 154). However, the chimera that appears in the Lalibela relief is, like the holy rider himself, an ambiguous figure, to which I will turn shortly.

Princely Hunters

The principal elements of the relief participate in an iconographic repertoire with roots in the late antique Mediterranean, but which is found in the art of Ethiopia and Eritrea at an early date (see fig. 141), whether part of a continuous tradition or not. However, other elements are less easily accommodated within such a longue durée perspective. These include the raptor, most likely a falcon, astride the rear of the horse ridden by the second equestrian figure (see fig. 138; fig. 148).[69] At first glance, its presence might support a secular identification, for just as the figure of the holy rider seems to be rooted in late Roman imperial iconography,[70] its transformation into a falconer reflects the addition of an element heavily indebted to an iconography of royal hunters current in the arts of the Islamic lands. In fact, however, this feature only heightens the ambiguity or polyvalence of the relief, which combines elements of apotropaic imagery integral to the holy rider with aspects of the secular hunting scenes that were part of a widely diffused "princely cycle" shared between Christians and Muslims in the twelfth and thirteenth centuries across an area ranging from al-Andalus to Iraq and Georgia to Ethiopia.

The popularity of falconry in the Islamic world is well documented from the tenth century onward, by which time the image of the falconer circulated widely. Dedicated treatises on falconry surviving from the same period include the *Kitāb al-bayzara*, an extended discourse on falconry written by the chief falconer to the Fatimid caliph of Egypt, al-ʿAziz billah (r. 975–996 CE).[71] The image of the falconer was especially popular in the eleventh through thirteenth centuries, appearing

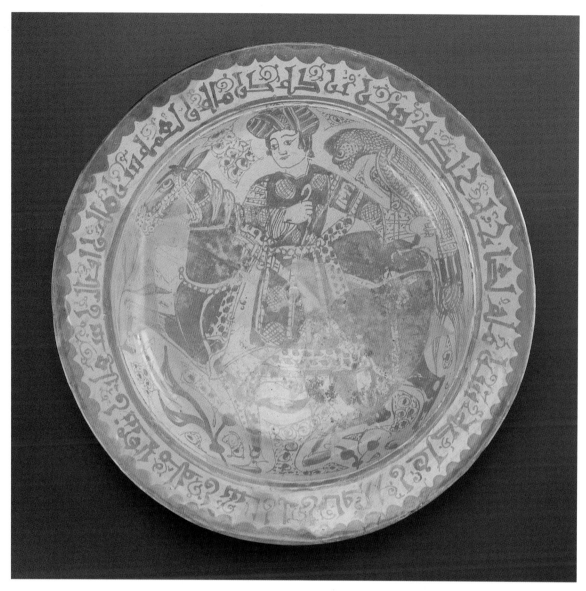

Fig. 149 Luster plate with an image of a mounted falconer, Fatimid Egypt, 11th–12th century. Glazed earthenware; dtr. 38.4 cm. Washington, DC, Freer and Sackler Gallery of Art, inv. no. F1941.12.

(RIGHT) *Fig. 150* Drawing of an equestrian falconer, Egypt, 11th–12th century. Ink on paper; 10.48 × 10.48 cm. Dallas, Dallas Museum of Art, The Keir Collection of Islamic Art, obj. no. K.1.2014.1137.

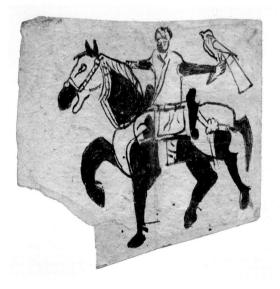

on portable media such as ceramic and metal vessels. Typical in this respect are the image of a rider with an outsize falcon perched on his left hand as depicted on a Fatimid luster-ware plate (fig. 149), and the schematic image of a similar equestrian falconer on a drawing of the same period (fig. 150) reportedly recovered from the rubbish dumps of Fustat, the first Islamic capital of Egypt.[72]

Comparisons for the Lalibela falconer may also be found among examples of metalwork

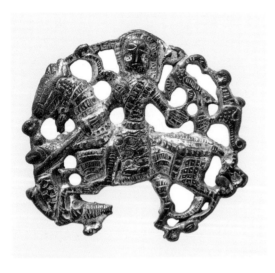

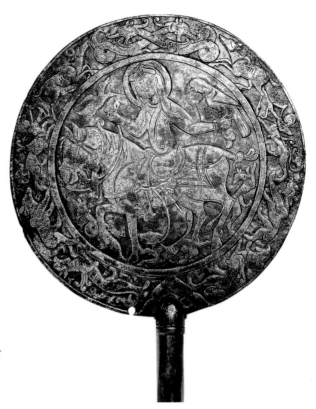

Fig. 151 Gilded bronze harness attachment or buckle, Syria or Anatolia, 12th–13th century, showing a falconer spearing a dragon or serpent. Vaduz (Liechtenstein), Furusiyya Art Collection.

(RIGHT) *Fig. 152* Mirror, Anatolia, early 13th century, showing a royal falconer trampling a knotted dragon, surrounded by a procession of animals that include centaurs and griffins, the whole surmounted by a pair of knotted dragons. Steel inlaid with silver and gold; dtr. 41.5 cm. Istanbul, Topkapı Palace Museum, inv. no. 2/1792.

from twelfth- and thirteenth-century Anatolia and Syria. These include a pierced gilded bronze harness ornament, datable to the twelfth or thirteenth century, in which the falconer is in the process of dispatching a large serpentine dragon with a spear (fig. 151).[73] Equally relevant is a well-known early thirteenth-century steel mirror depicting a royal falconer spearing a serpentine knotted dragon, framed by an outer array of natural and fantastic images—bears, gazelles, centaurs, and griffins (fig. 152). At the summit, a pair of entangled dragons with gaping jaws recalls the cosmic forces similarly evoked in the magic-medicinal bowls discussed in chapter 4 and frequently depicted in the art and architecture of the region in which the mirror was produced (see figs. 111–115). The object is quite literally a "mirror for princes," a reflection of an idealized vision of rulership as a mastery of cosmic and terrestrial forces given chimeric and zoomorphic form.

The iconography of the mirror reminds us of the formal and conceptual intersections and overlaps between the image of the holy rider and more profane, princely, pursuits, which nonetheless signify an idealized vision of the natural cosmic order. Moreover, although the image of the falconer is ultimately related to the "princely cycle" in medieval Islamic art, its popularity in areas with both Christian and Muslim populations,

such as medieval Anatolia and Egypt, transcended sectarian boundaries. It appears, for example, on the carved wooden doors and screens in the medieval Coptic churches of Cairo, the iconography of which reflects the contemporary courtly art of the Fatimid caliphs. The image of a turbaned equestrian figure bearing a falcon on his wrist is carved on one of the door panels of the twelfth-century wooden sanctuary from the upper chapel of Saint George in the church of Sitt Barbara in Cairo.[74] In the spandrel above, the adjoining section of the iconostasis features a second falconer with the raptor perched on the back of the horse (fig. 153), as in the Lalibela relief.

Similar figures appear at the entrances to twelfth- and thirteenth-century churches in the Jazira region of northern Iraq, where the image of the falconer has been described as a "fashionable variation" of the more traditional figure of the equestrian saint, an adaptation that reflects the transplantation of a motif "from a secular Islamic context to a Christian one."[75] Given its associations, the figure of the falconer may have been considered especially appropriate for the facade of a royal foundation at Lalibela.

In the Christian architecture of the Islamic lands, both "traditional" and "Islamicate" versions of the equestrian hunter motif can appear together, the choice between them perhaps deter-

Fig. 153 Detail of the carved wooden sanctuary screen in the chapel of Mar Giorgis, Church of Sitt Barbara, Fustat (Old Cairo), 11th–12th century (= Pauty (1930), pl. II, detail).

mined by context.[76] However, while the Egyptian falconers sport prominent turbans, this is not the case at Lalibela, where the outline of the hair of the riders is much more faithful to earlier, late antique types, despite the presence of the falcon. The distinction complicates the temporality of the relief (a point to which I will return), while underlining the fact that we are dealing with something much more than a passive reception of iconography developed elsewhere. This impression is reinforced by other details of the carving.

Maritime Chimeras

As we have seen, both the iconography of the holy rider and its association with a diverse zoomorphic universe may have a long history in the art of Ethiopia (see figs. 132 and 141). However, just as the magic-medicinal bowls discussed in chapter 4 conjoin apotropaic imagery inherited (albeit transformed) from late antiquity with novel iconographic types such as the dragon, so the Beta Maryam relief also contains elements that represent innovative additions to the iconographic repertoire of Ethiopian art. In addition to

the raptor (see fig. 148), the most obvious of these is the striding sphinx at the extreme right of the relief, turning to meet the gaze of the viewer while clutching a fish in its raised paw (fig. 154; see also fig. 132). The creature is afforded prominence by its scale relative to the other animals and its position, as the terminal point of the panel.

The sphinx was not unknown in earlier Ethiopian art. Two small stone sculptures of sphinxes, one a protome in the form of a lion with a female head wearing an Egyptian-style headdress, were found at Addi Keramaten in Eritrea, while fragments of others were found around Axum, and a relief with two sphinxes of south Arabian type was found at Feqya near Matara. All appear to date from the sixth to fourth centuries BCE (fig. 155).[77] These examples reflect connections with Egypt (or, more likely, the Kushite kingdoms of Nubia) and south Arabia during a period of intense transregional contacts. But despite these outliers produced more than a millennium before the Beta Maryam relief, the sphinx is not common in the iconography of medieval Ethiopian art. Rather, it is among several elements in the Lalibela relief that point to the impact of contemporary artistic

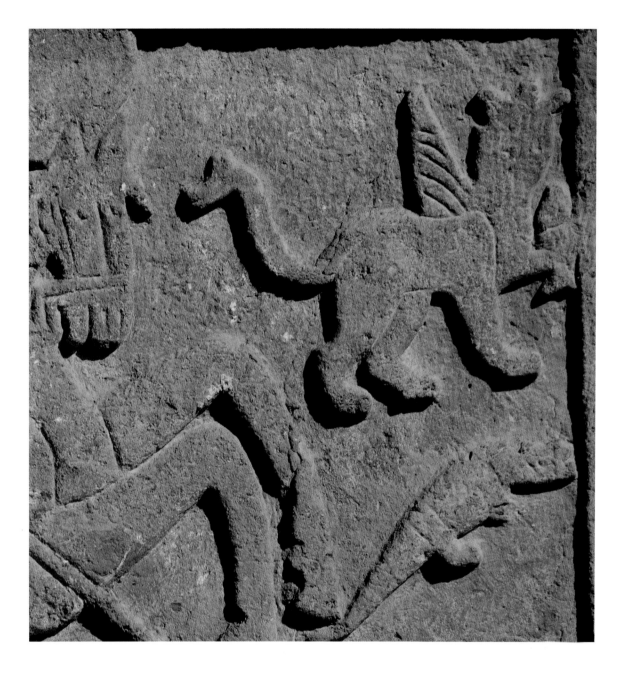

Fig. 154 Detail of figs. 132 and 138, showing a dragon-tailed sphinx wearing a trihorned crown.

developments in the regions beyond the Zagwe kingdom, most obviously the Islamic lands to the east and north.

Like the image of the equestrian warrior, that of the sphinx has deep historical roots in the arts of the eastern Mediterranean and west Asia, but enjoyed particular popularity in the arts of the Islamic world during the twelfth and thirteenth centuries. At this time, images of hybrid creatures such as harpies and sphinxes proliferated on a wide array of portable arts, including ceramics, metalwork, and textiles (fig. 156), and even as free-standing statuettes (fig. 157).[78] The specific form of the beast at Beta Maryam leaves little doubt that it

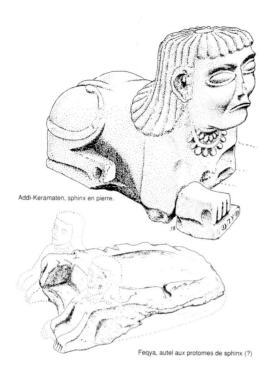

Addi-Keramaten, sphinx en pierre.

Feqya, autel aux protomes de sphinx (?)

Fig. 155 Fragmentary stone sphinxes found at Addi Keramaten and Feqya in Eritrea, 6th–4th century BCE (from Anfray [1990]).

Fig. 156a and 156b Detail of dragon-tailed sphinx on a fragment of unglazed molded ceramic excavated at Balis, northern Syria, 12th–13th century (drawing by Khalid Alhamid).

156a

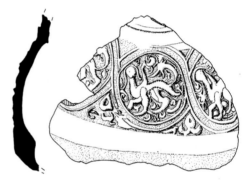

156b

was inspired by images of the sphinx produced in the Islamic world around the time that the church is believed to have been carved.

The creature in the Beta Maryam relief has the body of a feline, a tail that terminates in a dragon's or serpent's head, a clearly articulated triangular wing, and holds a fish in an extended, raised paw (see fig. 154). Although the facial features are blank, these were likely originally painted and human. Most telling of all are the three vertical protrusions from the forehead, for these correspond to the tripartite or triple-pointed crown or diadem worn by sphinxes in images and sculptures produced in the contemporary Islamic world. Headdresses of this type are occasionally worn by the sphinxes that appear on eastern Iranian metalwork,[79] but Egyptian and Syrian artifacts offer especially close parallels. Among them is a pair of sphinxes sporting triple-pointed diadems that appear in a tapestry roundel on a *ṭirāz* textile that was produced in Damietta, Egypt, in 1096–97 and later transformed into a Christian relic.[80]

The pointed crown is also similar to that worn by a freestanding glazed ceramic sculpture

of a sphinx produced in Raqqa, in Syria, in the second half of the twelfth century (fig. 157). The sculpture was part of a group which included a parrot-tailed cockerel and an equestrian figure fighting a dragon,[81] a constellation reminiscent of the combinations found in the Beta Maryam relief. Like the Lalibela sphinx, the wings of the Raqqa sphinx are strongly demarcated from the body, and the tail ends in a reptilian head. Similar images of sphinxes with cephalic tails circulated in more mundane and portable wares, including both glazed ceramics produced in Syria and Iran and unglazed molded wares produced in Syria and Iraq during the twelfth and thirteenth centuries, which also featured hunting scenes (see figs. 156 and 201).[82]

That the image of a sphinx appears in the equestrian scene carved on the facade of Beta Maryam is perhaps not surprising. Like the raptor perched on the mount of the hunter (see fig. 148), the beast had been integrated into a Christian artistic repertoire in the contemporary Coptic churches of Egypt. The juxtaposition of equestrian warrior and sphinx at Lalibela recalls,

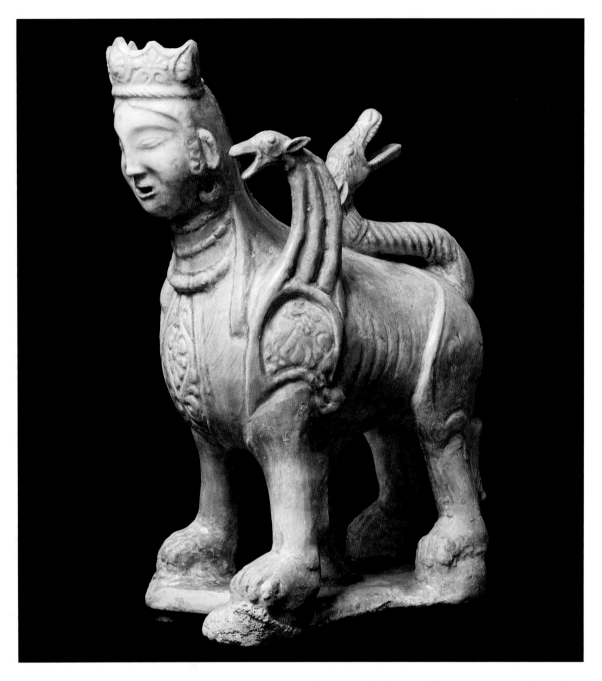

Fig. 157 Sphinx with dragon tail, and horned crown, Raqqa (Syria), second half of twelfth century. Cast, modeled, and carved fritware; h. 37 cm. Copenhagen, Davids Samling (The David Collection), inv. no. Isl. 56.

for example, the twelfth-century carved wooden sanctuary screen in the church of Abu Sayfayn in Fustat, where the lintel of the entrance to the sanctuary is terminated at either end by the figure of a rampant sphinx, each flanked by a panel carved with an equestrian saint (fig. 158).[83] Just as the equestrian figures may be seen as protecting the church whose entrance they surmount, the presence of the sphinx in these medieval Egyptian and Ethiopian churches recalls the role that images of hybrid creatures have often played as guardian figures, perhaps because they mirror the monstrous that they help to deflect.[84]

Figs. 158a and 158b Details of carved wooden sanctuary, church of Abu Sayfayn, Fustat (Old Cairo), 12th century. (Fig. 158b = Pauty (1930), pl. II, detail.)

As suggested earlier, the presence of the sphinx among the creatures pursued by the equestrian figure might be understood as reflecting the role that such hybrids played in Christian tales of the taming of wild beasts as a metaphor for subduing chthonic demonic forces. But this was not the only association of the sphinx. In the Islamic world, the sphinx was an ambivalent creature, a harbinger of untamed chaos on the one hand, and an emblem of luck and protection on the other (see fig. 201). The ambivalence that the creature aroused is evident from its perception in medieval Egypt, where the monumental stone sphinx adjacent to the pyramids was known as the "Father of Fear" (Abu'l-Hawl), but also identified as a talisman that stopped the encroachment of the desert.[85]

Similar to the figure of the equestrian hunter itself, the sphinx might be seen as a transregional archetype, capable of assuming different valences in the contexts in which it appears, and with a history that stretches across not only connected geographies but also distinct temporalities—something that we will revisit in chapter 6. Like its earlier manifestation in Ethiopia, the sphinx's appearance in Lalibela might be seen as indexing a moment when the networks linking Ethiopia to the surrounding regions waxed. It is even possible that these long-distance connections were self-consciously signaled in the Lalibela relief, by a curious detail. Although the prototype of

the Lalibela sphinx was almost certainly furnished by the portable arts of Egypt or Syria, the relief includes an unusual iconographic feature: the fish raised in the left paw (see fig. 154). I can think of no parallels, from among the many published examples produced in the Islamic lands, for sphinxes (whether single or paired) holding a fish. At the very least, if such an iconography existed, it was by no means common.

It is, therefore, all the more significant that this detail recurs in another medieval Ethiopian rendering of the sphinx, painted on the north walls of the church of Qorqor Maryam in the Geralta region of Tigray, generally dated to the thirteenth century. The image (fig. 159) shows a pair of confronting sphinxes, the tails of which each terminate in a single dragon head. The Islamicate filiations of these figures has been noted in passing.[86] A single, prominent, vertically oriented fish shared between them recalls the fish held by the Lalibela sphinx. While the Lalibela sphinx wears a triple-pointed crown, those worn by the Qorqor Maryam sphinxes have multiple points. Other unusual features include the speckled or spotted skin, which recalls late antique depictions of the Egyptian god Tutu, master of the disease-causing demons and a common apotropaic image, sometimes painted as a spotted sphinx with a human face and a tail in the form of a cobra.[87] But the most obvious of the differences from the Beta Maryam sphinx is the striated hump that sits atop the back of each of the Qorqor Maryam sphinxes, which seems to be a mis-rendering of the striated wings associated with the sphinx in its standard medieval incarnations. By contrast, the same striations occur on the Lalibela sphinx (see fig. 154), but here their orientation in relation to the triangular wing leaves little doubt that they are intended to indicate folds of flesh or ranks of feathers. This transformation of a standard iconography at Qorqor Maryam reinforces the impression that the imagery was copied from a prototype that was not part of the repertoire of medieval Ethiopian church painters.

However, the repetition of the fish motif and the prominence afforded it at both Beta Maryam and Qorqor Maryam highlights additional aspects of reception and transformation, suggesting that the feature was considered integral to the iconography (and likely meaning) of the sphinx in an Ethiopian context. Once again, the consistent addition of a feature not associated with the iconography of the sphinx in an Islamicate context suggests an innovation: an active and adaptive reconceptualization based on specific cultural associations and expectations. That such creatures

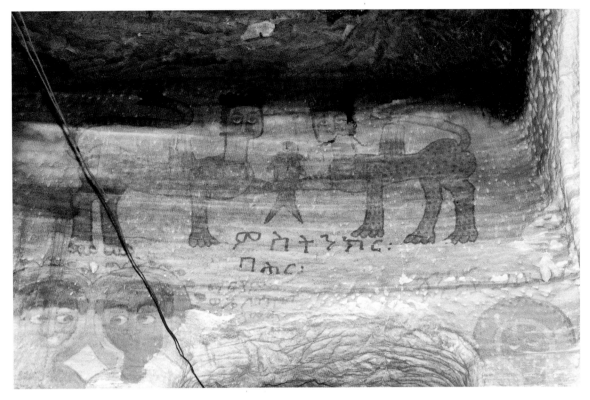

Fig. 159 Painting on northern wall of Qorqor Maryam, Tigray (northern Ethiopia), 13th century, showing sphinxes holding a fish.

were considered exotic is hinted at by a dipinto written in Geʿez, the Ethiopian liturgical language, directly below the sphinxes, which identifies them as *məstankər bāḥr*: wonder or wonders of the sea (fig. 159).[88]

The combination of maritimity and wonder was not unique: as we shall see in chapter 6, even in the Islamic lands the presence of such beasts was sufficient to denote an exotic place of marvels that lay across the sea. Moreover, the appearance of peacocks in association with fish on the painted ceiling in the church of Yemrehanna Krestos near Lalibela (fig. 160) suggests a more widespread acknowledgment of the maritime associations of certain kinds of exotic beasts, whether chimeras or drawn from the natural world. One of the canon tables in a thirteenth-century Ethiopian gospel manuscript now in Paris is surmounted by a pair of plump, crested, wingless birds labeled in Geʿez as "sea ostriches."[89] Similarly, one of the canon tables in the Zir Ganela Gospels (1400–1401 CE) depicts a pair of entwined or interlocking thin-necked, sharp-beaked birds, possibly of Islamicate inspiration, labeled in Geʿez "Picture of birds that dwell in the midst of the sea" (fig. 161), suggesting an origin in or association with lands that lay over the seas from Ethiopia.[90] In Qorqor Maryam, the maritime

associations of the sphinxes are reinforced by the fish held between them, just as the solitary sphinx at Lalibela raises a fish, prominently displaying it in an extended paw, drawing our attention to this small but significant detail.

Both the iconography of the Ethiopian sphinxes and the Qorqor Maryam inscription point to the exotic nature of such hybrids and their association with the wonders of lands across the sea, complementing riverine elements of the Lalibela relief, such as the crocodile. In light of the presence of the falcon in the Beta Maryam relief, it may be no more than coincidence that medieval Arabic manuals on falconry divide the peregrine falcon into two categories: those from Kurdistan, and those known as "maritime" (*baḥriyya*) because of their association with the coast.[91] In Arabic and Persian, commodities, including animals such as horses, that were exported—shipped across the sea to India, for example—were often designated as *baḥrī*, "of the sea."[92] By extension, the maritime association of the sphinxes and strange birds occasionally found in medieval Ethiopian art may acknowledge their role as cultural imports.

In the medieval Islamic world, the harpy, that other hybrid creature with which the sphinx

Fig. 160 Detail of paintings on the western ceiling in the church of Yemrehanna Krestos near Lalibela, twelfth or thirteenth century CE, showing peacocks and fishes below an inverted ship sailing on a sea of fish (see fig. 179).

Fig. 161 Canon table, Zir Ganela Gospels, Ethiopia, 1400 CE, depicting two birds, inscribed in Geʿez "Birds that dwell in the midst of the sea." Painting on vellum; 36.2 × 25.1 cm. New York, Pierpont Morgan Library, MS. M.828, fol. 5v.

was often associated, was designated as *baḥrī*.[93] It is, therefore, possible that, through a displacement, the sphinx adopted in Ethiopian art came to be invested with some of the attributes of its absent companion. Worth noting is that, according to the Arab geographers, both Ethiopia and India were the homes of wondrous beasts, including wonders of the sea (*ʿajāʾib al-baḥr*). A tenth-century Arabic source reports, for example, that the seas off the coast of Ethiopia are populated by fish with human faces and other hybrid creatures.[94]

It seems likely that the addition of the fish represents an Ethiopian adaptation of the sphinx imagery common to the Islamic lands that underlines the maritime associations of the creature. Here, again, there may be further echoes of the Sisinnios/Abyzou/Wërzëlyā legends, for in addition to the capacity of the demoness to transform into a fish, according to some versions found in Arabic, Coptic, and Greek sources she was responsible for causing shipwreck and frustrating maritime trade.[95] Like the appearance of the sphinx in the same relief, the apparently minor detail of a fish

might be seen as hinting at the long-distance connections of a site that, despite its location in the high mountainous interior of Ethiopia, lay at the intersection of African, Indian Ocean, and Middle Eastern circuits of exchange. One final detail of the relief raises the possibility, moreover, that those connections may have extended even further than the Islamic world.

Indian Antecedents?

Among the most intriguing elements of the Lalibela relief is the archer crouching beneath the foot of the right-hand rider, his bow drawn back and taut, on the point of being loosed at the elephant being speared by the rider (fig. 162). One of the four equestrian saints painted on the sanctuary wall of the church of Yemrehanna Krestos near Lalibela seems to be shown dispatching a bull or elephant (fig. 163), a scene rare enough to suggest a relationship to the Lalibela relief.[96] But although arrow and bow were among the weapons employed by medieval Ethiopian armies,[97] the

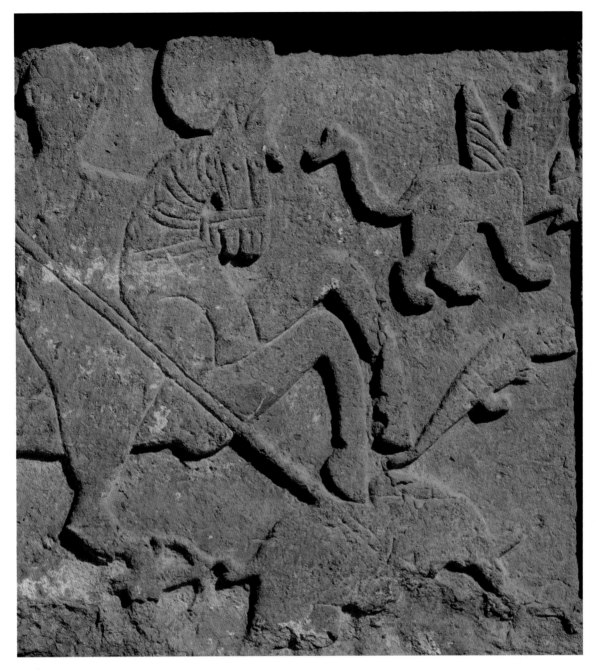

Fig. 162 Detail of the relief on the facade of Beta Maryam,
Lalibela, seen in fig. 132.

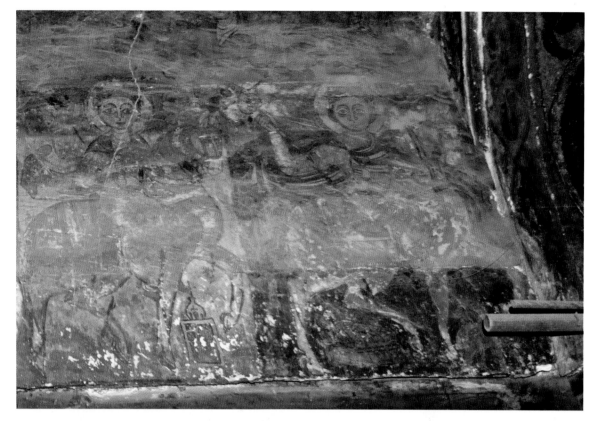

Fig. 163 Painting on sanctuary wall, church of Yemrehanna Krestos, near Lalibela, twelfth or thirteenth century, showing an equestrian saint spearing a quadruped (an elephant?).

iconography of the scene is unusual. As a recent study of the Lalibela churches notes, the source of the diminutive archer participating in the ensemble awaits identification.[98]

Both the scale of the archer and his relationship to the scene as whole distinguish him from the equestrian figures. In fact, he has more in common with the animals, depicted at a range of scales, some of which I have suggested were copied from portable objects produced in the Islamic lands to the north. In the same way, the figure of the archer may have been inspired by the imagery found on objects of foreign origin imported to Ethiopia during the twelfth and thirteenth centuries. But rather than a source in the portable arts of the Islamic world, the filiations of the figure may point in another, far more unexpected, direction.

Recently, Claude Lepage and Jacques Mercier have drawn attention to a series of shields almost certainly of Indian origin still in situ around the triumphal arch of the Savior of the World (Medhane Alem) church adjacent to Beta Maryam (fig. 164).[99] Like the shields held aloft by the riders in the Beta Maryam relief, these are circular; the group originally consisted of three large shields (55 to 60 cm in diameter each) and a smaller shield. The shields are made from skin (probably elephant or rhinoceros) stretched across doweled wooden boards and encrusted with glass paste or semi-precious stones set within what appear to be metal, possibly gilded, bezels on their exterior. These bear similar (but not identical) exterior designs consisting of heart-shaped elements alternating in their orientation with raised clusters of colored glass or stone in their interstices (fig. 165).[100] They are among a range of medieval Indian artifacts preserved in the churches of Lalibela and the surrounding region; the surface treatment of a leather cuirass formerly in the church of Beta Maryam (fig. 166) shows a clear formal and technical relationship to the shields, and is likely to also be of Indian origin, if not contemporary.[101]

Lepage and Mercier quite correctly suspected that the shields may have originated in southern India, possibly in the territories under the control of the Hoysala rajas, who exercised authority over the regions around the modern state of Karnataka between the twelfth and fourteenth centuries.

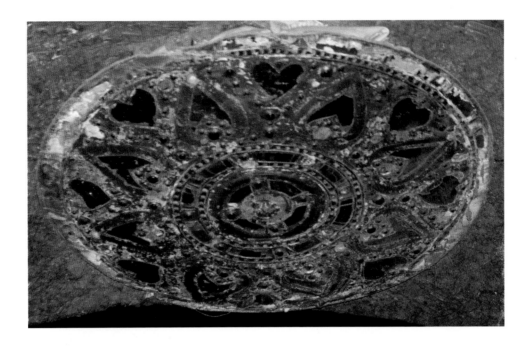

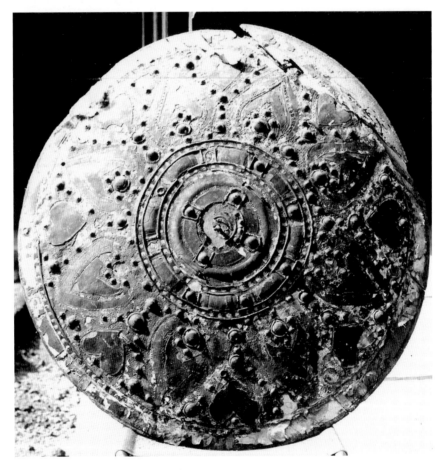

(TOP) *Fig. 164* Shield attached to the underside of the triumphal arch before the sanctuary, church of Medhane Alem, Lalibela.

(BOTTOM) *Fig. 165* A shield currently attached to the face of the triumphal arch, church of Medhane Alem, Lalibela. Photograph taken when the shield was temporarily removed during the restorations of 1966. Bergamo, Biblioteca Civica Angelo Mai, Sandro Angelini Archive, *provini fotografici no. 6.*

Chapter 5

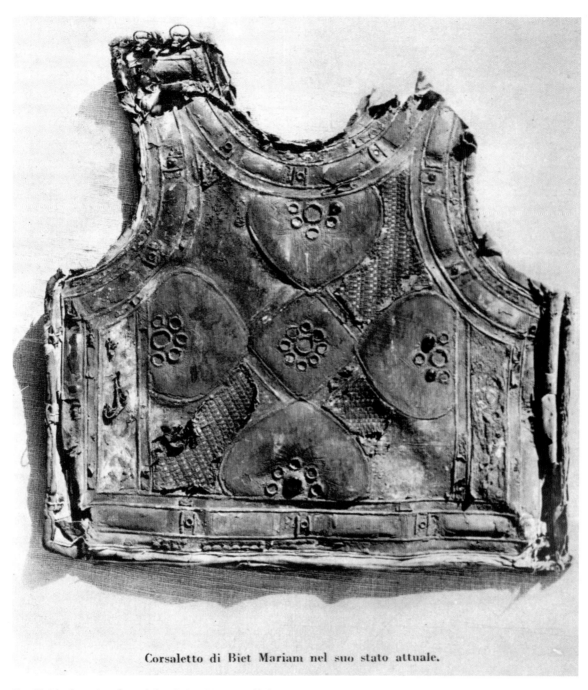

Corsaletto di Biet Mariam nel suo stato attuale.

Fig. 166 A leather cuirass formerly kept in Beta Maryam, Lalibela,
likely of Indian origin, current whereabouts unknown
(= Monti della Corte (1940), pl. XXXVI).

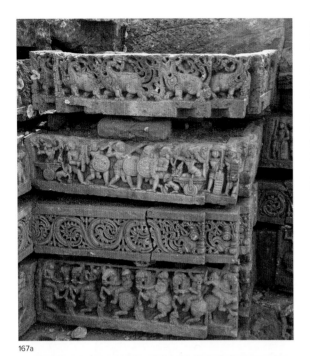

167a

(LEFT AND BELOW) *Figs. 167a and 167b* Details of the base carvings of the unfinished mid-twelfth-century Nagareśvara temple at Halebid, the Hoysala capital, Karnataka, southern India.

(FACING PAGE TOP) *Fig. 168* Painted wooden plaques nailed above the exterior of the northern entrance to the church of Yemrehanna Krestos, near Lalibela.

(FACING PAGE MIDDLE) *Fig. 169* Detail of a fragment of a painted wooden casket used to decorate the church of Yemrehanna Krestos, near Lalibela, ca. 1200, featuring a *hamsa* motif (left), now disappeared (= Monti della Corte (1940), pl. XXXVIII).

(FACING PAGE BOTTOM) *Fig. 170* Detail of *hamsa* frieze, Hoysaleśvara Temple, Halebid, Karnataka, southern India, 1121 CE.

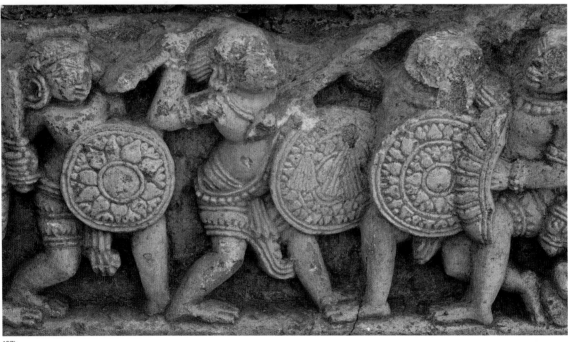

167b

Although no shields of this date survive in India, as far as I am aware, the Hoysalas are famed for the rich plastic and sculptural arts that proliferated on the exterior of their temples, including elaborate friezes depicting ceremonial processions and battles. The basement moldings of twelfth-century Hoysala temples in and around Dorasamudra/Halebid, the Hoysala capital, preserve numerous representations of shields identical in their exteriors to those preserved in Lalibela. On the basement carvings of the unfinished mid-twelfth-century Nagareśvara temple at Halebid, the Hoysala capital, for example, a series of depicted shields shows a central medallion surrounded by one or two rows of tear-shaped leaves (fig. 167); on some, the interstices are filled by heart-shaped ornaments, exactly as on the two large shields preserved in Lalibela. The tear-shaped ornament is recognizable as the leaf of the pipal, the sacred fig, or the betel vine, whose leaves are chewed still

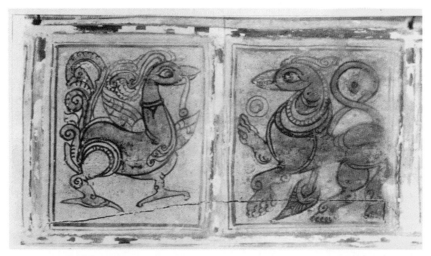

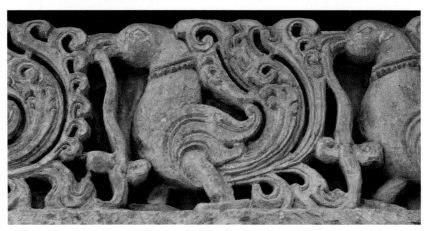

today in south Asia, valued for their mildly stimulant effects.

The shields are only the most spectacular of a range of Indian artifacts preserved in the churches in and around Lalibela. Among them are fragments from what appears to be a painted box or casket, taken apart and used to ornament the church of Yemrehanna Krestos. Two panels from this casket, depicting a cheetah or leopard and a lion are currently nailed in place above the north-

ern entrance to the church (fig. 168). Others once preserved there have now vanished. The latter included depictions of a series of birds (fig. 169), among them a *hamsa*, or celestial swan similar to that commonly found on eleventh- and twelfth-century Indic objects (see fig. 4), and temple carvings (fig. 170).

The paintings on the panels currently in situ are especially diagnostic, including as they do the form of a lion with a stylized mane resembling a

Figs. 171a and 171b Details of the plaques above the northern entrance to the church of Yemrehanna Krestos, near Lalibela seen in fig. 168.

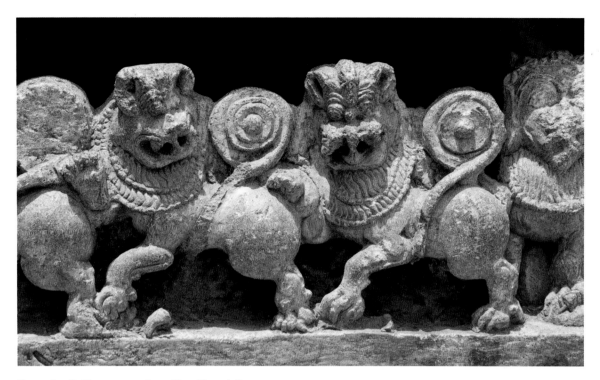

Fig. 172 Detail of basement carvings with emblematic lions, Hoysaleśvara Temple, Halebid, Karnataka, southern India, 1121 CE.

hanging torc and a tail that doubles back on itself to form a distinctive loop containing a concentric disc (fig. 171a). This type of lion was the dynastic emblem of two medieval dynasties whose territories included the southwestern coast of India, and who are known to have been involved in trade around the Indian Ocean in the eleventh and twelfth centuries. The first of these, the Kadambas, ruled over the Konkan coast around the present location of Goa.[102] This type of lion also served as the emblem of the neighboring Hoysala kingdom, which occupied the coastal and inland areas of Karnataka, immediately to the south of Goa. It not only circulated as a portable statuette, but also appeared on the richly carved temples that the Hoysalas built, featuring as an element of their basement friezes (fig. 172) and even as freestanding monumental sculptures that flanked their entrances.

It seems likely that before it was dismembered (fig. 173), the box or casket came from southern India, bearing rarities that can only be imagined but—to judge from contemporary texts—may have included aromatics, betel nut, cloth, copper vessels, dye stuffs, medicinal herbs, pepper, perfumes (civet and musk), spices, or textiles.[103] The iconography of the paintings on the dismembered casket leaves little doubt that these paintings now in Ethiopia originated in the Kadamba or Hoysala

Fig. 173 Proposed reconstruction of the original context of the panels seen in figs. 168, 169, and 171 (drawing by Cem Ozdeniz).

kingdoms of southwest India. This was the region from which it appears on other grounds that the shields now in Lalibela originated. Taken collectively, these objects suggest an intensity of contacts (direct and/or indirect) between the Zagwe kingdom and those of south India in the late twelfth and early thirteenth centuries, contacts not otherwise documented.

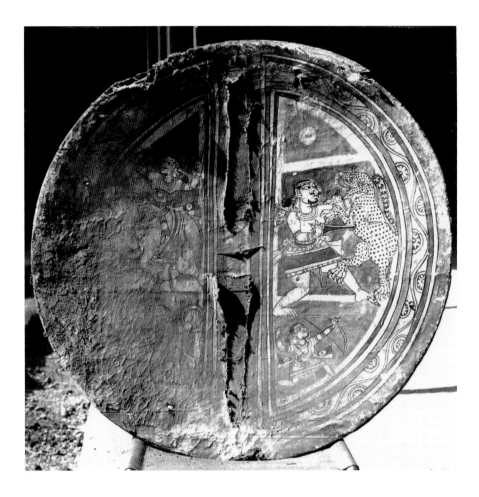

Fig. 174 Interior of the shield in the church of Medhane Alem, Lalibela seen in fig. 165, showing animal combat scenes. Photograph taken during the restorations of 1966-69. Bergamo, Biblioteca Civica Angelo Mai, Sandro Angelini Archive, provini fotografici no. 6.

These objects of Indian origin may have been favored for their aesthetic qualities, their rarity, or as indexes of long-distance connections. It is worth emphasizing that they were displayed in prominent and iconographically significant locations in the churches of Lalibela and its surrounds; the shields in Lalibela ornament the approach to the Holy of Holies of the church of Medhane Alem, and the painted wooden panels are set above what functioned as the main entrance to the church of Yemrehanna Krestos. Whether or not their Indian origins were recognized is unknowable, but it is worth keeping open the possibility that they were also privileged for their ability to materialize connections to a Christian ecumene or imaginary that extended beyond Egypt and the Mediterranean world.[104] The existence of communities of Syriac Christians in Kerala on the Malabar coast of India was known of in Ethiopia as early as the

eleventh or twelfth centuries, as was the tradition of pilgrimage to the arm relic of Saint Thomas the Apostle (d. 72 CE), seen as responsible for the proselytization of the region, in Chennai (Madras).[105] The Syriac Christians of India held to the Monophysite or Miaphysite rite of Christianity, which professed belief in the single nature of Christ as both divine and human, to which the Ethiopian church also held. Although Malabar was located further along the southwestern coast of India than the region whence the Indian materials in and around Lalibela are likely to have originated, it is an open possibility that this Indian flotsam was valued for its capacity to materialize a relation to a distant outpost of the Christian ecumene on the other side of the Indian Ocean.

The two large shields at Lalibela each had a single loop on each side (presumably for a grip) and interior paintings of very high quality (fig. 174). One of these includes two combat scenes: a warrior charging on a rampant elephant with a standing warrior raising a shield in the field below; and a standing warrior plunging a sword into a cheetah, leopard, or tiger, while a diminutive warrior below raises a bow in one hand and

Chapter 5

175a

an arrow in the other, about to take aim at the unfortunate beast. Although the lone figure on the Beta Maryam relief is depicted in the process of drawing an arrow back in the bow, his diminutive size with regard to the scene as a whole is strikingly reminiscent of the Indian painting as, more generally, is the presence of the elephant, albeit here hunted rather than ridden. There is, in addition, a suggestive echo of the composition of the shield painting in the triangular relationship between archer, prey, and large warrior shown in action on the Lalibela relief (fig. 175).

The quality of the paintings on the interior of the shields is extraordinary; taken with the quality of the workmanship as a whole, and the spectacular encrustations on their exterior, it suggests that they may have been elite, perhaps even royal, objects. Their full implications will be considered in detail elsewhere, but what is relevant here is the possibility that these shields or other such exotic objects may have served those responsible for the Beta Maryam relief as sources for the mining of motifs and perhaps compositions. Once again, the selective, and adaptive, mining of imagery derived from diverse sources, including imported artifacts, suggests an agentive engagement with a cosmopolitan array of materials that accumulated in and around the Lalibela churches, an impression reinforced by the transmedial qualities of these adaptive appropriations.[106]

175b

Figs. 175a and 175b. Detail of the relief on the facade of Beta Maryam, Lalibela seen in fig. 132 compared with a detail of fig. 174.

Fig. 176 Detail of painted ornamentation emulating Delft tiles, church of Narga Selassé, Lake Tana, Ethiopia, ca. 1730–50 CE.

A much later parallel for the types of adaptive appropriations being suggested here might be sought in painted imitations of the characteristic blue and white landscapes found on imported Delft tiles from the Low Countries used in the churches of Lake Tana in eastern Ethiopia in the seventeenth and eighteenth centuries (fig. 176). Once incorporated into the local artistic repertoires, such blue and white painted "tiles" were perpetuated, reproduced, and reimagined into the nineteenth century, a process marked by multiple variations and transformations.[107]

In all these cases, the use of such elements is selective. Whether falcons, sphinxes, diminutive archers, or Delft-style paintings, they are elements of contemporary media and imagery subsumed into larger iconographic wholes with deep local and translocal roots. Just as the imagery in the magic-medicinal bowls discussed in chapter 4 above conjoins apotropaic imagery inherited (if transformed) from late antiquity with novel iconographic types, the iconography of the Beta Maryam relief may have deep roots in the Chris-

tianized art of late antiquity (including that of Ethiopia, as the Asmara carvings suggest; see fig. 141) but also integrates new and contemporary elements that reflect the possibilities provided by the presence of portable objects that had traveled by land and sea over very long distances. In short, the Lalibela relief is rich with diachronic sedimentations, but also with synchronic innovations. Novel elements are selectively adopted or integrated in meaningful ways according to iconographic codes common to the imagery of some contemporary Egyptian churches. But their reception is marked by innovative adaptations of the iconographic elements adopted from foreign sources or imported artifacts that appear to have been mined for the imagery of a monumental frieze carved from the living rock on the facade of a royal foundation.

If my interpretation is correct, it suggests that those responsible for carving the Beta Maryam relief were using exotic objects contained in the treasury of this or nearby churches as iconographic reservoirs into which they dipped in order to create original and adaptive iconographies. Technical analysis has cast doubt on diffusionist claims that the Lalibela churches were excavated by "foreign" artisans or masons (generally assumed to be Egyptian; more rarely, Indian).[108] With the possible exception of an inscription in Arabic and Coptic on the ʿāmda berhān, the central monolith in Beta Maryam, which states that an unnamed Christian made the church (amala al-kanīsa; although what exactly this means is unclear),[109] such claims often seem to be rooted more in a priori assumptions about hierarchies of cultures than in any empirical evidence. Instead, it appears that those responsible for carving Beta Maryam and other of the churches were fully cognizant of the underlying geomorphology of the terrain, knowledge likely gained from long experience of excavating the rock in the surrounding regions.[110]

If the bas relief was carved by artisans imported from elsewhere, it is likely to have reiterated iconographic schemes drawn from established repertoires, rather than mining portable artifacts on site. Yet, those who carved the relief were not only perpetuating iconographic types with a long and complex history in the east Christian lands, but also seem to have drawn on more contemporary imagery derived from portable objects of varied origins. Such objects seem to have been integral to the self-fashioning and self-representations of medieval elites who, by virtue of their geographically or politically interstitial situations, often had access to a far greater and more eclectic

array of materials with which to stage their long-distance connections than did contemporaries in larger, more metropolitan centers.

There are parallels here with practices of assimilation and strategies of appropriation known from other Christian courts in contact with the Islamic world in the twelfth and thirteenth centuries. In fact, the long twelfth century preceding the Mongol conquests of the 1250s was a period of maximum receptivity to Islamicate forms and practices on the part of non-Muslim elites living on or outside the frontiers of the Islamic world across a wide swath of territory, from western Tibet to the Christian kingdoms of the Mediterranean and the Caucasus.[111] The Norman court of Sicily is the obvious case in point, with its capacity to stage evidence of relationships to Fatimid Egypt, Byzantium, and the regions of the western Mediterranean through the skillful manipulation of artistic forms, media, and technique. Indeed, the rich eclecticism of the late twelfth- or early thirteenth-century painted ceilings in the church of Yemrehanna Krestos, not far from Lalibela, has sometimes been seen as an Ethiopian counterpart to the paintings in an Islamicate style found on the wooden stalactite vaulted (muqarnas) ceiling of the palatine chapel of the Norman rulers of Palermo.[112] Even the imperial culture of Byzantium, which was among the sources for Norman self-fashioning, was not immune to this vogue for ceilings of elaborate geometric construction painted in a frankly Islamicate mode. In the thirteenth century the palace of the Byzantine emperors in Constantinople featured a muqarnas dome painted with scenes of Turkic princes and their revelries. Where we have accounts of such painted ceilings, they are hailed as marvels and wonders,[113] a theme to which we will return here in chapter 6. Their appearance in the heartlands of three great Christian powers of the twelfth and thirteenth centuries—Sicilian, Byzantine, and Ethiopian—suggests that we are dealing with something much more than a series of entirely localized phenomena.

Along with such architectonic marvels, many of the images and artifacts discussed here might be seen as indexes of "distance made tangible," to borrow a phrase from the anthropologist Mary Helms, instantiating long-distance connections in object form, or through the display of novel iconographies, techniques, and rare and prestigious materials.[114] The explicit identification of some of the exotic birds and chimeras painted in medieval Ethiopian churches and manuscripts as creatures hailing from maritime environments or distant shores is perhaps a case in point.

Beyond a contemporary taste for exoticism, the selective adoption of Islamicate elements such as the sphinx might be seen as an endeavor to stage a relationship between transregional connections advertised by novel artifacts, forms and iconographies, and notions of dominion. It has, for example, been suggested that certain contemporary Byzantine artifacts and monuments drew "from the artistic languages of 'others' in order to define the nature of imperial power." The phenomenon was defined by a degree of stylistic and iconographic diversity, selective adoption, and the meaningful manipulation of elements derived from imported or foreign artifacts.[115]

Such alterations and adaptations remind us that beyond acknowledging the participation of pre-modern elites in a "shared culture of objects" that often transcended political and sectarian boundaries,[116] we need to pay close attention to the specific ways in which traveling objects, the images associated with them, and the techniques underlying them were perceived, deployed, transformed and reimagined in the places in which they came to rest. The material from Lalibela reminds us that the particularities of transcultural reception were often governed by local and deeply rooted cultural traditions.

Nevertheless, a comparative approach suggests that the appearance of Islamicate iconographies at Lalibela should be seen as part of a broader phenomenon of transcultural and transregional reception, marked by a strong agentive dimension. To describe the phenomena of reception witnessed in Lalibela as derivative, passive, or as reflecting a cultural lack would thus run counter not only to the evidence offered by the Beta Maryam relief itself, but also to broader patterns of reception witnessed in the arts of contemporary Christendom to which the Zagwe monument conforms.

Objects, Images, and Material Connections

The available (primarily Arabic) textual sources regarding the circulation of artifacts, commodities, and materials between medieval Ethiopia and the Islamic world tend to put the emphasis on those things exported from the region. As François-Xavier Fauvelle notes,

Merchants are often more careful and scrupulous with the products they buy than those they sell. As a result, the written documentation is more prolific for products purchased by foreign merchants

with African partners in African warehouses and capitals and then exported toward the outside world than it is for products imported in Africa.[117]

Consequently, there is a tendency in much modern scholarship toward imagining medieval Africa as a place of exports (and often exports of raw materials and slaves rather than of manufactured goods), rather than imports.

Considering it alongside the range of imported artifacts preserved in the church treasuries of Lalibela and the surrounding regions, analysis of the Beta Maryam relief provides a richer context for understanding the nature and origins of the foreign artifacts reaching the site in the twelfth and thirteenth centuries, and their reception. The connections and networks to which they attest extend well beyond the northern route to Egypt, which has been almost exclusively privileged in scholarship on medieval Ethiopian art. In contrast, the material presented here highlights the need to consider Ethiopia as existing at the intersection of maritime and trade networks connecting north and south (including the lands of the African south) and the Indian Ocean littoral with the southern Mediterranean.

As we have seen, likely sources for certain elements within the Beta Maryam relief include portable objects bearing images of falconers and sphinxes, such as ceramics or metalwork. The presence of these kinds of objects is not in doubt, for the many examples of medieval Islamic metalwork (predominantly trays and incense burners) with Arabic inscriptions (primarily Mamluk, but also Rasulid and Ayyubid) from Egypt, Syria and Yemen, and occasional fragments of Islamic textiles, found in the treasuries of the churches around Lalibela and further north in Tigray offer ample evidence of a receptivity to Islamicate artifacts.[118] Textual evidence helps expand the array of materials likely to have reached Ethiopia. A thirteenth-century customs manual from Aden specifically prohibits the export of Egyptian gilded glass to Ethiopia and India in order that such objects be reserved for use as diplomatic gifts by the Rasulid sultans of Yemen, who sent them to curry favor with the commercially important elites of western India; the need for such a prohibition suggests that such Egyptian ornamented, possibly enameled, glass was finding its way across the Red Sea, presumably for use by Ethiopian elites.[119] By the late thirteenth or early fourteenth century, imported Egyptian, Yemeni, and Iraqi textiles seem to have been in high demand in Ethiopia, and there is little reason to

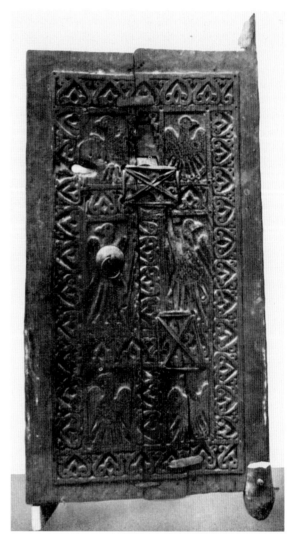

Fig. 177 Carved wooden door with eagle ornament, formerly in the monastery of Gunaguna, Eritrea, possibly Fatimid Egypt, 11th–12th century (= Mordini (1940), 105–7).

imagine that this taste did not develop earlier.[120] Indeed, the presence in the monastery of Debra Damo of Egyptian *ṭirāz* textiles, some bearing the names of caliphs who reigned from Baghdad in the ninth century, others datable to the period of Ikshidid reign over Egypt in the tenth, attests to a much earlier trade in Islamic textiles. Some of these bore embroidered human and animal figures, a reminder of the potential of textiles to act as iconographic repertoires and artistic vectors.[121]

Should it seem implausible that motifs derived from the arts of the Islamic lands (or even further afield) could be integrated into the ornamentation of a Christian church, one might point to the appearance of many other elements in medi-

Fig. 178 Remains of a carved stone Arabic inscription in Kufic, church of Abraha and Atsbeha, Wuqro, Tigray, Ethiopia, 11th–12th century.

eval Ethiopian churches that reflect a common source in an Islamicate artistic vocabulary. These include wall decoration with interlaced eight-pointed stars carved in stone on the lower walls of the southeast funerary chamber in the church of Abraha and Atsbeha in the Geralta region of Tigray.[122] This church lay in close proximity to a well-documented Muslim community, and the design may imitate forms of stucco or tilework found in contemporary Islamic architecture. In addition, certain structural features of medieval Ethiopian churches seem to indicate the presence of peripatetic Yemeni (rather than Egyptian) craftsmen, suggesting that those with specialized technical skills may have operated across sectarian boundaries.[123] It is even possible that carved architectural and architectonic elements were imported: a wooden door carved with palmettes and eagles with strong Fatimid affinities was preserved at Gunaguna monastery in Eritrea before it was removed by the Italian occupation forces in the late 1930s and subsequently lost (fig. 177).[124] Whether it was carved in a Fatimid style by Egyptian or Ethiopian carpenters or imported from Egypt (which is entirely possible) is not clear.

The shift in scale from portable objects to stone relief implied in the idea of adaptive appropriations from ceramic, metalwork, or painted shields in the details of the Beta Maryam carving by no means lacks parallels. It has been suggested, for example, that imagery found on portable

objects (ranging from coins to ceramics and metalwork) may have provided models for the monumental figurative reliefs that proliferated in the contemporary architecture of southern Anatolia and northern Iraq, some of which are related in content to the magic-medicinal bowls discussed above in chapter 4.[125] Moreover, evidence that such portable artifacts were capable of inspiring forms of ornament even in the most iconographically sensitive of contexts in medieval Ethiopia is indicated by the appearance of a pseudo-Kufic inscription surrounding an image of the crucified Christ on the upper surface of a twelfth- or thirteenth-century altar table (*manbara tābot*) from the church of Terasfare Estifanos near Lalibela.[126] The units of the inscription are comprised of the most common type of pseudo-inscription from the medieval Islamic world, likely an abbreviation for the Arabic doxology *al-mulk lillāh* (dominion belongs to God); the phrase appears in a fragmentary Kufic inscription now preserved in the church of Abraha and Atsbeha in Tigray (fig. 178).[127] This may come from a medieval mosque, but given the presence of Arabic or pseudo-Kufic inscriptions in some of the medieval churches of Ethiopia, the possibility that it was associated with a church from its inception cannot be entirely ruled out.[128] Although originating in the arts of the Islamic lands, like the falcon and sphinx in the Beta Maryam relief, such elements might better be described as Islamicate, since they were by no means exclusive to either Muslim or

religious contexts, even in their likely points of origin.[129]

If the evidence for the selective adaptation of elements derived from the portable arts of the Islamic lands in the Beta Maryam relief is clear, the precise mechanisms by which such portable objects circulated are not. In addition to the portability of objects, the mobility of those who carried, gifted, and traded them is relevant. The presence of Muslim merchants from Egypt and Syria operating in Ethiopia in the later eleventh and early thirteenth centuries is well attested.[130] Among them was Ibn Sayqal (d. 688 H/1289 CE), a Damascene who conducted his business between India, Yemen, and Ethiopia.[131] The likely role of the Egyptian metropolitan bishops appointed from Alexandria (and their retinues) in introducing new architectural and visual models to the repertoire of Ethiopian artisans has also been noted.[132] In addition, there are consistent reports that Arabic-speaking Muslims, especially Muslim merchants involved in trade between Ethiopia, Yemen, and Egypt, served in embassies between the Ethiopian royal house and the Ayyubid and Mamluk sultans of Egypt in the twelfth through fifteenth centuries.[133] Egyptian and Syrian merchants seem to have served as informants for the descriptions of Ethiopia provided by Arab geographers and historians of the thirteenth and fourteenth centuries who were curious about Ethiopia and other distant lands.[134]

Some of these peripatetic mediators came from the Muslim communities of Ethiopia itself, however: communities whose histories are beginning to come into focus thanks to recent fieldwork.[135] Two regions in particular have produced extensive evidence for the existence of early Muslim communities with trade and other connections to the wider Islamic world. In northern Ethiopia, recent research around Bilet and Kwiha, near Mekele in Tigray, has demonstrated the existence of Muslim communities from at least the tenth century, which flourished in the twelfth and thirteenth; there are epigraphic indications of Arabian, Egyptian, and Iranian links, and suggestions that some among these communities were involved in trade.[136] The fragmentary Arabic inscription in Kufic script now preserved in the church of Abraha and Atsbeha in nearby Wuqro (see fig. 178) may be a remnant from a tenth- or eleventh-century mosque serving this community.[137]

In eastern Ethiopia, meanwhile, recent excavations at the site of Harlaa, near Harar, have produced evidence that the site was an entrepot serving a predominantly Muslim community in the eleventh to thirteenth centuries, one with an astonishingly cosmopolitan array of direct and indirect maritime and terrestrial connections to both the wider Islamic world as far east as Iran and Central Asia and around the Indian Ocean littoral, including likely evidence for connections with western India.[138]

The communities in Tigray and Harlaa were well situated to take advantage of the trade routes leading from the Red Sea ports of Massawa in the north and Zayla in the south to the highlands of the Zagwe kingdom (see map 5), and may have acted as de facto mediators or middlemen. It has even been suggested that the Muslim sultanates of Ethiopia occupied ecological thresholds, liminal spaces that enabled them to act as brokers, situated at intersections between maritime and terrestrial routes leading to the highlands: "as the Christians were in possession of the resources of the highlands and the Muslims were in charge of the routes, for a while a 'competitive symbiosis' ensued between the competing Muslim and Christian powers."[139] Given this arrangement, it takes little imagination to understand how the objects from the Islamic lands that provided occasional models for Ethiopian artists, and whose presence is still attested by the medieval treasuries of Lalibela and elsewhere, may have made the journey from Egypt, Syria, or Yemen to the Ethiopian highlands. The likely role of the self-styled sultans of the Dahlak archipelago (off the coast of Eritrea) in brokering the traffic in such artifacts between the Indian Ocean, Red Sea, and Ethiopian highlands should also be mentioned.[140]

The possible trajectories of the Indian objects in the churches of Lalibela (see figs. 164–166 and 174) and its surrounds (see figs. 168, 169, and 171) are less easy to reconstruct, even though some sorts of commodities such as Indian textiles were imported to Ethiopia at least as early as the late thirteenth or early fourteenth century.[141] In addition, the import of Indian goods into neighboring Yemen is well documented for the twelfth and thirteenth centuries: when he died in 1151 or 1152 CE, the belongings of Bilal ibn Jarir, governor of Aden, included Indian rarities (tuḥaf al-Hind).[142] The importation of Indian spears is attested by early thirteenth-century documents from Quseir al-Qadim on the Red Sea coast of Egypt, and Indian shields were used in Ethiopia by the armies of Ahmad al-Ghazi/Gran in the sixteenth century.[143] The presence of such shields in Lalibela might therefore be seen as reflecting direct or indirect trade links with India under the Zagwes. Beyond any practical function, that the shields were placed around the triumphal arch directly in front of the Holy of Holies of the church of Med-

hane Alam is indication enough of their status as valued rarities, possibly dedicated to the church as offerings or votives.

However, like the materials from the Islamic lands in medieval Ethiopian church treasuries,[144] the range of Indian materials in and around Lalibela suggests that they may have reached the Zagwe kingdom by different routes, not all of them either commercial or direct. The stunning quality of the Indian shields in Lalibela (and possibly the related cuirass; see figs. 164–166 and 174) suggests that they were, at least originally, something more than market commodities, reminding us of the need to avoid reducing transregional connections to commercial exchange alone.[145] On the contrary, their delicacy and refinement suggest that they were ceremonial shields, whose possession is likely to have been the prerogative of ruling elites. It is perhaps conceivable that they were diplomatic gifts, such as those (including an elegant gold crown) carried by the embassies exchanged between the Muslim rulers of Egypt and the Christian kings of Ethiopia on the appointment of a metropolitan for the Ethiopian church, among other occasions.[146]

Even if this is so, it does not follow that they were sent directly from south India. The 'regifting' of Mamluk enameled and gilded glass produced in Egypt and likely received as a diplomatic gift by the Rasulid sultans of Yemen, who attempted to reserve it as an exclusive diplomatic gift for the rulers of western India (and possibly China) and forbade its export to Ethiopia, reminds us how complex were the multiple mediations and redistributive networks through which diplomatic contacts were often effected, even when it came to the most fragile and ephemeral of materials.[147]

Just as Chinese ceramics and coins reaching East Africa in the tenth to twelfth centuries are likely to have been brought by Arab or Indian traders,[148] so it is possible that some or all of the Indian artifacts reaching the highlands of Ethiopia in the twelfth century were mediated by long-distance traders. We might bear in mind here suggestions that cotton cultivation and the use of a loom type associated with it were introduced to highland Ethiopia around the twelfth century from India, likely via the mediation of Arab merchants and travelers.[149]

The twelfth century saw powerful mercantile guilds operating in southern India,[150] and it is conceivable that their contacts extended westwards in ways previously unsuspected. Recent research has highlighted the material evidence for contacts between East Africa and India in the first millennium CE, and the presence of goods from Ethiopia in the ports of southern India is mentioned by the Timurid ambassador ʿAbd al-Razzaq al-Samarqandi in the early 1440s.[151] Yet, there is, as far as I am aware, virtually no epigraphic or textual evidence for contacts of any kind between Ethiopia and the maritime kingdoms of western India as early as the twelfth and thirteenth centuries. A rare exception is an inscription datable to ca. 1042–49 CE in the name of Jayakeshi I, one of the Kadamba rajas of Goa, mentioning that his trading connections extended as far west as Zangavar (Zanzibar).[152] This may be no more than a rhetorical flourish, but it is worth bearing in mind the slightly later case of the Rasulid sultans of Yemen, who claimed authority over India, and offered financial support to Muslim diasporic communities living on the west coast of India in exchange for the recognition of their rule in Friday prayers.[153]

It is not beyond the realm of possibility that direct or indirect connections with India, or even an Indian diaspora, already existed in Ethiopia at an earlier date than is sometimes assumed. Both are well attested for the early modern and modern periods;[154] but an Indian diaspora existed in the port cities of southern Iraq as early as the ninth and tenth centuries.[155] In Africa, excavations at Shanga, on the Swahili coast, have produced an eleventh-century bronze lion figurine of a type associated with the Deccan region of south India, but representing an African lion probably cast from Chinese copper coins.[156] Its excavator, Mark Horton, speculated that the Shanga lion was cast in East Africa and may have formed part of a portable Hindu shrine, cast for a member of an Indian diaspora.

Equally relevant is the existence of an Ethiopian diaspora in the Islamic and Indian Ocean worlds in the twelfth and thirteenth centuries. Occasional fragments of twelfth- and thirteenth-century Ethiopic manuscripts have been documented in Egyptian monasteries, presumably attesting to the presence of the monks who produced or used them.[157] In the Islamic lands, Ethiopians constituted a diaspora that extended well beyond the monasteries of Egypt or the churches of Jerusalem, which had a well-documented Ethiopian presence from at least as early as the thirteenth century.[158] In the Mamluk period, Ethiopian students are documented at al-Azhar University in Cairo, one of the greatest universities of the Muslim world, while inscriptions in Geʿez accompanied by paintings, attest to the contemporary presence of Ethiopian monks in the Qadisha Valley in Lebanon.[159]

Fig. 179 Detail of paintings on the western ceiling in the church of Yemrehanna Krestos near Lalibela, 12th or 13th century, depicting a ship sailing on a sea of fish.

Insofar as the history of this Ethiopian diaspora has been addressed by scholars, the focus has tended to be on the early modern period, from the fifteenth century onward.[160] There is, however, evidence for an Ethiopian diaspora in the Islamic world at a much earlier period, even if this has never been systematically collected. Arabic sources report the presence of Ethiopian Mus-

lims in the mosques of Tripoli (now in Lebanon) as early as the tenth century, for example.[161] In the twelfth century, an Ethiopian (ḥabashī) patron founded a mosque as far east as Lahore, then the capital of the Ghaznavid sultans of Afghanistan.[162]

In addition, as we have seen, under the Zagwe and Solomonid dynasties both Ethiopian Christians and Muslims were active along the terrestrial and maritime networks connecting Ethiopia to the Islamic lands and beyond.[163] Especially relevant is evidence for the involvement of both Christian and Muslim Ethiopians in the Red Sea and Indian Ocean trade in various capacities, plying the high seas as far away as south India.[164] The twelfth-century letters of the Jewish traders resident there refer to merchants and their agents arriving from various parts of East Africa, including Abyssinia and the port of Berbera on the Somali coast. A letter written to the Jewish merchant Abraham ben Yiju, residing in Mangalore in south India in the later 1130s, mentions an Abyssinian (ḥabashī) captain of one of his ships trading between Aden and south India who, with the name of Masʿud, was evidently an Ethiopian Muslim, although whether from the Muslim communities of the Red Sea or the Ethiopian highlands is unclear. In the same letter, ben Yiju's agent mentions that he has sent him gifts, including a good Ethiopian hide (used for dining). Other letters to ben Yiju mention the dispatch of gifts including hide mats, apparently a frequent export to India, from the port of Berbera.[165]

The extent and nature of Ethiopian involvement in the pre-modern Indian Ocean world remains to be determined. Material evidence attests to the role of both Indian seafarers and Ethiopian sailors from Axum in the late antique maritime networks connecting the Red Sea and Indian Ocean,[166] but it is unclear whether such activities continued, even on a diminished scale, between the decline of Axum in the sixth or seventh century and the rise of the Zagwe dynasty in the eleventh or twelfth. Once again, we are confronted with a significant lacuna in the archive. It is worth noting, however, that studies of maritime activities in another part of East Africa, the Swahili coast, have drawn attention to an intensification of maritime activity from around the eleventh or twelfth century.[167] Similarly, the proliferation of materials and imagery relating to the Islamicate and Indic worlds in and around Lalibela during the late twelfth and early thirteenth centuries seems to point to a significant intensification of both terrestrial and maritime transregional contacts—a phenomenon likely related to contemporary geopolitical conditions.

In view of their maritime associations, it is equally noteworthy that the images of sphinxes at Beta Maryam in Lalibela, and Qorqor Maryam in Tigray (see figs. 154 and 159) both appear in churches dedicated to the Virgin, the traditional protectress of sailors and maritime voyagers. The association is not abstract. An inscription in Geʿez on the legs of an altar table (manbara tābot) in the church of Beit Giyorgis at Lalibela, dedicated to the Virgin in the name of Masqal Kebra, the wife of King Lalibela, reportedly includes a remarkable prayer to God and the Virgin. In addition to several supplications, which recall those found on amuletic texts (to preserve crops, protect from illness and demonic possession, and so forth), the inscription continues in the voice of the Virgin:

> Those who voyage on the sea in ships and who invoke my name, save them from the gushing of the waves of the sea and the violence of the winds; those who have journeyed in a distant land and who invoke my name, return them speedily to their own land.[168]

There is no shortage of evidence for a self-conscious awareness, perhaps even the careful staging of evidence, of these maritime contacts in and around the churches of Lalibela, where they can be understood as part of similar supplications. It includes a spectacular depiction of a ruddered long-distance vessel sailing amidst shoals of fish preserved within an array of figurative paintings on the western ceiling in the cave church of Yemrehanna Krestos, about twenty-five kilometers from Lalibela (fig. 179), generally (but not uncontroversially) believed to be of late twelfth-century date.[169]

That such a painting appears in a cave church constructed in the highlands of Ethiopia, roughly three hundred kilometers from the coast and at a height of 2,500 meters above sea level, is testament enough to the importance of transregional connections that depended on the intersections between maritime and terrestrial networks. The ship forms part of an eclectic iconographic ensemble that awaits further investigation, but that may have magical or talismanic associations.[170] The image may, therefore, represent pictorially the sorts of supplications for safety inscribed on the altar in Lalibela. The vessel appears to be manned by Ethiopian sailors, providing a unique visual counterpart to the textual and epigraphic evidence for the involvement of Ethiopians in an Indian Ocean world that was to a remarkable degree in motion.[171]

Map 6 Locations of the principal sites discussed in chapter 6 . Map by Matilde Grimaldi

Chapter 6

Narrative and Wonder in the Indian Ocean

It is your Lord who drives your ships across the seas that you may seek of His bounty. He is verily kind to you. When a calamity befalls you on the sea all those you invoke fail you except Him. But when He brings you safely to the shore, you turn away, for man is most ungrateful.

—Qur'an 17:66-67[1]

An Iraqi *Maqāmāt*

At around the same time (give or take a few decades) that the Yemrehanna Krestos painting was set in place in the highlands of Ethiopia, another image of a ship plying the Indian Ocean was painted, in a manuscript produced in Iraq. If the Ethiopian painting and the Lalibela relief discussed in chapter 5 attest to contacts between the highlands of Ethiopia, the Islamic lands, and possibly even the worlds of the Indian Ocean in the twelfth and thirteenth centuries, then something of that world is captured too in this image (fig. 180). The near simultaneous creation of these images of mobile microcosms is in itself striking, offering a visual shorthand for contemporary transregional connectivity and mobility.

But there is also a historiographic connection. Among the Islamic materials that have been compared to the Beta Maryam relief in Lalibela is an image following that of the ship in the same manuscript. The painting evokes a landscape populated by a dense profusion of wildlife (figs. 181 and 182).[2] Here, familiar animals such as parrots and monkeys coexist with exotic birds and hybrids such as sphinxes and harpies, reflecting the contemporary popularity of the kinds of chimeras that found their way onto the facade of the Ethiopian church.

Both images appear in an illustrated copy of the *Maqāmāt* (Assemblies) penned by the author Abu Muhammad al-Qasim ibn ʿAli ibn Muhammad ibn ʿUthman al-Hariri (1030-1122 CE). Al-Hariri's *Maqāmāt* was one of the most popular texts in the medieval Arab lands, "the best seller of its age," with more than seven hundred copies reportedly produced in the author's lifetime alone.[3] The idea of both mobility and dispersed geography is intrinsic to the text of the *Maqāmāt*, a series of fifty picaresque tales concerning the machinations of a brilliant but amoral character, Abu Zayd, as narrated by an observer and erstwhile traveling companion, al-Harith. Abu Zayd is gifted of tongue, endowed with a superlative capacity for linguistic eloquence, which he mostly uses to further his advantage by beguiling and enchanting the naïve and gullible. The fifty self-contained episodes or "assemblies" (*maqāmāt*) are each named after a different locale in which the action takes place, moving from city to site, almost never in linear sequence. Appropriately enough, al-Hariri's text circulated widely in the medieval and early modern world, with copies found from North Africa to Beijing.[4]

Al-Hariri's text is heavily indebted to an example of the *maqāma* genre as written a century earlier by Badiʿ al-Zaman al-Hamadhani (d. 1008 CE), but expands its geographic range to cities not included in the earlier text. If earlier iterations of the genre are "rich in peregrinations and toponyms," in al-Hariri's text the cumulation of place, from the Maghreb, the western edge of the Islamic world, through Egypt, Palestine, Syria, Arabia, Iraq, and Iran to Central Asia and even the Caucasus, delineates an itinerary of profane pilgrimage, a geographic imaginary that maps the major centers and regions of the medieval Islamic world in discrete episodic fashion.[5] Occasionally this imaginary includes unnamed exotic locales

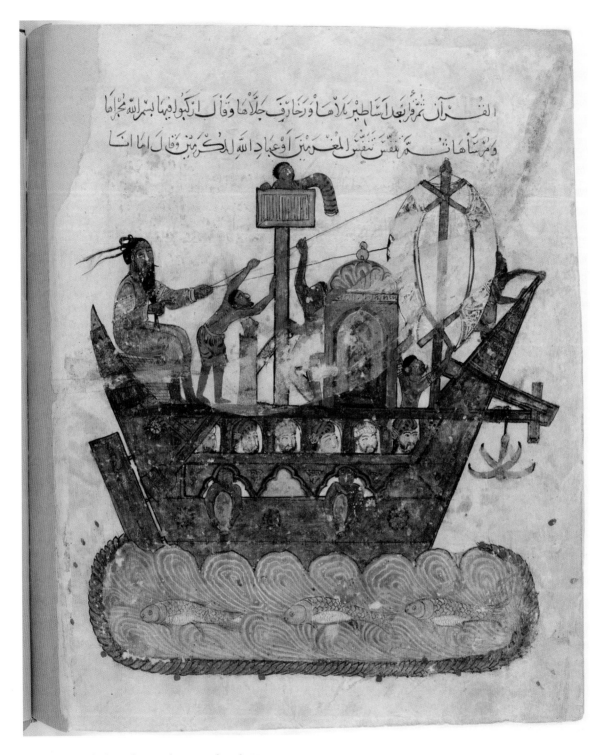

Fig. 180 Image of a ship sailing to Sohar, Oman, from the *Maqāmāt* of al-Hariri, *maqāma* 39, painted by Yahya al-Wasiti, 634 H/1237 CE. 37 × 28 cm. Paris, BnF, MS Arabe 5847, fol. 119b.

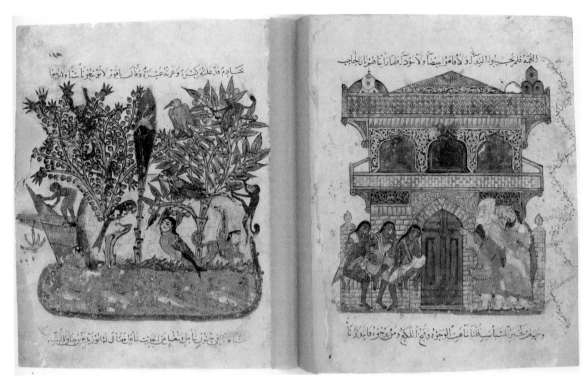

Figs. 181 and 182 Reading from right to left: Scenes of arrival at the palace (fig. 181), and an enchanted island (fig. 182), from the *Maqāmāt* of al-Hariri, *maqāma* 39, painted by Yahya al-Wasiti, 634 H/1237 CE. Each 37 × 28 cm. Paris, BnF, MS Arabe 5847, fols. 120b–121a.

into which fortune casts the protagonists. This is the case with *maqāma* (assembly) 39, to which the iconic images of the ship and island mentioned above belong, a tale involving a sea voyage, a stranding on a mysterious isle, aid rendered to its rulers, and rich rewards being heaped on Abu Zayd in consequence (see figs. 180–182 and fig. 183).

The copy of the text in which these images appear was completed on 7 Ramadan 634 according to the Islamic or *hijri* calendar, equivalent to May 4, 1237 CE, almost certainly in Baghdad. Unlike for the artifacts and images discussed in chapters 4 and 5 above, in this case we know the name of the artist, for the colophon offers the crucial information that a single individual, Yahya ibn Mahmud ibn Yahya ibn Abi'l-Hasan ibn Kurriha al-Wasiti, was responsible for both calligraphy and illustrations.[6]

While illustrated Arabic books seem to have been rare before around 1100 CE, in the twelfth and thirteenth centuries the arts of the book flourished in Iraq and Syria, with major centers of production in Baghdad and Mosul. There is little indication that this illustrated copy of the text, produced more than a century after the author's death, was a royal commission, or indeed com-

missioned at all. Instead, it seems symptomatic of a moment when the emergence of a powerful urban bourgeoisie in the central Islamic lands led to the expansion of the base of patronage and a burgeoning of the portable arts, including manuscripts produced for sale in the famous book bazaars of the Islamic world.[7] In this sense the manuscript belongs to the world of commodities and commodification which gave rise to the portable objects that served as a source for some of the Ethiopian imagery discussed here in chapter 5, or to the magic-medicinal bowls discussed in chapter 4. In fact, although this manuscript was almost certainly produced in Baghdad, some of its imagery may have been inspired by manuscripts produced slightly earlier for the Artuqid rulers of the Jazira, around the same time and in the same region as the "poison bowls" discussed above in chapter 4.[8]

In a series of case studies dedicated to the archival value of artifacts and images lacking any substantial textual context, it may seem paradoxical, if not contradictory, to select the illustrations to a text as a case study; and all the more so since the 1237 *Maqāmāt* manuscript is perhaps the most accomplished and innovative of the illustrated Arabic manuscripts surviving from the

pre-Mongol Islamic world, the cynosure of a tradition that reached its apogee in Iraq and Syria in the twelfth and thirteenth centuries. It is also the most frequently discussed in modern scholarship, for the number and scale of its images, for their aesthetic virtue, emotional complexity, and transmedial filiations, for the insights they provide into contemporary social life, and for their illustrious afterlife as a source of inspiration for modernists in the Arab lands.[9]

Most studies of the manuscript have focused on the nature of the relationship between the images and the text that they accompany. For Oleg Grabar, for example, the images in medieval manuscripts of the *Maqāmāt* could be seen as both commentaries on the text and as visual experiences inspired by, but running parallel to it.[10] More recent scholarship has highlighted intermedial dimensions of the images, including a likely relation to shadow plays and puppets.[11] Others have noted that the content of the images in the manuscript far exceeds the cues provided by the text, with opinion split about how to interpret this. When it comes to the image cycle accompanying maqāma 39, the subject of this chapter, some ascribe the unusual iconography to a combinatory artistic agency (elements being drawn from observation and/or the artist's imagination), while others have suggested that the images preserve an echo of earlier illustrated texts related to the Indian Ocean world, which do not survive.[12]

What I want to suggest here is that the truth lies somewhere in between. Many of al-Wasiti's paintings seem to draw upon the artist's experience, exceeding the specifications of the text by adding details that evoke contemporary social life rather than hewing precisely to the textual cues. In terms of the image cycle accompanying maqāma 39, however, the images do much more than respond to or supplement the textual cues provided by al-Hariri's text, offering a de facto exegesis on the text itself. In doing so, they extend the purview on the text in ways that suggest the impact of oral and textual lore relating to maritime adventures and wondrous distant lands. In other words, the images accompanying maqāma 39 in al-Wasiti's copy of the *Maqāmāt* perform an intertextual function that operates by means of the visual. Performing their subtle exegesis on the complex text, al-Wasiti's images forge suggestive connections linking the heartlands of the Abbasid caliphate in Iraq to Africa and India. None of these relationships is made explicit in the original text of the manuscript—instead, the clues are in the images themselves and the questions that

they raise regarding artistic agency, transmedial filiations, and the afterlives of certain ancient iconographic types.

The maqāma genre to which al-Hariri's text belongs combined rhymed prose with poetry and is itself marked by what Abdelfattah Kilito calls "a dialogue of genres," an intertextual dimension that relates it to traditions of geographical writing, works on wonder (*ʿajāʾib*) and the genre of practical ethics known as *adab* (belles-lettres).[13] The paintings in al-Wasiti's copy of al-Hariri's *Maqāmāt* extend the intertextual logic of the maqāma genre itself to the domain of the image. The cycle of paintings accompanying maqāma 39 constitutes the paradox of a visual medium deployed to extend the intertextual dimension of the genre by visualizing fabulous scenarios conjured with words in other verbal and textual genres concerned with distant voyages, far-off lands, and wondrous topographies. Considering these complex entanglements between orality, textuality, and visuality, it is worth bearing in mind the suggestion that the paintings in some copies of the *Maqāmāt* were intended to accompany public recitations—oral performances of the text.[14]

The story of maqāma 39 begins as a ship is about to depart an unnamed port to sail to Sohar, a port in the Gulf of Oman that lies at the mouth of the Indian Ocean (see map 6). At the last minute, a passenger (Abu Zayd) pleads to be taken on board, promising that he has in his possession a charm that can protect the voyagers from the vagaries of the sea.[15] No sooner have they set sail, however, than a fierce storm forces the ship to take refuge on a mysterious unnamed island. Obliged to hunt for provisions, the protagonists venture into the interior of the island, where they encounter a splendid palace outside which a group of servants are loudly lamenting. Enquiring as to the cause of their lament, Abu Zayd and al-Harith are informed that the wife of the ruler of the place has been suffering a difficult labor for days, with mounting concerns for her safety and that of her as yet unborn child. Ever one to seize an opportunity, and not in the least inhibited by the ineffectiveness of his earlier charm, Abu Zayd immediately offers to produce an amulet to aid the woman's labor, penning verses which, unbeknown to his patron, contain nonsense regarding the precarity and undesirability of birth. Attached to the thigh of the woman on Abu Zayd's order, the amulet has the desired effect, and the scamster is heaped with rich rewards by the lord of the place.

For reasons unclear, but perhaps because of the scope that it gave to a highly original artist, this

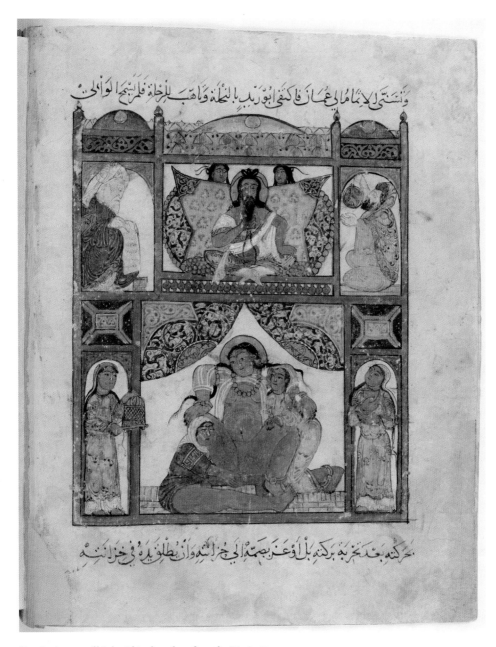

وَاشْتَرَى الِامَامَ اي عِمَانٌ فَاكْتَفَى ابُو رَيْدَ بِالنَّخْلَةِ وَاهَبَ لِلرِّخْلَةِ فَلَمْ يَسِمَحَ الوَاىلِى

حَرَكَتُهُ بَعْدَ بَحَرِ بَحَرِ بَرَكَتِهِ بَلْ اُوعِزَ بِصَمْتِهِ الِى جَرْ حَرَائِشِهِ وَانْ يَطْوِيَهُ فِى خَزَائِنِهِ

Fig. 183 A scene of birth within the palace, from the *Maqāmāt* of al-Hariri, *maqāma* 39, painted by Yahya al-Wasiti, 634 H/1237 CE. 37 × 28 cm. Paris, BnF, MS Arabe 5847, fol. 122b.

assembly or tale is singled out for special treatment in the 1237 CE manuscript, distinguished by the number, scale, and quality of its paintings, and the interrelationships between them (see figs. 180–183).[16] The artist provides a sequence of images to accompany the text, from an initial image of the voyage to the island and the palace of its ruler, in which the sequence culminates in a remarkable scene of parturition (fig. 183). The tale occupies eleven pages, four of which are taken by paintings framed only by two lines of text, an extraordinary

commitment to the image in a manuscript of this period. This is, in fact, the most heavily illustrated tale in the entire manuscript, which currently has ninety-nine paintings and may originally have had up to ten more. Of the sixteen full-page paintings that occur in the entire manuscript, a full 25 percent, accompany this story, an unprecedented exploitation of the pictorial potential of the codex form.[17]

The first image occurs three pages into the text and shows a ship sailing the ocean (see fig. 180)

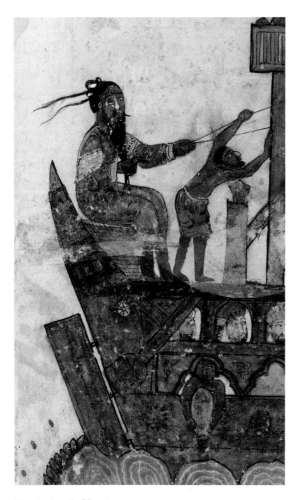

Fig. 184 Detail of fig. 180.

facing a page of text. Turning the page, the reader is confronted with two facing folios, each occupied by paintings bearing minimal texts. That on the right, the earliest in the sequence (Arabic manuscripts proceeding from right to left) shows the narrator and Abu Zayd arriving at a richly ornamented palatial building outside which three servants stand (see fig. 181), their distress evident from their gestures and comportment. Facing this is the image frequently singled out as the most original in the manuscript, and which has been compared to the Ethiopian relief discussed here in chapter 5. This presents the viewer with a fantastical rendering of the island on which the hapless voyagers have sought refuge, a maritime landscape populated by colorful exotic birds perched in fruit trees in which monkeys play, while a harpy observes, and a sphinx wanders nonchalantly past (see fig. 182). To the far left of the island scene, sheltered behind a rocky outcrop, a sailor attends to the prow of a ship from which hangs an anchor. The two images should be read as

a single unit, providing a simultaneous vista, synchronic snapshots of the island: the arrival at the palace, the surrounding topography of the island on which the hapless voyagers have sought refuge, and the ship on which they voyaged at anchor in a bay.

Followed by two pages of text, this cycle of images culminates in a spectacular rendering of the interior of the palace whose exterior we have just glimpsed, in which a section through a two-tiered structure frequently employed in contemporary Iraqi painting (see fig. 203) is pushed to its limits to reveal multiple actors segregated by gender, but all simultaneously involved in the moment of highest drama: the struggle of the queen to give birth (see fig. 183).

Sailors and Slaves in a Maritime Cosmopolis

The sequence begins with the oft-reproduced image of the boat en route to Sohar in Oman (see fig. 180). The scene opens a window onto the cosmopolitan, or at least heterogeneous, world of Indian Ocean travel, offering us a glimpse of the ship navigating the Gulf as it makes its way toward Oman. This is, quite literally, the calm before the storm. The makeup of the crew is not specified in the text, but al-Wasiti's rendering constitutes a kind of visual ethnography of the maritime world connecting the Gulf and Indian Ocean. The passengers seen inside the ship are light-skinned and wear contemporary Arab dress consisting of turbans and loose-fitting robes. They are further distinguished by their facial hair, or in one case its absence, suggesting a range of ages. By contrast, those at work on the ship are dark-skinned. Although non-Arab figures, including Greeks, are sometimes shown with dark skin in contemporary Arab painting,[18] here the captain or pilot comfortably seated at the rear of the ship of the boat is, along with the lord of the palace discovered upon the island (see fig. 183) and his servants (see fig. 181), depicted according to conventions used for Indians in Islamic art of the twelfth and thirteenth centuries.[19] These include dark skin, long hair gathered in a top-knot, and a long beard. While the lord of the palace is depicted with the conventional bare torso of Indians, the captain of the ship is dressed in a fine robe bearing golden, inscribed *ṭirāz* bands (fig. 184).

By contrast the three sailors working the rigging and the fourth in the crow's-nest (see figs. 180 and 184) have shorter hair and beards, bare torsos (with the exception of the figure on the right, who sports armbands), and wear a waist wrap (*izār*).

Comparison with depictions of Africans in this and other illustrated Arabic manuscripts suggests that they are likely to be African, and it has been suggested that they may in fact be Ethiopian.[20] Sailors of a similar type operate the boats depicted in other contemporary copies of the *Maqāmāt* produced in Iraq and Syria.[21] As Roxani Margariti notes,

> Through the use of these iconographic types, the space of the ship seems to connect distinct groups of people, just as its maritime trajectory connects diverse places on the map. [. . .] The image hints at the ethnic, religious, social, and geographical diversity of the cast of characters who plied the Indian Ocean, and then collapses them into a set of contrasts that (to us today and possibly to the author and audience of this painting) stand for that world's diversity.[22]

The image reminds us of the many contributions made by Africans, Indians, and others who labored to grease the wheels of commerce around the Indian Ocean littoral in pre-colonial trade networks, and their role in connecting Africa and Asia with the central Islamic lands. As a recent essay on the role of East Africa in the early Indian Ocean trade networks puts it,

> Traditional thinking and historical sources stress the role of wealthy merchants, ship owners, and political and commercial leaders in early trade, yet many of these people moved little if at all, and many social strata (and/or cultural divisions) separated them from the people who did move. Journeys by ship across the Indian Ocean and back took years of people's lives and demanded levels of nomadism that came much more naturally to some groups than others. These groups are largely invisible archaeologically and historically, but agency and visibility should not be confounded.[23]

Appropriately, the images also remind us that if the world of the Indian Ocean trade networks was a cosmopolitan one, it was also hierarchical, its networks sustained by physical labor: emblematized perhaps by the two small figures seen at the bottom bailing water from the interior of the ship (see figs. 180, 190, and 191).

Although rarely discussed in modern scholarship, the proliferation of figures identifiable by their dress as Indian or African in Islamic art of the twelfth and thirteenth century is striking.[24] It seems that, by this time, images of Africans were widely dispersed even in popular visual culture.[25] It is true that the quantity of artifacts from this period is far greater than from earlier, and that during this period we see an expansion of the range of media, from illustrated books to ceramics and inlaid metalwork, marked by an exponential interest in the human figure. However, the interest in visual difference articulated by modes of dress, hairstyle, or skin color is no less evident, even if many (but by no means all) of the relevant figures are subaltern types, involved in entertainment, manual labor, or service, as is the case with many of the figures depicted in al-Wasiti's images.[26] In the decades preceding the production of the 1237 *Maqāmāt*, for example, the image of bare-chested or naked black-skinned wrestlers or entertainers seems to have been a popular visual trope, found in contexts as distant as Iranian ceramics and the ceiling of the Capella Palatina in Palermo (painted in the 1140s, probably by a workshop from Fatimid Egypt).[27] Such images may represent the popularization of topoi derived from the imagery of courtly pursuits, but they are sometimes accompanied by attributes that locate them geographically with more precision. A painting in a Mamluk illustrated copy of the *Kitāb al-ḥayawān* (Book of animals) by al-Jahiz (d. 868 CE) produced in Syria in the fourteenth century, shows a bare-chested dark-skinned figure, likely African, leading a giraffe (fig. 185). The image recalls the role of such African fauna in direct or indirect diplomatic exchanges between the rulers of Ethiopia, Egypt, and Yemen, a role which may underlie their depiction on several luster bowls produced in Egypt in the eleventh and twelfth centuries.[28]

In both contemporary manuscript illustration and ceramics Indian figures often appear riding elephants. The scene on a late twelfth- or early thirteenth-century Iranian bowl shown here (fig. 186) occurs on several similar bowls, and has been interpreted as depicting Sapinud, the Indian bride of the Sasanian shah Bahram Gur mentioned in the Iranian epic, the *Shāhnāma* (Book of kings); if so, the dark-skinned bare-chested figure on the rear of the elephant may be intended to evoke the Indian milieu.[29]

In the case of manuscripts, the presence of Indian figures is sometimes called for by the texts that they accompany. This is true of the well-known work on automata by Badiʿ al-Zaman al-Jazari (d. 603 H/1206 CE), completed at the court of the Artuqids, the region in which the "poison bowls" discussed above in chapter 4 seem

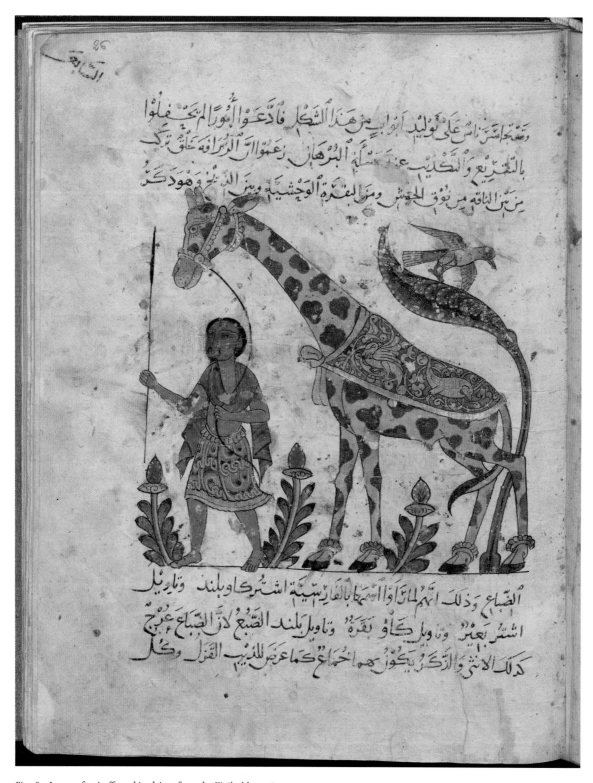

Fig. 185 Image of a giraffe and its driver, from the *Kitāb al-ḥayawān*
(Book of animals) of Al-Jahiz, Mamluk Egypt or Syria, ca. 1350 CE.
Milan, Biblioteca Ambrosiana, MS 140 inf. S. P. 67, fol. 26a.

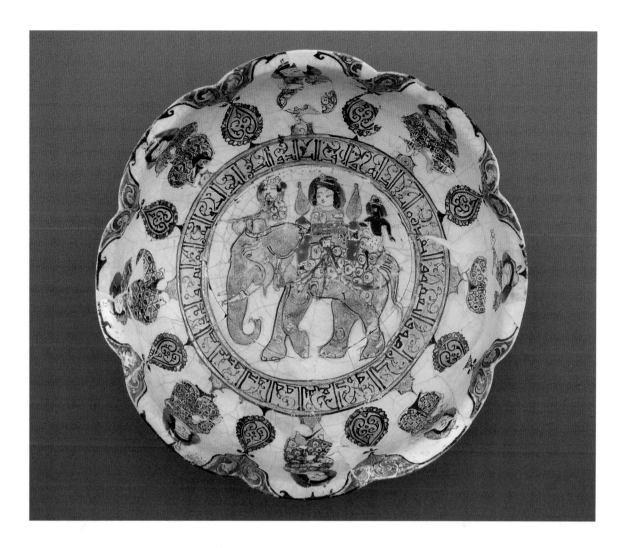

Fig. 186 Mina'i (enameled ware) bowl with elephant scene, Kashan, Iran, late 12th or early 13th century. Stonepaste glazed and painted ceramic; dtr. 18.9 cm. Washington, DC, Freer and Sackler Gallery of Art, inv. no. F1927.3.

to have first appeared. Copies of al-Jazari's text may even have been among the sources of inspiration for Yahya al-Wasiti's images in the copy of the *Maqāmāt* that he completed in 1237 CE.[30] In all copies of the Jazari manuscripts, a figure that appears as a mahout mounted on an elephant clock (figs. 187 and 188) follows the specification of the text that the mahout should be an Indian: "A head is made for the mahout like the heads of the people of India (*ahl al-hind*) with abundant hair on the head and with a beard."[31]

The earliest extant illustrated manuscripts of al-Jazari's text add a further detail, showing the mahout bare-chested, with a light shawl around the shoulders, a trope that recurs in other thirteenth-century Arabic manuscripts, including the *Maqāmāt*

(see fig. 183).[32] Here, the artist responsible for producing the illustrations to al-Jazari's text was following a convention rather than establishing one; from as early as the ninth century, Arab and Persian authors consistently report that among the defining characteristics of Indians is that they have long hair and let their beards, which are sometimes plaited, grow exceptionally long; they are bare-chested but wear waist cloths (lungis) and both men and women wear golden bangles.[33]

In al-Wasiti's paintings, conventions similar to those used for the mahout are deployed for the depiction of the lord of the isle (variously identified in the text as *wāli* and *shāh*; that is, governor or ruler), although the paler shade with which the skin of the "Indian" figures in this royal scene is colored compared to the captain or pilot of the ship (see fig. 180) may suggest a hierarchy that operates even within conventional renderings of alterity. More definitive is the distinction conferred on the royal figure (and on his queen

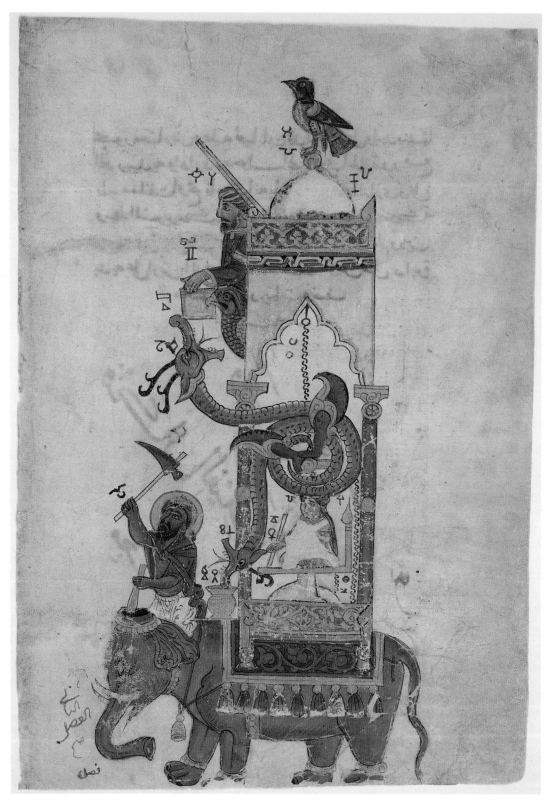

Fig. 187 Image of the elephant water-clock from a copy
of the *Book of Knowledge of Ingenious Mechanical Devices* by
Badiʿ al-Zaman al-Jazari, Mamluk, probably Syria, 715 H/1315
CE. Ink, color, and gold on paper; 30 × 19.7 cm. New York,
Metropolitan Museum of Art, inv. no. 57.51.23

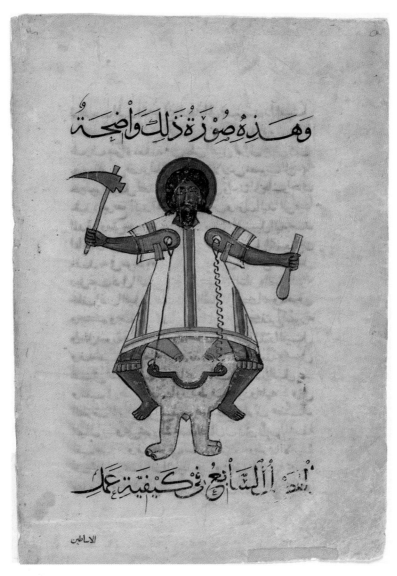

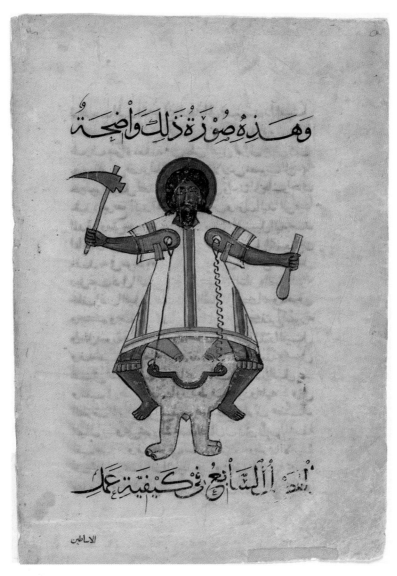

وهذه صورة ذلك واضحة

بعد السابع في كيفية عمل

الاطين

Fig. 188 Image of the Indian mahout for the elephant water-clock, from Badiʿ al-Zaman al-Jazari's *Book of Knowledge of Ingenious Mechanical Devices,* Mamluk, probably Syria, 715 H/1315 CE. Ink, color, and gold on paper; 30 × 19.7 cm. New York, Metropolitan Museum of Art, inv. no. 55.121.13.

in labor below) by a prominent golden halo (see fig. 183), a consistent signifier of authority in al-Wasiti's paintings.[34] The use of such conventional tropes of difference has been ascribed to "a general medieval tendency to cast all human types into a small number of optically perceived images."[35] This may be true, but, however paradoxically, in deploying these conventional tropes in his images, al-Wasiti lends the tale a topographic and geographical specificity lacking in the text that they accompany. In effect, he sets the mysterious island on which the ship is stranded somewhere

off the coast of India, a plausible location in light of reports of ships sailing directly from Sohar in Oman (the destination of the ship in maqāma 39) to the west coast of India.[36]

The proliferation of such figures in the arts of the central Islamic lands at this period coincides with a period when a similar interest in "types" can be found in certain genres of literature, from geography to medicine. Among these are representatives of a genre of writing on the merits of Africans in general, and Ethiopians in particular, which flourished in Iraq from at least the ninth

century, a period when the presence of large numbers of African slaves is well documented.[37] Many of the scholars who penned these texts rejected the (evidently widespread) idea that the darkness of Africans was an inherited mark of the sin of Ham, who saw his father, Noah, naked and refused to cover him. Instead, most subscribed to a form of environmental determinism inherited from classical antiquity, according to which the perceived darkness of Africans, the blackness of their hair, and their temperament derived from the effects of the hot climate in the regions whence they came, even as the whiteness of northern peoples was related to the coldness of theirs.[38]

While there is no doubting the generally negative impressions of Africans conveyed in many medieval Arabic texts, or the associations of blackness with slavery,[39] in such texts Abyssinians or Ethiopians were consistently singled out for praise, often remembered for the asylum that the Negus, the ruler of the Axumite kingdom of Ethiopia, provided for the nascent Muslim community when some among them had to flee from Mecca around 613 CE.[40] Ethiopians receive a favorable mention in a variety of Iraqi sources, including those intended to support what was evidently a dynamic trade in East African slaves. For example, the Baghdadi doctor Ibn Butlan (eleventh century) included a positive evaluation of the character of Abyssinians (in spite of their purported physical fragility) in his epistle on the physical qualities and medical care of slaves, intended for prospective slave owners.[41] But there was also a less instrumental literary genre dedicated to the merits of Ethiopians. It may be no coincidence that one of the most extensive and influential examples of this genre was produced around the time that al-Wasiti was working, when the Baghdadi scholar Abu'l-Faraj ibn al-Jawzi (d. 597 H/1200–1201 CE) penned the *Tanwīr al-ghabash fī faḍl al-sūdān wa'l-ḥabash* (The enlightenment of the darkness concerning the merits of the blacks and Ethiopians). In it, he argued the need to respect Africans for the excellence of their deeds, evaluating them on the basis of their behavior rather than their skin color.[42] While there is no suggestion that the artist drew directly on this or other texts of the same genre, al-Wasiti's paintings betray an almost ethnographic interest in the characteristics and visual qualities of non-Arabs, especially Africans and Indians. That this visual interest in alterity or diversity (depending on one's perspective) arose at a time when texts like Ibn al-Jawzi's were being penned and circulated in Baghdad is suggestive.

First-hand experience of Africans and Indians in Iraq itself may also be relevant. There is no systematic study of the textual and visual evidence for the presence of Africans and Indians in the medieval Islamic world, but both may be assumed.[43] Some, but not all, of these people were slaves. Large numbers of East African slaves were present in the Abbasid caliphate, and not only in its armies.[44] The presence of large numbers of East African and Ethiopian slaves in the Gulf is mentioned by the eleventh-century traveler Nasir-i Khusrau, while their presence in Baghdad itself inspired the sorts of twelfth- and thirteenth-century texts on the merits of blacks and Ethiopians mentioned earlier.[45] Similarly, documents from the Cairo Geniza attest to the presence of both Indian and Ethiopian slaves in Egypt in the eleventh and twelfth centuries.[46] Large numbers of slaves are, in addition, likely to have been brought west in the wake of the dramatic and rapid military expansion of the Ghurid sultans of Afghanistan into north India in the last decade of the twelfth century and the first of the thirteenth. Passing mentions in texts suggest that these Indian slaves were taken quite far west: we hear of several such slaves in the city of Harran in the Jazira in 613 H/1216–17 CE, for example.[47] This is the region of Iraq in which al-Jazari, the author of the manuscript on automata in which Indians feature prominently (see map 4 and figs. 187 and 188), lived and worked, and we might suspect that some of this interest was inspired by first-hand experience of Indians present in the Jazira. Sometimes, we can trace the subsequent biography of such slaves, as in the case of Shadbakht, a manumitted Indian slave who rose to high office in Aleppo in the second half of the twelfth century.[48] Similarly, we sometimes hear of Ethiopian slaves who, after manumission and conversion to Islam, could rise to significant positions and amass significant capital.[49]

But there is no reason to assume that all those who labored on the ship depicted by al-Wasiti were enslaved. On the contrary, the painting suggests a hierarchical cosmopolis, highly stratified in ways conveyed by dress and gesture. Those bailing out in the hull of the ship (see figs. 190 and 191) were likely slaves,[50] but the same cannot be assumed about the African sailors working the rigging (see figs. 180 and 184). As we saw in chapter 5, there is scattered but consistent evidence for the participation of both Indians and Africans in the Indian Ocean trade networks in a variety of circumstances at exactly the time that al-Wasiti was producing his manuscript. Among them was Bama, the Indian slave and agent of

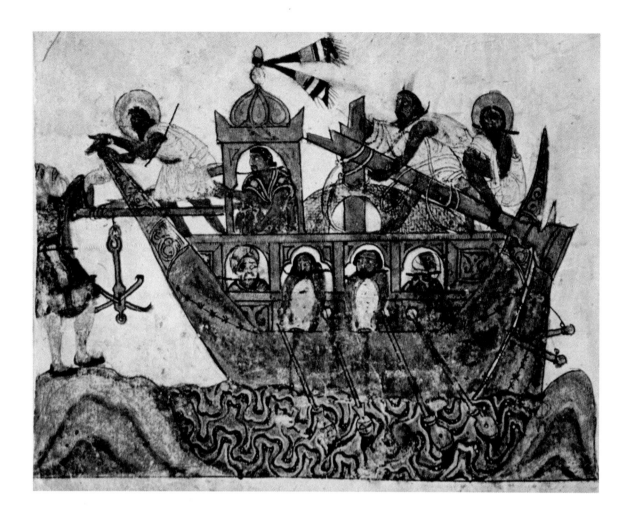

Fig. 189 Scene of Abu Zayd requesting a passage on a ship sailing to Sohar, Oman, from the *Maqāmāt* of al-Hariri, *maqāma* 39, Iraq, probably Baghdad, ca. 1230 CE. 25.9 × 28 cm. St. Petersburg, Oriental Institute, Academy of Sciences, MS C-23, p. 260.

Abraham ben Yiju, the Jewish merchant based in Mangalore mentioned in chapter 5, who was sent as his agent to Aden in the 1130s.[51] The same merchant employed an Ethiopian (*ḥabashī*) named Mas'ud as one of his *nākhūdas* (captains) plying the Indian Ocean.[52] Whether he was a free man, freedman, or slave is not clear: the Karimi merchants who came to dominate the trade between the Red Sea and Indian Ocean from the thirteenth century employed itinerant slave agents (*al-'abīd al-saffār*) in their trade between Ethiopia, Yemen, and India.[53]

Al-Wasiti's ship may also have been manned by members of African and Indian diaspora communities. The likelihood that medieval Indian communities were resident on the coast of East Africa has been raised by recent archaeological finds.[54] Similarly, ceramic evidence suggests the presence of an East African community on the south coast of Arabia from at least the eleventh century.[55] Closer to the milieu in which al-Wasiti was working, there are reports of Indian merchants and sailors living in the southern Iraqi ports of al-Uballa and Basra.[56]

While there is no doubting al-Wasiti's originality in the prominence he affords to images, their content, and their disposition in the copy of the *Maqāmāt* that he produced, the constitution of the ship's crew reminds us that many of the images in the manuscript make use of contemporary conventions. It is also possible, as suggested by Richard Ettinghausen and Oleg Grabar, that the artist drew on pre-existing visual models.[57] The recurrence of certain visual tropes in different copies of the *Maqāmāt* is especially suggestive. The two bailers emptying their vessels from portholes at the bottom of the ship in al-Wasiti's illustration to *maqāma* 39 recur, for example, in a similar scene depicted in an anonymous copy of the *Maqāmāt* now in Saint Petersburg (fig. 189), but produced in Iraq around 1230 CE, so roughly contemporary with al-Wasiti's manuscript (compare

Fig. 190 Detail of fig. 180.

Fig. 191 Detail of fig. 189.

figs. 190 and 191), and in another image of the same scene in a manuscript in Istanbul.[58] Similarly, the arrangement at the left of the image in the Saint Petersburg manuscript, with the prow, the hanging anchor, the clear depiction of sewn planks, and the crouching figure is echoed in exactly the same position in al-Wasiti's image of the wondrous island (compare figs. 180, 182 and 189). It is, therefore, possible that some of the details were drawn from existing templates.

The Artist as Exegete

It has been suggested that those templates may have included earlier depictions of the Indian Ocean world that are no longer extant.[59] However, it seems more likely that the content of al-Wasiti's images was shaped by earlier oral and textual lore. It has, for example, sometimes been noted

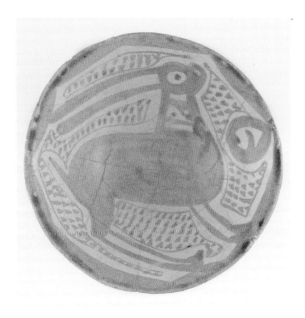

Fig. 192 Luster bowl with image of a hare, Iraq, probably Basra, 10th century. Glazed earthenware ceramic; 4.5 × 13 cm. Los Angeles, Los Angeles County Museum of Art, The Nasli M. Heeramaneck Collection, gift of Joan Palevsky, inv. no. M.73.5.272.

Fig. 193 Fragment of an Iraqi luster bowl, 10th century, excavated at the trading emporium of Sanjan in southern Gujarat, on the west coast of India (= Nanji (2011), pl. 8.

in passing that the ambience of this painting cycle seems to echo some of the earliest extant reports of maritime adventures along the trade routes connecting Abbasid Iraq with the ports of India and China. These networks are attested by finds of Iraqi ceramics, exported from Basra and other Gulf ports. Basra was the center of production of luxury ceramics such as luster, which was pioneered in Abbasid Iraq (fig. 192). The city was conveniently located for exporting the products of the Iraqi kilns, remnants of which have been found in the Gulf and Red Sea as far as Egypt and the Indian Ocean (from South Africa to India) and as far east as Thailand and China.[60] Excavations in the ruins of the emporium of Sanjan, north of Mumbai, for example, have produced the remains of Iraqi lusterware (fig. 193), some of it likely unpacked from the cargo of ships like that later to be depicted in the *Maqāmāt*, along with a fragment of a dirham, a silver coin minted in Abbasid Iraq.[61]

Such exports represent extraordinary developments in Iraqi ceramic technology at a moment in the ninth century when the Abbasid caliphate was at the height of its power. In addition to luster, they included tin-glazed wares decorated with cobalt blue, an Iraqi innovation that would have major implications for the future of ceramics, including those produced by Chinese artisans, with whom the Iraqi potters were engaged in a competitive aesthetic and technical dialogue.[62] During this period, Arabs and Persians were favored as

governors of some of the cities of the western seaboard of India under the rule of Hindu rajas, who were keenly aware of their ability to mobilize diplomatic and economic networks across the Indian Ocean.[63]

Reports (*akhbār*) about the Indian Ocean trade and the sites of exchange around the Indian Ocean littoral were evidently circulating in large numbers in the ninth and tenth centuries, the heyday of trade with Abbasid Iraq. Some of these were committed to writing. The earliest extant example of the genre, the *Akhbār al-Ṣīn wa ʾl-Hind* (Reports of China and India), is a two-part compilation. The first book, generally attributed to Sulayman the Merchant, was completed in 237 H/851–52 CE. A second book was added by Abu Zayd al-Sirafi, a native of one of the most important trading emporia in the Gulf, in the first decades of the tenth century.[64] A similar compilation, the *Kitāb ʿAjāʾib al-Hind* (Book of the wonders of India), attributed to the Persian *nākhūda* (captain or shipmaster) Buzurg ibn Shahriyar al-Ramhurmuzi, but possibly compiled by another author in Cairo, was also completed in the tenth century.[65] Both include in their purview the Gulf, India, China, and, to a lesser extent, the East African coast.

These compilations of wonders of the sea (ʿajāʾib al-baḥr) belong to the genre of ʿajāʾib or mirabilia: reports of the wonders of the world, that proliferated in Arabic and Persian, especially from the twelfth century onward. A source of

edification and entertainment, both texts contain ripping yarns of marvels and wonders, of storms and shipwrecks, enchanted islands, incredible beasts, munificent or malevolent kings, and fortunes won and lost through the vagaries of nature. Giant serpents and seabirds, hybrid creatures and ships offering passage to men of China, India, and Persia all make appearances, a cosmopolitan scenario well captured in the images of the 1237 CE *Maqāmāt* manuscript (see figs. 180 and 182, for example).[66] References in these texts to portraits of Arab and Persian mariners commissioned by Indian rulers appear as a suggestive detail in light of the interest that al-Wasiti shows in the depiction of the mariners who operated the ships sailing the Gulf and Indian Ocean.[67]

In contrast to the more structured, encyclopedic compilations of wonders compiled in the twelfth and thirteenth centuries, these early texts are explicitly anecdotal.[68] They aim to convey the frisson of dangers avoided, strange customs, or threats outwitted and outmaneuvered, providing the reader with a myriad of adventures experienced vicariously. However, although some modern scholars have dismissed the content of such texts as the products of "mere yarning sailors,"[69] they also convey valuable tidbits of historical information and insights into foreign court cultures that can be verified from other sources.[70] The appeal to veracity which is such a marked feature of later texts on wonder is no less evident, for the sources of information on which these compilations drew are both acknowledged and named.

Just as some of the merchants trading between Ethiopia and Egypt in the twelfth through fourteenth centuries served as informants for the Arab chroniclers and geographers working in Egypt,[71] both the *Akhbār al-Ṣīn wa'l-Hind* and the *Kitāb ʿAjāʾib al-Hind* are collations of oral accounts gathered from captains (*nakhūdas*),[72] mariners or pilots (*rubbāns*), and merchants—informants who had made the perilous voyage from the ports of Iraq to the emporia of Africa, India, and China. Most were based in the ports of Iraq or the Gulf, especially Basra and Siraf. The former was the great port of Abbasid Iraq, the latter a major trading emporium.[73] Such informants must have been over-taxed with questions to judge from the frequency with which they are cited by contemporary scholars who performed ethnographic reconnaissance. For example, the Baghdadi author al-Masʿudi (d. 956 CE), who himself traveled to western India, reports that some of the information in his *Murūj al-dhahab* (Meadows of gold) was derived from speaking with captains

and merchants from Siraf and Oman in Basra.[74]

Some of these accounts were related second hand, passed from mariner to mariner, or even from Indian informants to ships' captains.[75] This suggests the existence of vibrant oral traditions that circulated beyond the textual compilations in which they were ultimately preserved. The association of such narratives with the ports of southern Iraq takes on a particular interest in terms of the *nisba* (toponym) of the artist responsible for the 1237 CE manuscript—al-Wasiti—which suggests that he or his family hailed from Wasit, a southern Iraqi city situated on the Tigris river, along which goods from Basra traveled north. One can well imagine how the memory of tales told about fabulous sea voyages rich with conjurations of the marvelous fed into the remarkable series of images that accompany maqāma 39 in Yahya al-Wasiti's manuscript. As tales transmitted from those who experienced these wonders first-hand, the narratives preserved in such texts bear comparison with those related in the *Maqāmāt* by the narrator al-Harith himself, who claims to have participated in the adventure described in maqāma 39, from the boarding of the boat, through the storm, to the adventures on the magical island and their conclusion. If, as has been suggested, al-Wasiti's images emphasize discourse as the central theme of the *Maqāmāt*,[76] it seems entirely appropriate that such oral lore should have contributed to the discursive or extra-textual connections forged by the images of the manuscript.

The anecdotes preserved in such compilations of maritime lore are generally reminiscent of the ambience of maqāma 39, but in some cases the correspondence is even more suggestive. In the *Kitāb ʿajāʾib al-Hind* we read, for example, of a tale of a ship sailing from Oman toward India, whose crew were shipwrecked on an island near the coast of India, an enchanted isle whose natural abundance included sweet water, trees rich with fruit and other sustenance, and monkeys who had the fortunate habit of quarrying gold to present to the shipwrecked sailors.[77] The latter eventually escape, much the richer for the vicissitudes that they have suffered, not unlike the scheming Abu Zayd after his adventures on the enchanted isle of maqāma 39.

Although dating to the ninth and tenth centuries, such compilations were copied into the eleventh and twelfth; some of the tales that they contain made their way into the most famous of all Arabic story cycles, the *Thousand and One Nights*.[78] Moreover, our only extant manuscript of the *Kitāb ʿAjāʾib al-Hind* was copied in 644 H/1246 CE, while the sole surviving copy of the *Akhbār al-Ṣīn*

waʾl-Hind is dated 596 H/1199 CE, suggesting the continued currency of such tales into the period in which al-Wasiti was working.[79] It is even conceivable that al-Hariri, the author of the *Maqāmāt*, was inspired by such tales. Produced over a century later, al-Wasiti's visual exegesis of al-Hariri's text may have drawn upon the same sources as the original in order to extend its narrative range in ways that made the common debt to this earlier lore of wonders and marvels more explicit.[80]

The idea that tales compiled in such accounts of marvelous events and places provided the inspiration for al-Wasiti's paintings is further supported by a detail of a depiction of a slave market in the same manuscript, an image accompanying maqāma 34, a tale set in Zabid, Yemen (figs. 194 and 195).[81] The tale concerns a handsome youth (al-Hariri's text compares him to the prophet Joseph, a byword for beauty in the medieval Islamic world) sold as a slave in a scam orchestrated by the roguish Abu Zayd, despite the fact that, as a Muslim, legally the youth could not be enslaved. As al-Wasiti has imagined the scene, the rather coy youth appears at the extreme left of the scene, his would-be purchaser at the extreme right. Between them are four figures, three depicted as Africans according to contemporary conventions. The text nowhere mentions Africans; instead, the artist's choice to represent the slave market in this way underlines a common association between slavery and Africans found in many medieval Arabic texts.[82] Yet, it is the enslaved African at the center of the scene, displacing the main protagonists to either side, who is not only its focal point, but is represented gesturing in a way that suggests speech.

The manner in which the artist has chosen to depict this figure implies an agency at odds with the conventions of type, subverting, it has been suggested, the "archival silencing" of the slave.[83] More significantly, there is a striking detail that has so far eluded much comment: this figure is also provided with a prominent golden nimbus (see fig. 195). In one of the very few attempts to explain the presence of the feature, Robert Hillenbrand has argued that it represents the artist's sympathy for the plight of the enslaved.[84] It is even possible that this apparent elevation of the slave was informed by some of the texts on the merits of Africans and Ethiopians circulating in Baghdad at the time that al-Wasiti was working.

However, the specificity of the focus on this one figure from among the Africans suggests that something more was in play. Among the several renderings of this scene in surviving medieval manuscripts of the *Maqāmāt*, this is the only version in which the figure of the slave is singled out in this way. Like other idiosyncrasies and innovations (including the image of the mysterious island) it is therefore likely to be related to the working method of Yahya al-Wasiti; as Bernard O'Kane notes, we can expect the artist's "choices at all stages to have been deliberate ones."[85] Many of al-Wasiti's contemporaries made indiscriminate and promiscuous use of halos, even providing animals and birds with them. An image illustrating the same scene in the slave market in another Iraqi copy of the *Maqāmāt*, produced around the same time as al-Wasiti's manuscript, provided all the figures shown (including all slaves) with golden halos, with the exception of the roguish protagonist Abu Zayd, who is thus distinguished by its absence.[86] By contrast, in al-Wasiti's paintings, the halo is used precisely and sparingly, reserved for figures of authority: atabegs, governors, kings, and scholars, including non-Arabs, as the depiction of the Indianized royal couple who feature in maqāma 39 demonstrates (see fig. 183).

The presence of this detail and the prominence afforded the African figure sets up an apparent paradox: an African who is also a figure of some authority or respect being sold as a slave. Nothing within the text of maqāma 34 can resolve the conundrum; it is as if this figure has wandered in from an entirely different narrative. And indeed, this appears to be the case, for the detail provides further circumstantial evidence that al-Wasiti drew upon the tales compiled in works such as the *Kitāb ʿajāʾib al-Hind*, or tales like them, for the exegetical work that his images perform on al-Hariri's text. This apparent anomaly in the iconography of the slave resonates suggestively with one of the longest tales in that tenth-century compilation. It concerns a ship of merchants who wrong a young and handsome king of the Zanj (the inhabitants of the East African coast) ruling at Sofala, a trading center on the coast of Mozambique. Despite providing generous hospitality to his Arab guests, the king is tricked by them, taken aboard their ship, enslaved, and sold in Oman. After many adventures in Basra, Baghdad, Mecca, and Cairo, the enslaved king finds his way home via Egypt and is reinstated in his rule. When fate casts his captors once again upon the shores of his kingdom, they are amazed to find their erstwhile captive ruling once again over his realm, and even more so by the magnanimity that he shows them.[87]

If al-Wasiti's provision of a nimbus for the enslaved African in the painting marks him as an authority figure in ways that cannot be explained by the text of the *Maqāmāt* alone, it seems likely

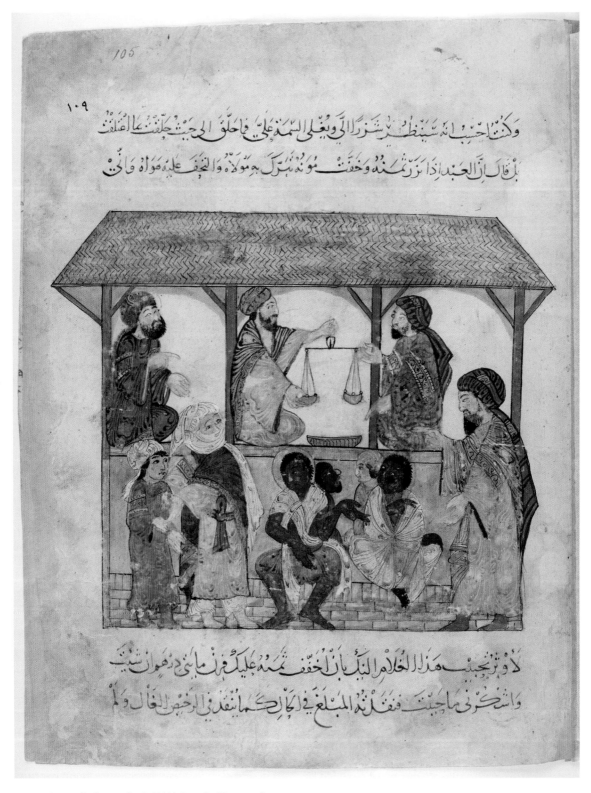

١٠٥

١٠٩

وكيف احتسب انه سيتظرّ شزرا ويغلى الشمّن علىّ فاحلق الحيث جلفت طا اعلق
بل قال ان العبد اذا نزر ثمنه وخفت منه تزل بمولاه والتحفف عليه مولاه فانّى

لا وترنجبنّ هذا الغلام النبّل بان اخفف ثمنه عليكّم الّا مائين درهون ستيّن
واشتّرونى ماجيت ففقّنه المبلغ فى اكاركما انفقدنى اخيص الغال والم

Fig. 194 Scene of a slave market in Zabid, from the *Maqāmāt* of
al-Hariri, *maqāma* 34, painted by Yahya al-Wasiti, 634 H/1237 CE.
25.9 × 28 cm. Paris, BnF, MS Arabe 5847, fol. 105a.

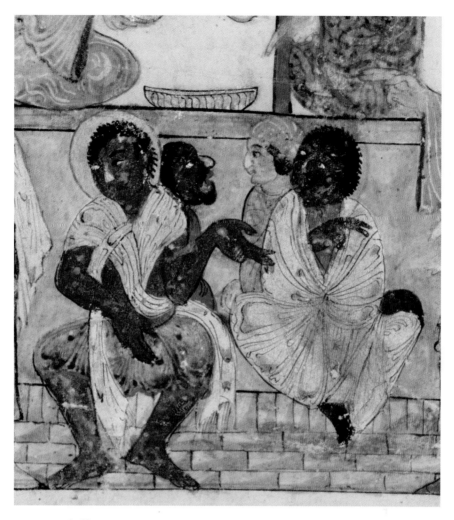

Fig. 195 Detail of fig. 194.

that al-Hariri's tale of wrongful enslavement res-
onated with al-Wasiti, bringing to mind a similar
story of wrongful enslavement in the maritime
tales of wonder that evidently inspired the iconog-
raphy of al-Wasiti's copy of the *Maqāmāt*. In this
way, the image maps the telling of one tale onto
another, a tale told in an eleventh-century text
copied in 1237 CE mapped onto a tale contained
in a tenth-century compilation of Indian Ocean
lore, which still enjoyed currency in the centuries
after it was first compiled. It is worth noting that
the peregrinations of an enslaved African ruler
as narrated in this tenth-century text anticipate
those of the manumitted Ethiopian slaves who
rose to high office in the sultanates of western
India and the Deccan centuries later. The most
famous of these, Malik Ambar (d. 1626 CE) was,
for example, sold in the slave markets of Mokha,
Yemen, was taken to Baghdad, and then ended up
as a powerful independent agent in the Deccan.[88]

But the complexities of the intertextual work
done by this painting extend even still further.
In the text of maqāma 39, not only is the beauty
of the enslaved youth compared to that of the
prophet Joseph, but the hapless youth attempts to
warn his buyer of the illegality of the sale by allud-
ing to the Qurʾanic narrative in which Joseph is
sold into slavery by his brothers, undergoes many
trials in Egypt, and eventually returns to confront
the brothers who wronged him and who now
beg his forgiveness.[89] Al-Wasiti's image seems to
connect the Qurʾanic account of the wrongful
enslavement of Joseph alluded to in the text of
the *Maqāmāt* with tales of wonder concerning the
treacherous enslavement of noble Africans that
circulated in both oral and textual variants. The
tribulations and triumph of Joseph are something
of an archetype in medieval Arabic biographies of
African slaves who transcend a series of abject tri-
als through which they are led to convert to Islam,

in what has been called "the happy enslavement topos."[90] In the tale from the *Kitāb ʿajāʾib al-Hind* this discovery of Islam through the vagaries of enslavement is the reason for the magnanimity that the king of the Zanj shows toward his former abductors when they return to his kingdom. It is, therefore, surely no coincidence that the structure and content of this tale, which seems to be evoked by al-Wasiti's painting, are virtually identical to that of Joseph: a handsome and noble individual wrongfully enslaved, subject to trials and tribulations and who, passing by way of Egypt, eventually regains his position and lives to confront and forgive those who wronged him. In its creation of an intertextual relationship between three distinct narratives, it is surely not too far-fetched to see this image as a commentary on questions of slavery and justice that are addressed in a more oblique fashion in some of the narratives that seem to have inspired it.

These complex entanglements between picaresque tales of morally dubious scams and Qurʾanic accounts of Joseph are present in al-Hariri's text of the *Maqāmāt*, which makes reference to the Joseph narrative, but it is al-Wasiti's image that extends their potential range of signification to wondrous tales of Africans wronged by Arab merchants. Significantly, this further intertextual dimension is effected by the image alone, not by any written commentary. The image cycle accompanying maqāma 39 in the same manuscript (see figs. 180-183) seems to draw from a similar wellspring: compilations of maritime lore in which Africa, Iraq, and India are imbricated.

The use of highly original imagery to forge complex exegetical and intervisual allusions occurs in concert with the artist's use of conventional depictions of non-Arabs to lend some of the tales in the *Maqāmāt* a topographic specificity not provided by the text. But the Indians depicted in al-Wasiti's text have a detail which is not standard in depictions of Indians found in contemporary Islamic art—a white streak which extends from the forehead to the nose, or down the nose. The mark appears on all the "Indian" figures in this series of paintings, but is perhaps most visible on the three servants standing outside the palace in the third image in the maqāma 39 cycle (see fig. 181; fig. 196). It is recognizable as a *tilaka*, the streak of sandalwood paste that many Hindus apply. In this case, the specificity of the mark, the fact that it extends vertically from the forehead rather than horizontally across it, raises the possibility that we are witnessing a Vaishnavite *tilak*, associated with devotees of Vishnu, rather than that worn by devotees of Shiva. We therefore seem to be dealing

with the refraction of a south Indian tradition, which may say something about the sources that al-Wasiti drew upon, perhaps to underline the Indian setting which he gave to the tale and to add verisimilitude to it. In this regard, it is noteworthy that some of the earliest accounts of Arab involvement in the Indian Ocean mention ships sailing directly from Sohar in Oman (the destination of the ship in maqāma 39) to Kulam Mali (Quilon or Kollam) in Kerala on the southwestern coast of India, the seas around which are reportedly peppered with islands.[91] These south Indian connections have generally been overlooked in favor of contacts with northwestern India, especially Gujarat. However, as we saw in chapter 5, the contemporary Indian materials preserved in the churches around Lalibela in Ethiopia, including remnants of painted caskets and shields (see figs. 164-166, 168, 169, 171, 174, and 175), which may have originated in the south Indian Hoysala kingdom, reinforce the impression of more intensive contacts between medieval south India and the western Indian Ocean than has been previously realized.[92]

Although the consistency of al-Wasiti's application of the *tilaka* to those conforming to the conventional (or stereotypical) characteristics of Indians is clear, a version of the mark also appears on the Africans depicted in the manuscript, including those shown in the slave market of Zabid (see figs. 194 and 195). The artist seems to have extended the parameters of this ethnographic detail to include not only Indians, but other types of dark-skinned non-Arabs, perhaps reflecting the fact that in medieval Arabic discussions of the peoples of the earth, the term black (*aswad*) is used to refer to both Africans and Indians;[93] the perceived relationship between the two is in keeping with their joint labors on the boat whose depiction initiates the image cycle for maqāma 39 (see fig. 180). The common attribution of this feature to both Africans and Indians may also reflect the perception of India and Ethiopia as contiguous or even identical, an idea well established in classical antiquity, but also found in medieval Arabic and Latin sources.[94]

Beyond evoking the ambience of maritime tales of Indian wonders, or demonstrating knowledge of Indian customs, some of the techniques used in al-Wasiti's manuscript suggest the possibility of artistic contacts with India. The most obvious of these is the protrusion of the eye from the line of the face in several paintings in the manuscript (not, however, in the "Indian" scenes under discussion). Although this has been ascribed to poor draftsmanship, it may be related,

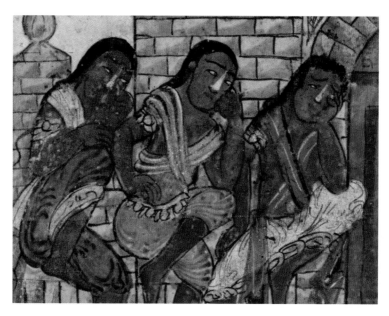

Fig. 196 Detail of fig. 181.

as Grabar noted, to a convention known as the "further eye," well documented in north Indian painting from at least a century or so before the date of al-Wasiti's manuscript.[95] If so, this minor detail points to dimensions of transcultural artistic reception that await further investigation.

A Wondrous Interlude

Al-Wasiti's images provide a visual exegesis of the *Maqāmāt* that extends its geographical range, substitutes iconographic specificity for topographic vagueness, and forges a series of intertextual relationships between different literary genres. The exegetical work of the images enhances and embellishes the themes of dispersal, mobility, and travel inherent to the maqāma genre, mapping al-Hariri's narrative onto tales of wonder that were first committed to writing a century or more before he was writing, and two to three centuries before al-Wasiti was painting. In these texts, while wonders and marvels can be found both within and beyond the boundaries of the Islamic lands, certain distant regions seem to have been seen as particularly replete with the marvelous:[96] India is the obvious case in point; in al-Jazari's elephant clock, for example (see figs. 187 and 188), the wonder of automata coincides with that of India, a byword for marvels and magic in Arabic tradition.

Conversely, however, interest in similar marvels in the medieval Arab lands may be reflected in references to automata found in a series of Sanskrit texts produced in India from the end of the first millennium. Inspired perhaps by descrip-

tions of automata at the Byzantine court and that of the Abbasid caliphs of Baghdad, if has been suggested that this Indian interest in automata "was surely the result of wider cosmopolitan interaction with the Abbasid world, even if we cannot point to any specific transfers of knowledge." In a passage with particular relevance to the way in which the images in al-Wasiti's manuscript draw on tales of wonder carried by merchants and mariners to effect the imbrication of the Abbasid heartlands with the maritime cultures of the west coast of India, the historian Daud Ali writes,

> Although more research needs to be done on the topic, one may hypothesize that the aesthetics of wonder served as a kind of shared communicative idiom across diverse spheres of elites in the medieval world—a cosmopolitan idiom if ever there was one—more suitable in some ways for crossing boundaries because wonder was conveyed through objects and material technologies as much as stories and discursive tropes.[97]

At least within the universe of al-Wasiti's paintings, marked as it is by evocative exoticism and peripatetic cosmopolitanism, this was a reciprocal world of wonder. Take, for example, the corner domes of the palace in which the scene of birthing takes places (see fig. 181; fig. 197). Subdivided into superimposed registers of hexagonal cells, they are legible as muqarnas domes, a form of tall conical dome whose interior is divided into

diminishing registers of small concave arched units. Such domes seem to have first appeared in Iraq in the eleventh century (fig. 198) and became more common in the twelfth and thirteenth.[98] Interestingly, the mode of depicting such domes in al-Wasiti's painting is almost identical to that employed in the depiction of a palace on the painted muqarnas ceiling of the Capella Palatina in Palermo, probably executed a century earlier by a workshop from Fatimid Egypt (fig. 199). As we saw in chapter 5, this may reflect a contemporary vogue for painted geometric ceilings of Islamicate origin among Christian elites across a geography linking the central Mediterranean and Byzantium with the highlands of Ethiopia. Here, the similarities in the rendering of muqarnas domes hint at the transregional use of standardized visual models, especially for the representation of unusual forms or subjects.

The provision of such domes on the palace of a distant ruler in al-Wasiti's paintings is, therefore, at once an acknowledgment of status and an extension to a mysterious Indian ruler of a technological marvel that would have been familiar but by no means prosaic in contemporary Baghdad, where the manuscript was produced. Their appearance in this context provides one further reminder of the ways in which architecture, image, and narrative (both oral and textual) can be mutually implicating in the transcultural generation, dissemination, and reception of marvels.[99] Indeed, where descriptions survive of the effects that muqarnas domes, vaults, and ceilings produced on beholders when used in the palaces of non-Muslim rulers outside the central Islamic lands in the century before the 1237 manuscript was produced, the consistent impression is that of wonder.[100]

As Daud Ali suggests, the theme of wonder and its physical manifestations, whether in facture or nature, *technē* or *physis*, may have been particularly susceptible to transcultural reception. In al-Wasiti's paintings, the natural wonders of the mysterious island are no less evident than the constructed marvels of its palace. They are in fact juxtaposed with the latter, facing the palace across the same opening of the manuscript (see fig. 182). Each of the images in the cycle accompanying maqāma 39 narrates a moment in the unfolding of the story—the sea voyage, the arrival at the palace, a tense scene of childbirth—with the exception of this image. The scene evokes the rich flora and fauna of the island itself, a subject about which the text says nothing.

If the medieval Indian Ocean should be conceived of, both figuratively and literally, as "an ocean of islands,"[101] the sentiment is well captured

Fig. 197 Detail of fig. 181.

in al-Wasiti's image. As is appropriate to an Indian or Indianized island, the artist has pictured a world of marvelous fruit-laden flora populated by exotic birds, monkeys, and wondrous beasts such as harpies and sphinxes (see fig. 182; fig. 200), of which the text makes no mention. Earlier tales of Indian Ocean voyages are replete with stories of shipwrecked mariners being cast upon mysterious islands off the Indian coast populated by wondrous fauna, including enormous tree-dwelling birds,[102] recalling the brilliant over-sized birds that inhabit the trees in al-Wasiti's rendering of the mysterious isle (see fig. 182). The compilations in which these accounts are preserved include tales told by mariners who had visited the Red Sea port of Zayla, relating how the seas and isles off the coast of Ethiopia are populated by creatures that are half man, half fish: the kinds of chimeras discussed above in chapter 5. These recall the harpies and sphinxes with which al-Wasiti populates the island—another detail not mentioned in the text. In medieval Arabic and Persian texts the harpy is glossed as "of the sea" (*baḥrī*),[103] that great vector of transregional connections that unites as much as it divides. The association reminds us that their appearance in al-Wasiti's rendering of the mysterious isle is, like much else in the imagery of this cycle, governed by a specific iconographic logic.

This has long been hailed as the most original painting in the manuscript; it has even been sug-

(LEFT) *Fig. 198* Tomb of Imam Dur north of Samarra, Iraq, late 11th century, one of the earliest examples of a muqarnas dome.

(TOP) *Fig. 199* Detail of ceiling paintings, Capella Palatina, Palermo, probably by a Fatimid Egyptian workshop, ca. 1140. Slide Collection of the Khalili Research Centre, University of Oxford, ISL15383.

gested that it derives from an earlier tradition of illustrated tales of travel and wonder, now lost.[104] The imagery might also have been inspired by that found on the portable arts of the contemporary Islamic world, including metalwork, within whose entangled arabesques harpies and sphinxes often parade.[105] Reflecting a contemporary transregional and transcultural penchant for chimeras and hybrids common to the magic-medicinal bowls discussed above in chapter 4 and the relief discussed in chapter 5, such an inspiration from other kinds of contemporary portable arts would be perfectly in keeping with the phenomena discussed in the preceding case studies.

Although al-Wasiti's double-page spread depicting the palace and isle (see figs. 181 and 182) is evidently intended to be read as evoking "a continuous temporality,"[106] it has sometimes been noted that the order of the images in the double-page painting reverses the narrative, so that, reading from right to left (the order of reading for an Arabic manuscript), the arrival at the palace (see fig. 181) precedes the scene showing the arrival

of the boat on the wondrous island, glimpsed to the far left of the landscape scene (see fig. 182). The tendency for the images in other contemporary copies of the *Maqāmāt* to refuse a sequential logic, sometimes conflating or reversing the order of the narrative, has been noted: in several versions of the ship scene, for example, Abu Zayd is seen boarding a ship with a broken mast, the result of a storm that has yet to happen (see fig. 189).[107] Moreover, the content of the break lines—the lines of text that precede the images in this cycle—sometimes relates events that happened after those depicted in the accompanying image, an interesting peculiarity in light of the fact that al-Wasiti was himself both calligrapher and illustrator.[108]

The scene at the far left of al-Wasiti's double image, however, rather than showing the ship's arrival at the island, is better understood (despite the oddity of the raised anchor) as depicting it at anchor in a bay, its bulk hidden behind a rocky outcrop, so that only its prow and a single crew member are visible. In terms of its narrative function, the image can be understood not only

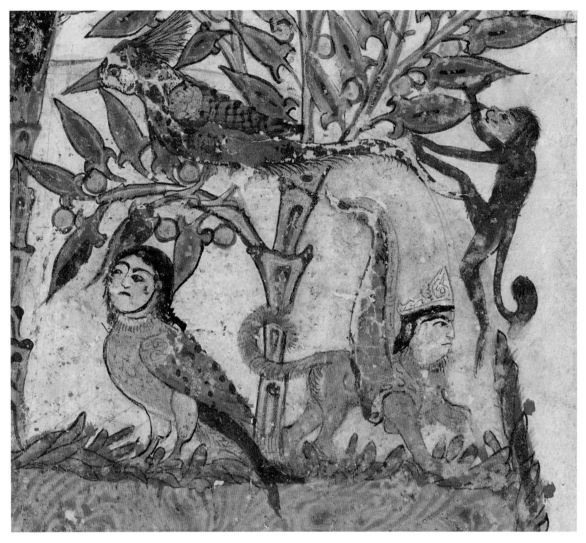

Fig. 200 Detail of fig. 182.

as setting the scene, but as slowing the action. Each of the other images is action-packed; to this the apparent superfluity of the island scene with respect to the narrative, and its immensely calm evocation of a kind of earthly paradise, runs counter. Instead of simply following a cue from the text, the image might instead be understood as a device intended to tease the reader/viewer—to delay the visual and textual denouement which follows two pages later. In fact, such devices are documented in twelfth- and thirteenth-century narrative painting from the central Islamic lands, in which "visual *caesurae*" are deployed to control the tempo of the action, speeding or slowing it by inserting images that, rather than contributing to the temporal progression, delay it and, with that, the anticipation of the viewer/reader. Read in this way, the purpose of the image of the enchanted

island with the boat at rest is to indicate something like "meanwhile back at the ranch," in the parlance of a modern western.[109]

But in addition to slowing the narrative, the iconography of this scene may also hint at the denouement of the tale, following the events in the palace which unfold in the final image of the cycle. The very presence of sphinxes and harpies, along with monkeys, parrots, and spectacular avian creatures, marks this island out as an exotic, if not enchanted, place. In contemporary Islamic art, the auspicious associations of harpies and sphinxes made them appropriate visual counterparts to the epigraphic evocations of blessings and fortune found on many of the objects on which they appear (fig. 201).[110] The positive connotations of sphinxes and harpies and their association with good fortune may in fact be relevant to their

Chapter 6

Fig. 201 Minaʾi (enameled ware) bowl, Kashan, Iran, second half of the twelfth century, with scene of an enthronement flanked by sphinxes and inscribed with invocations of blessings and good fortune. Stonepaste ceramic; 20.5 × 8.7 cm. Henley (Oxon.), The Sarikhani Collection, inv. no. I.CE. 2118.

Fig. 202 Mirror, Iran or Anatolia, 12th–13th century, depicting a pair of addorsed scorpion-tailed sphinxes. Cast bronze; dtr. 10.5 cm. New York, Metropolitan Museum of Art, inv. no. 15.43.285.

appearance in al-Wasiti's painting, for they may anticipate the denouement of al-Hariri's tale and the riches that await the protagonist, Abu Zayd, as a result of the service that he will render in the adjoining palace by producing an amulet to aid the queen in childbirth.

Also relevant are the magical associations of sphinxes and other hybrids, suggested by their appearance on a series of twelfth- and thirteenth-century metal mirrors (fig. 202), a genre often used for divinatory and talismanic practices, as we saw in chapter 4.[111] Such associations may explain the occasional appearance of harpies (but not sphinxes, curiously) on medieval Islamic magic-medicinal bowls similar to those discussed in chapter 4, some of which are described as talismans (ṭilasmāt) in their inscriptions.[112] That al-Wasiti evokes these magical harbingers of good fortune immediately before the resolution of al-Hariri's tale, in which Abu Zayd's good fortune is achieved by magical means (however dubious their efficacy), can hardly be coincidental.

A Magical Denouement

In the final scene in the cycle accompanying maqāma 39, we arrive at the heart of the palace, to witness the harrowing and unusually frank scene of the queen's prolonged parturition (see fig. 183). Through a skillful deployment of an architectural

frame similar to those found in other contemporary Iraqi manuscripts (fig. 203), we are presented with a de facto section through the structure, a kind of scaenae frons in which both vertical and horizontal axes signify a gendered hierarchy.

In the upper register, the lord of the palace, flanked by male attendants, tugs his beard in anguish. Directly below, his wife strains in childbirth, flanked by her female attendants. The image of a semi-naked women, with genitals visible and breasts partially exposed, is remarkable, unique in the paintings of this period—that the woman whose body is rendered up to the gaze in such an unusual way is (to judge from the manner of her depiction) a non-Arab, and likely an Indian, is surely relevant to the explicit manner of her depiction. To the left and right of the scene two more attendants enter to assist (fig. 204). These echo the subsidiary male figures directly above: to the left of the ruler, Abu Zayd is engaged in writing the amulet that will end the queen's suffering and the anguish of the royal house (fig. 205), aided by al-Harith on the other side of the enthronement scene (fig. 206), using an astrolabe to determine the position of the stars.

The motif of the amulet is in fact, like many tropes in the text of al-Hariri's Maqāmāt, borrowed from an earlier example of the maqāmā genre, often seen as its epitome: the Maqāmāt of Badiʿ al-Zaman al-Hamadhani (d. 1007 CE).

لَا يَشْتَهِي الطَّعَامَ اوَمَنْ كَانَتْ قُوَّتُهُ تَحَلَّلُ وَصِفَتُهُ عَلَى هَذِهِ الصِفَة

وَزِنْ مَا العِينُ دَرْدِرْ يُؤْخَذُ مِنَ العَسَلِ جُزْءٌ وَيُخْلَطُونَهُ بِالعَسَلِ وَيَطْحَنُونَهُ عَلَى الصِفَه الَّتِي الذَّهَبِ

اللَّتَينِ ثُمَّ يَرْفَعُونَهُ ع ع م م :: وَقَدْ :: يَحِلُ ثَرَابٌ

نَقَالَ لَهُ أَبُو مَاأَلِي عَلَى هَذِهِ الصِفَه وَيُؤْخَذُ ثُمَّ الصِفَه فَيُغْسَلُ

بِآلماً وَيُؤْخَذُ ذَلِكَ اللَّماً وَيُرْفَعُ ه وَيَنْبَغِي اذَا أَثْرَبَ هَذَا الشَرَابَ انَّ

بَصَرفَ وَمِنَ النَّاسِ مَنْ طَهَنَهُ وَمَوغَيرَ مَوافِقٍ لِلمَرَضِ لكَثْرَه مَا فِيهِ مِنَ الشَّيْ

Fig. 203 "Preparing Medicine from Honey," from a dispersed
manuscript of an Arabic translation of the *De materia medica* of
Dioscorides, Iraq, 621 H/1224 CE. Ink, opaque watercolor, and gold
on paper; 31.4 × 22.9 cm. New York, Metropolitan Museum of Art,
inv. no. 57.51.21.

Fig. 204 Detail of fig. 183.　　　*Fig. 205* Detail of fig. 183.　　　*Fig. 206* Detail of fig. 183.

Al-Hamadhani's text is especially sensitive to the material world (there are chapters named after coins, wine, butter, and so forth),[113] but the twenty-third of its fifty-one assemblies or seances, entitled *al-Ḥirz* (The amulet), tells the tale of a ship sailing across the Caspian Sea when it encounters a violent storm. One of the passengers offers to provide each of those on board with an amulet (*ḥirz*) to prevent them from drowning, upon immediate payment of a fee followed by another amount when they reach dry land safely. The amulets or incantations (*ruqan*) are then distributed from an ivory box wrapped in brocade cloth (*dībāj*).[114] The medium of the amulets is not specified, but their implied multiplicity suggests paper; dramatic evidence for the use of such paper amulets by thirteenth-century merchants and travelers engaged in maritime voyages has been excavated at Quseir al-Qadim, a trade emporium on the Red Sea coast of Egypt.[115]

In al-Hariri's later *Maqāmāt*, however, the ship sets sail to Oman, and there are two charms or amulets involved in maqāma 39. The first, clearly inspired by al-Hamadhani's text, is that produced by Abu Zayd to ensure his passage to Oman by advertising his possession of a charm designed to protect against the dangers of the deep, its efficacy ascribed to the prophet Noah (who as we saw in chapter 4, was often invoked on amuletic and talismanic objects). As a purveyor of amulets, Abu Zayd was in good company, for the sale of such objects was commonplace even in mosques,

to judge from the repeated opposition of the jurists.[116] The second amulet is produced later in the text, to ease the pangs of childbirth suffered by the queen of the mysterious island. There is, perhaps, a conscious irony in the fact that al-Wasiti's location of maqāma 39 on a mysterious Indian isle whose ruler has need of Arabic amulets represents a homecoming of occult technologies whose origins many contemporaries situated in India or Hindustan, which was sometimes referred to by the punning moniker "Jadustan" (Land of magic).[117]

Sea voyages and childbirth are precisely the contexts in which one might reasonably expect amulets to be employed in the medieval Islamic world. Fragments of medieval grimoires found in the Geniza of the Ben Ezra synagogue in Fustat, the first capital of Islamic Egypt, include spells to be used in amulets designed to quell a storm at sea, amongst medleys of recipes that can include those to protect against scorpion bite, those for female fertility, and prescriptions for amulets designed to facilitate childbirth (see fig. 126), a combination also known from medieval Arabic texts on talismans.[118] The constellation recalls the inscriptions found on certain Islamic magic-medicinal bowls, which (in addition to their efficacy in curing ailments and aiding childbirth) sometimes advertise their capacity to guard the locus in which they stand from theft and fires, and explicitly state that, taken on board a ship, they will protect against the dangers of the sea.[119]

The exact nature of the charm with which Abu Zayd negotiates his passage is not specified. It is referred to by two distinct terms. The first, ʿūdha, an amulet, charm, or spell, suggests a verbal incantation, similar perhaps to the prayers and supplications that were customary on such occasions.[120] Particular prayers, especially those associated with saints or holy persons, were often recited to calm stormy waters;[121] given Abu Zayd's morally dubious nature, a parodic intent is possible. However, later in the same passage the charm is described as the traveler's amulet or refuge (ḥirz). This vagueness regarding the exact nature of the charm is perhaps not surprising in light of the wide variety of materials that might serve to protect passengers or to quell the violence of the seas and winds on a sea voyage: in addition to spoken prayers and written amulets, these ranged from a cloth soaked in menstrual blood attached to a ship's stern to dust and earth taken from the shrine of a saint (and understood as charged with his protective power), used to calm troubled waters during a sea passage.[122]

Whatever form the charm took, and despite Abu Zayd's reassurances to his fellow passengers regarding its capacity to still the waves and guarantee safe passage, in keeping with the character of the protagonist, it turns out to be a mere nostrum: for moments later, the ship is struck by a violent storm, which blows it off course and onto the mysterious island. Its failure to protect the ship hints at Abu Zayd's role as a charlatan or quack more generally, but the skepticism (if not cynicism) regarding the efficacy of amulets implicit in the narrative is not exclusive to the Maqāmat; it permeates some of the earliest textual references to their use in Iraq and elsewhere.[123]

The second amulet mentioned in maqāma 39 is a material object produced by Abu Zayd for the queen of the mysterious island. It is an amulet to aid labor, a circumstance in which recourse was often made to amulets and talismans.[124] The text specifies that it was written on meerschaum using rose-water tinged with saffron and then sprinkled with ambergris (a kind of dry suffumigation) and wrapped in silk, like the amulet in al-Hamadhani's text. The use of saffron and rose-water in such contexts has a long history in the occult traditions of the eastern Mediterranean and west Asia; it is mandated in the inscriptions found on some medieval Islamic magic-medicinal bowls used to ease labor, including the "poison bowls" discussed above in chapter 4.[125] Abu Zayd specifies that the amulet should not be touched by any menstruating woman (considered a source of pollution), underlining the ritual aspect of amulet production, which often required protocols of purification on the part of the amulet-maker.

We are told that the amulet produced by Abu Zayd was designed to be attached to the thigh of the woman in the throes of childbirth. In fact, the thread that will be used to attach the amulet once completed is visible in the right hand of the servant entering to the left of the image (see figs. 183 and 204). The tying of such an amulet to the thigh follows, once again, a tradition with roots stretching back to late antiquity, as witnessed in Greek lapidaries and medieval Western texts related to them, which recommend tying particular kinds of efficacious amulets to the leg or thigh to assist a woman in childbirth. These include specific kinds of stones which, according to the principle of sympathetic correspondences, were considered effective against certain kinds of ailments or maladies.[126] Like the practices associated with the magic-medicinal bowl discussed in chapter 4, which could either be used for ingestion or placed upon the body, lithotherapy operated through contagion—through contact between the body and efficacious matter.[127] Through translation, such traditions passed into Arabic, where they appear in medieval lapidaries such as that of Ahmad ibn Yusuf al-Tifashi (d. 1253 CE), a contemporary of al-Wasiti, who writes of emerald (zumurrud), "Another property is that all varieties of emerald can be hung on the upper arm for protection and for talismanic purposes and on the thigh to speed childbirth."[128]

In al-Hariri's text, the amulet that Abu Zayd produces is of another kind of stone, meerschaum or sepiolite. This is a surprising choice, given that meerschaum is a soft, soapy stone, not an obvious writing medium. Its use in such contexts is not, however, unknown: the lapidary of Jean de Mandeville (d. 1371), for example, preserves a tradition that recommends tying meerschaum to the thigh of a woman in labor to aid childbirth.[129] It is therefore possible that al-Hariri's text conflated two distinct, if related, amuletic traditions: a tradition of attaching stones seen to possess therapeutic powers to the body of a woman in labor, and a tradition of inscribing amuletic texts and signs on paper scrolls, which might be folded and also attached to the body for protective, prophylactic, or therapeutic purposes. Ninth- and tenth-century Arabic texts specifically commend the use of 3×3 magic squares such as those found in the magic-medicinal bowls discussed in chapter 4 (see figs. 102–103 and 106–109) for such purposes, explaining that they should be attached to the body (often the thigh) of a woman in labor.[130]

The reason for this conflation or condensation is not clear. It may be intended to slyly ridicule beliefs in the efficacy of so improbable an object as an inscribed soft stone. However, the German and English term "meerschaum" (sea foam or froth) preserves the sense of the Arabic name for the stone, *zabad al-baḥr*, literally froth or foam of the sea. This association is reinforced by the fact that the same term can sometimes refer to coral or the "bone" of a cuttlefish.[131] Given that the tale in al-Hariri's text in which the amulet figures is infused with a maritime flavor, a punning intention is also quite possible, recalling perhaps the ineffective use of an amulet earlier in the same tale to still the waves of a violent sea.

The maritime theme is further underlined by the use of ambergris, an aromatic substance derived from the digestive tract of whales and collected as flotsam in the Indian Ocean, to sprinkle the amulet before it was wrapped in silk and tied to the thigh of the woman in labor.[132] In al-Hariri's image, the use of such aromatics is evoked by the image of the incense brazier carried in the left hand of the attendant entering from the queen's right, bearing the thread to attach the amulet in her other hand (see fig. 204). Its presence reflects intersections between traditions of magic and medicine, for not only was incense valued as a pharmaceutical or therapeutic substance, but fumigation with aromatics was a practice often deployed for gynecological purposes in the medieval Islamic world,[133] in which *zabad al-baḥr*, the material on which Abu Zayd's amulet was written, was also used for medicinal purposes.[134] The appearance of this brazier or censer returns us to the magic-medicinal use of incense discussed above in chapter 1, and reinforces the points made in chapter 4 regarding the parallel and often intersecting trajectories of therapeutic regimes that depended on amulets and pharmacology: Similarly, a character in another twelfth-century example of the maqāma genre laments that in his attempts to stem the pain caused by the disease of love, he has spurned the temptation to ask God "either for a physician's medicine or for the charms produced by a maker of amulets."[135]

In illustrating the tale, however, al-Wasiti has avoided the challenge of depicting an amulet inscribed on a soft stone and instead gone for the default option, showing Abu Zayd as a scribe, writing in ink on a long paper scroll (see fig. 205). This was the standard format for many of the amulets produced in the medieval Islamic world, an association between form and function sufficiently well established for the format to signify the nature of the document to an informed viewer. On the opposite side of the frame, Al-Harith is seen determining the position of the stars with an astrolabe (see fig. 206), a reminder that the instrument was as central to astrology as to astronomical investigations. The determination of the position of the stars was an endeavor considered necessary for the production of certain amulets and talismans, including some of the magic squares used to ease childbirth and the magic-medicinal bowls that bore them (see figs. 102–103 and 106–109), both of which were sometimes inscribed or engraved under the sign of an auspicious constellation.[136] The depiction of the astrolabe may also allude to the custom of casting the horoscope of newborns. Here, again, al-Wasiti introduces a detail not mentioned in the text, but evidently drawn from the world around him.

Anachronisms, Survivals, and Revivals

Rather than in a capacity for either observation or pure invention, al-Wasiti's originality lay in an ability to draw on multiple images and narratives and integrate them into a single visual artifact. In his images, elements drawn from observation coexist with the use of contemporary conventions and likely inspiration from oral and textual traditions that pre-dated the period in which he was working. As this suggests, the temporality of the images in al-Wasiti's manuscript is as complex as their relationship to the text, tinged as much with anachronism as with innovation, a temporality that transcends the simple chronological fact conveyed by the completion date inscribed on the colophon of the manuscript that al-Wasiti produced in 634 H/1237 CE.

In the first place, the intertextual work undertaken by the thirteenth-century images relates the tales in al-Hariri's text, written in the eleventh century, to textual (and likely oral) narratives generated and compiled during the heyday of Iraq's Indian Ocean trade in the ninth and tenth centuries. This was during a moment when the Indian Ocean has been described as an "Arab Mediterranean," a descriptor that captures the intensity of transregional connections, even as it minimizes the involvement of Africans and Indians.[137] As we saw above, copies of the texts in which such tales were recounted continued to be produced into the period in which our manuscript appeared.

However, by the time that al-Wasiti was working on his copy of al-Hariri's text in the early thirteenth century, the rise of the Fatimids, the rivals to the Abbasid caliphs in Cairo, had seen the principle orientation of the Indian Ocean trade routes shift westward, away from Iraq and the Gulf

and toward Egypt and the Red Sea.[138] If in the early twelfth century we still hear of merchants such as Ramisht of Siraf who traded between the Gulf and India, and could even cover the Ka'ba in Mecca with Chinese textiles, from the end of the twelfth century onward the India trade was dominated by the Karimi, an Egyptian mercantile guild.[139] There is no doubting that trade between the ports of India and the Gulf continued—the presence of Muslim merchants from the Gulf in western India in the thirteenth century, during the period when al-Wasiti was painting, is in fact well documented.[140] But it did so with diminished intensity, with Egypt rather than Iraq as the center of gravity.

What al-Wasiti's paintings preserve is an anachronistic echo of past entanglements, the memory of which was perpetuated in the tales of wonder that seem to have inspired some of his paintings, and which retained currency into the twelfth and thirteenth centuries. But alongside such echoes of a time when Iraq was truly the center of the Islamic world, the images also integrate features of much more recent derivation: the appearance of the muqarnas domes that had become common in Baghdad only in the preceding century, for example (see figs. 197-199).

The case of the harpy and sphinx that make an appearance on the mysterious island (see figs. 182 and 200) is less clear-cut. Harpies and sphinxes had occasionally appeared on earlier textiles and other portable arts, but as we saw in chapter 5, their popularity in the Islamic lands seems to have increased exponentially during the twelfth and thirteenth centuries at a moment when figurative art proliferated on a range of media.[141] Their appearance in al-Wasiti's painting, as in the near contemporary rock relief at Lalibela (see figs. 132 and 154) is therefore indicative of a very contemporary artistic phenomenon.

And yet, the temporality of such creatures is less straightforward than is sometimes assumed. Both harpies and sphinxes have a very long history in the arts of the Mediterranean and west Asia, a history whose implications for their proliferation in medieval Islamic art has never been seriously considered. On the contrary, the popularity of these chimeras in medieval Islamic art is usually explained in a circular fashion, by referring vaguely to their perdurance across time and space.[142]

It has been suggested that the role of the sphinx in medieval Islamic art reflects the fact that "a stream of ancient mythopoeic topoi survived into medieval times."[143] Whether or not meaning was in fact so stable, the form of the har-

pies and sphinxes found in the arts of the Islamic lands during the twelfth and thirteenth centuries is often remarkably similar to that of their ancient predecessors. Take, for example, the image of a sphinx that appears on a series of laqabi-ware plates produced in Syria in the thirteenth century (fig. 207).[144] Unlike the pointed crown worn by the sphinx in Lalibela (see fig. 154), the creature on this and other plates sports a flat headdress, similar to the *polos* crown found on the heads of sphinxes that appeared in ancient Mediterranean art, such as that worn by a sphinx found on a bronze vessel stand produced in Cyprus more than three millennia earlier (fig. 208). How are we to understand these formal parallels? Is this a case of an iconographic revival—a mining of ancient imagery across the centuries—or a continuous artistic tradition linking the arts of medieval Islam with those of ancient west Asia? Or both? The question is directly relevant to a longue durée reading of the hybrids in al-Wasiti's painting, and in the arts of the twelfth and thirteenth century more generally, even well beyond the central Islamic lands (see figs. 154 and 159).

Given the striking formal parallels between ancient iconographies of the sphinx and harpy and those found in medieval Islamic art, an entirely independent invention seems unlikely. Conversely, the evidence for a continuous tradition is currently lacking. Instead, we might consider the possibility of a "disjunctive continuity," a revival of interest in ancient iconographic types based on first-hand experience of the material remains of the past. Such a scenario would fit well with what we know about attitudes to the instantiated past in the eastern Islamic world between the eleventh and thirteenth centuries. On the one hand, this is a moment that sees a renewed interest in the material remains of the past, with ancient architectural fragments, reliefs, and inscriptions reinscribed, reused, and even re-established as talismans. On the other, we find the deliberate emulation of ancient forms and iconographic types, something well documented for coinage, but also witnessed in architecture.[145] Both phenomena exist at the intersection between random survivals and deliberate revivals.

The focus in modern scholarship has generally been on the reception of classical antiquities; hence these phenomena are often referred to collectively as a "classical revival." While there is no dearth of evidence for the reinvestment of classical forms and fragments during this period, from the reuse of spolia to the emulation of earlier Roman and Byzantine imagery and ornament, the very fact of such temporally disjunct continuities

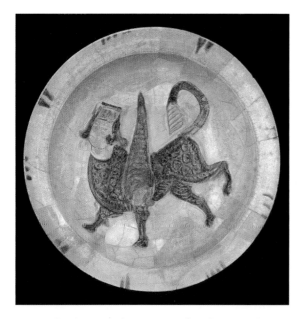

Fig. 207 Plate depicting sphinx wearing a flat *polos*, Syria, 13th century. Laqabi-ware ceramic. Copenhagen, Davids Samling (The David Collection), inv. no. Isl. 143.

(RIGHT) *Fig. 208* Detail of a vessel stand with sphinx wearing a flat *polos*, Cyprus, 1250–1100 BCE. Bronze; h. 29.2 cm. London, British Museum, inv. no. 1946/10–17/1.

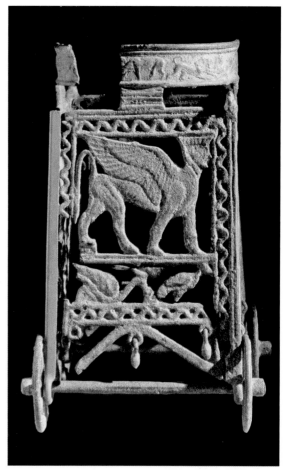

should alert us to the possible use of models that pre-dated classical antiquity. That first-hand experience of such antiquities was available in Syria and Iraq is not in doubt. The reception of reliefs dating from the second and first millennia BCE and their use as sources of iconographic inspiration in Roman Syria has been noted,[146] but there is no shortage of evidence for the reception of similar ancient imagery in the medieval Islamic period, leaving open the possibility that it served as a source of artistic inspiration.

The reception of antique inscriptions and reliefs is especially well documented for Egypt, where such survivals were often identified as talismans invested with protective and therapeutic properties, but is well documented too for Syria, Iraq, and Yemen, all of which attest to the existence of a preference for antique inscriptions, reliefs, and sculptures as talismans to protect against a variety of ills.[147] Many of these served as protection or prophylaxis against snake or scorpion bite, addressing a common concern also explicitly engaged in the texts and images on the magic-medicinal bowls discussed above in

chapter 4. Among them was a relief of a hybrid scorpion-man set up as a talisman at the entrance to the Friday Mosque of Hims in northern Syria, whose existence is documented as early as the tenth century (fig. 209).[148] Most descriptions refer to a stone relief or sculpture, but some texts refer to a copper image, perhaps confusing the relief with an earlier metal talisman in Hims, reportedly designed by Apollonius of Tyana, to whom medieval Arabic sources ascribed the invention of the magic squares and talismans discussed in chapter 4.[149] Some medieval descriptions mention the practice of rubbing a lemon against the image to produce a juice which could be diluted and drunk to treat the sting of a scorpion,[150] recalling the role of images in the magic-medicinal bowls also discussed there. Others report the use of a clay bolus to take an impression of the image, which could then be dissolved in water and drunk as a cure for scorpion bite or intestinal problems. In effect, the image functioned as a large-scale stamp or seal to impress clay, relating it to other kinds of magical and therapeutic practices described in chapter 4 (see figs. 120 and 121). Medieval Arabic therapeutic

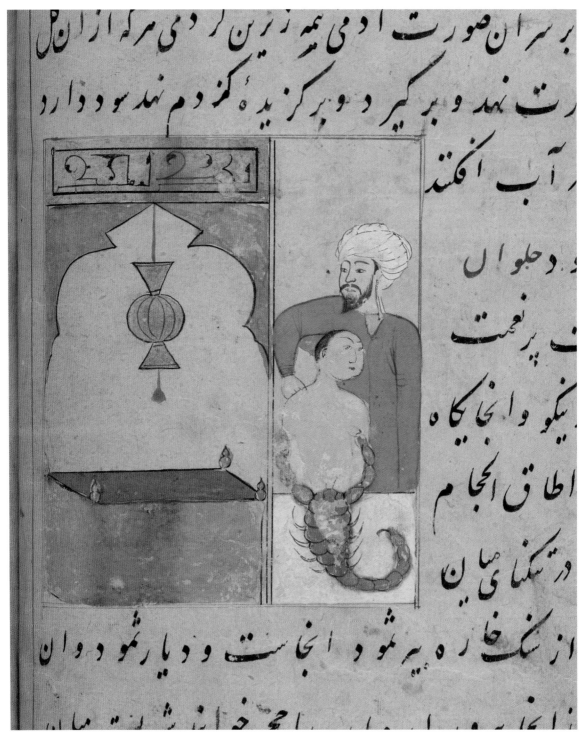

Fig. 209 Imaginative depiction of the scorpion-man at the gate
of the Friday Mosque of Hims, as described by Muhammad ibn
Ahmad al-Tusi in his *ʿAjāʾib al-makhlūqāt wa gharāʾib al-mawjūdāt*
(Marvels of creation and rarities of existence), Iraq, 790 H/1388 CE
or later. Paris, BnF, Supplément Persan 332, fol. 95b (detail).

texts recommend applying a dead scorpion to the site of a scorpion sting; here the relief image and its imprint on a medium are invested with the powers of the beast itself, similar to the poisonous beasts depicted in the magic-medicinal bowls we have discussed. Indeed, some authors emphasize that the efficacy of the Hims talisman was not located in the clay (a common pharmacological ingredient in its own right) but rather in the image and its imprint. Chroniclers report that the curative properties of the earth were tried and tested (*mujarraba*), a claim for efficacy associated with amulets and medicinal substances and often made in the inscriptions on medieval magic-medicinal bowls.[151]

Descriptions suggest that the relief in Hims was in fact an example of the scorpion-men known as *aqrabuamelu* or *girtablullu*, magical guardians of gates in ancient west Asian art, where they assumed different hybrid forms, each of which combined the head, torso, and legs of a human with a scorpion tail.[152] In fact, hybrid scorpion-men figures datable to between 1400 and 900 BCE have recently been excavated from a temple of the storm god in the citadel of Aleppo (fig. 210), suggesting that such hybrid creatures were indeed part of the landscape of medieval Syria.[153] Like the hybrid creature depicted above the entrance to the church in Lalibela (see figs. 132 and 154), the scorpion-man of Hims was set at the gate of the mosque. Its location as an apparent guardian figure would have been perfectly intelligible in its original context, raising the possibility of continuities in meaning even when traditions of use and reuse were temporally disjunct.[154] That spolia of such antiquity were pressed into service as talismans is not surprising: a carved stone Hittite Hieroglyphic-Luwian foundation text dating to the thirteenth century BCE was identified as such in the mosque of al-Qayqan in Aleppo, reflecting a close associated between ancient alphabets, esoteric inscriptions, and occult artifacts and practices that operate at different scales, extending to amulets and the magic-medicinal bowls discussed in chapter 4.[155] Although there is no indication that such reliefs and sculptures were ever originally consecrated as talismans, they were clearly identified as such by virtue of their antiquity and unusual material or visual properties, regardless of whether they conformed to contemporary normative or theoretical notions of the talisman.[156]

The discovery of such antiquities and their identification as talismans is something of a topos in the regional histories produced in medieval Syria. In his history of Aleppo, the Mamluk histo-

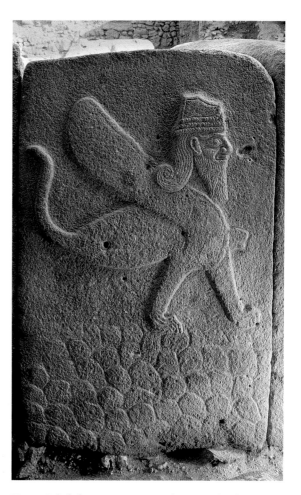

Fig. 210 Relief of a scorpion-man recently excavated in the temple of the storm god on the citadel of Aleppo, 1400–900 BCE.

rian Ibn al-Shihna (d. 1412 CE) reports that when excavations were made within the Friday Mosque of the city for a cistern, a basalt lion poised on a basalt socle was discovered; when it was removed, the mosque suffered numerous misfortunes by earthquake and fire. He also mentions that in the eleventh century, when the Seljuqs ruled Aleppo, excavations of the foundations of a palace on the citadel led to the discovery of a basalt lion, whose removal led to the collapse of part of the citadel.[157] The talismanic function attributed to these sculptures is common to a range of ancient inscriptions and reliefs reused in the medieval monuments of Aleppo. Moreover, even the reported circumstance of their discovery supports the veracity of such accounts, for a Syro-Hittite tradition of ritual burial of basalt lion orthostats has been documented; and lions of similar type, evidently excavated and re-established in the Islamic period, were visible on the Aleppo citadel until the early twentieth century.[158] A basalt orthostat

carved in relief with a sphinx from the Temple of Hadad-Jupiter (ninth century BCE) was found in the lower levels of the northeastern corner of the temenos wall within which the Friday Mosque of Damascus was built on the same site in 715 CE.[159] Whether or not it was ever visible, its presence lends plausibility to medieval accounts of similar discoveries in other mosques.

One can easily imagine, therefore, how first-hand experience of ancient iconographies combined with a renewed interest in the past and its material remains led to an enhanced interest in the harpy and sphinx at this period. It is, of course, a leap from the reinstatement and reinvestment of literal fragments of the past to their use as sources of inspiration for contemporary imagery, but this is exactly what we see in Anatolia, Syria, and Iraq in the twelfth and thirteenth centuries. The reappearance of copper coinage in the region after an interval of several centuries is a case in point, with many of the images on these coins adapted from earlier Byzantine, Roman, and Sasanian issues (see fig. 115). The phenomenon represents an adaptive reappearance of imagery mined across centuries and cultures in what amounts to a disjunctive continuity with the arts of antiquity; it is particularly well documented among the Artuqids of the Jazira in whose realms the magic-medicinal bowls discussed in chapter 4 almost certainly originated.[160]

The revival of ancient forms of ornament in some of the monuments of northern Syria during the same period suggests that the phenomenon extended well beyond coinage. It is thus quite conceivable that proliferation of the sphinx in the arts of these regions at this period reflects the direct experience of antique iconographies, even if it is not reducible to this factor alone. The possibility has been raised that certain iconographic elements (including hybrid beasts) found on medieval Iraqi ceramics were inspired by the experience of pre-Islamic Mesopotamian antiquities.[161] In addition, it has been suggested that striking similarities between the images of jinns as hybrid creatures associated with Solomon in medieval Iraqi book painting on the one hand and the composite images found in neo-Assyrian art on the other may reflect medieval encounters with neo-Assyrian art, with the result that certain medieval Islamic images were "drawn from the local ruins of antiquity."[162] The survival of such antiquities into the Islamic period is certain, as is their frequent identification as amulets and talismans. Among the most striking examples is a remarkable stone tablet inscribed in cuneiform with a text referencing Gudea, king of Lagash in Iraq

(r. ca. 2150–2125 BCE); on its sides and reverse, the tablet has been later reinscribed with an Arabic text in Kufic script, similar in arrangement to texts found on amulets of the ninth and tenth centuries CE (fig. 211; see also figs. 120 and 121).[163]

If the existence of antique images and objects capable as serving as models confounds the certainties of synchronic time, the temporality of many of the images and objects discussed in these chapters is further complicated by the fact that long-established iconographic types (whether part of a continuous tradition or a deliberate revival) were often deployed in combination with novel or newly introduced imagery. In the magic-medicinal bowls discussed in chapter 4, an ancient triad of quadruped, snake, and scorpion was, for example, paired with a double-headed dragon newly introduced to the repertoire of medieval Islamic art. Similarly, the appearance of raptor and archer in addition to the familiar figure of the equestrian ruler or saint in the Ethiopian relief discussed above in chapter 5 reflects the reception of novel imagery likely derived from portable objects that may have traveled long distances.

The combination captures something of a contemporary phenomenon that extended well beyond occult technologies, stone reliefs, or portable objects. A more literal and monumental expression of such temporal montage is exemplified by the entrance to the hospital that the Syrian ruler Nur al-Din (mentioned on what seem to be the earliest magic-medicinal bowls) built in Damascus in 1154 (fig. 212). Here a reused classical pediment is combined with a muqarnas semi-dome and muqarnas dome similar to those seen in al-Wasiti's paintings (see figs. 197–199), now introduced to Syria from Iraq for the very first time.

The component elements of all the artifacts and images discussed here moved at different temporal velocities. Their constellation on metal bowls, stone reliefs, and painted images constituted each of these as what Georges Didi-Huberman calls "an object of complex, impure temporality: an *extraordinary montage of heterogeneous times forming anachronisms*."[164] Like the phenomenon of copying itself, their temporality calls into question the very idea of synchronicity, even as the circulation and reception of their component elements across a vast area extending from East Africa to the Gulf and beyond undermines the idea of bounded cultural forms. This is not to insist on a landscape constituted by the uniformity of a shared universe of artistic forms. On the contrary, all of the case studies presented

Fig. 211 Blackstone plaque with a bronze peg for suspension, Lagash (Sumeria), ca. 2150 BCE. 9.5 × 5.8 × 1.5 cm. Originally inscribed in cuneiform as a foundation plaque for a temple constructed by Gudea, Sumerian ruler of Lagash, the reverse of the plaque was inscribed in Arabic using Kufic script in the late seventh or early eighth century CE, following a formula often used on early Islamic amulets (see, e.g., figs. 120–122). Oslo, The Schøyen Collection, inv. no. MS 2400.

here exemplify selective and highly structured engagements with the possibilities presented by the circulation of both ancient and novel iconographic types.

The basic argument underlying the selection and presentation of the case studies in the second part of this book has been the need to acknowledge the interconnectedness of Africa with west and south Asia in the twelfth and thirteenth centuries on the eve of the Mongol conquest, and the potential value of material artifacts for elucidat-

ing some of these connections even in the absence of contemporary texts. The objects and images discussed here attest to connections that were both maritime and terrestrial, involving the mobility (both voluntary and involuntary) of certain kinds of human beings, and the circulation of commodities, gifts, imagery, and raw materials. Some of these materials served as models or sources of inspiration for artisans and artists operating in locales that were far distant from their point of origin. Close attention to the nature of their reception as manifest in the manner in which they were reimagined provides insights into aspects of artistic agency that otherwise remain elusive. Such traces of reception also remind us that beyond the tendency to celebrate and highlight what seem from our own presentist perspectives remarkable or surprising instances of pre-modern mobility, it is equally important to pay attention to the way in which highly mobile artifacts, imagery, or persons

Fig. 212 Entrance to the *bīmāristān* (hospital) of Nur al-Din ibn
Zangi in Damascus, 549 H/1154 CE, in which a reused Roman
pediment is set below a muqarnas semidome, with the profile
of the muqarnas dome of the vestibule visible above.

interacted with those found in situ, long established at the point of reception.

The reception of such imagery transculturally was often governed by deeply rooted regional traditions that could operate transhistorically, challenging a historiographic tendency to describe these phenomena in terms of "influence." The passive connotations of this concept, with its hint of cultural hierarchies marked by perceived superfluity and lack, captures little of the agentive and often highly innovative instances of reception discussed in these chapters. Some of the imagery discussed in the preceding case studies had first appeared in the regions in question up to a millennium before the twelfth and thirteenth centuries; other kinds of imagery represent more recent additions to established iconographic repertoires. Although significant gaps in the material archive sometimes frustrate our ability to distinguish continuity through time from more temporally disjunct phenomena of rupture and reinvestment, in other cases the imagery in question was so long naturalized that it is difficult to identify a point of origin. In short, each of the objects or images discussed here is the composite product of iconographic or technical innovations, revivals, and survivals brought into constellation. Even the individual elements deployed within such visual, technical, and functional assemblages are often possessed of distinct chronological trajectories.

The image of the sphinx is a case in point, reminding us that even chimeras have patterns of migration. Studies of the proliferation of chimeras or hybrids, including sphinxes, that circulated westwards from Mesopotamia and Egypt in the late second and first millennia BCE to be incorporated into the arts of Greece have suggested a relationship between these "supermobile composites" and the long-distance trade and other networks that flourished between the Mediterranean and west Asia during this period. Such chimeras were component elements of what has been called the "International Style" of the late Bronze Age Mediterranean, characterized by receptivity to iconographic motifs (especially chimeras) of west Asian origin.[165]

The circulation of certain kinds of artifacts bearing such imagery was integral to the self-fashioning of cosmopolitan elites,[166] a function which may be no less relevant to the elites of the twelfth or thirteenth centuries CE, whether in Ethiopia, India, or Iraq. The meaning ascribed to such imagery was likely determined by regional cultural traditions and expectations (as suggested by the Ethiopian alterations to the iconography of the sphinx, for example), but as exotic imports they played a role in staging evidence of access to long distance trade and other kinds of networks. This being so, the wanderings of sphinxes or alighting of harpies in the arts of this period, from Anatolian magic-medicinal bowls to Ethiopian reliefs and Iraqi book illustration, might embolden one to offer a hypothesis. To suggest that the creatures chosen by a medieval Iraqi artist to emblematize a maritime world of wonders are in fact indexes of the very geographic and temporal entanglements that these case studies have endeavored to highlight.

Conclusion

Global, Local, and Temporal

In an earlier publication, one of the authors of this volume followed the anthropologist James Clifford in arguing the need for historians of pre-modern material culture to be attentive to "routes, not roots," to consider the trajectories of objects and the complex identities that they acquire and which they articulate, rather than obsessing about their origins.[1] Arguably, however, in the past decade or so, this has become the dominant mode of much scholarship on pre-modern material history, often at the expense of attention to more immobile and deeply rooted cultural forms and practices. As our case studies demonstrate, even in the case of highly mobile forms, objects, and techniques, processes of production and possibilities of reception are often determined by aesthetic, iconographic, or material values that are local, or at least regionally situated. The material presented here thus highlights the need for a recalibration, toward a focus on routes *and* roots.

The challenge is to acknowledge the often remarkable trajectories of particularly mobile images and objects, while also paying close attention to the specifics of their reception. In particular, we need to be attentive to the way in which highly mobile artifacts, images, and techniques interacted with deeply rooted artistic forms and cultural traditions that were themselves constituted relationally: in other words, to acknowledge both lines of circulation and dots, or nodes, of reception.[2] The objects of our study thus emerge as nodes within networks characterized both by the horizontal flows associated with trans-regional mobility and by the ways in which the agents, ideas, images, materials, and objects that moved along them intersected with the vertical axes of the local, the particular, and the rooted.[3]

The resulting dialectic is captured in the image of the railroad invoked by the sociologist and anthropologist Bruno Latour in his dis-cussion of the idea of network. Latour uses the metaphor to make the distinction between the local and the global, the railroad being a translo-cal (but non-universal) network that is local at all points.[4] As the Africanist Frederick Cooper puts it, networks are "more than local and less than global," marked by uneven densities of connec-tivity.[5] Unlike Cooper, who signals the importance of a variety of pre-modern and pre-colonial net-works in fostering connectivity, Latour assumes that the extent of pre-modern networks was limited by the need to assert and maintain the ter-ritorial claims of political formations. Yet, recent scholarship emphasizes the idea that networks, including (or especially) pre-modern networks, "have no center-point or command chain."[6] The networks reflected in the materials presented here pre-date both the Mongol conquests and the period of European colonialism; their opera-tion, while dependent on a shifting constellation of cultural, ecological, economic, and political factors (including coerced labor) was neither ran-dom nor necessarily dependent on the exercise of political dominion.

In our Introduction we suggested that, rather than think of artifacts and images as self-subsisting, we might instead imagine them as embedded in a variety of networks existing relationally. Like the places in which they origi-nated and in which they came to rest, the objects discussed in our case studies appear as what the historian Pamela H. Smith has described as "nodes of convergence" within such networks.[7] Acknowledging the need to conceive of the objects discussed in our case studies as nodes within which local and translocal cultural forms and practices intersect mitigates the dangers of emphasizing commonalities and sharing at the expense of differences and particularities. As we saw in chapter 3, a rock crystal lion produced in

the Islamic lands could be physically and conceptually transformed to conform with Christian salvific iconographies. Similarly, as described in chapter 4, the reception in medieval Ethiopia of a type of sphinx probably mined from the portable arts on the contemporary Islamic world is marked by subtle yet significant iconographic changes, likely related to its meaning in its African Christian context. In many cases, these formal alterations reflect a conceptual reframing that remains somewhat opaque, but that nonetheless qualifies any assumption that the sharing indexed by reception necessarily constitutes homogeneity. The point is underlined by the capacity of the tri-metallic niello technique discussed in chapter 2, a technique that seems to have originated in the Islamic lands, to manifest the Christian concept of the Trinity, the threefold nature of God.

As Michel-Rolph Trouillot reminds us, "[t]he experience of globality is always that of historically situated individuals with specific resources and limits."[8] In addition, like all networks, the pre-modern networks whose existence is attested to by the circulation of artifacts, images, techniques, and the human agents associated with them were erratic in their coverage—not everywhere was connected to the same degree or with the same degree of intensity at the same moment. We need therefore to acknowledge a bias in the information available to us, with some aspects of pre-modern connectivity remaining invisible.[9] Moreover, as has often been noted, not all participants in the sorts of pre-modern networks of the kinds highlighted by our case studies were equally mobile. These networks were generally nodal or segmented, and it was rare for a single agent to travel their entirety. As we saw in chapter 6, even wealthy merchants and shipowners often made use of agents, rarely themselves traveling the routes followed by their employees, goods, and slaves. Similarly, many of the Arab geographers and historians were sedentary: armchair travelers whose accounts of long-distance voyages to India and China were gleaned by interviewing mariners and merchants in the ports of the Gulf or southern Iraq. For all the celebratory emphasis on circulation and mobility, the phenomenon reminds us that while certain classes of individual (merchants, pilgrims, or warriors, for example) may have traveled over long distances, whether by choice or necessity, many were far less mobile than the portable objects which we have discussed in the preceding chapters.

The phenomenon necessitates approaches that move beyond a common focus on major empires or hegemonic centers, away from a "vertical" nar-rative of art history toward a more "horizontal" approach, a shift that also considers nodes and networks that operate at a scale or speed different from those associated with the great empires of history.[10] One result of this move would be to question the privilege long afforded to centers of artistic production in major metropolises, such as Alexandria, Baghdad, or Constantinople, in diffusionist histories of pre-modern art. The consequent conception of regions outside these centers as marginal, places of dissemination and reception rather than of artistic production in their own right, is not only problematic in its implicit assumptions of a passivity often articulated in terms of "influence," but is also rooted in diffusionist models often marked by strong colonialist overtones.[11]

Margins imply edges and limits, but also conditions of contact and contiguity. Since marginality is always relational—constituted in relation to hegemonic centers—each margin is itself a center relative to the cultural and spatial geographies to which it is connected and contiguous. As a result, the artistic production of regions located at the interstices between major imperial formations often manifests a more cosmopolitan array of regional and transregional sources of inspiration than does that associated with imperial centers. Yet, the hegemony traditionally enjoyed by a select group of imperial centers in art-historical narratives of origins denies the possibility that works produced in centers (or networked nodes) outside the boundaries of major empires, or in urban centers considered marginal or provincial within them, could serve as potential models or sources of inspiration. As we saw in chapter 1, for example, although Nubia has emerged in recent scholarship as a major center of artistic production,[12] it has been assumed on very little evidence that a spectacular censer from Old Dongola (see fig. 30) must have been inspired by the art of the Byzantine capital, rather than representing a distinct (even if related) Nubian tradition.[13]

A recent essay by Parul Dave Mukherji on the role of art history in a globalizing world captures the imperatives and possibilities that stem from a shift of scale away from existing canons, familiar archives, and hegemonic centers:

If global art history abandons its overarching story of progress and canonization and turns its gaze on the non-Western and postcolonial archive and its overlooked sites, it will have much to gain from a local and regional focus, which can be conducted as case studies. For a new

theory to emerge, it will have to consider these overlooked histories and sites of experimentation in which space will have a new primacy and become a source of new temporality: not the temporality of homogeneous time, but temporality as a construct that acquires coherence within a specific, located spatiality.[14]

Although written as a critique of Eurocentric narratives of modernism, Mukherji's comments are no less relevant to the case studies presented in the preceding chapters, each marked by complex intersections between regional and transregional cultural forms and practices or by dialectical tensions between diachronic and synchronic registers of temporality.

Acknowledging the multiplicity of nodes that constitute any network, comparable in their density to the dotted centers clustered and dispersed across medieval and early maps,[15] such approaches mitigate the reductive unidirectionality that characterizes the center-periphery model integral to many theorizations of the global. A recent essay by the art historian Claire Farago suggests that

[o]rganizing the history of art and material culture into historical spatial networks leads to an entirely different, but extensively documentable, history focused on cultural interaction that does not rely on modern categories such as nation-states, continents, period styles, and other monolithic and often anachronistic entities to organize the material. [. . .] Such a deterritorialized model for organizing the discipline according to regional networks of interaction has the advantage of producing numerous regional chronologies, rather than a single linear chronology tied to European events.[16]

This shift in perspective toward networked relations necessitates a broadening of the range of materials and sources used to write pre-modern history—a central claim of our volume.[17] It also demands transcending a high-low distinction that has been and is still pervasive in our own discipline of art history, and that has led to the marginalization of materials not associated with elites, a tendency that is arguably especially pervasive in the field of medieval studies, whether focused on the medieval Islamic world or Christendom. Although posed in the context of a somewhat facetious 1908 essay on modernism, Adolf Loos's musings on why he has yet

to encounter a Carolingian workbench (rather than a manuscript) in a museum collection still ring true.[18]

A related appeal of the concept of the network is its ability to account for the entangled relations between human subjects, the objects which they used and viewed, and the materials from which these were crafted. This might lead us to acknowledge the distributed or networked nature of agency (whether conceived in material, ontological, or social terms) rather than locating it exclusively in a human subject.[19] The implications of such a shift are well captured by the art historian Jennifer L. Roberts, who explains that "the notion of the distribution of agency through objects demands that we imagine things not as isolated beings in a single place, but as active nodal delegates linking and coordinating different entities and forces."[20] At a moment when the certainties of humanism regarding the absolute distinction between persons and things, humans and technology, are being challenged by developments both in the humanities and the hard sciences, and by the emerging idea of the "post-human,"[21] some of the materials presented in the preceding chapters raise fundamental questions about the networked relationships between human beings, forms of knowledge, systems of belief, and material objects. Those questions are closely related not only to material histories of religion, but also to histories of magic, medicine, and even mathematics.

As this suggests, the networks that facilitated the kinds of mobilities that constitute early globalisms, and were constituted by them, were not just geospatial, but also included social practices such as commerce, craft, learning, and ritual, whether the forms these took were shared across regions or particular to specific locales. They included temporal networks that are every bit as palpable as the geographic and spatial networks indexed by the circulation and reception of the artifacts we have discussed. Within such networks, our chosen objects appear not only as nodes of intersection between local and translocal, regional and transregional cultural forms and practices, but also as knotted residues of different temporalities, whether constituted by continuities, disjunctions, or revivals.

The challenge that networked histories of early globalisms pose to established taxonomies of time and the periodizations arising from them remind us that questions of temporality are as relevant as considerations of spatiality.[22] At the micro-level of analysis, the materials from which our understanding of chronology is constructed are themselves often more heterogeneous in

their temporality than the attribution of singular dates of making would suggest. Yet, just as our disciplines have tended to privilege the idea of single creators rather than cumulative (including non-human) agencies, or to insist on privileging points of origin over histories of circulation and reception, so the time assigned to objects is often reduced to the moment of their making.

Jennifer L. Roberts has noted that objects "are geo-eco-political events."[23] Many of the objects discussed in the preceding case studies illustrate the point, whether in their use of natural and crafted matter, their relationship to dynamic social practices, their capacity to index mobility and transregional connectivity, or their relationship to shifting constellations of intercontinental geopolitics. However, we also need to acknowledge that "object events" are constituted by a complex temporality that inheres in form, facture, and matter. The same object can be a product of different moments in time and incorporate older parts, contemporary elements, newer joints, or be subject to later alterations and additions, accumulating the traces of multiple layers of time. Even those of our objects that seem to be products of a particular time and place, are often conceptual or material assemblages, composites whose component elements have their own histories and skeins of historical relationships linking them to preceding, contemporary, and future creations.

If the geo-spatial and transcultural complexities of the objects that form our case studies necessitate the assumption of multiple perspectives, so the temporalities of such objects invite us to acknowledge that artifacts, images, and techniques move at different velocities, and sometimes with different trajectories along the networks that they travel. The use of the objects as models for the dissemination of novel techniques (as in chapter 2), for the production of copies (as in chapters 1 and 4), or for the improvisation of new forms of imagery (as in chapter 5) further complicates the complexity and density of temporal sedimentation and the consequent difficulties of accommodating them within the discrete taxonomies of periodization traditionally favored in the discipline of art history. In many cases one suspects that the efficacy of the images and objects that we have discussed, their ability to work their protective magic, as it were, was closely related to this very quality.

If our chosen objects resist established taxonomies by their capacity to confound categorization according to singular identities, genres, media, and origins, they also highlight the ways in which diachronic processes can inflect even artifacts assumed to be the product of a single moment. Instead of singular identities and linear temporalities, the objects we have presented here suggest the need to acknowledge that we are often dealing with heterogeneous histories and identities condensed in material form.

Writing of the temporality of images, the art historian Georges Didi-Huberman suggests that any image is constituted as a "knot of anachronisms," a history of continuities, discontinuities, receptions, repetitions, and revivals which "is hard to analyze in the absence of written archives."[24] Hard perhaps, but by no means impossible, as we hope the preceding case studies have shown. Leaving aside this faith in the capacity of the textual archive to reveal the historical truth of images and objects, Didi-Huberman's insistence on the anachronic temporality of the image (and here, by extension, the object) provides a useful reminder that "[t]he history of images is a history of objects that are temporally impure, complex, overdetermined. It is therefore a history of polychronistic, heterochronistic, or anachronistic objects."[25] Just as the complexities of cross-cultural reception imbue our chosen images and objects with a capacity to resist reductive categorizations and singular identities, their temporality is messy and multilayered, involving anachronisms, innovations, repetitions, survivals, and revivals sometimes within the same object.

Such readings of the temporality of the objects of study as complex, nonlinear, and impure is in tension with the cleaner, neater version of history traditionally favored by art historians.[26] This often favors forms of periodization conceived in dynastic, regional, or sectarian terms, inviting a temporal segmentation or fracturing that privileges European (essentially, Christian) time as the default.[27] As discussed in our Introduction, the very category of "the medieval" (the period between the eras of the classical and the Renaissance) is itself open to such a charge, even leaving aside its Eurocentric origins.[28] This emphasis on synchronic time is often at odds with (or even attempts to tame) the complex sedimentations of time instantiated in objects such as those discussed here, whether complex assemblages of exotic materials as favored in medieval European treasuries, bowl technologies used for healing, or the chimeras that feature in the carved ornamentation of some medieval Ethiopian churches.

In this sense, many of our case studies exemplify the phenomenon and effects of *Nachleben* (literally, living on), a concept developed by the celebrated German art historian Aby Warburg, on whose work Didi-Huberman's observations

are based. In a remarkable essay, written in 1912, on a series of astrological images with hermetic overtones painted on the walls of the Palazzo Schifanoia in Ferrara, Warburg traced the trajectory of their forms across time, from their origins in India and Greece, through their compilation and inclusion in the Arabic work of Abu Ma'shar al-Balkhi (d. 886 CE) produced in Abbasid Baghdad, and their subsequent transmission through illustrated Hebrew, French, and Latin versions of the Arabic text. Warburg ends by expressing his hope for an art history that would not only range freely across the boundaries of canonical periodization, but also ignore the high-low division that has often led to the marginalization of certain kinds of objects in the discipline's grand narratives. He imagined a kind of analysis "that can range freely, with no fear of border guards, and can treat the ancient, medieval, and modern worlds as a coherent historical unity—an analysis that can scrutinize the purest and most utilitarian of arts as equivalent documents of expression."[29]

Setting aside questions of purity and the evolutionary framework within which such a hope was expressed, the studies presented here have been undertaken as a contribution to such an undertaking, at a moment when the supposed certainties of post-Enlightenment epistemologies and the taxonomies that undergird them are looking increasingly unsustainable. They constitute an endeavor to craft a series of macro-narratives from selected micro-historical vignettes centered on particularly resonant objects and images; to fashion loosely constructed narratives of early globalism from the micro-histories of what, in the Introduction, we suggested resembles archives of flotsam.

Notes

Introduction: Archives, Flotsam, and Tales of Globalism

1 Yet, this is not universally true of all the discipline's subfields: in addition to architecture, portable objects (the so-called minor arts) have been central to many fields of medieval studies, including art histories of the Islamic lands, where the production of the kind of stand-alone paintings that have been the traditional focus of much art-historical enquiry is a relatively recent development. In this sense, what has sometimes been seen as a deficiency might in fact appear as avant-garde, even if the Islamic materials on which art historians focus have generally been drawn from an elite milieu.

2 Porter (1988), 188. See also Elsner (2013).

3 El-Leithy (2011); Rustow (2020). On the materiality of the archive, see Steedman (2001).

4 Rudy (2011); Borland (2013); Flood (2014); Marinis (2014); Rudy (2018).

5 Among many others, see Bredekamp (2007); Candlin and Guins (2009); Coole and Frost (2010); Bennett (2010); Harman (2011); Latour (2012); Shalem (2012); Boschung, Kreuz, and Kienlin (2015); Bredekamp (2015); Bredekamp (2018); Wolf (2019).

6 Elsner (2013), 167; Bloom (2013), 242.

7 On the disjunction between medieval textual accounts regarding the production of Islamic amulets and talismans and extant objects see, Porter, Saif, and Savage-Smith (2017), 533. For an endeavor to reconcile the material and textual evidence in relation to medieval Islamic artifacts, see Talmon-Heller, Cytryn-Silverman, and Tabbaa (2015).

8 Horton (2004), 76. For an interesting object-oriented approach to pre-modern cultural history, albeit focused on northern Europe, see Lund and Semple (2021).

9 See the comments of Keating and Markey (2017), 203.

10 Bowersock (2005).

11 See the comments of Normore (2017), 4. For a recent endeavor to write an object-based global art history, see Cooke (2022). For a critique of the idea of the Silk Road and the ways in which it has eclipsed other contemporary Eurasian networks, including maritime networks, see Sen and Smith (2019), 34.

12 See the comments of Baader and Weinryb (2016), 6.

13 See, for example, Flood (2009a) (2009b); (2012); Fricke (2012); (2020); Fricke and Kumler (2022).

14 See, among many others, Brown (2004). Most recent discussions of the distinction owe a debt to the foundational essay by Heidegger (1967).

15 Ben-Shammai (2011); Goldberg (2012); Lambourn (2018).

16 Burak (2019); Berenbeim (2021), 221, 223. For a useful overview of the various concepts and connotations associated with the term archive in contemporary scholarship, see Manoff (2004).

17 See, for example, D'Erme (2004); Walker (2008).

18 Bahrani (2021), 252.

19 In a similar vein but a different context, see Joselit (2020), 237.

20 Among them see Flood (2009a); Walker (2012a); Nees (2014); Brown (2016).

21 Roux and Manzo (2018), 970.

22 Smith and Schmidt (2008); Smith (2019).

23 Contadini (1998), 76. The migration of this highly specialized technical knowledge coincides with a decline in the fortunes of Iraq under the Abbasid caliphs and the rising possibilities of patronage in Egypt under their sworn enemies, the Fatimids.

24 Bier (2004), 181.

25 Schaeffer (2006), 2–6; D'Ottone (2013), 67–74; Flood (2019a), 104.

26 Flood (2012).

27 Cutler (1999).

28 Foucault (1972), 79–134; Derrida (1995), 4.

29 Holmes and Standen (2018), 35.

30 Elsner (2013), 166.

31 Weitin and Wolf (2012).

32 For example, the textile from Debra Damo published in Mordini (1957a), 35 and fig. 38; (1957b), XVc is now inventoried as textile TR.2.1998 in the collections of the Museum of Islamic Art, Doha. See also ch. 5 n. 121 below.

33 Hopkins, Costello, and Davis (2021).

34 Cheng (2018), 12. See also Bahrani et al. (2014), 187.

35 See, however, the cautionary comments of Julian Raby regarding the tendency to assume that the central Islamic lands "were closed to inspiration from the West": Raby (2022), 233.

36 Shalem (1998). Islam, by contrast, does not possess an elaborate liturgy that requires a range of richly elaborated artifacts: carpets, lamps, and pulpits (minbars) are among the furnishings required for a mosque, which may also possess a library with richly calligraphed and illuminated manuscripts. Insofar as treasuries were in question in the Islamic world, these were generally associated with dynastic palaces and therefore subject to the vagaries of politics. The extraordinary riches of the treasury amassed by the Fatimid caliphs of Egypt (r. 969–1171 CE), for example, is wonderfully documented in a contemporary text, rich in descriptions of the marvels that it contained: Ibn al-Zubayr's *Book of Gifts and Rarities.* But the treasury was looted in a period of civil strife on at least one occasion and dispersed when the Fatimids fell from power.

37 Berenbeim (2021), 229.

38 Hawkes and Wynne-Jones (2015). For recent approaches to non-commercial exchange in transcultural contexts, see Komaroff (2011); Hilsdale (2014); Biedermann, Gerritsen, and Riello (2018); Freddolini and Musillo (2020).

39 Certeau (1988), 4. See also the comments of Graves (2018), 12.

40 Guo (2004), 90.

41 Kubler (1962), 40.

42 Quoted in Shalem (2011), 10; Didi-Huberman (2003).

43 Kopytoff (1986). For examples of such approaches see Holtorf (1998); Gell (1998); Marshall and Gosden (1999); Joy (2009); Swift (2012); Jennings (2014); Wittekind (2015); Cremer and Mulsow (2017); Wenzel (2019).

44 Appadurai (1986), 34.

45 Hicks et al. (2021).

46 Allen (1988); Korn (2003).

47 Ierusalimskaia (2012), 363–69. See also Shepard (2018), 134.

48 According to the Viking saga, Gudrid Thorbjarnardóttir traveled several times to New Foundland, a region in which archaeologists have excavated Viking longhouses: Ingstad and Ingstad (2000); Wallace (2003); Brown (2007); Ashley (2016).

49 Among those, the Franciscan Giovanni de' Marignolli (1290–1357)—mentioned in chapter 3—traveled to almost all the sites discussed in our six case studies—and even further, to Java: Baumgärtner (1993); Marignolis, *Chronicon bohemorum,* 292.

50 For examples of such approaches see Herzfeld (1928); Curta (2004), 190–226; Pekarskaja (2011).

51 Hoffmann (1970), 163–64; Zarnecki, Holt, and Holland (1984), 287; Barnet and Wu (2005), nos. 65 and 194; Holod and Rassamakin (2012), 373–81. For the Swedish counterparts, see Andersson (1983). The closest similarities can be found in a twelfth-century bowl kept in the Muzhi Museum (inv. no. Ф-810; see fig. 73), with similar protruding crafted golden elements and a nielloed

235

background. Finds from the same region include a gilded silver cup of Byzantine origin with similarities to contemporary Islamicate metalwork: Walker (2017).

52 Contributing to this imbalance regarding the history and memory of past cultural exchange are the uneven number of collections, hoards, and treasuries (extant or otherwise documented) preserving such mobile objects. For examples see Montell (1938); Laing (1991); Ying (2003); Macabeli (2016); Mierse (2017).

53 Holod and Rassamakin (2012), 380.

54 Schwarzer (2004), WP 64, 382, 385, and 386, figs. 21.4, 21.15, 21.16.

55 Walker (2012a), 71–76, 127–31; (2012b), 188–92.

56 Guérin (2013); (2017), 108–12; (2018).

57 Schwarzer (2004), WP 64, 382, 385, and 386, figs. 21.4, 21.15, 21.16.

58 For medieval Indian diasporas in another maritime context, see ch. 5 nn. 154–56 below.

59 For a useful overview, see Holmes and Standen (2018), esp. 12. For examples of analyses rooted in either connection or comparison, see Wickham (2007); Haour (2007); Elsner (2020); Klimek et al. (2021).

60 Walker (2012b), 185.

61 Subrahmanyam (2005); Douki and Minard (2007); Holmes and Standen (2018), esp. 12; Subrahmanyam (2022).

62 Werner and Zimmerman (2006).

63 Komaroff (2011); Hilsdale (2014); Trivellato, Halevi, and Antunes (2014); Biedermann, Gerritsen, and Riello (2018); Freddolini and Musillo (2020).

64 See, for example, Daston (2004); Lamb (2011); Findlen (2013); DaCosta Kaufmann, Dossin, and Joyeux-Prunel (2015); Bleichmar and Martin (2016); Gerritsen and Riello (2016); Göttler and Mochizuki (2018); Yonan and Sloboda (2019); Burghartz et al. (2021); Gleixner and Santos Lopez (2021). For a thoughtful analysis of this phenomenon, see Keating and Markey (2017).

65 Chakrabarty (2000).

66 Heng (2018); Karkov, Kłosowska, and Gerven Oei (2020).

67 Shalem (1998); Horden and Purcell (2000); Hoffman (2001); Schmidt Arcangeli and Wolf (2010); Grossman and Walker (2013).

68 For example, Chaudhuri (1990); Rao (2005); and chapters 5 and 6 of this volume.

69 See, among others, Ho (2006); Meier and Purpura (2018); Jean-François and Jeychandran (2022).

70 De Silva (1999). For an excellent overview, see Stahl (2014). Recent exceptions to this focus on early modernity include Horton (2004); Beaujard (2005); LaViolette (2008); Beaujard (2012); Fauvelle (2017); Horton, Boivin and Crowther (2020).

71 Akbari (2019), 90.

72 For such an approach, see Insoll (2021), 452; Loiseau (2019a). See also Myers Achi and Chaganti (2020).

73 For some divergent perspectives on the question, see Elkins, Valiavicharska, and Kim (2010); Flood et al. (2010). See also Frank and Gills (1996); Jennings (2010), esp. 121–43; Holmes and Standen (2018), esp. 6–7.

74 For a good overview and summary of Wallerstein's views, see Wallerstein (2004).

75 Abu-Lughod (1989). For an incisive review of the book, suggesting the need for an even more longue durée perspective on a dynamic and continuous world system, see Frank (1990).

76 See, among others, Symes (2021).

77 Harris (2007); Jennings (2010); Dudbridge (2018); Guidetti and Meinecke (2020); Hansen (2020).

78 Bentley (1996); Manning (1996).

79 Heng (2014), 244.

80 Nye (2002).

81 Strathern (2018), 334.

82 Steedman (2001), 1165.

83 On the idea of micro-history, see Ginzburg (1993).

84 Adamson and Riello (2013), 179.

85 The historian Marshall Hodgson saw this period as marking the emergence of what he called "the new Sunni Internationalism," which he saw as fundamental to the establishment of "an international civilization": Hodgson (1977), vol. 2, 255–92. See also Voll (1994). The idea was revisited more recently by Said Amir Armojand, who noted that Hodgson's take on the long twelfth century was marked by an "implicit argument that the Islamicate civilization was on the verge of a breakthrough to modernity" cut short by the Mongol invasions: Armojand (2004), 215.

86 See the essays in Árnason and Wittrock (2004).

87 Fleisher et al. (2015), and chapter 5 in this volume.

88 Heng (2014), 236–37; Fazioli (2017); Heng (2021). For a critical approach to the use of "medieval pasts" in current debates, see Karkov, Kłosowska, and Gerven Oei (2020).

89 Fauvelle (2018); Gomez (2018); Akbari (2019), 87–89; Bosc-Tiessé and Mark (2019), 4; Kelly (2020a), 16–19. For a thoughtful review of the books of Fauvelle and Gomez in relation to questions of periodization, see Derat (2020a). For a variety of views on the value of the term "medieval" in non-European contexts, see Varisco (2007); Davis and Altschul (2009); Davis and Puett (2015).

90 Holsinger (2007).

91 Heng (2104), 237.

92 Trouillot (2002), 7.

93 Shepard (2018), 118, 125.

94 Abu-Lughod (1989). Similarly, it has recently been suggested that the global reach of Europeans in the "Age of Discovery" was enabled, at least in part, by the existence of "pre-existing worlds of connections [. . .] which had been thickening across the Global Middle Ages": Holmes and Standen (2018), 42.

Chapter 1. Melting, Merchandise, and Medicine in the Eastern Mediterranean

1 Breusch's collection is now located in the Antikenmuseum in Basel: Dozio (2016); for the censers, see Billod (1987).

2 The lightest censer, which was purchased by the art dealer Lahman in Cairo in 1914, weighs 540 g: Musées royaux d'art et d'histoire, Brussels, inv. no. 5004 (Richter-Siebels (1990), 282, cat. no. 17). The heaviest, in the Staatliche Kunstsammlungen, Skulpturensammlung im Albertinum, Dresden, weighs 1,470 g (Richter-Siebels (1990), 283f., cat. no. 20).

3 Ilse Richter-Siebels completed her groundbreaking dissertation on eighty-six censers in the former GDR and was often forced by travel restrictions to support her observations by photographs or oral information. The first scholarly articles on these objects were Pétridès (1904); Maspero (1908), 148; Wulff (1909–11); Reil (1910). For later studies, see Przeworski (1930); Jerphanion (1939), 297. Censers in US collections were published in the exhibition catalogues Brooklyn Museum (1941), nos. 91 and 92; Miner and Ross (1947), 277; Weitzmann (1944); Der Nersessian (1969), 135, fig. 47; Elbern (1970); (1972–74); Hamilton (1974); Leroy (1976); Frazer (1979), figs. 563 and 564; Billod (1987); Bénazeth (1988); Elvira Barba (1986); Mirzoyan (1992); Fischer (2015); Ballian (2018), 73. Only a selection is discussed by Eder (2000). For articles in Russian and Georgian on these censers, see Loosley Leeming (2018), 73 n. 37.

4 Richter-Siebels's 1990 study contains the best-known examples of this kind of object today (excluding those in Amsterdam, Basel, Cambridge, MA, Bloomington, IN, and at Kykkos), but it is

important to note that the known number of early medieval bronze censers has grown considerably, with several appearing on the art market in the past decade. Secondary literature on the censers that Richter-Siebels did not include in her study includes Elvira Barba (1986). See also Billod (1987); Loosley Leeming (2018), 52.84. I know of 108 censers in all: of the ninety-three still extant that Richter-Siebels listed in her catalogue, seven were sold at auction before 1989. The censer sold by Blumka Gallery is now in the Boston Museum of Fine Arts; the one from the Ledoulx collection (Constantinople) is now in Brussels; that from the Reber collection (Lausanne) is now in a private collection in Luzern; and that found in Kamechlié has been bought by the Louvre, Paris. The censers from the former collection of Friedrich Sarre (Berlin) and Lipchitz (Paris)—mentioned as "unknown location/lost" in Richter-Siebels (1990)—have not resurfaced. We can add to the Richter-Siebels catalogue the six censers in the Breusch collection in Basel, those at the Allard Pierson Museum, Amsterdam (APM 8471), the Fogg Museum, Harvard—originating from the Hagop Kevorkian collection—and the Sidney and Lois Eskenazi Museum of Art, Bloomington (79.31), and the two censers at the Kykkos Monastery museum in Cyprus. Four have been offered at auction since 1989, at the Barakat Gallery, Bertolami Fine Arts, and Bidsquare auctions. I presume the censer in the David collection (inv. no. 7/1994) is one of the forty-eight Richter-Siebels lists under auctioned censers. Hamilton (1974) addresses the difficulties in dating these objects.

5 For technical analyses, see Lazović et al. (1977), 31, figs. 25 and 26, cat. no. 18; Hamilton (1974), 53.

6 Otto Pelka suggested in 1906 that these censers may have originated in Syro-Palestine and that they may have seen liturgical use during Christian services in the region. Pelka's article appeared after the purchase of such a censer through the museum in Nuremberg; in 1910 Johannes Reil, and then in 1939 Guillaume de Jerphanion, repeated the connection between pilgrimage to the Holy Land and the creation and dissemination of these bronze censers with Christian scenes—an idea that became cemented into current scholarship with André Grabar's study on pilgrim ampullae and Gary Vikan's study of pilgrimage art. See Pelka (1906); Jerphanion (1939); Grabar (1958); Vikan (1990).

7 This assumption is based on the surviving written accounts. For the period until the ninth century, eight Latin pilgrimage accounts are known: the Bordeaux Pilgrim, 333; Egeria, 381–384; the Breviary of Jerusalem, ca. 400; Saint Eucherius, ca. 440; Theodosius, ca. 518; the Piacenza Pilgrim, ca. 570; Adomnán, before 683; and Willibald of Eichstätt, ca. 787. Only one Greek text survives (Epiphanius Hagiopolites, ca. 800), and there are no independent accounts from Syriac, Armenian, or Coptic voices; see Johnson (2016), 44 n. 5. On travel literature in Byzantium, see Mullett (2002). As Alice-Mary Talbot has pointed out, however, Byzantines continued to go on pilgrimages to Syria and Palestine even after these lands came under Arab control, as numerous hagiographical accounts include the journey of a holy man to see the holy places and the monasteries of the Levant; see Külzer (1994); Talbot (2001); Talbot (2002).

8 Carole Billod has suggested a likely date of ca. 600 for the earlier examples based on comparisons with coins. However, she also emphasized that these coins circulated throughout the seventh century: Billod (1987), 52. Jerphanion suggested that a censer preserved in Odessa (cat. no. 1 in Richter-Siebels (1990)) was produced in a twelfth-century Genoese colony on the Black Sea: Jerphanion (1939), 300, 310–11. For a later example, dated to the thirteenth century on the basis of an inscription added in the fourteenth, see Mirzoyan (1992).

9 Legible inscriptions include those written in Armenian, dated to 1646 (New Julfa, Iran: see Hamilton (1974), 53; Loosley Leeming

(2018), 74); in Memphitic dialect (written in Greek: see transcription and dating to the fourteenth century by Maspero (1908), 148); and in Greek, dating to the ninth century or later (Dumbarton Oaks: see Richter-Siebels (1990), 238). Two Syriac inscriptions that mention donors and a dedication to the monastery in Samosata are found on censers preserved at Oxford (Richter-Siebels (1990), 233–34). Hamilton points out that the Arabic names of the donors—John of Qasim on the one hand and Ali Abu and his sons Abraham and Isaac on the other—suggest a date after the Islamic conquest of Syria (Hamilton (1974), 65). Additional extant inscriptions include one in Syriac in Geneva (Richter-Siebels (1990), 235) and others in Arabic on censers currently in Saint Petersburg, Mestia, and Mainz (Richter-Siebels (1990), 235–37).

10 See Hamilton (1974); Richter-Siebels (1990), 229–38; Loosley Leeming (2018), 74.

11 See n. 7 above.

12 MWNF (2022).

13 Reil (1910); Walmsley (2010).

14 Anderson (2004), 81.

15 Grabar (1958); Frank (2006); Barrero González (2017).

16 Vikan (1990).

17 Rothenberg (1972); Zavagno (2011); Daim et al. (2017), 211–13.

18 For example, the censer from the monastery of Saint Hakob in Arts'akh in Armenia dates to the twelfth or thirteenth century: see Ballian (2018), 75. An additional three thirteenth-century censers with scenes from the life of Jesus originate from the church of Saint Gregory in Ani: see Nersessian (2001), 123. Indeed, there seems to be a continuity of censer production across more than a thousand years, as the objects were still being made by Armenian artisans as late as the sixteenth century. A sixteenth-century Armenian censer is preserved in the Hermitage in Saint Petersburg and a whole collection of such objects, the most recent with a seventeenth-century inscription date, is held by the museum of Vank Kilise in New Julfa, Iran: see Loosley Leeming (2018), 73–74.

19 Richter-Siebels (1990), 251, 256. (The iconography of the birth scenes resembles thirteenth-century manuscript illuminations.)

20 The censers for which Richter-Siebels (1990) suggests a date during the period of the Crusades are those preserved today at Yerevan; see her figs. 19 and 192—Dresden, inv. no. ZV 2673: 98 Yerevan and cat. no. 109 Florence, Bargello.

21 See Koch (1965) and Meurer (1969) for Western examples. There are earlier examples in non-Christian contexts, such as the Torah shrine of the Dura Europos synagogue (ca. 240 CE), and in Islamic art: see Lermer (2015). Several examples can, for example, be found in the famous copy of the Māqāmāt of al-Hariri dated 634 H/1237 CE (BnF, MS Arabe 5847), discussed here at length in chapter 6. See, for example, Hillenbrand (2010).

22 Richter-Siebels (1990); see also, for bronze techniques, Weinryb (2016).

23 Richter-Siebels (1990), 172. Richter-Siebels refers to Forrer (1911) and Satzinger (1984): 277–79 n. 11, cat nos. 252 and 254.

24 BRE 644. Information on the results of the analysis is from the records preserved at the Antikenmuseum, Basel.

25 An exception is the censer preserved at the Sidney and Lois Eskenazi Museum of Art in Bloomington, Indiana (79.31).

26 Richter-Siebels (1990), 266.

27 Piguet-Panayotova (1998), figs. 11–23. The three censers, 1986.3.11, 1986.3.12, and 1986.313, are silver with gilding and copper lining; see Frazer (1988), 13–14 and Piguet-Panayotova (1998). For the hallmarks, see the latter's figs. 2, 9, and 17; for the Attarouthi censer, see Evans and Ratliff (2012). nos. 22, 9, 42, and 43, and Elbern (2004), fig. 1.

28 Kitzinger (1955); Wolf (1990); Dagron (1991); Cameron (1992); Belting (1994); Vikan (1995); Cameron (1998); Andaloro (2002);

Elsner (2012); Mathews and Muller (2016). Mathews and Muller, following up on Elsner (2012), have argued for the earlier popularity of discourses about the icon rather than any necessary increase in practices involving icons.

29 Grabar (1958), 63; Engemann (1973); Weitzmann (1974); Vikan (1990); Engemann (2002); Arad (2007); Vikan (2020). See also Filipová (2015); for the fact that the attribution of sacredness to Christian buildings and things was a relatively late phenomenon, see Camber (1981); Rahmani (1993); Jäggi (2017).

30 Eder (2000).

31 Hexagonal silver censers are preserved at collections in Washington, DC, Dumbarton Oaks (527–65 CE); Munich, Bayerisches Nationalmuseum; New York, Metropolitan Museum of Art (both 580–602 CE); and London, British Museum (602–10 CE. Round silver censers are preserved in Saint Petersburg, Hermitage Museum (Chersonese censer); New York, Metropolitan Museum of Art (the Attarouthi censers); and Karlsruhe, Badisches Landesmuseum (cat. no. IV 120, inv. no. 93/1055, purchased by Nikolas Koutoulakis, perhaps from the Bekaa region in Lebanon; see Mango (1998), 215. For more information on Byzantine silver censers, see Mango (2009). Here, we limit the discussion to censers, although the question of forms and their adequacy for different kinds of narrativity can and should be also posed for other metal objects such as lamps, bowls, and caskets.

32 A silver gilt censer with scenes from the New Testament, however, is preserved in the Antalya Museum. It is thought to be from the Sion treasury, which was uncovered in Kumluca, Turkey, and consisted of objects such as an oil lamp, a censer, book covers, and various liturgical vessels. Some of these items are now part of the Dumbarton Oaks Museum collection; the treasury likely belonged to the monastery of Sion at Myra (modern Demre), Lycia; see Vikan (1991), 22–23; Boyd (1992).

33 Stavros (2002).

34 The silver censer now in London came, like the similar one now in Munich, from Istanbul; another silver hexagonal censer with medallions and bust portraits, now at the Metropolitan Museum in New York, came from the church dedicated to the Holy Mother of God in Nessebur (ancient Mesembria): Piguet-Panayotova (1999), 9; inscribed "In fulfillment of the vow of those whose names God alone knows." The inscription on the censer in Karlsruhe also refers to it as a votive gift: "Μεγαλοὺς ὑπὲρ ναπαύσ[εως] Καρίλου προσένεγκ[εν] τῷ ἁγ[ίῳ] Κο[ν]σταν τίνῳ" (Megalous, for the rest/peace of mind of Karilos, offered [it] to Saint Constantine).

35 For a later history of censers, see Westermann-Angerhausen (2014); for their history before 1000 CE, see the unpublished dissertation by Eder (2000), with its catalogue of ca. one hundred censers of the early Christian period.

36 Wyżgoł (2017), 783.

37 Ibid., 784.

38 This section has benefited tremendously from discussions with Theresa Holler, whose forthcoming study "The Other Herbal: Literature and Art as Medicine" addresses the conjunction between medical knowledge and religious practice in early and high medieval art. I owe several of these ideas to conversations with her.

39 Müller (1978).

40 Piguet-Panayotova (1999), 7.

41 See Krueger (2014), 68–69. Krueger does not address the medical dimension of incense, which is explicit in several hymns that mention it. See the ostracon preserved in the British Museum: EA33051, Deir el-Bahri (Thebes), Monastery of Saint Phoibammon, 7th–8th century, O.Crum 362, written by the same scribe as O.Crum 138 and 482: "If then thou wouldst have a little incense for the 'τόπος', lo, here is a man [who] has brought a little good [. . .]. Send

to me [as to] what thou desirest, that I may buy it for thee." In addition, see Krueger (2018).

42 Theophanes, *Chronicle*, 596–97 and n. 2. See also Elbern (1967); Simic (2017), 168–69.

43 The inscription runs around the outer edge of a bronze censer now in the archaeological museum of Syracuse, Sicily; see Mennella (1990), no. 132, = *IGLS* 3/2, no. 1217.

44 For the importance of smell in ancient religious culture, see Harvey (2006).

45 Pentcheva (2010), 26–27 and 36–37 n. 46. There are bronze censers without narrative scenes that mention incense in their inscriptions; however, Pentcheva's suggestion that these inscriptions cite the biblical Zacharias, an important model for the burning of incense, who once lit it in order to receive offspring, has been contested by other scholars. This inscription can be read in multiple ways, and not all support an explicit reference to Zacharias. Pentcheva reads, "God, who received the incense of the Holy Prophet Zacharias, receive this incense," while Mennella reads, "+ πρόσδεξαι, ἅγιε, τὸ θυμίαμα κ(αὶ) πάντας ἴασαι / O Saint, accept the incense, a[nd] heal everyone!" See Mennella (1990), no. 132, = *IGLS* 3/2, no. 1217.

46 Pentcheva (2010), 38.

47 Dioskurides, *De materia medica*, 89–90.

48 Annette Weissenrieder has argued that medical effects and healing are key features of the Gospels and other late antique texts, and that these dimensions must be included in their interpretation and translation. See Weissenrieder (2003); Weissenrieder and Alkier (2013); Wessenreider and Etzelmüller (2016). See also the edition of primary sources, Weissenrieder and Dolle (2019).

49 The story is recounted in the gospels of Matthew (9:20–22), Mark (5:25–34), and Luke (8:43–48).

50 Gell (1977), 29.

51 Germanos, *Ecclesiastical History*, 30, 78–81: "The censer demonstrates the humanity of Christ, and the fire his divinity. The sweet-smelling smoke reveals the fragrance of the Holy Spirit. [. . .] Again, the interior of the censer [. . .] is understood as the [sanctified] womb of the [holy] virgin, who bore the divine coal, Christ, in whom the fullness of deity dwells bodily (Col. 2:9). Altogether, therefore, give forth the sweet-smelling fragrance."

52 Caseau (1994); (2001); (2013); (2016).

53 Ibn Khurdadhbih, *Kitāb al-masālik wa'l-mamālik* (likely written before 845), 111, and Theodulphus, *Carmina*, 497–500.

54 See Chatterjee (2018), 28.

55 These could also be lamps, since their shapes were often very similar: see Elsner (2019). A clear difference is visible from the censers depicted in the fifth- and sixth-century frescoes in Egypt's Red Monastery: see Nathan Dennis's article in Fricke (2023). On lamps, see Bielfeldt (2014a); (2014b); (2018).

56 Corippus, *In laudem Iustini*, lib. III.36–56, 103; and Holum and Vikan (1979).

57 Censers, candles, and processions with hymns were also part of rituals expressing gratitude to the emperor for more profane reasons, such as the abolition of certain kinds of taxes: see, for example, Pseudo-Joshua, *Chronicle*, 30.

58 Egeria, *Itinerarium*, § 24, 10: "Dictis ergo his tribus psalmis et factis orationibus tribus ecce etiam thiamataria inferuntur intro speclunca Anastasis, ut tota basilica Anastasis repleatur odoribus."

59 A terracotta medallion preserved in the museum of Bobbio Abbey in northern Italy shows a person climbing the column of Saint Symeon while holding an object, offering it to the saint. Paweł Nowakowski (2015) suggests this may be a censer, though it appears larger than the censers in use at the time; see Mennella (1990), no. 132, = *IGLS* 3/2, no. 1217. In the case of Saint Symeon,

however, the presence of censers in the imagery of the cult may also be related to the saint's notorious stench. The abbey at Bobbio was founded in 614, so if these tokens were interred from the beginning, they are probably from the early seventh century.

60 For a translation of the inscription, see Nowakowski (2015); see too the *Cult of Saints in Late Antiquity* database http://csla.history .ox.ac.uk (accessed 13 January 2023), CSLA no. E02367.

61 See Vikan (1984), 67–74.

62 Recounting his own illness, Gregory recalls sending for a physician; however, he soon decided that "secular means could not help the perishing," and sought dust from Saint Martin's tomb, which he put in water and drank, and was soon cured: Gregory, *Miracles*, II.1.

63 Burridge (2020). See also Caseau (1994); Pfeifer (1997); Caseau (2001); (2013); Thurlkill (2016).

64 See Reudenbach (2011); Niehr (1994), 62.

65 "Τὸ μικρὸν ἔργον τῶν ὅλων μεγας τύπος·αἰθίμ, ὁ χρυσός, ἄργυρος, φῶς, οἱ λίθοι, ἄστρων χορεῖαι· τοὺς ὕπερθεν καὶ πόλου τύπους παρεμφαίνουσιν ἄνθρακες, μύρα, ἣν πᾶς λατρεύει θυσίαν τῷ Δεσπότῃ": John Geometres *Anecdota graeca*, 310, translation by Andrew Griebeler. I owe this reference to Ivan Drpić, who graciously read and commented on this entire chapter.

66 Krautheimer (1942), 19; Verstegen (2002); (2009); (2015).

67 Westermann-Angerhausen (2011); (2014); (2016).

68 To date, only two examples of censers with depictions of similar Nilotic scenes are known; the other is held in Berlin (SMB, inv. no. 3/99), of unknown origin and dated to the third or fourth century on the basis of the loose arrangement of the figures (according to the museum record).

69 Billod (1987); (2015): cat. nos. 370 and 335.

70 This vagueness is not unusual in early Christian art. Like images of the Good Shepherd, fish, or grapes, depictions of the story of Jonah and the whale were relatively commonplace: the tale was a motif used by Romans, Jews, and Christians. For an excellent overview of its development across these related visual cultures, their textual tradition, and the story's exegetical use, see Scirocco (2015), who points out that the Book of Jonah was used in Jewish and Christian ritual practice during the celebrations of Holy Thursday at the end of the fourth century, and in the rite of preparation for baptism between the fourth and sixth centuries. See also Jensen (2011); Lenk (2019, to be published).

71 Watta (2018), 115–18.

72 For the figurative ornamentation on pilgrim ampullae, see Grabar (1958); Weitzmann (1974); Arad (2007); Brazinski (2014). For ivory pyxides, see Poglayen-Neuwall (1919); Capps (1927); Wessel (1960); St. Clair (1978); (1979); Nussbaum (1979); Wixom (1981); Sanjosé i Llongueras (2018).

73 As Jan Assmann has observed, however, a dualistic opposition between linear and cyclical concepts of time and history becomes less tenable when one considers the significant number of cyclical aspects in the Hebrew-Jewish world and the linear elements present in Greco-Roman culture. See Sambursky and Pines (1971); Ariotti (1972); Assmann (1996); Jeck (1997), Sivan (2008).

74 Grabar (1958); Vikan (2010). A slightly later pilgrimage account was written by Arculf and recorded by Adomnán, abbot of Iona (679–704). For a critical edition of the Latin text, see Adamnan, *De locis sanctis*.

75 Since Hans Belting made his distinction between votive and donor portraits, a great deal of scholarship has explored the relationship between donors and gifted objects as well as that between images and the imaginary power that was bestowed upon objects, establishing a link between sacred site and devotee. However, much of this work is based on late Byzantine examples. See Belting (1970), 48; (1994); Weyl Carr (2006).

76 Drpić (2014), 913.

77 Ibid.

78 Drawing by Carole Billod: see Billod (1987).

79 The Gospels do not mention where the two meet; in Luke 1:39, Mary is traveling to a city in the hills of Judaea, while in Luke 1:9 it is noted that John the Baptist's father Zachariah returns to his hometown of Ein Kerem in the hill country of Judah, close to Jerusalem and Bethlehem. Medieval pilgrim accounts do not mention this site as a location of pilgrimage, however.

80 The date for Easter, the first Sunday after the first full moon on or after March 21, was calculated for each year, and a compilation of texts and tables, the so-called *computus* manuscripts, was used for the calculation of the exact date. However, as Easter would often fall after March 25, the Annunciation would be celebrated after the Baptism but before the Easter events, so the events on the censer would not follow chronological order. See Mosshammer (2008).

Chapter 2. Knowledge and Craft in Medieval Spain and Germany

1 This chapter benefited from discussions with Corinne Mühlemann and Latin translation suggestions made by Aden Kumler and Christoph Sander. An earlier version of this research was presented with Corinne Mühlemann as part of a workshop in Madrid for the COST *Action Islamic Legacy: Narratives East, West, South, North of the Mediterranean (1350–1750)*, organized by Borja Franco and Antonio Urquízar Herrera.

2 Robinson (1992), 214.

3 Latin: *nigellum*, Persian: *mīnā/mujra* or *sim-i sukhta*; Ancient Greek: *egkopsin/egkapsin/egkaupsin*; Goitein (1999), 212–13, 425 nn. 452–55; (2008), 170 n. 15. In a recent translation of *The Book of Gifts and Rarities* (an eleventh-century Arabic account of gifts and treasures of the Fatimid court of Egypt), *muḥarraqah bi al-sawād* is translated as "niello," as noted in Ghada Hijjawi Qaddumi's introduction to her translation: "I translated the term *muḥarraq* when it was associated with silver (*muḥarraq bi al-sawād*) as 'inlaid with niello' (that is, blackened)": Ibn al-Zubayr, *Book of Gifts and Rarities*, 51.

4 Aschan (1996); Diba (1996).

5 Paul Kahle suggested that the expression derives from the Latin *minium* (red lead) (Kahle (1936), 349 n. 1). Mehmet Aga-Oğlu follows Kahle, and suggests that written sources describing the dispersion of the Fatimid treasury in Egypt ca. 1060 use the term for objects made with niello: Aga-Oğlu (1946). See also Röder (1937); Calderoni Masetti, Durand, and Shalem (1999).

6 Allan (1976), 48.

7 Pliny, *Naturalis historiae*, XXIII, 131 (46), 27. There are numerous late antique silver platters which use the technique: e.g., the plates of the Sevso Treasure: see Mango and Bennett (1994).

8 On the practice of control stamps, see Mango (1992).

9 For an excellent overview of the historical methods used to create nielloed objects (including practical experiments to reproduce the ancient recipes and a review of the objects analyzed), see Wolters (1996).

10 La Niece (1983), 287.

11 The terms used for borax are *atincar* or *tinder* in Latin, *tzaparikón* in Ancient Greek, and *atincar*, *bauraq*, or *natrun* in Arabic.

12 For both sources, see Allan (1979), 19–20, 48–49.

13 *Της τιμιωτατης και ποδυφην χρυσοχοικης* (On the noble and illustrious art of the goldsmith), is preserved in a single manuscript in Paris: BnF, MS Grec 2327, fols. 280r–291r. This manuscript is a copy (made in 1478 on the island of Crete by Theodoros Pelecanos

of Corfu) of the now-lost original. The dating of the text to the eleventh century is based on similarities to a manuscript in Venice, Cod. Marcianus graecus 299. For a helpful overview of the written sources, see Wolters (2006), nos. 5, a14b; and nos. 34, 262, 263, 268, 274, and 275 published previously in Wolters (2004), in English as Wolters (2008). Antje Bosselmann-Ruickbie points to the shift to leaded niello and explicitly aims to relate primary sources to a careful analysis of Byzantine objects made with it; however, she dates some of these sources to the ninth century, while the recipe for niello is mentioned only in the twelfth-century copy of the text. See Bosselmann-Ruickbie (2013).

14 The melting points of the sulfides of silver, copper, and lead are 8350°C, 1121°C, and 1140°C respectively, whereas a mixture of the three sulfides in the proportions of 5:7:8 will melt at about 440°C. See Moss (1953), 50; on the history of niello, see also Rosenberg (1908).

15 Wolters (1996), 181.

16 Theophilus Presbyter, *De diversis artibus*, 1.28. See also Heraclius, *Von den Farben*, 58–61.

17 The text of the manuscript was published in 1847 by Thomas Phillipps, its owner before it came to the Corning Museum of Glass (MS 5). The recipe for niello is not included in the ninth-century manuscript preserved in the Sélestat MS, Sélestat, Bibliothèque humaniste, MS 17, fols. 2r–34r, 37r–51r. For an English translation, see *Mappae clavicula*. See also Beretta (2004), 199: "during the XII century, to the 'improved' second nucleus were added recipes from the English and Arab traditions (niello and false gilding)."

18 Recipe no. 53 in the *Liber sacerdotum*, 198.

19 Berthelot uses the manuscript MS lat. 6514, fols. 41–51 at the BnF in Paris as the basis of his text, which also includes a list of Arabic and Latin terms. It is with reference to recipe no. 112 that Berthelot suggests an origin in Spain. See *Liber sacerdotum*, 181.

20 Bosselmann-Ruickbie (2013), 358.

21 See the amulet case held by the Metropolitan Museum of Art, New York, https://www.metmuseum.org/art/collection/search/452861 (accessed January 13, 2023). See also Schweizer (1977), 61; Newman, Dennis, and Farrell (1982), 81; Oddy, Bimson, and La Niece (1983), 31; La Niece (1983), 280; (1998), 52; Bosselmann-Ruickbie (2013), 357–58.

22 Rosser-Owen (2012).

23 Schibille et al. (2020); I owe this reference and idea to Gregor von Krosigk–von Kerssenbroick.

24 Carboni (1993), 100.

25 Robinson (1992), 214.

26 Results from the October 14, 2020 x-ray fluorescence analysis report by the Kunsthistorisches Museum, Vienna, with analysis by Dr. Katharina Uhlir (personal communication from Franz Kirchweger).

27 Carboni (1993), 100.

28 Raby (2018).

29 Ettinghausen, Grabar, and Jenkins-Madina (2001), 277–78.

30 Court personnel were recruited from widely diverse backgrounds and frequently changed location; how widely the Iraqi Jew could have traveled during his life bears comparison with the biography of another court official, known through written Fatimid records, George of Antioch. Born a Greek Christian in Syria, George served the Zirids of north Africa, ended up at the Norman court in Palermo, and served as Norman envoy to the Fatimids in the twelfth century. See Johns (2002), 80–83.

31 Nasir-i Khusraw, *Safarnāmah*, 76; Ward (1993), 57 and fig. 39; Mols (2006), 20.

32 See Gray (1939).

33 Viegas Wesołowska (2011); Rosser-Owen (2012).

34 Martin and Rosser-Owen (2021), 293.

35 Jenkins (1993), 94; Labarta Gómez (2015); (2017).

36 According to Alessandra Giumlia-Mair, trimetallic niello was hardly used; see Giumlia-Mair (2000), 140. See Rosser-Owen (2012).

37 La Niece (1983), 280; (1998); (2010) and Oddy, Bimson, and La Niece (1983), 31. On the mobility of craftsmen between these regions, see Cutler (1999), 63–69. One important exception to the practice of restricting the study of objects with characteristics shared across a broad geography to specific regions, instead of considering their wider circulation, is Priscilla Soucek's discussion of noteworthy similarities among objects made in Andalusia and Byzantine ivories, as well as manuscript illuminations and textiles—all objects that travel easily: Soucek (1997).

38 Hahn and Shalem (2020).

39 Carboni (1993), 99. A further example with both parts of the box revealing a convex surface is held in the Museo archeologico in Cagliari (Sardinia); see Gabrieli and Scerrato (1979), 567, fig. P.

40 For an excellent study of the politics involved in building the treasury of San Isidoro (addressing the geographically charged nature of objects and the role of elite women as vectors of cultural exchange), see Martin (2019).

41 Calvo Capilla (2001).

42 Therese Martin has recently redated this ivory casket to the fourteenth century, based on the dating of the wood. She shows that the treasury was reorganized twice, and that a series of written documents—the "1063" charter and the *Historia silense*, both written in the twelfth century, and the thirteenth-century *Liber miraculorum beatissimi Isidori* and *Chronicon mundi* of Lucas van Tuy—retrospectively write about the treasury and its donations, with different agencies involved. What might be assumed is that the niello casket and the two heart-shaped boxes were stored in an ivory casket with silver clasps, as recorded in the "1063" charter. See Martin (2019).

43 The record reads, "[An] ivory casket worked with gold, and two more ivory caskets decorated with silver: inside one of these are three small caskets of the same material" (et capsam eburneam operatam cum auro, et alias duas eburneas argento laboratas: in una ex eis sedent intus tres alie capselle in eodem opere facte): Martín López (2007), 536–37.

44 Moore (2013).

45 Jasperse (2019), 144. Aleppo has been identified by Ignacio Montero Ruiz and Sergio Vidal as the marble's place of origin; see ibid., n. 53.

46 Jasperse (2019), 128.

47 As Jitske Jasperse observes, the unusual aspects of its inscription suggest "that the work was done under the orders of someone far from the politics of early twelfth-century León." See Jasperse (2019), 131; Ruiz Albi (2003), 315. On the dating systems employed in inscriptions and the rarity of indiction in Iberia, see Favreau (1997), 178. See also Handley (1999), 192. On León, see Martín López (2003), 314–15.

48 On the epigraphical reasons for the production of the strips in Spain, see García Lobo and Martín López (1995), pl. xxi; see p. 103 for an analysis of the Carolingian script. Manuel Gómez-Moreno identifies the script as Spanish (Gómez-Moreno (1925), 1:206 and 2:fig. 225), and Clara Bango García concurs (Bango García (2001), 353).

49 Jasperse (2019), 128 and Martín López (2003), nos. 38, 42, 52, 54, 59, 61, 64, 65, 67, 68, 73, 76, 86, 88, 90, and 94. Jasperse connects the introduction of "Regina" to the arrival of a new scribe, Gudesteo, whose name first appears in a charter dating to 1147 (Jasperse (2019), 182–83).

50 [top] + REGINA: SANCIA: RAIMVNDI: ME: DEARGENTAVIT: ANNO: DNICE: ĪCARNACIONIS: M: C: XL: IIII: Ī DICTIONE: + VII: CCURRENTE: VI: VIII: KA: AVG: DEDICATV: Ē: HOC: ALTARE: AVENE/RABILI: EPO:

SCE: BETHLLEE: ANSELMO: ĪNOME: SCE: ET: IDIVIDVE: /
[sides] TRINITATIS: ETS: ET: SCE: CRVCIS: SCCEQ: I: DI: GENITRICIS: MARIE:
ET: INHONORE: EORU: QORV: SCA: HIC: CONTINETUR: BTI: PATRIARC/
HE: ABRAE: PELAGIE:VR: DE: ANNVNCIONE: SC: MAR: ET:
HELISABET: E: PE/TRA: SALVTACIONS: S: M: DE: NATIVITE: DNI: DE:
PSEPIO: DNI: DE: LOCO: TNSFIGVRATIOS: I: MOTE:T ABOR: DE: S:
PRT/D : TABVLA: DNICE: CENE: DE: MOTE: CALVARIE: D: PETQ: DR:
GETHSAMANI: VI: DNS:/
COMPREHES': E: D: PET: SUP: QVA: CORONAT: E: IPRETORIO: D:
CRVCE: DNI: D: SEPVLCRO: DNI: DTABVLA: SVP: QM: /DNS: COMEDIT:
PISCF: ASSV: ET: FAVV: MELLIS: D: PET: ASSCESSIO/NIS: DNI:I :
MOTE: OLIVETI: D: PET: COFESSIONIS: I:TEMPLO: DNI: D: IVETIONE:
S:CRUCIS: I: MOTE: CALVARIE:D: MONTE SINAI: /D: LECTO: S:
MARIE: I: MONTE: SION: D: SEPULCRO: SM: I: IOSAPHAT:

51 Jasperse (2019), 133.

52 Goldschmidt (1918), nos. 27, 5, 27, pl. x; 23, 38, 41–43, 52, 54, 70 (as no. 710); Bousquet (1979), 42, fig. 4; Little (1993), 272, no. 131; (2004), 165; Calì (2008), 231, 235–37, 239, fig. 5; Franco Mata (2011), 111; Abenza Soria (2014), 50–51, fig. 11; Álvarez da Silva (2014), 265, fig. 107.

53 The ensemble is named after the Wilten monastery (Innsbruck), from which it came to the museum in Vienna.

54 Unpublished analysis undertaken on October 14, 2020 by Katharina Uhlir (Naturwissenschaftliches Labor, KHM Vienna). I am grateful to Franz Kirchweger for scheduling the analysis and for his help.

55 Fillitz and Pippal (1987), 171–72, cat. no. 41, figs. 41.1 and 41.6, pls. 18 and 19. Piotr Skubiszewski argues that the Wilten chalice and that in Tremessen cannot have been made in the same workshop: Skubiszewski (1980).

56 Diehl (1956), 147; Braun (1932), 227, 239; Klapsia (1938), 29.

57 "His tribus indiciis [. . .] manifestavit se Christus mundo, et in omnibus Deus esse apparuit." Hildebert, *Sermones*, col. 414B.

58 INDICIIS PROBAT HIS SE VICTOR VIVERE MORTIS MEMBRIS IN CAPITE SPES EST FIRMISSIMA VITE VT REDIVIVVS ABIT SIC OMNES VIVIFICABIT (By these signs the victor over death provides evidence that he lives. The firm hope of life is in the mind of the members. As he comes forth [from the grave] with new life, so shall he give life to all. [translation by Beate Fricke]).

59 De Winter (1985), 150. See also Weiss (1860); Swarzenski (1954), 74–75; Sommer (1957); Lasko (1972), 205–7; Skubiszewski (1980).

60 HIC QVOD CV(m)Q(ue) VIDES RES SIGNAT SPIRITVALES SP(iritu) S EST QVI VIVIFICAT S(ed) NIL CARO PRODEST. I am grateful to Aden Kumler and Christoph Sander for their thoughts and suggestions regarding this translation. The inscription refers to thoughts articulated by Augustine on the Gospel of John 6:63–64, and relates to the eucharist (Augustine, *Enchiridion* 52, ll. 59–62). For the exegetical tradition of the passage, see Tondelli (1923).

61 For a summary of the discussions following a 2005 colloquium that revealed that the portable altar at Paderborn was not in fact the scrinium of Heinrich of Werl (as mentioned in the document relating the donation, dated to 1100 but interpolated in the thirteenth century), see Beuckers (2007). The altar is still believed to have originated in the workshop of Roger of Helmarshausen.

62 For an excellent introduction to Theophilus's text, see Speer and Westermann-Angerhausen (2006). For an extensive discussion of several of the passages in which Theophilus elaborates on the relation of form, matter, and ritual, see Gearhart (2017).

63 Marshak (1986), 114–20.

64 Ibid., 115–16.

65 Hoffmann (1970), 163–64, no. 169; Zarnecki, Holt, and Holland (1984), 287; Marshak (1986), 116 and 358–60; Barnet and Wu (2005), nos. 32, 65, and 194. For the Swedish counterparts, see Andersson (1983). The most similar example is a bowl at the Hermitage in Saint Petersburg, also from the twelfth century and with protruding crafted golden elements and a nielloed background: Andersson (1983), fig. 74.

66 They have not yet been compared with the liturgical objects discussed above and have not been subject to technological analysis regarding the use of leaded niello.

Chapter 3. Coconuts and Cosmology in Medieval Germany

1 The coconut goblet at Münster was previously considered in the context of a volume on rock crystal; see Fricke (2020).

2 Personal conversation with Marcus Pilz, who has suggested that the lion was carved by an Abbasid craftsman.

3 Pradines (2019).

4 Kurtze (2017) and Hahn and Shalem (2020).

5 Vatican City, BAV, MS Barb.lat.171, "Sinomina magistri Simonis de Januuo [Simon of Genoa]," fols. 1r–115r: fol. 48v. I owe this reference to Katherine Kennedy, who is preparing a monograph on coconuts in late medieval Europe.

6 "Das Ganze ohne Parallele": Geisberg (1937), 414. See also entry no. 45 in Pieper (1981); Géza (1991), 33; Géza (2000).

7 Keller (1965); Legner (1982); (1989); (1995); Kühne (2000); Shalem (2004); Klein (2004); (2005); Wittekind (2009); Toussaint (2011).

8 Starnawska (2006); Ronig (2012).

9 On the reconstruction of the ensemble of rock crystal objects made for Münster Cathedral in the thirteenth century, see Fricke (2020).

10 The Sulmona lion, once mounted on a reliquary in the cathedral of San Panfilo, is mentioned by Carl J. Lamm: see Lamm (1930); and in articles by Leopold Gmelin: see, e.g., Gmelin (1890); Erdmann (1942), 9. The reliquary and the mounted lion are missing at present, likely stolen. I would like to thank Dr. Lucia Vernacotola for providing information and assistance, and Theresa Holler for her persistence in trying to determine the lion's current location. Additional lions (unrelated to the Münster lion) include the lion heads in Paris and one in Karlsruhe; see Shalem (1999).

11 "In ipso agno Dei de sanguine Domini nostri, in ipsa nuce vero de ligno Domini": *Thesaurus sanctarum reliquiarum*; the inventory was made on November 19, 1622.

12 Maloney (1993).

13 A rich informant for this connection is Theodulf of Orleans; see Pirenne (1963).

14 Coconut is mentioned in Ibn Wahshiyya's ninth-century text *Nabatean Agriculture*, and in the tabular medical book by Ibn Biklarish, a Judeo-Arab physician and pharmacist who lived in Almería ca. 1100. Fragments of the latter text were found among the Geniza documents. For the pre-Islamic history of coconuts, see King (2015); on the medical use of coconuts, see Amar and Lev (2017); on the Geniza documents, see Goitein (1999); (2008); Goldberg (2012); Frenkel and Lester (2015); Rustow (2020). On the use of coconuts in the Indian Ocean, for example as water containers on land and during sea voyages, see Lambourn (2018).

15 Fritz (1983), 8–10.

16 Coconut appears on the basis of Persian literature to have been known in the Sasanian period, the term for it being *anārgil/anārgēl*, hence the Arabic *nārajīl*. Coconut was best known in Iran by its Indic name, since it was introduced as such before a Persian equivalent was registered. The Arabic use of a Persian form of the Sanskrit testifies to the importance of Sasanian culture in the transmission of Asian products into Islamicate culture: see King (2015), 507. Also derived from the Sanskrit is the Greek form *argellion* (ἀργελλίων), as recorded in the sixth-century Greek of Cosmas Indicopleustes, who describes it as the great nut of India, which grows from a tree that resembles the date palm except for the

height and breadth of its upper branches. Cosmas also describes the milk and says that Indians drink it instead of wine; when drunk, it is called *ronchosura*: Cosmas Indicopleustes, *Topographia Christiana*, 1968–73, XI.11. For recent discussions of Cosmas Indicopleustes, see Bowersock (2013), 22–33; Kominko (2013).

17 Camus (1886). Versions of the *Circa instans* date to the mid-twelfth century.

18 The green coat of the coconut is depicted in *Compendium salernitanum*, made in Italy (possibly Venice), 1350–75: New York, Pierpont Morgan Library, MS M.873, fol. 65v. The album is supposedly based on Mattheaus Platearius's *Compendium salernitanum*. Opsomer (1980) discusses the additions and sources for the *Circa instans*. A coconut without its green coat is depicted in the Platearius manuscript *Tractatus de herbis* held in London, which dates to between 1280 and 1310: BL, Egerton MS 747, fols. 67v and 68r.

19 See Fricke (2020).

20 In previous scholarship, the Münster coconut goblet has been described as the oldest coconut goblet in Europe; see Fritz (1977). However, if coconut was already part of the romanesque chalice of Saint Heribert, made around 1200, that would be an older example. A palmette frieze, a round plaque showing two bishops donating a round vessel, and the fragments of a coconut shell are older parts incorporated into a new reliquary around 1520. See Seidler (1985).

21 The drawing of 1850, preserved in the Landesmuseum Hannover, can probably be traced to a fifteenth-century drawing after the high altar around the new Goldene Tafel was established; see Richter (2019), fig. 1 and cat. no. 26. For a picture of the coconut vessel from the treasury of Cammin, see Borchers (1933), 44, no. 21.

22 Fritz (1983), 90.

23 During the ninth century, for a brief period, some rock crystals were adorned with lavish designs; these were engraved into the back of polished quartz by French craftsmen. See Kornbluth (1995); (2014).

24 Rudolph (1990); Castelnuovo (1991); Reudenbach (1994); Claussen (1996), 41; Büchsel (2010). See also *Historia compostellana*, written between 1130 and 1139.

25 "hoc ego Suggerius offero vas Domino": see Fricke (2015), 230–32.

26 Shalem (1998); Toussaint (2010); (2012); Rosser-Owen (2015).

27 Flood (2001); Hoffman (2001); Shalem (2005); Flood (2009b); Tronzo (2011); Hoffman and Redford (2017).

28 Shalem (2008); (2010a); (2010b).

29 Hoffman and Redford (2017), 427.

30 Fritz (1983), cat. no. 12, Freiburg, 91.

31 Ibn Battuta, *The Travels*, vol. 4, 115.

32 Karl Heppe bases his dating of the vessel on stylistic comparisons with works made by other goldsmiths made in Westphalia, the Lower Rhine region, and Cologne that have similar carved decorations, and concludes that it was made in the first half of the thirteenth century. He presumes that the relics originated in Hildesheim and suggests the Weser region as the site of the vessel's production; see Heppe (1973), 169.

33 In a previous article on this object, Fricke (2020), I understood the hinges to have varying thicknesses, and so presumed a time differential in the vessel's construction. Further research, however, has shown the hinges to be of equal size; therefore, I argue here that all parts of the ensemble were mounted at the same time, and that the primary purpose of the ensemble was for it to be a reliquary.

34 Kohl (1987), 477:

In nuce nigra cum agno Dei chrystallino: In ipso agno Dei de sanguine Domini nostri, in ipsa nuce vero de ligno Domini, de sepulchro Domini, de statua ad quam Dominus fuit ligatus et flagellatus, de praesepio Domini, de tabula de qua caenavit Dominus, de lapide in quo ascendit Dominus in caelum, de

tabula in qua post resurrectionem suam Dominus cum discipulis suis comedit piscem et favum mellis, de oleo beatae Mariae, de calicamentis beatae Mariae, de petra supra quam obiit beata Maria, de vestimentis beatae Mariae, de sepulchro eius, de sancta Anna, de sancto Joanne baptista, de virga aaron, de sancto Petro apostolo, de sancto Barnaba apostolo, de sancto Bartholomaeo apostolo, de sancto Simone apostolo, de sancto Jacobo apostolo, de sancto Paulo apostolo, de sancto Andrea apostolo, de sancto Jacobo apostolo, de sancto Thoma apostolo, de sancto Luca evangelista, de sancto Matthaeo evangelista, de sancto Stephano, de sancto Laurentio, de sancto Vincentio, de sancto Nicolao episcopo, de sanctis innocentibus, de sancto Martino episcopo, de sancto Benedicto, de sancto Bernardo, de sancta Catharina virgine, de sancta Maria Magdalena, de sancta Agata virgine, de sancta Agnete, de sancta Lucia, de sancta Ursula, de sancta Barbara virgine, de veste sanctae Julianae virginis, de sancta Margareta, de undecim millibus virginibus, de sancto Willehado episcopo et patrono nostro, unde colligitur has reliquias ex ecclesia Hildesiensi acceptas esse.

35 These *cedulae* have yet to be studied. A paleographical analysis would be extremely helpful and would reveal important information.

36 I am grateful to Gerlinde Huber-Rebenich for her observation that the paleographic information points to different dates: the earliest writing dates to the thirteenth century, while the use of the most widely spread Gothic script, the so-called bastarda script, and the simple line on the "i" of *marie virgini* was replaced in the fifteenth century with a dot. Other scripts are written in black letter/textualis bookhand; later scripts typical of the long fifteenth century (like the bastarda) appear as well.

37 Kalinowski (2001), 153–57.

38 A critical edition of this text is still lacking. See the edition by Joseph Emler, Marignolis, *Chronicon bohemorum*. For a partial English translation (used here), see the translation by Yule: *Cathay and the Way Thither*, 242–43. For an overview of scholarship on this text, see Baumgärtner (1993), col. 292; for a helpful discussion of exegetical influence on his account, Brincken (1967).

39 Pabst (2004), n. 5.

40 Paradise was not mentioned in the accounts of John of Plano Carpini (traveling 1245–47), Wilhelm of Rubruk (traveling 1253–55), John of Monte Corvino (traveling 1292–1328), Odorich of Pordenone (traveling 1320–30), and Marco Polo (traveling 1271–95, if true); see Pabst (2004), 46.

41 Rhys Davids (1908); Pabst (2004), n. 141; for the relevance of Adam's Peak in Islamic accounts, see Arnold (1913), 874; Seligsohn (1913).

42 Marignolis, *Chronicon bohemorum*, 499–500b.

43 Ibid., 539.

44 Ibid., 501.

45 For European written sources dating to the seventeenth century, see Fritz (1977), 20; Fricke (2020), 357–61.

46 See cat. nos. 1 and 12 in Bock (2005), 217–18, 225.

47 *Physiologus*, 8–9.

48 Bock (2005), 219.

49 Kochanowska (2004), 24, no. 36.

50 "Noch ein swarthe Indische nodt In sulver gefatett mith eynen kleinen Andreße," Zink et al. (1980), 161. The author also emphasizes that the vessel is filled with relics, partly unidentified: "Z. Zt. ist das Gefäß, dessen Deckel sich leicht abheben läßt, mit einer ganzen Reihe nicht identifizierter Reliquien gefüllt. Noch 1823 wurden zahlreiche Reliquien hinzugefügt, die man zwi zum Einschmelzen bestimmten barocken Monstranzen entnahm."

51 Richter (2015); (2019).

52 Richter (2015), 151. Richter also notes that the coat of arms with the lilies could have belonged to Nikolaus Burchardi of Höxter, who would have brought the vessel with him after he returned from his studies in Paris.

53 A history of theological discussions of the properties attributed to rock crystal can be found in Gerevini (2014), 92–99. On the history of the allegoresis of gemstones, see Meier (1977); Henze (1991).

For critical editions of Marbod, see Marbodus, *Liber de lapidibus*; Marbodus, *Liber lapidum*.

54 Berengaudus, *Expositio*, col. 962B.

55 For the Arabic and Persian tradition, see Shalem (1994), 5. See also the Qurʾan 76:15–16 for the association of rock crystal and Paradise. For the most relevant late medieval Latin edition (as it was the most widely read and was translated into several vernacular languages), see Cantimpre, *De natura rerum* XIV, 355.1, 16–23.

56 See Meier (1977), 342–45.

Chapter 4. Magic and Medicine in Medieval Mesopotamia

1 Martin (1739), 427–29, pl. XII. On this type of bowl, see Rehatsek (1873–74), 150–54, no. 1; Canaan (1936), 79–127; Gladiss (1999), 158–60, nos. 4–6. pl. 25a–c; Ittig (1982), 79–94; Savage-Smith (1997), 72–78; Pormann and Savage-Smith (2007), 152; Giunta (2018), 171–75, 283–85.

2 Rehatsek (1873–74), 161; Canaan (1936), 119; Giunta (2018), 250 and 157–67 for an excellent overview of the historiography of Islamic magic-medicinal bowls.

3 Giunta (2018), 312, 329–31.

4 Savage-Smith (1997); Canby et al. (2016), 212, no. 129; Ragab (2015), 49–58.

5 Shehada (2013), 403. For comparable earlier uses of saffron see, e.g., Gager (1999), no. 33. The preference for saffron ink continues in modern iterations of the practice: Nieber (2017), 458–59.

6 Oxford, Bodleian Library, MS Marsh 663, p. 274; first noted by Emilie Savage-Smith in Pormann and Savage-Smith (2007), 157–58.

7 Giunta (2018), 255–62.

8 Ibid., 261, 267. For similar functions in earlier amulets and talismans see, e.g., Bohak (2015), 88.

9 Morony (2003). In general, the texts in the bowls have received more attention than their imagery, as if each belongs to an entirely separate universe rather than contributing to the overall efficacy of the bowls. For exceptions, see Vilozny (2013); (2015).

10 See, for example, Pormann and Savage-Smith (2007), 151; Faraj (2017); Giunta (2018), 304.

11 Among them is the invention of otherwise undocumented peripatetic Iraqi Jews, whose peregrinations purportedly took them as far as late antique Nubia, where they introduced the Christian use of bowl magic: Hägg (1993); Żurawski (1992). See also Gordon (1994), 194–95. For a critique of the insistence on a diffusionist connection between these disparate examples, see Hunter (1996), 226.

12 Frankfurter (2015). On the relationship between technology, technical virtuosity, and magic (although tending in a different direction from our approach here), see Gell (1988); (1992), 40–63. For examples of relevant usages of bowls, whether inscribed ceramic bowls or metal receptacles engraved with figurative imagery, see *Greek Magical Papyri*, PDM xiv, 318–20; Jördens and Ast (2011), 32, no. 2. For suggestions of continuity with later Islamic traditions, see Fodor (1994).

13 See, for example, Gyselen (1995), 76–77.

14 Note, however, the survival at the Cairo Geniza, the storeroom of medieval papers associated with the Ben Ezra synagogue in Fustat, of a Babylonian grimoire, datable to roughly the eleventh century, containing spells very similar to those in the Aramaic bowls: Bohak and Morgenstern (2014), 13–14. For a more convincing suggestion of continuity in early Islamic Iraq, closer in place and time to the incantation bowls, see al-Khamis (1990). See also Giunta (2018), 304–5.

15 Reportedly, one such bowl inscription written in Arabic can be dated to the reign of the caliph Muʿawiya (r. 661–680 CE), although,

like the majority of the incantation bowl inscriptions written in Arabic, this has never been published: Shaked, Ford, and Bhayro (2013), i n. 2. In addition, something of the content and spirit of the Iraqi bowls was preserved in later fragmentary grimoires found in Damascus: Bohak and Morgenstern (2014).

16 See, for example, an eighth- or ninth-century jug from Nishapur in Iran, https://www.metmuseum.org/art/collection/search/450760 (accessed January 13, 2023). I am grateful to Marika Sardar for drawing my attention to this object.

17 The exception is a type of bowl on the exterior of which a personification of the sun or moon sits above an enthroned figured, likely Solomon, to judge by the flanking horned, animal-headed demons. I know of only two or possibly three examples of this bowl type, all of which bear the name of the Mamluk sultan Malik Mansur Lajin (r. 1296–1299 CE), suggesting that they were produced in Cairo, although the dates that they bear are not consonant with the known dates of the sultan's reign: Christie's (1998), lot 228, https://www.christies.com/lot/lot-1318353?ldp_breadcrumb =back&intObjectID=1318353&from=salessummary&lid=1 (accessed November 12, 2022). This seems to be the same as that now in a private collection published Faraj (2017). Another bowl of identical type is on display in the Museum of Islamic Art in Cairo.

18 Levene (2002), 13, 23, figs. 9–10; Faraj (2014), 12–17. Another Mandaic incantation bowl featuring the image of a scorpion is kept in the Museum of Glass and Ceramics in Teheran (inv. no. 626c), and was presented by Zohreh Mohammadian Moghayer in the online conference "Ceramics from Islamic Lands, Victoria and Albert Museum," London, July 20, 2021.

19 Indeed, the bowls are evidence for what has been called an "Eastern" branch of late antique Jewish magic which intersected with, but was distinct from, its "Western" counterpart in Egypt, Palestine, and Syria: Bohak (2009), esp. 326–27.

20 Morony (2003), 95–96; Frankfurter (2015).

21 For an excellent overview, see Zadeh (2009). In addition to juridical texts, reference to such practices is made in *al-ṭibb al-nabawī*, a genre of medicine based on the precedents of the Qurʾan and traditions of the Prophet Muhammad discussed below: see, for example, Ibn Qayyim al-Jawziyya, *Medicine of the Prophet*, 128.

22 Lane (1871), vol. 1, 320–21; Canaan (1914), 101–3, fig. 37; Nieber (2017).

23 See, for example, Naveh and Shaked (1993), 147–52, 169–71, 220–22, nos. 9, 14, and 23 respectively. Note also that while the Cairo Geniza contained a range of fragmentary grimoires and spells, many written in Judeo-Arabic, some were written in Arabic, ascribing magical properties to the inking of certain letters in cups or bowls, then washed with liquids for ingestion: Ebied and Young (1974), 408.

24 Flood (2019a), 113–14, 118–19.

25 In addition to the twenty examples published in Giunta (2018), 199–204, I know of three unpublished examples in private collections, while five additional examples in Turkish collections are published online in *Selçuklu Şifa Tasları*, http://girlandkultursanat.com/wp-content/uploads /sel%C3%A7uklu-%C5%9Fifa-tas%C4%B1.pdf (accessed January 13, 2023). For other examples, see Langer (2016), 23, no. 4; Christie's (1995), lot 220; Sotheby's (2009), lot 60, https:// www.sothebys.com/en/auctions/ecatalogue/2009/arts-of-the -islamic-world-l09721/lot.60.html?locale=en (accessed January 13, 2023); Bonhams (2011), lot 137; Dmitry Markov/Baldwin's/ M&M Numismatics Ltd (2013), no. 430, "A Fine Brass Magic Bowl"; https://www.catawiki.com/l/11855371-an-excessively-rare -islamic-seljuq-dynasty-talismanic-medicine-bowl-12th-century (accessed February 12, 2021, no longer available); Bonhams (2022),

lot 34, https://www.bonhams.com/auction/27408/lot/34/an
-ayyubid-tinned-bronze-magic-bowl-or-poison-cup-egypt-or-syria
-13th-14th-century/ (accessed January 13, 2023).

26 Halsted (2022), 180.

27 Giunta (2018), 263. For a discussion of this phenomenon in
relation to another type of Islamic magic-medicinal bowl, see Flood
(2019a), 133–37.

28 Gell (1992); (1998), 86.

29 For another such variant, closer in its iconography of the bowls
discussed here, see Canova (1995), 79, fig. 1.

30 Ittig (1982), 88–90.

31 Jabir ibn Hayyan, *Le Livre des balances*, 150–51; Hallum (2021),
esp. 78–104. On Apollonius in the Islamic world, see Raggetti
(2019). For the invocation of Apollonius on late antique amulets,
see Spier (2014), 59, fig. 8. See also ch. 6 n. 149 below.

32 Spier (2014), 45; Mastrocinque (2011), 64.

33 As also noted by Canby et al. (2016), 211, no. 128.

34 Giunta (2018), 280, nos. axvii and axviii; Canova (1995), 79, no.
1, fig. 1.

35 Wiet (1932), 173–74, no. 53.

36 One published example reportedly bears the date
642 H/1243–44 CE, but neither the inscription nor the location of
the bowl is provided: Langer (2016), 23 n. 8, with an accompanying
image.

37 See also Giunta (2018), 281–82

38 See Giunta (2018), 285 for an overview. For a Mamluk attribu-
tion, see Ittig (1982), 94. For a Jaziran attribution, see Gierlichs
(1993), 41, no. 8; Gladiss (1999), 151–52, 158–60, nos. 4–6, pl. 25a–c.

39 The chapter represents a revision of an earlier ascription of
such bowls to a potential Egyptian or Mamluk source based solely
on formal similarities to engraved metal amulets from Egypt rather
than a more holistic approach: Flood (2019a), 119–23.

40 Collinet and Bourgarit (2021), 266, no. 66.

41 Hill (1915), 30–31; Irani (1955), 4–7; Ittig (1982), 89. It is worth
noting that, at this date, the same form of the numeral was in use
in the Artuqid regions where I will suggest that the first examples of
the bowls originated: Ward (1985), 70–71.

42 Rustow (2020), 323. See also ibid., 337–38, fig 3.7.

43 Another group of Islamic magic-medicinal bowls, remarkably
standardized in content and bearing an image of Mecca at the
center of their interiors, all bear the same date, 574 H/1174–75 CE
(fig. 105 here), even though it is likely that they were produced at
different times, probably through practices of copying. It is as if
they are frozen in time, products of an originary moment whose
significance is not entirely clear: Flood (2019a), 109–18.

44 Kubler (1962), 39–65. See also Davis (1996), 92–93; Wood
(2008), 36–42.

45 See, for example, Witkam (1988).

46 For a general discussion of the phenomenon, see Flood (2019a).

47 Scott (1951), 201; Hägg (1993), 380; Gordon (2012), 164–65. For
the diachronic transmission of certain formulae, see Bohak (2009).

48 Gordon (2012), 167–68; Frankfurter (2019), 648–56.

49 Bohak (2011), 30, 33. For a rare example of the use of such
scripts in a Syriac incantation bowl, see Moriggi (2014), 138–43, no.
28.

50 Giunta (2018), 61–62, 132.

51 After a period of provinciality, from around 1150 Damascus
emerged as the capital of a Syria newly unified under the rule of
the Zangids (1127–1250), who professed allegiance to the Abbasid
caliph in Baghdad. Through this kind of networked or franchised
rule, the power of the Baghdad Abbasids waxed again at this time
after a period of political stagnation.

52 Wiet (1971) 84, no. 110, pl. xxiv; Ali Ibrahim (1976), 15–16;
(2008), 91–109.

53 For an introduction to the Jazira and its art, see Whelan (2006);
Korn and Müller-Wiener (2017).

54 Kühnel (1950), 1–18; Gierlichs (1996), pls. 7.1–2, 10.1–2, 33.1–3,
38.1–2, 39.1, 56.1–2, 65.1–3. A particularly close comparison for the
dragons in the bowls and their flickering tongues is found on the
facade of the church of Tigran Honents in Ani, finished in 1215 CE:
ibid., pl. 70.6.

55 The connection was made in Whelan (2006), 36–37. See also
Eastmond (2015), 207–10; (2017), 231–33.

56 Cahen (1934), 110–11.

57 Al-Harawi, *A Lonely Wayfarer's Guide*, 145.

58 Gandzakets'i, *History of the Armenians*, 63.

59 Graves (2018), 91. For varying interpretations of such imagery,
see Hartner (1938), 143–44, figs. 27–29; Kühnel (1950).

60 Berlekamp (2016), 90–98.

61 See ch. 6 nn. 31–32, and figs. 187 and 188 below. Also, Canby et
al. (2016), 57, no. 7. For a good overview of Artuqid art and architec-
ture, see Korn (2011). On medical and astrological sciences in the
Jazira, see Brentjes (2017).

62 Whelan (2006), 192–96.

63 Sara Kuehn, noting the association with Turkic dynasties ruling
in the region, suggests an origin in Central Asian art: Kuehn (2011),
45–46. See also Azarpay (1978), 366; Ittig (1982), 91.

64 Spengler and Sayles (1992), 7–11. See also Azarpay (1978), 366–
67, fig. 5; Whelan (2006), 158–60, fig. 132.

65 Ittig (1982), 82–83. For such invocations, see al-Damiri, *Kitāb
Ḥayāt al-ḥayawān*, vol. 7, 349 (Arabic); vol. 10, 643 (tr.). The asso-
ciation seems to be based on the belief that both creatures had
pledged to the prophet Noah not to sting or bite as a condition of
being included in the Ark: Robson (1934), 39–40.

66 Ittig (1982), 82–85.

67 Jabir ibn Hayyan, *Le Livre des balances*, 150–51; Hallum (2021),
esp. 78–104.

68 Al-Kahhal ibn Tarkhan, *Al-Aḥkām al-nabawiyya*, 376. Around the
same time, the use of amulets along with drugs is attested in the
other great hospital/*bīmāristān* of the Islamic world, completed by
the Mamluk sultan Qalawun in Cairo in 1285 CE, in which a magic-
medicinal bowl reportedly remained in use until the nineteenth
century: Pacha (1916), 248. See also Perho (1995), 114; Ragab
(2015), 182; Giunta (2018), 206.

69 Wilcox and Riddle (1995), esp. 9.

70 Baker (2012), 270–71. See also Berlekamp (2016).

71 Redford (2007), 9. For the late antique world, see Frankfurter
(2019), 632–35.

72 For a discussion, see Flood (2019a), 116.

73 Provera (1973), fols. 24r, 25v, 26r, 31v.

74 For a relevant discussion of the images, see Barnabò (2017),
97–108. On the demonic associations of the dog in medieval
Byzantine art, see Foskolou (2005), 252–53.

75 Saif (2017).

76 Gonnella (2010), 115 and nn. 91, 92.

77 In a recent comprehensive survey of Islamic magic-medicinal
bowls, this formula appears on eighteen of the twenty published
"poison bowls," but on only thirty-one of the ninety-four bowls of
other types included in the corpus: Giunta (2018), 213. For exam-
ples of similar inscriptions on other bowls, see Spoer (1935), 256;
Giunta (2018), 263. The Palestinian ethnographer Tawfiq Canaan
was one of the few to comment on this feature, suggesting that
although the logic of its operation is unclear, this invocation of an
agent may reflect situations in which the bowl lay distant from the
ailing person and was not easily accessible to her or him: Canaan
(1936), 115

78 For a discussion of this question of surrogacy in relation to
another type of Islamic magic-medicinal bowl, see Flood (2019a),

133–37. One is reminded of James Frazer's distinction between contagion and imitation as two operational modes of sympathetic magic: Frazer (2009), 26–59.

79 Al-Damiri, *Kitāb Ḥayāt al-ḥayawān*, vol. 7, 349 (Arabic); vol. 10, 643–44 (tr.). It is not clear from the context whether the use of such proxies also extends to the person bitten by a dog or poisoned.

80 See, e.g., Giunta (2018), 263, aI–aVIII and aXVII–aXIX.

81 A detail noted by Rehatsek (1873–74), 153.

82 Al-Suyuti, *Livre de la miséricorde*, 78; Raggetti (2018), 82–83, nos. 8.16 and 8.17.

83 Pormann (2003), 225. For al-Kashkari's version of the same idea, see ibid., 229–31.

84 Mély, *Lapidaires grecs*, 69.

85 Raggetti (2018), 82–83, nos. 8.16 and 8.17. See also al-Suyuti, *Livre de la miséricorde*, 78.

86 Flood (2006), 143–66; Calasso (1992), 93–104.

87 Ibn Wahshiyya, *Book on Poisons*, 72–73. See also Wilcox and Riddle (1995), 44.

88 See, for example, Ibn Qayyim al-Jawziyya, *Medicine of the Prophet*, 129; al-Suyuti, *Medicine of the Prophet*, 153.

89 Kerner (2004), 140–43; (2007), 32.

90 Pancaroğlu (2001), 160.

91 Mély, *Lapidaires grecs*, 69.

92 Raggetti (2018), 458–61, nos. 80.4–80.7

93 Ibid., 460–61, nos. 80.7 and 80.8.

94 Ibid., 462–63, nos. 80.11–80.13.

95 To date, two examples of this amulet type have been published, one in the collections of Dumbarton Oaks, the other in the Kelsey Museum of Archaeology, University of Michigan at Ann Arbor: Ross (1962), no. 60; Nesbitt (2003), 109, fig. 13.10–11; Maguire, Maguire, and Duncan-Flowers (1989), no. 134.

96 Bonner (1942), 471, fig. 8; (1950), 219–20, 307, pl. XVII, no. 325; Gyselen (1995), 26–30, 49–52, types 2 and 10; Michel (2004), no. 37.A.2, pl. 20.1; Spier (2013), no. 879.

97 Cunningham (1997), 79–80, 177; Green (1997), 155, 157, fig. 19; Wiggermann (2000), 234.

98 See ch. 6 nn. 161–63. The ancient conjunction of lion, scorpion, and serpent survives in the skandola, a talismanic signet ring or seal of iron used by initiates into the rites of Mandaeism, a monotheistic religion that flourished in the Jazira, and in rites to protect against evil at certain key moments in the lifecycle of believers, including childbirth: Rudolph (1978), 7, fig. 2; Baker and Bejjani (2017), 91.

99 The triad continues to appear in Latin medical treatises into the late medieval period, even in regions to which scorpions were not native: Hill (1965), 347, 353, 357, fig. 1.

100 Bonner (1942), 471, fig. 8; (1950), 219–20, 307, pl. XVII, no. 325; Porter, Saif, and Savage-Smith (2017), 525.

101 Porter, Saif, and Savage-Smith (2017), 533–34, fig. 21.4. On the imprinting of earth, see Flood (2019a), 97–103. Versions of the same amulet exist in medallion form provided with a loop for suspension, suggesting that they were worn on the body: Kiyanrad (2017), fig. 15.

102 Barrucand (1991), 113–42; Peacock (2020), 163–79. For the mirrors, see Erginsoy (1978), 351–52, fig. 187; Melikian-Chirvani (1982), 131–32, no. 59; Turkish Ministry of Culture and Tourism (1983), 72–73, no. 131.

103 *Tibb al-A'imma*, 120–21.

104 Ibn Qayyim al-Jawziyya, *Medicine of the Prophet*, 138.

105 Canby et al. (2016), 211, no. 128.

106 Ibn al-Faqih, *Kitāb al-Buldān*, 240–43; Ibn al-Faqih, *Abrégé du livre des pays*, 290–94.

107 Anawati (1966), 24 (Arabic), 26–27 (tr.); al-Buni, *Shams al-maʿārif al-kubrā*, 90–97; Ittig (1982), 85–87. Some elements of this

sigil are of considerable antiquity: two are among the symbols that appear in a magical inscription in a Syriac divination bowl: Moriggi (2014), 138–43, no. 28.

108 Berlekamp (2011), 134.

109 The relationship is noted by Baker (2012), 270–71; Whelan (2006), 36–37. For examples of cosmological imagery on metalwork from southern Anatolia and the Jazira, see Canby et al. (2016), 232–33, no. 145.

110 Berlekamp (2016), 66. See also Pancaroğlu (2001), 165–66.

111 See, e.g., Wilcox and Riddle (1995).

112 Ibn Wahshiyya, *Book on Poisons*, 73.

113 Spoer (1935), 255–56; Giunta (2018), 268.

114 Jenkins and Keene (1983), 21, fig. 1, no. 3f.

115 Michel (2001), vol. 1, 216–17, nos. 342–44. Moreover, lion and scorpion are linked in other ways too—late antique Greek lapidaries refer, for example, to agate as having the same color as the skin of a lion and recommend its application to alleviate a scorpion bite: Halleux and Schamp, *Lapidaires*, 115, 255.

116 Majriti, *Ghāyat al-ḥakīm*, 34; *Picatrix*, 58; Porter (2004), 151. The sealing of incense pills with rings carved with efficacious images is already mentioned in magical papyri from pre-Islamic Egypt. Similar prescriptions occur in other genres of medieval Arabic texts: al-Tifashi, *Arab Roots of Gemology*, 129–30; Ibn al-Zubayr, *Book of Gifts and Rarities*, 116, no. 104. The motif survives in the *Three Books on Life (De vita libri tres)* of Marsilio Ficino (d. 1499), a work heavily indebted to Arabic texts on astrology, magic, and medicine: Ficino, *De vita libri tres*, 304–30.

117 See, for example, Michel (2001), 65–66, nos. 62 and 63. For a formula to produce a ring with similar properties, but consisting of inscriptions (including the name of God) rather than figurative images, see Pormann and Savage-Smith (2007), 156–57, fig. 5.2.

118 Ibn Khaldun, *Muqaddimah*, vol. 3, 163.

119 Maddison and Savage-Smith (1997), 138.

120 See, for example, a bowl in the Museo e Real Bosco di Capodimonte, Naples: Giunta (2018), aIII; Vanoli (2019), 51, no. 15.

121 Hartner (1938), 117; Ittig (1982), 92.

122 Pancaroğlu (2001), 163–66, quotation at 166. For this manuscript, see Kerner (2004); Caiozzo (2008), 36–42; Kuehn (2011), 171–80, esp. 177.

123 Hartner (1938), esp. 120–44.

124 Azarpay (1978), 371–72; Kuehn (2015), 71–97.

125 Such bowls were, for example, denounced by the Egyptian jurist Ibn al-Hajj (d. 1336 CE), for their use of figurative images (including those of dogs): Ibn al-Hajj, *Al-Madkhal*, vol. 3, 141.

126 See, for example, the use of the name of the Egyptian tyrant pharaoh on West African magical garments, where it is "always restrained and enclosed" within squares surrounded by God's name: Silverman (1991), 24.

127 See, for example Shalem (2010a), 297–313; (2011), 3–5, fig. 1; Berlekamp (2011), 134.

128 Pormann and Savage-Smith (2007), 158.

129 Kuehn (2011), 45–46. See also Azarpay (1978), 366; Ittig (1982), 91.

130 Maddison and Savage-Smith (1997), 138–39, nos. 77–81; Jenkins and Keene (1983), 25, no. 7; Porter, Saif, and Savage-Smith 2017, 525. For the term "Linear Kufic," see Casanova (1921), 52–53. On its use, see Porter (2010), 131–40.

131 For a discussion of a similar distinction in the scripts found on early Islamic amulets, see Bsees (2019), 133–34.

132 Frankfurter (2019), 645; Saar (2019), 480. Similar overlining continued in certain medieval Arabic and Hebrew occult texts: Raggetti (2019), 164, fig. 3. I hope to explore this possible connection elsewhere.

133 George (2010); Blair (2007), 101–237.

134 Redford (1993), 153–55.

135 I am indebted here to Bennett (2010), 20–38. In Bennett's usage, which owes a clear debt to actor-network theory, an assemblage is a constellation of agents, forms, and materials whose effects are characterized by emergent properties, possessed of an agency and potency irreducible to the sum of its parts.

136 See, among others, Ibn Qayyim al-Jawziyya, *Medicine of the Prophet*, 122–31; al-Suyuti, *Medicine of the Prophet*, 160–67. The grouping of these afflictions perpetuates a late antique association between the toxic gaze, the bite of serpents, and the sting of the scorpion. See Tod (1939), 58; Dunbabin and Dickie (1983), 18–19.

137 Bohak (2009), 329, 333–36.

138 Bremer-McCollum (2018), 118.

139 As early as the eighth century a fragmentary papyrus from the Fayyum in Egypt refers to a scroll amulet made for the Umayyad caliph al-Walid (r. 705–715 CE) which had been used to cure the caliph's wife and which was now in the possession of an inhabitant of the Fayyum, who had reproduced its formula for a hundred men and women, all of whom it had cured: Garel (2016), 48–49. On a talisman said to have protected the palace of the Abbasid caliph in Baghdad, see Dols (1977), 137–38. See also Shehada (2013), 398.

140 Flood (2019a), 123–29.

141 Majriti, *Ghāyat al-ḥakīm*, 305–6; *Picatrix*, 266–67; Gordon (2012), 164–65.

142 Ibn al-Zubayr, *Book of Gifts and Rarities*, 166–224.

143 Gordon (2012), 147.

144 Raggetti (2018), 228–29, 294–95, 458–59, 544–45, nos. 22.35, 42.4, 80.4, and 108.5 respectively.

145 Flood (2019a), 123–28.

146 A work on magical alphabets and operations written by one Khusraushah the Magician, during the reign of the Mamluk sultan Baybars (d. 1277 CE) mentions that the author had the chance to examine relevant works in the *khizāna* of the first Fatimid caliph al-Muʿizz li-Din Allah (r. 953–975 CE) when it was opened by the Mamluk sultan ʿIzz al-Din al-Turkmani al-Salihi (r. 1250–1257 CE): BnF, MS Arabe 2674 (formerly Supplément arabe 990), fol. 106r, discussed in Casanova (1921), 39–41. See also Ibn Wahshiyya's book on ancient scripts and their magical and talismanic associations which he states that he placed in the royal library or treasure house (*dhakhīra al-khizāna*) of the Umayyad caliph ʿAbd al-Malik in Damascus when the latter completed it in 856 CE—a striking anachronism, given that the caliph had died in 705 CE: Ibn Wahshiyya, *Ancient Alphabets*, 53–54, 135. For medical knowledge found in a royal library, see Ibn Sina, *Life of Ibn Sina*, 37.

147 Gutas (1998), 28–33; Flood (2019a), 126–27.

148 Pancaroğlu (2001), 169–70; Contadini (2017), 436.

149 In addition to Contadini (2017), see ch. 6 n. 7 below. There are interesting anthropological parallels to be drawn here with the links between economic prosperity and the "democratization" of occult technologies in earlier Mediterranean cultures; see, e.g., Ritner (1997), 104.

150 Dasen and Nagy (2019), 416, 424; Nagy (2012), 104.

151 Dasen and Nagy (2019), 432.

152 Nicolas de Nicolay, *Les Quatres Premiers Livres*, 204–6 and accompanying illustration.

153 See, e.g., Ivanov (2014), 217–18, no. 114; Ibrahim b. ʿAli al-Kafʿami, *Miṣbāḥ al-Kafʿami* (Qumm, 1984), 224, cited in Sindawi (2012), 310.

154 For a study of this later bowl type, see Langer (2016). On the related shift from figurative magic toward letter magic and texts in Islamic occult materials, see Dorpmueller (2012), 189–208; Gardiner (2017), 62.

155 Halleux and Schamp, *Lapidaires*, 255; Nagy (2012), 81–86.

156 Faraone (2017). For another Egyptian bronze plaque engraved with similarly dense amuletic/magical imagery, including Horus on the crocodiles, which probably served the same function, see Petrie (1914), 30–32, pl. xlix, no. 135aa. On the role of Horus in such contexts, see notes ch. 5 nn. 60 and 61 below.

157 For an extremely rare example of such a bowl, dated 606 H/1209 CE, which informs us that it is made of seven metals (evoking a relationship to the seven cosmic luminaries) and was engraved when the moon was in Scorpio, see Wiet (1932), 34–35; *RCEA*, no. 3648. For the sympathetic correspondences of certain metals see, e.g., Brethren of Purity, *On Magic*, 17, 134

158 Rice (1961); Giunta (2018), 311–12.

159 See n. 6 above.

Chapter 5. Distance Made Tangible in Medieval Ethiopia

1 Balicka-Witakowska (2009–10), 124–25.

2 Derat (2019), 46–62.

3 Lepage (1999), 901–67; Mercier and Lepage (2012), 199–202.

4 Lepage (1999), 948–49, 960, notes the likelihood of an Islamic source, pointing to the occurrence of the motif in Syria, Anatolia, and the Jazira. See Ousterhout (2009), 159–61; Çağaptay (2018), 309–38.

5 Munro-Hay (1997), 183; Lepage (1999), 947–50.

6 Bosc-Tiessé (2020), 335–36, fig. 12.4.

7 Mordini (1940), 105–7, figs. 2 and 3; Derat et al. (2021), 475–81, esp. 475, 477, 482, figs. 7, 8, and 10; University of Toronto (online).

8 For an excellent drawing showing the location of the relief in relation to the church, see Bosc-Tiessé and Derat (2019), 25–26, fig. 9. Unfortunately, permission to reproduce this drawing was denied by the authors.

9 It has been suggested that these discs are part of the equine headdresses rather than shields raised in the hands of the riders: Lepage (2006), 159. However, similar images can be found in the thirteenth-century wall paintings in the church of Qorqor Maryam in Tigray, where a band of equestrian warriors gallops forward, wielding swords in their left hands and raising circular shields in their right, in an identical position in relation to the horses' heads as in the Lalibela relief: Balicka-Witakowska (2009–10), 116, fig. 11.

10 The creature was originally identified as a buffalo or lion: Lepage (2006), 157, fig. 4. For the correct identification, see Balicka-Witakowska (2009–10), 116.

11 For an example from the portable arts, see Xanthopoulou (2010), 28, fig. 10.

12 In the church of Yemrehanna Krestos near Lalibela polychromatic figurative and geometric paintings were also executed on a prepared layer of gypsum: Gebremariam, Kvittingen, and Banica (2013), 467; Worku (2018), 117–20. Some of the eleventh- and twelfth-century carved wooden iconostases and sanctuary doors in the Coptic churches of Fustat show traces of gesso, used as a substrate for gilding or painting: Hunt (1996), 53.

13 Fauvelle-Aymar et al. (2010), 1147.

14 Lepage (2006), 162–65.

15 Munro-Hay and Juel-Jensen (1995), 39–40; Hahn and West (2016), nos. 1–21, 33–40, 45–50, 61–90, 97–128, 192–221.

16 Derat (2010), 162–63; (2019), 115–16; (2020b), 51–52; Gnisci (2020), 27–29. See also Phillipson (2004).

17 Bolman (2002), 42–44, 116–18, figs. 4.8 and 4.9; Snelders and Jeudy (2006), 103–40; Bolman (2016), 208, fig. 16.10.

18 Lepage (2006), 159–60; Balicka-Witakowska (2009–10), 112.

19 Anfray (1965), 13–14, figs. 14 and 15; Sauter (1967–68), 229, figs. 18–20; Heldman (1993), 118–19, figs. 12 and 13; Bosc-Tiessé (2020),

321. For the church, see Lüpke (1913), 195–98. For the Debra Damo ceilings, see Matthews and Mordini (1959).

20 Élias, Lepage, and Mercier (2001); Balicka-Witakowska and Gervers (2001).

21 As suggested by Lepage (2006), 154.

22 Lepage (2006), 166–67; Mercier and Lepage (2012).

23 Abu Salih, *Churches and Monasteries*, 286.

24 Pancaroğlu (2004), 151, 156.

25 Brune (1999); Pancaroğlu (2004), 158–61. The ambiguities associated with these images are perhaps not surprising considering the origins of the equestrian saint figure in Roman imperial iconography: see Walter (2003), 9–38.

26 Lewis (1973), 62.

27 Lepage (2006), 161; Mercier and Lepage (2012), 203.

28 In Chapel 17 and in Room 6 of a large complex: Clédat (1904), 80 81, pls. LV and LVI. The existence of the latter painting has only recently been noted, based on archival material from Clédat's excavations: Bénazeth (2005), 3–5, figs. 5 and 6. See Papaconstantinou (2001), 213.

29 Clédat (1904), 80, pls. LIII–LVI; Papaconstantinou (2001),190–91, 204–14; Walter (2003), 235, 241–42, nos. XXIV and XXVII.

30 Now in the Brooklyn Museum and the Musée du Louvre: Bussmann (2009), 24–25; Viaud (1978), 117; Clédat (1999), photo 208.

31 Snelders and Jeudy (2006).

32 Bolman (2002), 116–17, figs. 7.15 and 7.25

33 Thierry (1999), 233–47, esp. 238–43; Snelders and Jeudy (2006).

34 Badamo (2011), 71.

35 Viaud (1978), 114; Schwartz (1996), 253–57; Torijano (2012), 116–17. See also Naveh and Shaked (1987), 120–22.

36 Dunbabin and Dickie (1983), 7–37.

37 Walter (1989–90), 36–37; Spier (2014), 45–46, fig. 1; Faraone (2018), 112–15

38 Vikan (1984), 79–81; Spier (1993), 35–36; Foskolou (2014), 338–41, figs. 7, 11. It has been suggested that the similarities in iconography between these amulets and the Bawit painting reflect their derivation from a common source: Spier (2014), 51.

39 Westenholz (2007), nos. 93 and 94.

40 Bonner (1942), 467–69, figs. 3 and 5; (1950), 307, no. 325, pl. XVII; Viaud (1978), 112; Walter (1989–90), 41–42; Spier (1993), 37, pl. 6e; Spier (2014), 50–55, figs. 4–6.

41 Perdrizet (1903), 50–52; Spier (1993), 30, no. 33.

42 Bonner (1950), 220; Spier (1993), 37, 60–62, pl. 6e; Vikan (1984), 79–81.

43 Bonner (1950), 220; Maguire, Maguire, and Duncan-Flowers (1989), 25–28, figs. 22 and 23; Michel (2001), vol. 1, 268–80, nos. 430–50; vol. 2, pls. 64–67; Michel (2004), 323–24, no. 44; Mastrocinque (2014), 240–41, nos. 520–530

44 Spier (1993), 30, no. 33, pl. 3a. For the suggestion that the figure of Solomon/Sissinios survived, if transformed, in Islamic texts on talismans produced in medieval Anatolia, see Pancaroğlu (2004), 161, fig. 12.

45 Derat (2019), 157–60; Derat (2020b), 55.

46 Walters (1989), 195, fig. 19.

47 Żurawski (2012), 301–9, cat. no. S8/S/1; Innemée and Zielińska (2019), 128–29, fig. 3; Ruffini (2012), 227, 231. A partially preserved similar fresco dating to around 1000 CE was found in the church at Abdallah Nirqi in northern Nubia, although the identity of the equestrian figure is disputed: Moorsel (1975), 109–11, pls. 63 and 67.

48 Mercier (1992), 168–69, nos. 129–31; Mercier (1997), 80, 83, figs. 83 and 86; Isaac (1980), 41–48.

49 *Légendes de S. Tërtag et de S. Sousnyos*, 10–28; Winkler (1931), 93–97 for the Ethiopic version. See also Fries (1893); Grébaut (1937), 177–83; Wagner (1967), 711–14; Gusarova (2019), 340–45.

50 It has been suggested that one of four equestrian saints depicted in the wall paintings of the church of Yemrehanna Krestos near Lalibela depicts Sisinnios dispatching Wërzëlyä: Balicka-Witakowska and Gervers (2001), 41; Balicka-Witakowska (2009–10), 129. However, the foe in question is in fact a male figure (perhaps the Roman emperor Diocletian) wearing Turkic military dress, very similar to the military figures depicted in the early thirteenth-century paintings in Saint Anthony's monastery on the Egyptian Red Sea coast.

51 *Testament of Solomon*, 973–74; Viaud (1978), 119–31; Greenfield (1989), 115–16; Spier (1993), 33–37.

52 *Légendes de S. Tërtag et de S. Sousnyos*, 38–42; Fries (1893), 65. For comparative studies of the motif, see Winkler (1931); Fauth (1999).

53 Greenfield (1989), 97.

54 Naveh and Shaked (1987), 104–22.

55 Greenfield (1989), 99–100.

56 See, e.g., the hagiography of the monk Abba Gabra Manfus Qeddus: *Book of the Saints of the Ethiopian Church*, vol. 3, 755–72.

57 Godlewski (1982), 95–97; Innemée (2016), 422–24, fig. 11.

58 Spier (1993), 47–48, fig. 3.

59 Miquel et al. (1993), fig. 81; Frankfurter (2004), 107, fig. 8.

60 Scott (1951); Ritner (1989), esp. 114.

61 Néroutsos-Bey (1888), 46–50; Godlewski (1982), 95–97. See also ch. 4 n. 156 above.

62 Barb (1964), 10–16, pls. 2a and 2b.

63 Frankfurter (2004), 106–7; Mayeur-Jaouen (2000), 740–45. Talismans against crocodiles are commonly mentioned among medieval descriptions of Egyptian magic and wonders: Pettigrew (2004), 200.

64 Rassart-Debergh (1987), 377–78; (2001), 187–90, figs. 3–4; Ballet, Bosson, and Rassart-Debergh (2003), 350–51, 452, 482–83, 485, figs. 52 and 111, pl. 36.

65 Bonner describes the figure as "sphinxlike": Bonner (1950), 219–20, no. 342. See also Schlumberger (1892), 74–75; Maguire, Maguire, and Duncan-Flowers (1989), 27–28, nos. 133 and 134; Spier (1993), 35; (2014), 57–58, fig. 9.

66 Athanasius of Alexandria, *Life of Antony*, 198, # 9; Jerome, *Life of Paulus*, 500, # 7–8. See also Viaud (1978), 115.

67 Innemée and Zielińska (2019), 132–33, figs. 7 and 8.

68 Mercier (1992), 170, no. 132.

69 Lepage (2006), 165, fig. 8.

70 Immerzeel (2004), 36–39.

71 Ibn al-Husain, *Kitāb al-bayzara*.

72 Grube (1976), 60–61, pl. 9; Digard (2002), 182, no. 148.

73 Digard (2002), 189, no. 160. For a similar object, albeit with the falcon replaced by a cheetah, see Canby et al. (2016), 104, no. 33.

74 Pauty (1930), 14, pls. I–III; Hunt (1996), 50–51, figs. 3 and 4; Snelders and Jeudy (2006), 116–17, pls. 9 and 10.

75 Snelders and Jeudy (2006), 106, 138; see also 116–19, 126–38, figs. 15–21.

76 As suggested by Snelders and Jeudy (2006), 138.

77 Duncanson (1947), 160–62; Anfray (1965), 7–8; Anfray and Annequin (1965), 59, pl. LXIII, fig. 4; Anfray (1990), 42–44; Manzo (1994), 119–38, esp. 120–23; (2009), 295–96, fig. 4; Tesfaye et al. (2011), 277–79, fig. 11; Tesfaye et al. (2011), 277–79, fig. 11.

78 Gierlichs (1993), 20–25; Canby et al. (2016), no. 154.

79 See, for example, Scerrato (1980), 72, fig. 11.

80 Elsberg and Guest (1936), 140–45, pls. IB and IC.

81 See https://www.metmuseum.org/art/collection/search/642122 (accessed January 13, 2023).

82 See, for example, Riis and Poulsen (1957), nos. 875, 885, 888, and 889. A corpus of such molded ceramics excavated at Balis in northern Syria is the subject of an ongoing study by Stephennie Mulder.

83 Pauty (1930), 33, pls. XVII, XVIII, XXIII; Snelders and Jeudy (2006), 119–20, pls. 12–14.

84 Donceel-Voûte (2019), 19. The possibility that the sphinx contributes to the apotropaic associations of the holy rider is not considered by Snelders and Jeudy (2006), 119, but this seems likely; see ch. 6 n. 110 below.

85 Haarmann (1978).

86 Lepage and Mercier (2005), 76–77, 112–25, esp. 121. The comparison with the Lalibela sphinx is made in Lepage (2006), 161–62, fig. 6. It has been suggested that the presence of the sphinxes was related to "magical processes": Tribe (1997), 46. The church and its paintings are the subject of an ongoing study: Bosc-Tiessé (2014).

87 Kaper (2003), 255–57, no. R-35; Wilburn (2013), 181–93.

88 Lepage and Mercier (2005), 121. I am very grateful to Jacopo Gnisci and Jonas Karlsson for their help with this inscription.

89 BnF, MS Éthiopien 32, fol. 7r.; mentioned in Platt (1823), 21.

90 Morgan Library, New York, 1401MS M.828, fol. 5v. Heldman (1972), 102; Balicka-Witakowska (2009–10), 114 n. 18.

91 Viré (1966), 53.

92 Lambourn (2016).

93 Baer (1965), 33, 48, 80.

94 Buzurg ibn Shahriyar, *Kitāb ʿajāʾib al-Hind*, 39

95 Viaud (1978); Greenfield (1989), 106.

96 For the identification as a bull see Balicka-Witakowska (2009–10), 129, figs. 22 and 23. The combination of dim lighting and accumulated soot makes it difficult to be certain—hence the vague description of the beast as a quadruped: Balicka-Witakowska and Gervers (2001), 41–42, fig. 22; Élias, Lepage, and Mercier (2001), 326–32. The paintings in the church are generally dated to the twelfth century, although some scholars argue for a thirteenth-century date (see n. 169 below). However, the chemical compositions of the figurative and geometric paintings and the wall paintings in the church show clear differences: Gebremariam, Kvittingen, and Banica (2013), 468. This opens the possibility that the figurative wall paintings are slightly later in date than the church or than some of the paintings within it. See Worku (2018), 50–53, 144–45, 188.

97 Al-ʿUmari, *Masālik al-abṣār*, 25–26. From as early as the twelfth century, Crusader sources refer to the role played by "Ethiopian" bowmen in the Muslim armies that they opposed, although this may be a generic term for dark-skinned Muslims: Zouache (2019), 30, 32, 38.

98 Bosc-Tiessé and Derat (2019), 25–26, figs. 8–9.

99 Mercier and Lepage (2012), 315–17.

100 During the International Fund for Monuments restoration campaign of 1966 the shields were removed and photographed. A single photo appeared in the preliminary report: International Fund for Monuments (1967). However, copies of other printed images (without negatives) are preserved in the archive of Sandro Angelini, one of the architects involved in the restoration, in the Biblioteca Civica Angelo Mai in Bergamo. Some of these were published in Mercier and Lepage (2012), 315–16, figs. 10.32 and 10.33, without attribution.

101 Monti della Corte (1940), 150–53, pl. XXXVI.

102 For the appearance of the motif on Kadamba coinage, see http://coinindia.com/galleries-kadambas-goa.html (accessed January 13, 2023).

103 Finbarr Barry Flood is currently preparing a monograph on all the Indian materials in and around Lalibela, including a detailed rationale for the reconstruction of the casket from which the panels were cut.

104 On Ethiopia and the Christian ecumene, see Bausi (2020), 217–51.

105 Enrico Cerulli has, for example, demonstrated that a mention of the Indian cult of Saint Thomas in a thirteenth-century Arabic history of the churches and monasteries of Egypt is likely to have been derived from an Ethiopian synaxarion or compilation of the biographies of saints and martyrs: Abu Salih, *Churches and Monasteries*, 292; Cerulli (1943–47), vol. 1, 174–79, esp. 175–80; Rouxpetel (2012), esp. 75–80. Unfortunately, Richard Pankhurst's suggestion that one of two figures seen riding an elephant painted in the interior of the church of Debra Selam Mikael in Tigray represents Saint Thomas in India cannot be sustained, since the "halo" apparently worn by the figure is in fact a product of the decomposition of the original paint of the hair: Pankhurst (1974), 248, fig. 1, where the image is misidentified as coming from the church of Yemrehanna Krestos in Lasta. On the possibility that this image reflects "knowledge of, or contacts with, South Asia," see Insoll (2021), 459.

106 For the suggestion that portable objects such as these Indian shields were the source of the (probably twelfth century) painted image of the elephant and riders on the wall of the church of Debra Selam Mikael in Tigray mentioned in n. 105 above, see Mercier and Lepage (2012), 317. See also Balicka-Witakowska (2009–10), 114.

107 Bosc-Tiessé (2002), 54–59; (2005), 101–5.

108 For the Egyptian theory see, among others, Doresse (1970), 42–43; Lepage (2002). On the purported Indian connection, see Jarzombek (2016).

109 Bosc-Tiessé et al. (2010), 45–51, fig. 1; Mercier and Lepage (2012), 107–10.

110 Finneran (2009); Fauvelle-Aymar et al. (2010); Bosc-Tiessé et al. (2014).

111 Flood (2009a), 65–75; Flood (2017).

112 Gervers (2017), 36–37.

113 Hunt (1984), 138–56; Asutay-Effenberger (2004); Johns (2016a). For the reception of the Palermo ceiling in terms of wonder (Gr. *thauma*), see Lavagnini (1990).

114 Helms (1994).

115 Walker (2012a), 171, also 165–67. See also Johns (2016b).

116 Grabar (1994), 115–29. In similar vein, see Hoffman (2001), 17–50.

117 Fauvelle (2017), 19. See also Wion (2020).

118 Balicka-Witakowska (2009–10), 121–24; Tesfaye et al. (2010), 264, fig. 4; Bittar (2012); Bosc-Tiessé (2020), 359.

119 *Nūr al-maʿārif*, 498; Vallet (2015), 211 and 450–72 for Rasulid trade with Ethiopia.

120 Al-ʿUmari, *Masālik al-abṣār*, 25. See also Vallet (2015), 412–13; Regourd and Hanley (2019), 489–90.

121 Mordini (1957a); (1957b), 75–79; (1960a). The same monastery preserved Kushan gold coins from India of the Axumite period, suggesting connections also hinted at by reported finds of Axumite or imitation Axumite coins in India: Mordini (1960b); Day (2011).

122 Lepage and Mercier (2005), 76; Balicka-Witakowska (2009–10), 111–12, fig. 2.

123 Finbarr Barry Flood will explore the Yemeni connection in a forthcoming article on the long-distance connections manifest in Zagwe architecture.

124 Mordini (1940).

125 Whelan (2006), 34.

126 Bosc-Tiessé (2011), 258–62. The nature of the inscription was first noted by Mercier and Lepage (2012), 120, fig. 5.53.

127 Smidt (2010), 179–91; (2011), 151–54.

128 See, for example, Bosc-Tiessé et al. (2010), 45–51, fig. 1; Mercier and Lepage (2012), 107–10. For the suggestion that the fragmentary inscription came from a mosque, see Muehlbauer (2021).

129 Although the formulation has attracted recent criticism for its

assumption of a secular–religious divide, on the utility of this term see Hodgson (1977), vol. 1, 57–60.

130 *History of the Patriarchs*, 350–51.

131 Al-Jazari, *Chronique de Damas*, 3. For another Syrian merchant operating between Ethiopia and Arabia in the early fourteenth century, see Rosenthal (1983).

132 Heldman (2007); Derat et al. (2020), 473–507.

133 Wiet (1955), 120–22; Loiseau (2019b), 650–53; Loiseau (2019c), 73–74.

134 Rosenthal (1983); Gori (2020), 150–51; al-Baghdadi, *A Physician on the Nile*, 1.4.64, 96–97.

135 For an excellent overview of the current state of research, see Chekroun and Hirsch (2020). Among the pioneering studies related to the material remains of the Muslim communities of medieval Ethiopia, see Tilahun (1990), 303–20; Fauvelle-Aymar, Bruxelles, et al. (2006), 1–11; Fauvelle-Aymar, Hirsch, et al. (2006). For a useful overview of recent research, see Fauvelle-Aymar et al. (2009–10).

136 Schneider (1967), 107–17; Gori (2007); Bauden (2011); Loiseau (2018a); (2018b); Loiseau et al. (2019); Derat (2020c); Loiseau (2020), 59–96; Loiseau et al. (2021).

137 Muehlbauer (2021).

138 Schneider (1969); (2005); Insoll et al. (2021); Insoll (2023).

139 Fauvelle-Aymar and Hirsch (2011), 41–42. The idea is currently being developed by François-Xavier Fauvelle. See also Gori (2006); Insoll et al. (2021). On these sultanates see Vallet (2015), 407–21; Chekroun and Hirsch (2020).

140 Margariti (2009); (2012), 215–16; Chekroun and Hirsch (2020).

141 Al-ʿUmari, *Masālik al-abṣār*, 25; Machado (2011). Finbarr Barry Flood is currently preparing a study of the Indian materials preserved in the churches of Lalibela and the surrounding areas and their implications for understanding transregional connections under the Zagwes; but see Gervers (2017), 44, figs. 27–28.

142 Al-Hakami, *Yaman* (Arabic), 58–59, (tr.) 79–80.

143 Regourd (2011), 343, fig. 24.4; Ibn ʿAbd al-Qadir, *Futūḥ al-Ḥabasha*, 62.

144 See n. 118 above.

145 On this, see Hawkes and Wynne-Jones (2015).

146 A suggestion made by Mercier and Lepage (2012), 317.

147 On Rasulid "regifting" of Mamluk glass, see Hardie (1998); Porter (1998), 91–95; Kenney (2021), 46–47; Smithsonian (online). In 970 CE, the Ziyadid ruler of Yemen gifted a zebra that had been sent to him from Ethiopia (whether as a diplomatic rarity is not clear) to the Buyid amir of Iraq, ʿIzz al-Dawla; Ibn al-Zubayr, *Book of Gifts and Rarities*, 103–4, no. 76.

148 See the essays in Kusimba, Zhu, and Kiura (2020).

149 Gervers (1990), 13–30; Wion (2020), 411.

150 See, e.g., Abraham (1988); Ali (2009); Chakravarti (2022).

151 Horton (2004); Hawkes and Wynne-Jones (2015); Thackston (1989), 300–303.

152 Moraes (1931), 398–99.

153 Vallet (2007); Lambourn (2008); Sadek (2019), 24.

154 See, for example, Monneret de Villard (1937–39); Pankhurst (1974), 205–311; Ranasinghe (2001), 204–38; Chojnacki (2003).

155 Bosworth (1984), 7; Flood (2009a), 21–26. For a general overview of the mercantile entanglements between western India and the western Indian Ocean, see Jain (1990), 71–90.

156 Horton (2004), 66–67, fig. 2; Hawkes and Wynne-Jones (2015).

157 El-Antony, Blid, and Butts (2016); Bausi (2020), 234–35. For later evidence for the presence of Ethiopians in the same monastery, see Bolman (2002), 189–90.

158 See, among others, Cerulli (1943–47); Meinardus (1965), esp. 116–19; Donzel (1980); O'Mahony (1996), 140–54; Kelly (2020b); Krebs (2021).

159 Loiseau (2019c); Jacob (1996).

160 In addition to the sources cited in n. 158 above, see, e.g., Beaujard (2005); Vernet (2015).

161 Reported by Abu al-Khayr al-Tinnati (d. 349 H/961 CE): Taylor (1999), 138. See also Nasir-i Khusraw, *Safarnāmah*, 63, 69, 85, 93, 103, 112.

162 Fakhr-i Mudabbir, *Adāb al-Ḥarb*, 390.

163 Perhaps not surprisingly, Ethiopians were active in the maritime ports of the Red Sea. Visiting the Red Sea port city of Aydhab (through which Indian products including pepper often passed) in 1183, for example, the Moroccan traveler Ibn Jubayr records that he lodged with one Munih, an Ethiopian who had several houses and small vessels (*jilab*s), which could be used to ferry pilgrims to the holy cities on the other side of the Red Sea: Ibn Jubayr, *The Travels*, 64.

164 Digby (2008), 149. On the modern neglect of African participation in the Indian Ocean world, albeit at a slightly later date, see De Silva (1999).

165 Goitein, *India Traders*, 321, 325, 535, 603–4; Margariti (2014), 51.

166 Strauch (2012), esp. 438–46.

167 Fleisher et al. (2015).

168 After Tesfaye (1987), 77–78. The inscription was partially photographed and transcribed by a priest. It is not included in the most comprehensive publication of inscriptions on altars and altar tables at Lalibela, some of which contain similar invocations to the Virgin: Bosc-Tiessé, (2010).

169 While the ceiling paintings are likely to be twelfth century, the wall paintings on the northern and eastern walls may be later in date: see n. 96 above. For the suggestion of a thirteenth-century date for the paintings in the church, see Gervers (2014), esp. 38–40.

170 Some of the iconography of the most richly painted ceiling, that above the western entrance to the church (which includes angels, saints, and scorpions), seems to anticipate a repertoire of amuletic or magical imagery found later on Ethiopian healing scrolls.

171 The evidence for this identification rests, among other things, on the manner in which the mariners in the ship are depicted. Finbarr Barry Flood is currently preparing a detailed analysis of this image and its implications for the history of Ethiopian involvement in the medieval Indian Ocean networks.

Chapter 6. Narrative and Wonder in the Indian Ocean

1 Translation by Ahmed Ali, from *Al-Qurʾān: A Contemporary Translation by Ahmed Ali*. Princeton, NJ: Princeton University Press, 2001 (rev. edn).

2 Lepage (1999), 951 n. 155; (2006), 162 n. 21

3 O'Kane (2012), 52.

4 Pomerantz (2018), 228–42.

5 Kilito (1983), 19; Barrucand (1992).

6 BnF, MS Arabe 5847, fol. 167b.

7 Grabar (2006a); Contadini (2017).

8 Ward (1985), 80.

9 In addition to the references below, see Lenssen, Rogers, and Shabout (2018), 150–51, 371, 448; al-Bahloly (2018); Flood (2018).

10 Grabar (2006b). For a recent sensitive reading of the relationship, see Roxburgh (2013).

11 Grabar (1984), 142; A. F. George (2011).

12 See, for example Grabar (1963a); Ettinghausen (1977), 123; Grabar (1984), 143. A good overview of the various opinions can be found in James (2013), 64–65, 133.

13 Kilito (1983), 19–94.

14 George (2012); Roxburgh (2013), 181–82.

15 BnF, MS Arabe 5847, fols. 117b–123a; al-Hariri, *Maqāmāt*, 324–33; al-Hariri, *Assemblies*, vol. 2, 93–101. A recent experimental translation attempts to capture some of the literary virtuosity of the text: al-Hariri, *Impostures*, 359–65.

16 The story cycle has four images that are clearly related to the text. In the manuscript it is, however, preceded by an enthronement scene (BnF, MS Arabe 5847, fol. 118a). Although this has sometimes been included among the cycle of images related to maqāma 39 (making it the only tale to be accompanied by five images), the relationship to maqāma 39 seems tenuous. For a convenient tabulation of the images in the manuscript against the text, see Roxburgh (2013), 185.

17 For an analytical overview, see O'Kane (2012).

18 Contadini (2017), 442.

19 Ettinghausen (1977), 109, 123; Grabar (1984), 143, Barrucand (1992), 5–6; Flood (2009a) 21; Margariti (2014), 44–45; Brac de la Perrière (2015).

20 Brac de la Perrière (2015), 159–60. See also Balafrej (2021), 1027–29.

21 See, for example, a copy of the *Maqāmāt* produced in Iraq in 619 H/1222 CE: BnF, MS Arabe 6094, fol. 68a.

22 Margariti (2014), 44–45.

23 Horton, Boivin and Crowther (2020), 399.

24 The best studies are those of Brac de la Perrière (2015), esp. 158–60, and Balafrej (2021).

25 See, e.g., Graves (2022), 102. In his history of Aleppo and its vicinity, Ibn Shaddad (d. 1285 CE) mentions the image of a black slave set within a domed pavilion. He reports that barren women sought to conceive by rubbing their private parts against the nose of the figure, a practice that suggests a relationship between stereotypical perceptions and the proliferation of such images: Ibn Shaddad, *Description d'Alep*, 125; Meri (2002), 209.

26 Balafrej (2021).

27 Canby et al. (2016), no. 42, 114; Johns and Grube (2005), 123, fig. 18.6; Patton (2019), 186–88, fig. 14.4. That the attention to skin color, facial hair, and dress reflects an interest in depicting cultural and ethnic (not necessarily racial) difference can hardly be doubted, for in the slightly later *Liber ad honorem Augusti* by Peter of Eboli, Greek, Latin, and Saracen scribes are labeled and distinguished by dress and facial hair: Peter of Eboli, *Liber ad honorem Augusti*, fol. 101r, 58–59. Paradoxically, at the opposite end of the contemporary Islamic world, in the Christian kingdoms of al-Andalus, Muslims were often depicted as dark-skinned or black by Christian illustrators. This may have formed part of a visual polemic, but perhaps also reflected the experience of West Africans serving in the armies of the Almohad and Almoravid caliphates of the Maghreb: Patton (2012), 115–20; Heng (2018), 181–256, esp. 187–92.

28 Hillenbrand (1990), 153, fig. 4; Mercier and Lepage (2012), 202; Suleman (2022).

29 Atil (1973), no. 39.

30 Ward (1985), 80.

31 Al-Jazari, *Al-Jamiʿ bayn al-ʿilm*, 127; al-Jazari, *Book of Knowledge*, 62.

32 The earliest extant copy of al-Jazari's manuscript dates to 603 H/1206 CE and is preserved in Istanbul (Topkapı Palace Museum, Hazine 414): Ward (1985), 74. For images of the elephant clock in this earlier manuscript, see Roxburgh (2022), 49, figs. 2.14 and 2.16.

33 Nasir-i Khusraw, *Safarnāmah*, 103; Abu Zayd al-Sirafi, *Accounts of China and India*, 61, 65, 131, passages 1.10.4, 1.10.10, and 2.18.1 respectively.

34 The use of the same type for ship's captain and ruler might call into question a suggestion that the ruler is depicted in the guise of a *sadhu*, an Indian holy man, who would not normally be expected to be ruling over an island kingdom: Guthrie (1995), 162.

35 Grabar (2006a), 179.

36 Abu Zayd al-Sirafi, *Accounts of China and India*, 31–33, passages 1.4.1 and 1.4.2.

37 Muhammad (1985), 47–74.

38 Hunwick (2005), 103–36; Goldenberg (2003), 23–47. For this idea in medieval Iraq, see, among others, Hunayn ibn Ishaq, *Questions on Medicine*, 391–94.

39 Lewis (1990), esp. 43–53; Brown (2019), 119–24.

40 Rotter (1967); Enderwitz (1979).

41 Sanagustin (2010), 233–34. For Abyssinian slaves in Abbasid Iraq, see Renault (1989), 47, 49, 56, 59, 68, 77.

42 Muhammad (1985), 51–56; Donzel (1986), 243–56; (1989), 113–20. For later works in the same vein, see Bahl (2017), 118–42; Cecere (2019), 117–21.

43 See ch. 5 nn. 154–56 and 161–66 above.

44 Bacharach (1981), 471–95; Zouache (2019).

45 Nasir-i Khusraw, *Safarnāmah*, 111–12. Studies of African slaves in the central Islamic lands and India tend to focus on the early modern period, but see Abir (1985); Campbell (2008); Médard et al. (2013), esp. the essay by Marie-Laure Derat (121–48); Bouanga (2017); Bonacci and Meckelburg (2017); Moorthy Kloss (2021), 8–9.

46 Perry (2014), 39–40, 64, 79, 133, 169–70, 175, 225–30.

47 Al-Jawbari, *Book of Charlatans*, 101–3. On the presence of Indians, although not necessarily slaves, in Anatolia during this period, see Flood (2019b), 16 and Jackson (2020), 57 and n. 95.

48 Herzfeld, *MCIA*, 255–60.

49 Loiseau (2019c), 72, 61–84.

50 The manner of depiction is very similar to that of a small figure engaged in the heavy labor of trampling grapes for wine in a tavern in another image accompanying maqāma 12 in the same manuscript: BnF, MS Arabe 5847, fol. 33r.

51 Ghosh (1993).

52 See ch. 5 n. 165 above.

53 Vallet (2015), 414, 531, 587–88.

54 Horton (2004), 66–67, fig. 2.

55 Ibid., 77; Rougeulle (2015), 168–74.

56 See ch. 5 n. 165 above.

57 See n. 12 above.

58 Grabar (1963b), 104, fig. 29; James (2013), 63, figs. 2.27 and 5.9. For all images of this scene in extant illustrated copies, see Grabar (1984), 87–89 and the accompanying images on microfiche.

59 See n. 12 above.

60 Hallett (2005), 21–39; Priestman (2011); Stargardt (2014).

61 Nanji (2011), 38–42, pl. 8; Bhandare (2021), 257; Guy (2022). An Abbasid luster bowl of very similar type to that shown here in figs. 192 and 193 is preserved in the collections of the Museum für Kunst und Gewerbe in Hamburg.

62 Hallett (2010); Nanji (2016); Shen (2017); Nanji (2019).

63 Flood (2009a), 21–24.

64 Al-Sirafi, *Akhbār as-sīn wa l-hind*, esp. xxxi–xxxiii; al-Sirafi, *Accounts of China and India*.

65 Buzurg ibn Shahriyar, *Kitāb ʿajāʾib al-Hind*; Buzurg ibn Shahriyar, *Les Merveilles de l'Inde*; Buzurg ibn Shahriyar, *ʿAjāʾib al-Hind*. For the most recent study of the text and its sources, see Shafiq (2013). Another variant of what appears to be the same text is preserved in the writings of the fourteenth-century author Ibn Fadl al-ʿUmari: al-Sirafi, *Al-Saḥīḥ min akhbār al-biḥār wa-ʿajāʾibihā*. For a discussion of the relationship between both versions and their authors, see Ducène (2015).

66 Buzurg ibn Shahriyar, *Kitāb ʿajāʾib al-Hind*, 21.

67 Ibid., 98.

68 For these later texts see, e.g., Berlekamp (2011); Zadeh (2010).

69 Al-Sirafi, *Accounts of China and India*, 7.

70 Flood (2009a), 50.

71 See ch. 5 nn. 130–34 above.

72 On the ambiguities of this term, see Vallet (2015), 589–600.

73 Buzurg ibn Shahriyar, *Kitāb ʿajāʾib al-Hind*, 2, 5, 12, 14–15, 36, 98.

74 Al-Masʿudi, *Prairies d'or*, vol. 1, 251–52, 321, 387. For a list of sources mentioned in the *Kitāb ʿAjāʾib al-Hind*, see Shafiq (2013), 64–67.

75 Buzurg ibn Shahriyar, *Kitāb ʿajāʾib al-Hind*, 12, 14, 29, 36, 38, 65–66.

76 Roxburgh (2013), 206.

77 Buzurg ibn Shahriyar, *Kitāb ʿajāʾib al-Hind*, 70–77.

78 Hees (2005), 106–7.

79 Buzurg ibn Shahriyar, *Kitāb ʿajāʾib al-Hind*, ix; al-Sirafi, *Accounts of China and India*, 147.

80 In a case of the wheel coming full circle, the image of the enchanted isle from al-Wasiti's manuscript (here fig. 182) was chosen as the frontispiece to Pieter van der Lith and L. Marcel Devic's 1883 edition and translation of the *Kitāb ʿajāʾib al-Hind*.

81 BnF, MS Arabe 5847, fols. 103b–107b; al-Hariri, *Maqāmāt*, 275–87; al-Hariri, *Assemblies*, vol. 2, 62–71.

82 See ch. 5 nn. 38–39 above. For a good discussion of the social context of this image, see Guthrie (1995), 100–107.

83 Balafrej (2021), 1033.

84 Hillenbrand (2017), 221 n. 35.

85 O'Kane (2012), 44.

86 Saint Petersburg, Oriental Institute, Academy of Sciences C-23, fol. 116v; James (2013), fig. 2.24; Balafrej (2021), 1023–24, fig. 4. For a comprehensive survey of the way this scene was illustrated in extant manuscripts, accompanied by microfiche images, see Grabar (1984), 83–85.

87 Buzurg ibn Shahriyar, *Kitāb ʿajāʾib al-Hind*, 51–60.

88 Subrahmanyam (2019), esp. 818–19, 827–28. The question of whether the later presence of prominent Ethiopian (Habshi) slaves in India represents an intensification of an earlier trade occasioned by the rise of the Deccani sultanates remains to be investigated. Ethiopian slave-girls are among the gifts listed as appropriate to foreign rulers in the *Ādāb al-Ḥarb*, an early thirteenth-century north Indian Persian text on diplomacy and warfare, while Ethiopian mercenaries or slaves were in the employ of some of the merchants of western India around the same period: Nizami (2002), 344; Ibn Battuta, *The Travels*, vol. 4, 800. For an overview of the history of Ethiopians, including slaves, in India see Basu (1995); Pankhurst (2003); Alpers (2004).

89 Qurʾan, sura 12.

90 Cecere (2019), 115 and n. 128, where this tale from the *Kitāb ʿajāʾib al-Hind* is referenced.

91 Al-Sirafi, *Accounts of China and India*, 31–33, passages 1.4.1, 1.4.2.

92 See ch. 5 nn. 150–52 above.

93 Muhammad (1985), 49.

94 For the history of this idea, see Schneider (2004); (2015). For the same idea in an Egyptian Arabic text written around 1200 CE, see Abu Salih, *Churches and Monasteries*, 285, 296. In addition, medieval Arab writers often make explicit comparisons between the elites of medieval Ethiopia and the court cultures of India: Rosenthal (1983), 497–98.

95 George (2012), 21, pls. 7 and 8; Grabar (1984), 27, 147. Among the images in al-Wasiti's manuscript displaying this feature are those on fol. 27a (maqāma 10, of Rahba) and fol. 35a (maqāma 13, of Baghdad).

96 Touati (2010), 227–32.

97 Ali (2016), 471, 484, 486.

98 Tabbaa (1985). See also James (2013), 33.

99 In similar vein, see Kinoshita (2008), 374–76.

100 See ch. 5 n. 133 above.

101 Margariti (2012), 199.

102 Buzurg ibn Shahriyar, *Kitāb ʿajāʾib al-Hind*, 12–14.

103 Baer (1965), 33, 48, 80.

104 See n. 12 above.

105 See, for example, a silver-inlaid brass pen box from Herat dated 1210–11 CE: Atil, Chase, and Jett (1985), 102–6.

106 Roxburgh (2013), 186.

107 James (2013), 63–64. O'Kane (2012), 48–49.

108 A peculiarity noted by Guthrie (1995), 157–58; O'Kane (2012), 44 n. 22.

109 My discussion is indebted to Simpson (1981), esp. 20.

110 See, among many others, Watson (2020), 274–75, no. 135.

111 Scerrato (1980). For their earlier associations, see Reiner (1987), 28–29.

112 Giunta (2018), 44–45, 48–61, nos. 4 and 5.

113 Kilito (1983), 149–50.

114 Al-Hamadhani, *Maqāmāt*, 40–41; al-Hamadhani, *The Máqámát*, 98–99.

115 Guo (2004), 98–99.

116 Sanami, *Niṣāb al-iḥtisāb*, 230; Sanami, *Theory and the Practice*, 70; al-Shayzari, *Kitāb Nihāyat al-rutba fī ṭalab al-ḥisba*, 174–75.

117 Coulon (2017), 104–12; Brac de la Perrière (2015), 21.

118 Another example of such a maritime amulet can be found in Bohak and Hoog (2015), no. 217. For earlier examples, see Naveh and Shaked (1993), 174–81, no. 16. For similar medieval Arabic texts, see Porter, Saif, and Savage-Smith (2017), 528.

119 Giunta (2018), 215–16, dIX, dX.

120 Shafiq (2013), 87

121 Cecere (2019), 113.

122 Schöller and Diem (2004), 88, 89, 94–98; Agius (2014), 238–41; Raggetti (2018), 10–11, no. 1.13; Cecere (2019), 113. For a similar use of the Syrian eulogiae in the form of clay tokens from sanctified Christian sites, discussed here in chapter 1 (see figs. 17, 18 and 32), see Vikan (1984), 69.

123 Pormann (2005), 222–25; Bosworth (1976), vol. 1, 86, 88; vol. 2, 199, 243; al-Jawbari, *Book of Charlatans*, 204–9.

124 Giladi (2014), 138–43.

125 Giunta (2018), 264. For an alleged depiction of the writing of an amulet (*nushreh*) using saffron in a sixteenth-century Persian manuscript from Mandu in central India, the *Miftāḥ al-Fuzalāʾ* (BL, MS Or. 3299, fol. 286a), see Meredith-Owens (1973), 20–21, pl. XIII.

126 Gontero-Lauze (2010), 198; Beckman (2017), 71.

127 Dasen (2018).

128 Al-Tifashi, *Arab Roots of Gemology*, 106. Among many other references to applying or tying efficacious stones to ailing parts of the body in medieval Arabic texts, see Ibn al-Zubayr, *Book of Gifts and Rarities*, 115, nos. 100–101.

129 Gontero-Lauze (2010), 278.

130 In addition to the sources cited in ch. 4 n. 67, above, see Porter, Saif, and Savage-Smith (2017), 538–39; Coulon (2021), 348.

131 Rapaport and Savage-Smith (2014), 504.

132 Buquet (2016).

133 See, for example, Raggetti (2018), 208–9, no. 21.13. For a discussion of the larger social context, see Guthrie (1995), 156–64; Giladi (2014), 138–43. On the use of incense in magic rituals, see Coulon (2016).

134 Rapaport and Savage-Smith (2014), 504; Fiori (2017), 224–25.

135 Al-Ashtarkuni, *Al-Maqāmāt al-Luzūmīyah*, 266.

136 Saliba (1992), 48, 57; Giunta (2018), 250–51, 268–69; Hallum (2021), 97–102.

137 Wink (1996), 65.

138 Beaujard (2019), 67–71, 299–316.

139 Stern (1967). On the Karimi, see Wiet (1955); Ashtor (1956), 45–56; Labib (1970); Vallet (2015), 471–539.

140 Chakravarti (2000); Patel (2006); Chakravarti (2021), 220–42.

141 Whelan (2006), 32, 34. For contemporary examples of reliefs featuring harpies and sphinxes from northern Iraq, see Gierlichs (1996), pls. 25.3–5, 36.2, 45.1, 51.1–2, and 62.3

142 Jail and Bernus-Taylor (2001), 138.

143 Daneshvari (2006), 181.

144 For this and another example preserved in the Louvre, see Makariou (2001), 182–83, no. 182. A third example showing a harpy (rather than a sphinx) wearing similar headgear is preserved in the British Museum, inv. no. 1923.2–17.1.

145 Rogers (1971); Allen (1986); Raby (2004); Gonnella (2010), esp. 113–14; Heidemann (2013), 9–22; D'Ottone Rambach et al. (2020), 143–76.

146 Bunnens (2015), 107–28. See in particular a Neo-Assyrian relief of the storm god reinscribed in Greek in the first century BCE/CE: 124, fig. 9.16.

147 Ibn Shihna, *Perles choisies*, 135–36; Ibn Shaddad, *Description d'Alep*, 122–28; Nasir-i Khusraw, *Safarnāmah*, 14; Flood (2006); Gonnella (2010).

148 Al-Qazwini, *Athār al-bilād,* 123–24; al-Muqaddasi, *Kitāb aḥsan at-taqāsīm*, 186; al-Muqaddasi, *Meilleure repartition*, 231–32; Meri (2001), 75; (2002), 209; Flood (2006), 150–51.

149 Raggetti (2019), 167–68, 176–78. See ch. 4 n. 67 above.

150 Ibn al-Faqih, *Kitāb al-Buldān*, 112; Ibn al-Faqih, *Abrégé du livre des pays*, 136.

151 Al-Muqaddasi, *Kitāb aḥsan at-taqāsīm*, 186; al-Muqaddasi, *Meilleure repartition*, 231–32; Meri (2002), 19–20. On the use of this term in relation to magic and medical formulae, see Álvarez Millán (2010), esp. 197, 200–201.

152 Gane (2012), 187–96. The image of the scorpion-man appears on late antique amulet-seals from the eastern Mediterranean: Michel (2001), 217, no. 345. See also Hartner (1938), 148–49, fig. 38.

153 Gonnella, Khayyata, and Kohlmeyer (2005), 97, fig. 134; Gonnella (2010), 115–16.

154 On the general issue of the persistence of Mesopotamian elements into the Islamic period, see Dalley (1998), especially 163–81. See also Crone and Silverstein (2010), esp. 431–32, 446–50; Stewart (2012), esp. 347. See also nn. 162–63 below.

155 Gonnella (2010), 105–7, fig. 2.

156 For such normative notions of the talisman in the medieval Islamic world and Byzantium, see Berlekamp (2011); Griebeler (2020).

157 Ibn al-Shihna, *Perles choisies,* 136–37.

158 Ussishkin (1970), 124–28.

159 Abd El-Kader (1949).

160 Spengler and Sayles (1992); Whelan (2006), esp. 17–18, 29.

161 Reitlinger (1951), 13–14.

162 Berlekamp (2011), 75.

163 A. R. George (2011), 19–20, no. 15, pl. XI.

164 Didi-Huberman (2003), 38 (original emphasis).

165 Aruz (2014), nos. 2 and 37, 28–29, 98–99, 112–13.

166 Wengrow (2014), esp. 62–65, 91–92, 103.

Conclusion: Global, Local, and Temporal

1 Clifford (1988), 344; (1997); Flood (2009a), 1–5.

2 After Kirwin Shaffer, cited in De Vito and Gerritsen (2018), 7.

3 For a similar point, see Guidetti and Meinecke (2020), 18–19; Smith (2019), 5–24.

4 Latour (1993), 117–18. See also the comments of Cooper (2001), 191–92.

5 Cooper (2001), 208–10.

6 Shepard (2018), 121.

7 Smith (2019), 5–7.

8 Trouillot (2002), 15.

9 Shepard (2018), 156.

10 On this question, see Douki and Minard (2007). On the distinction between vertically and horizontally oriented art history, see Piotrowski (2008); Jakubowska and Radomska (2022).

11 Eastmond (2008).

12 Hatke (2020); Emberling and Williams (2020).

13 Wyżgoł (2017). See, ch. 1 n. 37 above.

14 Mukherji (2014), 154.

15 See the suggestive remarks of Sood (2011), 125.

16 Farago (2017), 116. See also Cheng (2018), 14–15.

17 See also Guidetti and Meinecke (2020), 8–13, although one might take issue with the emphasis on the notions of appropriation central to their approach.

18 Loos (1998), 168.

19 In addition to the works already cited, see Gell (1998); Bennett (2010); Hodder (2012); Bredekamp (2018); Jones and Boivin (2010), 333–51.

20 Roberts (2017), 65.

21 See, among others, Hazard (2013); Desmond and Guynn (2020).

22 See, for example, Heng (2014), 239–42.

23 Roberts (2017), 67.

24 Didi-Huberman (2016), 33.

25 Didi-Huberman (2003), 42. See also Betancourt (2020), esp. 216.

26 For notable exceptions, see Wood (2008); Nagel and Wood (2010).

27 For a thoughtful critique see Hirschler and Bowen Savant (2014).

28 See Introduction, nn. 87–88.

29 Warburg (1999), 585–86.

Bibliography

Manuscript Sources

Cambridge, Cambridge University Library
 T-S K1.19
Florence, Biblioteca Medicea Laurenziana
 Orientali 387
 Plutei 1.56
Istanbul, Topkapı Palace Museum
 TSM A. 3472
London, British Library [BL]
 Egerton MS 747
 MS Or. 3299
Milan, Biblioteca Ambrosiana
 MS 140 inf. S. P. 67
Münster, Bistumsarchiv
 MS DA 6 A.33
New York, Pierpont Morgan Library
 MS M.828
 MS M.873
Oxford, Bodleian Library
 MS Marsh 663
Paris, Bibliothèque nationale de France [BnF]
 MS Arabe 2674
 MS Arabe 2964
 MS Arabe 5847
 MS Arabe 6094
 MS Éthiopien 32
 MS Grec 2327
 MS Persan 174
 Supplément Persan 332
Saint Petersburg, Oriental Institute, Academy of Sciences
 MS C-23
Vatican City, Biblioteca Apostolica Vaticana [BAV]
 MS Barb.lat.171

Primary Sources

Abu Salih, *Churches and Monasteries*
The Churches and Monasteries of Egypt and Some Neighbouring Countries, attributed to Abû Şâliḥ, the Armenian, trans. by B.T.A. Evetts, with added notes by Alfred J. Butler. Oxford: Clarendon Press, 1895.

Adamnan, *De locis sanctis*
Adamnan. *Adamnan's "De locis sanctis,"* ed. by Denis Meehan (Scriptores Latini Hiberniae 3). Dublin: Dublin Institute for Advanced Studies, 1958.

al-Ashtarkuni, *Al-Maqāmāt al-Luzūmīyah*
Muhammad ibn Yusuf ibn al-Ashtarkuni. *Al-Maqāmāt al-Luzūmīyah*, trans. by James T. Monroe (Studies in Arabic Literature 22). Leiden: Brill, 2002.

Athanasius of Alexandria, *Life of Antony*
Athanasius of Alexandria. "Life of Antony," trans. by H. Ellershaw, in *A Select Library of the Christian Church: Nicene and Post-Nicene Fathers*, ed. by Philip Schaff and Henry Wace, series 2, vol. 4: *Select Writings and Letters of Athanasius, Bishop of Alexandria*,

pp. 195–221. New York: Christian Literature Publishing Company, 1924.

Augustine, *Enchiridion*
Augustinus hipponensis. *Enchiridion ad Laurentium, seu de fide, spe et caritate*, ed. by E. Evans, in Corpus Christianorum Series Latina (CCSL), vol. 46. Turnhout: Brepols, 1969.

al-Baghdadi, *A Physician on the Nile*
ʿAbd al-Laṭif al-Baghdadi. *A Physician on the Nile: A Description of Egypt and Journal of the Famine Years*, trans. by Tim Mackintosh-Smith. New York: New York University Press, 2021.

Berengaudus, *Expositio*
Berengaudus of Ferrières. *Expositio super septem visiones libri Apocalypsis*. Patrologia Latina, ed. by Jacques-Paul Migne, vol. 17. Paris, 1864.

Book of the Saints of the Ethiopian Church
The Book of the Saints of the Ethiopian Church: A Translation of the Ethiopic Synaxarium "Maṣḥafa Sĕnkĕsâr," trans. by E. A. Wallis Budge, 4 vols. Cambridge: Cambridge University Press, 1928.

Brethren of Purity, *On Magic*
Iḥwān aṣ-Ṣafāʾ. *On Magic, 1: An Arabic Critical Edition and English Translation of Epistle 52a*, ed. and trans. by Godefroid de Callatay and Bruno Haflants. Oxford: Oxford University Press in association with The Institute of Ismaili Studies, 2011.

al-Buni, *Shams al-maʿārif al-kubrā*
Ahmad al-Buni. *Shams al-maʿārif al-kubrā*. Beirut: Maktabat al-'Ilmiya al-Falkiya, n.d.

Buzurg ibn Shahriyar, *ʿAjāʾib al-Hind*
Buzurg ibn Shahriyar. *ʿAjāʾib al-Hind: Barruhu wa-baḥruhu wa-jazāʾiruh*, ed. by Muhammad Saʿid Turayhi. Beirut: Dār al-Qāriʾ, 1987.

Buzurg ibn Shahriyar, *Kitāb ʿajāʾib al-Hind*
Buzurg ibn Shahriyar. *Kitāb ʿajāʾib al-Hind/Livre des merveilles de l'Inde*, ed. by P. A. van der Lith, trans. by L. Marcel Devic. Leiden: Brill, 1993 (repr.; orig. Leiden: Brill, 1883–86).

Buzurg ibn Shahriyar, *Les Merveilles de l'Inde*
Buzurg ibn Shahriyar. "Les Merveilles de l'Inde," trans. by Jean auvaget, in *Mémorial Jean Sauvaget*, vol. 1, pp. 190–312. Damascus: Institut français de Damas, 1954.

Cantimpre, *De natura rerum*
Thomas Cantimpre. *Liber de natura rerum / Thomas Cantimpratensis*, ed. by Helmut Boese. Berlin: De Gruyter, 1973.

Cathay and the Way Thither
Cathay and the Way Thither: Being a Collection of Medieval Notices of China, ed. and trans. by Henry Yule, vol. 3. London: Hakluyt Society, 1913–16.

Compendium salernitanum
Matthaeus Platearius. *Compendium salernitanum*, made in Italy, possibly Venice, 1350–75 (New York, Pierpont Morgan Library, MS M.873).

Corippus, *In laudem Iustini*
Flavius Cresconius Corippus. *In laudem Iustini Augusti minoris, libri III*, ed. and trans. by Averil Cameron. London: Athlone Press, 1976.

Cosmas Indicopleustes, *Christliche Topographie*
Cosmas Indicopleustes. *Kosmas Indikopleustes: Christliche Topographie; Textkritische Analysen; Übersetzung, Kommentar*, ed. by Horst Schneider. Turnhout: Brepols, 2011.

al-Damiri, *Kitāb Ḥayāt al-ḥayawān*
Muhammad ibn Musa al-Damiri. *Kitāb Ḥayāt al-ḥayawān*, vols. 7–12 (vols 7–8 repr. of the 1284/1867 Bulaq edition; vols 9–12 repr. of the translation by A.S.G. Jayakar, London/Bombay, 1906–08). Frankfurt a. M.: Institute for the History of Arabic-Islamic Science at the Johann Wolfgang Goethe University, 2001.

Dioskurides, *De materia medica*

Pedanius Dioskurides [Dioscorides]. "De materia medica," in *Des Pedanios Dioskurides aus Anazarbos Arzneimittellehre, in fünf Büchern*, trans. by Julius Berendes, pp. 89–90. Stuttgart: Enke, 1902.

Egeria, *Itinerarium*

Itinerarium Egeriae (Peregrinatio Aetheriae), 5th edn, ed. by Otto Prinz (Sammlung vulgärlateinischer Texte, 1). Heidelberg: Winter, 1960.

Fakhr-i Mudabbir, *Adāb al-Ḥarb*

Muhammad b. Mansur Fakhr-i Mudabbir. *Adāb al-Ḥarb waʾl-Shujāʿa*, ed. by Ahmad Suhayli Khwansari. Tehran: Eqbal, 1967.

Ficino, *De vita libri tres*

Marsilio Ficino. *Three Books on Life (De vita libri tres)*, ed. and trans. by Carol V. Kaske and John R. Clark (Medieval and Renaissance Texts and Studies 57; Renaissance Text Series 11). Tempe, AZ: Arizona Center for Medieval and Early Renaissance Studies/ Renaissance Society of America, 2002.

Gandzakets'i, *History of the Armenians*

Kirakos Gandzakets'i. *History of the Armenians*, trans. by Robert Bedrosian. New York: n.p., 1986.

Germanos, *Ecclesiastical History*

Germanos I. "Ecclesiastical History and Mystical Contemplation," in *On the Divine Liturgy: Saint Germanos of Constantinople*, ed. and trans. by Paul Meyendorff, pp. 78–81. Crestwood, NY: St. Vladimir's Seminary Press, 1984.

Goitein, *India Traders*

Goitein, Shelomoh Dov, and Mordechai Akiva Friedman, trans. and eds. *India Traders of the Middle Ages: Documents from the Cairo Geniza* (Études sur le judaïsme médiéval 33). Leiden: Brill, 2008.

Greek Magical Papyri

The Greek Magical Papyri in Translation, including the Demotic Spells, ed. by Hans Dieter Betz. Chicago: University of Chicago Press, 1992.

Gregory, *Miracles*

Gregory of Tours. *The Miracles of Bishop Martin [De virtutibus sancti Martini episcopi]*, in Gregory of Tours, *Lives and Miracles*, ed. and trans. by Giselle de Nie (Dumbarton Oaks Medieval Library 39), pp. 421–856. Cambridge, MA: Harvard University Press, 2015.

al-Hakami, *Yaman*

ʿUmara Ibn-ʿAli al-Yamani, et al. *Yaman: Its Early Mediaeval History*, ed. and trans. by Henry Cassels Kay. London: Edward Arnold, 1892.

Halleux and Schamp, *Lapidaires*

Halleux, Robert, and Jacques Schamp, trans. and eds. *Les Lapidaires grecs*. Paris: Société d'Édition "Les Belles Lettres," 1985.

al-Hamadhani, *Maqāmāt*

Badiʿ al-Zaman al-Hamadhani. *Maqāmāt*. Istanbul, 1298/1881.

al-Hamadhani, *The Maqámát*

Badiʿ al-Zaman al-Hamadhani. *The Maqámát of Badiʿ al-Zamán al-Hamadhání*, trans. by W. J. Prendergast. London: Luzac, 1915.

al-Harawi, *A Lonely Wayfarer's Guide*

Ali b. Abi Bakr al-Harawi. *A Lonely Wayfarer's Guide to Pilgrimage: ʿAlī ibn Abī Bakr al-Harawī's "Kitāb al-Ishārāt ilā Maʿrifat al-Ziyārāt,"* ed. and trans. by Josef W. Meri. Princeton, NJ: Darwin Press, 2004.

al-Hariri, *Assemblies*

Abu Muhammad al-Qasim ibn ʿAli al-Hariri. *The Assemblies of al-Harîrî*, 2 vols, trans. by Francis J. Steingass (Oriental Translation Fund New Series 3). London: The Royal Asiatic Society, 1898.

al-Ḥariri, *Impostures*

Abu Muhammad al-Qasim ibn ʿAli al-Hariri. *Impostures*, trans. by Michael Cooperson. New York: New York University Press, 2020.

al-Hariri, *Maqāmāt*

Abu Muhammad al-Qasim ibn ʿAli al-Ḥariri. *The Assemblies of Harîrî: Student's Edition of the Arabic Text*, ed. and trans. by Francis J. Steingass. London: Sampson Low, Marston & Co., 1897.

Heraclius, *Von den Farben*

Heraclius. *Von den Farben und Künsten der Römer*, trans. by Albert Ilg (Quellenschriften für Kunstgeschichte und Kunsttechnik des Mittelalters und der Renaissance 4). Osnabrück: Zeller, 1970 (repr.; orig. Vienna: Wilhelm Braumuller, 1873).

Herzfeld, *MCIA*

Ernst Herzfeld. *Matériaux pour un Corpus Inscriptionum Arabicarum, deuxième partie: Syrie du Nord; Inscriptions et monuments d'Alep*, vol. 1. Cairo: Institut français d'archéologie orientale du Caire, 1956.

Hildebert, *Sermones*

Hildebert of Tours. "Ven. Hildeberti Sermones," in *Venerabilis Hildeberti [. . .] Opera omnia*, ed. by J.-J. Bourassé, = Patrologia Latina, ed. by Jacques-Paul Migne, vol. 171, pp. 339–964. Paris, 1854.

Historia compostellana

Historia compostellana, ed. by Emma Falque Rey. Corpus Christianorum Continuatio Medieavalis (CCCM), vol. 70 Turnhout: Brepols, 1988.

History of the Patriarchs

History of the Patriarchs of the Coptic Church, ed. by Aziz Suryal Atiya, Yassa ʿAbd al-Masih, and O.H.E Khs-Burmester, vol. 2, part 3: "Christodoulus-Michael (AD 1046–1102)." Paris: Firmin-Didot, 1959.

Hunayn ibn Ishaq, *Questions on Medicine*

Hunayn ibn Ishaq Abu Zayd al-ʿIbadi. *Hunain Ibn Ishaq's "Questions on Medicine for Students": Transcription and Translation of the Oldest Extant Syriac Version (Vat. Syr. 192)*, ed. and trans. by E. Jan Wilson and Samuel Dinkha (Studi e testi 459). Vatican City: Biblioteca Apostolica Vaticana, 2010.

Ibn ʿAbd al-Qadir, *Futūḥ al-Ḥabasha*

Shihab ad-Din Ahmad ibn ʿAbd al-Qadir. *Futūḥ al-Ḥabasha (The Conquest of Abyssinia)*, [16th century], trans. by Paul Lester Stenhouse. Hollywood, CA: Tsehai Publishers, 2003.

Ibn Battuta, *The Travels*

Shams al-Din Abi ʿAbdallah Muhammad b. ʿAbdallah al-Lawati al-Tanji ibn Battuta. *The Travels of Ibn Baṭṭūṭa, AD 1325–1354*, ed. and trans. by H.A.R. Gibb, 4 vols. London: Routledge, 1958–71.

Ibn al-Faqih, *Abrégé du livre des pays*

Ahmad ibn Muhammad ibn al-Faqih al-Hamadani. *Abrégé du livre des pays (Mukhtasar kitāb al-buldān)*, trans. by Henri Massé. Damascus: Institut français de Damas, 1973.

Ibn al-Faqih, *Kitāb al-Buldān*

Ahmad ibn Muhammad ibn al-Faqih al-Hamadani. *Kitāb al-Buldān*, ed. by Michael J. de Goeje (Bibliotheca Geographorum Arabicorum 5). Leiden, 1885.

Ibn al-Hajj, *Al-Madkhal*

Muhammad ibn Muhammad, Ibn al-Hajj. *Al-Madkhal*, 4 vols. Cairo: Maṭbaʿat Muṣṭafā al-Bābī al-Ḥalabī, 1960.

Ibn al-Husain, *Kitāb al-bayzara*

Abu ʿAbdallah al-Hasan b. al-Husain. *Le Traité de l'art de volerie (Kitāb al-bayzara) rédigé vers 385/995 par le Grand-Fauconnier du calife fāṭimide al-ʿAzīz bi-llāh*, ed. and trans. by François Viré. Leiden: Brill, 1967.

Ibn Jubayr, *The Travels*

Ibn Jubayr. *The Travels of Ibn Jubayr: Being the Chronicle of a Mediaeval Spanish Moor concerning His Journey to the Egypt of Saladin, the Holy Cities of Arabia, Baghdad the City of Caliphs, the Latin Kingdom of Jerusalem, and the Norman Kingdom of Sicily*, trans. by R.J.C. Broadhurst. London: Jonathan Cape, 1952.

Ibn Khaldun, *Muqaddimah*

Abu Zayd ʿAbd al-Rahman ibn Muhammad ibn Khaldun. *The Muqaddimah: An Introduction to History*, trans. by Franz Rosenthal, 3 vols. (Bollingen Series 43). Princeton, NJ: Princeton University Press, 1967.

Ibn Khurdadhbih, *Kitāb al-masālik wa'l-mamālik*

Ibn Khurdādhbih. *Kitāb al-masālik wa'l-mamālik (Liber viarum et regnorum)*, ed. by Michael Jan de Goeje. Leiden: Brill, 1889.

Ibn Qayyim al-Jawziyya, *Medicine of the Prophet*

Ibn Qayyim al-Jawziyya. *Medicine of the Prophet*, trans. by Penelope Johnstone. Cambridge: Islamic Texts Society, 1998.

Ibn Shaddad, *Description d'Alep*

Muhammad ibn Ibrahim ibn-Shaddad. *La Description d'Alep d'Ibn Šhaddād: Édition critique d'al-A'lāq al-Ḥaṭīra (Tome 1—Section 1)*, ed. by Dominique Sourdel. Damascus: Institut français de Damas, 1953.

Ibn al-Shihna, *Perles choisies*

Muḥibb al-Dīn Muḥammad ibn Muḥammad Ibn al-Shiḥnah. *"Les Perles choisies" d'Ibn ach-Chihna: Matériaux pour servir à l'histoire de la ville d'Alep, tome 1*, trans. by Jean Sauvaget (Mémoires de l'Institut français de Damas). Beirut: Institut français de Damas, 1933.

Ibn Sina, *Life of Ibn Sina*

Abu Ali al-Husain ibn Abd Allah ibn Sina. *The Life of Ibn Sina: A Critical Edition and Annotated Translation*, ed. and trans. by William E. Gohlman. Albany, NY: SUNY Press, 1974.

Ibn Wahshiyya, *Ancient Alphabets*

Ahmad ibn Ali Ibn Wahshiyya. *Ancient Alphabets and Hieroglyphic Characters Explained; With an Account of the Egyptian Priests, Their Classes, Initiation, and Sacrifices*, trans. by Joseph Hammer [Joseph von Hammer-Purgstall]. London, 1806.

Ibn Wahshiyya, *Book on Poisons*

Martin Levey. *Medieval Arabic Toxicology: The "Book on Poisons" of ibn Waḥshīya and Its Relation to Early Indian and Greek Texts*, = *Transactions of the American Philosophical Society* n.s. 56, part 7. Philadelphia: American Philosophical Society, 1966.

Ibn al-Zubayr, *Book of Gifts and Rarities*

Aḥmad ibn al-Rashid Ibn al-Zubayr. *Book of Gifts and Rarities (Kitāb al-Hadāyā wa al-Tuḥaf)*, ed. and trans. by Ghada Hijjawi Qaddumi (Harvard Middle Eastern Monographs 29). Cambridge, MA: Center for Middle Eastern Studies of Harvard University/Harvard University Press, 1996.

Jabir ibn Hayyan, *Le Livre des balances*

Jabir ibn Hayyan. "Le Livre des balances," in *La Chimie au Moyen Âge*, vol. 3: *L'Alchimie arabe*, ed. by Marcellin Berthelot, pp. 139–62. Paris: Imprimerie nationale, 1893.

al-Jawbari, *Book of Charlatans*

Jamal al-Din ʿAbd al-Rahim al-Jawbari. *The Book of Charlatans*, ed. by Manuela Dengler, trans. by Humphrey Davies (Library of Arabic Literature 64). New York: New York University Press, 2020.

al-Jazari, *Book of Knowledge*

Badiʿ al-Zaman ibn al-Razzaz al-Jazari. *The Book of Knowledge of Ingenious Mechanical Devices*, trans. and annotated by Donald R. Hill (One Hundred Great Books of Islamic Civilization 97). Islamabad: Hijra Council, 1989 (repr.; orig. Dordrecht: Reidel, 1974).

al-Jazari, *Chronique de Damas*

Ibrahim ibn Abu Bakr al-Jazari. *La Chronique de Damas d'al-Jazari (années 689–698 H)*, ed. and trans. by Jean Sauvaget (Bibliothèque de l'École des hautes études 4). Paris: Champion, 1949.

al-Jazari, *Al-Jamiʿ bayn al-ʿilm*

Badiʿ al-Zaman ibn al-Razzaz al-Jazari. *Al-Jamiʿ bayn al-ʿilm wa'l-ʿamal al-nāfiʿ fī ṣināʿat al-ḥiyal*. Aleppo: Aleppo University Publications, 1979.

Jerome, *Life of Paulus*

Jerome. "The Life of Paulus the First Hermit," trans. by W. H. Fremantle, in *A Select Library of the Christian Church; Nicene and Post-Nicene Fathers*, ed. by Philip Schaff and Henry Wace, series 2, vol. 6: *Jerome: Letters and Select Works*, pp. 498–502. New York: Christian Literature Publishing Company, 1892.

John Geometres, *Anecdota graeca*

John Geometres. *Anecdota graeca*, in *Appendix ad excerpta poetica: Codex 352 suppl., Anecdota graeca e codd. manuscriptis Bibliothecae regiae parisiensis*, ed. by J. A. Cramer, vol. 4. Oxford, pp. 265–352. Hildesheim: Olms, 1967 (repr.; orig. Oxford: Oxford University Press, 1841).

al-Kahhal ibn Tarkhan, *Al-Aḥkām al-nabawiyya*

al-Kahhal ibn Tarkhan. *Al-Aḥkām al-nabawiyya fī al-ṣināʿa al-ṭibbīya*. Beirut: Dār ibn Ḥazm, 2003.

Légendes de S. Tërtag et de S. Sousnyos

"Les Légendes de S. Tërtag et de S. Sousnyos," in *Les Apocryphes éthiopiens*, ed. and trans. by René Basset, vol. 4: pp. 1–42. Paris: Librairie de l'art indépendant, 1894.

Liber sacerdotum

"Liber sacerdotum," in *La Chimie au Moyen Âge*, ed. by Marcellin Berthelot, vol. 1: *Essai sur la transmission de la science antique au Moyen Âge [. . .]*, pp. 179–228. Paris: Imprimerie nationale, 1893.

Majriti, *Ghāyat al-ḥakīm*

Maslamah ibn Aḥmad Majriti. *Ghāyat al-ḥakīm wa-aḥaqq al-natījatayn bi'l-taqdīm*, ed. by Hellmut Ritter (Studien der Bibliothek Warburg, Kulturwissenschaftliche Bibliothek Warbug 12.1). Leipzig: Teubner, 1933.

Mappae clavicula

Mappae clavicula: A Little Key to the World of Medieval Techniques, ed. and trans. by Cyril Stanley Smith and John G. Hawthorne, = *Transactions of the American Philosophical Society* 64 (4). Philadelphia: American Philosophical Society, 1974.

Marbodus, *Liber de lapidibus*

Marbodus Redoniensis. "Liber de lapidibus: De lapidis or Liber lapidum, seu De gemmis, De lapidibus (avant 1090)," in Valérie Gontero-Lauze, *Sagesses minérales: Médecine et magie des pierres précieuses au Moyen Âge*, pp. 151–76. Paris: Éditions classiques Garnier, 2010.

Marbodus, *Liber lapidum*

Marbodus Redoniensis. *Liber lapidum/Lapidario*, ed. by Maria Esthera Herrera (Auteurs latins du Moyen Âge 15). Paris: Les Belles Lettres, 2005.

Marignolis, *Chronicon bohemorum*

"Iohannis de Marignola, Chronicon" ["Kronika Jana z Marignoly," with introduction in Czech], ed. by Joseph Emler, in *Fontes rerum Bohemicarum*, vol. 3, pp. 485–604. Prague: Nákladem nadání Františka Palackého, 1882.

al-Masʿudi, *Prairies d'or*

Abu al-Hasan Ali ibn al-Husain al-Masʿudi. *Les Prairies d'or (Murūj al-dhahab wa-maʿādin al-jawāhir)*, 9 vols, ed. and trans. by C. Barbier de Meynard and Pavet de Courteille. Paris: La Société asiatique, 1861–1917.

Mély, *Lapidaires grecs*

Fernand de Mély. *Les Lapidaires de l'antiquité et du Moyen Âge*, vol. 3, fasc. 1: *Les Lapidaires grecs*. Paris: E. Leroux, 1902.

al-Muqaddasi, *Kitāb aḥsan al-taqāsīm*

Muhammad ibn Ahmad al-Muqaddasi. *Kitāb aḥsan al-taqāsīm fī maʿrifat al-aqālīm*, ed. by Michael J. de Goeje (Bibliotheca Geographorum Arabicorum 3). Leiden: Brill, 1877.

al-Muqaddasi, *Meilleure repartition*

Muhammad ibn Ahmad al-Muqaddasi. *Ahsan at-taqasim fī maʿrifat al-aqālīm (Le Meilleure Repartition pour la connaisance des*

provinces), trans. by André Miquel. Damascus: Institut français de Damas, 1963.

Nasir-i Khusraw, *Safarnāmah*

Nasir-i Khusraw. *Nasir-i Khusraw's Book of Travels (Safarnāmah)*, ed. and trans. by Wheeler M. Thackston (Bibliotheca Iranica; Intellectual Traditions Series 6). Costa Mesa, CA: Mazda Publishers, 2001.

Nicolas de Nicolay, *Les Quatres Premiers Livres*

Nicolas de Nicolay. *Les Quatres Premiers Livres des navigations et pérégrinations orientales.* Lyon, 1567.

Nūr al-maʿārif

Nūr al-maʿārif fī nuẓum wa qawānīn wa aʿrāf al-Yaman fī al-ʿahd al-Muẓaffarī al-wārif/Lumière de la connaissance: Règles, lois et coutumes du Yémen sous le règne du sultan rasoulide al-Muẓaffar, ed. by Muḥammad ʿAbd al-Rahim Jazim, vol. 1. Sanʿaʾ: CFAS, 2003.

Peter of Eboli, *Liber ad honorem Augusti.*

Petrus de Ebolo. *Liber ad honorem Augusti sive de rebus Siculis: Codex 120 II der Burgerbibliothek Bern; Eine Bilderchronik der Stauferzeit*, ed. by Theo Kölzer and Marlis Stähli. Sigmaringen: Thorbecke, 1994.

Physiologus

The Old English Physiologus, trans. by Albert Stanburrough Cook (text and prose) and James Hall Pitman (verse) (Yale Studies in English 63). New Haven, CT: Yale University Press, 1821.

Picatrix

Picatrix: A Medieval Treatise on Astral Magic, ed. and trans. by Dan Attrell and David Porreca. University Park, PA: Pennsylvania State University Press, 2019.

Pliny, *Naturalis historiae*

Pliny the Elder. *Naturalis historiae libri XXXVII: Libri XXXI–XXXVII*, ed. by Karl Mayhoff (Bibliotheca Scriptorum Graecorum et Romanorum Teubneriana 5). Berlin: De Gruyter, 2002 (repr. of the critical edition of 1897).

Pseudo-Joshua, *Chronicle*

The Chronicle of Pseudo-Joshua the Stylite, ed. and trans. by Frank R. Trombley and John W. Watt. Liverpool: Liverpool University Press, 2000.

al-Qazwini, *Athār al-bilād*

Zakariyya ibn Muhammad al-Qazwini. *Athār al-bilād wa akhbar al-ʿibād*, ed. by Ferdinand Wüstenfeld. Göttingen: Dieterich, 1848.

RCEA

Étienne Combe, Jean Sauvaget, and Gaston Wiet, gen. eds. *Répertoire chronologique d'épigraphie arabe*, vol. 10. Cairo: L'Institut français d'archéologie orientale, 1939.

Sanami, *Niṣāb al-iḥtisāb*

ʿUmar ibn Muhammad Ibn ʿAwaḍ Sanami. *Niṣāb al-iḥtisāb*, ed. by Murayzin Saʿid Murayzin ʿAsiri. Mecca: Maktabat al-Ṭalib al-Jāmiʿī, 1986.

Sanami, *Theory and Practice*

ʿUmar ibn Muhammad Ibn ʿAwaḍ Sanami. *The Theory and the Practice of Market Law in Medieval Islam*, trans. by Mawil Izzi Dien. Cambridge: E.J.W. Gibb Memorial Trust, 1997.

al-Shayzari, *Kitāb Nihāyat al-rutba fī ṭalab al-ḥisba*

ʿAbd al-Rahman b. Nasr al-Shayzari. *The Book of the Islamic Market Inspector. Kitāb Nihāyat al-rutba fī ṭalab al-ḥisba (The Utmost Authority in the Pursuit of Ḥisba) by ʿAbd al-Raḥmān b. Naṣr al-Shayzarī*, ed. and trans. by R. P. Buckley, = *Journal of Semitic Studies Supplement* 9. Oxford: Oxford University Press, 1999.

al-Sirafi, *Accounts of China and India*

Abu Zayd al-Sirafi; Ahmad Ibn Fadlan. *Two Arabic Travel Books: "Accounts of China and India" and "Mission to the Volga,"* ed. and trans. by Tim Mackintosh-Smith and James E. Montgomery (Library of Arabic Literature 17). New York: New York University Press, 2014.

al-Sirafi, *Akhbār as-sīn wa l-hind*

al-Ḥasan al-Sīrāfī (Abū Zayd). *Relation de la Chine et de l'Inde rédigée en 851: Aḥbār as-sīn wa l-hind*, ed. and trans. Jean Sauvaget. Paris: Les belles lettres, 1948.

al-Sirafi, *Al-Saḥīḥ min akhbār al-biḥār wa-ʿajāʾibihā*

Abu ʿImran Musa ibn Rabah al-Awsi al-Sirafi, *Al-Saḥīḥ min akhbār al-biḥār wa-ʿajāʾibihā*, ed. by Y. al-Hadi. Damascus: Dār Iqraʾ, 2006.

al-Suyuti, *Livre de la miséricorde*

Jalal al-Din ʿAbd al-Rahman ibn Abi Bakr, al-Suyuti. *Sidi-Siouti: Livre de la miséricorde dans l'art de guérir les maladies et de conserver la santé*, trans. by Alphonse-François Bertherand and Florian Pharaon. Algiers/Paris, 1856.

al-Suyuti, *Medicine of the Prophet*

Jalal al-Din ʿAbd al-Rahman ibn Abi Bakr, al-Suyuti. *Jalalu'd-Din ʿAb-d'ur Rahman as-Suyuti's* Tibb an-Nabbi: *Medicine of the Prophet*, ed. by Ahmad Thomson. London: Ta-Ha Publishers, 2015 (rev. edn).

Theodulphus, *Carmina*

Theodulphus. *Carmina*, in MGH Poetae Latini Medii Aevi 1: *Poetae Latini Aevi Carolini*, vol 1, ed. by Ernst Dümmler. Berlin: Weidmann, 1881, S. 437–581.

Theophanes, *Chronicle*

Theophanes Confessor. *The Chronicle of Theophanes Confessor: Byzantine and Near Eastern History, AD 284–813*, ed. by Cyril A. Mango, Roger Scott, and Geoffrey Greatrex. Oxford: Clarendon Press, 1997.

Theophilus Presbyter, *De diversis artibus*

Theophilus Presbyter. "*De diversis artibus*, or *Schedula diversarum artium*," in *The Various Arts/De diversis artibus*, ed. and trans. by C. R. Dodwell. Oxford: Clarendon Press, 1986 (repr. [1961]).

Testament of Solomon

D. C. Duling. "The Testament of Solomon (First to Third Century AD)," in *The Old Testament Pseudepigrapha*, ed. by James H. Charlesworth, vol. 1: *Apocalyptic Literature and Testaments*, pp. 935–87. Peabody, MA: Hendrickson, 1983.

Thesaurus sanctarum reliquiarum

Thesaurus sanctarum reliquiarum nominatarum, que in cathedrali ecclesia divi Pauli Monasteriensi asservantur, post errectionem novi altaris (Münster, Bistumsarchiv, DA 6 A.33).

Tibb al-Aʾimma

Islamic Medical Wisdom: The "Tibb al-Aʾimma," ed. by Andrew J. Newman, trans. by Batool Ispahany. London: Muhammadi Trust, 1991.

al-Tifashi, *Arab Roots of Gemology*

Aḥmad ibn Yusuf al-Tifashi. *Arab Roots of Gemology: Aḥmad ibn Yūsuf al-Tifaschi's "Best Thoughts on the Best of Stones,"* trans. by Samar Najm Abul Huda. Lanham, MD: Scarecrow Press, 1998.

Tractatus de herbis

Bartholomeus Mini de Senis (?). *A Collection of Medical Texts including "Tractatus de herbis,"* made in Italy (Salerno), 1280–1310 (BL, Egerton MS 747, fols. 67v and 68r).

al-ʿUmari, *Masālik al-abṣār*

Ahmad Ibn-Yahya ibn-Fadlallah al-ʿUmari. *Masālik el abṣār fi mamālik el amṣār*, vol 1: *L'Afrique moins l'Égypte*, trans. by Maurice Gaudefroy-Demombynes (Bibliothèque des géographes arabes 2). Paris: Geuthner, 1927.

Secondary Literature

Abd el-Kader, Djafar. 1949. "Un orthostate du temple de Hadad a Damas," *Syria* 26: 191–95.

Abenza Soria, Verónica Carla. 2014. "El Díptic de Jaca i la reina Felicia de Roucy," *Síntesi: Quaderns dels Seminaris de Besalú* 2: 50–51.

Abir, Mordechai. 1985. "The Ethiopian Slave Trade and Its Relation to the Islamic World," in *Slaves and Slavery in Muslim Africa*, vol. 2: *The Servile Estate*, ed. by John Ralph Willis, pp. 123–36. London: Frank Cass.

Abraham, Meera. 1988. *Two Medieval Merchant Guilds of South India*. New Delhi: Manohar Publications.

Abu-Lughod, Janet. 1989. *Before European Hegemony: The World System AD 1250–1350*. Oxford: Oxford University Press.

Adamson, Glenn, and Giorgio Riello. 2013. "Global Objects: Contention and Entanglement," in *Writing the History of the Global: Challenges for the Twenty-First Century*, ed. by Maxine Berg, pp. 177–94. Oxford: Oxford University Press.

Aga-Oğlu, Mehmet. 1946. "The Origin of the Term *Mīnā* and its Meaning," *Journal of Near Eastern Studies* 5: 241–56.

Agius, Dionisius A. 2014. *Classic Ships of Islam: From Mesopotamia to the Indian Ocean*. Leiden: Brill.

Akbari, Suzanne Conklin. 2019. "Where is Medieval Ethiopia? Mapping Ethiopic Studies within Medieval Studies," in *Toward a Global Middle Ages: Encountering the World through Illuminated Manuscripts*, ed. by Bryan C. Keene, pp. 82–93. Los Angeles: J. Paul Getty Museum.

Ali, Daud. 2009. "Between Market and Court: The Careers of Two Courtier-Merchants in the Twelfth-Century Deccan," *Journal of the Economic and Social History of the Orient* 52: 795–821.

Ali, Daud. 2016. "Bhoja's Mechanical Garden: Translating Wonder across the Indian Ocean, circa 800–1100 CE," *History of Religions* 55: 460–93.

Ali Ibrahim, Laila. 1976. "Dragons on a Cairene Mosque," *Art and Archaeology Research Papers* 10: 11–19.

Ali Ibrahim, Laila. 2008. "Dragons on a Cairene Mosque," *Mishkah: Egyptian Journal of Islamic Archaeology* 3: 91–109.

Allan, James W. 1976. "The Metalworking Industry in Iran in the Early Islamic Period." D.Phil thesis, University of Oxford.

Allan, James W. 1979. *Persian Metal Technology, 700–1300 AD*. London: Ithaca Press.

Allen, Terry. 1986. *A Classical Revival in Islamic Architecture*. Wiesbaden: Reichert.

Allen, Terry. 1988. *Five Essays on Islamic Art*. Manchester, MI: Solipsist Press.

Alpers, Edward A. 2004. "Africans in India and the Wider Context of the Indian Ocean," in *Sidis and Scholars: Essays on African Indians*, ed. by Amy Catlin-Jairazbhoy and Edward A. Alpers, pp. 27–41. Trenton, NJ: Rainbow.

Álvarez da Silva, Noemi. 2014. "El trabajo de marfil en la España del siglo xi." PhD dissertation, Universidad de León.

Álvarez Millán, Cristina. 2010. "The Case History in Medieval Islamic Medical Literature: *Tajārib* and *Mujarrabāt* as Source," *Medical History* 54: 195–214.

Amar, Zohar, and Efraim Lev. 2017. *Arabian Drugs in Early Medieval Mediterranean Medicine*. Edinburgh: Edinburgh University Press.

Anawati, Georges C. 1967. "Le Nom suprême de Dieu (Ism Allāh Al-Aʿẓam)," in *Atti del terzo Congresso di studi arabi e islamici: Ravello, 1–6 settembre 1966*, pp. 8–58. Naples: Istituto universitario orientale.

Andaloro, Maria. 2002. "Le icone a Roma in età preiconoclasta," in *Roma fra Oriente e Occidente* (Settimane di studio del Centro italiano di studi sull'alto medioevo 49), pp. 719–54. Spoleto: Centro italiano di studi sull'alto medioevo.

Anderson, William. 2004. "An Archaeology of Late Antique Pilgrim Flasks," *Anatolian Studies* 54: 79–93.

Andersson, Aaron. 1983. *Mediaeval Drinking Bowls of Silver Found in Sweden*. Stockholm: Kunglig Vitterhets.

Anfray, Francis. 1965. "Le Musée archéologique d'Asmara," *Rassegna di studi etiopici* 21: 5–15.

Anfray, Francis. 1990. *Les Anciens Éthiopiens: Siècles d'histoire*. Paris: Colin.

Anfray, Francis, and Guy Annequin. 1965. "Maṭara, deuxième, troisième et quatrième campagne de fouilles," *Annales d'Éthiopie* 6: 49–86.

Appadurai, Arjun. 1986. "Introduction: Commodities and the Politics of Value," in *The Social Life of Things: Commodities in Cultural Perspective*, ed. by Arjun Appadurai, pp. 3–63. Cambridge: Cambridge University Press.

Arad, Lily. 2007. "The Holy Land Ampulla of Sant Pere de Casseres: A Liturgical and Art-Historical Interpretation," *Miscellània litúrgica catalana* 15: 59–86.

Ariotti, Piero E. 1972. "The Conception of Time in Late Antiquity," *International Philosophical Quarterly* 12: 526–52.

Armojand, Said Amir. 2004. "Transformation of the Islamicate Civilization: A Turning-point in The Thirteenth Century?," *Medieval Encounters* 10 (1): 213–45.

Árnason, Jóhann P., and Björn Wittrock, eds. 2004. *Eurasian Transformations, Tenth to Thirteenth Centuries: Crystallizations, Divergences, Renaissances*. Leiden: Brill.

Arnold, T. W. 1913. "Ceylon," in *Enzyklopädie des Islam*, vol. 1, ed. by M. Th. Houtsma et al., p. 874. Leiden: Brill.

Aruz, Joan, ed. 2014. *Assyria to Iberia at the Dawn of the Classical Age*. New Haven, CT: Yale University Press.

Aschan, Marit Guinness. 1996. "Enamel," in *The Dictionary of Art*, ed. by Jane Shoaf Turner, vol. 10, pp. 192–95. London: Grove.

Ashley, Scott. 2016. "Global Worlds, Local Worlds: Connections and Transformations in the Viking Age," in *Byzantium and the Viking World*, ed. by F. O. Androshchuk, Jonathan Shepard, and Monica White, pp. 363–90. Uppsala: Uppsala Universitet.

Ashtor, Eliyahu. 1956. "The Karīmī Merchants," *Journal of the Royal Asiatic Society* 88 (1/2): 45–56.

Assmann, Jan. 1996. "Denkformen des Endes in der altägyptischen Welt," in *Das Ende: Figuren einer Denkform*, ed. by Karlheinz Stierle and Rainer Warning, pp. 1–31. Munich: Fink.

Asutay-Effenberger, Neslihan. 2004. " 'Muchrutas,' der Seldschukische Schaupavillon im grossen palast von Konstantinopel," *Byzantion* 74: 313–28.

Atil, Esin. 1973. *Ceramics from the World of Islam*. Washington, DC: Smithsonian Institution.

Atil, Esin, W. T. Chase, and Paul Jett, eds. 1985. *Islamic Metalwork in the Freer Gallery of Art*. Washington, DC: Smithsonian Institution.

Azarpay, Guitty. 1978. "The Eclipse Dragon on an Arabic Frontispiece-Miniature," *Journal of the American Oriental Society* 98: 363–74.

Baader, Hannah and Ittai Weinryb. 2016. "Images at Work: On Efficacy and Historical Interpretation," *Representations* 133: 1–19.

Bacharach, Jere L. 1981. "African Military Slaves in the Medieval Middle East: The Cases of Iraq (869–955) and Egypt (868–1171)," *Journal of Middle East Studies* 13: 471–95.

Badamo, Heather A. 2011. "Image and Community: Representations of Military Saints in the Medieval Eastern Mediterranean." PhD dissertation, University of Michigan.

Baer, Eva. 1965. *Sphinxes and Harpies in Medieval Islamic Art: An Iconographical Study*. Jerusalem: Israel Oriental Society.

Bahl, Christopher D. 2017. "Preservation through Elaboration: The Historicisation of the Abyssinians in al-Suyūṭī's *Rafʿshaʾn al-Ḥubshān*," in *Al-Suyūṭī, a Polymath of the Mamlūk Period*, ed. by Antonella Ghersetti, pp. 118–42. Leiden: Brill.

al-Bahloly, Saleem. 2018. "History Regained: A Modern Artist in Baghdad Encounters a Lost Tradition of Painting," *Muqarnas* 35: 229–72.

Bahrani, Zainab. 2021. "Aby Warburg's Babylonian Paradigm:

Toward an Epistemology of the Irrational in the Bilderatlas," *Res: Anthropology and Aesthetics* 75/76: 250–64.

Bahrani, Zainab, Jaś Elsner, Wu Hung, and Rosemary Joyce, with Jeremy Tanner. 2014. "Questions on 'World Art History,'" *Perspective* 2: 181–94.

Baker, Patricia. 2012. "Medieval Islamic Hospitals: Structural Design and Social Perceptions," in *Medicine and Space*, ed. by Patricia Baker, Han Nijdam, and Karine van't Land, pp. 245–71. Leiden: Brill.

Baker, Karen, and Amal Bejjani. 2017. *The Mandaeans: Baptizers of Iraq and Iran*. Eugene, OR: Wipf and Stock.

Balafrej, Lamia. 2021. "Domestic Slavery, Skin Colour, and Image Dialectic in Thirteenth-Century Arabic Manuscripts," *Art History* 44 (5): 1012–36.

Balicka-Witakowska, Ewa. 2009–10. "Islamic Elements in Ethiopian Pictorial Tradition: A Preliminary Survey," *Civiltà del Mediterraneo* 16–17: 109–31.

Balicka-Witakowska, Ewa, and Michael Gervers. 2001. "The Church of Yəmrähannä Krəstos and Its Wall-Paintings: A Preliminary Report," *Africana Bulletin* 49: 9–47.

Ballet, Pascale, Nathalie Bosson, and Marguerite Rassart-Debergh. 2003. *Kellia II: L'ermitage copte QR 195. 2: La céramique, les inscriptions, les décors*. Cairo: Institut français d'archéologie orientale.

Ballian, Anna. 2018. "Liturgical Censers," in *Armenia: Art, Religion, and Trade in the Middle Ages*, ed. by Helen C. Evans, pp. 73–75. New York: The Metropolitan Museum of Art.

Bango García, Clara Isabel. 2001. "El Ara portátil," in *Maravillas de la España medieval: Tesoro sagrado y monarquía*, ed. by Isidro G. Bango Torviso, vol. 1, pp. 351–54. Valladolid: Junta de Castilla y León.

Barb, A. A. 1964. "Three Elusive Amulets," *Journal of the Warburg and Courtauld Institutes* 27: 1–22.

Barnabò, Massimo. 2017. "Images of Women in an Arabic Apocryphal Gospel of the Year 1299," *Egitto e Vicino Oriente* 40: 97–108.

Barnet, Peter, and Nancy Y. Wu. 2005. *The Cloisters: Medieval Art and Architecture*. New York: The Metropolitan Museum of Art.

Barrero González, M. Luisa. 2017. "Enseñas y sellos de peregrino en el contexto de la peregrinación medieval," *Revista digital de iconografía medieval* 9: 5–32.

Barrucand, Marianne. 1991. "The Miniatures of the 'Daqa'iq al-Haqa'iq' (Bibliothèque nationale, pers. 174): A Testimony to the Cultural Diversity of Medieval Anatolia," *Islamic Art* 4: 113–42.

Barrucand, Marianne. 1992. "Les Voyages d'Abû Zayd, ou la représentation des régions lointaines dans les miniatures islamiques du Moyen Âge," in *Diesseits- und Jenseitsreisen im Mittelalter/Voyages dans l'ici-bas et dans l'au-delà au Moyen Âge*, ed. by Wolf-Dieter Lange, pp. 1–10. Bonn: Bouvier.

Basu, Helene. 1995. *Habshi-Sklaven, Sidi-Fakire: Muslimische Heiligenverehrung im westlichen Indien*. Berlin: Das Arabische Buch.

Bauden, Frédéric. 2011. "Inscriptions arabes d'Éthiopie," *Annales islamologiques* 5: 285–306.

Baumgärtner, Ingrid. 1993. "Marignolli, Giovanni de'," in *Lexikon des Mittelalters*, vol. 6, ed. by Robert Auty, col. 292. Munich: Artemis.

Bausi, Alessandro. 2020. "Ethiopia and the Christian Ecumene: Cultural Transmission, Translation, and Reception," in *A Companion to Medieval Ethiopia and Eritrea*, ed. by Samantha Kelly, pp. 217–51. Leiden: Brill 2020.

Beaujard, Philippe. 2005. "The Indian Ocean in Eurasian and African World-Systems before the Sixteenth Century," trans. by S. Fee, *Journal of World History* 16: 411–65.

Beaujard, Philippe. 2012. *Les Mondes de l'Océan indien*, vol. 2: *L'Océan indien au coeur des globalisations de l'ancien monde (7ᵉ—15ᵉ siècle)*. Paris: Colin.

Beaujard, Philippe. 2019. *The Worlds of the Indian Ocean: A Global History*, vol. 2: *From the Seventh Century to the Fifteenth Century CE*. Cambridge: Cambridge University Press.

Beckman, Eric. 2107. "Color-Coded: The Relationship between Color, Iconography, and Theory in Hellenistic and Roman Gemstones," in *What Shall I Say of Clothes?: Theoretical and Methodological Approaches to the Study of Dress in Antiquity*, ed. by Megan Cifarelli and Laura Gawlinski, pp. 67–82. Boston, MA: Archaeological Institute of America.

Belting, Hans 1970. *Das illuminierte Buch in der spätbyzantinischen Gesellschaft*. Heidelberg: Winter.

Belting, Hans. 1994. *Likeness and Presence: A History of the Image before the Era of Art*. Chicago: University of Chicago Press.

Bénazeth, Dominique. 1988. "Les Encensoirs de la collection copte du Louvre," *La Revue du Louvre* 38: 294–300.

Bénazeth, Dominique. 2005. "Calques de Baouit archives à l'IFAO," *Bulletin de l'Institut français d'archéologie orientale* 105: 1–12.

Bennett, Jane. 2010. *Vibrant Matter: A Political Ecology of Things*. Durham, NC: Duke University Press.

Ben-Shammai, Haggai. 2011. "Is 'The Cairo Genizah' a Proper Name or a Generic Noun? On The Relationship between the Genizot of the Ben Ezra and the Dar Simha Synagogues," in *From a Sacred Source: Genizah Studies in Honour of Professor Stefan C. Reif*, ed. by Phillip I. Ackerman-Lieberman, pp. 43–52. Leiden: Brill.

Bentley, Jerry H. 1996. "Cross-cultural Interaction and Periodization in World History," *The American History Review* 101 (3): 749–70.

Berenbeim, Jessica. 2021. "Fictions of the Archive," *Res: Anthropology and Aesthetics* 75–76: 221–32.

Beretta, Marco, ed. 2004. *When Glass Matters: Studies in the History of Science and Art from Graeco-Roman Antiquity to Early Modern Era*. Florence: Olschki.

Berlekamp, Persis. 2011. *Wonder, Image, and Cosmos in Medieval Islam*. New Haven, CT: Yale University Press.

Berlekamp, Persis. 2016. "Symmetry, Sympathy, and Sensation: Talismanic Efficacy and Slippery Iconographies in Early Thirteenth-Century Iraq, Syria, and Anatolia," *Representations* 133: 59–109.

Betancourt, Roland. 2020. "The Exiles of Byzantium: Form, Historiography, and Recuperation," in *Disturbing Times: Medieval Pasts, Reimagined Futures*, ed. by Catherine Karkov, Anna Kłosowska, and Vincent W. J. van Gerven Oei, pp. 215–45. Santa Barbara, CA: Punctum Books.

Beuckers, Klaus Gereon. 2007. "[Review of] Christoph Stiegemann / Hiltrud Westermann-Angerhausen (Hgg): Schatzkunst am Aufgang der Romanik: Der Paderborner Dom-Tragaltar und sein Umkreis. München: Hirmer 2006," *Kunstform* 8: 10.

Bhandare, Shailendra. 2021. "Connected Words: Coins and Maritime Worlds of the Indian Ocean," in *The Archaeology of Knowledge Traditions of the Indian Ocean World*, ed. by Himanshu Prabha Ray, pp. 240–60. London: Routledge.

Biedermann, Zoltán, Anne Gerritsen, and Giorgio Riello, eds. 2018. *Global Gifts: The Material Culture of Diplomacy in Early Modern Eurasia*. Cambridge: Cambridge University Press.

Bielfeldt, Ruth. 2014a. "Lichtblicke—Sehstrahlen: Überlegungen zur Präsenz kaiserzeitlicher Lampen," in *Ding und Mensch in der Antike*, ed. by Ruth Bielfeldt, pp. 195–238. Heidelberg: Winter.

Bielfeldt, Ruth. 2014b. "The Lure and Lore of Light: Roman Lamps in the Harvard Art Museums," in *Ancient Bronzes through a Modern Lens: Introductory Essays on the Study of Ancient Mediterranean and Near Eastern Bronzes*, ed. by Susanne Ebbinghaus, pp. 171–91. New Haven, CT: Yale University Press.

Bielfeldt, Ruth. 2018. "*Candelabrus* and Trimalchio: Embodied Histories of Roman Lampstands and Their Slaves," *Art History* 41: 420–43.

Bier, Carol. 2004. "Patterns in Time and Space: Technologies of Transfer and the Cultural Transmission of Mathematical Knowledge," *Ars Orientalis* 34: 172–94.

Billod, Carole. 1987. "Les Encensoirs syro-palestiniens de Bâle," *Antike Kunst* 30: 39–56.

Billod, Carole. 2015. "Encensoir à décor nilotique," in *Byzance en Suisse*, ed. by Marielle Martiniani-Reber, p. 335. Geneva: Musée d'art et d'histoire de Genève.

Bittar, Thérèse. 2012. "Metal Objects Imported from the Islamic World," in *Lalibela: Wonder of Ethiopia: The Monolithic Churches and Their Treasures*, ed. by Claude Lepage and Jacques Mercier, pp. 317–20. London: Holberton.

Blair, Sheila S. 2007. *Islamic Calligraphy*. Edinburgh: Edinburgh University.

Bleichmar, Daniela and Meredith Martin, eds. 2016. *Objects in Motion in the Early Modern World*. Chichester: Wiley.

Bloom, Jonathan M. 2013. "A Cultural History of the Material World of Islam," in *Cultural Histories of the Material World*, ed. by Peter Miller, pp. 240–48. Ann Arbor, MI: University of Michigan Press.

Bock, Sebastian. 2005. *Ova struthionis: Die Straußeneiobjekte in den Schatz-, Silber- und Kunstkammern Europas*. Leipzig: Neumann & Nürnberger.

Bohak, Gideon. 2009. "The Jewish Magical Tradition from Late Antique Palestine to the Cairo Genizah," in *From Hellenism to Islam. Cultural and Linguistic Change in the Roman Near East*, ed. by Hannah M. Cotton, Robert G. Hoyland, Jonathan J. Price, and David J. Wasserstein, pp. 324–42. Cambridge: Cambridge University Press 2009.

Bohak, Gideon. 2011. "The *charaktêres* in Ancient and Medieval Jewish Magic," *Acta classica Universitatis scientiarum debreceniensis* 47: 25–44.

Bohak, Gideon. 2015. "Amulets," in *A Companion to the Archaeology of Religion in the Ancient World*, ed. by Rubina Raja and Jörg Rüpke, pp. 81–95. Chichester: Wiley.

Bohak, Gideon, and Anne Hélène Hoog, eds. 2015. *Magie: Anges et démons dans la tradition juive*. Paris: Flammarion.

Bohak, Gideon, and Matthew Morgenstern. 2014. "A Babylonian Jewish Aramaic Magical Booklet from the Damascus Genizah," *Ginzei Qedem* 10: 9–44.

Bolman, Elizabeth S., ed. 2002. *Monastic Visions: Wall Paintings in the Monastery of St. Anthony at the Red Sea*. New Haven, CT: Yale University Press.

Bolman, Elizabeth S., ed. 2016. *The Red Monastery Church: Beauty and Asceticism in Upper Egypt*. New Haven, CT: Yale University Press.

Bonacci, Giulia, and Alexander Meckelburg. 2017. "Revisiting Slavery and the Slave Trade in Ethiopia," *Northeast African Studies* 17: 5–30.

Bonhams. 2011. *Islamic and Indian Art* (auction catalogue, London, October 4).

Bonhams. 2022. *Islamic and Indian Art* (auction catalogue, London, October 25–26), https://www.bonhams.com/auction/27408/ (accessed 13 January 2023).

Bonner, Campbell. 1942. "Two Studies in Syncretistic Amulets," *Proceedings of the American Philosophical Society* 85: 466–71.

Bonner, Campbell. 1950. *Studies in Magical Amulets, Chiefly Graeco-Egyptian*. Ann Arbor, MI: University of Michigan Press.

Borchers, Walter. 1933. *Der Camminer Domschatz*. Stettin: Saunier.

Borland, Jennifer. 2013. "Unruly Reading: The Consuming Role of Touch in the Experience of a Medieval Manuscript," in *Scraped, Stroked, and Bound: Materially Engaged Readings of Medieval Manuscripts*, ed. by Jonathan Wilcox, pp. 97–114. Turnhout: Brepols.

Bosc-Tiessé, Claire. 2002. "Musée de l'Homme: La décoration de carreaux de faïence hollandaise d'une église royale éthiopienne au XVIIIᵉ siècle (Qwesqwam, Gondar)," *Revue du Louvre* 3: 54–59.

Bosc-Tiessé, Claire. 2005. "Aux marges du sacré: Du luxe de la faïence hollandaise à la peinture du quotidien," in *Peintures sacrées d'Ethiopie: Collection de la Mission Dakar-Djibouti*, ed. by Claire Bosc-Tiessé and Anaïs Wion, pp. 101–5. Saint-Maur-des-Fossés: Sépia.

Bosc-Tiessé, Claire. 2010. "Catalogue des autels et meubles d'autel en bois (*tābot* et *manbara tābot*) des églises de Lālibalā: Jalons pour une histoire des objets et des motifs," *Annales d'Éthiopie* 25: 55–101.

Bosc-Tiessé, Claire. 2011. "Catalogue des autels et meubles en bois (*tābot* et *manbara tābot*) de Ṭerāsfarē Eṣṭifānos: Jalons pour une histoire des objets et des motifs (II)," *Annales d'Éthiopie* 26: 249–67.

Bosc-Tiessé, Claire. 2014. "Le Site rupestre de Qorqor (Garʿāltā, Éthiopie) entre littérature et peinture: Introduction à l'édition de la *Vie et des miracles de saint Daniel de Qorqor* et aux recherches en cours," *Afriques*, November 19, http://journals.openedition.org/afriques/1486.

Bosc-Tiessé, Claire. 2020. "Christian Visual Culture in Medieval Ethiopia: Overview, Trends and Issues," in *A Companion to Medieval Ethiopia and Eritrea*, ed. by Samantha Kelly, pp. 322–64. Leiden: Brill.

Bosc-Tiessé, Claire, and Marie-Laure Derat, eds. 2019. *Lalibela: Site rupestre chrétien d'Éthiopie*. Toulouse: Presses universitaires du Midi.

Bosc-Tiessé, Claire, Marie-Laure Derat, Laurent Bruxelles, François-Xavier Fauvelle, Yves Gleize, and Romain Mensan. 2014. "The Lalibela Rock Hewn Site and Its Landscape (Ethiopia): An Archaeological Analysis," *Journal of African Archaeology* 12: 141–64.

Bosc-Tiessé, Claire, Marie-Laure Derat, Emmanuel Fritsch, and Wadi Awad Abullif. 2010. "Les Inscriptions arabes: Coptes et guèzes des églises de Lālibalā," *Annales d'Éthiopie* 25: 43–53.

Bosc-Tiessé, Claire, and Peter Mark. 2019. "Towards an Art History of Precontemporary Africa: Preliminary Thoughts for a State-of-the-Art Assessment," *Afriques* 10, https://journals.openedition.org/afriques/2496.

Boschung, Dietrich, Patric-Alexander Kreuz, and Tobias Kienlin, eds. 2015. *Biography of Objects: Aspekte eines kulturhistorischen Konzepts*. Paderborn: Fink.

Bosselmann-Ruickbie, Antje. 2013. "Das Verhältnis der 'Schedula diversarum artium' des Theophilus Presbyter zu byzantinischen Goldschmiedearbeiten: Grenzüberschreitende Wissensverbreitung im Mittelalter?," in *Zwischen Kunsthandwerk und Kunst: Die 'Schedula diversarum artium'*, ed. by Andreas Speer, pp. 333–68. Berlin: De Gruyter.

Bosworth, Clifford Edmund. 1976. *The Mediaeval Islamic Underworld: The Banū Sāsān in Arabic Life and Lore*, 2 vols. Leiden: Brill.

Bosworth, Clifford Edmund. 1984. "The Coming of Islam to Afghanistan," in *Islam in Asia*, vol. 1: *South Asia*, ed. by Yohanan Friedmann, pp. 1–22. Jerusalem: Magnes Press; Boulder, CO: Westview Press.

Bouanga, Ayda. 2017. "Gold, Slaves, and Trading Routes in Southern Blue Nile (Abbay) Societies, Ethiopia, 13th–16th Centuries," *Northeast African Studies* 17: 31–60.

Bousquet, Jacques. 1979. "Les Ivoires espagnols du milieu du XIᵉ siècle: Leur position historique et artistique," *Les Cahiers de Saint-Michel de Cuxa* 10: 29–58.

Bowersock, Glenn Warren. 2005. "The East–West Orientation of Mediterranean Studies and the Meaning of North and South in Antiquity," in *Rethinking the Mediterranean*, ed. by W. V. Harris, pp. 167–78. Oxford: Oxford University Press.

Bowersock, Glenn Warren. 2013. *Throne of Adulis: Red Sea Wars on the Eve of Islam*. Oxford: Oxford University Press.

Boyd, Susan A. 1992. "A 'Metropolitan' Treasure from a Church in the Provinces: An Introduction to the Study of the Sion Treasure," in *Ecclesiastical Silver Plate in Sixth-Century Byzantium: Papers of the Symposium Held May 16–18, 1986 at the Walters Art Gallery, Baltimore and Dumbarton Oaks, Washington, DC*, ed. by Susan A. Boyd and Marlia Mundell Mango, pp. 22–23. Washington, DC: Dumbarton Oaks Research Library and Collection.

Brac de la Perrière, Éloïse. 2015. "Des idées aux images: Les personnages indiens dans la miniature islamique," in *De la figuration humaine au portrait dans l'art islamique*, ed. by Houari Touati, pp. 153–73. Leiden: Brill.

Braun, Joseph. 1932. *Das christliche Altargerät in seinem Sein und in seiner Entwicklung*. Munich: Hueber.

Brazinski, Paul A. 2014. *Late Antique Pilgrimage and Ampullae: History, Classification, Chronology*. Saarbrücken: LAP Lambert Academic Publishing.

Bredekamp, Horst. 2007. *Theorie des Bildakts*. Frankfurt a. M.: Frankfurter Adorno-Vorlesungen.

Bredekamp, Horst. 2015. *Der Bildakt*. Berlin: Wagenbach.

Bredekamp, Horst. 2018. *Image Acts: A Systematic Approach to Visual Agency*, trans. by Elizabeth Clegg. Berlin: De Gruyter.

Bremer-McCollum, Adam Carter. 2018. "Notes and Colophons of Scribes and Readers in Georgian Biblical Manuscripts from St. Catherine's Monastery (Sinai)," in *Bible as Notepad: Tracing Annotations and Annotation Practices in Late Antique and Medieval Biblical Manuscripts*, ed. by Liv Ingeborg Lied and Marilena Maniaci, pp. 111–24. Berlin: De Gruyter.

Brentjes, Sonja. 2017. "Practitioners of the Mathematical and Medical Sciences and Their Relationship to the Jazira from the Ninth to the Fourteenth Centuries," in *Central Periphery?: Art, Culture and History of the Medieval Jazira (Northern Mesopotamia, 8th–15th centuries)*, ed. by Lorenz Korn and Martina Müller-Wiener, pp. 97–110. Wiesbaden: Reichert.

Brincken, Anna-Dorothee von den. 1967. "Die universalhistorischen Vorstellungen des Johann von Marignola OFM: Der einzige mittelalterliche Weltchronist mit Fernostkenntnis," *Archiv für Kulturgeschichte* 49: 297–339.

Brooklyn Museum. 1941. *Pagan and Christian Egypt: Egyptian Art from the First to the Tenth Century AD; Exhibited at the Brooklyn Museum by the Department of Ancient Art, January 23–March 9, 1941* (exhibition catalogue). New York: Brooklyn Institute of Arts and Sciences Brooklyn Museum.

Brown, Bill. 2004. *Things*. Chicago: University of Chicago Press.

Brown, Nancy Marie. 2007. *The Far Traveler: Voyages of a Viking Woman*. Orlando, FL: Harcourt.

Brown, Michelle. 2016. "Imagining, Imaging, and Experiencing the East in Insular and Anglo-Saxon Cultures: New Evidence for Contact," in *Anglo-Saxon England and the Visual Imagination*, ed. by John D. Niles, Stacy S. Klein, and Jonathan Wilcox, pp. 49–84. Tempe, AR: Arizona Center for Medieval and Renaissance Studies.

Brown, Jonathan A. C. 2019. *Slavery and Islam*. London: Oneworld Academic.

Brune, Karl-Heinz. 1999. *Der koptische Reiter: Jäger, König, Heiliger; Ikonographische und stilistische Untersuchung zu den Reiterdarstellungen im spätantiken Ägypten und die Frage ihres "Volkskunstcharakters."* Altenberge: Oros.

Bsees, Ursula. 2019. "Qurʾānic Quotations in Arabic Papyrus Amulets," in *Qurʾān Quotations Preserved on Papyrus Documents, 7th–10th Centuries*, ed. by Andreas Kaplony and Michael Marx, pp. 112–38. Leiden: Brill.

Büchsel, Martin. 2010. "Materialpracht und die Kunst für 'Litterati': Suger gegen Bernhard von Clairvaux," in *Intellektualisierung und Mystifizierung mittelalterlicher Kunst: "Kultbild": Revision eines Begriffs*, ed. by Martin Büchsel and Rebecca Müller, pp. 155–82. Berlin: Mann.

Bunnens, Guy. 2015. "The Re-emergence of Iron Age Religious Iconography in Roman Syria," in *Religious Identities in the Levant from Alexander to Muhammed: Continuity and Change*, ed. by Michael Blömer, Achim Lichtenberger, and Rubina Raja, pp. 107–28. Turnhout: Brepols.

Buquet, Thierry. 2016. "De la pestilence à la fragrance: L'origine de l'ambre gris selon les auteurs arabes," *Bulletin d'études orientales* 64: 113–33.

Burak, Guy. 2019. "The Section on Prayers, Invocations, Unique Qualities of the Qurʾan, and Magic Squares in the Palace Library Inventory," in *Treasures of Knowledge: An Inventory of the Ottoman Palace Library (1502/3–1503/4)*, vol. 1: *Essays*, ed. by Gülru Necipoğlu, Cemal Kafadar, and Cornell H. Fleischer, pp. 341–66. Leiden: Brill.

Burghartz, Susanna, Lucas Burkart, and Ulinka Rublack, eds. 2021. *Material Identities in Early Modern Culture: Objects–Affects–Effects (1450–1750)*. Amsterdam: ARC, Amsterdam University Press.

Burridge, Claire. 2020. "Incense in Medicine: An Early Medieval Perspective," *Early Medieval Europe* 28: 219–55.

Bussmann, Edna B. 2009. *Unearthing the Truth: Egypt's Pagan and Coptic Sculpture*. New York: Brooklyn Museum.

Çağaptay, Suna. 2018. "On the Wings of the Double-headed Eagle: *Spolia in re* and Appropriation in Medieval Anatolia and Beyond," in *"Spolia" Reincarnated: Afterlives of Objects, Materials, and Spaces in Anatolia from Antiquity to the Ottoman Era*, ed. by Ivana Jevtić and Suzan Yalman, pp 309–38. Istanbul: ANAMED, Koç University Research Center for Anatolian Civilization.

Cahen, Claude. 1934. "*La Djazira* au milieu du treizième siècle d'après ʿIzz ad-Din Ibn Chaddad," *Revue des études islamiques* 8: 109–28.

Caiozzo, Anna. 2008. "Three States of the Moon: Perspective for Understanding the Frontispiece of the Book of Theriac," in *The Paris Kitab al-Diryaq (fac similé et commentaire du Manuscrit Arabe 2964 de la BNF)*, ed. by Oleg Grabar, Jaclynne J. Kerner, and Marie-Geneviève Balty-Guesdon, pp. 36–47. Madrid: Eikon Editores.

Calasso, Giovanna. 1992. "Les Remparts et la loi, les talismans et les saints: La protection de la ville dans les sources muslmanes médiévales," *Bulletin d'études orientales* 44: pp. 93–104.

Calderoni Masetti, Anna Rosa, J. Durand, and Avinoam Shalem. 1999. "Smalto," in *Enciclopedia dell' arte medievale*, vol. 10, ed. by Angiola Maria Romanini, available at https://www.treccani.it/enciclopedia/smalto_%28Enciclopedia-dell%27-Arte-Medievale%29/ (accessed November 14, 2022). Rome: Istituto della Enciclopedia Italiana.

Calì, Maria. 2008. "Per il crocifisso in avorio, già nella cattedrale di Canosa," in *L'enigma degli avori medievali da Amalfi a Salerno*, vol. 1, ed. by Ferdinando Bologna, pp. 231–39. Pozzuoli: Paparo.

Calvo Capilla, Susana. 2001. "Arqueta," in *Maravillas de la España medieval: Tesoro sagrado y monarquía*, ed. by Isidro G. Bango Torviso, p. 113. Valladolid: Junta de Castilla y León.

Camber, Richard. 1981. "A Hoard of Terracotta Amulets from the Holy Land," in *Actes du XVᵉ Congrès internationale d'études byzantines, Athènes, Septembre 1976, II: Art et archéologie, Communications A*, pp. 99–106. Athens: Association internationale des études byzantines.

Cameron, Averil. 1992. "The Language of Images: The rise of Icons and Christian Representation," in *The Church and the Arts*, ed. by Diana Wood, pp. 1–42. Oxford: Blackwell.

Cameron, Averil. 1998. "The Mandylion and Byzantine Iconoclasm," in *The Holy Face and the Paradox of Representation*, ed. by Herbert L. Kessler and Gerhard Wolf, pp. 33–54. Bologna: Nuova Alfa.

Campbell, Gwyn. 2008. "Slave Trades and the Indian Ocean World," in *India in Africa, Africa in India: Indian Ocean Cosmopolitanisms*, ed. by John C. Hawley, pp. 17–54. Bloomington, IN: Indiana University Press.

Camus, Giulio. 1886. *L'Opera salernitana "Circa instans" ed il testo primitivo del "Grant herbier en francoys," secondo due codici del secolo xv, conservati nella Regia biblioteca estense* [extracted from *Memorie della Regia accademia di scienze, lettere ed arti in Modena*, vol. 4, ser. 2, pp. 49ff.]. Modena.

Canaan, Tawfiq. 1914. *Aberglaube und Volksmedizin im Lande der Bibel*. Hamburg: Fiederichsen.

Canaan, Tawfiq. 1936. "Arabic Magic Bowls," *Journal of the Palestine Oriental Society* 16: 79–127.

Canby, Sheila R., Deniz Beyazit, Martina Rugiadi, and A.C.S. Peacock, eds. 2016. *Court and Cosmos: The Great Age of the Seljuqs*. New York: The Metropolitan Museum of Art.

Candlin, Fiona, and Raiford Guins, eds. 2009. *The Object Reader*. London: Routledge.

Canova, Giovanni. 1995. "La *ṭāsat al-ism*: Note su alcune coppe magiche yemenite," *Quaderni di studi arabi* 13: 73–92.

Capps, Edward. 1927. "An Ivory Pyxis in the Museo cristiano and a Plaque from the Sancta sanctorum," *The Art Bulletin* 9: 331–40.

Carboni, Stefano. 1993. "Casket" (cat. no. 47), in *The Art of Medieval Spain, AD 500–1200* (exhibition catalogue, The Metropolitan Museum of Art, New York, November 18, 1993–March 13, 1994), pp. 99–100. New York: The Metropolitan Museum of Art.

Casanova, M. 1921. "Alphabets magiques arabes," *Journal asiatique*, 11th series, 18: 37–55.

Caseau, Beatrice. 1994. "εὐωδία: The Use and Meaning of Fragrances in the Ancient World and Their Christianization (100–900 AD)." PhD dissertation, Princeton University.

Caseau, Beatrice. 2001. "Les Usages médicaux de l'encens et des parfums: Un aspect de la médecine populaire antique et de la christianisation," in *Air, miasmes et contagion: Les épidémies dans l'Antiquité et au Moyen Age*, ed. by Sylvie Bazin-Tacchella, Danielle Quéruel, and Evelyne Samama, pp. 75–85. Langres: Guéniot.

Caseau, Beatrice. 2013. "L'Encens au 7e et 8e siècle: Un marqueur du commerce en Méditerranée?," in *Proceedings of the International Symposium Byzantium and the Arab World. Encounter of Civilizations (Thessaloniki, 16–18 December 2011)*, ed. by Apostolos Kralides and Andreas Gkoutzioukostas, pp. 105–16. Thessaloniki: Aristotle University.

Caseau, Beatrice. 2016. "Encens et sacralisation de l'espace dans le christianisme byzantin," in *Espaces sacrés dans la Méditerranée antique*, ed. by Yves Lafond and Vincent Michel, pp. 253–70. Rennes: Presses universitaires de Rennes.

Castelnuovo, Enrico. 1991. "Materiam superabat opus," in *Ori e argenti dei santi: Il tesoro del Duomo di Trento*, ed. by Enrico Castelnuovo, pp. 11–20. Trento: Temi.

Cecere, Giuseppe. 2019. "From Ethiopian Slave to Egyptian Ṣūfī? Yāqūt al-Ḥabashī in Mamluk and Ottoman Sources," *Northeast African Studies* 19: 87–137.

Certeau, Michel de. 1988. *The Writing of History*, trans. by Tom Conley. New York: Columbia University Press.

Cerulli, Enrico. 1943–47. *Etiopi in Palestina: Storia della comunità di Gerusalemme*, 2 vols. Rome: Libreria dello Stato.

Chakrabarty, Dipesh. 2000. *Provincializing Europe: Postcolonial Thought and Historical Difference*. Princeton, NJ: Princeton University Press.

Chakravarti, Ranabir. 2000. "Nakhudas and Nauvittakas: Ship-owning Merchants in the West Coast of India (c. AD 1000–1500)," *Journal of the Economic and Social History of the Orient* 43: 34–64.

Chakravarti, Ranabir. 2021. *Trade and Traders in Early Indian Society*. London: Routledge.

Chakravarti, Ranabir. 2022. "Indic Mercantile Networks and the Indian Ocean World: A Millennial Overview (c. 500–1500 CE)," in *Early Global Interconnectivity across the Indian Ocean World*, vol. 1: *Commercial Structures and Exchanges*, ed. by Angela Schottenhammer, pp. 191–226. Cham: Palgrave MacMillan.

Chatterjee, Paroma. 2018. "Iconoclasm's Legacy: Interpreting the Trier Ivory," *The Art Bulletin* 100: 28–47.

Chaudhuri, K. N. 1990. *Asia Before Europe: Economy and Civilisation of the Indian Ocean from the Rise of Islam to 1750*. Cambridge: Cambridge University Press.

Chekroun, Amélie, and Bertrand Hirsch. 2020. "The Sultanates of Medieval Ethiopia," in *A Companion to Medieval Ethiopia and Eritrea*, ed. by Samantha Kelly, pp. 86–112. Leiden: Brill.

Cheng, Bonnie. 2018. "A Camel's Pace: A Cautionary Global," in *Re-assessing the Global Turn in Medieval Art History*, ed. by Christina Normore and Carol Symes, pp. 11–34. Amsterdam: ARC, Amsterdam University Press.

Chojnacki, Stanislaw. 2003. "New Aspects of India's Influence on the Art and Culture of Ethiopia," *Rassegna di studi etiopici* n.s. 2: 5–21.

Christie's. 1995. *Islamic Art, Indian Miniatures, Rugs and Carpets* (auction catalogue, London, April 25).

Christie's. 1998. "Islamic" (auction, London, October 13), https://www.christies.com/en/auction/islamic-8271/ (accessed January 13, 2023).

Claussen, Peter Cornelius. 1996. "*Materia* und *opus*: Mittelalterliche Kunst auf der Goldwaage; Mit Hinweisen von Darko Senekovic," in *Ars naturam adiuvans: Festschrift für Matthias Winner zum 2. März 1996*, ed. by Victoria von Flemming and Sebastian Schütze, pp. 40–49. Mainz: Von Zabern.

Clédat, Jean. 1904. *Le Monastère et la Nécropole de Baouit*. Cairo: L'Institut français d'archéologie orientale.

Clédat, Jean. 1999. *"Le Monastère et la Nécropole de Baouit": Notes mises en œuvre et éditées par Dominique Bénazeth et Marie-Hélène Rutschowscaya; avec des contributions de Anne Boud'hors, René-Georges Coquin, Éliane Gaillard*. Cairo: Institut français d'archéologie orientale.

Clifford, James. 1988. *The Predicament of Culture: Twentieth-century Ethnography, Literature, and Art*. Cambridge, MA: Harvard University Press.

Clifford, James. 1997. *Routes: Travel and Translation in the Late Twentieth Century*. Cambridge, MA: Harvard University Press.

Collinet, Annabelle, and David Bourgarit. 2021. *Précieuses matières: Les arts du métal dans le monde iranien médiéval*, vol. 1: *Xe–XIIIe siècles*. Paris: Faton.

Contadini, Anna. 1998. *Fatimid Art at the Victoria and Albert Museum*. London: V&A Publications.

Contadini, Anna. 2017. "Patronage and the Idea of an Urban Bourgeoisie," in *A Companion to Islamic Art and Architecture*, ed. by Finbarr Barry Flood and Gülru Necipoğlu, vol. 2: *From the Mongols to Modernism*, pp. 431–52. Hoboken, NJ: Wiley Blackwell.

Cooke, Edward S., Jr. 2022. *Global Objects: Toward a Connected Art History*. Princeton, NJ: Princeton University Press.

Coole, Diana H. and Samantha Frost, eds. 2010. *New Materialisms: Ontology, Agency, and Politics*. Durham, NC: Duke University Press.

Cooper, Frederick. 2001. "What is the Concept of Globalization Good For? An African Historian's Perspective," *African Affairs* 100 (399): 189–213.

Coulon, Jean-Charles. 2016. "Fumigations et rituels magiques: Le rôle des encens et fumigations dans la magie arabe médiévale," *Bulletin d'études orientales*: 179–248.

Coulon, Jean-Charles. 2017. *La Magie en terre d'islam au Moyen Âge*. Paris: Éditions du Comité des travaux historiques et scientifiques.

Coulon, Jean-Charles. 2021. "The Kitāb Sharāsīm al-Hindiyya and Medieval Islamic Occult Sciences," in *Islamicate Occult Sciences in Theory and Practice*, ed. by Liana Saif, Francesca Leoni, Matthew Melvin-Koushki, and Farouk Yahya, pp. 317–79. Leiden: Brill.

Cremer, Annette Caroline, and Martin Mulsow, eds. 2017. *Objekte als Quellen der historischen Kulturwissenschaften: Stand und Perspektiven der Forschung*. Cologne: Böhlau.

Crone, Patricia, and Adam Silverstein. 2010. "The Ancient Near East and Islam: The Case of Lot-Casting," *Journal of Semitic Studies* 55: 423–50.

Cult of Saints in Late Antiquity database, CSLA no. E02367, http://csla.history.ox.ac.uk/record.php?recid=E02367 (accessed January 13, 2022).

Cunningham, Graham. 1997. *"Deliver Me from Evil": Mesopotamian Incantations, 2500–1500 BC*. Rome: Editrice Pontificio Istituto Biblico.

Curta, Florin. 2004. *The Making of the Slavs: History and Archaeology of the Lower Danube Region, c. 500–700*. Cambridge: Cambridge University Press.

Cutler, Anthony. 1999. "A Christian Ewer with Islamic Imagery and the Question of Arab Gastarbeiter in Byzantium," in *Iconographica: Mélanges offerts à Piotr Skubiszewski par ses amis, ses collègues, ses élèves*, ed. by Marie-Hélène Debiès and Robert Favreau, pp. 63–69. Poitiers: Université de Poitiers.

DaCosta Kaufmann, Thomas, Catherine Dossin, and Béatrice Joyeux-Prunel, eds. 2015. *Circulations in the Global History of Art*. Burlington, VT: Ashgate.

Dagron, Gilbert. 1991. "Holy Images and Likeness," *Dumbarton Oaks Papers* 45: 23–33.

Daim, Falko, Benjamin Fourlas, Katarina Horst, and Visiliki Tsamakta, eds. 2017. *Spätantike und Byzanz: Bestandskatalog Badisches Landesmuseum Karlsruhe; Objekte aus Bein, Elfenbein, Glas, Keramik, Metall und Stein*. Mainz: Verlag des Römisch-Germanischen Zentralmuseums.

Dalley, Stephanie. ed. 1998. *The Legacy of Mesopotamia*. Oxford: Oxford University Press.

Daneshvari, Abbas. 2006. "From Mashu to Qāf: The Iconography of a Minai Bowl," in *Sifting Sands, Reading Signs: Studies in Honour of Professor Géza Fehérvári*, ed. by Patricia L. Baker and Barbara Brend, pp. 177–85. London: Furnace Publishing.

Dasen, Véronique. 2018. "Amulets, the Body and Personal Agency," in *Material Approaches to Roman Magic. Occult Objects and Supernatural Substances*, ed. by Adam Parker and Stuart McKie, pp. 127–35. Oxford: Oxbow Books.

Dasen, Véronique, and Árpád Nagy. 2019. "Gems," in *Guide to the Study of Ancient Magic*, ed. by David Frankfurter, pp. 416–55. Leiden: Brill.

Daston, Lorraine, ed. 2004. *Things That Talk: Object Lessons from Art and Science*. New York: Zone Books.

Davis, Whitney. 1996. *Replications: Archaeology, Art History, Psychoanalysis*. University Park, PA: Pennsylvania State University Press.

Davis, Kathleen, and Nadia Altschul. 2009. "The Idea of the 'Middle Ages' outside Europe," in *Medievalisms in the Postcolonial World: The Idea of "the Middle Ages" outside Europe*, ed. by Kathleen Davis and Nadia Altschul, pp. 1–26. Baltimore: Johns Hopkins University Press.

Davis, Kathleen, and Michael Puett. 2015. "Periodization and 'The Medieval Globe': A Conversation," *The Medieval Globe* 2 (1): 1–14.

Day, Rebecca. 2011. "Imitation in Aksumite Coinage and Indian Imitations of Aksumite Coins," *Rosetta* 9: 16–22.

Derat, Marie-Laure. 2010. "The Zāgwē Dynasty and King Yemreḥanna Krestos," *Annales d'Éthiopie* 25: 157–96.

Derat, Marie-Laure. 2019. *L'Énigme d'une dynastie sainte et usurpatrice dans le royaume chrétien d'Éthiopie du XIᵉ au XIIIᵉ siècle*. Turnhout: Brepols.

Derat, Marie-Laure. 2020a. "Moyen Âge africain: Plaidoyers pour des histoires de l'Afrique," *Médiévales* 79: 209–20.

Derat, Marie-Laure. 2020b. "Before the Solomonids: Crisis, Renaissance, and the Emergence of the Zagwe Dynasty (Seventh–Thirteenth Centuries)," in *A Companion to Medieval Ethiopia and Eritrea*, ed. by Samantha Kelly, pp. 31–56. Leiden: Brill.

Derat, Marie-Laure. 2020c. "L'Affaire des mosques: Interactions entre le vizirat fatimide, le patriarcat d'Alexandrie et de Nubie à la fin du XIᵉ siècle," *Médiévales* 79: 15–36.

Derat, Marie-Laure, Claire Bosc-Tiessé, Antoine Garric, Romain Mensan, François-Xavier Fauvelle, Yves Gleize, and Anne-Lise Goujon. 2021. "The Rock-Cut Churches of Lalibela and the Cave Church of Washa Mika'el: Troglodytism and the Christianisation of the Ethiopian Highlands," *Antiquity* 95: 467–86.

Derat, Marie-Laure, Emmanuel Fritsch, Claire Bosc-Tiessé, Antoine Garric, Romain Mensan, François-Xavier Fauvelle, and Hiluf Berhe. 2020. "Māryām Nāzrēt (Ethiopia): The Twelfth-Century Transformations of an Axumite Site in Connection with an Egyptian Christian Community," *Cahiers d'études africaines* 239: 473–507.

D'Erme, Giovanni M. 2004. "The Capella Palatina in Palermo: An Iconographical Source to be Read in Lieu of Lacking Texts," *Oriente moderno* n.s. 23: 401–16.

Der Nersessian, Sirarpie. 1969. *The Armenians*. London: Thames and Hudson.

Derrida, Jacques. 1995. *Archive Fever: A Freudian Impression*, trans. by Eric Prenowitz. Chicago: University of Chicago Press.

De Silva, Chandra Richard. 1999. "Indian Ocean but not African Sea: The Erasure of East African Commerce from History," *Journal of Black Studies* 29: 684–94.

Desmond, Marilynn, and Noah D. Guynn. 2020. "We Have Always Been Medieval: Bruno Latour and Double Click, Metaphysics and Modernity," *Romanic Review* 111 (1): 1–7.

De Vito, Christian G., and Anne Gerritsen. 2018. "Micro-spatial Histories of Labour: Towards a New Global History," in *Micro-spatial Histories of Global Labour*, ed. by Christian G. De Vito and Anne Gerritsen, pp. 1–28. London: Palgrave Macmillan.

De Winter, Patrick M. 1985. *The Sacral Treasure of the Guelphs*. Cleveland, OH: Indiana University Press.

Diba, L. S. 1996. "Islamic Art VIII, Other Arts 4: Enamel," in *The Dictionary of Art*, ed. by Jane Shoaf Turner, vol. 8, pp. 514–16. London: Grove.

Didi-Huberman, Georges. 2003. "Before the Image, before Time: The Sovereignty of Anachronism," trans. by Peter Mason, in *Compelling Visuality: The Work of Art in and out of History*, ed. by Claire Farago and Robert Zwijnenberg, pp. 31–44. Minneapolis: University of Minnesota Press.

Didi-Huberman, Georges. 2016. *The Surviving Image: Phantoms of Time and Time of Phantoms; Aby Warburg's History of Art*, trans. by Harvey Mendelsohn. University Park, PA: Pennsylvania State University Press.

Diehl, Ursula. 1956. "Die Darstellung der Ehernen Schlange von

ihren Anfängen bis zum Ende des Mittelalters." PhD dissertation, LMU München.

Digard, Jean-Pierre, ed. 2002. *Chevaux et cavaliers arabes dans les arts d'Orient et d'Occident: Exposition présentée a l'Institut du monde arabe, Paris, du 26 novembre 2002 au 30 mars 2002*. Paris: Gallimard.

Digby, Simon. 2008. "The Maritime Trade of India" in *The Cambridge Economic History of India*, vol. 1: *c. 1200–c. 1750*, ed. by Tapan Raychaudhuri and Irfan Habib, pp. 125–60. Cambridge: Cambridge University Press. 2008.

Dmitry Markov/Baldwin's/M&M Numismatics Ltd. 2013. *The New York Saù, Auction XXX: Ancient Greek, Roman and Byzantine Coins, Islamic and World Coins, including an Old Collection of Syracuse Tetradrachms, Coins of Judea* (auction catalogue, New York, January 9, 2013).

Dols, Michael. 1977. *The Black Death in the Middle East*. Princeton, NJ: Princeton University Press.

Donceel-Voûte, Pauline. 2019. "The (In)Visible Evil in Sacred Space: Codes, Keys and Clues to Reading Its Image," in *Zeichentragende Artefakte im sakralen Raum: Zwischen Präsenz und UnSichtbarkeit*, ed. by Wilfried E. Keil, Sarah Kiyanrad, Christoffer Theis, and Laura Willer, pp. 17–54. Berlin: De Gruyter.

Donzel, Emeri van. 1980. "The Ethiopian Presence in Jerusalem until 1517," in *The Third International Conference on Bilad al-Sham, Palestine 19–24 April 1980*, vol. 1, pp. 93–104. Amman: Royal Scientific Society Press.

Donzel, Emeri van. 1986. "Quelque remarques sur le *Tanwīr al-Ghabash fī faḍl al-Sūdān wa l-Ḥabash* d'Ibn al-Djawzī," in *Actas del XII Congreso de la U.E.A.I. Malaga, 1984*, pp. 243–56. Madrid: Union Européenne D'Arabisants et D'Islamisants.

Donzel, Emeri van. 1989. "Ibn al-Jawzī on Ethiopians in Baghdad," in *The Islamic World from Classical to Modern Times: Essays in Honour of Bernard Lewis*, ed. by C. E. Bosworth, Charles Issawi, Roger Savory, and A. L. Udovitch, pp. 113–20. Princeton, NJ: Darwin Press.

Doresse, Jean. 1970. *Histoire de l'Éthiopie*. Paris: Presses universitaires de France.

Dorpmueller, Sabine. 2012. "Seals in Islamic Magical Literature," in *Seals and Sealing Practices in the Near East: Developments in Administration and Magic from Prehistory to the Islamic Period*, ed. by Ilona Regulski, Kim Duistermaat, and Peter Verkinderen, pp. 189–208. Leuven: Peeters.

D'Ottone, Arianna. 2013. "A Far Eastern Type of Print Technique for Islamic Amulets from the Mediterranean: An Unpublished Example," *Scripta* 6: 67–74.

D'Ottone Rambach, Arianna, Erika Zwierlein-Diehl, and Hadrien J. Rambach. 2020. "The Roman Past in 7th/13th century Ḥamā (Syria): A Brass Cast of a Cameo with the Portrait of Nero in the Treasure of al-Malik al-Manṣūr II," in *Before Archaeology. The Meaning of the Past in the Islamic Pre-Modern Thought (and After)*, ed. by Leonardo Capezzone, pp. 143–76. Rome: Artemide.

Douki, Caroline, and Philippe Minard. 2007. "Global History, Connected Histories: A Shift of Historiographical Scale?," *Revue d'histoire moderne et contemporaine* 54–4 (5): 7–21.

Dozio, Esaù. 2016. "Friedrich Ludwig Breusch und die byzantinische Sammlung des Basler Antikenmuseums," *Numismatica e antichità classiche: Quaderni ticinesi* 45: 273–82.

Drpić, Ivan. 2014. "The Patron's 'I': Art, Selfhood, and the Later Byzantine Dedicatory Epigram," *Speculum* 89: 895–935.

Ducène, Jean-Charles. 2015. "Une nouvelle source arabe sur l'océan indien au Xᵉ siècle: Le *Ṣaḥīḥ min aḫbār al-biḥār wa-'aǧā'ibihā* d'Abū 'Imrān Mūsā ibn Rabāḥ al-Awsī al-Sīrāfī," *Afriques* 6, https://journals.openedition.org/afriques/1746.

Dudbridge, Glen. 2018. "Rethinking the World System Paradigm," in *Past and Present* 238, supplementary issue 13, *The Global Middle Ages*, ed. by Catherine Holmes and Naomi Standen, pp. 297–316.

Dunbabin, Katherine M. D., and M. W. Dickie. 1983. "*Invida rumpantur pectora*: The Iconography of Phthonos-Invidia in Graeco-Roman Art," *Jahrbuch für Antike und Christentum* 26: 7–37.

Duncanson, D. J. 1947. "Girmaten: A New Archaeological Site in Eritrea," *Antiquity* 2: 158–63.

Eastmond, Anthony. 2008. "Art and the Periphery," in *The Oxford Handbook of Byzantine Studies*, ed. by Robin Cormack, John F. Haldon, and Elizabeth Jeffreys, pp. 770–76. Oxford: Oxford University Press, 2008.

Eastmond, Anthony. 2015. "Other Encounters: Popular Belief and Cultural Convergence in Anatolia and the Caucasus," in *Islam and Christianity in Anatolia and the Caucasus*, ed. by A.C.S. Peacock, pp. 183–213. Farnham: Ashgate.

Eastmond, Anthony. 2017. *Tamta's World: The Life and Encounters of a Medieval Noblewoman from the Middle East to Mongolia*. Cambridge: Cambridge University Press.

Ebied, R. Y. and M.J.L. Young. 1974. "A Fragment of a Magic Alphabet from the Cairo Genizah," *Sudhoffs Archiv* 58: 404–8.

Eder, Barbara. 2000. "Christliche Weihrauchfässer des ersten Jahrtausends." PhD dissertation, University of Salzburg.

El-Antony, Maximous, Jesper Blid, and Aaron Michael Butts. 2016. "An Early Ethiopic Manuscript Fragment (Twelfth–Thirteenth Century) from the Monastery of St. Antony (Egypt)," *Aethiopica* 19: 27–51.

Elbern, Viktor H. 1967. *Symeon Stylites: Verehrung und Darstellung der Säulenheiligen im christlichen Osten und frühen Abendland; Neu aufgetauchte koptische Reliefs*. Berlin: De Gruyter.

Elbern, Viktor H. 1970. "Neuerworbene Bronzebildwerke in der Frühchristlichbyzantinischen Sammlung," *Berliner Museen* 20: 2–16.

Elbern, Viktor H. 1972–74. "Zur Morphologie der bronzenen Weihrauchgefässe aus Palästina," *Arquivo español de arqueología* 45–47 (12): 447–62.

Elbern, Viktor H. 2004. "Zehn Kelche und eine Taube: Bemerkungen zum liturgischen Schatzfund von Attarouhti [Attarouthi]," *Oriens christianus* 88: 233–53.

Élias, Girmah, Claude Lepage, and Jacques Mercier. 2001. "Peintures murales du XIIIᵉ siècle découvertes dans l'église Yemrehanna Krestos en Éthiopie," *Comptes rendus des séances de l'Académie des inscriptions et belles-lettres* 145: 311–34.

Elkins, James, Zhivka Valiavicharska, and Alice Kim, eds. 2010. "The Prehistory of Globalization," in *Art and Globalization*, vol. 1 (seminar 3), ed. by James Elkins, Zhivka Valiavicharska, and Alice Kim, pp. 37–49. University Park, PA: Pennsylvania State University Press.

El-Leithy, Tamer. 2011. "Living Documents, Dying Archives: Towards a Historical Anthropology of Medieval Arabic Archives," *Al-Qantara* 32 (2): 389–434.

Elsberg, H. A., and R. Guest. 1936. "The Veil of Saint Anne," *The Burlington Magazine for Connoisseurs*, 68 (396): 140–47.

Elsner, Jaś. 2012. "Iconoclasm as Discourse: From Antiquity to Byzantium," *The Art Bulletin* 94: 7–27.

Elsner, Jaś. 2013. "Objects and History," in *Cultural Histories of the Material World*, ed. by Peter Miller, pp. 165–71. Ann Arbor, MI: The University of Michigan Press.

Elsner, Jaś. 2019. "Concealment and Revelation: The Pola Casket and the Visuality of Early Christian Relics," in *Conditions of Visibility*, ed. by Richard Neer, pp. 74–110. Oxford: Oxford University Press.

Elsner, Jaś, ed. 2020. *Empires of Faith in Late Antiquity: Histories of Art and Religion from India to Ireland*. Cambridge: Cambridge University Press.

Elvira Barba, Miguel Ángel. 1986. "Un nuevo incensario palestino," *Erytheia: Revista de estudios bizantinos y neogriegos* 7: 253–69.

Emberling, Geoff, and Bruce Williams. eds. 2020. *The Oxford Handbook of Ancient Nubia*. New York: Oxford University Press.

Enderwitz, Susanne. 1979. *Gesellschaftlicher Rang und ethnische Legitimation: Der arabische Schriftsteller Abū ʿUt̲mān al-Ǧāḥiẓ (gest. 868) über die Afrikaner, Perser und Araber in der islamischen Gesellschaft*. Freiburg: Klaus Schwarz.

Engemann, Josef. 1973. "Palästinensische Pilgerampullen im F. J. Dölger-Institut in Bonn," *Jahrbuch für Antike und Christentum* 16: 5–27.

Engemann, Josef. 2002. "Palästinensische frühchristliche Pilgerampullen," *Jahrbuch für Antike und Christentum* 45: 133–69.

Erdmann, Kurt. 1942. "Die Bergkristall-Arbeiten der Islamischen Abteilung," *Berliner Museen* 63: 7–10.

Erginsoy, Ülker. 1978. *İslam Made Sanatinin Gelişmesi*. Istanbul: Kültür Bakanlığı Yayinlari.

Ettinghausen, Richard. 1977. *Arab Painting*. New York: Rizzoli.

Ettinghausen, Richard, Oleg Grabar, and Marilyn Jenkins-Madina. 2001. *Islamic Art and Architecture 650–1250*. New Haven, CT: Yale University Press.

Evans, Helen C., and Brandie Ratliff, eds. 2012. *Byzantium and Islam: Age of Transition, 7th–9th Century*. New York: The Metropolitan Museum of Art.

Farago, Claire. 2017. "Imagining Art History Otherwise," in *Global and World Art in the Practice of the University Museum*, ed. by Jane Chin Davidson and Sandra Esslinger, pp. 115–30. London: Routledge.

Faraj, Ali. 2014. "Iconografia delle coppe di incantesimo aramaiche-babilonesi," *Quaderni asiatici* 106: 7–20.

Faraj, Ali. 2017. "An Arabic Incantation for the Sulṭān al-Malik al-Manṣūr Ḥusām al-Dīn Lāǧīn," *Studi sull'oriente cristiano* 21: 323–31.

Faraone, Christopher A. 2017. "A Copper Plaque in the Louvre (inv. AD 003732): Composite Amulet or Pattern-Book for Making Body-Amulets?," *Kernos* 30: 187–220.

Faraone, Christopher A. 2018. *The Transformation of Greek Amulets in Roman Imperial Times*. Philadelphia: University of Pennsylvania Press.

Fauth, Wolfgang. 1999. "Der christliche Reiterheilige des Sisinnios-Typs im Kampf gegen eine vielnamige Dämonin," *Vigilae Christianae* 53: 401–25.

Fauvelle, François-Xavier. 2017. "Trade and Travel in Africa's Global Age (AD 700–1500)," in *Global Africa: Into the Twenty-First Century*, ed. by Dorothy L. Hodgson and Judith A. Byfield, pp. 17–26. Oakland, CA: University of California Press.

Fauvelle, François-Xavier. 2018. *The Golden Rhinoceros: Histories of the African Middle Ages*, trans. by Troy Tice. Princeton, NJ: Princeton University Press.

Fauvelle-Aymar, François-Xavier, Laurent Bruxelles, Amélie Chekroun, Romain Mensan, Olivier Onézime, Asnake Wutebe, Deresse Ayenatchew, Hailu Zeleke, Bertrand Hirsch, and Ahmed Mohamed. 2006. "A Topographic Survey and Some Soundings at Nora, an Ancient Muslim Town of Ethiopia," *Journal of Ethiopian Studies* 39 (1–2): 1–11.

Fauvelle-Aymar, François-Xavier, Laurent Bruxelles, Romain Mensan, Claire, Bosc-Tiessé, Marie-Laure Derat, and Emmanuel Fritsch. 2010. "Rock-Cut Stratigraphy: Sequencing the Lalibela Churches," *Antiquity* 84 (326): 1135–50.

Fauvelle-Aymar, François-Xavier, and Bertrand Hirsch. 2011. "Muslim Historical Spaces in Ethiopia and the Horn of Africa: A Reassessment," *Northeast African Studies* 11: 25–53.

Fauvelle-Aymar, François-Xavier, Bertrand Hirsch, Laurent Bruxelles, Chalachew Mesfin, Amélie Chekroun, and Deresse Ayenatchew.

2006. "Reconnaissance de trois villes musulmanes de l'époque médiévale dans l'Ifat," *Annales d'Éthiopie* 22: 133–75.

Fauvelle-Aymar, François-Xavier, Bertrand Hirsch, Clément Ménard, Romain Mensan, and Stéphane Pradines. 2009–10. "Archéologie et histoire de l'Islam dans la Corne de l'Afrique: État des recherches," *Civiltà del Mediterraneo* 16–17: 29–58.

Favreau, Robert. 1997. *Épigraphie médiévale*. Turnhout: Brepols.

Fazioli, K. Patrick. 2017. *The Mirror of the Medieval: An Anthropology of the Western Historical Imagination*. New York: Berghahn.

Filipová, Alžběta. 2015. "On the Origins of the Monza Collection of Holy Land 'ampullae': The Legend of Gregory the Great's Gift of Relics to Theodelinda Reconsidered," *Arte lombarda*: 5–16.

Fillitz, Hermann, and Martina Pippal. 1987. *Schatzkunst: Die Goldschmiede- und Elfenbeinarbeiten aus österreichischen Schatzkammern des Hochmittelalters*. Salzburg: Residenz.

Findlen, Paula, ed. 2013. *Early Modern Things: Objects and Their Histories, 1500–1800*. Abingdon: Routledge.

Finneran, Niall. 2009. "Built by Angels? Towards a Buildings Archaeology Context for the Rock-Hewn Medieval Churches of Ethiopia," *World Archaeology* 41: 415–29.

Fiori, Emiliano. 2017. "A Hitherto Unknown Medical Fragment in Syriac: Evidence of Recipes from the Qubbet el-Ḥazne of the Umayyad Mosque in Damascus," *Aramaic Studies* 15: 200–229.

Fischer, Ellinor. 2015. "Ein Weihrauchgefäss mit neutestamentlichen Szenen," in *Zeugnisse spätantiken und frühchristlichen Lebens im römischen Reich*, ed. by Suzana Hodak, Dieter Korol, and Peter Maser, pp. 86–95. Oberhausen: Athena.

Fleisher, Jeffrey, Paul Lane, Adria LaViolette, Mark Horton, Edward Pollard, Eréndina Quintana Morales, Thomas Vernet, Annalisa Christie, and Stephanie Wynne-Jones. 2015. "When Did the Swahili Become Maritime?," *American Anthropologist* 117 (1): 100–115.

Flood, Finbarr Barry. 2001. "The Medieval Trophy as an Art Historical Trope: Coptic and Byzantine 'Altars' in Islamic Contexts," *Muqarnas* 18: 41–72.

Flood, Finbarr Barry. 2006. "Image against Nature: *Spolia* as Apotropaia in Byzantium and the Dar al-Islam," *The Medieval History Journal* 9 (1), special issue: *Mapping the Gaze. Vision and Visuality in Classical Arab Civilisation*, ed. by Nadia al-Bagdadi: 143–66.

Flood, Finbarr Barry. 2009a. *Objects of Translation: Material Culture and Medieval "Hindu-Muslim" Encounter*. Princeton, NJ: Princeton University Press.

Flood, Finbarr Barry. 2009b. "An Ambiguous Aesthetic: Crusader *spolia* in Ayyubid Jerusalem," in *Ayyubid Jerusalem: The Holy City in Context 1187–1250*, ed. by Robert Hillenbrand and Sylvia Auld, pp. 202–15. London: Altajir Trust.

Flood, Finbarr Barry. 2012. "Gilding, Inlay and the Mobility of Metallurgy: A Case of Fraud in Medieval Kashmir," in *Metalwork and Material Culture in the Islamic World: Art, Craft and Text; Essays Presented to James W. Allan*, ed. by Venetia Porter and Mariam Rosser-Owen, pp. 131–42. London: I.B. Tauris.

Flood, Finbarr Barry. 2014. "Bodies and Becoming: Mimesis, Mediation, and the Ingestion of the Sacred in Christianity and Islam," in *Sensational Religion: Sensory Cultures in Material Practice*, ed. by Sally M. Promey, pp. 459–93. New Haven, CT: Yale University Press.

Flood, Finbarr Barry. 2017. "A Turk in the Dukhang? Comparative Perspectives on Elite Dress in Medieval Ladakh and the Caucasus," in *Interaction in the Himalayas and Central Asia: Processes of Transfer, Translation and Transformation in Art, Archaeology, Religion and Polity; Proceedings of the Third International Conference of the Société européenne pour l'étude des civilisations de l'Himalaya et de l'Asie centrale, Vienna, 2013*, ed. by Eva Allinger, Frantz Grenet, Christian Jahoda, Maria-Katharina Lang, and

Anne Vergati, pp. 227–53. Vienna: Austrian Academy of Sciences Press.

Flood, Finbarr Barry. 2018. "Picasso the Muslim: Or, How the *Bilderverbot* Became Modern (Part 2)," *Res: Anthropology and Aesthetics* 69–70: 251–68.

Flood, Finbarr Barry. 2019a. *Technologies de dévotion dans les arts de l'Islam: Pèlerins, reliques et copies*. Paris: Hazan/Musée du Louvre.

Flood, Finbarr Barry. 2019b. "Before the Mughals: Material Culture of Pre-Mughal North India," *Muqarnas* 36: 1–40.

Flood, Finbarr Barry, David Joselit, Alexander Nagel, Alessandra Russo, Eugene Wang, Christopher Wood, and Mimi Yiengpruk-sawan. 2010. "Roundtable: The Global before Globalization," *October* 133 (Summer): 3–19.

Fodor, Alexander. 1994. "Arabic Bowl Divination and the Greek Magical Papyri," in *Proceedings of the Colloquium on Popular Customs and the Monotheistic Religions in the Middle East and North Africa*, ed. by Alexander Fodor and Avihai Shivtiel (= *The Arabist* 9–10), pp. 73–101. Budapest: Eőtvős Loránd University Chair for Arabic Studies.

Forrer, Robert. 1911. *Die römischen Terrasigillata-Töpfereien von Heiligenberg-Dinsheim und Ittenweiler im Elsass: Ihre Brennöfen, Form- und Brenngeräte, ihre Künstler, Fabrikanten und Fabrikate*. Stuttgart: Kohlhammer.

Foskolou, Vassiliki. 2005. "The Virgin, the Christ-child and the Evil Eye," in *Images of the Mother of God: Perceptions of the Theotokos in Byzantium*, ed. by Maria Vassilaki, pp. 251–62. London: Routledge.

Foskolou, Vicky A. 2014. "The Magic of the Written Word. The Evidence of Inscriptions on Byzantine Magical Amulets," Δελτίον της Χριστιανικής Αρχαιολογικής Εταιρείας 35: 329–48.

Foucault, Michel. 1972. *The Archaeology of Knowledge and the Discourse on Language*, trans. by A. M. Sheridan Smith. New York: Pantheon.

Franco Mata, María Ángela. 2011. "Arte medieval leonés fuera de España," in *La dispersión de objetos de arte fuera de España en los siglos XIX y XX*, ed. by Fernando Pérez Mulet and Immaculada Socias Batet, p. 111. Barcelona: Universitat de Barcelona.

Frank, Andre Gunder. 1990. "The Thirteenth-Century World System: A Review Essay," *Journal of World History* 1 (2): 249–56.

Frank, Andre Gunder, and Barry K. Gills, eds. 1996. *The World System: Five Hundred Years or Five Thousand?*. London: Routledge.

Frank, Georgia. 2006. "Loca Sancta Souvenirs and the Art of Memory," in *Pèlerinages et lieux saints dans l'Antiquité et le Moyen Âge: Mélanges offerts à Pierre Maraval*, ed. by Béatrice Caseau-Chevallier, Jean-Claude Cheynet, and Vincent Déroche, pp. 193–201. Paris: Association des amis du Centre d'histoire et civilisation de Byzance.

Frankfurter, David. 2004. "The Binding of Antelopes: A Coptic Frieze and its Egyptian Religious Context," *Journal of Near Eastern Studies* 63: 97–109.

Frankfurter, David. 2015. "Scorpion/Demon: On the Origin of the Mesopotamian Apotropaic Bowl," *Journal of Near Eastern Studies* 74: 9–18.

Frankfurter, David. 2019. "The Magic Writing in Mediterranean Antiquity," in *Guide to the Study of Ancient Magic*, ed. by David Frankfurter, pp. 626–58. Leiden: Brill.

Frazer, James George. 2009. *The Golden Bough: A Study in Magic and Religion: A New Abridgement from the Second and Third Editions*, ed. by Robert Fraser. Oxford: Oxford University Press.

Frazer, Margaret E. 1979. "Holy Sites Representations," in *Age of Spirituality*, ed. by Kurt Weitzmann, pp. 564–68. New York: The Metropolitan Museum of Art.

Frazer, Margaret E. 1988. "Silver Liturgical Objects from Attarouthi

in Syria," in *Fourteenth Annual Byzantine Studies Conference: Abstracts of Papers*, pp. 13–14. Madison, WI: Byzantine Studies Conference.

Freddolini, Francesco, and Marco Musillo, eds. 2020. *Art, Mobility, and Exchange in Early Modern Tuscany and Eurasia*. New York: Routledge.

Frenkel, Miriam, and Ayala Lester. 2015. "Evidence of Material Culture from the Geniza: An Attempt to Correlate Textual and Archeological Findings," in *Material Evidence and Narrative Sources*, ed. by Daniella Talmon-Heller, pp. 147–87. Leiden: Brill.

Fricke, Beate. 2012. "Matter and Meaning of Mother-of-Pearl: The Origins of Allegory in the Spheres of Things," *Gesta* 51: 35–53.

Fricke, Beate. 2015. *Fallen Idols, Risen Saints: Sainte Foy of Conques and the Revival of Monumental Sculpture in Medieval Art*. Turnhout: Brepols.

Fricke, Beate. 2020. "Hinges as Hints: Heaven and Earth in the Coconut Goblet at the Cathedral of Münster, Part of a Lost Rock Crystal Ensemble," in *Seeking Transparency: Rock Crystals Across the Medieval Mediterranean*, ed. by Cynthia Hahn and Avinoam Shalem, pp. 197–209. Berlin: Mann.

Fricke, Beate, and Aden Kumler. 2022. "Introduction," in *Destroyed—Disappeared—Lost—Never Were*, ed. by Beate Fricke and Aden Kumler, pp. 1–21. University Park, PA: Pennsylvania State University Press.

Fricke, Beate. 2023. *Holy Smoke*. Munich: Hirmer.

Fries, Karl. 1893. "The Ethiopic Legend of Socinius and Ursula," in *Actes du Huitième congrès international des orientalists, tenu en 1889 à Stockholm e à Christiania; Section 1: Semitique*, vol. 2, pp. 55–70. Leiden: Brill.

Fritz, Rolf. 1977. "Der Kokosnußpokal der persischen Sibylle von Hermann tom Ring und seine Bedeutung," *Westfalen* 55: 93–97.

Fritz, Rolf. 1983. *Die Gefässe aus Kokosnuss in Mitteleuropa, 1250–1800*. Mainz: Von Zabern.

Gabrieli, Francesco, and Umberto Scerrato. 1979. *Gli arabi in Italia: Cultura, contatti e tradizioni*. Milan: Scheiwiller.

Gager, John G. 1999. *Curse Tablets and Binding Spells from the Ancient World*. Oxford: Oxford University Press.

Gane, Constance Ellen. 2012. "Composite Beings in Neo-Babylonian Art." PhD dissertation, University of California, Berkeley.

García Lobo, Vicente, and Encarnación Martín López (with Santiago Domínguez Sánchez and Ana Isabel Suárez González). 1995. *De epigrafía medieval: Introducción y álbum*. León: Universidad de León.

Gardiner, Noah. 2017. "Stars and Saints: The Esotericist Astrology of the Sufi Occultist Aḥmad al-Būnī," *Magic, Ritual and Witchcraft* 12: 39–65.

Garel, Esther. 2016. "Lettre concernant l'envoi d'un papyrus iatro-magique et une requisition de lain be mouton (P. Vindob. Inv. K55)," *Journal of Coptic Studies* 18: 45–55.

Gearhart, Heidi C. 2017. *Theophilus and the Theory and Practice of Medieval Art*. University Park, PA: Pennsylvania State University Press.

Gebremariam, Kidane Fanta, Lise Kvittingen, and Florinel-Gabriel Banica. 2013. "Application of a Portable XRF Analyzer to Investigate the Medieval Wall Paintings of Yemrehanna Krestos Church, Ethiopia," *X-Ray Spectrometry* 42: 462–69.

Geisberg, Max. 1937. *Die Stadt Münster*, vol. 5: *Der Dom*. Münster: Aschendorf.

Gell, Alfred. 1977. "Magic, Perfume, Dream," in *Symbols and Sentiments: Cross-Cultural Studies in Symbolism*, ed. by Ioan Lewis, pp. 25–38. London: Academic Press.

Gell, Alfred. 1988. "Technology and Magic," *Anthropology Today* 4: 6–9.

Gell, Alfred. 1992. "The Technology of Enchantment and the Enchantment of Technology," in *Anthropology, Art, and Aes-*

thetics, ed. by Jeremy Coote and Anthony Shelton, pp. 40–63. Oxford: Clarendon Press.

Gell, Alfred. 1998. *Art and Agency: An Anthropological Theory*. Oxford: Clarendon Press.

George, Alain F. 2010. *The Rise of Islamic Calligraphy*. London: Saqi.

George, Alain F. 2011. "The Illustrations of the *Maqāmāt* and the Shadow Play," *Muqarnas* 28: 1–42.

George, Alain F. 2012. "Orality, Writing and the Image in the *Maqamat*: Arabic Illustrated Books in Context," *Art History* 35: 10–37.

George, Andrew R., ed. 2011. *Cuneiform Royal Inscriptions and Related Texts in the Schøyen Collection*. Bethesda, MD: CDL Press.

Gerevini, Stefania. 2014. "*Christus crystallus*: Rock Crystal, Theology and Materiality in the Medieval West," in *Matter of Faith: An Interdisciplinary Study of Relics and Relic Veneration in the Medieval Period*, ed. by James Robinson and Lloyd de Beer, with Anna Arnden, pp. 92–99. London: British Museum Press.

Gerritsen, Anne, and Giorgio Riello, eds. 2016. *The Global Lives of Things: The Material Culture of Connections in the Early Modern World*. London: Routledge.

Gervers, Michael. 1990. "Cotton and Cotton Weaving in Meroitic Nubia and Medieval Ethiopia," *Textile History* 21: 13–30.

Gervers, Michael. 2014. "Churches Built in the Caves of Lasta (Wällo Province, Ethiopia): A Chronology," *Aethiopica* 17: 25–64.

Gervers, Michael. 2017. "The West Portal Ceiling Paintings in the Zagwe Church of Yəmrəḥannä Krəstos," in *Studies in Ethiopian Languages, Literature, and History: Festschrift for Getatchew Haile*, ed. by Adam Carter McCollum, pp. 35–64. Wiesbaden: Harrasowitz.

Géza, Jászai. 1991. *Die Domkammer der Kathedralkirche Sankt Paulus in Münster: Kommentare zu ihrer Bilderwelt*. Münster: Domverwaltung.

Géza, Jászai. 2000. *Der Dom zu Münster und seine Kunstschätze*. Münster: Dialogverlag.

Ghosh, Amitav. 1993. "The Slave of Ms. H.6," in *Subaltern Studies VII: Writing on South Asian History and Society*, ed. by Partha Chatterjee and Gyanendra Pandey, pp. 159–220. Delhi: Oxford University Press.

Gierlichs, Joachim. 1993. *Drache, Phönix, Doppeladler: Fabelwesen in der islamischen Kunst*. Berlin: Mann.

Gierlichs, Joachim. 1996. *Mittelalterliche Tierreliefs in Anatolien und Mesopotamien: Untersuchungen zur figürlichen Baudekoration der Seldschuken, Artuqiden und ihrer Nachfolger bis ins 15. Jahrhundert*. Tübingen: Wasmuth.

Giladi, Avner. 2014. *Muslim Midwives: The Craft of Birthing in the Premodern Middle East*. Cambridge: Cambridge University Press.

Ginzburg, Carlo. 1993. "Microhistory: Two or Three Things that I Know about It," trans. by John Tedeschi and Anne C. Tedeschi, *Critical Inquiry* 20: 10–35.

Giumlia-Mair, Alessandra. 2000. "Solfuri metallici su oro, argento e leghe a base di rame," in *Le scienze della terra e l'archeometria: Atti della 6ª giornata, Este, Museo nazionale atestino, 26 e 27 febbraio 1999*, ed. by Claudio D'Amico and Chiara Tampellini, pp. 135–41. Este: Grafica atestina.

Giunta, Roberta. 2018. *The Aron Collection—1: Islamic Magic-Therapeutic Bowls*. Rome: Istituto per l'oriente C. A. Nallino.

Gladiss, Almut von. 1999. "Medizinische Schalen: Ein islamisches Heilverfahren und seine mittelalterlichen Hilfsmittel," *Damaszener Mitteilungen* 11: 147–61.

Gleixner, Ulrike, and Marília dos Santos Lopez, eds. 2021. *Things on the Move—Dinge unterwegs: Objects in Early Modern Cultural Transfer*. Wiesbaden: Harrassowitz.

Gmelin, Leopold. 1890. "Die mittelalterliche Goldschmiedekunst in den Abruzzen," *Zeitschrift des Bayerischen Kunstgewerbevereins in München*: 133–49.

Gnisci, Jacopo. 2020. "Constructing Kingship in Early Solomonic Ethiopia: The David and Solomon Portraits in the Juel-Jensen Psalter," *The Art Bulletin* 102: 7–36.

Godlewski, Włodzimierz. 1982. "Some Comments on the Wall Paintings of Christ from Old Dongola," in *Nubian Studies: Proceedings of the Symposium for Nubian Studies, Selwyn College, Cambridge, 1978*, ed. by J. M. Plumley, pp. 95–99. Warminster: Aris & Philips.

Goitein, Shlomo Dov. 1999. *A Mediterranean Society: The Jewish Communities of Arab World as Portrayed in the Documents of the Cairo Geniza*. Berkeley, CA: University of California Press.

Goitein, Shlomo Dov. 2008. *India Traders of the Middle Ages: Documents from the Cairo Geniza*, 2 vols. Leiden: Brill 2008.

Goldberg, Jessica L. 2012. *Trade and Institutions in the Medieval Mediterranean: The Geniza Merchants and Their Business World*. Cambridge: Cambridge University Press.

Goldenberg, David M. 2003. *The Curse of Ham: Race and Slavery in Early Judaism, Christianity, and Islam*. Princeton, NJ: Princeton University Press.

Goldschmidt, Adolph. 1918. *Die Elfenbeinskulpturen aus der Zeit der karolingischen und sächsischen Kaiser, VIII.–XI. Jahrhundert*, vol. 2. Berlin: Bruno Cassirer.

Gomez, Michael A. 2018. *African Dominion: A New History of Empire in Early and Medieval West Africa*. Princeton, NJ: Princeton University Press.

Gómez-Moreno, Manuel. 1925. *Catálogo monumental de España: Provincia de León*. Madrid: Ministerio de Instrucción Pública y Bellas Artes.

Gonnella, Julia. 2010. "Columns and Hieroglyphs: Magic '*spolia*' in Medieval Islamic Architecture of Northern Syria," *Muqarnas* 27: 103–20.

Gonnella, Julia, Wahid Khayyata, and Kay Kohlmeyer, eds. 2005. *Die Zitadelle von Aleppo und der Tempel des Wettergottes: Neue Forschungen und Entdeckungen*. Münster: Rhema.

Gontero-Lauze, Valérie. 2010. *Sagesses minerales: Médecine et magie des pierres précieuses au Moyen Âge*. Paris: Garnier.

Gordon, Cyrus H. 1994. "Incantation Bowls from Knossos and Nippur," *American Journal of Archaeology* 68: 194–95.

Gordon, Richard. 2012. "Memory and Authority in the Magical Papyri," in *Historical and Religious Memory in the Ancient World*, ed. by Beate Dignas and R.R.R. Smith, pp. 145–80. Oxford: Oxford University Press.

Gori, Alessandro. 2006. *Contatti culturali nell'Oceano Indiano e nel Mar Rosso e processi di islamizzazione*. Venice: Cafoscarina.

Gori, Alessandro. 2007. "Inscriptions: Arabic Inscriptions in the Ethiopian Regions," in *Encylopaedia Aethiopica*, ed. by Siegbert Uhlig et al., vol. 3: *He–N*, pp. 165–67. Wiesbaden: Harrassowitz.

Gori, Alessandro. 2020. "Islamic Cultural Traditions of Medieval Ethiopia and Eritrea," in *A Companion to Medieval Ethiopia and Eritrea*, ed. by Samantha Kelly, pp. 142–61. Leiden: Brill.

Göttler, Christine, and Mia M. Mochizuki. eds. 2018. *The Nomadic Object: The Challenge of World for Early Modern Religious Art*. Leiden: Brill.

Grabar, André. 1958. *Ampoules de Terre Sainte (Monza–Bobbio)*. Paris: Klincksieck.

Grabar, Oleg. 1963a. "The Illustrations of the *Maqamat*," in *Proceedings of the 25th International Congress of Orientalists, Moscow, August 9–16 1960*, vol. 2, pp. 46–47. Moscow: 1963.

Grabar, Oleg. 1963b. "A Newly Discovered Illustrated Manuscript of the *Maqāmāt* of Ḥarīrī," *Ars Orientalis* 5: 97–109.

Grabar, Oleg. 1984. *The Illustrations of the Maqamat*. Chicago: University of Chicago Press.

Grabar, Oleg. 1994. "The Shared Culture of Objects," in *Byzantine*

Court Culture from 829 to 1204, ed. by Henry Maguire, pp. 115–29. Washington, DC: Dumbarton Oaks Research and Library Collection.

Grabar, Oleg. 2006a. "The Illustrated *Maqamat* of the Thirteenth Century: The Bourgeoisie and the Arts," in Grabar, *Islamic Visual Culture, 1100–1800*, vol. 2: *Constructing the Study of Islamic Art*, pp. 167–86. Aldershot: Ashgate 2006 [first published in *The Islamic City*, ed. by A. H. Hourani and S. M. Stern, pp. 207–22. Oxford: Bruno Cassirer, 1970].

Grabar, Oleg. 2006b. "Pictures or Commentaries: The Illustrations of the *Maqamat* of al-Hariri," in Grabar, *Islamic Visual Culture, 1100–1800*, vol. 2: *Constructing the Study of Islamic Art*, pp. 187–205. Aldershot: Ashgate [first published in *Studies in Art and Literature of the Near East in Honor of Richard Ettinghausen*, ed. by Peter J. Chelkowski, pp. 85–104. Salt Lake City: Middle East Center, University of Utah; New York: New York University Press, 1974].

Graves, Margaret S. 2018. *Arts of Allusion: Object, Ornament, and Architecture in Medieval Islam*. Oxford: Oxford University Press.

Graves, Margaret S. 2022. "Beyond the Beholder's Share: Painting as Process," in *Fruits of Knowledge, Wheel of Learning: Essays in Honour of Robert Hillenbrand*, ed. by Melanie Gibson, pp. 98–129. London: Gingko.

Gray, Basil. 1939. "A Seljuq Hoard from Persia," *The British Museum Quarterly* 13: 73–79.

Grébaut, Sylvain. 1937. "Le Légende de Sousneyos et de Werzelyâ d'après le ms. éthiop. Griaule no. 297," *Orientalia* 6: 177–83.

Green, Anthony. 1997. "Myths in Mesopotamian Art," in *Sumerian Gods and their Representations*, ed. by Irving L. Finkel and Markham J. Geller, pp. 135–58. Groningen: STYX.

Greenfield, Richard H. 1989. "Saint Sisinnios, the Archangel Michael and the Female Demon Gylou: The Typology of the Greek Literary Stories," *Byzantina* 15: 83–142.

Griebeler, Andrew. 2020. "The Serpent Column and the Talismanic Ecologies of Byzantine Constantinople," *Byzantine and Modern Greek Studies* 44 (1): 86–105.

Grossman, Heather E., and Alicia Walker, eds. 2013. *Mechanisms of Exchange: Transmission in Medieval Art and Architecture of the Mediterranean, ca. 1000–1500*. Leiden: Brill.

Grube, Ernst J. 1976. "Fostat Fragments," in Basil W. Robertson, Ernst J. Grube, Glynn M. Meredith-Owens, and Robert Skelton, *Islamic Painting and the Art of the Book (The Keir Collection)*, pp. 25–66. London: Faber and Faber.

Guérin, Sarah M. 2013. "Forgotten Routes: Italy, Ifrīqiya, and the Trans-Saharan Ivory Trade," *Al-Masāq* 25 (1), pp. 71–91.

Guérin, Sarah M. 2017. "Exchange of Sacrifices: West Africa in the Medieval World of Goods, c. 1300," *The Medieval Globe* 3: 97–123.

Guérin, Sarah M. 2018., "Gold, Ivory and Copper: Arts and Materials of Trans-Saharan Trade," in *Caravans of Gold, Fragments in Time: Art, Culture, and Exchange across Medieval Saharan Africa*, ed. by Kathleen Bickford Berzock, pp. 174–201. Princeton, NJ: Princeton University Press.

Guidetti, Fabio and Katharina Meinecke, eds. 2020. *A Globalized Visual Culture? Towards a Geography of Late Antique Art*. Oxford: Oxbow Books.

Guo, Li. 2004. *Commerce, Culture, and Community in a Red Sea Port in the Thirteenth Century: The Arabic Documents from Quseir*. Leiden: Brill.

Gusarova, Ekaterina V. 2019. "The St. Sisynnios Ethiopian Legend Revisited: A Hitherto Unknown Version from the St. Petersburg Institute of Oriental Manuscripts (Eth. 119)," *Scrinium* 15: 340–45.

Gutas, Dimitri. 1998. *Greek Thought, Arabic Culture: The Graeco-Arabic Translation Movement in Baghdad and Early ʿAbbasid Society (2nd–4th/8th–10th Centuries)*. London: Routledge.

Guthrie, Shirley. 1995. *Arab Social Life in the Middle Ages: An Illustrated Study*. London: Saqi.

Guy, John. 2022. "Shipwrecks in the Late First Millennium Southeast Asia: Southern China's Maritime Trade and the Emerging Role of Arab Merchants in Indian Ocean Exchange," in *Early Global Interconnectivity across the Indian Ocean World*, vol. 1: *Commercial Structures and Exchanges*, ed. by Angela Schottenhammer, pp. 121–64. Cham: Palgrave MacMillan.

Gyselen, Rika. 1995. *Sceaux magiques en Iran sassanide*. Paris: Association pour l'avancement des études iraniennes/E. Peeters.

Haarmann, Ulrich. 1978. "Die Sphinx: Synkretistische Volksreligiosität im spätmittelalterlichen islamischen Ägypten," *Saeculum* 24: 367–84.

Hägg, Tomas. 1993. "Magic Bowls Inscribed with an Apostles-and-Disciples Catalogue from the Christian Settlement of Hambukol (Upper Nubia)," *Orientalia* 62: 376–99.

Hahn, Cynthia, and Avinoam Shalem, eds. 2020. *Seeking Transparency: Rock Crystals across the Medieval Mediterranean*. Berlin: Mann.

Hahn, Wolfgang, and Vincent West. 2016. *Sylloge of Aksumite Coinage in the Ashmolean Museum, Oxford*. Oxford: Ashmolean Museum.

Hallett, Jessica. 2005. "Iraq and China: Trade and Innovation in the Early Abbasid Period," *Taoci* 4: 21–39.

Hallett, Jessica. 2010. "Pearl Cups like the Moon: The Abbasid Reception of Chinese Ceramics," in *Shipwrecked: Tang Treasures and Monsoon Winds*, ed. by Regina Krahl, John Guy, J. Keith Wilson, and Julian Raby, pp. 75–81. Washington, DC: Smithsonian Institution.

Hallum, Bink. 2021. "New Light on Early Arabic Awfāq Literature," in *Islamicate Occult Sciences in Theory and Practice*, ed. by Liana Saif, Francesca Leoni, Matthew Melvin-Koushki, and Farouk Yahya, pp. 57–161. Leiden: Brill.

Halsted, Lyla Marie. 2022. "Seeking Refuge from the Envious: The Material Culture of the Evil Eye from Late Antiquity to Islam." PhD dissertation, Institute of Fine Arts, New York University.

Hamilton, R. W. 1974. "Thuribles: Ancient or Modern?," *Iraq* 36: 53–65.

Handley, Mark A. 1999. "Tiempo e identidad: La datación por la era en las inscripciones de la España tardorromana y visigoda," *Iberia* 2: 191–201.

Hansen, Valerie. 2020. *The Year 1000: When Explorers Connected the World and Globalization Began*. New York: Scribner.

Haour, Anne. 2007. *Rulers, Warriors, Traders, Clerics: The Central Sahel and the North Sea, 800–1500*. London: The British Academy.

Hardie, Peter. 1998. "Mamluk Glass from China?," in *Gilded and Enamelled Glass from the Middle East*, ed. by Rachel Ward, pp. 85–90. London: British Museum Press.

Harman, Graham. 2011. *The Quadruple Object*. Winchester: Zero Books.

Harris, Anthea, ed. 2007. *Incipient Globalization?: Long-Distance Contacts in the Sixth Century* (BAR International Series 1644). Oxford: Archaeopress.

Hartner, Willy. 1938. "The Pseudoplanetary Nodes of the Moon's Orbit in Hindu and Islamic Iconographies," *Ars Islamica* 5: 112–54.

Harvey, Susan Ashbrook. 2006. *Scenting Salvation: Ancient Christianity and the Olfactory Imagination*. Berkeley, CA: University of California Press.

Hatke, George. 2020. "Northeast Africa," in *A Companion to the Global Early Middle Ages*, ed. by Erik Hermans, pp. 299–332. Amsterdam: ARC, Amsterdam University Press.

Hawkes, Jason D., and Stephanie Wynne-Jones. 2015. "India in

Africa: Trade Goods and Connections of the Late First Millennium," *Afriques* 6, https://journals.openedition.org/afriques/1752.

Hazard, Sonia. 2013. "The Material Turn in the Study of Religion," *Religion and Society: Advances in Research* 4: 58–78.

Hees, Syrinx von. 2005. "The Astonishing: A Critique and Re-reading of ʿAğāʾib literature," *Middle Eastern Literatures* 8: 101–20.

Heidegger, Martin. 1967. *What Is a Thing?*, trans. by W. B. Barton Jr. and Vera Deutsch, with an analysis by Eugene T. Gendlin. Chicago: Henry Regnery Company.

Heidemann, Stefan. 2013. "Memories of the Past? The 'Classical' or 'Sunni Revival' in Architecture and Art in Syria between the Mediterranean and Iran in the 12th and 13th Centuries," in *Proceedings of the International Conference on Islamic Civilization in the Mediterranean, Nicosia, 1–4 December 2010*, ed. by Halit Eren, pp. 9–22. Istanbul: Research Centre for Islamic History, Art and Culture.

Heldman, Marilyn Eiseman. 1972. "Miniatures of the Gospels of Zir Ganela: An Ethiopian Manuscript dated AD 1400/01." PhD dissertation, Washington University, St. Louis.

Heldman, Marilyn Eiseman. 1993. *African Zion: The Sacred Art of Ethiopia*. New Haven, CT: Yale University Press.

Heldman, Marilyn Eiseman. 2007. "Metropolitan Bishops as Agents of Artistic Interaction between Egypt and Ethiopia during the Thirteenth and Fourteenth Centuries," in *Interactions: Artistic Interchange between the Eastern and Western Worlds in the Medieval Period*, ed. by Colum P. Hourihane, pp. 84–105. University Park, PA: Pennsylvania State University Press.

Helms, Mary W. 1994. "Essay on Objects: Interpretations of Distance Made Tangible," in *Implicit Understandings: Observing, Reporting, and Reflecting on the Encounters between Europeans and Other Peoples in the Early Modern Era*, ed. by Stuart B. Schwartz, pp. 355–77. Cambridge: Cambridge University Press.

Heng, Geraldine. 2014. "Early Globalities, and Its Questions, Objectives, and Methods: An Inquiry into the State of Theory and Critique," *Exemplaria: Medieval, Early Modern, Theory* 26 (2–3): 234–53.

Heng, Geraldine. 2018. *The Invention of Race in the European Middle Ages*. Cambridge: Cambridge University Press.

Heng, Geraldine. 2021. *The Global Middle Ages: An Introduction*. Cambridge: Cambridge University Press.

Henze, Ulrich. 1991. "Edelsteinallegorese im Lichte mittelalterlicher Bild- und Reliquienverehrung," *Zeitschrift für Kunstgeschichte* 54: 428–51.

Heppe, Karl Bernd. 1973. "Gotische Goldschmiedekunst in Westfalen vom zweiten Drittel des 13. bis zur Mitte des 16. Jahrhunderts." PhD dissertation, Universität Münster.

Herzfeld, Ernst. 1928. "The Hoard of the Kâren Pahlavs," *The Burlington Magazine for Connoisseurs* 52 (298): 21–23 and 27.

Hicks, Dan (coordinator) et al. 2021. "Necrography: Death-Writing in the Colonial Museum," https://www.britishartstudies.ac.uk/issues/issue-index/issue-19/death-writing-in-the-colonial-museums (accessed January 13, 2023).

Hill, Boyd H., Jr. 1965. "A Medieval German Wound Man: Wellcome MS 49," *Journal of the History of Medicine and Allied Sciences* 4: pp. 334–57.

Hill, George Francis. 1915. *The Development of Arabic Numerals in Europe*. Oxford: Clarendon Press.

Hillenbrand, Robert. 1990. "Mamlūk and Īkhānid Bestiaries: Convention and Experiment," *Ars Orientalis* 20: 149–87.

Hillenbrand, Robert. 2010. "The Schefer Ḥarīrī: A Study in Islamic Frontispiece Design," in *Arab Painting: Text and Image in Illustrated Arabic Manuscripts*, ed. by Anna Contadini, pp. 117–34. Leiden: Brill.

Hillenbrand, Robert. 2017. "The Image of the Black in Islamic Art: The Case of Painting," in *The Image of the Black in African and Asian Art*, ed. by David Bindman, Suzanne Preston Blier, and Henry Louis Gates Jr., pp. 215–53. Cambridge, MA: Harvard University Press.

Hilsdale, Cecily J. 2014. *Byzantine Art and Diplomacy in an Age of Decline*. New York: Cambridge University Press.

Hirschler, Konrad, and Sarah Bowen Savant. 2014. "Introduction: What Is in a Period? Arabic Historiography and Periodization," *Der Islam* 91 (1): 6–19.

Ho, Enseng. 2006. *The Graves of Tarim: Genealogy and Mobility across the Indian Ocean*. Berkeley, CA: University of California Press.

Hodder, Ian. 2012. *Entangled: An Archaeology of the Relationships between Humans and Things*. London: Wiley Blackwell.

Hodgson, Marshall G. S. 1977. *The Venture of Islam: Conscience and History in a World Civilization*, 3 vols. Chicago: University of Chicago Press.

Hoffman, Eva. R. 2001. "Pathways of Portability: Islamic and Christian Interchange from the Tenth to the Twelfth Century," *Art History* 24: 17–50.

Hoffman, Eva R., and Scott Redford. 2017. "Transculturation in the Eastern Mediterranean," in *A Companion to Islamic Art and Architecture*, ed. by Finbarr Barry Flood and Gülru Necipoğlu, vol. 1: *From the Prophet to the Mongols*, pp. 405–30. Hoboken, NJ: Wiley Blackwell.

Hoffmann, Konrad, ed. 1970. *The Year 1200: A Centennial Exhibition at The Metropolitan Museum of Art*, vol. 1. New York: The Metropolitan Museum of Art.

Holmes, Catherine, and Naomi Standen. 2018. "Introduction: Towards a Global Middle Ages," *Past and Present* 238, supplementary issue 13, *The Global Middle Ages*, ed. by Catherine Holmes and Naomi Standen, pp. 1–44.

Holod, Renata, and Yuriy Rassamakin. 2012. "Imported and Native Remedies for a Wounded 'Prince': Grave Goods from the Chungul Kurgan in the Black Sea Steppe of the Thirteenth Century," *Medieval Encounters* 18: 339–81.

Holsinger, Bruce. 2007. *Neomedievalism, Neoconservatism, and the War on Terror*. Chicago: Prickly Paradigm Press.

Holtorf, Cornelius. 1998. "The Life-Histories of Megaliths in Mecklenburg-Vorpommern (Germany)," *World Archaeology* 30: 23–38.

Holum, Kenneth G., and Gary Vikan. 1979. "The Trier Ivory, *Adventus* Ceremonial, and the Relics of St. Stephen," *Dumbarton Oaks Papers* 33: 113–33.

Hopkins, John North, Sarah Kielt Costello, and Paul R. Davis. 2021. *Object Biographies: Collaborative Approaches to Ancient Mediterranean Art*. New Haven, CT: Yale University Press.

Horden, Peregrine, and Nicholas Purcell. 2000. *The Corrupting Sea: A Study of Mediterranean History*. Oxford: Blackwell.

Horton, Mark. 2004. "Artisans, Communities, and Commodities: Medieval Exchanges between Northwestern India and East Africa," *Ars Orientalis* 34: 62–81.

Horton, Mark, Nicole Boivin, and Alison Crowther. 2020. "Eastern Africa and the Early Indian Ocean: Understanding Mobility in a Globalising World," *Journal of Egyptian History* 13: 380–408.

Hunt, Lucy-Anne. 1984. "Comnenian Aristocratic Palace Decoration: Descriptions and Islamic Connections," in *Byzantine Aristocracy, IX to XIII Centuries*, ed. by Michael Angold, pp. 138–56. Oxford: BAR.

Hunt, Lucy-Anne. 1996. "Churches of Old Cairo and Mosques of al-Qāhira: A Case of Christian-Muslim Interchange," *Medieval Encounters* 2: 43–66.

Hunter, Erica C. D. 1996. "Incantation Bowls: A Mesopotamian Phenomenon?," *Orientalia* 65: 220–33.

Hunwick, John O. 2005. "A Region of the Mind: Medieval Arab Views of African Geography and Ethnography and Their Legacy," *Sudanic Africa* 16: 103–36.

Ierusalimskaia, A. A. 2012. *Moshchevaĩa Balka: Neobychnyĭ arkheologicheskiĭ pamĩatnik na Severokavkazskom shelkovom puti* [= *Moshtcevaya Balka: An Unusual Archeological Site at the North Caucasus Silk Road*]. St. Peterburg: Izdatel'stvo Gosudarstvennogo Ėrmitazha.

Immerzeel, Mat. 2004. "Holy Horsemen and Crusader Banners: Equestrian Saints in Wall Paintings in Lebanon and Syria," *East Christian Art* 1: 29–60.

Ingstad, Helge, and Anne Stine Ingstad, 2000. *The Viking Discovery of America: The Excavation of a Norse Settlement in L'Anse Aux Meadows, Newfoundland*. St. John's, NF: Breakwater.

Innemée, Karel C. 2016. "Monks and Bishops in Old Dongola, and What Their Costumes Can Tell Us," in *Aegyptus et Nubia Christiana: The Włodzimierz Godlewski Jubilee Volume on the Occasion of His 70th Birthday*, ed. by Adam Lajtar, Artur Obluski, and Iwona Zych, pp. 411–34. Warsaw: Polish Centre of Mediterranean Archaeology, University of Warsaw.

Innemée, Karel C., and Dobrochna Zielińska. 2019. "Faces of Evil in Nubian Wall-Painting: An Overview," *Études et travaux* 32: 121–44.

Insoll, Timothy. 2021. "The Archaeology of Complexity and Cosmopolitanism in Medieval Ethiopia: An Introduction," *Antiquity* 95: 450–66.

Insoll, Timothy. 2023. "Archaeological Perspectives on Contacts between Cairo and Eastern Ethiopia in the 12th to 15th Centuries," *Journal of the Economic and Social History of the Orient* 66: 154–205.

Insoll, Timothy, Nadia Khalaf, Rachel MacLean, Hannah Parsons-Morgan, Nicholas Tait, Jane Gaastra, Alemseged Beldados, Alexander J. E. Pryor, Laura Evis, and Laure Dussubieux. 2021. "Material Cosmopolitanism: The Entrepot of Harlaa as an Islamic Gateway to Eastern Ethiopia," *Antiquity* 95: 487–507.

International Fund for Monuments. 1967. *Lalibela—Phase I: Adventure in Restoration*. New York: International Fund for Monuments, Inc.

Irani, Rida A. K. 1955. "Arabic Numeral Forms," *Centaurus* 4: 1–12.

Isaac, Ephraim. 1980. "The Princeton Collection of Ethiopic Manuscripts," *The Princeton University Library Chronicle* 42: 33–52.

Ittig, Annette. 1982. "A Talismanic Bowl," *Annales islamologiques* 18: 79–94.

Ivanov, A. A. / Anatoly. 2014. *Mednye i bronzovye (latunnye) izdeliia Irana vtoroi poloviny XIV–serediny XVIII veka: Katalog kollektsii / Iranian Copper and Bronze (brass) Artefacts from the Second Half of the 14th to the Mid-18th Century: Catalogue of the [Hermitage] Collection*. Saint Petersburg: The State Hermitage Publishers.

Jacob, Pierre. 1996. "Étude analytique de l'inscription éthiopienne dans l'ermitage de Mar Assia Mont Liban, vallée de la Qadisha," *Spéléorient* 1: 35–38.

Jackson, Cailah. 2020. *Islamic Manuscripts of Late Medieval Rum*. Edinburgh: Edinburgh University Press.

Jäggi, Carola. 2017. "Heiliges zum Mitnehmen: Überlegungen zur Mobilität heiliger Dinge in Spätantike und Frühmittelalter," in *Heilige und geheiligte Dinge. Formen und Funktionen*, ed. by Andrea Beck, Klaus Herbers, and Andreas Nehring, pp. 213–34. Stuttgart: Franz Steiner.

Jail, Cécile, and Marthe Bernus-Taylor, eds. 2001. *L'étrange et le merveilleux en terres d'Islam*. Paris: Réunion des Musées Nationaux.

Jain, Vardhman Kumar. 1990. *Trade and Traders in Western India (AD 1000–1300)*. New Delhi: Munshiram Manoharlal.

Jakubowska, Agata, and Magdalena Radomska. 2022. *Horizontal Art History and Beyond: Revising Peripheral Critical Practices*. New York: Routledge.

James, David. 2013. *A Masterpiece of Arab Painting: The "Schefer"* Maqāmāt *Manuscript in Context*. London: East & West Publishing.

Jarzombek, Mark. 2016. "A Connection to India? Lalibela and Libonos [*sic*]: The King and the Hydro-engineer of 13th-century Ethiopia," in *Cities of Change Addis Ababa: Transformation Strategies for Urban Territories in the 21st Century*, ed. by Marc Angélil and Dirk Hebel, pp. 74–77. Basel: Birkhäuser.

Jasperse, Jitske. 2019. "Between León and the Levant: The Infanta Sancha's Altar as Material Evidence for Medieval History," *Medieval Encounters* 2: 124–49.

Jean-François, Emmanuel Bruno, and Neelima Jeychandran. 2022. "African–Asian Affinities: Indian Oceanic Expressions and Aesthetics," *Verge: Studies in Global Asia* 8 (1): vi–xxi.

Jeck, Udo Reinhold. 1997. "Zeitkonzeptionen im frühen Mittelalter: Von der lateinischen Spätantike bis zur Karolingischen Renaissance," in *Zeitkonzeption, Zeiterfahrung, Zeitmessung: Stationen ihres Wandels vom Mittelalter bis zur Moderne*, ed. by Trude Ehlert, pp. 179–202. Paderborn: Schöningh.

Jenkins, Marilyn. 1993. "Casket" (cat. no. 38a)," in *The Art of Medieval Spain, AD 500–1200* (exhibition catalogue, The Metropolitan Museum of Art, New York, November 18, 1993–March 13, 1994), p. 94. New York: The Metropolitan Museum of Art.

Jenkins, Marilyn, and Manuel Keene. 1983. *Islamic Jewelry in the Metropolitan Museum of Art*. New York: The Metropolitan Museum of Art.

Jennings, Justin. 2010. *Globalizations and the Ancient World*. Cambridge: Cambridge University Press.

Jennings, Benjamin. 2014. *Travelling Objects: Changing Values: The Role of Northern Alpine Lake-Dwelling Communities in Exchange and Communication Networks during the Late Bronze Age*. Oxford: Archaeopress.

Jensen, Robin Margaret. 2011. *Living Water: Images, Symbols, and Settings of Early Christian Baptism*. Leiden: Brill.

Jerphanion, Guillaume de. 1939. "Un nouvel encensoir syrien et la série des objets similaires," in *Mélanges syriens offerts à monsieur René Dussaud [. . .] par ses amis et élèves*, vol. 1, pp. 297–312. Paris: Geuthner.

Johns, Jeremy. 2002. *Arabic Administration in Norman Sicily: The Royal "Dīwān."* Cambridge: Cambridge University Press.

Johns, Jeremy. 2016a. "A Tale of Two Ceilings: The Capella Palatina in Palermo and the Mouchroutas in Constantinople," in *Art, Trade, and Culture in the Near East and India: From the Fatimids to the Mughals*, ed. by Michael Rogers, Alison Ohta, and Rosalind Wade Haddon, pp. 56–71. London: Gingko.

Johns, Jeremy. 2016b. "Diversity by Design," *Apollo* 183: 80–85.

Johns, Jeremy, and Ernst J. Grube. 2005. *The Painted Ceilings of the Cappella Palatina* (Islamic Art, supplement 1). Genoa: Bruschettini Foundation for Islamic and Asian Art.

Johnson, Scott Fitzgerald. 2016. *Literary Territories: Cartographical Thinking in Late Antiquity*. Oxford: Oxford University Press.

Jones, Andrew M., and Nicole Boivin. 2010. "The Malice of Inanimate Objects: Material Agency," in *The Oxford Handbook of Material Culture Studies*, ed. by Dan Hicks and Mary C. Beaudry, pp. 333–51. Oxford: Oxford University Press.

Jördens, Andrea, and Rodney Ast, eds. 2011. *Ägyptische Magie im Wandel der Zeiten*: Eine Ausstellung des Instituts für Papyrologie in Zusammenarbeit mit dem Institut für Ägyptologie der Universität Heidelberg. Heidelberg: Universitätsmuseum.

Joselit, David. 2020. *Heritage and Debt: Art in Globalization*. Cambridge, MA: MIT Press.

Joy, Judy. 2009. "Reinvigorating Object Biography: Reproducing the Drama of Object Lives," *World Archaeology* 41: 540–56.

Kahle, Paul. 1936. "Bergkristall, Glas und Glasflüsse nach dem Steinbuch von el-Bērūnī," *Zeitschrift der Deutschen Morgenländischen Gesellschaft* 90: 322–56.

Kalinowski, Anja. 2001. "Eptinger Kelch," in *Der Basler Münsterschatz* (exhibition catalogue: The Metropolitan Museum of Art, New York, February 27–3 June, 2001; Historisches Museum, Basel, July 13–October 21, 2001; Bayerisches Nationalmuseum, Munich, December 1, 2001–24 February, 2002), ed. by Brigitte Meles, pp. 153–57. Basel: Christoph Merian.

Kaper, Olaf E. 2003. *The Egyptian God Tutu: A Study of the Sphinx-God and Master of the Demons with a Corpus of Monuments*. Leuven: Peeters and Departement Oosterse Studies.

Karkov, Catherine, Anna Kłosowska, and Vincent W. J. van Gerven Oei, eds. 2020. *Disturbing Times: Medieval Pasts, Reimagined Futures*. Santa Barbara, CA: Punctum Books.

Keating, Jessica, and Lia Markey. 2017. "Response: Medievalists and Early Modernists—A World Divided?," *The Medieval Globe* 3 (2): 203–18.

Keller, Harald. 1965. "Der Flügelaltar als Reliquienschrein," in *Studien zur Geschichte der europäischen Plastik*, ed. by Kurt Martin and Halldor Soehner, pp. 125–44. Munich: Hirmer.

Kelly, Samantha. 2020a. "Introduction," in *A Companion to Medieval Ethiopia and Eritrea*, ed. by Samantha Kelly, pp. 1–30. Leiden: Brill.

Kelly, Samantha. 2020b. "Medieval Ethiopian Diasporas," in *A Companion to Medieval Ethiopia and Eritrea*, ed. by Samantha Kelly, pp. 425–53. Leiden: Brill.

Kenney, Ellen. 2021. "Treasuring Yemen: Notes on Exchange and Collection in Rasūlid Material Culture," *Der Islam* 98 (1): 27–68.

Kerner, Jaclynne J. 2004. "Art in the Name of Science: Illustrated Manuscripts of the *Kitāb al-Diryāq*." PhD dissertation, New York University.

Kerner, Jaclynne J. 2007. "Art in the Name of Science: The *Kitāb al-Diryāq* in Text and Image," in *Arab Painting: Text and Image in Illustrated Arabic Manuscripts*, ed. by Anna Contadini, pp. 25–40. Leiden: Brill.

al-Khamis, Ulrike. 1990. "The Iconography of Early Islamic Lusterware from Mesopotamia: New Considerations," *Muqarnas* 7: 109–18.

Kilito, Abdelfattah. 1983. *Les Séances: Récits et codes culturels chez Hamadhanî et Harîrî*. Paris: Sindbad.

King, Anya. 2015. "The New *materia medica* of the Islamicate Tradition: The Pre-Islamic Context," *Journal of the American Oriental Society* 135: 499–528.

Kinoshita, Sharon. 2008. "Translatio/n, Empire and the Worlding of Medieval Literature: The Travels of *Kalila wa Dimna*," *Postcolonial Studies* 11 (4): 371–85.

Kitzinger, Ernst. 1955. "On Some Icons of the Seventh Century," in *Late Classical and Mediaeval Studies in Honor of Albert Mathias Friend, Jr.*, ed. by Kurt Weitzmann, pp. 132–50. Princeton, NJ: Princeton University Press.

Kiyanrad, Sarah. 2017. *Gesundheit und Glück für seinen Besitzer: Schrifttragende Amulette im islamzeitlichen Iran (bis 1258)*. Würzburg: Ergon.

Klapsia, Heinrich. 1938. "Der Bertholdus-Kelch aus dem Kloster Wilten," *Jahrbuch der kunsthistorischen Sammlungen* 12: 7–34.

Klein, Holger A. 2004. *Byzanz, der Westen und das "wahre" Kreuz: Die Geschichte einer Reliquie und ihrer künstlerischen Fassung in Byzanz und im Abendland*. Wiesbaden: Reichert.

Klein, Holger A. 2005. "Eastern Objects and Western Desires: Relics and Reliquaries between Byzantium and the West," *Dumbarton Oaks Papers* 58: 283–314.

Klimek, Kimberly, Pamela L. Troyer, Sarah Davis-Secord, and Bryan C. Keene, eds. 2021. *Global Medieval Contexts, 500–1500*. New York: Routledge.

Koch, Margarete. 1965. *Die Rückenfigur im Bild: Von der Antike bis zu Giotto*. Recklinghausen: Bongers.

Kochanowska, Janina. 2004. *Der Domschatz zu Cammin*. Szczecin: Oficyna In-Plus.

Kohl, Wilhelm. 1987. *Das Bistum Münster 4.1: Das Domstift St. Paulus zu Münster*. Berlin: De Gruyter.

Komaroff, Linda. 2011. *Gifts of the Sultan: The Art of Giving at Islamic Courts*. New Haven, CT: Yale University Press.

Kominko, Mary. 2013. *The World of Kosmas: Illustrated Byzantine Codices of the Christian Topography*. New York: Cambridge University Press.

Kopytoff, Igor. 1986. "The Cultural Biography of Things: Commoditization as Process," in *The Social Life of Things: Commodities in Cultural Perspective*, ed. by Arjun Appadurai, pp. 64–92. Cambridge: Cambridge University Press.

Korn, Lorenz. 2003. "Iranian Style 'Out of Place'? Some Egyptian and Syrian Stuccos of the 5–6th/11–12th Centuries," *Annales islamologiques* 37: 237–60.

Korn, Lorenz. 2011. "Art and Architecture of the Artuqid Courts," in *Court Cultures in the Muslim World: Seventh to Nineteenth Centuries*, ed. by Albrecht Fuess and Jan-Peter Hartung, pp. 385–407. London: Routledge.

Korn Lorenz, and Martina Müller-Wiener, eds. 2017. *Central Periphery?: Art, Culture and History of the Medieval Jazira (Northern Mesopotamia, 8th–15th Centuries)*. Wiesbaden: Reichert.

Kornbluth, Genevra Alisoun. 1995. *Engraved Gems of the Carolingian Empire*. University Park, PA: Pennsylvania State University Press.

Kornbluth, Genevra Alisoun. 2014. "Active Optics: Carolingian Rock Crystal on Medieval Reliquaries," *Different Visions* 4: 1–36.

Krautheimer, Richard. 1942. "Introduction to an 'Iconography' of Medieval Architecture," *Journal of the Warburg and Courtauld Institutes* 5: 1–33.

Krebs, Verena. 2021. *Medieval Ethiopian Kingship, Craft, and Diplomacy with Latin Europe*. London: Palgrave.

Krueger, Derek. 2014. *Liturgical Subjects: Christian Ritual, Biblical Narrative, and the Formation of the Self in Byzantium*. Philadelphia: University of Pennsylvania Press.

Krueger, Derek. 2018. "Healing and Salvation in Byzantium," in *Life is Short, Art Long: The Art of Healing in Byzantium; New Perspectives*, ed. by Brigitte Pitarakis and Gülru Tanman, pp. 15–28. Istanbul: Istanbul Araştırmaları Enstitüsü.

Kubler, George. 1962. *The Shape of Time: Remarks on the History of Things*. New Haven, CT: Yale University Press.

Kuehn, Sara. 2011. *The Dragon in Medieval East Christian and Islamic Art*. Leiden: Brill.

Kuehn, Sara. 2015. "The Dragon in Transcultural Skies: Its Celestial Aspect in the Medieval Islamic World," in *Spirits in Transcultural Skies*, ed. by Niels Gutschow and Katharina Weiler, pp. 71–97. Cham: Springer.

Kühne, Hartmut. 2000. *Ostensio reliquiarum: Untersuchungen über Entstehung, Ausbreitung, Gestalt und Funktion der Heiltumsweisungen im römisch-deutschen Regnum*. Berlin: De Gruyter.

Kühnel, Ernst. 1950. "Drachenportale," *Zeitschrift für Kunstwissenschaft* 4: 1–18.

Külzer, Andreas. 1994. *Peregrinatio graeca in Terram Sanctam: Studien zu Pilgerführern und Reisebeschreibungen über Syrien,*

Palästina und den Sinai aus byzantinischer und metabyzantinischer Zeit. Frankfurt a. M.: Lang.

Kurtze, Anne. 2017. *Durchsichtig oder durchlässig: Zur Sichtbarkeit der Reliquien und Reliquiare des Essener Stiftsschatzes im Mittelalter*. Petersberg: Michael Imhof.

Kusimba, Chapurukha M., Tieuqan Zhu, and Purity Wakabari Kiura, eds. 2020. *China and East Africa: Ancient Ties, Contemporary Flows*. Lanham, MD: Lexington Books.

Labarta Gómez, Ana. 2015. "The Casket of Hisham and its Epigraphy," *Summa* 6: 104–28.

Labarta Gómez, Ana. 2017. "La Arqueta de Hišām Vista de Cerca," *Summa* 10: 15–42

Labib, S. Y. 1970. "Les Marchands Kārimīs en Orient et sur l'Océan indien," in *Sociétés et compagnies de commerce en Orient et dans l'Océan Indien: Actes du huitième colloque international d'histoire maritime (Beyrouth, 5 10 septembre 1966)*, ed. by Michel Mollat, pp. 209–14. Paris: SEVPEN.

Laing, Ellen Johnston. 1991. "A Report on Western Asian Glassware in the Far East," *Bulletin of the Asia Institute* n.s. 5: 109–21.

Lamb, Jonathan. 2011. *The Things Things Say*. Princeton, NJ: Princeton University Press.

Lambourn, Elizabeth. 2008. "India from Aden: *Khuṭba* and Muslim Urban Networks in Late Thirteenth-Century India," in *Secondary Cities and Urban Networking in the Indian Ocean Realm c. 1400–1800*, ed. by Kenneth R. Hall, pp. 55–97. Lanham, MD: Lexington Books.

Lambourn, Elizabeth. 2016. "Towards a Connected History of Equine Cultures: *Bahrī* (Sea) Horses and 'Horsemania' in Thirteenth-Century South India," *The Medieval Globe* 2: 57–100.

Lambourn. Elizabeth. 2018. *Abraham's Luggage: A Social Life of Things in the Medieval Indian Ocean World*. Cambridge: Cambridge University Press.

Lamm, Carl J. 1930. *Mittelalterliche Gläser und Steinschnittarbeiten aus dem Nahen Osten*, 2 vols. Berlin: Reimer.

Lane, Edward William. 1871. *An Account of the Manners and Customs of the Modern Egyptians*, [. . .], 2 vols. London: John Murray.

Langer, Ernst. 2016. *Islamische magische Schalen und Teller aus Metall*. Berlin: epubli.

La Niece, Susan. 1983. "Niello. An Historical and Technical Survey," *The Antiquaries Journal* 63: 279–97.

La Niece, Susan. 1998. "Metallurgical Case Studies from the British Museum's Collections of Pre-Hispanic Gold," *Boletín del Museo del Oro* 44: 139–57.

La Niece, Susan. 2010. "Islamic Copper-Based Metalwork from the Eastern Mediterranean: Technical Investigation and Conservation Issues," *Studies in Conservation*: 35–39.

Lasko, Peter. 1972. *Ars Sacra, 800–1200*. Harmondsworth: Penguin.

Latour, Bruno. 1993. *We Have Never Been Modern*, trans. by Catherine Porter. Cambridge, MA: Harvard University Press.

Latour, Bruno. 2012. *Enquête sur les modes d'existence: Une anthropologie des modernes*. Paris: La Découverte.

Lavagnini, Bruno. 1990. "Profilo di Filagato da Cerami con traduzione dell'Omelia XXVII, pronunziata dal pulpito della Cappella Palatina in Palermo," *Bollettino della Badia greca di Grottaferrata* n.s. 44: 231–44.

LaViolette, Adria. 2008. "Swahili Cosmopolitanism in Africa and the Indian Ocean World, AD 600–1500," *Archaeologies* 4: 24–49.

Lazović, Miroslav, Nicolas Dürr, Harold Durand, Claude Houriet, and François Schweizer. 1977. "Objets byzantins de la collection du Musée d'art et d'histoire," *Genava* n.s. 25: 5–62.

Legner, Anton. 1982. "Reliquienpräsenz und Wanddekoration: Mit einem Beitrag über Kriegsschäden und Wiederherstellung von Anton Goergen," in *Die Jesuitenkirche St. Mariae Himmelfahrt in Köln: Dokumentation und Beiträge zum Abschluss ihrer Wie-*

derherstellung, ed. by Udo Mainzer, pp. 269–98. Düsseldorf: Schwann.

Legner, Anton, ed. 1989. *Reliquien: Verehrung und Verklärung; Skizzen und Noten zur Thematik und Katalog zur Ausstellung der Kölner Sammlung Louis Peters im Schnütgen-Museum*. Cologne: Schnütgen-Museum.

Legner, Anton. 1995. *Reliquien in Kunst und Kult: Zwischen Antike und Aufklärung*. Darmstadt: Wissenschaftliche Buchgesellschaft.

Lenk, Stefanie. 2019. "Baptismal Art and Identity Construction in the Western Mediterranean in the Fifth and Sixth Centuries." DPhil thesis, University of Oxford.

Lenssen, Anneka, Sarah A. Rogers, and Nada M. Shabout, eds. 2018. *Modern Art in the Arab World: Primary Documents*. New York: The Museum of Modern Art.

Lepage, Claude. 1999. "Les Peintures murales de l'église Betä Maryam à Lalibäla, Éthiopie (rapport préliminaire)," *Comptes rendus des séances de l'Académie des inscriptions et belles-lettres* 143: 901–67.

Lepage, Claude. 2002. "Un métropolite égyptien bâtisseur à Lalibäla (Éthiopie) entre 1205 et 1210," *Comptes rendus des séances de l'Académie des inscriptions et belles-lettres* 146: 141–74.

Lepage, Claude. 2006. "Un bas-relief royal à Lalibäla (Éthiopie) vers 1200," *Comptes rendus des séances de l'Académie des inscriptions et belles-lettres* 150: 153–73.

Lepage, Claude, and Jacques Mercier. 2005. *Ethiopian Art: The Ancient Churches of Tigrai*. Paris: ERC.

Lermer, Andrea. 2015. "Öffentlicher Raum und Publikum in den Illustrationen der *Maqāmāt* al-Hariris im 13. Jahrhundert," in *The Public in the Picture: Involving the Beholder in Antique, Islamic, Byzantine and Western Medieval and Renaissance Art*, ed. by Beate Fricke and Urte Krass, pp. 57–74. Zurich: Diaphanes.

Leroy, Jules. 1976. "L'encensoir 'syrien' du Couvent de Saint-Antoine dans le désert de la Mer Rouge," *Bulletin de l'Institut français d'archéologie orientale* 76: 381–90.

Levene, Dan. 2002. *Curse or Blessing: What's in the Magic Bowl?* (The Ian Karten Lecture, Parkes Institute Pamphlet 2) Southampton: Parkes Institute.

Lewis, Bernard. 1990. *Race and Slavery in the Middle East: An Historical Enquiry*. Oxford: Oxford University Press.

Lewis, Suzanne. 1973. "The Iconography of the Coptic Horsemen in Byzantine Egypt," *Journal of the American Research Center in Egypt* 10: 27–63.

Little, Charles T. 1993. "Crucifix" (cat. no. 131), in *The Art of Medieval Spain, AD 500–1200* (exhibition catalogue, The Metropolitan Museum of Art, New York, November 18, 1993–March 13, 1994), pp. 272–73. New York: The Metropolitan Museum of Art.

Little, Charles T. 2004. "Along the Pilgrimage Road: Ivories and the Role of Compostela," in *Patrimonio artístico de Galicia y otros estudios: Homenaje al Prof. Dr. Serafín Moralejo Álvarez*, ed. by María Ángela Franco Mata, vol. 3, pp. 159–66. Santiago de Compostela: Xunta de Galicia.

Loiseau, Julien. 2018a. "Two Unpublished Arabic Inscriptions from Bilet (Tigray, Ethiopia)," https://hal-amu.archives-ouvertes.fr/hal-02111959v1 (accessed January 15, 2023).

Loiseau, Julien. 2018b. "Two Arabic Inscriptions from Bilet (Eastern Tigray, Ethiopia)," https://hal-amu.archives-ouvertes.fr/hal-02111959 (accessed January 15, 2023).

Loiseau, Julien. 2019a. "Ethiopia and Nubia in Islamic Egypt: Connected Histories of Northeastern Africa," *Northeast African Studies* 19: 1–8.

Loiseau, Julien. 2019b. "The Ḥaṭi and the Sultan: Letters and Embassies from Abyssinia to the Mamluk Court," in *Mamluk Cairo, a Crossroads for Embassies. Studies on Diplomacy and*

Diplomatics, ed. by Frédéric Bauden and Malika Dekkiche, pp. 638–57. Leiden: Brill.

Loiseau, Julien. 2019c. "Abyssinia at al-Azhar: Muslim Students from the Horn of Africa in Late Medieval Cairo," *Northeast African Studies* 19: 61–84.

Loiseau, Julien. 2020. "Retour à Bilet: Un cimitière musulman medieval du Tigray orientale (Inscriptiones Arabicae Aethiopiae 1)," *Bulletin d'études orientales* 67: 59–96.

Loiseau, Julien, Yared Assefa, Deresse Ayenachew, et al. 2019. *Bilet (Tigray, Ethiopia) Preliminary Report Excavations and Surveys, 1–20 December 2018*, https://hal-amu.archives-ouvertes.fr/hal-02909979 (accessed January 15, 2023).

Loiseau, Julien, Simon Dorso, Yves Gleize, et al. 2021. "Bilet and the Wider World: New Insights into the Archaeology of Islam in Tigray," *Antiquity* 95: 508–29.

Loos, Adolf. 1998. "Ornament and Crime (1929)," in *Adolf Loos, Ornament and Crime: Selected Essays*, ed. by Adolf Opel, trans. by Michael Mitchell, pp. 167–76. Riverside, CA: Ariadne Press.

Loosley Leeming, Emma. 2018. *Architecture and Asceticism: Cultural Interaction between Syria and Georgia in Late Antiquity*. Leiden: Brill.

Lund, Julie, and Sarah Semple. 2021. *A Cultural History of Objects in the Medieval Age*. London: Bloomsbury Academic.

Lüpke, Theodor von. 1913. "Die alte Kirche zu Asmara," in Daniel Krencker and Theodor von Lüpke, *Deutsche Aksum-Expedition: Ältere Denkmäler Nordabessiniens*, vol. 2, pp. 195–98. Berlin: Reimer.

Macabeli, Kiti. 2016. "La Croix vénitienne des XIIIᵉX–XIVᵉ siècles en Svanétie," *Iconographica* 15: 93–101.

Machado, Pedro. 2011. "Awash in a Sea of Cloth: Gujarat, Africa, and the Western Indian Ocean, 1300–1800," in *The Spinning World: A Global History of Cotton Textiles, 1200–1850*, ed. by Giorgio Riello and Prasannan Parathasarathi, pp. 161–79. Oxford: Oxford University Press.

Maddison, Francis, and Emilie Savage-Smith, eds. 1997. *Science, Tools and Magic. Part 1: Body and Spirit*. Oxford: The Nour Foundation.

Maguire, Eunice Dauterman, Henry Maguire, and Maggie J. Duncan-Flowers. 1989. *Art and Holy Powers in the Early Christian House*. Urbana, IL: University of Illinois Press.

Makariou, Sophie, ed. 2001. *L'Orient de Saladin: L'art des Ayyoubides; Exposition présentée à l'Institut du monde arabe, Paris, 23 octobre 2001–10 mars 2002*. Paris: Gallimard.

Maloney, B. K. 1993. "Palaeocology and the Origin of the Coconut," *GeoJournal* 31: 355–62.

Mango, Marlia Mundell. 1992. *The Purpose and Places of Byzantine Silver Stamping*. Washington, DC: Dumbarton Oaks Research Library and Collection.

Mango, Marlia Mundell. 1998. "The Archaeological Context of Finds of Silver in and beyond the Eastern Empire," *Vjesnik za arheologiju i historiju dalmatinsku* 87–89: 207–52.

Mango, Marlia Mundell. 2009. "Tracking Byzantine Silver and Copper Metalware, 4th–12th Centuries," in *Byzantine Trade, 4th–12th Centuries*, ed. by Marlia Mundell Mango, pp. 221–36. Farnham: Ashgate.

Mango, Marlia Mundell, and Anna Bennett. 1994. *The Sevso Treasure, Part One*, = *Journal of Roman Archaeology* Supplementary Series 12.

Manning, Patrick. 1996. "The Problem of Interactions in World History," *The American Historical Review* 101 (3): 771–82.

Manoff, Marlene. 2004. "Theories of the Archive from Across the Disciplines," *Libraries and the Academy* 4 (1): 9–25.

Manzo, Andrea. 1994. "Riflessioni sulle sfingi etiopiche ed il loro significato culturale," *Rassegna di studi etiopici* 38: 119–38.

Manzo, Andrea. 2009. "Capra nubiana in Berbere Sauce?: Pre-Aksumite Art and Identity Building," *The African Archaeological Review* 26: 291–303.

Margariti, Roxani Eleni. 2009. "Thieves or Sultans?: Dahlak and the Rulers and Merchants of Indian Ocean Port Cities, 11th to 13th Centuries AD," in *Connected Hinterlands: Proceedings of Red Sea Project IV Held at the University of Southampton, September 2008*, ed. by Lucy Blue, pp. 155–64. Oxford: BAR Publishing.

Margariti, Roxani Eleni. 2012. "An Ocean of Islands: Islands, Insularity, and Historiography of the Indian Ocean," in *The Sea: Thalassography and Historiography*, ed. by Peter N. Miller, pp. 198–229. Ann Arbor, MI: University of Michigan Press.

Margariti, Roxani Eleni. 2014. "Aṣḥābunā l-tujjār—Our Associates, the Merchants: Non-Jewish Business Partners of the Cairo Geniza's India Traders," in *Jews, Christians and Muslims in Medieval and Early Modern Times: A Festschrift in Honor of Mark R. Cohen*, ed. by Arnold E. Franklin, Roxani Eleni Margariti, Marina Rustow, and Uriel Simonsohn, pp. 40–58. Leiden: Brill.

Marinis, Vasileios. 2014. "Piety, Barbarism, and the Senses in Byzantium," in *Sensational Religion: Sensory Cultures in Material Practice*, ed. by Sally M. Promey, pp. 321–40. New Haven, CT: Yale University Press.

Marshak, Boris. 1986. *Silberschätze des Orients: Metallkunst des 3.–13. Jahrhunderts und ihre Kontinuität*. Leipzig: Seemann.

Marshall, Yvonne, and Chris Gosden. 1999. "The Cultural Biography of Objects," *World Archaeology* 31:168–78.

Martin, Jacques. 1739. *Explication des divers monumens singuliers qui ont rapport à la religion des plus anciens peuples. Avec l'examen de la derniere edition des ouvrage de S. Jerôme et un traité sur l'astrologie judiciaire*. Paris: Lambert.

Martin, Therese. 2019. "Caskets of Silver and Ivory from Diverse Parts of the World: Strategic Collecting for an Iberian Treasury," *Medieval Encounters* 25: 1–38.

Martin, Therese, and Mariam Rosser-Owen. 2021. "Silver and Niello in Islamic Iberia: A New Look at the Material Evidence," *West 86th* 28 (2): 290–98.

Martín López, María Encarnación. 2003. "Colección documental de la Infanta Doña Sancha (1118–1159): Estudio crítico," in *León y su historia: Miscelánea histórica VIII* (Fuentes y Estudios de Historia Leonesa 99), pp. 139–345. León: Centro de Estudios e Investigación San Isidoro.

Martín López, María Encarnación. 2007. "Un documento de Fernando I de 1063: ¿Falso diplomático?," in *Monarquía y sociedad en el Reino de León: De Alfonso III a Alfonso VII*, ed. by José María Fernández Caltón, vol. 2, pp. 513–40. León: Centro de Estudios e Investigación San Isidoro.

Maspero, Gaston. 1908. "Un encensoir copte," *Annales du Service des antiquités de l'Egypte* 9: 148–49.

Mastrocinque, Attilio. 2011. "The Colours of Magical Gems," in *"Gems of Heaven": Recent Research on Engraved Gemstones in Late Antiquity, c. AD 200–600*, ed. by Chris Entwistle and Noël Adams, pp. 62–68. London: British Museum Press.

Mastrocinque, Attilio. 2014. *Les Intailles magiques du département des Monnaies, Médailles et Antiques*. Paris: Bibliothèque nationale de France.

Mathews, Thomas F., and Norman E. Muller. 2016. *The Dawn of Christian Art in Panel Paintings and Icons*. Los Angeles: J. Paul Getty Museum.

Matthews, Derek, and Antonio Mordini. 1959. "The Monastery of Debra Damo, Ethiopia," *Archaeologia* 97: 1–58.

Mayeur-Jaouen, Catherine. 2000. "Crocodiles et saints du Nil: Du talisman au miracle," *Revue de l'histoire des religions* 217: 733–60.

Médard, Henri, Marie-Laure Derat, Thomas Vernet, and Marie Pierre Ballarin, eds. 2013. *Traites et esclavages en Afrique orientale et dans l'océan Indien*. Paris: CIRESC.

Meier, Christel. 1977. *Gemma spiritualis: Methode und Gebrauch der Edelsteinallegorese vom frühen Christentum bis ins 18. Jahrhundert*. Munich: Fink.

Meier, Prita, and Allison Purpura, eds. 2018. *World on the Horizon: Swahili Arts across the Indian Ocean*. Champaign, IL: Krannert Art Museum and Kinkead Pavilion.

Meinardus, Otto. 1965. "The Ethiopians in Jerusalem," *Zeitschrift für Kirchengeschichte* 76: 112–47 and 217–32.

Melikian-Chirvani, Assadullah S. 1982. *Islamic Metalwork from the Iranian World, 8th–18th Centuries*. London: HMSO.

Mennella, Giovanni. 1990. *Dertona, Libarna, Forum Iulii Iriensium: Regio IX* (Inscriptiones Christianae Italiae 7). Bari: Edipuglia.

Mercier, Jacques. 1992. *Le roi Salomon et les maîtres du regard: Art et médecine en Éthiopie*. Paris: Réunion des Musées Nationaux.

Mercier, Jacques. 1997. *Art That Heals: The Image as Medicine in Ethiopia*. New York: Prestel.

Mercier, Jacques, and Claude Lepage. 2012. *Lalibela, Wonder of Ethiopia: The Monolithic Churches and Their Treasures*. London: Holberton.

Meredith-Owens, Glynn M. 1973. *Persian Illustrated Manuscripts*. London: Trustees of the British Museum.

Meri, Josef W. 2001. "A Late Medieval Syrian Pilgrimage Guide: Ibn al-Ḥawrānī's *Al-Ishārāt ilā Amākin al-Ziyārāt*," *Medieval Encounters* 7: 4–78.

Meri, Josef W. 2002. *The Cult of Saints among Muslims and Jews in Medieval Syria*. Oxford: Oxford University Press.

Meurer, Heribert. 1969. "Zwei antike Vorbilder und die Rückenfigur im Johannes-Altar des Rogier van der Weyden," in *Wallraf-Richartz-Jahrbuch*, ed. by Freunde des Wallraf-Richartz-Museums und des Museums Ludwig e.V., pp. 233–42. Cologne: M. Dumont Schauberg.

Michel, Simone. 2001. *Die magischen Gemmen im Britischen Museum*. London: British Museum Press.

Michel, Simone. 2004. *Die magischen Gemmen: Zu Bildern und Zauberformeln auf geschnittenen Steinen der Antike und Neuzeit*. Berlin: Akademie-Verlag.

Mierse, William E. 2017. "The Significance of the Central Asian Objects in the Shōsōin for Understanding the International Art Trade in the Seventh and Eighth Centuries," *Sino-Platonic Papers* 267: 1–52.

Miner, Dorothy Eugenia, and Marvin Chauncey Ross. 1947. *Early Christian and Byzantine Art: An Exhibition Held at the Baltimore Museum of Art, April 25 to June 22, 1947*. Baltimore: Trustees of the Walters Art Gallery.

Miquel, Pierre, Antoine Guillaumont, Marguerite Rassart-Debergh, Philippe Bridel, and Adalbert de Vogüé. 1993. *Déserts chrétiens d'Égypte*. Nice: Culture Sud.

Mirzoyan, Alvida. 1992. "Datation et localisation des encensoirs en bronze conservés dans les collections arméniennes," *Revue des études arméniennes* 23: 603–26.

Mols, Luitgard E. M. 2006. *Mamluk Metalwork Fittings in Their Artistic and Architectural Context*. Delft: Eburon.

Monneret de Villard, Ugo. 1937–39. "Note sulle influenze asiatiche nell'Africa orientale," *Rivista degli studi orientali* 17: 303–49.

Montell, Gösta. 1938. "Sven Hedin's Archaeological Collections from Khotan, II." *Bulletin of the Museum of Far Eastern Antiquities (Ostasiatiska Samlingarna)* 10: 83–113.

Monti della Corte, Alessandro Augusto. 1940. *Lalibelà: Le chiese ipogee e monolitiche e gli altri monumenti medievali del Lasta*. Rome: Società italiana arti grafiche.

Moore, Liam. 2013. "By Hand and Voice: Performance of Royal Charters in Eleventh- and Twelfth-Century León," *Journal of Medieval Iberian Studies* 5: 18–32.

Moorsel, Paul van. 1975. *The Central Church of Abdallah Nirqi*. Leiden: Brill.

Moorthy Kloss, Magdalena. 2021. "Eunuchs at the Service of Yemen's Rasūlid Dynasty (626–858/1229–1454)," *Der Islam* 98 (1): 6–26.

Moraes, George. 1931. *The Kadamba Kula: A History of Ancient and Mediaeval Karnataka*. Bombay: Furtado.

Mordini, Antonio. 1940. "Un'antica porta in legno proviente della Chiesa di Gunaguna (Scimezana, Eritrea)," *Rassegna degli studi orientali* 19: 105–7.

Mordini, Antonio. 1957a. "Tre tiraz abbasidi provenienti dal convento di Dabro Dammo," *Bollettino Istituto di studi etiopici* 2: 33–38.

Mordini, Antonio. 1957b. "Un tissu musulman du Moyen Âge provenant du couvent de Dabro Dāmmò (Tigrai, Éthiopie)," *Annales d'Éthiopie* 2: 75–79.

Mordini, Antonio. 1960a. "I tessili medioevali del convento di Dabra Dāmmo," in *Atti del Convegno internazionale di studi etiopici (Roma, 2–4 aprile 1959)*, pp. 230–48. Rome: Accademia nazionale dei Lincei.

Mordini, Antonio. 1960b. "Gli aurei di Kushāna del convento di Dabra Dāmmò. Un'indizio sui rapporti commerciali fra l'India e l'Etiopia nei primi secoli," in: *Atti del Convegno internazionale di studi etiopici (Roma, 2–4. apriel 1959)*, pp. 249–54. Rome: Accademia nazionale dei Lincei.

Moriggi, Marco. 2014. *A Corpus of Syrian Incantation Bowls: Syriac Texts from Late-Antique Mesopotamia*. Leiden: Brill.

Morony, Michael G. 2003. "Magic and Society in Late Sasanian Iraq," in *Prayer, Magic, and the Stars in the Ancient and Late Antique World*, ed. by Scott B. Noegel, Joel Thomas Walker, and Brannon M. Wheeler, pp. 83–107. University Park, PA: Pennsylvania State University Press.

Moss, A. A. 1953. "Niello," *Studies in Conservation* 1: 49–62.

Mosshammer, Alden A. 2008. *The Easter Computus and the Origins of the Christian Era*. Oxford: Oxford University Press.

Muehlbauer, Mikael. 2021. "From Stone to Dust: The Life of the Kufic Inscribed Frieze of Wuqro Cherqos in Tigray, Ethiopia," *Muqarnas* 38: 1–34.

Muhammad, Akbar. 1985. "The Image of Africans in Arabic Literature: Some Unpublished Manuscripts," in *Slaves and Slavery in Muslim Africa*, ed. by John Ralph Willis, vol. 1: *Islam and the Ideology of Enslavement*, pp. 47–74. London: Cass.

Mukherji, Parul Dave. 2014. "Whither Art History in a Globalizing World," *The Art Bulletin* 96 (2): 151–55.

Müller, Walter. 1978. "Weihrauch: Ein arabisches Produkt und seine Bedeutung in der Antike," in *Paulys Realencyclopädie der classischen Altertumswissenschaft*, ed. by Georg Wissowa, Wilhelm Kroll, Karl Mittelhaus, Konrat Ziegler, and Hans Gärtner, supplementary vol. 15, cols. 700–777. Munich: Druckenmüller.

Mullett, Margaret. 2002. "In Peril on the Sea: Travel Genres and the Unexpected," in *Travel in Byzantium: Papers from the Thirty-fourth Spring Symposium of Byzantine Studies, Birmingham, April 2000*, ed. by Ruth Macrides, pp. 259–84. Aldershot: Ashgate.

Munro-Hay, Stuart C. 1997. *Ethiopia and Alexandria: The Metropolitan Episcopacy of Ethiopia*. Krakow: ZAŚ PAN.

Munro-Hay, Stuart, and Bent Juel-Jensen. 1995. *The Coinage of Aksum*. London: Spink.

MWNF. 2022. "Incense burner," at *Museum With No Frontiers: Discover Islamic Art*, https://islamicart.museumwnf.org/database_item.php?id=object;EPM;dn;Mus21;2;en&pageD=N (accessed January 15, 2023).

Myers Achi, Andrea, and Seeta Chaganti. 2020. " 'Semper novi quid ex Africa': Redrawing the Borders of Medieval African Art and Considering Its Implications for Medieval Studies," in *Disturbing Times: Medieval Pasts, Reimagined Futures*, ed. by Catherine Karkov, Anna Kłosowska, and Vincent W. J. vanGerven Oei, pp. 73–106. Santa Barbara, CA: Punctum Books.

Nagel, Alexander, and Christopher Wood. 2010. *Anachronic Renaissance*. New York: Zone Books.

Nagy, Árpád M. 2012. "*Daktylios pharmakites*: Magical Healing Gems and Rings in the Graeco-Roman World," in *Ritual Healing: Magic, Ritual and Medical Therapy from Antiquity Until the Early Modern Period*, ed. by Ildikó Csepregi and Charles Burnett, pp. 71–106. Florence: SISMEL-Edizioni del Galluzzo.

Nanji, Rukshana J. 2011. *Mariners and Merchants: A Study of the Ceramics from Sanjan (Gujarat)*. Oxford: Archaeopress.

Nanji, Rukshana. 2016. "Melting Pots of Culture: The Archaeology of Early Medieval Ports on the West Coast of India," in *Bridging the Gulf: Maritime Cultural Heritage of the Western Indian Ocean*, ed. by Kapila Vatsyayan and Himanshu Prabha Ray, pp. 79–100. Delhi: Manohar.

Nanji, Rukshana. 2019. "A Chinese Muse in the Caliph's Court: The Influence of Chinese Ceramic Technology across the Indian Ocean (Eighth to Fourteenth Century CE)," in *Knowledge and the Indian Ocean: Intangible Networks of Western India and Beyond*, ed. by Sara Keller, pp. 47–64. Cham: Palgrave Macmillan.

Naveh, Joseph, and Shaul Shaked. 1987. *Amulets and Magic Bowls: Aramaic Incantations of Late Antiquity*. Jerusalem: Magnes Press.

Naveh, Joseph, and Shaul Shaked. 1993. *Magic Spells and Formulae: Aramaic Incantations of Late Antiquity*. Jerusalem: Magnes Press

Nees, Larry. 2014. "What's in the Box? Remarks on Some Early Medieval and Early Islamic Precious Containers," *Source: Notes in the History of Art* 33: 67–77.

Néroutsos-Bey, Tassos D. 1888. *L'Ancienne Alexandrie*. Paris: Leroux.

Nersessian, Vrej. 2001. *Treasures from the Ark: 1700 Years of Armenian Christian Art*. London: The British Library.

Nesbitt, John W. 2003. "Apotropaic Devices on Byzantine Lead Seals and Tokens in the Collections of Dumbarton Oaks and the Figg Museum of Art," in *Through a Glass Brightly: Studies in Byzantine and Medieval Art and Archaeology Presented to David Buckton*, ed. by Chris Entwistle, pp. 107–13. Oxford: Oxbow Books.

Newman, R., J. R. Dennis, and E. Farrell. 1982. "A Technical Note on Niello," *Journal of the American Institute for Conservation* 21: 80–85.

Nieber, Hanna. 2107. " 'They all just want to get healthy!': Drinking the Qur'an between Forming Religious and Medical Subjectivities in Zanzibar," *Journal of Material Culture* 22: 453–75.

Niehr, Klaus. 1994. "Skulptur des 13. Jahrhunderts in Sachsen-Anhalt: Aspekte einer hochmittelalterlichen Kunstlandschaft," *Mitteldeutsches Jahrbuch für Kultur und Geschichte* 1: 59–75.

Nizami, Khaliq Ahmad. 2002. *Religion and Politics in Indian during the Thirteenth Century*. Delhi: Oxford University Press.

Normore, Christina. 2017. "Editor's Introduction: A World Within Worlds? Reassessing the Global Turn in Medieval Art History," *The Medieval Globe* 3 (2): 1–10.

Nowakowski, Paweł. 2015. "Facets of the Cult of Saints in Asia Minor: The Epigraphic Patterns prior to the 7th c. AD." Unpublished dissertation, University of Warsaw.

Nussbaum, Otto. 1979. *Die Aufbewahrung der Eucharistie*. Bonn: Hanstein.

Nye, Joseph. 2002. "Globalism versus Globalization," *The Globalist*, April 15, https://www.theglobalist.com/globalism-versus-globalization/ (accessed January 15, 2023).

Oddy, Andrew W., Mavis Bimson, and Susan La Niece. 1983. "The Composition of Niello Decoration on Gold, Silver and Bronze in the Antique and Mediaeval Periods," *Studies in Conservation* 28: 29–35.

O'Kane, Bernard. 2012. "Text and Paintings in the al-Wāsiṭī *Maqāmāt*," *Ars Orientalis* 42: 41–55.

O'Mahony, Anthony. 1996. "Between Islam and Christendom: The Ethiopian Community in Jerusalem before 1517," *Medieval Encounters* 2: 140–54.

Opsomer, Carmélia. 1980. *"Livre des simples medecines": Codex Bruxellensis IV. 1024*, 2 vols. Antwerp: De Schutter.

Ousterhout, Robert. 2009. "Byzantium between East and West and the Origins of Heraldry," in *Byzantine Art: Recent Studies. Essays in Honor of Lois Drewer*, ed. by Colum Hourihane, pp. 153–70. Tempe, AZ: Arizona Center for Medieval and Renaissance Studies.

Pabst, Bernhard. 2004. "Ideallandschaft und Ursprung der Menschheit: Paradieskonzeptionen und -lokalisierungen des Mittelalters im Wandel," *Frühmittelalterliche Studien* 38: 17–53.

Pacha, Zéki. 1916. "Coupe magique dédiée à Salah ad-Din," *Bulletin de l'Institut egyptien* 10: 241–87.

Pancaroğlu, Oya. 2001. "Socializing Medicine: Illustrations of the *Kitāb al-Diryāq*," *Muqarnas* 18: 155–72.

Pancaroğlu, Oya. 2004. "The Itinerant Dragon-Slayer: Forging Paths of Image and Identity in Medieval Anatolia," *Gesta* 43: 151–64.

Pankhurst, Richard. 1974. "The History of Ethiopia's Relations with India prior to the Nineteenth Century," in *IV Congresso di studi etiopici (Roma, 10–15 aprile 1972)*, ed. by Enrico Cerulli, vol. 1, pp. 205–31. Rome: Accademia nazionale dei Lincei.

Pankhurst, Richard. 2003. "The Ethiopian Diaspora to India: The Role of Habshis and Sidis from Medieval Times to the End of the Eighteenth Century," in *The African Diaspora in the Indian Ocean*, ed. by Shihan de Silva Jayasuriya and Richard Pankhurst, pp. 189–221. Trenton, NJ: Africa World Press.

Papaconstantinou, Arietta. 2001. *Le Culte des saints en Égypte: Des Byzantins aux abbassides*. Paris: CNRS.

Patel, Alka. 2006. "Transcending Religion: Socio-Linguistic Evidence from the Somanatha-Veraval Inscription of 1264 CE," in *Ancient India and Its Wider World*, ed. by Carla Sinopoli and Grant Parker (eds.), pp. 143–64. Ann Arbor, MI: Centers for South and Southeast Asian Studies, University of Michigan.

Patton, Pamela A. 2012. *Art of Estrangement: Redefining Jews in Reconquest Spain*. University Park, PA: Pennsylvania State University Press.

Patton, Pamela A. 2019. "Color, Culture, and the Making of Difference in the *Vidal Mayor*," in *Toward a Global Middle Ages: Encountering the World Through Illuminating Manuscripts*, ed. by Bryan C. Keene, pp. 182–89. Los Angeles: J. Paul Getty Museum.

Pauty, Edmond. 1930. *Bois sculptés d'églises coptes (époque Fatimide)*. Cairo: L'Institut français d'archéologie orientale.

Peacock, Andrew C. S. 2020. "A Seljuq Occult Manuscript and its World: MS Paris persan 174," in *The Seljuqs and their Successors Art, Culture and History*, ed. by Sheila Canby, Deniz Beyazit, and Martina Rugiadi, pp. 163–79. Edinburgh: Edinburgh University Press.

Pekarskaja, Ljudmila V. 2011. *Jewellery of Princely Kiev: The Kiev Hoards in the British Museum and the Metropolitan Museum of Art and Related Material*. Mainz: Römisch-Germanischen Zentralmuseums.

Pelka, Otto. 1906. "Ein syro-palästinensisches Räuchergefäß," *Mitteilungen aus dem germanischen Nationalmuseum* (1906): 85–92.

Pentcheva, Bissera V. 2010. *The Sensual Icon: Space, Ritual, and the Senses in Byzantium*. University Park, PA: Pennsylvania State University Press.

Perdrizet, Paul. 1903. "Sphragis Solomonos," *Revue des études grecques* 16: 42–61.

Perho, Irmeli. 1995. *The Prophet's Medicine: A Creation of the Muslim Traditionalist Scholars*. Helsinki: Finnish Oriental Society.

Perry, Craig A. 2014. "The Daily Life of Slaves and the Global Reach of Slavery in Medieval Egypt, 969–1250 CE." PhD dissertation, Emory University, Atlanta, GA.

Pétridès, Sophrone. 1904. "Un encensoir syro-byzantin," *Échos d'orient* 7: 148–51.

Petrie, W. M. Flinders. 1914. *Amulets: Illustrated by the Egyptian Collection in University College, London*. London: Constable.

Pettigrew, Mark Fraser. 2004. "The Wonders of the Ancients: Arab-Islamic Representations of Ancient Egypt." PhD dissertation, UCLA.

Pfeifer, Michael. 1997. *Der Weihrauch: Geschichte, Bedeutung, Verwendung*. Regensburg: Pustet.

Phillipson, David W. 2004. "The Aksumite Roots of Medieval Ethiopia," *Azania* 39: 77–89.

Pieper, Paul. 1981. *Der Domschatz zu Münster: Mit einem Beitrag von Norbert Humburg, der Reliquienaltar und der Reliquienschatz des Domes zu Münster*. Münster: Aschendorff.

Piguet-Panayotova, Dora. 1998. "Silver Censers: A Hexagonal Decorated Silver Censer in the Bayerisches Nationalmuseum Munich," in *Acta XIII Congressus Internationalis Archaeologiae Christianae*, ed. by Nenad Cambi and Emilio Marin, vol. 3, pp. 646–53. Split: Pontificio Istituto di Archeologia Cristiana.

Piguet-Panayotova, Dora. 1999. "Three Hexagonal Decorated Silver Censers and Their Artistic Environment," *Münchner Jahrbuch der bildenden Kunst* 50: 7–34.

Piotrowski, Piotr. 2008. "On the Spatial Turn, or Horizontal Art History." *Umění* 56: 378–83.

Pirenne, Henri. 1963. *Mahomet und Karl der Grosse: Untergang der Antike am Mittelmeer und Aufstieg des germanischen Mittelalters*. Frankfurt a. M.: Fischer.

Platt, Thomas Pell. 1823. *A Catalogue of the Ethiopic Biblical Manuscripts in the Royal Library of Paris*. London: Richard Watts.

Poglayen-Neuwall, Stephan. 1919. "Eine koptische Pyxis mit den Frauen am Grabe aus der ehemaligen Sammlung Pierpont Morgans," *Monatshefte für Kunstwissenschaft* 12: 81–87.

Pomerantz, Maurice A. 2018. "Chasing after a Trickster: The *Maqāmāt* between Philology and World Literature," in *Studying the Near and Middle East at the Institute for Advanced Study, Princeton, 1935–2018*, ed. by Sabine Schmidke, pp. 228–42. Piscataway, NJ: Gorgias Press.

Pormann, Peter E. 2003. "Theory and Practice in the Early Hospitals in Baghdad: al-Kaškarī on Rabies and Melancholy," *Zeitschrift für Geschichte der Arabisch-Islamischen Wissenschaften* 15: 197–248.

Pormann, Peter E. 2005. "The Physician and the Other: Images of the Charlatan in Medieval Islam," *Bulletin of the History of Medicine* 79: 189–227.

Pormann, Peter E., and Emilie Savage-Smith. 2007. *Medieval Islamic Medicine*. Washington, DC: Georgetown University Press.

Porter, Roy. 1988. "Seeing the Past," *Past and Present* 118: 186–205.

Porter, Venetia. 1998. "Enamelled Glass Made for the Rasulid Sultans of Yemen," in *Gilded and Enamelled Glass from the Middle East*, ed. by Rachel Ward, pp. 91–95. London: Trustees of the British Museum.

Porter, Venetia. 2004. "Islamic Seals: Magical or Practical?," in *Magic and Divination in Early Islam*, ed. by Emilie Savage-Smith, pp. 179–200. Aldershot: Ashgate.

Porter, Venetia. 2010. "The Use of Arabic Script in Magic," in *Proceedings of the Seminar for Arabian Studies*, vol. 40, ed. by M.C.A. Macdonald, supplement: *The Development of Arabic as a Written Language: Papers from the Special Session of the Seminar for Arabian Studies held on 24 July, 2009*, pp. 131–40. Oxford: Archaeopress.

Porter, Venetia, Liana Saif, and Emilie Savage-Smith. 2017. "Medieval Islamic Amulets, Talismans, and Magic," in *A Companion to Islamic Art and Architecture*, ed. by Finbarr Barry Flood and Gülru Necipoğlu, vol. 1: *From the Prophet to the Mongols*, pp. 521–57. Hoboken, NJ: Wiley Blackwell.

Pradines, Stephane. 2019. "Islamic Archeology in the Comoros: The Swahili and the Rock Crystal Trade with the Abbasid and Fatimid Caliphates," *Journal of Islamic Archaeology* 6: 109–35.

Priestman, Seth M. N. 2011. "Opaque Glazed Wares: The Definition, Dating and Distribution of a Key Iraqi Ceramic Export in the Abbasid Period," *Iran* 49: 89–113.

Provera, Mario E. 1973. *Il Vangelo arabo dell'Infanzia secondo il ms. Laurenziano orientale (n. 387)*. Jerusalem: Franciscan Printing Press.

Przeworski, Stefan. 1930. "Les encensoirs du Syrie du nord," *Syria* 11: 133–45.

Raby, Julian. 2004. "Nur Al-Din, the Qastal al-Shuʿaybiyya, and the 'Classical Revival,'" *Muqarnas* 21: 289–310.

Raby, Julian. 2018. "The Inscriptions on the Pisa Griffin and the Mari-Cha Lion: From Banal Blessings to Indices of Origin," in *The Pisa Griffin and the Mari-Cha Lion. Metalwork, Art and Technology in the Medieval Islamicate Mediterranean*, ed. by Anna Contadini, pp. 305–60. Pisa: Pacini.

Raby, Julian. 2022. "An Ayyubid-era Figural Ivory: A Sculptural Miniature," in *Fruits of Knowledge, Wheel of Learning: Essays in Honour of Robert Hillenbrand*, ed. by Melanie Gibson, pp. 220–39. London: Gingko.

Ragab, Ahmed. 2015. *The Medieval Islamic Hospital: Medicine, Religion and Charity*. Cambridge: Cambridge University Press.

Raggetti, Lucia. 2018. *Īsā ibn ʿAlī's Book on the Useful Properties of Animal Parts*. Berlin: De Gruyter.

Raggetti, Lucia. 2019. "Apollonius of Tyana's *Great Book of Talismans*," *Nuncius* 34: 155–82.

Rahmani, Levi Y. 1993. "Eulogia Tokens from Byzantine Bet She'an," *Atiqot* 22: 109–19.

Ranasinghe, Shaalini L. V. 2001. "The Castle of Emperor Fasilidas: Missionaries, Muslims, and Architecture in Gondar, Ethiopia." PhD dissertation, Columbia University.

Rao, Nagendra, ed. 2005. *Globalization: Pre-Modern India*. New Delhi: Regency Publications.

Rapaport, Yossef, and Emilie Savage-Smith. 2014. *An Eleventh-Century Egyptian Guide to the Universe: The Book of Curiosities*. Leiden: Brill.

Rassart-Debergh, Marguerite. 1987. "Quelques croix kelliotes," in *Nubia et Oriens Christianus: Festschrift für C. Detlef G. Müller zum 60. Geburtstag*, ed. by Piotr O. Scholz and Reinhard Stempel, pp. 373–85. Cologne: Dinter.

Rassart-Debergh, Marguerite. 2001. "Animaux dans le peinture kelliote," in *L'Animal dans les civilisations orientales/Animals in the Oriental Civilizations*, ed. by Christian Cannuyer, Denyse Fredericq-Homes, Francine Mawet, Julien Ries, and Antoon Schoors, pp. 183–96. Brussels: La Société belge des études orientales/The Belgian Society of Oriental Studies.

Redford, Scott. 1993. "The Seljuqs of Rum and the Antique," *Muqarnas* 10: 148–56.

Redford, Scott. 2007. "Words, Books, and Buildings in Seljuk Anatolia," *International Journal of Turkish Studies* 13: 7–16.

Regourd, Anne. 2011. "Arabic Language Documents on Paper," in *Myos Hormos—Quṣeir al-Qadīm: Roman and Islamic Ports on the Red Sea; Survey and Excavations 1999–2003*, ed. by David

Peacock and Lucy K. Blue, vol. 2: *Finds from the Excavations*, pp. 339–34. Oxford: Archaeopress.

Regourd, Anne, and Fiona Hanley. 2019. "Late Ayyubid and Mamluk Quṣayr al-Qadīm: What the Primary Sources Tell Us," in *The Mamluk Sultanate from the Perspective of Regional and World History*, ed. by Reuven Amitai and Stephan Conermann, pp. 479–500. Bonn: Bonn University Press.

Rehatsek, E. 1873–74. "Explanations and Facsimiles of Eight Arabic Talismanic Medicine-Cups," *Journal of the Bombay Branch of the Royal Asiatic Society* 10: 150–62.

Reil, Johannes. 1910. *Altchristliche Bildzyklen des Lebens Jesu*. Leipzig: Dieterich.

Reiner, Erica. 1987. "Magic Figurines, Amulets, and Talismans," in *Monsters and Demons in the Ancient and Medieval Worlds: Papers Presented in Honor of Edith Porada*, ed. by Ann E. Farkas, Prudence O. Harper, and Evelyn B. Harrison, pp. 27–36. Mainz: Von Zabern.

Reitlinger, Gerald. 1951. "Unglazed Relief Pottery from Northern Mesopotamia," *Ars Islamica* 15–16: 11–22.

Renault, François. 1989. *Le traite des noirs au Proche-Orient medieval, VIIᵉ–XIVᵉ siècles*. Paris: Geuthner.

Reudenbach, Bruno. 1994. "Panofsky und Suger von St. Denis," in *Erwin Panofsky: Beiträge Des Symposions, Hamburg, 1992*, ed. by Bruno Reudenbach, pp. 109–22. Berlin: Akademie-Verlag.

Reudenbach, Bruno. 2011. "Ein Weltbild im Diagramm—ein Diagramm als Weltbild: Das Mikrokosmos-Makrokosmos Schema des Isidor von Sevilla" in *Atlas der Weltbilder*, ed. by Steffen Siegel, Achim Spelten, Christoph Markschies, Ingeborg Reichle, Jochen Brüning, and Peter Deuflhard, pp. 33–40. Berlin: Akademie-Verlag.

Rhys Davids, T. W. 1908. "Adam's Peak," in *Encyclopaedia of Religion and Ethics*, ed. by James Hastings, vol. 1: *A–Art*, pp. 87–88. Edinburgh: T&T Clark; New York: Scribner's Sons.

Rice, David Storm. 1961. "A Seljuq Mirror," in *Proceedings of the First International Congress of Turkish Art*, pp. 288–90. Ankara: Faculty of Theology of the University of Ankara.

Richter, Jörg. 2015. "*Claritas, puritas, splendor*: Bergkristall und kristalline Formen in der Kunst vom Mittelalter bis zum 20. Jahrhundert," in *Stein aus Licht: Kristallvisionen in der Kunst* (exhibition catalogue, Kunstmuseum Bern, April 24–September 6, 2015), ed. by Matthias Frehner and Daniel Spanke, pp. 66–81. Bielefeld: Kerber.

Richter, Jörg. 2019. "Die Welt im Schatz: Elfenbein und Bergkristall, Straußeneier und Kokosnuss in St. Michaelis," in *Zeitenwende 1400: Die goldene Tafel als europäisches Meisterwerk*, ed. by Antje Fee-Köllermann and Christine Unsinn, pp. 127–37. Petersberg: Imhof.

Richter-Siebels, Ilse. 1990. "Die palästinensischen Weihrauchgefäße mit Reliefszenen aus dem Leben Christi." PhD dissertation, Freie Universität Berlin.

Riis, P. J., and Vagn Poulsen. 1957. *Hama: Fouilles et Recherches 1931–1938. IV/2: Les verreries et poteries médiévales*. Copenhagen: Fondation Carlsberg.

Ritner, Robert K. 1989. "Horus on the Crocodiles: A Juncture of Religion and Magic in Late Dynastic Egypt," in James P. Allen, Jan Assmann, Alan B. Lloyd, Robert K. Ritner, and David P. Silverman, *Religion and Philosophy in Ancient Egypt* (Yale Egyptological Studies 3), pp. 103–16. New Haven, CT: Department of Near Eastern Languages and Civilizations, the Graduate School, Yale University.

Ritner, Robert K. 1997. *The Mechanics of Ancient Egyptian Magical Practice*. Chicago: Oriental Institute of the University of Chicago.

Roberts, Jennifer L. 2017. "Things: Material Turn, Transnational Turn," *American Art* 31: 64–69.

Robinson, Cynthia. 1992. "Box" (cat. no. 13), in *Al-Andalus: The Art of Islamic Spain* (exhibition catalogue, The Alhambra, Granada, March 18–June 7, 1992, and the Metropolitan Museum of Art, New York, July 1–27 September, 1992), ed. by Jerrilynn Denise Dodds, p. 214. New York: The Metropolitan Museum of Art.

Robson, James. 1934. "Magic Cures in Popular Islam," *The Moslem World* 24: 33–43.

Röder, Günther. 1937. *Ägyptische Bronzewerke*. Glückstadt: Augustin.

Rogers, J. Michael. 1971. "A Renaissance of Classical Antiquity in North Syria, 11th to 12th Centuries," *Les Annales archéologiques arabes syriennes* 21: 347–61.

Ronig, Franz. 2012. "Die Schatz- und Heiltumskammern: Zur ursprünglichen Aufbewahrung von Reliquien und Kostbarkeiten," in *Animum ad subtiliora deducere: Grundformen der Trierer Kunstgeschichte; Festgabe für Franz Ronig zum 85. Geburtstag*, ed. by Michael Embach and Franz Ronig, pp. 59–68. Trier: Verlag für Geschichte und Kultur.

Rosenberg, Marc. 1908. *Geschichte der Goldschmiedekunst auf technischer Grundlage*, vol. 2: *Niello*. Frankfurt a. M.: Keller.

Rosenthal, Franz. 1983. "A Fourteenth-Century Report on Ethiopia," in *Ethiopian Studies: Dedicated to Wolf Leslau on the Occasion of His Seventy-Fifth Birthday*, ed. by Stanislav Segert and András J. E. Bodrogligeti, pp. 495–506. Wiesbaden: Harrassowitz.

Ross, Marvin C. 1962. *Catalogue of the Early Mediaeval Antiquities in the Dumbarton Oaks Collection*, vol. 1: *Metalwork, Ceramics, Glass, Glyptics, Painting*. Washington, DC: Dumbarton Oaks Research Library and Collection.

Rosser-Owen, Mariam. 2012. "The Metal Mounts on Andalusi Ivories: Initial Observations," in *Metalwork and Material Culture in the Islamic World: Art, Craft and Text; Essays Presented to James W. Allan*, ed. by Venetia Porter and Mariam Rosser-Owen, pp. 301–16. London: I.B. Tauris.

Rosser-Owen, Mariam. 2015. "Islamic Objects in Christian Contexts: Relic Translation and Modes of Transfer in Medieval Iberia," *Art in Translation* 7: 39–64.

Rothenberg, Benno. 1972. *Timna: Valley of the Biblical Copper Mines*. London: Thames and Hudson.

Rotter, Gernot. 1967. *Die Stellung des Negers in der islamisch-arabischen Gesellschaft bis zum XVI. Jahrhundert*. Bonn: Rheinischen Friedrich-Wilhelms-Universität.

Rougeulle, Axelle, ed. 2015. *Sharma: Un entrepôt de commerce medieval sur la côte du Ḥaḍramawt (Yémen), ca. 980–1180*. Oxford: Archaeopress.

Roux, Valentine, and Gianluca Manzo. 2018. "Social Boundaries and Networks in the Diffusion of Innovations: A Short Introduction," *Journal of Archaeological Method and Theory* 25: 967–73.

Rouxpetel, Camille. 2012. "'Indiens, Éthiopiens et Nubiens' dans les récits de pèlerinage occidentaux: Entre altérité constatée et altérité construite (XIIᵉ–XIVᵉ siècles)," *Annales d'Éthiopie* 27: 71–90.

Roxburgh, David J. 2013. "In Pursuit of Shadows: Al-Hariri's *Maqāmāt*," *Muqarnas* 30: 171–212.

Roxburgh, David J. 2022. "Islamicate Diagrams," in *The Diagram as Paradigm. Cross-cultural Approaches*, ed. by Jeffrey F. Hamburger, David J. Roxburgh, and Linda Safran, pp. 33–52. Washington, DC: Dumbarton Oaks Research Library and Collection.

Rudolph, Conrad. 1990. *Artistic Change at St-Denis: Abbot Suger's Program and the Early Twelfth-Century Controversy over Art*. Princeton, NJ: Princeton University Press.

Rudolph, Kurt. 1978. *Mandaeism*. Leiden: Brill.

Rudy, Kathryn M. 2011. "Kissing Images, Unfurling Rolls, Measuring Wounds, Sewing Badges and Carrying Talismans: Considering Some Harley Manuscripts through the Physical Rituals they Reveal," *The Electronic British Library Journal*: 1–56.

Rudy, Kathryn M. 2018. "Eating the Face of Christ: Philip the Good and his Physical Relationship with Veronicas," in *The European Fortune of the Roman Veronica in the Middle Ages*, ed. by Eamon Duffy, Herbert L. Kessler, Guido Milanese, Amanda Murphy, and Marco Petoletti (*Convivium* Supplementum 2), pp. 169–78. Brno: Masarykova Univerzita.

Ruffini, Giovanni R. 2012. *Medieval Nubia. A Social and Economic History*. Oxford: Oxford University Press.

Ruiz Albi, Irene. 2003. *La reina Doña Urraca (1109—1126): Cancillería y colección diplomática*. León: Centro de Estudios e Investigación San Isidoro.

Rustow, Marina. 2020. *The Lost Archive: Traces of a Caliphate in a Cairo Synagogue*. Princeton, NJ: Princeton University Press.

Saar, Ortal-Paz. 2019. "Geniza Magical Documents," *Jewish History* 32: 477–84.

Sadek, Noha. 2019. *Custodians of the Holy Sanctuaries: Rasulid-Mamluk Rivalry in Mecca* Berlin: EB-Verlag.

Saif, Liana. 2017. "Between Medicine and Magic: Spiritual Aetiology and Therapeutics in Medieval Islam," in *Demons and Illness from Antiquity to the Early-Modern Period*, ed. by Siam Bhayro and Catherine Rider, pp. 313–38. Leiden: Brill.

Saliba, George. 1992. "The Role of the Astrologer in Medieval Islamic Society," *Bulletin d'études orientales* 44: 45–67.

Sambursky, Shmuel. and Shlomo Pines. 1971. *The Concept of Time in Late Neoplatonism*. Jerusalem: Brill.

Sanagustin, Floréal. 2010. *Médecine et société en Islam medieval: Ibn Butlān ou la connaissance médicale au service dl la communauté; Le cas de l'esclavage*. Paris: Geuthner.

Sanjosé i Llongueras, Lourdes de. 2018. *Al servei de l'altar: Tresors d'orfebreria de les eglésies catalanes, segles IX–XIII*. Vic: Arxiu i Biblioteca Episcopal de Vic i el Patronat d' Estudis Osonensis.

Satzinger, Helmut. 1984. *Land des Baal: 10.000 Jahre Kultur in Syrien*. Vienna: Bildener Künstler Österreichs.

Sauter, Roger. 1967–68. "L'Arc et les panneaux sculptés de la vielle église d'Asmara," *Rassegna di studi etiopici* 23: 220–31.

Savage-Smith, Emilie. 1997. "Magic Medicinal Bowls," in Francis Maddison and Emilie Savage-Smith, *Science, Tools and Magic, Part 1: Body and Spirit, Mapping the Universe* (The Nasser D. Kalili Collection of Islamic Art 12), pp. 72–100. Oxford: The Nour Foundation.

Scerrato, Umberto. 1980. "Specchi islamici con sfingi scorpioniche," *Arte orientale in Italia* 5: 61–94.

Schaeffer, Karl R. 2006. *Enigmatic Charms: Medieval Arabic Block Printed Amulets in American and European Libraries and Museums*. Leiden: Brill.

Schibille, N., J.D.J. Ares, M.T.C. García, and C. Guerrot. 2020. "Ex novo Development of Lead Glassmaking in Early Umayyad Spain," *Proceedings of the National Academy of Sciences* 117: 16243–49.

Schlumberger, Gustave. 1892. "Amulettes byzantins anciens, destinés à combattre les maléfices et maladies," *Revue des études grecques* 5: 73–93.

Schmidt Arcangeli, Catarina, and Gerhard Wolf, eds. 2010. *Islamic Artefacts in the Mediterranean World: Trade, Gift Exchange and Artistic Transfer*. Venice: Marsilio.

Schneider, Madeleine. 1967. "Stèles funéraires arabes de Quiha," *Annales d'Éthiopie* : 107–22.

Schneider, Madeleine. 1969. "Stèles funéraires de la region de Harar at Dahlak (Éthiopie)," *Revue des études islamiques* 2: 339–43.

Schneider, Madeleine. 2005. "Notes au sujet de deux stèles funéraires en arabe de Baté (Harar)," *Le Muséon* 118: 333–54

Schneider, Pierre. 2004. *L'Éthiopie et l'Inde:. Interférences et confusions aux extrémités du monde antique (VIIIᵉ siècle avant J.C.–VIᵉ siècle après J.C.)*. Rome: École française de Rome.

Schneider, Pierre. 2015. "The So-called Confusion between India and Ethiopia: The Eastern and Southern Edges of the Inhabited World from the Greco-Roman Perspective," in *Brill's Companion to Ancient Geography: The Inhabited World in Greek and Roman Tradition*, ed. by Serena Bianchetti, Michele Cataudella, and Hans-Joachim Gehrke, pp. 184–202. Leiden: Brill.

Schöller, Marco, and Werner Diem. 2004. *The Living and the Dead in Islam: Studies in Arabic Epitaphs*, vol. 2: *Epitaphs in Context*. Wiesbaden: Harrassowitz.

Schwartz, Martin. 1996. "*Sasm, Sesen, St. Sisinnios, Sesen Bar-pharangē, and . . . 'Semanglof,'" *Bulletin of the Asia Institute* 10: 253–57.

Schwarzer, Joseph K., II. 2004. "The Weapons," in *Serçe Limanı: An Eleventh-Century Shipwreck*, vol. 1: *The Ship and Its Anchorage, Crew, and Passengers*, ed. by George F. Bass, Shella D. Matthews, J. Richard Steffy, and Frederick H. van Doorninck Jr., pp. 363–98. College Station, TX: Texas A&M University Press.

Schweizer, François. 1977. "Analyse et examen technique," *Genava: Revue d'histoire de l'art et d'archéologie* 25: 51–62.

Scirocco, Elisabetta. 2015. "Jonah, the Whale and the Ambo: Image and Liturgy in Medieval Campania," in *The Antique Memory and the Middle Ages*, ed. by Ivan Foletti and Zuzana Frantová, pp. 87–123. Rome: Viella.

Scott, Nora E. 1951. "The Metternich Stela," *The Metropolitan Museum of Art Bulletin* 9: 201–17.

Seidler, Martin. 1985. "E 96: Reliquienziborium mit der Trinkschale des hl. Heribert," in: *Ornamenta Ecclesiae*, ed. by Anton Legner, vol. 2, p. 332. Cologne: Schnütgen.

Selçuklu Şifa Tasları, http://girlandkultursanat.com/wp-content /uploads/sel%C3%A7uklu-%C5%9Fifa-tas%C4%B1.pdf (accessed January 13, 2023)

Seligsohn, M. 1913. "Adam," in *Enzyklopaedie des Islām*, ed. by M. Th. Houtsma, T. W. Arnold, R. Basset, and R. Hartmann, vol.1: *A–D*, pp. 134–35. Leiden: Brill; Leipzig: Harrassowitz.

Sen, Tansen, and Pamela H. Smith. 2019. "Trans-Eurasian Routes of Exchange: A Brief Historical Overview," in *Entangled Itineraries: Materials, Practices, and Knowledges across Eurasia*, ed. by Pamela H. Smith, pp. 25–43. Pittsburgh, PA: University of Pittsburgh Press.

Shafiq, Suhanna. 2013. *Seafarers of the Seven Seas: The Maritime Culture in the "Kitāb 'Ajā'ib al-Hind" (The Book of the Marvels of India) by Buzurg ibn Shahriyār (d. 399/1009)*. Berlin: Schwarz.

Shaked, Shaul, James Nathan Ford, and Siam Bhayro, eds. 2013. *Aramaic Bowl Spells: Jewish Babylonian Aramaic Bowls*, vol. 1. Leiden: Brill.

Shalem, Avinoam. 1994. "Fountains of Light: The Meaning of Medieval Islamic Rock Crystal Lamps," *Muqarnas* 11: 1–11.

Shalem, Avinoam. 1998. *Islam Christianized: Islamic Portable Objects in the Medieval Church Treasuries of the Latin West*. Frankfurt a. M.: Lang.

Shalem, Avinoam. 1999. "The Rock Crystal Lion Head in the Badisches Landesmuseum in Karlsruhe," in *L'Égypte fatimide: Son art et son histoire*, ed. by Marianne Barrucand, pp. 359–66. Paris: Presses de l'Université de Paris-Sorbonne.

Shalem, Avinoam. 2004. *The Oliphant: Islamic Objects in Historical Context*. Leiden: Brill.

Shalem, Avinoam. 2005. "Objects as Carriers of Real or Contrived Memories in a Cross-cultural Context," *Mitteilungen zur spätantiken Archäologie und byzantinischen Kunstgeschichte* 4: 101–19.

Shalem, Avinoam. 2008. "Wie byzantinisch war der Schatz der Fatimiden," in *Grenzgänge im Östlichen Mittelmeerraum. Byzanz und die Islamische Welt vom 9. bis 13. Jahrhundert*, ed. by Ulrike

Koenen and Martina Müller-Wiener, pp. 65–81. Wiesbaden: Reichert.

Shalem, Avinoam. 2010a. "Hybride und Assemblagen in mittelalterlichen Schatzkammern: Neue ästhetische Paradigmata im Hinblick auf die 'Andersheit'," in *Le trésor au Moyen Âge: Discours, pratiques et objets*, ed. by Lucas Burkart, Philippe Cordez, Pierre Alain Mariaux, and Yann Potin, pp. 297–313. Florence: SISMEL.

Shalem, Avinoam. 2010b. "The Otherness in the Focus of Interest; or, If Only the Other Could Speak," in *Islamic Artefacts in the Mediterranean World. Trade, Gift Exchange and Artistic Transfer*, ed. by Catarina Schmidt Arcangeli and Gerhard Wolf, pp. 29–44. Venice: Marsilio.

Shalem, Avionam. 2011. "Histories of Belonging and George Kubler's Prime Object," *Getty Research Journal* 3: 1–14.

Shalem, Avinoam. 2012. "Multivalent Paradigms of Interpretation and the Aura or Anima of the Object," in *Islamic Art and the Museum. Approaches to Art and Archeology of the Muslim World in the Twenty-First Century*, ed. by Benoît Junod, George Khalil, Stefan Weber, and Gerhard Wolf, pp. 101–15. London: Saqi.

Shehada, Housni Alkhateeb. 2013. *Mamluks and Animals: Veterinary Medicine in Medieval Islam*. Leiden: Brill.

Shen, Hsueh-man. 2017. "The China-Abbasid Ceramics Trade during the Ninth and Tenth Centuries: Chinese Ceramics Circulating in the Middle East," in *A Companion to Islamic Art and Architecture*, ed. by Finbarr Barry Flood and Gülru Necipoğlu, vol. 1: *From the Prophet to the Mongols*, pp. 197–218. Hoboken, NJ: Wiley Blackwell.

Shepard, Jonathan. 2018. "Networks," *Past and Present* 238, supplementary issue 13, *The Global Middle Ages*, ed. by Catherine Holmes and Naomi Standen, pp. 116–57.

Silverman, Raymond. 1991. "Arabic Writing and the Occult," in *Brocade of the Pen: The Art of Islamic Writing*, ed. by Carol G. Fischer, pp. 19–30. East Lansing, MI: Kresge Art Museum.

Simic, Kosta. 2017. "Liturgical Poetry in the Middle Byzantine Period: Hymns Attributed to Germanos I, Patriarch of Constantinople (715–730)." PhD dissertation, Australian Catholic University.

Simpson, Marianna Shreve. 1981. "The Narrative Structure of a Medieval Iranian Beaker," *Ars Orientalis* 12: 15–24.

Sindawi, Khalid. 2012. " 'Tell Your Cousin to Place a Ring on His Right Hand and Set It with a Carnelian': Notes on the Wearing of the Ring on the Right Hand among Shīʻites," *Journal of Semitic Studies* 57: 295–320.

Sivan, Hagith. 2008. *Palestine in Late Antiquity*. Oxford: Oxford University Press.

Skubiszewski, Piotr. 1980. "Eine Gruppe romanischer Goldschmiedearbeiten in Polen (Trzemeszno, Czerwińsk)," *Jahrbuch der Berliner Museen* 22: 35–90.

Smidt, Wolbert G. C. 2010. "Another Unknown Arabic Inscription from the Eastern Tigrayan Trade Route: Indication for a Muslim Cult Site during the 'Dark Age,'" in *Juden, Christen und Muslime in Äthiopien: Ein Beispiel für abrahamische Ökumene* ed. by Walter Raunig and Prinz Asfa-Wossen Asserate (Orbis Aethiopicus 13), pp. 179–91. Dettelbach: Röll.

Smidt, Wolbert G. C. 2011. "A Note on the Islamic Heritage of Tigray: The Current Situation of the Arabic Inscription of Wuqro," *ITYOPIS—Northeast African Journal of Social Sciences and Humanities* 1: 151–54.

Smith, Pamela H. 2019. "Nodes of Convergence, Material Complexes, and Entangled Itineraries," in *Entangled Itineraries: Materials, Practices, and Knowledges across Eurasia*, ed. by Pamela H. Smith, pp. 5–24. Pittsburgh, PA: University of Pittsburgh Press.

Smith Pamela H., and Benjamin Schmidt, eds. 2008. *Making Knowledge in Early Modern Europe: Practices, Objects, and Texts, 1400–1800*. Chicago: University of Chicago Press.

Smithsonian. National Museum of Asian Art, https://asia.si.edu/object/F1934.19/ (accessed January 13, 2023).

Snelders, Bas, and Adeline Jeudy. 2006. "Guarding the Entrances: Equestrian Saints in Egypt and North Mesopotamia," *Eastern Christian Art* 3: 103–40.

Sommer, Johannes. 1957. "Der Niellokelch von Iber: Ein unbekanntes Meisterwerk der Hildesheimer Goldschmiedekunst des späten 12. Jahrhunderts," *Zeitschrift für Kunstwissenschaft* 11: 109–36.

Sood, Gagan D. S. 2011. "Circulation and Exchange in Islamicate Eurasia: A Regional Approach to the Early Modern World," *Past and Present* 212 (1): 113–62.

Sotheby's. 2009. "Arts of the Islamic World" (auction, London, April 1, 2009), https://www.sothebys.com/en/auctions/2009/arts-of-the-islamic-world-l09721.html (accessed January 13, 2023).

Soucek, Priscilla. 1997. "Byzantium and the Islamic East," in *The Glory of Byzantium: Art and Culture of the Middle Byzantine Era 843–1261*, ed. by Helen C. Evans and William D. Wixom, pp. 403–11. New York: The Metropolitan Museum of Art.

Speer, Andreas, and Hildtrud Westermann-Angerhausen. 2006. "Ein Handbuch mittelalterlicher Kunst?: Zu einer relecture der Schedula diversarium atrium," in *Schatzkunst am Aufgang der Romanik: Der Paderborner Dom-Tragaltar und sein Umkreis*, ed. by Christoph Steigemann and Hildtrud Westermann-Angerhausen, pp. 249–258. Munich: Hirmer.

Spengler, William F., and Wayne G. Sayles. 1992. *Turkoman Figural Bronze Coins and Their Iconography*, 2 vols. Lodi, WI: Clio's Cabinet.

Spier, Jeffrey. 1993. "Medieval Byzantine Amulets and Their Tradition," *Journal of the Warburg and Courtauld Institutes* 56: 25–62.

Spier, Jeffrey. 2013. *Late Antique and Early Christian Gems*. Wiesbaden: Reichert.

Spier, Jeffrey. 2014 "An Antique Magical Book Used for Making Sixth-Century Byzantine Amulets?," in *Les savoirs magiques et leur transmission de l'Antiquité à la Renaissance*, ed. by Véronique Dasen and Jean-Michel Speiser, pp. 43–66. Florence: SISMEL-Edizioni del Galluzzo.

Spoer, H. Henry. 1935. "Arabic Medicinal Bowls," *Journal of the American Oriental Society* 55: 237–56.

Stahl, Ann B. 2014. "Africa in the World: (Re)Centering African History through Archaeology," *Journal of Anthropological Research Spring* 70 (1): 5–33.

Stargardt, Janice. 2014. "Indian Ocean Trade in the Ninth and Tenth Centuries: Demand, Distance, and Profit," *South Asian Studies* 30: 35–55.

Starnawska, Maria. 2006. "Die Ausstellungen der Reliquien in der Kirchenprovinz Gnesen im Mittelalter," in *Wallfahrten in der europäischen Kultur: Tagungsband Příbram, 26–29 Mai 2004*, ed. by Eva Doležalová, Daniel Doležal, and Hartmut Kühne, vol. 1, pp. 221–33. Frankfurt a. M.: Lang.

Stavros, Margo. 2002. "Precious Metals in Byzantine Art and Society, 843–1204." PhD dissertation, Pennsylvania State University.

St. Clair, Archer. 1978. "The Iconography of the Great Berlin Pyxis," *Jahrbuch der Berliner Museen* 20: 5–27.

St. Clair, Archer. 1979. Cat. nos. 563 and 564 in *Age of Spirituality: Late Antique and Early Christian Art, Third to Seventh Century* (exhibition catalogue, the Metropolitan Museum of Art, New York, November 19, 1977–February 12, 1978), ed. by Kurt Weitzmann, pp. 626–27. New York: The Metropolitan Museum of Art.

Steedman, Carolyn. 2001. "Something She Called a Fever: Michelet, Derrida, and Dust," *The American Historical Review* 106 (4): 1159–80.

Stern, S. M. 1967. "Rāmisht of Sīrāf, a Merchant Millionaire of the Twelfth Century," *Journal of the Royal Asiatic Society* 1 (2): 10–14.

Stewart, Devin J. 2012. "The Mysterious Letters and Other Formal Features of the Qurʾān in Light of Greek and Babylonian Oracular Texts," in *New Perspectives on the Qurʾān* (The Qurʾān in Its Historical Context 2), ed. by Gabriel Said Reynolds, pp. 323–48, London: Routledge.

Strathern, Alan. 2018. "Global Early Modernity and the Problem of What Came Before," *Past and Present* 238, supplementary issue 13, *The Global Middle Ages*, ed. by Catherine Holmes and Naomi Standen, pp. 317–244.

Strauch, Ingo, ed. 2012. *Foreign Sailors on Socotra: The Inscriptions and Drawings from the Cave Hoq*. Bremen: Hempen.

Subrahmanyam, Sanjay. 2005. *Explorations in Connected Histories: Mughals and Franks*. New Delhi: Oxford University Press.

Subrahmanyam, Sanjay. 2019. "Between Eastern Africa and Western India, 1500–1650: Slavery, Commerce, and Elite Formation," *Comparative Studies in Society and History* 61: 805–34.

Subrahmanyam, Sanjay. 2022. *Connected History: Essays and Arguments*. London: Verso.

Suleman, Fahmida. 2022. "Reaching New Heights: The Giraffe in the Material Culture, Ceremonial, and Diplomacy of Fatimid Egypt," in *Made for the Eye of One Who Sees: Canadian Contributions to the Study of Islamic Art and Architecture*, ed. by Marcus Milwright and Evanthia Baboula, pp. 233–54. Montreal/Kingston: McGill-Queen's University Press.

Swarzenski, Hanns. 1954. *Monuments of Romanesque Art: The Art of Church Treasures in North-Western Europe*. London: Faber and Faber.

Swift, Ellen. 2102. "Object Biography, Re-Use and Recycling in the Late to Post-Roman Transition Period and Beyond: Rings Made from Romano-British Bracelets," *Britannia* 43: 167–215.

Symes, Carol. 2021. "Introduction: Exploring the Global North, from the Iron Age to the Age of Sail," *The Medieval Globe* 7 (1): 1–7.

Tabbaa, Yasser. 1985. "The Muqarnas Dome: Its Origin and Meaning," *Muqarnas* 3: 61–74.

Talbot, Alice-Mary. 2001. "Byzantine Pilgrimage to the Holy Land from the Eighth to the Fifteenth Century," *The Sabaite Heritage in the Orthodox Church from the Fifth Century to the Present*, ed. by Joseph Patrich, pp. 97–110. Leuven: Peeters.

Talbot, Alice-Mary. 2002. " 'Pilgrimage in the Byzantine Empire: 7th–15th Centuries' (Dumbarton Oaks Symposium, 5–7 May 2000): Introduction," *Dumbarton Oaks Papers* 56: 59–61.

Talmon-Heller, Daniella, Katia Cytryn-Silverman, and Yasser Tabbaa. 2015. "Introduction: Material Evidence and Narrative Sources. Interdisciplinary Studies of the History of the Muslim Middle East," in *Material Evidence and Narrative Sources*, ed. by Daniella Talmon-Heller, pp. 1–13. Leiden: Brill.

Taylor, Christopher Schurman. 1999. *In the Vicinity of the Righteous: Ziyāra and the Veneration of Muslim Saints in Late Medieval Egypt*. Leiden: Brill.

Tesfaye, Gigar. 1987. "Découverte d'inscriptions guèzes à Lalibela," *Annales d'Éthiopie* 14: 75–80.

Tesfaye, Habtamu, Aurèle Letricot, Bertrand Poissonnier, and François-Xavier Fauvelle-Aymar. 2010. "Découvertes archéologiques aux environs de Dessié (Éthiopie)," *Annales d'Éthiopie* 25: 261–68.

Tesfaye, Habtamu, Aurèle Letricot, Bertrand Poissonnier, and François-Xavier Fauvelle-Aymar. 2011. "Le lion de Kombolcha et le léopard d'Aksum: Des félins rupestres paléochrétiens?," *Annales d'Éthiopie* 26: 269–89.

Thackston, Wheeler M. 1989. *A Century of Princes: Sources on Timurid History and Art*. Cambridge, MA: Aga Khan Program for Islamic Architecture.

Thierry, Nicole. 1999. "Aux limites du sacré et du magique: Un programme d'entrée d'une église en Cappadoce," in *La science des cieux: Sages, mages, astrologues*, ed. by Rika Gyselen, pp. 233–47. Bures-sur-Yvette: Groupe pour l'étude de la civilisation du Moyen-Orient.

Thurlkill, Mary F. 2016. *Sacred Scents in Early Christianity and Islam*. Lanham, MD: Lexington Books.

Tilahun, Chernet. 1990. "Traces of Islamic Material Culture in North-Eastern Shoa," in *Proceedings of the First National Conference of Ethiopian Studies (Addis Ababa, April 11–12, 1990)*, ed. by Richard Pankhurst, Ahmed Zekaria, and Taddese Beyene. pp. 303–20. Addis Ababa: Institute of Ethiopian Studies, Addis Ababa University.

Tod, Marcus N. 1939. "The Scorpion in Graeco-Roman Egypt," *The Journal of Egyptian Archaeology* 25: 55–61.

Tondelli, Leone. 1923. "Caro non prodest quidquam (Ioh. 6, 64)," *Biblica*: 320–27.

Torijano, Pablo A. 2012. "Solomon and Magic," in *The Figure of Solomon in Jewish, Christian, and Islamic Tradition. King, Sage, and Architect*, ed. by Joseph Verheyden, pp. 107–25. Leiden: Brill.

Touati, Houari. 2010. *Islam and Travel in the Middle Ages*, trans. by Lydia G. Cochrane. Chicago: University of Chicago Press.

Toussaint, Gia. 2010. "Blut oder Blendwerk?: Orientalische Kristallflakons in mittelalterlichen Kirchenschätzen," in *Das Heilige sichtbar machen. Domschätze in Vergangenheit, Gegenwart und Zukunft*, ed. by Ulrike Wendland, pp. 107–20. Regensburg: Schnell & Steiner.

Toussaint, Gia. 2011. *Kreuz und Knochen: Reliquien zur Zeit der Kreuzzüge*. Berlin: Reimer.

Toussaint, Gia. 2012. "Cosmopolitan Claims: Islamicate Spolia during the Reign of King Henry II, 1002–1024," *Medieval History Journal* 15: 299–318.

Tribe, Tania Costa. 1997. "The Word in the Desert: The Wall-Paintings of Debra Maryam Korkor (Gerʿalta, Tigray)," in *Ethiopia in Broader Perspective: Papers of the 13th International Conference of Ethiopian Studies (Kyoto, 12–17 December 1997)*, ed. by Katsuyoshi Fukui, Eisei Kurimoto, and Masayoshi Shigeta, vol. 3, pp. 35–61. Kyoto: Shikado.

Trivellato, Francesca, Leor Halevi, and Cátia Antunes, eds. 2014. *Religion and Trade: Cross-cultural Exchanges in World History, 1000–1900*. Oxford: Oxford University Press.

Tronzo, William. 2011. "Restoring Agency to the Discourse on Hybridity: The Cappella Palatina from a Different Point of View," in *Die Cappella Palatina in Palermo: Geschichte, Kunst, Funktionen*, ed. by Thomas Dittelbach, pp. 579–80. Künzelsau: Swiridoff.

Trouillot, Michel-Rolph. 2002. "The Perspective of the World: Globalization Then and Now," in *Beyond Dichotomies: Histories, Identities, Cultures, and the Challenge of Globalization*, ed. by Elisabeth Mudimbe-Boyi, pp. 3–20. Albany, NY: SUNY Press.

Turkish Ministry of Culture and Tourism. 1983. *The Anatolian Civilisations* (exhibition catalogue, 18th European Art Exhibition, Istanbul, May 22–October 30, 1983, 3 vols), vol. 3: *Seljuk/Ottoman*. Istanbul: Topkapı Palace Museum.

University of Toronto. *New Rock-Hewn Churches of Ethiopia*, https://www.utsc.utoronto.ca/projects/ethiopic-churches/ambager-complex-dagmawi-lalibela/ (accessed January 13, 2023).

Ussishkin, David. 1970. "The Syro-Hittite Ritual Burial of Monuments," *Journal of Near Eastern Studies* 29: 124–28.

Vallet, Éric. 2007. "Les Sultans rasūlides du Yémen, protecteurs des communautés musulmanes de l'Inde," *Annales islamologiques* 41: 149–76.

Vallet, Éric. 2015. *L'Arabie marchande: État et commerce sous les*

sultans rasūlides du Yémen (626–858/1229–1454). Paris: Publications de la Sorbonne.

Vanoli, Alessandro, ed. 2019. *Water, Islam and Art: Drop by Drop, Life Falls from the Sky*. Turin: Silvana.

Varisco, Daniel Martin. 2007. "Making 'Medieval' Islam Meaningful," *Medieval Encounters* 13: 385–412.

Vernet, Thomas. 2015. "East African Travelers and Traders in the Indian Ocean: Swahili Ships, Swahili Mobilities, ca. 1500–1800," in *Trade, Circulation, and Flow in the Indian Ocean World*, ed. by Michael N. Pearson, pp. 167–202. New York: Palgrave Macmillan.

Verstegen, Ute. 2002. "Gemeinschaftserlebnis in Ritual und Raum: Zur Raumdisposition in frühchristlichen Basiliken des vierten und fünften Jahrhunderts," in *Religiöse Vereine in der römischen Antike* (Studien und Texte zu Antike und Christentum 13), ed. by Ulrike Egelhaaf-Gaiser, pp. 261–97. Tübingen: Mohr Siebeck.

Verstegen, Ute. 2009. "Die symbolische Raumordnung frühchristlicher Basiliken des 4. bis 6. Jahrhunderts: Zur Interdependenz von Architektur, Liturgie und Raumausstattung," *Rivista di archeologia cristiana* 85: 567–600.

Verstegen, Ute. 2015. "Die architektonische Inszenierung der christlichen Erinnerungsorte im Heiligen Land: Architektursemantische Betrachtungen zu einem konstantinischen Innovationskonzept," *In situ* 7: 151–70.

Viaud, Gérard. 1978. *Magie et coutumes populaires chez les coptes d'Egypte*. Saint-Vincent-sur-Jabron: Éditions Présence.

Viegas Wesołowska, Catia. 2011. "Metal Mounts on Ivories of Islamic Spain," in *The Art of the Islamic World and the Artistic Relationships between Poland and Islamic Countries*, ed. by Beata Biedrońska-Słota, Magdalena Ginter-Frołow, and Jerzy Malinowski, pp. 189–98. Kraków: Polish Institute of World Art Studies.

Vikan, Gary. 1984. "Art, Medicine, and Magic in Early Byzantium," *Dumbarton Oaks Papers* 38: 65–86.

Vikan, Gary. 1990. "Pilgrims in Magi's Clothing: The Impact of Mimesis on Early Byzantine Art," in *The Blessings of Pilgrimage*, ed. by Robert Ousterhout, pp. 97–107. Urbana, IL: University of Illinois Press.

Vikan, Gary. 1991. " 'Guided by Land and Sea': Pilgrim Art and Pilgrim Travel in Early Byzantium," *Jahrbuch für Antike und Christentum* 18: 74–92.

Vikan, Gary. 1995. "Icons and Icon Piety in Early Byzantium," in *Byzantine East, Latin West: Art-historical Studies in Honor of Kurt Weitzmann*, ed. by Christopher Moss and Katherine Kiefer, pp. 569–78. Princeton, NJ: Princeton University Press.

Vikan, Gary. 2010. *Early Byzantine Pilgrimage Art* (Dumbarton Oaks Byzantine Collection Publications 5). Washington, DC: Dumbarton Oaks Research Library and Collection.

Vikan, Gary. 2020. *Early Byzantine Pilgrimage Art* (rev. edn). Washington, DC: Dumbarton Oaks Research Library and Collection.

Vilozny, Naama. 2013. "The Art of the Aramaic Incantation Bowls," in *Aramaic Bowl Spells: Jewish Babylonian Aramaic Bowls*, ed. by Saul Shaked, James Nathan Ford, and Siam Bhayro, vol. 1, pp. 29–37. Leiden: Brill.

Vilozny, Naama. 2015. "Lilith's Hair and Ashmedai's Horns: Incantation Bowl Imagery in the Light of Talmudic Descriptions," in *The Archaeology and Material Culture of the Babylonian Talmud*, ed. by Markham J. Geller, pp. 133–52. Leiden: Brill.

Viré, François. 1966. "Le traité de l'art de volerie (*Kitāb al-bayzara*) rédigé vers 385/995 par le Grand-Fauconnier du calife fāṭimide al-ʿAzīz bi-llāh: IV," *Arabica* 13: 39–76.

Voll, John Obert. 1994. "Islam as a Special World-System," *Journal of World History* 5 (2): 213–26.

Wagner, Ewald. 1967. "Die illustrationen der Äthiopischen zauber-

rollen der Sammlung Littman," in *Der Orient in der Forschung: Festschrift für Otto Spies zum 5. April 1966*, ed. by Wilhelm Hoenerbach, pp. 706–32. Wiesbaden: Harrassowitz.

Walker, Alicia. 2008. "Cross-Cultural Reception in the Absence of Texts: The Islamic Appropriation of a Middle Byzantine Rosette Casket," *Gesta* 47 (2): 99–122.

Walker, Alicia. 2012a. *The Emperor and the World: Exotic Elements and the Imaging of Middle Byzantine Imperial Power, Ninth to Thirteenth Centuries CE*. Cambridge: Cambridge University Press.

Walker, Alicia. 2012b. "Globalism," *Studies in Iconography* 33: 183–96.

Walker, Alicia. 2017. "The Beryozovo Cup: A Byzantine Object at the Crossroads of Twelfth-Century Eurasia," *The Medieval Globe* 3 (2): 125–48.

Wallace, Birgitta. 2003. "The Norse in Newfoundland: L'Anse aux Meadows and Vinland," in *Newfoundland and Labrador Studies* 19: 5–43.

Wallerstein, Immanuel. 2004. *World-Systems Analysis: An Introduction*. Durham, NC: Duke University Press.

Walmsley, Alan. 2020. "Coinage and the Economy of Syria in the Seventh and Eighth Centuries CE," in *Money, Power and Politics in Early Islamic Syria: A Review of Current Debates*, ed. by John Haldon, pp. 21–44. New York: Routledge.

Walter, Christopher. 1989–90. "The Intaglio of Solomon in the Benaki Museum and the Origins of the Iconography of Warrior Saints," *Deltion XAE* 15: 33–42.

Walter, Christopher. 2003. *The Warrior Saints in Byzantine Art and Tradition*. Burlington, VT: Ashgate.

Walters, C. C. 1989. "Christian Paintings from Tebtunis," *The Journal of Egyptian Archaeology* 75: 191–208.

Warburg, Aby. 1999. *The Renewal of Pagan Antiquity: Contributions to the Cultural History of the European Renaissance*, trans. by David Britt. Los Angeles: Getty Research Institute for the History of Art and the Humanities.

Ward, Rachel. 1985. "Evidence for a School of Painting at the Artuqid Court," in *The Art of Syria and the Jazira, 1100–1250*, ed. by Julian Raby (Oxford Studies in Islamic Art 1), pp. 69–83. Oxford: Oxford University Press.

Ward, Rachel. 1993. *Islamic Metalwork*. London: British Museum Press.

Watson, Oliver. 2020. *Ceramics of Iran: Islamic pottery from the Sarikhani Collection*. New Haven, CT: Yale University Press.

Watta, Sebastian. 2018. *Sakrale Zonen im frühen Kirchenbau des Nahen Ostens: Zum Kommunikationspotenzial von Bodenmosaiken für die Schaffung heiliger Räume*. Wiesbaden: Reichert.

Weinryb, Ittai. 2016. *The Bronze Object in the Middle Ages*. Cambridge: Cambridge University Press.

Weiss, Karl. 1860. *Der romanische Speisekelch des Stiftes Wilten in Tirol nebst einer Übersicht der Entwicklung des Kelches im Mittelalter*. Vienna: K. K. Central-Commission zur Erforschung und Erhaltung der Baudenkmale.

Weissenrieder, Annette. 2003. *Images of Illness in the Gospel of Luke: Insights in Ancient Medical Texts*. Tübingen: Mohr Siebeck.

Weissenrieder, Annette, and Stefan Alkier, eds. 2013. *Miracles Revisited. New Testament Miracle Stories and their Concepts of Reality*. Berlin: De Gruyter.

Weissenrieder, Annette, and Katrin Dolle, eds. 2019. *Körper und Verkörperung: Neutestamentliche Anthropologie im Kontext antiker Medizin und Philosophie; Ein Quellenbuch für die Septuaginta und das Neue Testament*. Berlin: De Gruyter.

Weissenrieder, Annette, and Gregor Etzelmüller, eds. 2016. *Religion and Illness*. Eugene, OR: Cascade Books.

Weitin, Thomas, and Burkhardt Wolf. 2012. "Einleitung," in *Gewalt der Archive: Studien zur Kulturgeschichte der Wissensspeicherung*,

ed. by Thomas Weitin and Wolf Burkhardt, pp. 9–22. Konstanz: Konstanz University Press.

Weitzmann, Kurt. 1944. "An East Christian Censer," *Record of the Museum of Historic Art* 3 (2): 2–4.

Weitzmann, Kurt. 1974. "Loca Sancta and the Representational Arts of Palestine," *Dumbarton Oaks Papers* 28: 31–55.

Wengrow, David. 2014. *The Origins of Monsters: Image and Cognition in the First Age of Mechanical Reproduction.* Princeton, NJ: Princeton University Press.

Wenzel, Michael. 2019. "Objektbiographie: Die Mobilität der (Kunst-)Dinge als Beute, Gabe und Ware," in *Materielle Kultur und Konsum in der Frühen Neuzeit,* ed. by Julia A. Schmidt-Funke, pp. 195–221. Vienna: Böhlau.

Werner, Michael, and Bénédicte Zimmerman. 2006. "Beyond Comparison: Histoire Croisée and the Challenge of Reflexivity," *History and Theory* 45 (1): 30–50.

Wessel, Klaus. 1960. "Die grosse Berliner Pyxis," *Rivista di archeologia cristiana* 36: 263–307.

Westenholz, Joan Goodnick. 2007. *Three Faces of Monotheism.* Jerusalem: Bible Lands Museum.

Westermann-Angerhausen, Hiltrud. 2011. "Incense in the Space between Heaven and Earth: The Inscriptions and Images on the Gozbert Censer in the Cathedral Treasury of Trier," *Acta ad archaelogiam et artium historiam pertinentia* n.s. 10: 227–42.

Westermann-Angerhausen, Hiltrud. 2014. *Mittelalterliche Weihrauchfässer von 800–1500.* Petersberg: Imhof.

Westermann-Angerhausen, Hiltrud. 2016. "The Two Censers in the *Schedula diversarum artium* of Theophilus and their Place in the Liturgy," in *Les cinq sens au Moyen Âge,* ed. by Éric Palazzo, pp. 189–212. Paris: Les Éditions du Cerf.

Weyl Carr, Annemarie. 2006. "Donors in the Frames of Icons: Living in the Borders of Byzantine Art," *Gesta* 45: 189–98.

Whelan, Estelle J. 2006. *The Public Figure: Political Iconography in Medieval Mesopotamia.* London: Melisende.

Wickham, Christopher. 2007. *Framing the Early Middle Ages: Europe and the Mediterranean, 400–800.* Oxford: Oxford University Press.

Wiet, Gaston. 1932. *Catalogue général du Musée arabe du Caire: Objets en cuivre.* Cairo: Musée nationale de l'art arabe.

Wiet, Gaston. 1955. *Les Marchands d'épices sous les sultans mamlouks.* Cairo: Éditions des Cahiers d'histoire egyptienne.

Wiet, Gaston. 1971. *Catalogue général du Musée de l'art islamique du Caire: Inscriptions historiques sur pierre.* Cairo: L'Institut français d'archéologie orientale.

Wiggermann, Frans A. M. 2000. "Lamaštu, Daughter of Anu: A Profile," in M. Stol (and F.A.M. Wiggerman), *Birth in Babylonia and the Bible: Its Mediterranean Setting,* pp. 217–49. Groningen: STYX.

Wilburn, Andrew T. 2013. "A Wall Painting at Karanis Used for Architectural Protection: The Curious Case of Harpocrates and Toutou in Granary C65," in *Das Fayum in Hellenismus und Kaiserzeit: Fallstudien zu multikulturellem Leben in der Antike,* ed. by Carolin Arlt and Martin Stadler, pp. 181–93. Wiesbaden: Harrassowitz.

Wilcox, Judith, and John M. Riddle. 1995. "Qusṭā Ibn Lūqā's Physical Ligatures and the Recognition of the Placebo Effect," *Medieval Encounters* 1: 1–50.

Wink, André. 1996. *Al-Hind: The Making of the Indo-Islamic World,* vol. 1: *Early Medieval India and the Expansion of Islam.* Leiden: Brill.

Winkler, Hans Alexander. 1931. *Salomo und die Karīna: Eine orientalische Legende von der Bezwingung einer Kindbettdämonin durch einen heiligen Helden* (Veröffentlichungen des orientalischen Seminars der Universität Tübingen 4). Stuttgart: Kohlhammer.

Wion, Anaïs. 2020. "Medieval Ethiopian Economies: Subsistence, Global Trade and the Administration of Wealth," in *A Companion to Medieval Ethiopia and Eritrea,* ed. by Samantha Kelly, pp. 395–425. Leiden: Brill.

Witkam, Jan Just. 1988. "Establishing the Stemma: Fact or Fiction?," *Manuscripts of the Middle East* 3: 88–101.

Wittekind, Susanne. 2009. "Neue Tendenzen des Reliquien- und liturgischen Schmuckes im 13. Jahrhundert," in *Aufbruch in die Gotik: Der Magdeburger Dom und die späte Stauferzeit,* ed. by Matthias Puhle, pp. 168–79. Mainz: Von Zabern.

Wittekind, Susanne. 2015. "Versuch einer kunsthistorischen Objektbiographie," in *Biography of objects: aspekte eines kulturhistorischen Konzepts,* ed. by Dietrich Boschung, Patric-Alexander Kreuz, and Tobias L. Kienlin, pp. 143–72. Paderborn: Fink.

Wixom, William D. 1981. "A Middle Byzantine Ivory Liturgical Pyx," *Gesta* 20: 43–49.

Wolf, Gerhard. 1990. *Salus populi romani: Die Geschichte römischer Kultbilder im Mittelalter.* Weinheim: VCH Acta humaniora.

Wolf, Gerhard. 2019. *Die Vase und der Schemel: Ding, Bild oder eine Kunstgeschichte der Gefässe.* Dortmund: Kettler.

Wolters, Jochen. 1996. "Niello im Mittelalter," in *Europäische Technik im Mittelalter 800–1200: Tradition und Innovation. Ein Handbuch,* ed. by Uta Lindgren, pp. 169–86. Berlin: Mann.

Wolters, Jochen. 2004. "Schriftquellen zur Geschichte der Goldschmiedetechniken bis zur Rogerzeit," *Das Münster* 57: 162–79.

Wolters, Jochen. 2006. "Schriftquellen zur Geschichte der Goldschmiedetechniken bis zur Rogerzeit," in *Schatzkunst im Aufgang der Romanik: Der Paderborner Tragaltar und sein Umkreis,* ed. by Christoph Stiegemann and Hiltrud Westermann-Angerhausen, pp. 222–42. Munich: Hirmer.

Wolters, Jochen. 2008. "Written Sources on the History of Goldsmithing: Techniques from the Beginnings to the End of the 12th Century," *Jewellery Studies* 11: 46–66 [first published in *Das Münster* 57: 162–79].

Wood, Christopher S. 2008. *Forgery, Replica, Fiction: Temporalities of German Renaissance Art.* Chicago: University of Chicago Press.

Worku, Mengistu Gobezie. 2018. "The Church of Yimrhane Kristos: An Archaeological Investigation." PhD dissertation, Lund University.

Wulff, Oskar Konstantin. 1909–11. *Altchristliche und mittelalterliche, byzantinische und italienische Bildwerke,* 2 vols. Berlin: Reimer.

Wyżgoł, Maciej. 2017. "A Decorated Bronze Censer from the Cathedral in Old Dongola," *Polish Archaeology in the Mediterranean* 26: 773–80.

Xanthopoulou, Maria. 2010. "Martyrs, Monks and Musicians: Two Enigmatic Coptic Vases in the Benaki Museum and their Parallels," *Mouseio Benaki Journal* 10: 19–51.

Ying, Lin. 2003. "Sogdians and the Imitation of Byzantine Coins from the Heartland of China," in *Ērān ud Anērān: Studies Presented to Boris Ilich Marshak on the Occasion of His 70th Birthday,* ed. by Matteo Compareti, Paola Raffetta, and Gianroberto Scarcia, pp. 261–74. Venice: Cafoscarina; available at http://www.transoxiana.org/Eran/Articles/lin_ying.html (accessed January 13, 2023).

Yonan, Michael. 2011. "Toward a Fusion of Art History and Material Culture Studies," *West 86th* 18 (2): 232–48.

Yonan, Michael, and Stacey Sloboda. 2019. *Eighteenth-Century Art Worlds: Global and Local Geographies of Art.* New York: Bloomsbury.

Zadeh, Travis. 2009. "Touching and Ingesting: Early Debates over the Material Qurʾan," *Journal of the American Oriental Society* 129: 443–66.

Zadeh, Travis. 2010. "The Wiles of Creation: Philosophy, Fiction, and the ʿAjāʾib Tradition," *Middle Eastern Literatures* 13: 21–48.

Zarnecki, George, Janet Holt, and Tristram Holland, eds. 1984.

English Romanesque Art, 1066–1200. London: Weidenfeld and
Nicolson.

Zavagno, Luca. 2011. "At the Edge of Two Empires: The Economy
of Cyprus between Late Antiquity and the Early Middle Ages
(650s–800s CE)," *Dumbarton Oaks Papers* 65–66: 121–55.

Zink, Jochen, Jürgen Asch, Michael Brandt, and Ute Römer-
Johannsen, eds. 1980. *Die Kirche zum Heiligen Kreuz in
Hildesheim*. Hildesheim: Bernward.

Zouache, Abbès. 2019. "Remarks on the Blacks in the Fatimid Army,
Tenth–Twelfth Century CE," *Northeast African Studies* 19: 23–60.

Żurawski, Bogdan. 1992. "Magica et ceramica: Magic and Ceramics
in Christian Nubia," *Archaeologia Polona* 30: 87–107.

Żurawski, Bogdan. 2012. *St. Raphael Church I at Banganarti, Mid-
Sixth to Mid-Eleventh Century: An Introduction to the Site and
the Epoch* (Gdańsk Archaeological Museum African Reports 10).
Gdańsk: Archaeological Museum and Heritage Protection Fund.

Index

Note: Page numbers in italic type indicate illustrations.

A

Aachen, 95, 98
Abbasid caliphate, 2, 18, 123–124, 130, 138, 141–143, 194, 202, 205, 206, 211, 219, 233
'Abd al-Rahman III, 73
Abraha and Atsbeha church, Wuqro, Tigray, Ethiopia, 185, 185, 186
Abu'l-Qasim, 55, 56
Abu-Lughod, Janet, 16, 19
Abu Sayfayn church, Fustat, 168, 169
Abyzou, 157, 159, 171. See also Alabasdria; Lamashtu
Adam, 101, 103, 108
Aden, 184, 186, 189, 203
Adomnan, 239n74
Afghanistan, 53–54, 69, 82, 85, 95, 189, 202
Africa, 15, 17
African diaspora, 187–188, 203
Africans, textual and visual representation of, 197–198, 201–202, 207–208, 210. See also Ethiopians
agency: artistic, 4, 194, 207, 225; cumulative, 232; human, 5–7, 197; network conception of, 231; of objects, 1
'ajā'ib (mirabilia) genre, 194, 205–206
Alabasdria, 156, 157, 159, 162. See also Abyzou; Lamashtu
alchemy, 122
Aleppo: 74, 223, 240n45, 250n25; Serpent Gate, 125, 125, 138, 157
Alexandria, 32, 103, 161, 186, 230
Ali, Daud, 211, 212
alphabets, esoteric, 124, 233, 246n146
altar: of Infanta Sancha Raimúndez, 73–75, 74, 77; altars for display of treasures, 89, 100, 100
Ambar, Malik, 209
ambergris, 7, 218–219
Amid, drawing for a door knocker of the Artuqid palace at, 125–126, 126, 127
amulet-case, 57, 57
amulets: 3, 5, 18, 28, 32, 36, 57, 115, 118, 122, 123, 125, 128, 131–134, 133–135, 136, 138–141, 143, 145, 157–158, 158, 159, 160–161, 161, 194, 215, 217–219, 223–224, 235n7; showing holy rider, 157–159, 158, 159. See also engraved amulets
Anatolia, 16, 18, 118, 123–126, 128, 133–135, 138, 140, 145, 147, 151, 156–157, 159, 164, 185, 224
al-Andalus, 1, 2, 17, 53–54, 58, 60, 66, 69, 71, 73, 75, 82–83, 85, 141, 162, 240n37, 250n27
Andalusia. See al-Andalus
Anderson, William, 32
Andrew, Saint, 101, 106, 107
Anselm, bishop of Bethlehem, 74–75
Anthony, hermit saint, 162
Antioch, 240n30
Antoninus, 49
Apollonius of Tyana. See Balinus
Arabic, 28, 31, 42, 55–57, 60, 66, 68, 71, 73, 92, 105, 108, 116, 118, 123, 129, 131, 134, 140, 143–145, 158, 160, 170–171, 182–186, 188, 197, 199, 205–207, 217–219, 221, 224
Aramaic, 115, 116, 124, 140, 141, 157, 160, 243n14

archives: historiographical significance of, 3; objects as, 5, 51, 142, 147; objects in, 4; systems of inclusion/exclusion in, 5; totalizing character of, 7
Arculf, 239n74
Armenia, 33, 125, 237n18
Armenian, 28, 105, 237n9
Armojand, Said Amir, 236n85
aromatics, 219. See also incense; smell
art history: contingencies and subjectivities in, 6–10, 38, 230; early modern, 15; emphasis on elites and courtly milieu in, 2, 3, 8, 231, 233; high vs. low in, 2, 231; network-based approach to, 9, 229–233; object-oriented practices in, 1, 4, 9; totalizing narratives in, 7
Artuqids, 125–128, 133, 138, 193, 197, 224. See also Fakhr al-Din Qara Arslan
Asmara, Eritrea, Saint Mary church, 153, 155, 182
Assman, Jan, 239n73
Assyrian antiquities, 133, 224
astrolabes, 215, 219
astrological imagery, 118, 125–127, 129, 134–136, 145, 219, 233. See also zodiacal signs
Attarouthi Treasure, 35, 37, 40, 41
Augustine of Hippo, 103, 241n60
Augustus (Roman emperor), 95
automata, 125–126, 197, 202, 211
Axum, 151, 153, 165, 189
Aydhab, 249n163
Ayyubids, 115
al-Azhar University, Cairo, Egypt, 187
al-'Aziz billah, Fatimid caliph, 162

B

Baghdad, 17, 123–124, 125, 130–131, 138, 141, 143, 145, 184, 193, 202, 207, 209, 211–212, 220, 230, 233, 244n51; Talisman Gate 138, 139, 160
al-Baghdadi, 'Uthman, artisan, 122
Bahram Gur, 197
Balicka-Witakowska, Ewa, 147
Balinus (Apollonius) of Tyana, 122, 134, 221
al-Balkhi, Abu Ma'shar, 233
Bama, 202–203. See also ben Yiju, Abraham
Bargello quadruped, 66, 67
Basel, 5, 6, 8, 9, 19, 22, 23, 25b, 35, 36, 38, 50–51, 99, 101, 237n4, 237n14
Basra, 203
Bawit, Egypt, 156, 157, 160, 161, 162
Belting, Hans, 239n75
ben Yiju, Abraham, 189, 203
Berbera, 189
Berenbeim, Jessica, 7
Berengaudus of Ferrières, 108
Berlekamp, Persis, 135–136
Berthelot, Marcellin, 57
Beta Maryam, Lalibela, Ethiopia, 147–153, 148–150, 152, 156–157, 160–162, 162, 165–171, 166, 172, 173, 181–182, 181, 184–186, 189
Bethlehem, 50, 74, 75, 239n79
bezoar stones, 104, 136
Billod, Carole, 237n8
bīmāristān (hospital) of Nur al-Din ibn Zangi, Damascus, 118, 224, 226
Black Sea, 10, 12, 23, 32
block-printing, 5
Bolesław IV, Polish king, 79

boswellia plants, 41, 43. *See also* frankincense
bowls, 10, 12, *12*, 82, *83*. *See also* magic-medicinal bowls
Breusch, Friedrich Ludwig, 23, 27, 46–47
Buddha, 103; statuette from Kashmir or Swat, 9, *10*
Buddhist images and sutras, 9
al-Buni, Ahmad, 134–135
Byzantium: censers in, 33; iconography in images from, 126, 132, 147, 151, 183, 212, 220, 224; medical use of incense in, 42; niello in, 56, 81–83; and pilgrimage, 23, 32; plate from 55, *55;* trade involving, 10

C

Cairo, 2, *111,* 115, 124–125, 140, *140,* 164, 187, 205, 207, 219
Cairo Geniza, 2, 3, 92, 140, *141,* 202, 217, 241n14, 243n14, 243n23
calendrical systems, 17–18
camphor, 92
canon table, Zir Ganela Gospels, 170, *171*
Capella Palatina, Palermo, 197, 212, *213*
Capua, 71
Carboni, Stefano, 60, 66
caskets: from Colegiata de San Isidoro, 60, *65*, 69, 81; from the so-called Harari hoard, 69, *69*, 71; of Hisham II, *70*, 70 (detail), 71; of Sadaqa ibn Yusuf (León silver casket), 53, *54*, 54 (detail), 56, 58, 60, 66, 69, 71, 73, 77, 81
Caspian Sea, 217
Castile, Kingdom of, 73
Caucasus, 9, 18, 183, 191
cedulae, 101, *102*
centaurs, 157, 162
Central Asia, 41, 82, 92, 191
ceramics. *See* luster ceramics; *mina'i*
censers, 6, 18, 22–51, *25*; analysis of, 23, 31–32; on the art market, 23, 27, 236n4; bases of, 35, *36*, *37*; from cathedral in Old Dongola, Nubia, 41, *42*; circulation and reception of, 23, 31, 36; damage and repair to, 36; dating of, 23, 27–28, 33–34, 38–39, 49, 51, 237n18; fabrication and production of, 34–35; form of, 35, 38–41, 46; hexagonal, 38–39, *39*, *40*, 45; iconography of, 27–28, 33, 41, 49; imprints on, 36; incense burned in, 41–51; inscriptions on, 28, 31; lack of written sources on, 27, 31; location of fabrication of, 32, 33; material of, 33; with Nilotic scenes, 47–48, *48*; pilgrims associated with, 31, 32, 36, 49–50, 237n6; Roman, 38; scholarship on, 23, 31–32, 36; silver, 35, 38; size of, 23; Syro-Palestine proposed as source of, 28, 33, 38, 39, 237n6; temporalities of, 47–51; use of, 23, 38, 41–46, 49–51. *See also* censers with Christian scenes
censers with Christian scenes, 23, 27–28, *27*, 33–36, *34*, 38–39, 41, 46–51, *51*; Annunciation, *33*; Baptism of Christ, 23, 27, *28*, *36*; Crucifixion, 23, 27, *29*; flight to Egypt and Crucifixion, 27, *31*, 35, 39; Marys at the tomb of Christ, 23, *24*, 35, 39; narrative friezes, *26*, 27, 34–35, 39, 41, 50; Visitation and Nativity, 23, *24*, 27, 35, 39, 50; Visitation of Christ's tomb, 35, *36*; youthful Christ with a cruciform halo, two archangels, and crosses, 35, *37*, *40*, 41
center-periphery model, 41, 109, 230–231
Certeau, Michel de, 8
Ceylon. *See* Sri Lanka
chalice and paten from Trzemeszno, 77, *78*, 78 (detail), 79
cheetahs, 177, 180
Cheng, Bonnie, 6
Chennai, 107, 180
childbirth, magical assistance/protection for, 122, 127, 133, 145, 194, 215, 217–219
chimeras, 149, 151, 153, 157, 162, 165–170, 183, 191, 212–213, 220, 227, 232

China, 5, 6, 16, 101, 187, 205–206, 230
Christian practices: censers as source of information on, 36, 38, 41–46, 48–51; coconut and rock crystal composite objects and, 87, 92, 95, 99–108; Islamic objects and iconography repurposed for, 87, 98–99, 147, 157–159, 162–167, 170–171, 183–186; niello and, 54–55, 77–85; significance of material in objects for, 98; temporalities of, 48–49, 51
chronology and dating, 6; of censers, 23, 27–28, 33–34, 38–39, 49, 51, 237n18; of Ethiopian rock-cut churches, 151; of Islamic magic-medicinal bowls, 113, 115–118, 122–124, 138, 145; network conception of, 231–232; niello objects, 57. *See also* periodization
Chungul Kurgan. *See* Ukraine
ciborium, 105–106, *106*
circulation and reception of objects: Africa-India connections and, 225; censers, 23, 31, 36; coconuts, 92, 95, 104; composite objects, 99, 104; contexts for, 8, 15; Ethiopian iconography and objects, 147–189; information transmitted through, 4–5; Islamic magic-medicinal bowls, 115; material evidence of, 1, 9–10; niello technology, 8, 18, 53–85; repurposing and revaluation during, 2, 10, 87, 98–99, 224, 230; scholarship on, 229–233; technology transfer, 4–5, 53, 60, 66, 69, 71, 73, 81–83, 85; transcultural and transregional, 2–4, 9, 13, 15, 17–18, 51, 87, 99, 147, 154, 165, 169, 183–184, 187–189, 210–213, 219, 225, 227. *See also* maritime voyages
Cividale del Friuli, 95, 107
Cizre, door knockers from the Great Mosque of, 125, *126*, 131
Claussen, Peter Cornelius, 98
Cleopatra, 141
Clifford, James, 229
coconut (*nux indica*), from *Compendium salernitanum*, 92, *94*
coconut-cup from the treasury of the archbishops of Salzburg, 95, *97*, 104
coconut reliquaries: Hildesheim, 95, *96*, 107–108; with miniature of Saint Mary Magdalene, 95, *97*, 99, 107–109; Münster goblet, 87, *88*, 89, *89* (detail), 91–92, 95, 99–101, 103, 105–109, 113
coconuts, 18; circulation and reception of, 92, 95, 104; in composite objects, 87, 89, 91–92, 95, 99–101, 103–108; healing power associated with, 99, 104; meanings and associations of, 91, 92, 95, 101, 103–105, 108–109; Paradise associated with, 101, 103–105, 108–109
coconut tree, from *Codex sinaiticus graecus*, 92, *95*
Cologne, *88,* 92, 95, *95,* 98, 242n32
Comoros, 87
composite objects, 7; circulation and reception of, 99, 104; meanings of, 91, 99, 101, 103–109; temporalities of, 224, 227; uses of, 87, 89, 91, 95, 99–101, 104; visible and invisible aspects of, 89, 91, 106–108. *See also* Islamic magic-medicinal bowls: as assemblages
Constantinople (Istanbul), 5, 23, 27, 32, 44, 46, *113, 114, 152,* 183, 204, 230, 237n4, 238n34, 250n32
Cooper, Frederick, 229
copies and originals: censers, 27, 33, 41; Islamic magic-medicinal bowls, 8, 113, 123–124, 138, 143, 145; niello, 73–77
Coptic art, 48, *144,* 156, 157, 160–162, 164, 167, *165,* *169*
Coptic language and texts, 105, 139, 171, 182
Córdoba, 53, 58, 71, 73
Corippus, 44
Cosmas, Saint, 45, 46
Cosmas Indikopleustes, 92, 241n16
Cosmos/cosmological, 18, 32, 108, 137, 139. *See also* astrological imagery; zodiacal signs
crocodiles, 149, 151, 157, 160, 160–162, 170
Cross of Lothair, 95

crozier from the Cathédrale Saint-Pierre-de-Lisieux, Limoges, 82, *84*

crucifix, the so-called Herimann-Ida-Kreuz, 98, *98*

crystal. *See* rock crystal

cuirass, 173, *175*, 187

D

Dahlak archipelago, 186

Damascus, 31, 44, 115, 122, 124, 128, 138, 141, *212,* 224, 244n51

Damian, Saint, 45

Damietta, 167

Debra Damo, Tigray, Ethiopia, 5–6, 184, 235n32

Debra Selam Mikael, Tigray, Ethiopia, 248n105, 248n106

Deccan, 187, 209

Deir el-Bahri, 238n41

Delft tiles, 182

demons, 115, 116, 128, *129*, 157–160

De Winter, Patrick, 79

Didi-Huberman, Georges, 9, 147, 224, 232–233

diffusionist theories, 41, 115, 182, 230. *See also* circulation and reception of objects; technique and technical knowledge: transmission of

Diocletian, 247n50

Dioscorides, 42–43; *De materia medica* 215, *216*

diplomatic gifts, 10, 17, 83, 149, 184, 187

dogs, 115, 116, 118, 128–133, 137

Dongola (including Old Dongola), Nubia, 41, *42,* 159, 160, 230

double chalice: 95, *97*, 104, 107; the so-called Johannisweinpokal, 95, *97*; from the treasury of the archbishops of Salzburg, 95, *97*, 104

double cup, 105, *105*

dragons, 105–106, 124–127, 137–139, 145, 153, *154*, 157, 164, 167

dragon-tailed sphinx, 166, *167*

drawings, for an amulet or seal, 133, *135;* of a boy cured of a demon, 128, *129*, 131, 133; of an equestrian falconer, 163, *163*; of a magic-medicinal bowl, *114*, 118, *122*, 130, 138, 219; of a wall painting in Chapel 17, monastery of Bawit, *156*, 157

Drpić, Ivan, 50

E

East Africa, maritime connections with India, 18, 186–187, 189, 194, 196–197, 202–203. *See also* Ethiopia; Shanga; Swahili coast

Egeria, 44, 49

Egypt, as source for Ethiopian iconography and objects, 153, 157, 159–169, 182, 184–185. *See also* Bawit; Cairo; Deir el-Bahri; Fatimid Egypt; Mamluk Egypt

elephants, 149, 151, 153, 162, 171, *173*, 180–181, 197, 199, *200, 201*, 211, 248n105, 248n106

enamel, enameled, 55, 104, 107–108, 184, 187

engraved amulets: gem with a scorpion, *143*; plaque *144*, 145, 161; showing the child-killing demoness Lamashtu, 133, *134*; showing a holy rider, 132, *133*

Eptingen Chalice, 101, *104*

Eritrea, 151, 153, *155*, 165, 182, 185, 186

Essen, 95

Ethiopia and rock-cut churches, 6, 15; archer imagery in, 171, 173; circulation and reception of iconography and objects in, 147–189; dating of, 151; engagement with Egypt, 153, 157, 159–169, 182, 184–185; engagement with India, 171–181, 186–187, 189; engagement with Islamic lands, 147, 157–159, 162–167, 170–171, 183–189; falconry imagery in, 162–165; iconography of, 12–13, 147–154, 157–171; Islamic perceptions of the people of, 202, 207; scholarship on, 153; Sisinnios (Susenyos) and, 157–160; sphinx

imagery in, 165–171. *See also* Lake Tana; Lalibela; Tigray

Ethiopians, textual and visual representations of, 187–189, 202–203

Ethiopic. *See* Ge'ez

Ettinghausen, Richard, 203

eulogia tokens, 28, *31*, 32, 42, *43*, 44, 45, 49

Eurasia, 5, 15, 17, 126, 153

Eve, 101, 103, 108

F

Fakhr al-Din Qara Arslan, 126, *127*, 138, 224

al-Falahi, Abu Mansur ibn Yusuf, 60

falcon, 151, 162–165, 170, 185, 247n73

Farago, Claire, 231

Fatimid caliphs: al-'Aziz billah, 163, 235n36; Mu'izz li-Din Allah, 246n146; al-Mustansir billah, 60

Fatimid Egypt, 2, 12, 53, 60, 66, 69, 71, 185, 219

Fauvelle, François-Xavier, 183–184

Ferrara, Palazzo Schifanoia, 233

fish, 47, 75, *90*, 101, 151, 160, 162, 165, *166*, 167, 169, *170–171*, *188*, 189, 212, 239n70

flask, 28, 32, *42,* 44, *51, 52,* 56, *56,* 57, *57*, 66, 69, *83, 84,* 89; for rose-water (St. Petersburg bottle): *68*, 69, 71, 81

Florence, 66, 95

flotsam, as metaphor, 7–13, 23, 32, 82, 99, 142, 180

fountainhead in the shape of a stag, 66, *66*

frankincense, 32, 41, 43–44, 47, 49, 92

Frazer, James, 245n78

Freiburg, 95, *96*, 99, 107, 108, 109

Fritz, Rolf, 92, 99–101

Fustat: 3, 92, 140; Abu Sayfayn church, 168, *169;* chapel of Mar Giorgis, Church of Sitt Barbara, 164, *165*

G

Galen, 137

Ge'ez, 105, 159, 160, 170, 187, 189

Geisberg, Max, 87

Gell, Alfred, 43

gems, magical efficacy of, 130, 136, 143–145, 158, 218, 245n115. *See also* lapidaries

Geniza. *See* Cairo Geniza

Genoa, 87, 95

George of Antioch, 240n30

Georgia, 6, 32, 33, 162

Gerasa. *See* Jerash

Germanos I of Constantinople, 43–44

gesso, 34, 246n12

Ghāyat al-Ḥakīm (Goal of the Sages), 136, 141

al-Ghazi/Gran, Ahmad, 186

Ghaznavid empire, 69, 85, 189

giraffes, *149*, 197, *198*

Giunta, Robert, 117

glass: 5, 10, 12, 55, 57, *90*, 107, 173, 184, 187; enameled or gilded, 184, 187

globalisms, 2–4, 13, 15–17, 19, 230–231

Gniezno, 77, 79

Grabar, André, 32, 237n6

Grabar, Oleg, 138, 194, 203, 211

Greek, 28, 41, 55–57, 92, 105, 124, 130, 139, 141, 157–161, 218, 237n7

Gregory of Tours, 45

griffins, 66, 67. *See also* chimeras

Gröninger, Gerhard, 100

Gudea of Lagash, 224, *225*

Gujarat, 5, 6, 205, 210

Gulf, Arabian or Persian, 7, 15, 17, 105, 196, 205, 206, 219, 220, 224, 230

Gunaguna, Eritrea, wooden door with eagle ornament, *184*, 185

Gyllou, 157

H

hadith, 140

al-Hakam II, Umayyad caliph, 71; pyxis, 58, *58*, 71

Halebid (Dorasamudra), Karnataka, India, *177*, 179, *179*; Nagareś-vara temple, 176, *176*

Hamadan, 134

al-Hamadhani, Badi' al-Zaman, 191; *Maqāmāt*, 215, 217, 218

al-Hamdani, 56

hamsa (celestial swan), 12–13, *14*, 177

Hanseatic League, 92, 95

Harari hoard, 69, *69*, 71

al-Harawi, 125

al-Hariri, *Maqāmāt*, 143, 191–227; iconography of, 194, 196–197, 199, 201, 209, 211–214; images from, *142, 192, 193, 195, 196* (detail), *203, 204* (details), *208, 209* (detail), *211* (detail), *212* (detail), *214* (detail), *217* (details); image-text relationship in, 194, 195, 213–214; intertextuality of, 194, 209–211, 219; magic as theme in, 215–219; scholarship on, 194, 197; temporality of, 219–224; wonder as theme in, 205–207, 211–215. *See also* al-Wasiti, Yahya

harpies, 145, 166, 170, 191, 196, 212–215, 220, 224, 227, 252n141

Harran, 120, 202

healing. *See* medicine and healing

healing scrolls, Ethiopian, 159, *160*, 162, 249n170; scroll showing Saint Susenyos spearing a demon, 160, *160*

heart-shaped box with relics of Saint Pelagius, and lid, 71, *72*, 73

Hebrew, 140, *141*, 233

Helgö, Sweden, 9

Helms, Mary, 183

Heng, Geraldine, 16

Henry II (Holy Roman emperor), 98

Henry the Lion, duke of Saxony, 79, 81

Heraclius (Byzantine emperor), 56

Heraclius, *De coloribus et artibus omanorum*, 56–57

Heribert, Saint, 95

Hijaz, 44. *See also* Mecca

hijri system (H), 18

Hildebert of Tours, 79

Hildesheim, *89*, 95, 101, 107–108, 242n32

Hillenbrand, Robert, 207

Hims, scorpion-man at the gate of the Friday Mosque of, 221, *222*, 223

hippopotamus, 161

Hisham II, casket of, *70*, 70 (detail), 71

Hittite antiquities, 223

Hodgson, Marshall, 236n85

Hoffman, Eva, 99

Holod, Renata, 10

holy riders, *133*, 157–159, *158, 159*, 161–162

Horton, Mark, 1, 187

Horus on the crocodiles, 145, *161*, 246n156

Hoysala rajas, 173, 176, 179, 210

Hoysaleśvara Temple, Halebid, Karnataka, India, *177*, 179, *179*

humoral theory of medicine, 130, 137

hydrophobia, 130, 130–131

I

Ibn 'Ali, 'Isa, 130–131, 142

Ibn Battuta, 99

Ibn Butlan, 202

Ibn Jarir, Bilal, 186

Ibn al-Jawzi, Abu'l-Faraj, 202

Ibn Jubayr, 249n163

Ibn Khaldun, 136

Ibn Khurdadhbih, 44

Ibn Qayyim al-Jawziyya, 133

Ibn Sarabiyun, Yahya, 130, 137

Ibn Sayqal, 186

Ibn Shaddad, 125

Ibn al-Shihna, 223

Ibn Wahshiyya, 131, 136, 241n14

Ibn Yunus, Muhammad, artisan, 122

Ibn Yusuf, Sadaqa, 60

Ibn Yusuf al-Tifashi, Ahmad, 218

Ibn Zangi, Nur al-Din, 115

icons, 36

Imam Dur, tomb of, 212, *213*

incense: censers for burning, 41–51; medicinal and healing properties of, 41–44, 50–51, 136. *See also* ambergris; boswellia; camphor; frankincense; sandalwood

India: artistic contacts with, 210–211; Christianity in, 180; Ethiopian repurposing of objects from, 171–181, 186–187; maritime connections with Islamic lands and East Africa, 18, 186–187, 189–227; marvels associated with, 211–212; Paradise associated with, 101, 103, 107–109; as source of images in the *Maqāmāt*, 194; visual representations of people from, 197, 199, 202, 210. *See also* Chennai; Gujarat; Kerala; Malabar; Mumbai; Quilon; Sanjan

Indian diasporas, 13, 187, 203

Indian Ocean, 1, 2, 3, 7, 8, 15, 18, 171, 179, 180, 184, 186, 187, 189, 191, 194, 196–197, 203–206, 209–210, 212, 219, 241n14, 249n155, 249n164

Indians, textual and visual representations of, 182, *192, 193, 195*, 196–197, *199–201*, 202, 210

Indian slaves 202

Infancy of Jesus, 128

Infanta Sancha Raimúndez, altar of, 73–75, *74*, 77

influence, art historical concept of, 4, 227, 231

inlaid metal, 5

intertextuality, 194, 209–211, 219

Iran: animal imagery in, 132–134, 139; illustrated books from, 197; magic-medicinal bowls, 143; Sasanian art of, 153

Iraq: 2, 5, 6, 18, 60, 87, 115–116, 118, 123–126, 131–133, 135, 137–138, *139*, 140, 143, 145, 153, 162, 164, 167, 185, 187, 191–197, 201–203, 205–206, 210, 212, *213*, 218–221, 224; amulets from, 132–133; illustrated books from, 193–194, 203, 215; India's trade with, 219; lusterware from, 5, 205; magic-medicinal bowls, 18, 115–116, 118, 122–125, 140, 143, 145. *See also*: Baghdad; Basra; Jazira; Wasit

Islamic magic-medicinal bowls: *114*, 117–118, *120, 121*, 122, 136, 138, 219; animal imagery on, 113, 116, 118, 126, 128, 130–132, 136–138; as assemblages, 113, 138, 140, 145; attestations to efficacy of, 115, 118, 123–124, 127, 136–143; bearing the image of the Ka'ba, 117, *117*, 118, 136, 219, 220; composition of, 118; copies among, 8, 113, 123–124, 138, 143, 145; dating of, 113, 115–118, 122–124, 138, 145; history of, 8–9; iconography of, 117–118, 122, 124, 126, 131–138; inscriptions on, 8, 113, 115, 118, 122, 124, 127–130, 138–140, 144–145; makers of, 122; medicinal and healing properties of, 113–145; origins of, 113, 115, 117–118,

123–124, 128, 133, 137, 138, 143, 145; other objects compared to, 124–127, 131–145; parallels to, in other media, 122; possible antecedents of, 115–117; production of, 117, 126; size of, 118, 128; temporalities of, 117, 138–140; textual references to, 115; uses of, 116

Islamic world: censers in, 33; Christian repurposing of objects/iconography from, 87, 98–99, 147, 157–159, 162–167, 170–171, 183–186; Ethiopian engagement with, 147, 157–159, 162–167, 170–171, 183–189; iconographic revivals in, 220–224; maritime connections with India, 18, 186, 189–227; marvels associated with, 211; medical use of incense in, 42; niello in, 54, 56–58, 60, 66, 71, 73, 81, 83, 85; objects associated with, 235n36; rock crystal in, 87; sphinx imagery in, 166–171, 220; trade involving, 6, 10, 83. *See also* Islamic magic-medicinal bowls

Israel, 33. *See also* Palestine

Istanbul. *See* Constantinople

J

al-Jahiz, *Kitāb al-ḥayuwān* (Book of animals), 197, *198*

Jasperse, Jitske, 74–75

Java, 92

Jayakeshi I, Kadamba raja, 187

al-Jazari, Badiʻ al-Zaman, *Book of Knowledge of Ingenious Mechanical Devices*, 125–126, *126*, 197, 199, *200*, *201*, 202, 211

Jazira region, 118, 123–126, 128, 133, *134*, 137–139, 145, 157, 164, 193, 202, 224

Jerash (Gerasa), Jordan, 45, *46*

Jerphanion, Guillaume de, 237n6

Jerusalem, *7, 18,* 44, 50, *57,* 69, 109, 123, 187, 239n79; Gethsemane, 106; Holy Sepulchre, 44, 49, 50, 51

Jesus Christ: blood of, 79, 81, 87, 92, 99, 101, 104, 109; healing power associated with, 128, 129; human and divine nature of, 44; lamb as symbol of, 74, 87, 92, 99, 101, 103, 109; narrative friezes relating the life of, 27, 33, 36, 38–39, 41, 43, 47, 49–51; power of, 106; resurrection of, 79

John Geometres, 46

John the Baptist, 42, 50, 101

Joseph, prophet, 207, 209–210

Judeo-Arabic, 140

Justinian, 44

K

Kaʻba, 69, 117, *117,* 118, 135–136, 219, 220

Kadamba rajas, 179, 187

Kamień Pomarksi (formerly Cammin), 95, 107

Karimi, 203, 220

al-Kashkari, 130

Kebra, Masqal, 189

Kellia, 161

Kerala, 180, 210

Khusrau, Nasir-i, 202

Kilito, Abdelfattah, 194

Kitāb al-bayzara, 162

Kitāb al-diryāq (Book of theriacs), 131, *132*, 137–138, *137*

Konya, 140

Kopytoff, Igor, 9

Kubler, George, 8–9, 123

Kufic script, 31, 60, 66, 185, 186, 224. *See also* Linear Kufic

Kumluca, 238n32

L

Lake Tana, Ethiopia, 182, *182*

Lalibela, Ethiopia: Beta Maryam, 147–153, *148–150, 152,* 156–157, 160–162, *162,* 165–171, *166, 172,* 173, 181–182, *181,* 184–186, 189; Savior of the World (Medhane Alem) church, 147, 173, *174,* 180, *180,* 186–187; Yemrehanna Krestos church, near Lalibela, 153, *155,* 170–171, *171, 173,* 177, *177, 178,* 179–180, *188,* 189, 191

Lalibela, King, 147, 189

Lamashtu, 133, *134,* 157

La Niece, Susan, 56

lapidaries, 2, 108, 130–131, 136, 143–144, 158. *See also* gems

lapis lazuli, 95, 98

Latour, Bruno, 229

Lebanon, 33, 187, 189, 238n31

León, *39, 40,* 53–54, 56, 60, *61, 62,* 69, 71–75, 81

León silver casket. *See* Sadaqa ibn Yusuf

leopards, 177, 180

Lepage, Claude, 173

Liber sacerdotum, 57

libraries, 4, 122, 138, 140, *142,* 143

Lilith, 157

Limoges, 82, *84*

Linear Kufic, 139–140. *See also* alphabets

lions, 92, 105, 125, 135, 145, 149, 160, *179,* 223, 241n10; on composite objects, 87, 91–92, 99, 105, 109; in Ethiopian iconography, 147–154, 157, 160–162, 165–171; images for magical protection against, 105, 113, 115, 116, 125–138, 145, 160–162; Indian images of, 177, *179;* related to therapeutic practices, 125–127, 132–136, 223; small flasks in the form of a lion, 89, *91,* 92; as talismans, 223

long twelfth century, 17, 183

Loos, Adolf, 231

Lothar II (Carolingian king), 95

Lüneburg, 95

luster ceramics, 5, 163, *163,* 197, 205, *205*

M

Madras. *See* Chennai

Madrid, *45, 50, 53,* 60, *63,* 69, 73, 81

Magdelene, Mary, 101, 107

magic: animals linked to, 105, 113, 115, 116, 125–138; formula and repetition in, 123–124, 129–130; medicine in relation to, 18, 113, 136, 219. *See also:* alphabets; amulets; protection; talismans

magic-medicinal bowls. *See* Islamic magic-medicinal bowls

magic mirrors, 133, 145

magic squares, 118, 122, 123, 127, 134, 138, 139, 218, 219

Malabar, 101, 180. *See also* Kerala; Quilon

Mamluk Egypt, 118, 123, 124

al-Maʾmun, Abbasid caliph, 141

Mandaic, 115, 243n18

Mandeville, Jean de, 218

Mangalore, 189, 203

al-Mansur, Abbasid caliph, 123, 124, 143

Mappae clavicula, 57

maps, *22, 52, 86, 112, 146, 190*

maqāma genre, 191, 194, 215. *See also* al-Hamadhani, Badiʻ al-Zaman; al-Wasiti, Yahya

Mardin, 128

Margariti, Roxani, 197

Mar Giorgis, Church of Sitt Barbara, Fustat, 164, *165*

Marignolli, Giovanni de', 101, 103–104, 235n49

maritime voyages: crews and passengers on, 196–197, 199, 201–203, 210; images of, *188,* 189, 191; magical protection for, 3, 12, 18, 189, 217–219; oral accounts of, 194, 204–206, 210; wonders in

accounts of, 205–206, 209, 210, 212–213. *See also* circulation and reception of objects

Marshak, Boris, 82

Martin, Jacques, 113, 118

Martin, Therese, 240n42

Mary (mother of Jesus), 6, *13*, *15*, 27, 50–51, 75, 77, 91, *130*, 147, 189

Massawa, 186

al-Mas'udi, *Murūj al-dhahab* (Meadows of gold), 206

Maurus, Hrabanus, 108

Mayyafariqin, 125

Mecca, 18, 69, *105*, *117*, 117–118, 135, 202, 207, 220, 244n43

Medhane Alem. *See* Savior of the World (Medhane Alem) church

medicine and healing: animals linked to, 131; coconuts associated with, 99, 104; incense associated with, 41–44, 50–51, 136; Islamic metal bowls linked to, 113–145; Islamic practices of, 128; Jesus's acts of, 43; magic in relation to, 18, 113, 136, 219; microcosm-macrocosm relationship in, 45–46; pilgrimage objects associated with, 44, 49–50; Qur'anic verses linked to, 117, 127–129, 131, 133, 138, 139; relics associated with, 43–45, 109; Sisinnios and, 159–160. *See also* protection

Mediterranean, 1, 3, 7, 9, 12, 13, 15, 17, 18, 33, 53, 87, 98, 113, 15, 117, 122, 124, 132, 139, 143, 147, 157, 158, 159, 160, 162, 166, 180, 183, 184, 212, 219, 220, 227

meerschaum, 218–219

Meinwerk, bishop of Paderborn, portable altar, *80*, 81, *81* (detail)

Menas, Saint, cult of, 32

Mercier, Jacques, 173

micro-history, 2, 6, 16, 231, 233

mina'i (enameled ware) ceramics, 169, 197, *199*, 214, *215*

mirror: depicting a pair of addorsed scorpion-tailed sphinxes, 215, *215*; showing a royal falconer trampling a knotted dragon, 164, *164*

mirroring, 130

Mokha, 209

Mongols, 16–17, 19, 101, 183, 225, 229, 236n85

monkeys, 191, 196, 206, 212, 214

Monophysitism, 180

Moore, Liam, 73

mosaics, 45, *46*, *47*, 48

Moshchevaya Balka, Caucasus, 9

Mosul, 145, 193

Mu'awiya, Umayyad caliph, 243n15

al-Mu'ayyad Shaykh, Mamluk sultan, 124

Muhammad (Prophet), 131, 133, 138

Mu'izz li-Din Allah, Fatimid caliph, 246n146

Mukherji, Parul Dave, 230–231

Mumbai, 205

Munich, 39

Münster, *77*, *79*, 87, 91–92, 95, *97*, *98*, 99, 101, 103–104, 106–109

Münster goblet. *See* coconut reliquaries

muqarnas, 183, *211*, *212*, *213*, 220, 224

al-Mustansir billah, Fatimid caliph, 60

al-Mu'tamid, Abbasid caliph, 130

Muzhi, Siberia, 82

N

Nachleben (living on), 232–233

Nagareśvara temple, Halebid, Karnataka, India, 176, *176*

Naples, 101

Narga Selassé church, Lake Tana, Ethiopia, 182, *182*

al-Nasir, Abbasid caliph, 138

Negus of Ethiopia, 202. *See also* Axum

networks, 9, 229–233

niello, 5, 10; Andalusian-origin objects featuring, 53, 58, 60, 66, 73, 82–83, 85; Christian significance of trimetallic, 54–55, 77, 81, 82; composition of, 53, 55–57, 73; conceptions of, 55; dating of, 57; imitations of, 73–77; leaded, 18, 53, 56–58, 60, 66, 69, 71, 73, 75, 77, 81, 83; manuals about, 54, 56–57, 60; origins of, 56–57, 60, 66, 69, 71, 73, 81–83, 85; technical analysis of, 57–58, 60, 77; techniques of, 56, 58, 81, 83; transmission of techniques for, 8, 18, 53, 60, 66, 69, 71, 73, 81–83, 85

Nihavand, 57, 69

Nile, Nilotic scenes, 47–48, *48*, *49*

nimbus, 207

Noah, 127, 202, 217

Normans, 183, 240n30

Nubia, 41, *42*, 47, 159, 160, 162, 165, 230. *See also* Dongola

Nur al-Din ibn Zangi, 115, 128, 224, 226

nutmeg and coconut, from the *Tractatus de herbis*, 92, *93*

Nye, Joseph, 16

O

objects: archival value of, 4; "biographies" of, 9; concept of, 3; meanings (actual and potential) of, 4–5, 7–8; repurposing of, 10; scholarly approaches to, 9; as source of transmission of techniques, 5, 53; temporalities of, 232; written documents in relation to, 1, 4, 57, 60, 71, 82, 85. *See also* circulation and reception of objects

O'Kane, Bernard, 207

Okeanos, 48

Oman, 44, 192, 194, 201, 203

On the Noble and Illustrious Art of the Goldsmith, 56

Origen of Alexandria, 103

ostensories: 87, 89, 91; in the shape of a fish, 89, *90;* with rock crystal cylinder, 89, *90* with so-called Hedwig-beaker, 89, *90*. *See also* reliquaries

ostrich egg, 105

Otto III (Holy Roman emperor), 95

Ousanas, ruler of Axum, 151, 153, *153*

Ovid, 98

P

Pabst, Bernhard, 103

Paderborn, 81, 241n61

Palermo, Capella Palatina, 183, 197, 212, *213*

Palestine, 18, 28, 32, 33, 45, 132, 158, 191

Paradise, 101, 103–105, 107–109

parrots, 214

Paul, Saint, 108

Paul of Thebes, 162

Pelagius, Saint, 73

Pelka, Otto, 237n6

Pentcheva, Bissera, 42

periodization, 16, 17, 231–232. *See also* chronology and dating

Philippines, 92

Phillipps-Corning manuscript, 57

Physiologus, 105–106

Picatrix. *See* *Ghāyat al-Ḥakīm*

Piguet-Panayotova, Dora, 42

pilgrimage objects, 28, 32, 36, 42, 44, 49. *See also* eulogia tokens

Pisa Griffin, 66, *67*

Planets. *See* astrological imagery; zodiacal signs

Platearius, Mattheus: *Circa instans* (*The Book of Simple Medicines*), 92; *Compendium salernitanum*, 92, *94*

Pliny, 55

poison: coconut as antidote to, 99, 103–104; dragons linked to, 105–106; and theriacs 131, 133, 136, 145. *See also* Islamic magic-medicinal bowls
polos, 220, *221*
Pomerania, 79
Pompeii, Italy, 9
Poreč, 45
Porter, Roy, 1
prime objects, 8–9, 123–124
Prophetic medicine 131, 133, 139, 140, 243n21
protection, 2; in childbirth, 122, 127, 133, 145, 194, 215, 217–219; coconut used for, 99, 103–104; magic-medicinal bowls used for, 18, 113, 115, 125–135; on maritime voyages, 3, 12, 18, 189, 217–219; against snakes, scorpions, and dogs, 115, 116, 118, 125–138, 221, 223; temporalities of, 138. *See also* amulets; medicine and healing; talismans
proxies. *See* surrogacy
pyxides, 36, *38*, 58, *58*, *59*, 71

Q

Qal'at Sem'an, 43, *43*
Qalawun, Mamluk sultan, 244n68
Qara Arslan ibn Dawud, Fakhr al-Din, 126
Qasr Ibrim, 159
Qipchaqs, 10
Qorqor Maryam, Tigray, 169–170, *170*, 189
Quilon (Kollam), 101, 210
Qur'an, 117, 127–129, 131, 133, 138–140, 145, 191, 209, 243n55, 246n9
Quseir al-Qadim, 3, 8, 186, 217

R

Rabbula Gospels, 28, *29*, 49
rabies, 115, 118, 128, 130–132, 137
Raby, Julian, 235n35
al-Ramhurmuzi, Buzurg ibn Shahriyar, *Kitāb 'Ajā'ib al-Hind* (Book of the wonders of India), 205–207
Ramisht of Siraf, 220
Raqqa, 167
Rassamakin, Yuriy, 10
Rasulid sultans, 115, 184, 187, 249n147
Raymond of Burgundy, 73
Redford, Scott, 99
Red Sea, 2, 3, 7, 8, 154, 184, 186, 189, 203, 205, 212, 217, 219, 247n50
Regensburg, 95
Reil, Johannes, 237n6
relics: Christ's blood, 87, 92, 99, 101, 104, 109; containers for, 44, 73, 75, 87, 89, 91, 100–101, 103, 104, 106, 107; healing power associated with, 43–45, 109; housed in church treasuries, 89; Saint Heribert's chalice, 95; Saint Pelagius, 72, 73; Saint Thomas the Apostle, 180; secondary, 45, 49; True Cross fragments, 44, 92, 101
reliquaries, 73, 75, 89, 91, 92, 99–101; reliquary-ciborium with the chalice of Saint Heribert, 95, *96*, 109; reliquary crucifix, 60, *61*, *62*, 75, *75;* reliquary of the miraculous blood, 89, *90*; reliquary with flask in the shape of two birds, 98, *99*; reliquary with heart-shaped lid, 71, *71*. *See also* ostensories
Rhineland, 10, *11*, 82
rhinoceros, 153, 173
Richter, Jörg, 108
Richter-Siebels, Ilse, 34, 236n3
Roberts, Jennifer L., 231, 232
Robinson, Cynthia, 60, 66

rock crystal: 7, 18, 71, *77*, *78*, *79*, 87, 89, *90*, *91*, 92, 95, *96*, *99*, 101, 104, 108–109, 230; bottle in the shape of a lion, 89, *91*, 92; in composite objects, 18, 87–109; meanings and associations of, 101, 108; origin of work in, 71; sculpting of, 95
Roger, Eugène, 113
Roger of Helmarshausen, 77, 81, 241n61
Rosser-Owen, Mariam, 71
Rückenfiguren (figures seen from behind), 33–34
Rufus of Ephesus, 130

S

Sadaqa ibn Yusuf, casket of, 53, *54*, *54* (detail), 56, 58, 60, 66, 69, 71, 73, 77, 81
saffron, medicinal and occult uses of, 115, 118, 128, 133, 218, 243n5, 251n125
Saint Anthony's Monastery, Egypt, 153, *154*, 157, 162, 247n50
Saint Mary church, Asmara, Eritrea, wood panels, 153, *155*, 182
Saint Petersburg, 69, 71, 77, 81, 203, 204
Salzburg, 95
al-Samarqandi, 'Abd al-Razzaq, 187
Samarra, Iraq, 212, *213*
Sancha of León-Castilla, 73–75
sandalwood, 92, 210
Sanjan, 205
Sanskrit, 12, 211, 241n16
Sapinud, 197
Sasanian art, 153
Savior of the World (Medhane Alem) church, Lalibela, Ethiopia, 173, *174*, *180*, 180, 186–187
Schloss Ehrenburg, 95
scorpions, 115, 116, 118, 125, 127–138, 221, 223
scrolls. *See* healing scrolls
seals, sealing, 118, 127, 128, 132, 133, 135, 136, 138, 139, 140, 144, 145, 245n116
sea voyages. *See* maritime voyages
Seljuqs, 12, 140, 147, 151, 223
sensory experiences, 47, 50. *See also* smell
Serçe Limanı shipwreck, 12–13
Serpent Gate, Aleppo, 125, *125*, 138, 157
serpents. *See* dragons; snakes
Shadbakht, 202
Shāhnāma (Book of Kings), 140, 197
Shalem, Avinoam, 71
Shanga, 187
shields, 173, *174*, 176–177, 179–181, *180*, *181*, 187
Shiva, 210
Siberia, 10, 11, 82, 85
Sicily, 42, 98, 183
Silk Road, 2, 235n11
Simon of Genoa, 87
Siraf, 206, 220
al-Sirafi, Abu Zayd, *Akhbār al-Ṣīn wa'l-Hind* (Reports of China and India), 205–207
Sisinnios, Saint, 157–162, 247n50. *See also* Susenyos
slavery/slaves, 9, 202–203, 207, *208*, 209–210, 250n25; 251n88
smell, 42–44. *See also* aromatics
Smith, Pamela H., 229
snakes, 115, 118, 125, 127–138, 221
Sofala, 207
Sohar, *192*, 194, 196, 201, *203*, 210
Solomon, 141, 157–159, 161, 224, 243n17, 247n44
Somalia, 41
Soucek, Priscilla, 240n37

sphinxes, 151, 165–171, 191, 196, 212–215, 220, *221*, 224, 227, 230
spirals: circulation and reception of, 82; comparisons of, 69; meanings of, 55, 79–85; as ornament, 58, 60, 66, 69, 75, 77, 81–83, 85; structural purpose of, 77, 79; techniques for creating, 56, 58, 77
Sri Lanka, 101, 103, 109
Steedman, Carolyn, 16
stones. *See* bezoar; gems; lapis lazuli; rock crystal
St. Petersburg, *56*, 69, 71, *73, 74*, 77, 81, *189*, 203–204, 237n9
Strassburg, Ulrich von, 103
Strathern, Alan, 16
Suger, Abbot, 98
Sulayman the Merchant, *Akhbār al-Ṣīn wa'l-Hind* (Reports of China and India), 205–207
surrogacy, 50, 129–130
Susenyos, Saint, spearing a demon, 159–160, *160*
Swahili Coast, 187, 189
sword hilt featuring a *hamsa* (auspicious swan) motif, 12–13, *14*
Symeon the Elder, Saint, 42, 238n59; pilgrim token of, *43*, 44; relief with depiction of, *43*
sympathetic relationships, 131, 135, 136, 138
Syria: 5, 6, 31, 33, 35, 42, 44, 45, 115, 118, 123, 124, 125, 126, 132, 135, 140, 143, 147, 157, 164, 167, 169, 184, 186, 191, 193, 194, 197, 220, 221, 223, 224; censers, 28, 31, 35, 42, 44; illustrated books from, 193–194, 197; magic-medicinal bowls, 115, 118, 123–125, 140, 143, 157. *See also* Aleppo; Damascus; Hims; Qal'at Sem'an
Syriac, 28, 31, 105, 115, 124, 237n9
Syriac Christians, 180

T

Taifa kingdoms, 53, 66, 73
Talisman Gate, Baghdad, 138, *139*, 160
talismans, 18, 113, 115, 118, 122, 123, 125–126, 127, 131, 133–135, 137, *139*, 141, 169, 215, 217–221, 223–224
Tebtunis, 159
technique and technical knowledge: channels for transfers of, 53, 71, 73; for niello, 8, 18, 53–85; transmission of, 4–5, 53, 60, 66, 69, 71, 73, 81–83, 85
temporalities: of censers, 47–51; Christian, 48–49, 51; complexity of, 232; of composite objects, 224, 227; of cultures, 17–18; iconographic revivals, 220–224; of Islamic magic-medicinal bowls, 117, 138–140; network conception of, 231–232; of objects, 8–9, 232; of al-Wasiti's *Maqāmāt* images, 219–224. *See also* chronology and dating; periodization
Teruel, *51, 52*, 60, 66, 69, 81,
Testament of Solomon, 157, 159
textiles, 5, 6, 7, 48, *49*, 106, 166, 179, 184, 186, 196, 220, 240n37
Thailand, 205
Theodore Stratelates, Saint, 153, *154*
Theodoros, 45
Theodulph of Orleans, 44
Theophanes, 42
Theophilus Presbyter, *De diversis artibus*, 57, 77
theriacs, 131, 133, 136, 145. *See also* poison
thing, concept of, 1, 3–4, 8–9, 15, 79, 231
Thomas the Apostle, Saint, 101, 107, 180, 248n105
Thousand and One Nights, 206
Tiberius, Mauricius, 39
al-Tifashi, Ahmad ibn Yusuf, 218
Tigray: Abraha and Atsbeha church, Wuqro, 185, *185*, 186; Bilet, 186; Debra Damo, 5–6; Debra Selam Mikael, 248n105, 248n106; Kwiha, 186; Qorqor Maryam, 169 170,*170*, 189
Tigris, 124, 127, 206

Toledo, 66, 69
transmediality, 4, 181, 194
treasuries, 6, *29*, 51, 70, 71, 73, 83, 87, 89, 91, 92, 95, *96*, 98–101, 104–105, 107–108, 122, 124, 140, 142, 143, 182, 184, 186–187, 232, 235n36, 238n32, 239n5, 240n40, 240n42, 242n20
Trier Ivory, 44, *45*
Trinity, 55, 75, 77, 79, 81–83, 85, 92
Trouillot, Michel-Rolph, 17, 230
True Cross relics, 44, 92, 101
Trzemeszno, chalice and paten from, 77, *78*, *78* (detail), 79

U

al-Uballa, 203–205, 207
Ukraine, covered cup found at Chungul Kurgan, 10, *11*, 82
Umayyad caliphate, 33, 53, 124, 243n15, 246n139
UNESCO World Heritage sites, 147
Urraca, queen of León-Castilla, 73
'Uthman, artisan 60, 75

V

Vatican pilgrim casket, 28, *29*, 49
Venice, 95
Vermand Treasure, 77
Vienna, 77, 79
Vikan, Gary, 237n6
Vikings, 9–10, 235n48
Vishnu, 210

W

al-Walid I, Umayyad caliph, 246n139
Walker, Alicia, 13
Wallerstein, Immanuel, 16
Walsperger map, 10
Warburg, Aby, 232–233
Wasit, 206
al-Wasiti, Yahya, *Maqāmāt*, 193–194, 199, 202–204, 206–207, 209–215, 219–220, 224; image of a ship sailing to Sohar, Oman, 191, *192*, 193, 195–196, *196* (detail), 199, 206, 210; scene of an enchanted island, 191, 193, *193*, 196, 204, 206, 210, 213–214, *214* (detail), 220; scene of arrival at the palace, 191, 193, *193*, 196, 210, 210–213, *211* (detail), *212* (detail); scene of a slave market in Zabid, 207, *208, 209* (detail), 210; scene of birth within the palace, 195, *195*, 196, 201, 207, 210, 215, *217* (details), 218–219
wax, 34–35
Wërzëlyā, 159, 171, 247n50
west Asia, 15, 16, 17, 23, 32, 50, 98, 133, 115, 117, 166, 171, 218, 220, 227
Wilten chalice and paten, 60, *63, 64, 76* (details), 77, 79, 81
world systems theory, 16

Y

Yemen, 2, 3, 44, 56, 115, 184–187, 197, 203, 207, 209, 221, 249n147. *See also* Mokha; Zabid
Yemrehanna Krestos church, near Lalibela, Ethiopia, 153, *155*, 170–171, *171, 173*, 177, *177, 178*, 179–180, 183, *188*, 189, 191
Yonan, Michael, 1

Z

Zabid, 207, *208*, 210

Zacharias, Saint, 45, *47*, 238n45

Zagwe dynasty, 147, 149, 153, 156, 158–159, 166, 179, 183, 186–187, 189

al-Zahir Baybars, Mamluk sultan, 122, 246n146

Zahr's scent flask (or Albarracín flask), 60, *65*, 66, 69, 81

Zamora Pyxis, 58, *59*, 71

Zangid dynasty, 115, 244n51. *See also* Nur al-Din ibn Zangi

Zanj, 207, 210

Zanzibar, 187

Zayla, 186, 212

zebra, 249n147

Zir Ganela Gospels, 170, *171*

zodiacal signs, 127, 134, 136–138, 145, 246n157. *See also* astrological imagery

Image Credits

Fig. 1 © The Swedish History Museum/SHM, Stockholm. Photograph: Ola Myrin

Fig. 2 © Museum of Historical Treasures of Ukraine, Kyiv, Ukraine. Photograph: D. V. Klochko

Fig. 3 © The Metropolitan Museum of Art, New York

Fig. 4 © Institute of Nautical Archaeology

Fig. 5 photograph: © Beate Fricke

Fig. 6 © Antikenmuseum Basel und Sammlung Ludwig

Fig. 7 © Israel Museum, Jerusalem. Photograph: Avraham Hay

Fig. 8 after Carole Billod [Billod (1987), pl. 4], with permission

Fig. 9 after Carole Billod [Billod (1987), fig. 1], with permission

Fig. 10 photomontage: © Beate Fricke

Fig. 11 © Virginia Museum of Fine Arts, Richmond, VA. Adolph D. and Wilkins C. Williams Fund purchase. Photograph: Travis Fullerton

Fig. 12 © Skulpturensammlung und Museum für Byzantinische Kunst der Staatlichen Museen zu Berlin—Sammlung Preußischer Kulturbesitz

Fig. 13 © Biblioteca Medicea Laurenziana, Florence

Fig. 14 © Museo Sacro, Vatican City

Fig. 15 © Dumbarton Oaks Byzantine Collection, Washington, DC

Fig. 16 © The Museum of Art and Archeology, University of Missouri, Columbia

Fig. 17 © The Trustees of the British Museum

Fig. 18 © Israel Antiquities Authority

Fig. 19 photograph: © Beate Fricke

Fig. 20 © bpk/Staatliche Kunstsammlungen Dresden / Reinhardt Seurig / Hans-Jürgen Genzel

Fig. 21 © Ville de Genève, Musées d'art et d'histoire, 1975 purchase

Figs. 22 & 23 © Antikenmuseum Basel und Sammlung Ludwig

Fig. 24 © The Trustees of the British Museum

Fig. 25a © The Metropolitan Museum of Art, New York

Fig. 25b photograph: © Beate Fricke

Fig. 25c © Skulpturensammlung und Museum für Byzantinische Kunst der Staatlichen Museen zu Berlin—Sammlung Preußischer Kulturbesitz

Fig. 25d © The Walters Art Museum, Baltimore

Fig. 25e © Virginia Museum of Fine Arts, Richmond, VA. Adolph D. and Wilkins C. Williams Fund purchase. Photo: Travis Fullerton

Fig. 25f © RMN-Grand Palais. Photograph: Hervé Lewandowski

Fig. 26 © Kornbluth Photographs

Fig. 27 © Eskenazi Museum of Art. Photograph: Kevin Montague

Fig. 28 © Bayerisches Nationalmuseum. Photograph: Bastian Krack

Fig. 29 © The Metropolitan Museum of Art, New York

Fig. 30 © PCMA Dongola Project. Photograph: W. Godlewski

Fig. 31 © Skulpturensammlung und Museum für Byzantinische Kunst der Staatlichen Museen zu Berlin—Preußischer Kulturbesitz. Photograph: Jürgen Liepe

Fig. 32 © The Walters Art Museum, Baltimore

Fig. 33 photograph: © Ann Münchow

Figs. 34 & 35 scans from publication before 1923

Fig. 36 © Antikenmuseum Basel und Sammlung Ludwig

Fig. 37 © Abegg-Stiftung, CH-3132 Riggisberg. Photograph: Christoph von Virag

Fig. 38 photograph: © Beate Fricke

Figs. 39 & 40 © Museo San Isidoro de León. All rights reserved. Whole or partial reproduction prohibited. Photograph: Fernando Ruiz Tomé

Fig 41 © bpk/The Metropolitan Museum of Art, New York

Fig. 42 © Victoria and Albert Museum, London

Fig. 43 © The Trustees of the British Museum

Fig. 44 © Victoria and Albert Museum, London

Fig. 45 © Museo Arqueológico Nacional, Madrid. Photograph: Ángel Martínez Levas

Figs. 46 & 47 © bpk/The Metropolitan Museum of Art, New York

Figs. 48 & 49 © KHM-Museumsverband

Fig. 50 © Museo Arqueológico Nacional, Madrid. Photograph: Ángel Martínez Levas

Figs. 51 & 52 © Museo de Teruel, Archivo Fotográfico

Fig. 53 © Museo Arqueológico Nacional, Madrid. Photograph: Ángel Otero

Fig. 54 © Museo Nazionale del Bargello, Florence

Fig. 55 © Museo dell'Opera del Duomo, Pisa, Archivio Fotografico

Fig. 56 © The State Hermitage Museum, Saint Petersburg. Photograph: Vladimir Terebenin, Yuri Molodkovets

Fig. 57 courtesy of the L. A. Mayer Museum for Islamic Art, Jerusalem. Photograph: Avshalom Avital

Figs. 58 & 59 © Colección Capítol Catedral de Girona / Autor 3DTecnics

Fig. 60 © Museo Diocesano di Capua, Capua

Figs. 61 & 62 © Museo San Isidoro de León. All rights reserved. Whole or partial reproduction prohibited

Fig. 63 © Museo Arqueológico Nacional, Madrid. Photograph: Ángel Martínez Levas

Fig. 64 © Museo San Isidoro de León. All rights reserved. Whole or partial reproduction prohibited. Photograph: Fernando Ruiz Tomé

Fig. 65 © bpk/The Metropolitan Museum of Art, New York

Figs. 66 & 67 © KHM-Museumsverband, Vienna

Figs. 68 & 69 © Muzeum Archidiecezji Gnieźnieńskiej

Fig. 70 © bpk/The Metropolitan Museum of Art, New York

Figs. 71 & 72 © Diözesanmuseum Paderborn. Photographs: Ansgar Hoffmann

Figs. 73 & 74 © The State Hermitage Museum, Saint Petersburg. Photographs: Natalia Antonova, Inna Regentova

Fig. 75 © RMN-Grand Palais (Musée du Louvre) / Martine Beck-Coppolan

Fig. 76 © The Swedish History Museum/SHM, Stockholm

Figs. 77–79 © St.-Paulus-Dom, Domverwaltung, Münster

Figs. 80a & 80b © Elmar Egner M.A., Domschatz Quedlinburg

Fig. 80c © Archivio fotografico della procuratoria di San Marco

Fig. 81 © Domschatz Minden

Fig. 82 © The Trustees of the British Museum

Fig. 83 © RMN-Grand Palais (Musée du Louvre) / Hervé Lewandowski

Fig. 84 © Church of St. Ursula, Cologne. Photograph: Rheinisches Bildarchiv

Fig. 85 © The British Library Board

Fig. 86 © The Pierpont Morgan Library & Museum

Fig. 87 © St. Catherine's Monastery, Sinai

Fig. 88 © Kirchengemeinde St. Heribert, Cologne. Photograph: Klaus Maximilian Gierden/Rheinisches Bildarchiv

Fig. 89 © Dommuseum Hildesheim. Photograph: Florian Monheim

Figs. 90 & 91 © Palazzo Pitti, Museo degli argenti, Florence

Fig. 92 © Kunstsammlungen des Bistums Regensburg. Photograph: Wolfgang Ruhl

Fig. 93 photograph: © Axel Killian

Fig. 94 © Museo Cristiano, Cividale del Friuli

Fig. 95 © Kolumba, Cologne. Photograph: Lothar Schnepf

Fig. 96 © Elmar Egner M.A., Domschatz Quedlinburg

Fig. 97 © Christop Bathe, LWL-Denkmalpflege, Landschafts- und Baukultur in Westfalen

Fig. 98 © Bischoefliches Generalvikariat, Abtlg. Kunst und Kultur, Kunstpflege. Photograph: Dr. Michael Reuter, 2011, all rights reserved

Fig. 99 © Historisches Museum Basel. Photograph: P. Portner

Fig. 100 © Palazzo Pitti, Tesoro dei Granduchi, Florence

Fig. 101 © Kulturstiftung Sachsen-Anhalt, Domschatz Halberstadt. Photograph: Bertram Kober

Fig. 102 © Bibliothèque nationale de France

Fig. 103 © The David Collection, Copenhagen. Photograph: Pernille Kemp

Fig. 104 courtesy of the Penn Museum, Philadelphia. Image no. 295739

Fig. 105 © The al-Sabah Collection, Dar al-Athar al-Islamiyyah, Kuwait

Fig. 106 © bpk/Museum für Islamische Kunst (SMB), Berlin. Photograph: Georg Niedermeiser

Fig. 107 © bpk/Ethnologisches Museum (SMB), Berlin

Fig. 108 © Royal Ontario Museum, Toronto

Fig. 109 after E. Rehatsek [from Rehatsek (1873–74)]

Fig. 110 © SSPL/Science Museum / Art Resource, NY

Fig. 111 © Museum of Islamic Art, Cairo. Photograph: Bernard O'Kane

Fig. 112 © Alamy. Photograph: Bernard O'Kane

Fig. 113 © T.C. Kültür ve Turizm Bakanlığı, Türk ve İslam Eserleri Müzesi

Fig. 114 courtesy of Topkapı Palace Museum, Istanbul

Fig. 115a © Nomos Auctions

Fig. 115b © American Numismatic Society

Fig. 116 © Biblioteca Medicea Laurenziana, Florence

Fig. 117 © Bibliothèque nationale de France

Fig. 118 © Kelsey Museum of Archaeology, University of Michigan, Ann Arbor

Fig. 119 © Ashmolean Museum, University of Oxford

Fig. 120 © Musée du Louvre, Dist. RMN-Grand Palais / Claire Tabbagh / Collections Numériques

Fig. 121 © The Trustees of the British Museum

Fig. 122 © Bibliothèque nationale de France

Fig. 123 after E. Rehatsek [from Rehatsek (1873–74) (detail)]

Fig. 124 © Bibliothèque nationale de France

Fig. 125 © The Metropolitan Museum of Art / Art Resource, NY. Artist: Ernst Emil Herzfeld

Fig. 126 © Cambridge University Library, Taylor-Schechter Collection

Fig. 127 © Bibliothèque nationale de France

Fig. 128 © Eskenazi Museum of Art / Kevin Montague

Fig. 129 © Musée du Louvre, Dist. RMN-Grand Palais / Claire Tabbagh / Collections Numériques

Figs. 130–138 photographs: © Finbarr Barry Flood

Fig. 139 © Ashmolean Museum, University of Oxford

Fig. 140 reproduced by permission of the American Research Center in Egypt, Inc. (ARCE). Project funded by the United States Agency for International Development (USAID)

Fig. 141 after Francis Anfray [= Anfray (1965), pl. VII]

Fig. 142 photograph: © Georg Gerster

Fig. 143 after Jean Clédat [= Clédat (1904), pl. LVI]

Fig. 144 © The Walters Art Museum, Baltimore

Fig. 145 © Ashmolean Museum, University of Oxford

Fig. 146 © Wellcome Collection, London

Fig. 147 © The Trustees of the British Museum

Fig. 148 photograph: © Finbarr Barry Flood

Fig. 149 © Freer Gallery of Art, Smithsonian Institution, Washington, DC. Charles Lang Freer Endowment purchase

Fig. 150 © The Keir Collection of Islamic Art, on loan to the Dallas Museum of Art

Fig. 151 courtesy of Furūsiyya Art Foundation. Photograph: Noël Adams

Fig. 152 © Topkapı Palace Museum, Istanbul

Fig. 153 after Edmond Pauty [= Pauty (1932), pl. II (detail)]

Fig. 154 photograph: © Finbarr Barry Flood

Fig. 155 after Francis Anfray [from Anfray (1990)]

Fig. 156 courtesy of Stephennie Mulder. Drawing: Khalid Alhamid

Fig. 157 © The David Collection, Copenhagen. Photograph: Pernille Kemp

Fig. 158a courtesy of Adeline Jeudy

Fig. 158b after Edmond Pauty [= Pauty (1932), pl. II (detail)]

Figs. 159 & 160 photographs: © Finbarr Barry Flood

Fig. 161 © The Pierpont Morgan Library & Museum. Lewis Cass Ledyars Fund purchase, 1948

Figs. 162 164 photographs: © Finbarr Barry Flood

Fig. 165 © Bergamo, Biblioteca Civica Angelo Mai

Fig. 166 after Alessandro Augusto Monti della Corte [= Monti della Corte (1940), pl. XXXVI]

Figs. 167a,b & 168 photographs: © Finbarr Barry Flood

Fig. 169 after Alessandro Augusto Monti della Corte [= Monti della Corte (1940), pl. XXXVIII]

Figs. 170–172 photographs: © Finbarr Barry Flood

Fig. 173 © Finbarr Barry Flood. Drawing: Cem Ozdeniz

Figs. 174 & 175b © Biblioteca Civica Angelo Mai, Bergamo

Figs. 175a & 176 photographs: © Finbarr Barry Flood

Fig. 177 after Antonio Mordini [= Mordini (1940), 105–7]

Fig. 178 photograph: © Finbarr Barry Flood

Fig. 179 photograph: © Georg Gerster

Figs. 180–184 © Bibliothèque nationale de France

Fig. 185 © Veneranda Biblioteca Ambrosiana, Milan

Fig. 186 © Freer Gallery of Art, Smithsonian Institution, Washington, DC. Charles Lang Freer Endowment purchase

Figs. 187 & 188 © The Metropolitan Museum of Art / Art Resource, NY

Fig. 189 © Alamy

Fig. 190 © Bibliothèque nationale de France

Fig. 191 © Alamy

Fig. 192 © 2022 Museum Associates / LACMA. Licensed by Art Resource, NY

Fig. 193 after Rukshana J. Nanji [= Nanji (2011), pl. 8]

Figs. 194–197 © Bibliothèque nationale de France

Fig. 198 © Yasser Tabbaa Archive, courtesy of Aga Khan Documentation Center, MIT Libraries

Fig. 199 courtesy of Jeremy Johns, Khalili Research Centre, University of Oxford / © The Barakat Trust and the University of Edinburgh

Fig. 200 © Bibliothèque nationale de France

Fig. 201 courtesy of The Sarikhani Collection. Photograph: Clarissa Bruce

Figs. 202 & 203 © bpk/The Metropolitan Museum of Art, New York

Figs. 204–206 © Bibliothèque nationale de France

Fig. 207 © The David Collection, Copenhagen. Photograph: Pernille Klemp

Fig. 208 © The Trustees of the British Museum

Fig. 209 © Bibliothèque nationale de France

Fig. 210 photograph courtesy of Prof. Dr. Kay Kohlmeyer

Fig. 211 © The Schøyen Collection, Oslo and London

Fig. 212 © Alamy

Maps 1–6 by Matilde Grimaldi © Finbarr Barry Flood and Beate Fricke

Published by Princeton University Press,
41 William Street,
Princeton, New Jersey 08540

In the United Kingdom: Princeton University Press,
99 Banbury Road, Oxford OX2 6JX
press.princeton.edu

Front jacket images (*top to bottom*), details of:

Silver casket with blessings, from the Colegiata de an Isidoro, al-Andalus, Madrid, Museo Arqueológico Nacional, inv. no. 50867. © Museo Arqueológico Nacional, Madrid. Photograph: Ángel Martínez Levas

Maqāmāt of al-Hariri, Paris, BnF, MS Arabe 5847, fol. 121a. © Bibliothèque nationale de France

Amulet, Byzantine, 5th–6th century, London, British Museum, inv. no. 1938,1010. © The Trustees of the British Museum

Base carving, Nagareśvara temple, Halebid, Karnataka. © Finbarr Barry Flood

Back jacket images (*top to bottom*), details of:

Coconut goblet used as reliquary or pyxis. Münster, Domkammer St. Paulus, inv. no. E.6. © St.-Paulus-Dom, Domverwaltung, Münster

Aramaic incantation bowl. Nippur, Iraq, 3rd–4th century. Courtesy of Penn Museum, Philadelphia, image no. 295739 and object no. B2945

View of the base of a censer with New Testament scenes, 6th–7th century. Bronze. Paris, Musée du Louvre, inv. no. E 11710. © RMN-Grand Palais. Photograph: Hervé Lewandowski

Painted plaque above the northern entrance to the church of Yemrehanna Krestos, Ethiopia. © Finbarr Barry Flood

Library of Congress Cataloging-in-Publication Data
Names: Flood, Finbarr Barry, author. | Fricke, Beate, author.
Title: Tales things tell : material histories of early globalisms / Finbarr Barry Flood and Beate Fricke.
Other titles: Material histories of early globalisms
Description: Princeton : Princeton University Press, [2023] | Includes bibliographical references and index.
Identifiers: LCCN 2022059286 (print) | LCCN 2022059287 (ebook) | ISBN 9780691215150 (hardback) | ISBN 9780691252667 (ebook)
Subjects: LCSH: Civilization, Medieval—12th century—Sources. | Civilization, Medieval—13th century—Sources. | Material culture—Case studies. | Culture and globalization—Case studies. | History—Methodology—Case studies. | BISAC: ART / History / Medieval | HISTORY / Africa / East
Classification: LCC CB354.6 .F56 2023 (print) | LCC CB354.6 (ebook) | DDC 909.07—dc23/eng/20230602
LC record available at https://lccn.loc.gov/2022059286
LC ebook record available at https://lccn.loc.gov/2022059287

British Library Cataloging-in-Publication Data is available

This publication is supported by a Collaborative Research Fellowship from the American Council of Learned Societies (ACLS); the European Research Council; the University of Bern, Switzerland; and by the Ellen-Beer-Foundation.

Designed by Jeff Wincapaw
This book has been composed in Feijoa Medium and Source Sans Pro

Printed on acid-free paper. ∞
Printed in Italy
10 9 8 7 6 5 4 3 2 1